R-CH

The
Comprehensive Catalog
of

U.S.
PAPER MONEY

All United States federal currency
since 1812

Fifth Edition

Gene Hessler

Library of Congress Cataloging in Publication Data

Hessler, Gene, 1928-
 The comprehensive catalog of U.S. paper money.
 Bibliography: p.
 Includes index.
 1. Paper Money-United States. 2. Paper Money-Catalogs. I. Title.

Published by BNR Press
132 East Second Street, Port Clinton, Ohio 43452-1115
 (419) 732-6683 or 734-6683, FAX 732-6683
Manufactured in the United States
Library of Congress Catalog Number: 92-72745
International Standard Book Numbers:
 soft bound; 0-931960-30-4
 hard bound; 0-931960-29-0
American Numismatic Association Library Catalog Number: US40.H4 1992

Contents

Foreword . iv
Preface . v
Acknowledgments . vi
Syngraphics . viii
Paper money terms and abbreviations . ix, x
Chapter 1: A history of paper money . 1
Chapter 2: Types of United States paper money . 33
Chapter 3: Catalog of United States paper money 51
 Interest-bearing treasury notes 1812-1860 . 55
 $1 notes . 73
 $2 notes . 99
 $5 notes . 113
 $10 notes . 151
 $20 notes . 191
 $50 notes . 227
 $100 notes . 261
 $500 notes . 295
 $1,000 notes . 311
 $5,000 notes . 328
 $10,000 notes . 336
 $100,000 notes . 345
 Unissued and rejected designs . 347
 Fractional currency . 350
 Encased postage stamps . 379
 Postal Notes . 387
 Uncut sheets of currency . 390
 Notes of special interest . 409
 Error notes . 414
 Bureau of Engraving and Printing souvenir cards 429
 Paper money that circulated outside the continental U.S. 431
 Alaska . 431
 Hawaii . 432
 Philippines . 433
 Puerto Rico . 439
 Virgin Islands . 441
 Military payment certificates . 442
 Select biographies of paper money designers and engravers 470
 Food stamps and coupons . 472
Chapter 4: Cleaning, housing and caring for paper money 476
Appendix A: Note-issuing national banks . 480
Catalog number cross-reference . 508
Bibliography . 509
Index . 512

Foreword

The American Numismatic Association's Library copy of *The Comprehensive Catalog of U.S. Paper Money*, fourth edition, 1983, is worn and tattered. This condition is not from age, but rather because it is one of the most popular reference works on U.S. currency in the ANA's Resource Center. There is a copy of the same edition of the *Catalog* in the ANA library stacks immediately behind the librarian's desk. I know, as I often go to the library either to use it as a reference or to borrow it.

Indeed, Gene's *Catalog* **is** comprehensive. It begins with an extensive history of paper money, offers descriptions and illustrations of types of U.S. paper money, and ultimately examines, in-depth and by denomination, all types of U.S. federal paper money since 1812. It is a veritable treasure. I referred the producers of "Making a Dishonest Buck," a March 1992 NOVA Public Broadcasting System television documentary on counterfeiting, to *The Comprehensive Catalog of U.S. Paper Money* as the most concise and best presentation for reference and background purposes.

Gene told me he had some problems with the fourth edition; most of them concerned typographical errors that caused some inaccuracies. He has corrected these in this fifth edition, supplying additional information, photographs and bringing the *Catalog* up to date.

This new edition of *The Comprehensive Catalog of U.S. Paper Money* is again designed for easy use by the experienced syngraphist (a collector of paper money), the emerging collector and anyone in need of a great resource. In fact, any researcher will be caught by the layout and interesting facts and be led to study or pursue the *Catalog*'s other sections.

Gene Hessler is well-known to readers of *The Numismatist*, both as a columnist and a contributing editor. Gene received the 1991 first place award for Foreign Paper Money and the prestigious Howland Wood Award at the Centennial Convention of the American Numismatic Association held in Chicago for his Best of Show Exhibit, "Max Svabinsky – Czechoslovak Designer, His Complete Works."

It is my expectation that the fifth edition of *The Comprehensive Catalog of U.S. Paper Money*, now in its 18th year of publication, will be received as warmly, and even more extensively used, than its predecessors. I look forward to seeing many well-worn copies, not only in the ANA Resource Center, but among the reference sets of currency collectors. This is a most welcome new edition.

Robert J. Leuver
Executive Director, American Numismatic Association.
Former Director, U.S. Bureau of Engraving and Printing
 U.S. Department of the Treasury.

Preface

Since the first edition of *The Comprehensive Catalog of U.S. Paper Money* every effort has been made to present a work worthy of the title. In this edition all federal paper money issued since 1812 is listed; therefore the title is fulfilled. It is the only paper money catalog to meet the comprehensive criterion. Over the course of the past 20 plus years I have undertaken extensive, intensive research into the history of paper money of the United States. The research continues, but I am pleased to share the knowledge that I have gained to date. The study has been time-consuming but fascinating. It has truly been a journey into the past—and I am delighted to have you join me on the journey!

Some might ask why these early federal notes, most of which are uncollectible, are listed. They are part of our monetary history and I would be guilty of omission if they were not included.

Some extremely rare notes have been documented since the publication of the last edition. While gathering information for *An Illustrated History of U.S. Loans, 1775-1898*, I uncovered at least six notes at the Bureau of the Public Debt; none of these had heretofore been illustrated in any catalog. Series 1863, 1870 and 1875 large denomination gold certificates are examples of new illustrations in this catalog. They were thrilling to discover and I am delighted to present them here.

To attribute the art and engraving that appears on bank notes to the artists who were responsible for these pieces of history is a continuous quest in order to satisfy my interest in and respect for the art of engraving. In this edition you will find numerous additional attributions. And, for the first time, there is an index to facilitate locating specific information of this type.

This edition includes a foreword by Robert J. Leuver, Executive Director of the American Numismatic Association and former Director of the United States Bureau of Engraving and Printing. Mr. Leuver agreed without hesitation to introduce this edition. This is an honor for which I am truly grateful.

I sincerely hope the information presented in this fifth edition of *The Comprehensive Catalog of U.S. Paper Money* will help both collectors and non-collectors to understand and appreciate our monetary history.

Acknowledgments

The information presented here was compiled with the assistance of others. I wish to thank those who helped and sincerely hope that none have been omitted from the following listing: Walter T. Allan, William T. Anton, Jr., Richard J. Balbaton, John Breen, Walter Breen, Amon Carter, Jr. (deceased), Robert Cochran, Tom Conklin, Mark Davison, Charles A. Dean, Martin Delger, William P. Donlon (deceased), William Doovas, Dennis Forgue, Martin Gengerke, who has documented many notes, Len Glazer, James Grebinger, John Hickman, Robert Hield, Richard Hoenig, Ronald Horstman, Peter Huntoon, John Isted, Glenn E. Jackson, D.D.S. (deceased), Harry E. Jones, Lyn F. Knight, Abe Kosoff (deceased), Chester L. Krause, Phil Lampkin, Bob F. Lemke, Lester Merkin, Barbara Mueller, Doug Murray, Ed Neuce, James E. Noll, Dean Oakes, Chuck O'Donnell (deceased), Douglas Oswell, J. Roy Pennell, Morey Perlmutter, W.A. Philpott, Jr. (deceased), W.K. Raymond, Bruno S. Rzepka, Bernard Schaaf, M.D., C.F. Schwan, Dexter Seymour, PhD (deceased), Neil Shafer, Gary F. Snover, Mary Lou Stubbolo, Charles Surasky, Doug Walcutt, M.O. Warns (deceased), and L. Werner (deceased).

In addition I wish to thank the American Numismatic Association; the American Numismatic Society; *Coin World*, especially Beth Deisher and Margo Russell (retired); Stack's; The Bureau of Engraving and Printing, especially Director Peter H. Daly and former Directors Harry R. Clements, James Conlon, and Robert J. Leuver, also Ira Polikoff, Leah Akbar, Mary Halsall, Harriet R. Duckett (deceased), H.T. Krisak (retired), Michael L. Plant (retired), and Mary Workman (retired); The Bureau of the Public Debt, especially Peggy Diamond; The Comptroller of the Currency; The National Archives; The Essay-Proof Society; the Federal Reserve Bank of New York; the Higgins Foundation; R.M. Smythe & Co.; and the Society of Paper Money Collectors.

Paper money photographs are by William Devine and Gene Hessler; printing operation and COPE-PAK courtesy of J.M. Johnson and the Bureau of Engraving and Printing.

vi

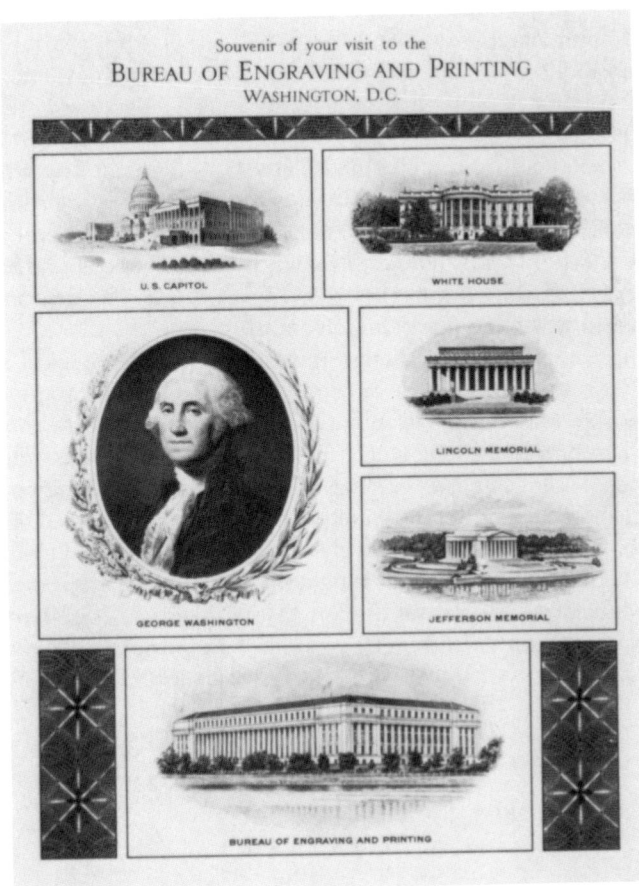

Souvenir of your visit to the
BUREAU OF ENGRAVING AND PRINTING
WASHINGTON, D.C.

U.S. CAPITOL

WHITE HOUSE

GEORGE WASHINGTON

LINCOLN MEMORIAL

JEFFERSON MEMORIAL

BUREAU OF ENGRAVING AND PRINTING

The author has received several awards for *The Comprehensive Catalog of U.S. Paper Money*: in 1974 he was awarded the Nathan Gold Memorial Award, sponsored by Krause Publications and presented by the Society of Paper Money Collectors; in 1975 the Professional Numismatists Guild presented him with the Robert Friedberg Award on behalf of the Louis Reagan Memorial Foundation; and in 1981 the Numismatic Literary Guild named the third edition the best paper money book of the year.

Syngraphics

A new word was born in 1974 with the publication of the first edition of this catalog in 1974. Syngraphics, denoting the study and collecting of paper money, will now take its place beside numismatics and philatelics.

The Reverend Richard Doyle, Chairman of the Department of Classical Languages at Fordham University in New York, coined the long-needed word at the request of the author. The word comes from the Greek *syn*, meaning with or together (as in synagogue – a place where people come together), and *graphikos*, which means to write. In Latin, *syngrapha* means a written agreement to pay, a promissory note, a bond. The *Oxford Dictionary* defines paper money as "a written promise to pay." In the same source *syngraph* is defined "as a written contract or bond signed by both or all parties, an obligation or bond between two or more." The first paper money in the western world was a handwritten goldsmith receipt.

The art of engraving, etching and other methods by which copies of an original design are printed from a plate, block or the like is referred to as graphic art. Modern bank notes are no longer handwritten but are made from engraved plates. Therefore, *syngraphics* is interpreted as the collecting of paper money, and since a serious collector studies what is collected, he or she is a syngraphist. The definition holds up with the original and the current definition of paper money. The science of paper money collecting and study thereof is on a level equal with the study of coins and stamps.

Soon after the first edition of this catalog was published the word *syngraphics* was added to the editorial vocabulary for the *Bank Note Reporter, Coin World, The Essay-Proof Journal, The Numismatist, Paper Money*, and other publications.

Paper Money Terms

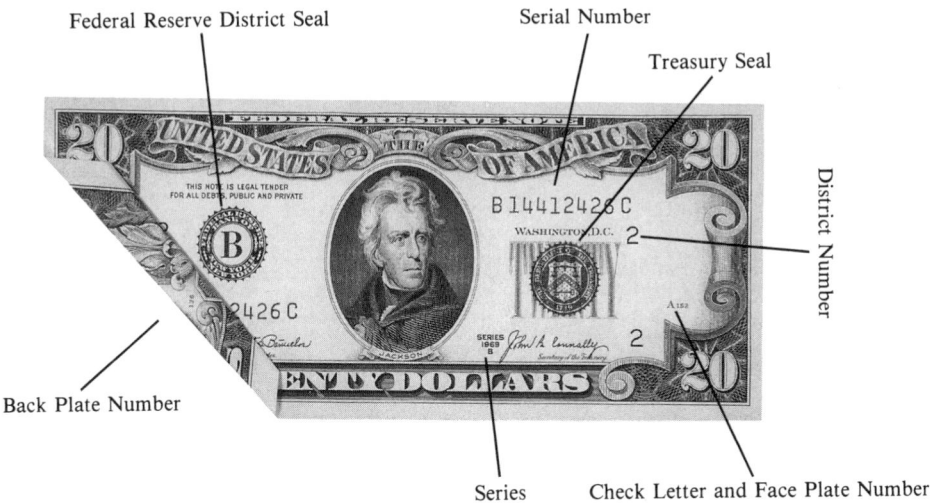

Federal Reserve District Seal

Serial Number

Treasury Seal

District Number

Back Plate Number

Series

Check Letter and Face Plate Number

Abbreviations

ABNCo	American Bank Note Co.	MDF&Co	Murray, Draper, Fairman & Co.
BEP	Bureau of Engraving and Printing	NBNCo	National Bank Note Co.
ColBNCo	Columbian Bank Note Co.	R	Rarity
ContBNCo	Continental Bank Note Co.	RW&H	Rawdon, Wright & Hatch
EPJ	*The Essay-Proof Journal*	RWH&E	Rawdon, Wright, Hatch & Edson
IBNS	International Bank Note Society	TC	Toppan, Carpenter & Co.
L–H	Lehman-Haupt	VB	Van Buren

A History of Paper Money

ALL money, whether paper, metal, stone, or shell, is a symbol of value that can be exchanged as needed for goods purchased or services rendered. In the simplest economic arrangement it is easy enough to exchange my cow for your horse or my cabbage for your cantaloupe. But we would have trouble exchanging cows for cabbages if we did not have some common measure of value. So, in early Greece we find an iron spit (obol) or a handful of iron spits (drachma) serving as tokens of exchange. In early Rome, blocks of bronze were used as exchange symbols.

The earliest metal money had a face value equal to its intrinsic value. The first coins were those ingots and nuggets that were stamped by a sovereign authority in Lydia during the 7th century B.C. as being guaranteed full weight and quality. It was not long before the coins themselves became lighter, less pure, and more like present-day paper money. The coin became an instrument inscribed with a specific amount. For example, there were the coins minted by the Roman Empire during the inflation of the 4th century, coins made of the cheapest possible mixture of base metals. Even these coins took much valuable metal from a degenerating economy.

Although there are no surviving examples, some writers refer to paper money that was used during the Kao-tsung Dynasty (A.D. 650-683). Others say paper money, actually a banker's draft, was introduced during the T'ang Dynasty during the reign of Yan H'u (A.D. 806-820). These deposit receipts, called flying money, could be cashed in different cities and locations. In 1024 the government began to print Jiao Zi, receipts for metal currency. In 1160, during the Sung Dynasty, a circulating bill, not exchangeable for cash, was introduced. Better control and improvements followed, including currency printed on silk to instill confidence and deter counterfeiting. By 1277 Kublai Khan (1215-1294) had abolished coins. Only paper money circulated in his domain (Kranister, 142-150). Today the latter are referred to as Ming notes, derived from the dynasty in power. The punishment for counterfeiters of these notes was decapitation.

THE DEVELOPMENT OF PAPER MONEY

The manufacture of paper money involves three elements: ink, the technique of engraving, and paper. Of these elements, ink was the first to be developed. Ink had been in use even before the use of papyrus in ancient Egypt. In both Egypt and China lampblack, a form of carbon, was suspended in gum or glue as early as 2,500 B.C. The invention of true ink took place in China in 400 A.D. Today, inks for printing are made of vegetable or mineral materials suspended in a vehicle, usually a type of linseed oil. Modern chemistry has developed a wide variety of printing inks for different conditions. Paper money requires ink that resists fading in sunlight, resists humidity and rubbing, and lacks odor.

The second element to be developed was paper. The history of paper begins with papyrus, which was made by laying strips of the stems of the papyrus plant crisscross and pressing the strips together. Next came parchment, the dried skin of sheep. Both papyrus and parchment were too variable in shape and quality for use as currency. True paper was invented in China ca. 105 A.D. by Ts'ai Lun, who made his paper from rags, bark, fish nets and hemp. A fragment of paper was found in a tomb in Shensi Province dating earlier than 105 A.D.

Later, paper was made by macerating a variety of cellulose fibers, cooking them in soda and lime, bleaching the result, and then pressing the mash into sheets for drying. In the 15th century rag pulp was bleached in sour milk and wood ash and then dried in the sun. On fine 18th century paper the pressing lines can be seen by holding the sheet to the light. Watermarks could be left in the paper during the pressing process, and many foreign governments used elaborate watermarks to further deter counterfeiting. One of the earliest watermarks can be traced to Fabriano, Italy in the year 1293.

It was the Arabs who brought fine paper to Europe; they had learned the secret of papermaking from the Chinese artisans ca. 751. Flax and its derivatives, such as linen cloth and linen rags, were used for the best papers. Linen papers in 18th century books are often as fresh and clean as the day they were made. Today, paper made from wood pulp browns and crumbles within a year or two and is used for ephemeral items, i.e., newspapers, for obvious reasons, non-scholarly journals and most paperback books. Governments, however, will use the best paper obtainable for paper money, often custom-made. "To the lay-mind, paper is paper, just as 'pigs is pigs'" (Coudert, 27). Different types of paper are required for specific needs, e.g., bonds, stock certificates, revenue stamps, etc. The first paper of quality made in the United States was produced by William Rittenhouse and Son in Germantown, Pennsylvania in 1690.

Engraving is the third element of a successful paper currency. Engraving differs from printing from woodcuts or stones in that an engraved imprint is made by incised lines rather than raised surfaces. The intaglio design is cut into the plate. (Here, intaglio refers to the deep, incised lines in a steel plate.) The surface of the plate is covered with ink and then wiped carefully so as to leave the incisions filled with ink.

The advantage of engraving is that the plates are extremely durable since the whole face of the plate wears down slowly and evenly. If steel plates are chromium plated periodically, they are virtually indestructible. The print from an engraved plate cannot be successfully reproduced photographically.

Printing was certainly within the capabilities of the Romans; they used seal stamps and stencils extensively. Perhaps the lack of an abundant medium on which to print made printing impractical for them. The earliest example of text printing on paper can be traced to Japan in 770 A.D.

Johann Gutenberg is credited as the first to print from movable type in Europe ca. 1452. However, movable type was invented in China by Pi Sheng in 1041. Eight years later the invention was abandoned; the numerous language characters did not lend themselves to this printing improvement. By 1403 movable type was produced in a typefoundry in Korea; examples are in the National Museum in Seoul.

The first examples of intaglio engraving were done as plates for playing cards in the 1430s. Costumes worn by the human figures on the cards helped Lehrs, Geisberg and others to arrive at this date (VB, 13); an anonymous artist, the Master of the Playing Cards, engraved these figures. In the early 1450s, both the Master and Gutenberg were working in Mainz—perhaps together.

Engravings of the Master "were not created *a priori* for a card game, but as technical steppingstones toward the multiple reproduction of [illuminated] miniatures" (L-H, 3). Playing card motifs, probably from a model book, were later found in a variety of manuscripts and codices, e.g., the *Book of Hours of Catherine of Cleves* (completed ca. 1435) and Gutenberg Bibles, specifically the Giant Bible of Mainz (completed ca. 1452) in the Library of Congress.

It is almost certain that Gutenberg cast relief metal plates from engraved molds and engaged in typographic experiments as early as 1436. He was therefore also fundamentally associated with the beginning of intaglio engraving.

As governments began to apply the techniques of printing and engraving to paper money, they employed fine artists in order to foil counterfeiters and to enhance the prestige of the issuing authority. Great printing offices in major capitals took on the job of printing the currency of other nations, with the engraving done by the best *etaliers*.

It is always the battle of the gun against armor, and as superior guns are invented better armor is developed. The counterfeiters were clever, and as soon as paper money was made more elaborate the efforts of counterfeiting improved. The counterfeiters strove to duplicate the official printing process. Fine engravers made careful copies of the real note, and the paper used was close to the original. Of course the governments kept up the race with better paper and with more sophisticated engravings.

Today counterfeiters use photoengraving devices that eliminate the need for a master engraver. Color photocopiers also present an increasing threat. Bills of $20, $50 and $100 are the notes most often counterfeited. Of course there is the story of the

very small-time New York City maker of "queer" (counterfeit notes), who made only $1 bills for daily needs and led the Secret Service on the longest case of its history. (This case was reenacted in the 1950 movie, "Mr 880" with Edmund Gwenn as the friendly felon.)

In time of war, governments have been known to counterfeit currencies to try to weaken their enemy's economy. Skilled prisoners of the Germans were recruited to counterfeit British bank notes as part of "Operation Bernhard." Japan tried to add to the troubles of Chiang Kai-shek during World War II by duplicating Chinese national currency that was printed in the United States by American Bank Note Company and flown over the "hump" to China.

EARLY PAPER MONEY IN EUROPE AND AMERICA

In 1255, after visiting Ghengis Khan, the French priest William of Rubruk returned to the court of Louis IX and reported that paper money circulated in Mongolia. Marco Polo, however, was the first to bring examples of Ming Dynasty paper money to Europe. A few European rulers were moderately impressed, but governments were not ready to take such a giant monetary step. Gold and silver were still the basis of monetary exchange, with bronze abundant enough to supply the token coinage of everyday small change. Promissory notes, IOUs, contracts, and other promises to deliver goods or services had been imprinted on clay, papyrus, parchment, metal, or stone since the earliest forms of writing were in use. All of these promissory notes were private exchange between individuals. In the case of a monetary note, however, the promisor is individual, either a bank or a government, but the promisee is unspecified and general.

According to J.P. de la Riva (IBNSJ, March 1965, 10) King James I of Catalonia and Aragon issued paper money in 1250. In 1453 emergency paper money was used by the besieged during a Moorish siege of Spain. Examples of neither have survived.

The first European "bank note," under this definition, was issued in Sweden by the Stockholm Banco on July 16, 1661. The earliest surviving note from this bank is dated 1662. Under Johann Palmstruch this bank issued too many bank notes, payable on demand against reserves of precious metals, and closed in 1666. The bank was reorganized as the Swedish Riksbank in 1668, but did not issue paper money until 1701, eleven years after paper money was issued in Massachusetts Colony.

In 1685 a form of paper money was issued in Canada. The paymaster for the French army had been delayed at sea, and, since there is nothing more surly than an unpaid army, Jacques de Meulles, the Intendant of New France, prevented a mutiny by issuing promissory notes redeemable when the ship arrived. His desperate expedient was to gather up all of the locally available paper, which happened to be playing cards, and to imprint them with values to be redeemed and with seals and signatures. The notes were redeemed within three months.

The basic ills of this paper money policy soon appeared. The first problem was counterfeiting. The second was depreciation. Discouraged soldiers sold off their notes at a reduced rate before the ship appeared. The third ill to appear was inflation, which was caused by the issuer and not the receiver. The authorities soon discovered how easy it was to solve financial problems by issuing as much paper as was needed to cover expenses and worrying about redemption in metal later. The authorities tried to refrain from this practice, but the playing card money was revived periodically as wars and ship delays caused more payment problems. The three problems of counterfeiting, depreciation, and over issuance are still with us today. However, the usefulness of paper money outshone its drawbacks. Thus the Massachusetts General Court decided to imitate its northern neighbor and authorize the first notes. These "Old Charter" bills were printed from engraved copperplates; denominations were 5, 10 and 20 shillings, and 5 pounds. With the outbreak of hostilities with Canada in King William's War in 1689, large numbers of these bills were issued to meet the provincial payrolls. These Old Charter bills were not like our paper money that is legal tender for all private debts and transactions. The Massachusetts notes were valid for paying taxes, a clever way for a government to issue excessive paper and then recall it at will.

The real troubles with paper money that was not backed sufficiently by metal had not yet begun, however. In 1694 the Bank of England issued notes to cover war expenses. In November 1696 the world's first bank run reduced the true value of its notes by 20 percent, making it apparent that what counted was not the value printed on the note but what the holder believed the note to be worth.

Paper money became well established across Europe in the following century, although France went bankrupt under Louis XVI because of experiments by Finance Minister John Law, who tried to overprint notes with reinforced promises to pay. The assignats issued during the French Revolution were equally disastrous. Paper money was obviously a good invention, but without proper controls it had a poor future in any stable society.

PRIVATE BANK NOTES IN AMERICA

In 1714 a group of Boston merchants, headed by John Colman, applied for a bank charter; their land security proposal was rejected. The unchartered New London Society United for Trade and Commerce issued bank notes dated October 25, 1732; this emission was a fiasco. In 1740 Colman was briefly successful in having "manufactory bills" issued. Forty years later the issue of private bank notes was tried again. What began as a trickle became an avalanche that ended in 1866.

Later in the 18th century, during the American Revolution, the Continental Congress tried to finance the war with voluminous issues of Continental currency. By the end of the war the new government was in a state of financial chaos. Alexander Hamilton came to the rescue and proposed that the central government assume all war debts incurred by the individual states. He also proposed a tariff on imports to raise revenues.

The Bank of the United States

In 1781 the Continental Congress authorized the Bank of North America as the first incorporated bank; the bank received a perpetual charter. Three years later the Bank of New York and the Massachusetts Bank were formed. The Bank of New York, under the leadership of Alexander Hamilton, was granted a charter in 1791.

Soon after his appointment as Secretary of the Treasury, Hamilton proposed the establishment of a national bank. He would have favored the Bank of North America as a national bank, but the state charters that the bank had accepted disqualified it. Although both Jefferson and Madison opposed him, Hamilton succeeded in establishing the Bank of the United States as the first national bank.

The Bank of the United States received the first of its two charters in 1791; it was preceded only by the Bank of North America, the Bank of New York, and the Massachusetts Bank. (The latter three banks are still operating; the Massachusetts Bank is now the First National Bank of Boston.) The Bank of the United States could have continued to serve the needs of the new nation if it had not been for the question of the constitutionality of the Bank. The effect of the Bank was obviously beneficial. Not only did it render valuable financial assistance to the government, but it exerted a profitable influence on the general economy. In a period of tremendous and sometimes precarious expansion and speculation, the Bank of the United States acted as a moderating force. For example, it refrained from calling in its loans from state banks, when such a move would have led to financial panic.

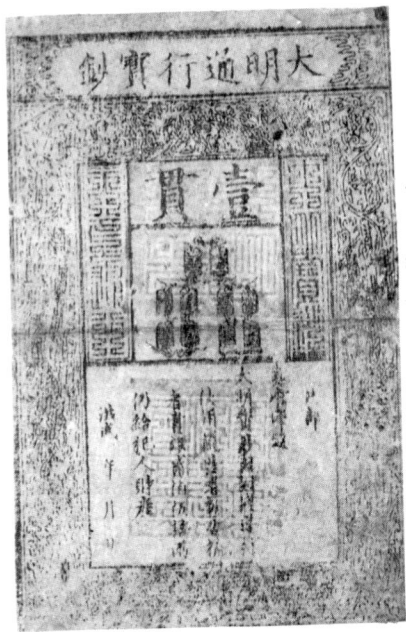

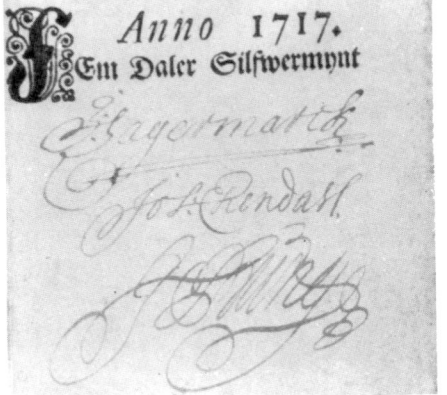

A Ming Dynasty note for one kwan (1,000 cash) issued during the reign of Emperor Hung Wu, similar to the type reported by Marco Polo. (Below) An early bank note from Sweden.

There are only about fifty acceptable examples of this type of Canadian playing card money; the Bank of Canada has half of them.

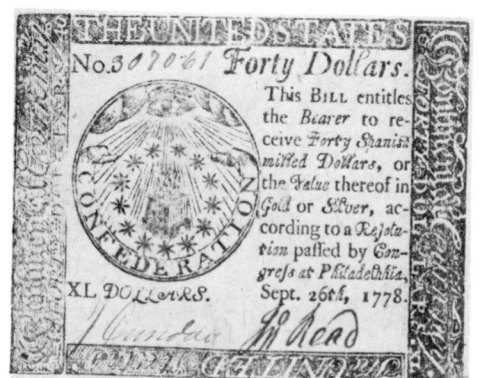
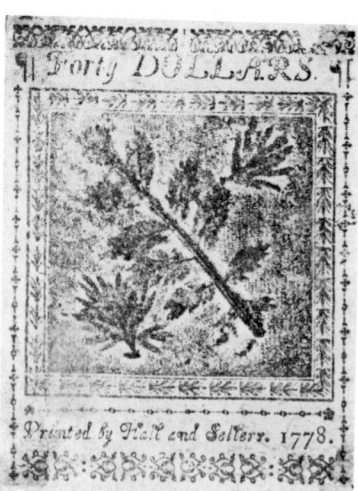

The face and back of a $40 Continental currency note dated
September 26, 1778. (Below) A colonial Pennsylvania note printed
by Benjamin Franklin.

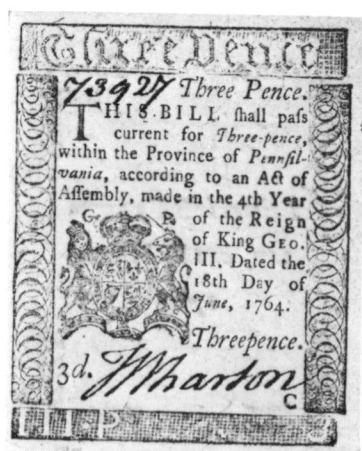

One of the earliest privately issued bank notes from New London, Connecticut.

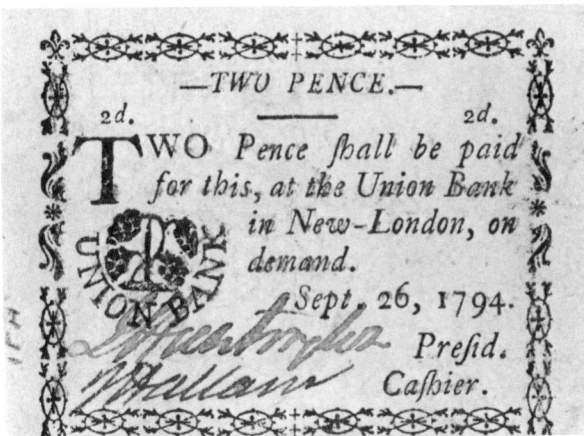

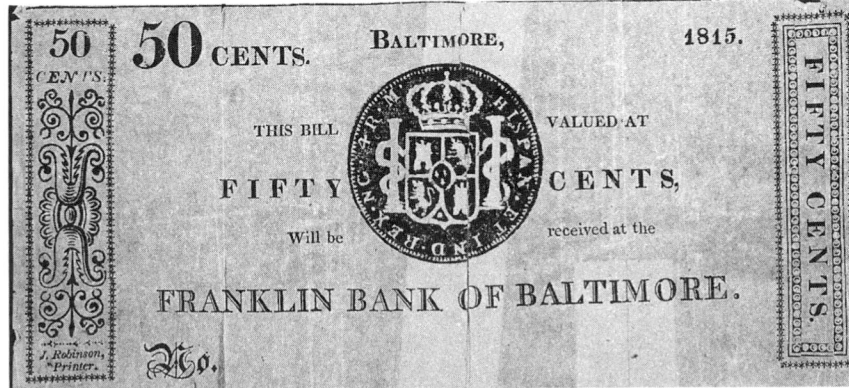

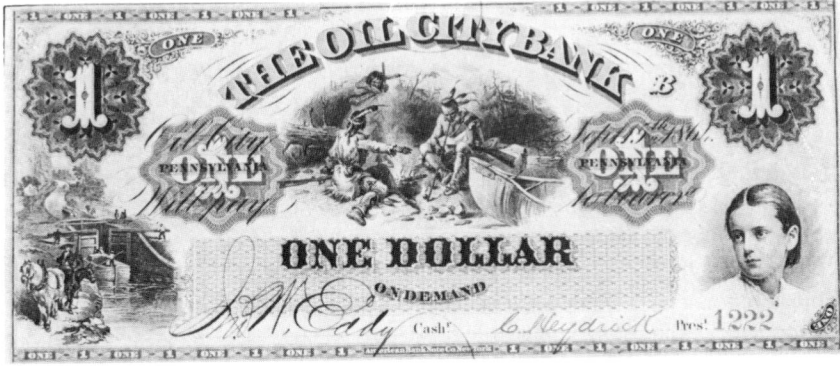

(Above) The coin on this note represents a 4-real coin (4 bits). (Below) The vignette in the center is adapted from the painting Indian Camp by Felix O.C. Darley; it was engraved by Charles and J.D. Smillie.

The first charter of the Bank was not renewed, and state banks proved inadequate when the War of 1812 forced the United States to borrow money. U.S. Treasury notes were issued in denominations of $5 to $100 amounting to $37 million, although up to $60.5 million had been authorized, to be receivable only in public dues and debts. These notes were not meant to circulate and were retired soon after the war. The Bank of the United States was rechartered in 1816, and it opened again for business on January 17, 1817.

In 1832, five years before the Bank's second charter was to expire, Andrew Jackson vetoed its recharter. Samuel D. Ingham, former Secretary of the Treasury, said, "The United States Bank has given us the best currency known among nations. It supplies a medium equal in value to gold and silver in every part of the Union [The Bank] enables the government to transmit its funds from one extremity of the Union to another . . . with a dispatch which is more like magic than reality."

Despite Ingham's protests, the Bank's second charter was not renewed. The Bank of the United States continued to operate, but as a state bank under a charter from the state of Pennsylvania.

With the demise of the Bank of the United States, state banks began to flourish, and soon caused a severe inflation. There was no uniformity in the laws under which the state banks operated. The banking system was up for grabs.

When the Civil War was imminent, Salmon P. Chase, then Secretary of the Treasury, devised a plan to stabilize the currency. His plan "included non-interest bearing notes payable on demand, interest-bearing notes for short terms, and bonds for long terms; the first to be convertible into the second and the second into the third form of obligation." Thus, he expected to avert the evil that many of his predecessors had experienced—being compelled to receive, as payments to the Treasury, notes of state banks, most of which were fluctuating in value and might even have become valueless. On July 17, 1861 Congress adopted Chase's plan and authorized the borrowing of $250 million. The demand notes ("greenbacks") that soon followed saved the Union and were the beginning of our national paper money.

Varieties of United States Paper Money

United States paper money falls into five major categories: Continental, Bank of the United States, State and Private Banks (obsolete or broken banks), Confederate, and Federal. Only the federal issues have survived into the twentieth century.

Of these five categories, we have already discussed the Continental and Bank of the United States notes. The history of state bank and Confederate notes will be surveyed later in this chapter. The primary subject of the present work will be federal issues, which comprise most of this book. Before we proceed, however, it is appropriate to mention some of the literature on the five categories of United States paper money.

The Colonial and Confederate issues have been cataloged by Eric P. Newman and Grover Criswell respectively. What may be the largest series of all, obsolete, or broken, bank notes has been magnificently compiled by James Haxby (see bibliography). These 30,000 varieties, issued by 3,000 different banks in 34 states between 1782 and 1866, are being cataloged by individual states. These individual catalogs will also include private scrip issued within the state. Individual members of the Society of Paper Money Collectors, the sponsor, have thus far cataloged obsolete notes and scrip for: Alabama, Arkansas, Florida, Illinois, Indian Territory/Oklahoma/Kansas, Iowa, Kentucky, Maine, Michigan, Minnesota, Mississippi, Nebraska, New Jersey, Pennsylvania, Rhode Island, Tennessee, Territorials, Texas, Vermont and Virginia.

With adequate catalogs for all of the states here or on the way, the collecting of obsolete bank notes has become a major part of our hobby. Collectors need these catalogs to guide them. They also need to know values and rarities so that they can buy and sell intelligently. Prices often rise rapidly as collecting popularity increases.

One interesting pattern for obsolete bank note collecting not available for other types of currency, is the collecting of odd denomination bills. Just about every cent and dollar figure was issued. A collection of $4 or $7 bills certainly would prove fascinating; or how about a collection of $1.25 and $1.75 notes? These bills are most often related to the Spanish milled dollar, "piece of 8", or "8 real" that was accepted in the United States as legal tender until 1857. This large silver coin was divided—at times physically—into bits equalling 12½ cents. The term two bits is derived from one quarter of one "piece of 8".

As for the cost of collecting these obsolete notes, numerous privately issued notes can be purchased for $25 or less, an inexpensive way to collect a tangible piece of history.

Frequently works of art were reproduced as engravings on these notes. The famous American painter, Gilbert Stuart, is frequently represented. Another is Felix O.C. Darley who illustrated *Scenes of Indian Life* in 1843, *Rip Van Winkle* in 1848 and *The Legend of Sleepy Hollow* in 1849. Darley is also responsible for more than five hundred drawings illustrating the novels of James Fenimore Cooper. James B. Longacre, United States Mint engraver from 1844-1869, prepared vignettes for Draper, Toppan, Longacre and Company, one of the historical printers of obsolete currency. More than one painting by Queen Victoria's favorite artist, Edwin Landseer, adorns obsolete state bank notes.

A History of Broken Bank Notes

As the name implies, a broken bank note (obsolete bank note) is one issued privately, most often by a bank that went under, or went broke. The confusion in the strange episode represented by these notes can be laid to the long distrust of a central government and of a central economic authority. Some of the distrust can be traced to the Continental Congress. The voluminous amounts of Continental currency poured

out to finance the Revolution originally was backed by Spanish milled dollars, but that backing was soon removed. The Continental currency gradually depreciated to a point where a $40 Continental note was worth only $1; ultimately it was worth nothing at all. In accordance with Gresham's Law – bad money drives out good money – gold and silver went out of circulation. Hoards of coins that have survived until today may be a boon to the coin collector, but they helped engender a deep distrust of any national currency, a distrust that lasted until the Civil War.

In 1789 the Constitution of the United States tried to prevent a repetition of the Continental currency fiasco by forbidding any state or federal authority to issue "bills of credit." However, an enormous loophole was discovered. The Constitution did not ban bills of credit issued by private or municipal authorities.

The first privately issued notes in colonial America were issued in New London, Connecticut in 1732, the year George Washington was born. The experiment failed then, but was reinstated and popular by the time Washington was on his way to the presidency in 1790. State and private note issues became a flood in the 1800s. The Constitution allowed state issues provided they were regulated by the state.

In his report to the Congress on December 9, 1861, Secretary of the Treasury Salmon P. Chase said: "It has been questioned by the most eminent statesmen, whether a currency of bank notes, issued by local institutions under State laws, is not, in fact, prohibited by the national Constitution. Such emissions certainly fall within the spirit, if not within the letter, of the constitutional prohibition of the emission of bills of credit by the States . . . " (Knox 12).

The history of broken bank notes ranges from the hilarious to the tragic. Crooks and sharpies perceived at once that what governments could do with paper money, they could do as well. A printing press, an impressive design, and a con man's talent could bring riches overnight. An example from the earliest days of state bank notes is instructive. In 1806 Judge Augustus B. Woodward of the village of Detroit, Michigan (population 600), organized the Bank of Detroit. He announced its capital at $1 million, ordered at least $3 million from the printer in notes of $1 to $10, signed them, or had them signed for him, and shipped them East. Smart Easterners can always take advantage of country folk, so they bought up the issue at discounts of 10 to 25 percent. When they tried to redeem the notes at face value in 1808, they found that the Bank of Detroit had closed its doors. Judge Woodward, a cheshire cat smile on his face, had in the meantime put quite a bit of money in the form of hard coin in another, honest bank. As late as 1824 outraged citizens were still trying to prevent Judge Woodward's continuing reappointment by the United States Senate to the local bench. Woodward's Bank of Detroit notes are today the most common of all broken bank notes.

The weak Michigan General Banking Law of 1837 really opened the gates of the paper flood. Fifty-five banks were immediately organized, most of them for the sole purpose of issuing paper money. A year later, after the disaster had almost wrecked the state, the law was suspended. The 55 banks and many previously established banks,

honest or not, had broken, adding notes for the modern collector and subtracting wealth from the Michigan citizenry.

A little caution might well have averted such a disaster. Supervision of bank operations seems obvious to our modern minds, and the bank examiner is a well-known contemporary official. What little inspection was done then was satisfied with false books, uncollectible collateral and mortgages, or cash borrowed for the day of the inspection. In light of what has happened with savings & loan institutions since 1989, there is something bordering on *deja vu*.

To discourage inspectors, or note-holders from paying a visit many banks had their "main office" far out in the woods. Some notes were postdated or had false bank addresses to hamper any attempts at redemption. The Bank of Battle Creek, Michigan (1838-1840) used the ruse of having its cashier, Tolman W. Hall, run out the back door whenever a note-holder came in the front. The "pigeon" found the bank deserted except for a singing janitor, who eventually drove the note-holder away by incessantly whistling or singing and answering all questions with gibberish. In Barry, Michigan the Farmers Bank of Sandstone (1837-1838) tried to be honest in that it offered to redeem its notes in merchandise of the locality. Since the principal natural resource of the area named Sandstone was exactly that, the bank would redeem a $10 note with one millstone, a $5 note with one grindstone, and $1 notes with one whetstone. As can be imagined, few note holders bent on redemption took advantage of the offer, especially if they had come by buggy from a great distance.

Bowen's *State Bank Notes of Michigan* has many such stories, some comic and some tragic. Many of the stories represent not only broken banks but broken hearts, homes, hopes, farms and families as well. The ultimate victims of these frauds were the local working people, the immigrants, the settlers.

There were also honest banks out in the sticks. After travelling by train and then horseback, Alexander L. Stimpson, an agent for Adams Express Company, finally reached what he was told was Morocco, Indiana, although he was in the middle of the prairie. It seems that the blacksmith, the only person around, was also the banker. When Stimpson presented $1,000 in notes issued by the Bank of America (Morocco, Indiana), the blacksmith, after removing pounds of potatoes from a large barrel, brought forth a bag from which he took five $20 gold pieces and gave them to his astonished visitor.

As if the broken bank problem was not enough it was compounded by counterfeiting! Notes that were almost worthless were nevertheless altered or counterfeited by other crooks trying to get in on the orgy. In order to combat these privately issued notes, dozens of counterfeit detectors were published to assist bankers and merchants in the detection of bogus bills. An Iowa banker, H. Price, said, "The two most important books that every businessman needed were a bible and a counterfeit detector. And of these two, the detector seemed to be the more important for at least six days out of seven."

The private bank note companies that prepared most of the notes issued by state banks employed the best engravers to produce designs difficult to engrave without years of experience. After the camera was invented, counterfeits were photoengraved. Even the previously mentioned counterfeit detector could not always come to the rescue. The result of the intricate, geometric patterns, the lovely vignettes, and the colors that were introduced, was some exceptionally beautiful notes. Some, in many respects, surpassed present-day currency.

Even during the worst period of the broken bank note era there were honest and far-seeing bankers who issued reliable money. They realized that the convenience of paper money was necessary if the nation was to develop and expand. These bankers were the ones who took the countermeasure of superb production to its limit. Seven engraving companies serving these bankers merged to form American Bank Note Company in 1858, which continues to produce currency and a variety of security paper for many nations.

The history of obsolete or broken bank notes came to an end after the Civil War. When the Confederacy was formed, paper money issued by the Richmond government and by the "sovereign states" supplanted private bank issues very quickly. In the beginning the Confederacy tried to back its paper money with cotton bales stored in Southern ports, but the Confederate notes went the way of Continental currency and ultimately became worthless paper. As part of the National Bank Act of 1863, a 10 percent tax was levied on all private bank note issues. The issue of scrip below $1 was also forbidden. By 1866 private and state banks had either joined the National Banking System or closed their doors. The colorful, fascinating, humorous and tragic broken bank note era came to an end.

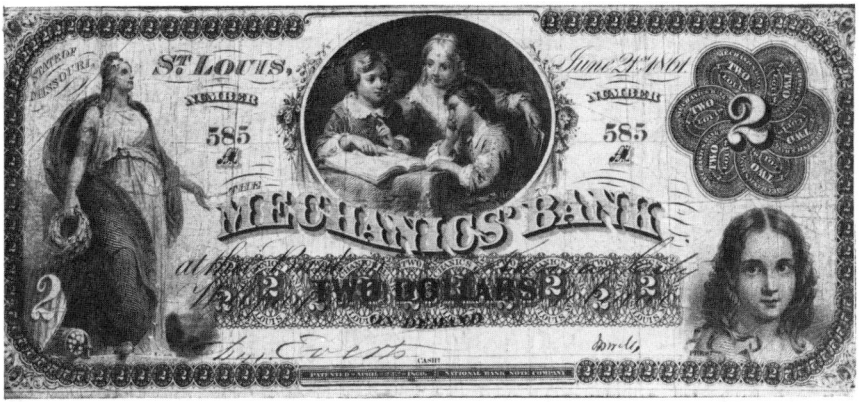

The original image of *Standing Liberty* by Thomas Crawford appears in the frieze of the Senate wing of the U.S. Capitol. The central engraving is the *Young Students*.

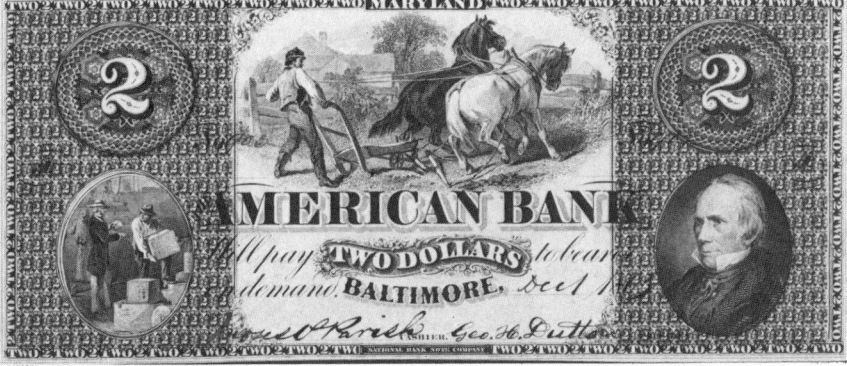

A portrait of Henry Clay appears on this note printed by the National Bank Note Co.

The little girl is named Mary Lamar. American Bank Note Co. printed this note.

State bank notes often pictured silver dollars in numbers equal to the denomination of the note.

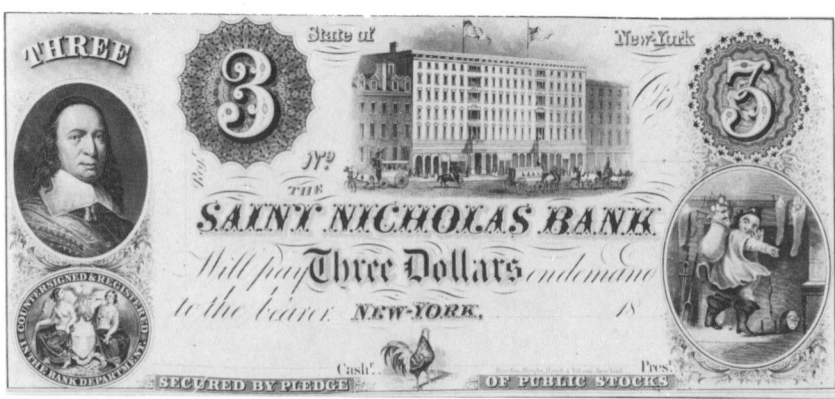

The portrait of Peter Stuyvesant was originally painted by Hendrick Courturier. The engraving of *St. Nicholas* is based on a painting by R.W. Weir.

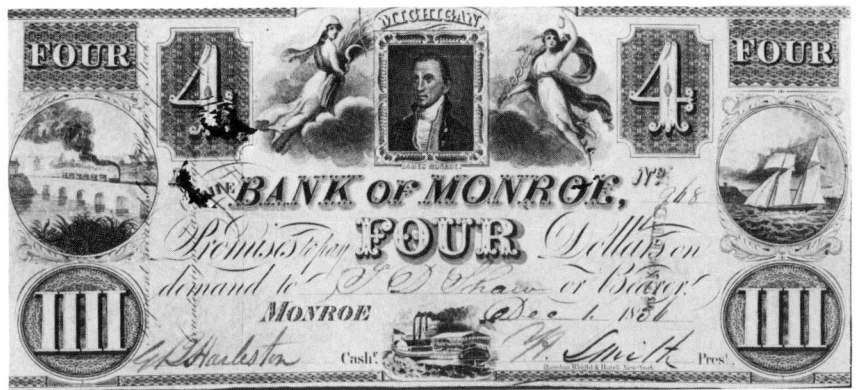

This note printed by Rawdon, Wright & Hatch bears a portait of James Monroe.

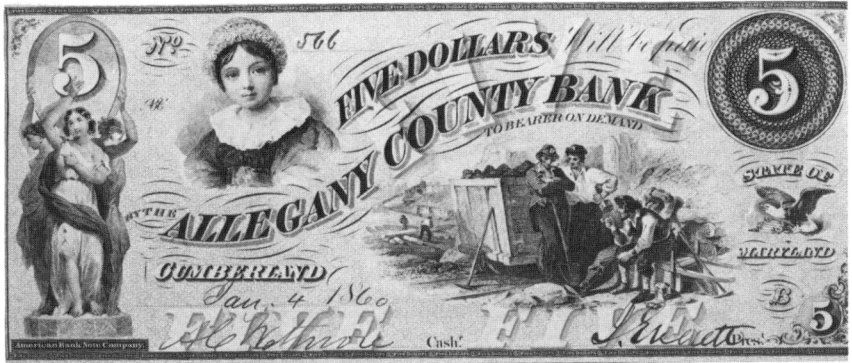

The image of the young girl was engraved by James Bannister for American Bank Note Co.

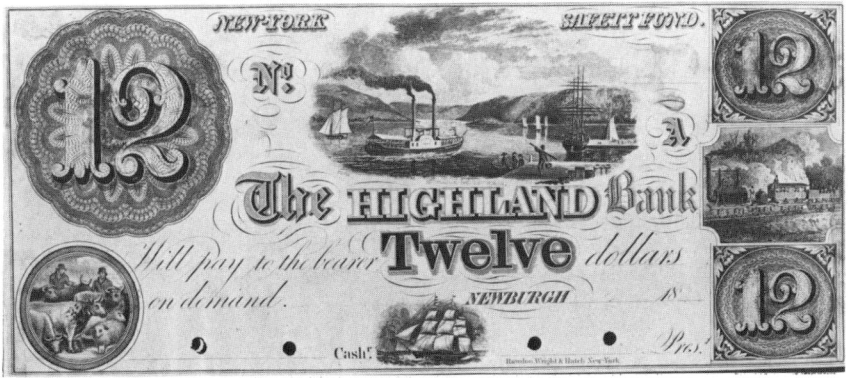

This attractive proof $12 note was printed by Rawdon, Wright & Hatch.

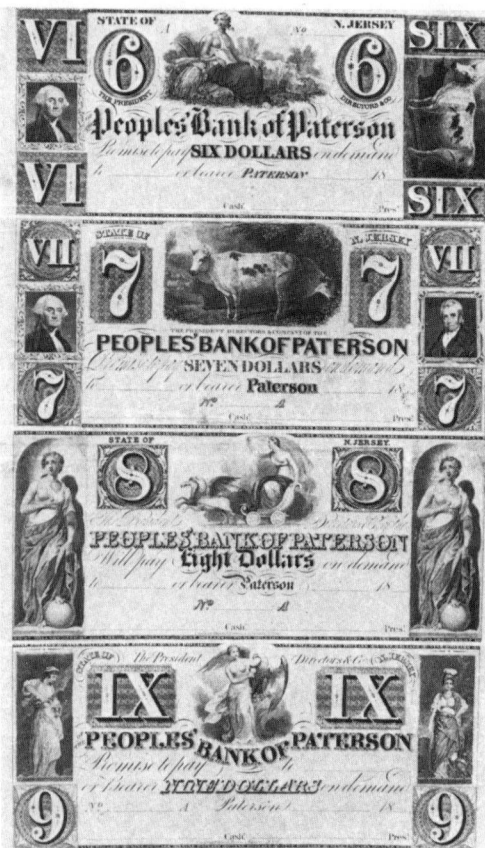

This sheet of odd
denominations was
prepared by Casilear,
Durand, Burton and
Edmonds.

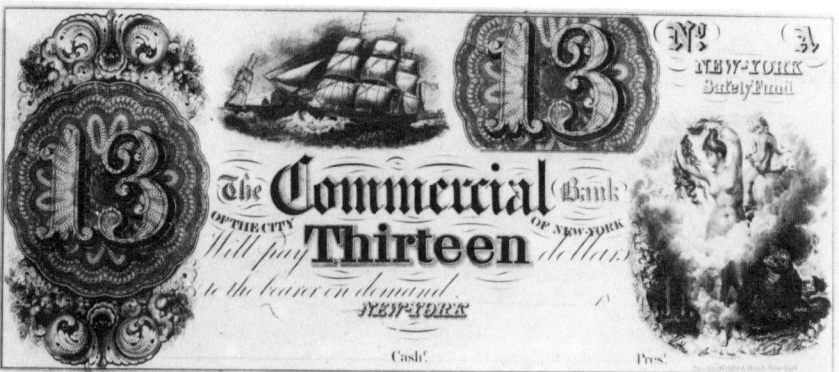

Rawdon, Wright and Hatch printed this ornate $13 note.

UNITED STATES PAPER MONEY SINCE THE CIVIL WAR

When Congress authorized the first demand notes on July 17, 1861, it was up to the executive branch of the government to see that the new notes were printed and distributed in a proper manner. The Secretary of the Treasury and the Office of the Treasurer of the United States thus became the vehicle for all financial and monetary functions of the federal government. Until the terms of U.S. Treasurer and Secretary of the Treasury Burke and McAdoo began, the signatures of the Register of the Treasury and the Treasurer appeared on United States bank notes.

Office of the Secretary of the Treasury

As a major policy advisor to the President, the Secretary of the Treasury and his office have primary responsibility for formulating and recommending tax policy; participate in formulating broad fiscal policies that have general significance for the economy; manage the public debt; and formulate policies for and generally oversee all operations of the Department. These duties are carried out by the ninety thousand department employees located in Washington, DC, and some 1,800 field offices in this country and abroad.

Office of the Treasurer of the United States

Both the Secretary of the Treasury and the Treasurer are appointed by the President with the advice and consent of the Senate. In 1974 the position of Treasurer was transferred to the Office of the Secretary of the Treasury. The Bureau of Government Financial Operations was given the complementary operating functions of the Treasurer at this time. The Treasurer now acts as a Department spokesperson, reviews currency and redemptions, signs currency and participates in the promotion of the selling and holding of United States Savings Bonds. The Office of the Treasurer now oversees the operations of the U.S. Mint and the Bureau of Engraving and Printing. This office has been held by a woman since the appointment of Georgia Neese Clark in 1949.

Initially, Michael Hillegas and George Clymer jointly held the office of U.S. Treasurer beginning September 6, 1777. Nevertheless, the office of Treasurer was not officially established by Congress until September 2, 1789.

On August 29, 1862 four women and two men began to separate and trim $1 and $2 United States (legal tender) notes that had been printed by American Bank Note Company and the National Bank Note Company in New York City. In 1863 seventy additional women were employed to perform this operation. (Late in life, Treasurer Francis E. Spinner said, "I don't claim that I have done much good in the world; but my success in introducing women into government employment makes me feel that I have not lived in vain.") This manual chore was done practically in a state of siege in beleaguered Civil War Washington, with sandbags filling the windows of the old Treasury Building, still at 15th Street and Pennsylvania Avenue, N.W. Thus began the Bureau of Engraving and Printing.

The U.S. Bureau of Engraving and Printing

As the Civil War continued, the need for a truly national currency became more and more apparent. The currency-cutting operation as described, designated as the First Division of the National Currency Bureau in 1862 under the leadership of S.M. Clark, was the first step toward such a national currency. By the fall of 1863 the Bureau had printed its first notes. In 1864 Secretary of the Treasury Salmon P. Chase established a distinct entity in the Treasury Department to be called "The Engraving and Printing Bureau of the Treasury Department." The first reference to the Bureau of Engraving and Printing can be traced to 31 July 1868. With more important matters at hand, such as Gettysburg and Appomattox, it was not until March 3, 1869 that an appropriation act was signed by President Andrew Johnson to give recognition to this agency.

In succeeding years the Bureau became increasingly important. In 1877 an appropriation act authorized the Bureau to print all internal revenue stamps. On October 1, 1887 the printing of all United States paper money was entrusted to the Bureau. Seven years later postage stamps were added to the list of items to be produced.

From a basement room with six employees, the Bureau has grown to a modern industrial plant housed in two buildings in Washington, DC where 2,100 people are employed; this includes 85 printers and about 20 designers and engravers. Over 8 billion Federal Reserve notes were produced in the fiscal year that ended in June 1992. By 1994, 11.5 billion will be produced annually.

In addition to revenue stamps, United States paper money and postage stamps, treasury bonds and certificates, food coupons, certificates of award, permits, and other

miscellaneous items emanate from the Bureau of Engraving and Printing. The Federal Reserve is responsible for 70 percent of the Bureau's business. The cost to print one piece of paper money is about three cents.

The satellite plant in Fort Worth, Texas, which opened in 1991, employs about 300 people; eventually this will increase to 400. This plant operates with two shifts, five days per week. The annual 1.5 billion notes will be increased to 5.4 billion notes by 1995. The notes printed in Texas, on four De La Rue Giori Model I-10 sheet-fed presses, bear "FW" as an identifying mark.

As previously stated, private bank note companies printed the first greenbacks for the Treasury Department in 1861. In 1862 Secretary Chase introduced a proposal in Congress that would authorize the Treasury Department to engrave and print notes. Approval of the proposal was granted in July of the same year, and work commenced one month later.

Printing Presses

In addition to nine COPE-PAK machines and one overprinting press (for overprinting uncut sheets) the Bureau uses four different Giori presses to print backs and faces

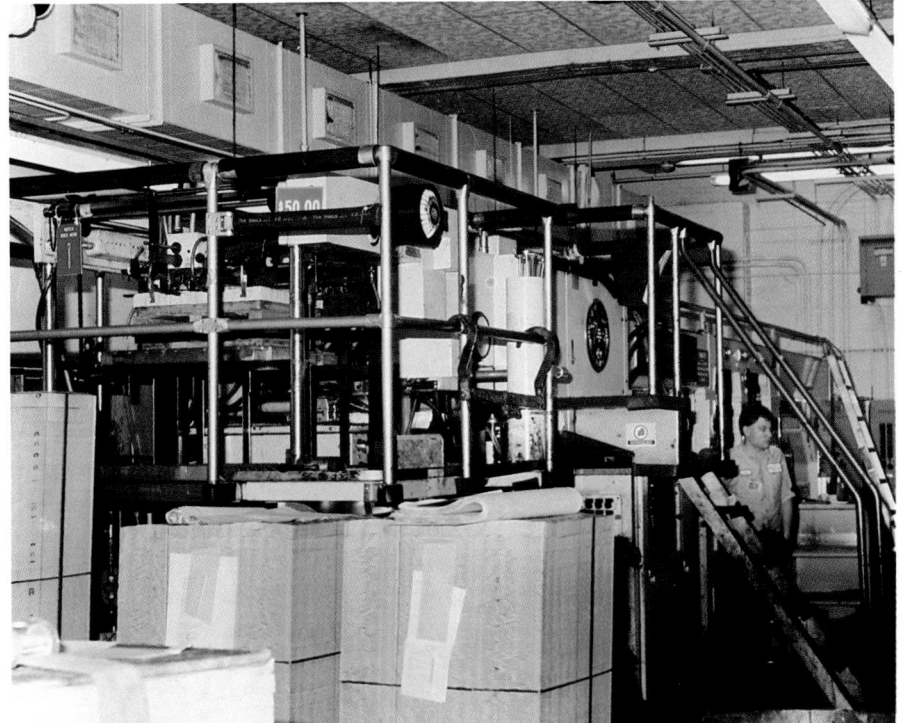

One of the I-8 presses at the Bureau of Engraving and Printing

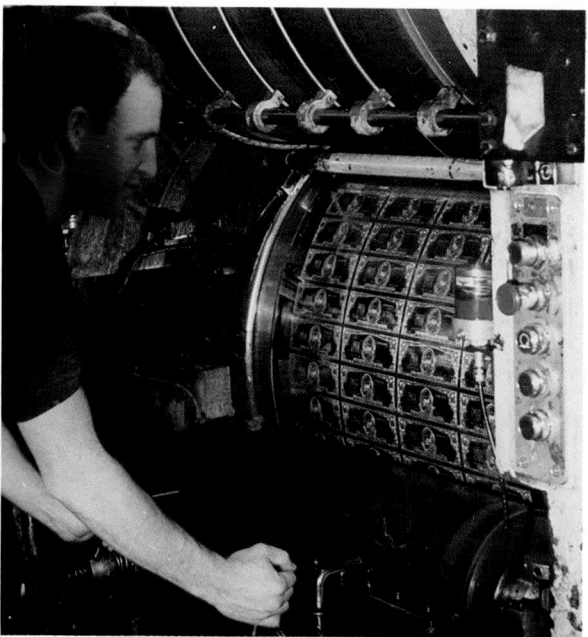

A 32-subject plate in position

of currency: twelve I-8s, four I-10s (at Fort Worth), two 98s and two 74s.

In February 1990 it was announced that the Hamilton Tool Co. in Hamilton, Ohio would produce a new web press that prints face and back of 32-subject sheets simultaneously. The estimated cost of this press is $10 million. Five of these systems will replace 16 sheet-fed presses, each of which produces about seven billion notes per year. Each new Hamilton press will considerably reduce the number of operators required. The first Hamilton press began operating in 1992.

COPE-PAK

In 1976 seven Currency Operating and Process Equipment (COPE) machines were installed. In April 1985 the Bureau began replacing the COPE machines with the first of nine Currency Overprinting, Processing Equipment and Packaging (COPE-PAK) machines. This is the most modern and automated equipment of its type in the world. Prior to the installation of COPE, overprinting, note examination and packaging were accomplished in three separate areas of the Bureau; now all are performed in one area.

Wheels that will number and print seals on 16-subject sheets of currency.

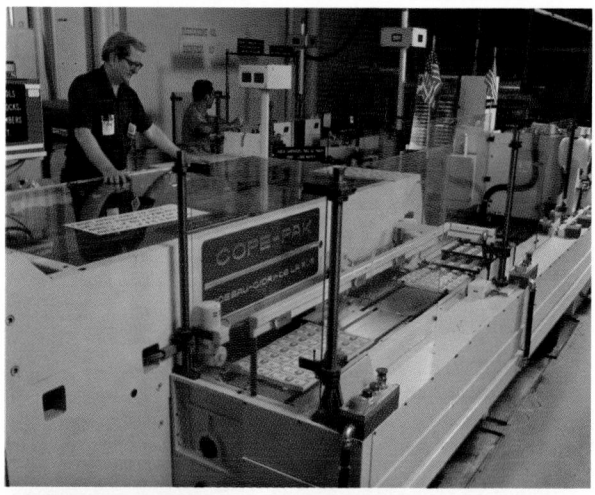

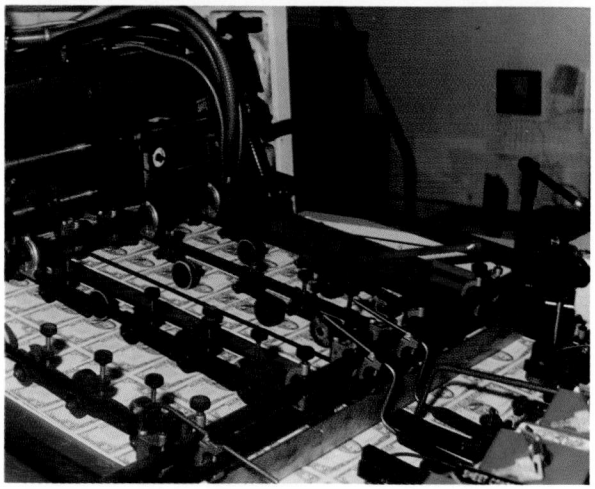

Sheets of 16-subjects about to receive numbers and seals.

Currency that continues to be printed in 32-subject sheets first on the back, and the face on the following day, is trimmed and halved into 16-subject sheets and then examined mechanically and spot checked by examiners. The half sheets are then delivered to the COPE-PAK machines, where they are fed simultaneously in two 10,000-sheet stacks for overprinting, examination and packaging.

Blowers, suction, and grippers move the sheets into the printing cylinders where serial numbers, Federal Reserve and Treasury seals, and Federal Reserve letters are applied. When stacks of 100 accumulate, they receive multi-cuts from both angles, and

stacks of individual notes are fed into a paper bander according to denomination. At this stage the new COPE-PAK demonstrates its superiority and efficiency over the original COPE.

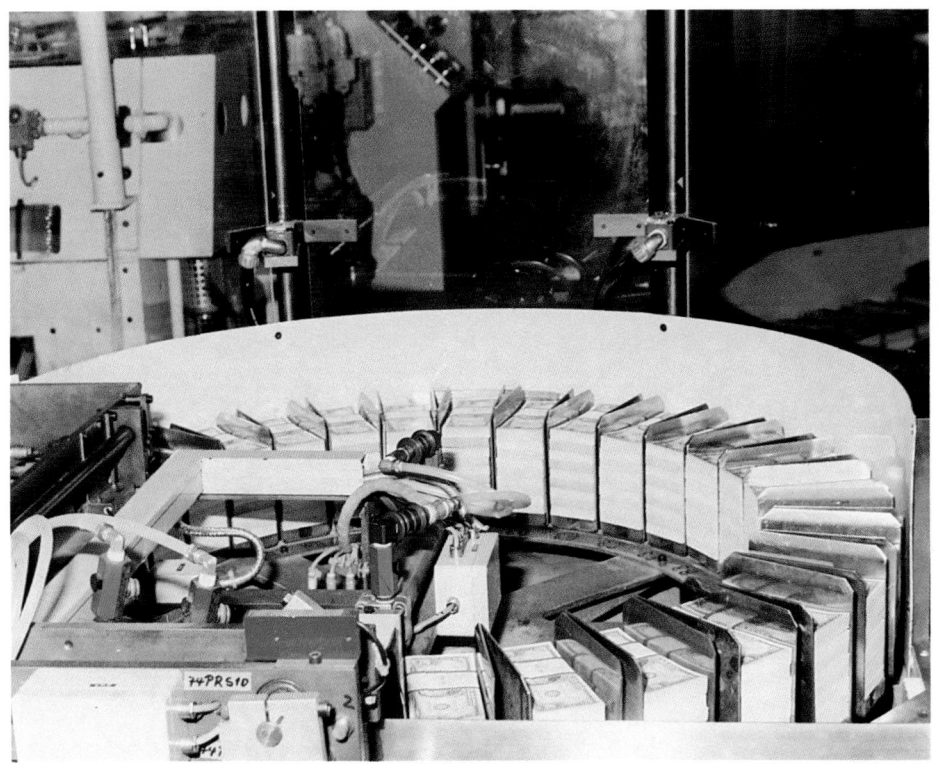

Banded notes before they are shrink-wrapped.

Banded notes pass into an examination station where they are checked at random by examiners. The notes proceed to a rotating carousel with 32 compartments. When 10 packages of 100 notes are collated in the carousel compartments, they move to another bander where they are banded and shrink-wrapped before they continue on in 1,000-note packages. Labels identify the package by denomination, bank and serial numbers. The last step, after two additional countings, is to shrink-wrap packages of four into a final 4,000-note brick weighing 8½ pounds.

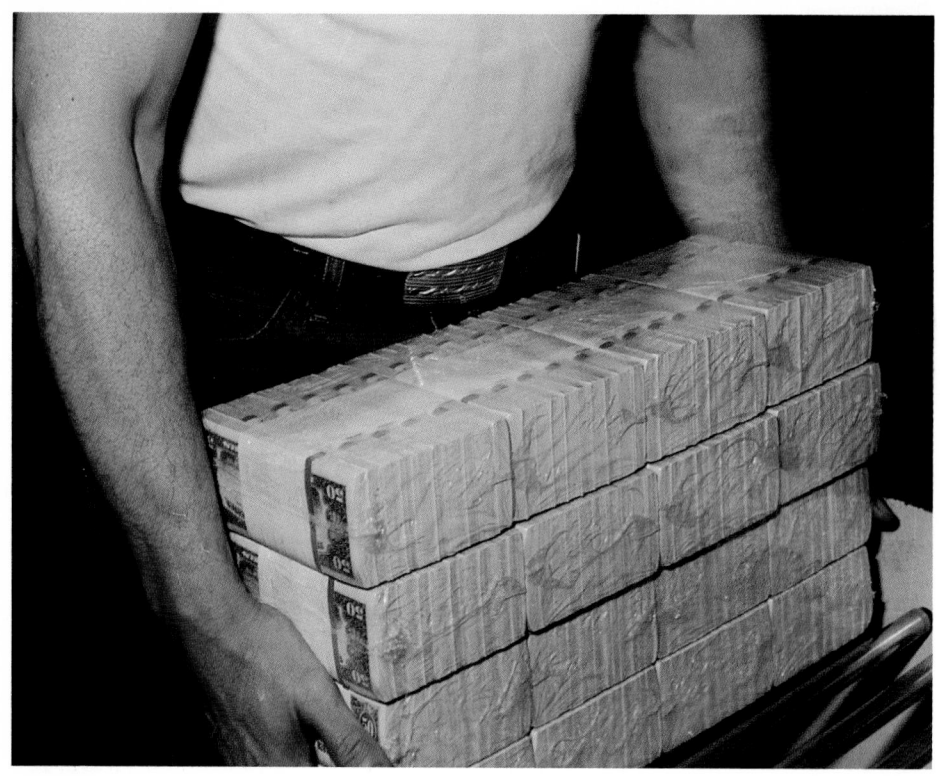

Bricks of currency ready for shipment.

The note production of COPE-PAK has increased note production over that of COPE by about 10 percent. A record number of over 41,000 notes has been processed in a nine-hour period. COPE-PAK is programmed to detect 700 different malfunctions, shut down automatically if a problem occurs, and identify the malfunction. Components for COPE-PAK are made in England, Switzerland and West Germany, where final assembly takes place.

Treasury Department Signatures

Bank notes are essentially promissory notes. Users do not feel secure if the notes do not have signatures that represent some authority. Handwritten signatures were

also thought necessary on the Union side in those bleak days of 1861, when Confederate campfires could be seen across the Potomac from the Treasury Building. Nineteen days after the first paper money was issued, President Lincoln signed a bill that allowed the Secretary of the Treasury to delegate personnel to sign the first demand notes for the two Treasury officials. Seventy employees were assigned the task of signing their own names, with a handwritten "For the" before the appropriate title. Almost immediately it was found necessary to have these words engraved into the printing plates. These signers received an annual salary of $1,200 in the greenbacks that they signed.

Starting in 1863 facsimile signatures were printed directly on the bills. Most United States paper money bears two signatures. National bank notes bear four. Those of the bank president and the cashier are added. Federal Reserve Bank notes bear the signatures of the governor and the cashier or the deputy governor of the issuing bank. A complete list of Treasury officials' signatures is included here.

The signature of the Register of the Treasury appeared from 1862-1925. The Register of the Treasury is an official appointed by the President. Seventeen Registers held office during the period during which they were required to sign notes and other security instruments. It is not generally known that four of the Registers were African-Americans: Blanche K. Bruce, Judson W. Lyons, William T. Vernon and James C. Napier. A fifth African-American Register, Louis B. Toomer was appointed in 1953; however, he did not sign currency.

Register of the Treasury	Treasurer	Terms of Office	
		Began	Ended
Lucius E. Chittenden	F.E. Spinner	4-17-1861	8-10-1864
S.B. Colby	F.E. Spinner	8-11-1864	9-21-1867
Noah L. Jeffries	F.E. Spinner	10-05-1867	3-15-1869
John Allison	F.E. Spinner	4-03-1869	6-30-1875
John Allison	John C. New	6-30-1875	7-01-1876
John Allison	A.U. Wyman	7-01-1876	6-30-1877
John Allison	James Gilfillan	7-01-1877	3-23-1878
Glenn W. Scofield	James Gilfillan	4-01-1878	5-21-1881
Blanche K. Bruce	James Gilfillan	5-21-1881	3-31-1883
Blanche K. Bruce	A.U. Wyman	4-01-1883	4-30-1885
Blanche K. Bruce	Conrad N. Jordan	5-01-1885	6-05-1885
William S. Rosecrans	Conrad N. Jordan	6-08-1885	5-23-1887
William S. Rosecrans	James W. Hyatt	5-24-1887	5-10-1889
William S. Rosecrans	J.N. Huston	5-11-1889	4-21-1891
William S. Rosecrans	Enos H. Nebeker	4-25-1891	5-31-1893
William S. Rosecrans	Daniel N. Morgan	6-01-1893	6-19-1893
James F. Tillman	Daniel N. Morgan	7-01-1893	6-30-1897
James F. Tillman	Elis H. Roberts	7-01-1897	12-02-1897
Blanche K. Bruce	Elis H. Roberts	12-03-1897	3-17-1898
Judson W. Lyons	Elis H. Roberts	4-07-1898	6-30-1905
Judson W. Lyons	Charles H. Treat	7-01-1905	4-01-1906
William T. Vernon	Charles H. Treat	6-12-1906	10-30-1909

Register of the Treasury	Treasurer	Terms of Office Began	Ended
William T. Vernon	Lee McClung	11-01-1909	3-14-1911
James C. Napier	Lee McClung	3-15-1911	11-21-1912
James C. Napier	Carmi A. Thompson	11-22-1912	3-31-1913
James C. Napier	John Burke	4-01-1913	9-30-1913
Gabe E. Parker	John Burke	10-01-1913	12-31-1914
Houston B. Teehee	John Burke	3-24-1915	11-24-1919
William S. Elliott	John Burke	11-24-1919	1-05-1921
William S. Elliott	Frank White	5-02-1921	1-24-1922
Harley V. Speelman	Frank White	1-25-1922	9-30-1927
Walter O. Woods	Frank White	10-01-1927	5-01-1928
Walter O. Woods	H.T. Tate	5-31-1928	1-17-1929
Edward E. Jones	Walter O. Woods	1-22-1929	5-31-1933

Secretary of the Treasury	Treasurer		
William G. McAdoo	John Burke	4-01-1913	12-15-1918
Carter Glass	John Burke	12-16-1918	2-01-1920
D.F. Houston	John Burke	2-02-1920	1-05-1921
A.W. Mellon	Frank White	5-02-1921	5-01-1928
A.W. Mellon	H.T. Tate	4-30-1928	1-17-1929
A.W. Mellon	Walter O. Woods	1-18-1929	2-12-1932
Ogden L. Mills	Walter O. Woods	2-13-1932	3-03-1933
W.H. Woodin	Walter O. Woods	3-04-1933	5-31-1933
W.H. Woodin	W.A. Julian	6-01-1933	12-31-1933
Henry Morgenthau, Jr.	W.A. Julian	1-01-1934	7-22-1945
Fred M. Vinson	W.A. Julian	7-23-1945	7-23-1946
John W. Snyder	W.A. Julian	7-25-1946	5-29-1949
John W. Snyder	Georgia Neese Clark	6-21-1949	1-20-1953
George M. Humphrey	Ivy Baker Priest	1-28-1953	7-28-1957
Robert B. Anderson	Ivy Baker Priest	7-29-1957	1-21-1961
C. Douglas Dillon	Elizabeth Rudel Smith	1-30-1961	4-13-1962
C. Douglas Dillon	Kathryn O'Hay Granahan	1-03-1963	3-31-1965
Henry H. Fowler	Kathryn O'Hay Granahan	4-01-1965	10-13-1966
Joseph W. Barr	Kathryn O'Hay Granahan	12-21-1968	1-20-1969
David M. Kennedy	Dorothy Andrews Elston*	5-08-1969	9-16-1970
David M. Kennedy	Dorothy Andrews Kabis	9-17-1970	2-01-1971
John B. Connally	Dorothy Andrews Kabis	2-11-1971	7-03-1971
John B. Connally	Romana Acosta Banuelos	12-17-1971	5-16-1972
George P. Shultz	Romana Acosta Banuelos	6-12-1972	5-08-1974
William E. Simon	Francine I. Neff	6-21-1974	1-13-1977
W. Michael Blumenthal	Azie Taylor Morton	9-12-1977	8-04-1979
G. William Miller	Azie Taylor Morton	8-06-1979	1-19-1981
Donald T. Regan	Angela M. Buchanan	3-17-1981	7-01-1983
Donald T. Regan	Katherine Davalos Ortega	9-23-1983	1-29-1985
James A. Baker, III	Katherine Davalos Ortega	1-29-1985	8-17-1988
Nicholas Brady	Katherine Davalos Ortega	9-15-1988	6-30-1989
Nicholas Brady	Catalina V. Villalpando	12-11-1989	–

* During her term, Mrs. Elston married Walter L. Kabis. This is the first time the signature of a United States Treasurer was changed while in office.

Directors of the Bureau of Engraving and Printing

Directors	Term Began	Term Ended	Directors	Term Began	Term Ended
Spencer Morton Clark	8-22-1922	11-17-1868	James L. Wilmeth	12-10-1917	3-31-1922
George B. McCartee	3-18-1869	2-19-1876	Louis A. Hill	4-21-1922	2-14-1924
Henry C. Jewel	2-21-1876	4-30-1877	Wallace W. Kirby	6-16-1924	12-15-1924
Edward McPherson	5-01-1877	9-30-1878	Alvin W. Hall	12-22-1924	12-15-1954
O.H. Irish	10-01-1878	1-27-1883	Henry J. Holtzclaw	12-15-1954	10-08-1976
Truman N. Burrill	3-30-1883	5-31-1885	James A. Conlon	10-09-1967	7-01-1977
Edward O. Graves	6-10-1885	6-30-1889	Seymour Berry	7-02-1977	4-07-1979
Claude M. Johnson	7-01-1893	5-10-1900	Harry Clements	7-05-1979	1-03-1983
William M. Meredith	11-23-1900	6-30-1906	Robert J. Leuver	2-22-1983	4-01-1988
Thomas J. Sullivan	7-01-1906	5-04-1908	Peter H. Daly	8-26-1988	
Joseph E. Ralph	5-11-1908	10-31-1917			

Prior to July 1896 the head of the Bureau of Engraving and Printing was designated as "Chief."

The Treasury Seal

The U.S. Treasury Seal appears on all notes printed by the Bureau with the exception of the demand notes of 1861 and the first three issues of fractional currency.

Following the first issue of United States paper money in 1861, Spencer Clark, the Chief Engineer of the small National Currency Bureau, was requested by Secretary of the Treasury Chase to design a new seal for the Department.

The Department of the Treasury has had a variety of seals. The first, supposedly designed by Governeur Morris in 1778. Francis Hopkinson, who designed other departmental seals, could have had a hand in creating the seal that was adopted by the Continental Congress in 1789.

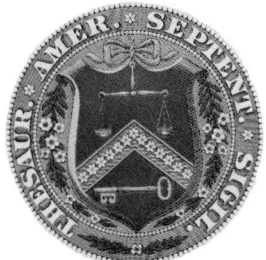 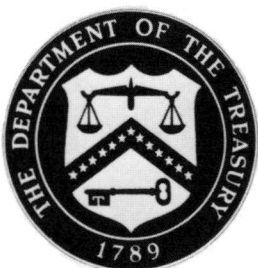

Spencer Clark had these words to say about his design, a variation of the 1789 version and still used today: " . . . its interior a facsimile of the seal adopted by the Treasury Department for its documents on a ground of geometric lathe work, the exterior being composed of thirty-four points, similarly executed. The points were designed to be typical of the thirty-four states, and to simulate the appearance of the seals ordinarily affixed to public documents." Clark preferred not to recognize the secession of eleven states the year before.

Until January 1968 the legend of the Seal appeared in Latin, THESAUR(I) AMER(ICAE) SEPTENT(RIONALIS) SIGIL(LUM); translated, "The Seal of the Treasury of North America." The new version of the Seal in English made its first appearance on the $100 United States note, Series 1966 printed in 1968. This new seal has the legend, "THE DEPARTMENT OF THE TREASURY 1789."

The Great Seal of the United States

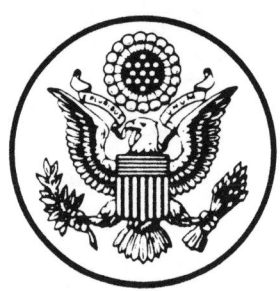 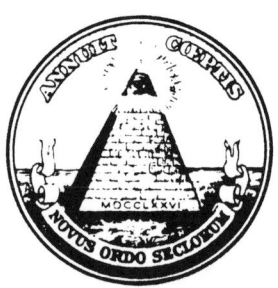

Three designs for the Great Seal were submitted (1776, 1780 and May 1782), however it was the Charles Thomson's obverse design, adopted on June 20, 1782, that resembles the one we see in use today. The reverse is by William Barton, who had submitted obverse and reverse designs in May 1782.

The Great Seal symbolizes strength and victory and became the National Emblem in 1782. It first appeared on U.S. paper money as part of the back design of the 1907, $20 gold certificate. Since 1935 it has remained part of the back design of our $1 notes. Always desiring peace the American bald eagle faces the olive branch with 13 leaves, and holds arrows, the American Indian symbol of war, in its left talon. There are 13 stars above the eagle, one for each original colony. "E PLURIBUS UNUM," with 13 letters, means "ONE FROM MANY" and the 13-striped shield represents the Continental Congress.

The Latin motto on the reverse, "ANNUIT COEPTIS," with 13 letters means "HE (GOD) HAS SMILED ON OUR UNDERTAKINGS." Below the pyramid is a second motto, "NOVUS ORDO SECLORUM," or "A NEW ORDER OF THE AGES," signifying a new American age. The pyramid is a symbol of strength and permanence; it is incomplete, signifying that the United States continues to grow and build. The eye in the triangle suggests the all-seeing Deity, emphasizing spiritual welfare; it also acknowledges education and freedom of knowledge. The date 1776 on the base of the pyramid with 13 steps refers to our Declaration of Independence.

The National Motto

The national motto, "In God We Trust," was added to the back of those $1 silver certificates that were printed on the Bureau of Engraving and Printing's new flatbed

presses. The changeover to high-speed presses was completed in April 1968, and so Series 1935G of silver certificates printed in 1962 is found with and without the motto. The suggestion to include "In God We Trust" was presented to Secretary of the Treasury George M. Humphrey in November 1953 by Matthew H. Rothert of Camden, Arkansas. Secretary Humphrey favored the idea but felt that Congressional sanction was required. In March 1955, through Mr. Rothert's efforts, bills to this effect were introduced into the Senate by Senator Fullbright of Arkansas and into the House of Representatives by Congressmen Bennet of Florida and Harris of Arkansas. The bill, which was approved by President Eisenhower on July 11, 1955, specified "that at such time as new dies for the printing of currency are adopted . . . by the Bureau of Engraving and Printing, the dies shall bear . . . the inscription "In God We Trust" and thereafter this inscription shall appear on all United States currency and coins."

In 1864 the motto had first appeared on a United States coin, the two-cent piece. It took 93 years and an act of Congress before the same motto was added to United States currency.

Dating, Size and Color of U.S. Paper Money

United States paper money includes at least one date, sometimes two. Large-size paper money most often included the date of issue, the date of the authorizing act, or a series date, and at times, two of the three. Coins bear an annual date; paper money does not. For some large-size notes a series did not change once it was established, even if United States Treasury signatures were changed. The note usually was given a different series date if the design was changed or altered.

With the exception of refunding certificates, compound interest and interest-bearing Treasury notes, all large-size notes are $7\frac{3}{8} \times 3\frac{1}{8}$ inches in size.

Originally, small-size notes received a new series date or, most often, had a letter added to the original series date if either of the signatures changed. Today, a letter is added to the series date for one change of signature. However, if more than one year elapses from the original date, a date that corresponds to the year of issue is assigned.

A patent originated by Dr. Thomas Sterry Hunt dated June 30, 1857 created an anti-photographic green ink. The primitive camera, a primary aid for counterfeiters, could not photograph this color. The 1857 interest-bearing treasury notes were the first United States federal currency to be printed with this ink. Green ink continues to be used for the back of current Federal Reserve notes.

Anti-counterfeiting Additions

Some predict a future cashless society. Cash now exceeds credit card payments by 300%. "By the year 2000 cash will account for 35% of consumer spending compared to only 14% of credit cards Cash in the U.S. is 7% coin and 93% bank notes . . ." (*The Nihlson Report*, February 1991).

Between 1985 and 1990 the loss to the public from counterfeit bank notes doubled from $7 million to $14 million. "Counterfeiting originates from three categories:

(1) individuals who are eccentric, mischievous, or criminal, (2) organized criminal groups, domestic and foreign, and (3) extremist groups sponsored or supported by unfriendly governments" (*The Nihlson Report*, March 1991).

As much as 70% of U.S. paper money circulates outside the U.S. Approximately 37% of all counterfeit U.S. bank notes come from abroad. During each of fiscal years 1990 and 1991 the U.S. Secret Service seized $131.8 million. For the latter year, $50.8 million was seized abroad. (The U.S. Secret Service now has offices abroad.) The $131.8 million is an increase of over $121.1 million for fiscal year 1989.

After seven years of research and development, two visible anti-counterfeiting devices have been added to U.S. Federal Reserve notes, the only circulating notes. Advanced color photocopiers pose a threat to all currencies. In an attempt to eradicate this threat, micro-printing and a plastic strip was added to the paper on which series 1990 was printed.

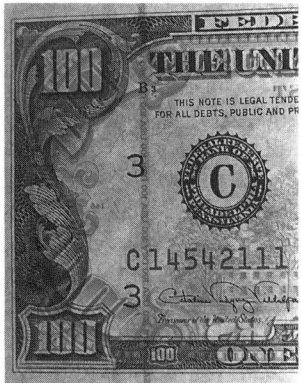

The first notes to be issued with these changes were the $100 and $50 denominations; eventually all but the $1 note will bear these same features.

"United States of America is repeated in micro letters around each portrait. There is also a vertical plastic strip that bears the repeated denomination. The strip is visible when the note is held against a light; a magnifying glass might be required to see the micro-printing. It is difficult for photocopiers to copy either feature.

Any document can be counterfeited, given both technology and time. Consequently, additional features will undoubtedly be added in the future. They might include: watermarks; color; precise registration of designs on both face and back, which would be apparent when the note is held to the light; an optical variable device, i.e., a configuration or image that changes color or shape, when viewed at a different angle, e.g., a Hologram.

Types of
United States
Paper Money

NUMBERING SYSTEMS OF UNITED STATES PAPER MONEY

ONE of the chief functions of the numbering systems used on United States currency has been to foil counterfeiters. At first the Treasury Department kept the details of the numbering systems secret so that forgers could not find the correct combinations of serial numbers and plate position letters and numbers. More recently, the Treasury's "Know Your Money" campaign has stressed maximum publicity of all details of the currency so that the general public can be well-prepared to detect counterfeits. Thus the details of the numbering systems have become better known, though, as will be demonstrated, gaps still exist.

No serial number prefix or suffix was added to United States currency prior to April 1869.

Repeat Numbering

The earliest numbering system used on United States paper money was repeat numbering. All notes from a given sheet would have the same serial number, including prefix and suffix letters and ornaments, if any. These notes are differentiated only by plate position letters, usually A, B, C and D or E. F, G and H on a 4-subject plate. A national bank note plate of $1-1-1-2 would have plate letters A-B-C-A. Sheets of other mixed denominations would use letters similarly. Repeat numbering is found on all classes of interest-bearing notes except the refunding certificates of 1879, and on large-size national bank notes of all charter periods. Repeat numbering was originally a device to avoid impossibly large serial numbers.

Consecutive Numbering

In consecutive numbering all notes on a sheet have consecutive numbers. The bottom note of a 4-subject sheet has a serial number divisible by 4 and a plate letter "D", or occasionally an "H". Consecutive numbering is found on all large-size notes except compound interest treasury notes, interest-bearing notes and national bank notes. This numbering system was continued on all 12-subject small-size notes (1929-1953) except for the special uncut sheets issued for use in Hawaii and North Africa during World War II. The relationship on these small-size notes between a serial number divisible by 12 and a plate position letter is an anticounterfeiting device.

Consecutive numbering enabled many early sheets to be reconstructed for display, affording an idea of the original appearance of plates even though no uncut sheets survived. This is generally not possible with skip numbering. The earliest bills – demand notes, United States notes, and gold certificates – bear serial numbers 1 to 1,000,000. The numbering system was then repeated with the addition of "series 1", "series 2", etc. United States notes of 1862 and 1863 are known with series as high as 284. Interest-bearing treasury notes were not issued in large enough quantities to require this practice; repeat numbering to six digits was sufficient.

Skip Numbering

Beginning in November 1952, 18-subject sheets show skip numbering, the first sheet bearing numbers 1, 8001, 16001, and so forth to 136001. The next sheet would commence with 2, 8002, 16002, through a run of 8,000 sheets. A similar system is now in use for 32-subject sheets.

Block Numbering

A new system, block numbering began with the 1869 United States notes. Serial numbers were prefixed with "A" (1 to 10,000,000), then B, K, V and Z advancing to the same figure. Other letters used with a star suffix (these are not replacement notes) appeared on higher denominations. On the United States notes of 1880, prefix letters and ornament suffixes continued, but a complete block was 10,000,000; many blocks are incomplete because prefix letters were changed when different seals were introduced. United States notes in 1917 introduce letter suffixes as well. Blocks A-A, B-A, D-A, E-A, H-A, K-A, M-A, N-A, R-A and T-A are found on $1 notes.

Silver certificates of 1878 are from block A-X, those of 1880 are from block "B" with ornament, those of 1866 are from block "B" with a different ornament, those of 1891 are from block "E" with yet another ornament, and the issues of 1896 (and the 1899 issue bearing signatures of Lyons and Roberts) have two pheons. Subsequent blocks are B, D, E, H, K, M, and so forth with an ornament as a suffix. In 1912 identical prefix and suffix letters were introduced, producing A-A, B-B, D-D, E-E and H-H.

From about 1917 the suffix "A" is constant: B-A, D-A, E-A, H-A . . . X-A. On small-size currency the block system is continued with the entire alphabet used except for

"O;" after 100,000,000 (today a star note) in block Z-A, the numbering starts again with A-B. The exception to this is Federal Reserve notes A through L on which the letter is always that of the Federal Reserve District.

Before August 22, 1925 all national bank notes bore both a Treasury serial number and a bank sheet number; after 1925 the bank sheet number was printed twice. The bank sheet number—generally not prefixed and never suffixed—is the cumulative total of notes of that denomination and type issued for that bank. Prefix "A" is rarely found on national bank notes issued between 1925 and 1929. Apparently, "A" signifies the second million sheets of that denomination and type. The Treasury number—to six digits, at first plain, then in parenthesis, suffix, and letter prefix—were cumulative for sheets of the denomination and type over all of the banks for which they were issued. Later, blocks in Treasury numbers were generally similar to those in other classes of notes. Double letters (A-A, B-B, D-D) were in use between 1899 and 1908; letters B-A, D-A and E-A began on May 5, 1911. Information allowing the accurate dating of a national bank note from the Treasury number is not available since certain archival records of 1916-1922 are incomplete.

Small-size national bank notes of type I, issued between 1919-1933, used repeat numbering with six subjects prefixed A to F and suffixed "A". The millionth sheet was then numbered A to F with suffix "B". The "B" suffix is known on $5 notes issued by The Chase National Bank of New York. Type II notes, issued from May 1933 through May 1935, were consecutively numbered with the bank's charter number in brown beside the bank serial number. The complete "A" block totals 699,996 notes from 166,666 sheets; the next sheet was numbered B1 to 6. Five dollar notes of block "B" are known from the Bank of America, San Francisco, California.

Star or Replacement Notes

Defective notes printed at the Bureau of Engraving and Printing before June 1910 were replaced with hand-stamped notes with the same serial number as the imperfect note. As the production of notes increased this became impractical. Star notes with different serial numbers were the answer. The use of a star as a prefix, on notes that replaced defective notes discovered at the Bureau of Engraving and Printing during inspection, began in 1910 with block ☆-B on United States notes and silver certificates; later, suffix "D" was used. The system continued with the use of a solid star (★), which was applied to small-size notes. Federal Reserve Bank notes and Federal Reserve notes employ the star as the suffix.

No star notes were issued for national bank notes, although a replacement system was used. Defective national bank notes were replaced with individually prepared matching serial numbers. These can sometimes be identified by the faulty alignment of the serial number.

The star (★) was also used after 1935 to complete a numbered series of 100,000,000 for all small-size notes. Since the highest number that can be printed by

an eight digit numbering cylinder is 99,999,999, the 100,000,000th note was, in some instances, a hand-inserted star note with a random serial number. Doug Murray and Frank Nowak have confirmed from Bureau records that serial number 100,000,000 was printed for many and could have been printed for all notes prior to 1935. All observed large-size notes with number 100,000,000 appear to have been hand-stamped (see No. H380). It is possible that some, perhaps many, of these scarce, attractive, serial-numbered large-and small-size notes could have been held back as presentation pieces, with a star note inserted to complete a pack of 100 notes, thus accounting for their rarity.

Throughout this catalog replacement notes are listed as a variety of the major entry. These are indicated by a star (☆) after the primary entry. Also listed is the number of known star notes issued, printed or delivered. Listed as well are figures received from collectors who have reported replacements for an issue.

A DESCRIPTION OF NOTE TYPES

Demand Notes

Congressional Acts of July 17 and August 5, 1861 authorized $60 million in demand notes, or "greenbacks" as they were soon called. Recruits from the United States Treasury Department were assigned the task of signing each of these notes for the two designated Treasury officials. At first, "For the", "For The", or "for the" was written as a prefix to the words "Treasurer" and "Register of the Treasury." The engraved plates were altered in late August 1861 to include the words "For the". A letter dated 27 August from American Bank Note Company (ABNCo) to the Treasury Department acknowledges the request for this change. Three days later, as requested, ABNCo wrote to say they would suspend the printing of demand notes payable at Cincinnati and St. Louis. These notes are now the rarest.

Demand notes are the only United States currency, excluding fractional currency, that do not bear the United States Treasury Seal. Nor do they include the names of the United States Treasurer and Register of the Treasury, but they do include the names of those who signed for them.

These notes, payable on demand, bore no interest as did treasury notes authorized by the same two acts, and they were not redeemable in coin. However, a circular from the office of the Secretary of the Treasury, prior to specie payment suspension on 21 December 1861, declared them payable in coin, on a par with gold. Prior to, and after the circular issuance, demand notes were acceptable at discount rates.

United States (Legal Tender) Notes

The first of five, large-size issues in denominations of $5 to $1,000 bears the date of March 10, 1862. Two different obligations appear on the back of the first issue.

First Obligation: "This note is legal tender for all debts, public and private, except duties on imports and interest on the public debt, and is exchangeable for U.S. six-percent, twenty-year bonds, redeemable at the pleasure of the United States after five years."

Second obligation: "This note is legal tender for all debts, public and private, except duties on imports and interest on the public debt, and is receivable in payment of all loans made to the United States."

The second issue, dated August 1, 1862, included notes of $1 and $2 only. The third issue, dated August 1, 1863, once again included denominations from $5 to $1,000. The Congressional Act of March 3, 1863 authorized the fourth issue; it included denominations of $1 to $10,000. Seven series are included in this issue: 1869 (labeled a Treasury Note), 1874, 1878, 1880, 1907, 1917 and 1923. A $10 note was the only denomination included in the fifth issue, series of 1901. In July 1873 the United States Treasury Department decided that the term United States notes would replace "legal tender notes" as the official designation for large-size notes.

Small-size United States notes of $1 (1928), $2 and $5 (1928, 1953 and 1963), and $100 (1966) have been issued. The latter denomination accounted for most of the $346,681,016 that technically remained in circulation as required by the Act of May 31, 1878 and the Old Series Currency Adjustment Act. In late 1986 it was announced that this obligation would be discontinued upon the passage of required legistlation. Although still legal tender, as is all circulating U.S. currency since 1861, the few red seal U.S. notes still in circulation are withdrawn as they come into banks.

History of Interest-bearing Treasury Notes

The first United States interest-bearing treasury notes were issued in 1812. Their recommendation came from Secretary of the Treasury Albert Gallatin on May 14, 1812, one month before war was declared against Great Britain on June 18. These notes, and most of those that were periodically issued during the following 53 years, gained interest. The lower denominations, at times including notes as high as $20, circulated as currency. Higher denominations were often held by banks "as high-powered reserves for the expansion of their own notes and deposits, and as clearing media for adverse balances with other banks" (Timberlake, 15). These notes did not enjoy legal tender status, but were nevertheless receivable for government debts, taxes and duties.

Section two of the Act of June 30, 1812 authorized the issue of treasury notes stating:

That the said treasury notes shall be reimbursed by the United States, at such places, respectively, as may be expressed on the face of the said notes, one year, respectively, after the day on which the same shall have been issued; from which day of issue they shall bear interest at the rate of five and two-fifths per centum

a year, payable to the owner and owners of such notes, at the treasury, or by the proper commissioner of loans, at the places and times respectively designated on the face of said notes for the payment of principal.

The first treasury notes were signed by designees of the President of the United States at a compensation of $1.25 for each 100 notes signed. These notes were then countersigned by United States Commissioner of Loans for the state in which the respective notes were payable. As part of the Act of December 26, 1814, signers had their fee reduced to 75¢ per 100 notes signed. The length of the loan for treasury notes issued between 1812 and 1860 was one year. Interest rates on treasury notes issued during this period ranged from 2 to 6 percent. There were three exceptions; those issued under the Acts of October 12, 1837, March 3, 1843 and June 22, 1846 bore interest at a minimum of 1 mill percent.

Interest accrued at the rate of 5, 6 and 7.3 percent over a period of sixty days to three years for treasury notes issued between 1861 and 1865. Three-year notes included five coupons, each redeemable after intervals of six months. The final payment was made when the note itself was redeemed. The acts that authorized some treasury notes also allowed for their reissuance, provided the outstanding amount did not exceed the authorized amount.

Beginning with emissions authorized under the Act of February 24, 1815, treasury notes received the countersignature of the United States Register of the Treasury. Treasury notes issued under the Act of October 12, 1837, and all that followed through 1865, bore the signature of the United States Treasurer and the countersignature of the United States Register of the Treasury.

"In April of 1864 $4,000 in interest-bearing [treasury] notes of unspecified denominations were issued misdated from 5-12-64 to 5-16-64, thus accounting for a [$20 note] dated 5-14-64" (Gengerke, 48).

After 1865, bonds, which had been issued concurrently, seemed to suffice as United States interest-bearing fiscal paper. United States treasury notes regained popularity in the 1970s. However, since a book entry is made at the time of purchase, a statement is received instead of a certificate.

Interest-bearing treasury notes, compound interest treasury notes in denominations of $10 and $20, and refunding certificates often circulated as currency.

INTEREST-BEARING TREASURY NOTES 1812-1860

The original body of this catalog, without the following treasury notes (1812-1860), is arranged by denomination. However, due to the greater variety of interest rates that often apply to early treasury notes, those issued between 1812 and 1860 will be listed and illustrated separately under each act at the beginning of the catalog. The illustrations comparatively reflect the actual size of these larger notes. Interest-bearing treas-

ury notes issued after 1860 are listed by denomination in this catalog. And, although catalog numbers are essential, they can be a nuisance. Rather than introduce yet another set of catalog numbers, those used to identify the following treasury notes as they first appeared in *An Illustrated History of Loans, 1775-1898* will be used here.

To avoid confusion, an "X" was placed before all numbers in the work just mentioned so that easy reference can be made. Thus, HX100 identifies treasury notes issued under the Act of 21 May 1838; H100 refers to 1969B, $1 Federal Reserve notes, listed under $1 notes in this catalog.

Compound Interest Treasury Notes

Notes of $10, $20, $50, $100, $500 and $1,000, bearing interest at 6 percent annually were authorized by Congressional Acts of March 3, 1863 and June 30, 1864. They were issued to force the retirement of 5 percent treasury notes issued under the latter act. All compound interest treasury notes had bronze overprints; the notes ceased to earn interest after maturity. Two and one-half years after these notes were issued 3 percent certificates were issued for their redemption.

An unknown number of these notes were issued with the incorrect act date of July 2, 1864. Two $10 notes (8275, plate B, and 9582, plate C) have been recorded.

Refunding Certificates

On February 26, 1879 the United States government authorized what was thought to be an appealing fiscal instrument of $10 that would pay 4 percent interest annually with an indefinite accumulation. In 1907 Congress passed a law that discontinued interest after July 1 of that year. At that time the notes with accrued interest were worth $21.30. The first of two types (Nos. 603 & 604 in this catalog) is extremely rare; only two are known.

Currency Certificates of Deposit

By the Act of June 8, 1872 the Secretary of the Treasury was authorized to issue certificates in denominations of $5,000 and to receive certificates of $10,000. The $10,000 notes were receivable on deposit without interest from national banking houses but were not to be included in the legal reserve. The $5,000 notes were payable on demand (in United States notes) at the place of deposit but were accepted in settlement of clearing house balances at the locations where such deposits were made. On March 14, 1900 the act authorizing these large denomination certificates was repealed.

Silver Certificates

All silver certificates were authorized by the Acts of February 28, 1878 and August 4, 1886. The first of five large-size issues had "Certificate of Deposit" printed on the face of $10 to $10,000 notes. The notes of 1878 all have the countersignature of

the United States Assistant Treasurer. Notes of $1 through $1,000 made up the second issue of 1886, 1891 and 1908. Notes of $1, $2 and $5 account for the third issue of 1896 and the fourth issue, Series of 1899. The fifth issue, series of 1923, included only $1 and $5 notes.

Small-size silver certificates in denominations of $1 (1928, 1934, 1935 and 1957), $5 (1934 and 1953), and $10 (1933, 1934 and 1953) are no longer printed. Series of 1934 $1 notes were the first to have the Treasury signatures overprinted on the notes; previous signatures were engraved into the printing plates. After June 24, 1968 silver certificates were no longer redeemable for silver.

Treasury (or Coin) Notes

The Legal Tender Act of July 14, 1890, passed with the help of the silver mining lobby, authorized the "Coin" notes of $1 through $1,000, Series of 1890 and 1891. The $50 note was issued only as Series 1891; only an essay for the $500 design was made.

Treasury, or coin, notes were used to purchase silver bullion, at inflated prices. They were received in payment, then redeemed for gold when possible; the Secretary of the Treasury could decide if the notes were to be payable in gold or silver. This ludicrous scenario continued until President Cleveland had the silver purchasing act repealed in 1893, thereby averting a serious panic.

Federal Reserve Notes

The Federal Reserve Act of 1913 authorized all Federal Reserve notes. The series of 1914 included only notes of $5 through $100; the higher denominations, $500 through $10,000, bore the series date of 1918. Series 1914 was issued in two types — one with red Treasury seal and serial number, the other with blue seal and number; the type in red is the scarcest. The obligation on the Federal Reserve notes was borne by the United States government and not by the individual banks.

Small-size Federal Reserve notes have been printed in denominations of $1 through $10,000; the $100 note is the largest denomination printed today. These small-size notes ($5 to $10,000) were first printed in 1929 with a series date of 1928. (Notes of $1 were not printed until 1963.)

Until 1934 the obligation of all Federal Reserve notes made a reference to redemption in gold. Following the passage of the Gold Reserve Act in 1933, United States paper money was no longer redeemable in gold and the obligation was changed to read, "redeemable in lawful money." All notes issued today by the United States government are Federal Reserve notes.

Federal Reserve Bank Notes

There were two issues of large-size Federal Reserve Bank notes — 1915 ($5, $10 and $20) and 1918 ($1-$50) — authorized by Federal Reserve Acts of December 23, 1913 and April 23, 1918. Not all banks within the Federal Reserve system issued notes of

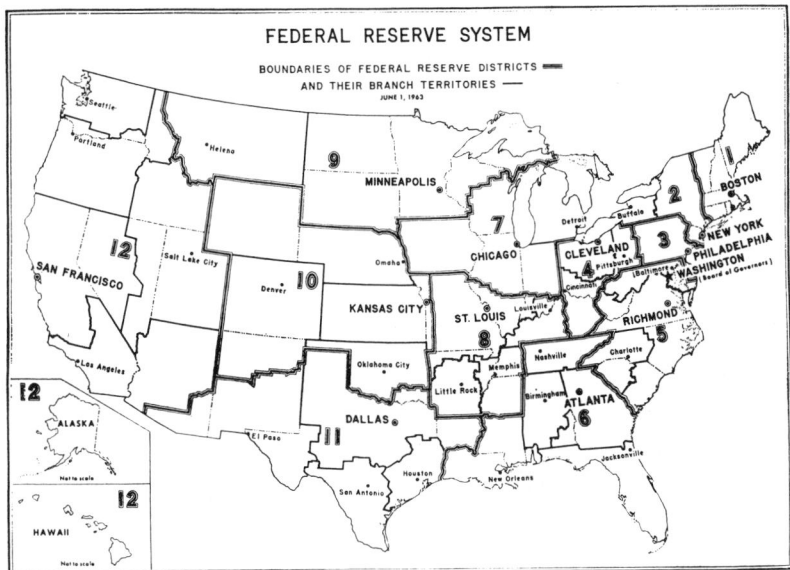

Photo by *Coin World.*

the first series, but all banks issued notes bearing the series date of 1918. The obligation to pay is made by the individual bank, not by the United States government. Approximately $760 million in notes was issued; only $2 million remain outstanding.

The small-size Federal Reserve Bank notes were authorized by the Act of March 9, 1933 and were issued to alleviate the shortage of paper money due to the massive withdrawal of Federal Reserve notes. National bank note plates with the date 1929 were adapted for this issue, which is similar to the earlier national bank notes with the exception of the overprinting, to accommodate the appropriate signatures and a larger brown seal.

National Gold Bank Notes

These gold-tinted notes are extremely beautiful as well as extremely rare. To alleviate the burden of handling gold in the form of dust and nuggets in business transactions, the United States Congress authorized ten banks—nine in California and one in Boston—to issue paper money in denominations of $5 through $500 redeemable in gold. The Kidder National Bank in Boston had $120,000 in notes prepared. However, none were issued. Three pairs of $50 and $100 specimen notes are known to exist from this bank.

These gold banks were also national banks, and it was therefore necessary for them to deposit United States Bonds as security with the U.S. Treasurer. Notes of up to 80

percent of the deposited bonds could circulate but gold coins equalling 25 percent of the note issue had to remain in the bank's vaults. The obligation on these notes is similar to that on national bank notes except that the gold bank notes were payable in "gold coin."

Fewer than 300 pieces—most in a poor state of preservation—in all denominations for all banks, are known. However, United States Treasury records show that 6,639 notes remain outstanding.

Gold Certificates

There were nine issues of large-size gold certificates, but only four issues were circulated widely. The first three (issued between 1865 and 1875), the fifth (1888), and the sixth (1900) were used primarily among banks and clearing houses. The 1882 series, the fourth issue, in denominations of $20 through $10,000, was the first to circulate widely. The seventh issue, Series of 1905, 1906 and 1907, included two denominations only—$10 and $20. Series 1907, the eighth issue, was limited to the $1,000 note. The ninth and final issue consisted of two series—1913 ($50) and 1922 ($10-$1,000).

Small-size gold certificates dated 1928 ($10-$10,000) had a short life; they were recalled following the Gold Reserve Act of 1933. Secretary of the Treasury Dillon's order of April 24, 1964 made it legal for collectors, and others, to hold gold certificates.

National Bank Notes

As the Civil War entered its third year, it became necessary to centralize and standardize paper money in the United States. In addition to demand notes, United States (legal tender) notes, and those interest-bearing treasury notes that, out of necessity, circulated, there was a plethora of state bank notes, many of dubious origin, that also continued to circulate. Secretary of the Treasury Salmon P. Chase initiated the National Bank Act of February 25, 1863. Notes of $1 through $1,000 were authorized. A $3 note was included but not issued.

The Act of 1863 allowed participating chartered banks to issue bank notes up to 90 percent of the value of specific United States bonds which had been deposited with the Treasurer of the United States. A circulating limit of $300 million for national banks was established on June 3, 1864. On March 3, 1865 legislation was enacted that apportioned the preceding figure based on population and banking capital. It was this act that imposed the 10 percent tax on all state bank notes in circulation; this sealed the doom of the wildcat banking period.

An additional $54 million in circulating notes was authorized in 1870, and a circulation limit of $500,000 was placed on each chartered bank. Five years later all restrictions were removed, and in 1900 banks were granted the privilege of issuing notes equalling 100 percent of the bonds deposited. When the last of these bonds were recalled, in July 1935, no more were issued.

Prior to 1875 national bank notes were prepared exclusively by three private bank note companies—American Bank Note Co., National Bank Note Co. and Continental Bank Note Co. The United States Treasury seal and both sets of serial numbers, treasury and bank, were added in Washington. Commencing in September 1875 face plates were sent to Washington for printing, but most backs continued to be printed by the private bank note companies. Beginning in January 1877 all currency printing was done at the National Currency Bureau in Washington.

Large-size currency was authorized under three charters. The first included two issues; the second and third, three issues each. All notes had the charter number of the bank imprinted on the face of the notes. Two types of small-size notes were issued; type II had the charter number printed two additional times on each note.

After 1935 the Federal Reserve Banking System, established in 1913, took precedence and the most fascinating chapter in the history of United States currency came to an end. The general rarity of national bank notes by state ranges from R(arity) 1, the most common, to R(arity) 9, the rarest. The table printed herein is arranged accordingly. For the most part the rarity of a national bank note is based on the number of such banks recorded for a particular state. However, there are other criteria that will affect the availability of particular notes, i.e., the size of the community or city where the bank was located, denominations issued, the length of time the bank operated and the desirability created by odd or interesting names.

Notes issued by the Alamo National Bank of San Antonio, TX, the Old Colony National Bank in Plymouth, MA, and the Lincoln National Bank of Lincoln, NE are just a few of these interesting names. Notes from interesting locales, e.g., Dry Run, PA, Painted Post, NY, and Buzzards Bay, MA are among many that are sought by collectors.

National Bank Note State and Type Rarity Table

State	Large Size	Small Size	State	Large Size	Small Size
Alabama	R4	R3	Montana	R4	R3
Alaska	R9	R9	Nebraska	R4	R2
Arizona	R8	R5	Nevada	R8	R6
Arkansas	R6	R3	New Jersey	R2	R2
California	R1	R1	New Mexico	R8	R5
Colorado	R5	R2	New York	R1	R1
Connecticut	R4	R2	North Carolina	R4	R2
Delaware	R7	R4	Ohio	R6	R2
District of Columbia	R5	R2	Oklahoma	R6	R2
Florida	R6	R3	Oregon	R6	R4
Georgia	R6	R5	Pennsylvania	R1	R1
Hawaii	R8	R5	Puerto Rico		R9
Idaho	R8	R5	Rhode Island	R7	R4
Illinois	R1	R1	South Carolina	R5	R2
Indiana	R1	R1	South Dakota	R5	R4
Iowa	R2	R1	Tennessee	R4	R2
Kansas	R3	R2	Texas	R7	R4
Kentucky	R3	R2	Utah	R7	R4
Louisiana	R5	R3	Vermont	R6	R3
Maine	R6	R2	Virginia	R4	R2
Maryland	R4	R2	Washington	R5	R3
Massachusetts	R2	R2	West Virginia	R5	R2
Michigan	R2	R2	Wisconsin	R3	R1
Minnesota	R3	R2	Wyoming	R7	R4
Mississippi	R7	R2	Territories		R8

Between January 11, 1902 and February 26, 1924 a letter was printed near the bank charter number. This letter helped with the sorting of the notes geographically. The letters and their meaning are as follows:

N	– New England States	M	– Middle States
E	– Eastern States	W	– Western States
S	– Southern States	P	– Pacific States

National Bank Note Charter Numbers

On June 20, 1863 the First National Bank of Philadelphia received charter number 1. Charter numbers were granted through 14,348 which was received by the Roodhouse Bank of Roodhouse, IL. However, some of the banks with higher numbers did not issue national bank notes for any of several reasons. The highest charter number to appear on a national bank note is 14,320 for the National Bank and Trust Company of Louisville, KY.

Charter Numbers	Year Granted	Charter Numbers	Year Granted	Charter Numbers	Year Granted
1–179	1863	3833–3954	1888	10120–10305	1912
180–682	1864	3955–4190	1889	10306–10472	1913
683–1626	1865	4191–4494	1890	10473–19672	1914
1627–1665	1866	4495–4673	1891	10673–10810	1915
1666–1675	1867	4674–4832	1892	10811–10932	1916
1676–1688	1868	4833–4934	1893	10933–11126	1917
1689–1696	1869	4935–4983	1894	11127–11282	1918
1697–1759	1870	4984–5029	1895	11283–11570	1919
1760–1912	1871	5030–5054	1896	11571–11903	1920
1913–2073	1872	5055–5108	1897	11904–12082	1921
2074–2131	1873	5109–5165	1898	12083–12287	1922
2132–2214	1874	5166–5240	1899	12288–12481	1923
2215–2315	1875	5241–5662	1900	12482–12615	1924
2316–2344	1876	5663–6074	1901	12616–12866	1925
2345–2375	1877	6075–6566	1902	12867–13022	1926
2376–2405	1878	6567–7081	1903	13023–13159	1927
2406–2445	1879	7082–7451	1904	13160–13269	1928
2446–2498	1880	7452–8027	1905	13270–13412	1929
2499–2606	1881	8028–8489	1906	13413–13516	1930
2607–2849	1882	8490–8979	1907	13517–13586	1931
2850–3101	1883	8980–9302	1908	13587–13654	1932
3102–3281	1884	9303–9622	1909	13655–13920	1933
3282–3427	1885	9623–9913	1910	13921–14217	1934
3428–3612	1886	9914–10119	1911	14218–14348	1935
3613–3832	1887				

Act of 28 January 1847/Two-Year Notes 6% *(continued)*

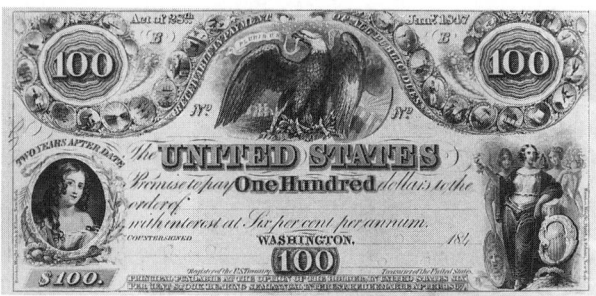

X115B $100 Female portrait, *E Pluribus Unum* and *Liberty* holding an olive branch. (RWH&H)

National Bank Notes Outstanding by State*

State	Number of banks through 1935	In Circulation June 29, 1929**	In Circulation Dec. 31, 1934***
Alabama	170	$ 13,638,000.00	$ 11,191,000.00
Alaska	5	58,000.00	171,000.00
Arizona	31	1,025,000.00	857,000.00
Arkansas	141	3,883,000.00	3,466,000.00
California	509	34,984,000.00	92,979,000.00
Colorado	216	4,403,000.00	6,628,000.00
Connecticut	120	9,754,000.00	9,159,000.00
Delaware	30	1,008,000.00	1,203,000.00
District of Columbia	31	4,891,000.00	2,402,000.00
Florida	132	4,791,000.00	8,016,000.00
Georgia	181	7,750,000.00	5,224,000.00
Hawaii	6	450,000.00	3,350,000.00
Idaho	109	1,389,000.00	1,301,000.00
Illinois	813	35,949,000.00	19,750,000.00
Indiana	430	21,834,000.00	13,965,000.00
Iowa	542	14,121,000.00	6,375,000.00
Kansas	445	9,565,000.00	8,374,000.00
Kentucky	245	15,248,000.00	10,306,000.00
Louisiana	101	6,207,000.00	8,659,000.00
Maine	127	4,848,000.00	3,986,000.00
Maryland	140	7,399,000.00	4,952,000.00
Massachusetts	370	19,157,000.00	16,483,000.00
Michigan	310	16,119,000.00	9,330,000.00
Minnesota	484	14,404,000.00	20,316,000.00
Mississippi	76	3,006,000.00	2,385,000.00
Montana	193	2,311,000.00	1,886,000.00
Nebraska	401	6,068,000.00	6,700,000.00
Nevada	16	1,194,000.00	407,000.00
New Jersey	414	22,835,000.00	25,314,000.00
New Mexico	82	1,253,000.00	1,155,000.00
New York	990	67,138,000.00	52,081,000.00
North Carolina	147	8,142,000.00	3,174,000.00
Ohio	689	35,963,000.00	34,367,000.00
Oklahoma	736	6,673,000.00	9,286,000.00
Oregon	147	5,222,000.00	7,599,000.00
Pennsylvania	1,274	82,256,000.00	95,243,000.00
Puerto Rico	1	–	–
Rhode Island	67	3,799,000.00	5,753,000.00
South Carolina	118	5,811,000.00	2,422,000.00
South Dakota	219	1,885,000.00	1,508,000.00
Tennessee	205	14,738,000.00	16,047,000.00
Texas	1,151	44,136,000.00	12,210,000.00
Utah	38	2,233,000.00	2,471,000.00
Vermont	85	4,304,000.00	3,941,000.00
Virginia	248	19,679,000.00	18,120,000.00
Virgin Islands	1	–	–
Washington	220	11,453,000.00	16,023,000.00
West Virginia	188	10,323,000.00	9,136,000.00
Wisconsin	269	15,991,000.00	12,812,000.00
Wyoming	58	1,485,000.00	1,355,000.00
Totals	14,348	$649,542,000.00	$654,456,000.00

* Van Belkum, pp.15–16. ** Large-size notes *** Small-size notes

FREQUENTLY USED PORTRAITS ON UNITED STATES PAPER MONEY

Portraits of 13 Americans have frequently appeared on United States paper money since 1961. Brief biographical sketches of these famous Americans along with the catalog numbers of the notes on which their portraits appear follow. Additional information pertaining to these and the portraits of the lesser known personalities that have appeared on United States currency is included with the respective listing.

Salmon P. Chase, b. Cornish, NH 13 Jan. 1808, d. New York City 7 May 1873. After moving to Ohio as a boy he attended Dartmouth; Chase returned to Ohio to practice law in Cincinnati. He served as President Lincoln's Secretary of the Treasury and practically established the National Banking System singlehandedly. In 1864 Chase was appointed to the United States Supreme Court and remained in that position until his death. (Nos. 1-4, 493-496, 945b, 1396-1398 and 1493-1497)

Steven Grover Cleveland, b. Caldwell, NJ 18 Mar. 1837, d. Princeton, NJ 24 June 1908. He practiced law in New York, served there as governor, and was twice elected to the U.S. Presidency. (Nos. 848-850 and all small-size $1,000 notes)

Benjamin Franklin, b. Boston, MA 17 Jan. 1706, d. Philadelphia, PA 17 April 1790. Franklin is recognized by philatelists for his contributions to the postal service. In 1727 he was appointed Postmaster in Philadelphia. In 1753, along with William Hunter, Franklin was placed in charge of the Colonial Postal Service. (Nos. 603-604, 929-941, 1244-1245, X115A, all small-size $100 notes and 30-cent encased postage)

Ulysses S. Grant, b. Point Pleasant, OH 27 April 1822, d. Mount McGregor, NY 23 July 1885. Grant served his country as a military officer and eighteenth U. S. President. (Nos. 349-360, 1040-1042, 1044-1046 and all small-size $50 notes)

Alexander Hamilton, b. Nevis, W. Indies 11 Jan. 1757, d. New York City 12 July 1804. It was through the genius of Hamilton that the financial chaos left by the American Revolution was resolved. As the first Secretary of the Treasury (1789-1795) he established the Bank of the United States and a sensible federal monetary system. In 1799, along with Aaron Burr—(Hamilton died from a gunshot wound in a duel with Burr)—Hamilton founded the Manhattan Company in New York City. This company, which gave birth to the Bank of the Manhattan Company, survived wars and epidemics and, through a series of mergers, became The Chase Manhattan Bank, one of the largest banks in the nation. Hamilton is one of five Americans of foreign birth to appear on U.S. paper money. The others are R. Morris (Nos. 578 and 1376), A. Gallatin (No. 1320), E.D. Baker (No. 1441) and G.G. Meade (No. 1425). (Nos. 153, 242-244, 703-723, 926-927, 942, 945a, 1346-1347, 1413-1424, 1429 and all small-size $10 notes)

Andrew Jackson, b. Waxhaw, SC 15 March 1767, d. Nashville, TN 8 June 1845. He studied law in North Carolina and began to practice in Nashville, Tennessee. After serving in the United States House of Representatives and Senate, Jackson served two terms as U.S. President. (Nos. 245-273, 492, 618-620, 1465-1492, all small-size $20 notes and 2-cent encased postage)

Thomas Jefferson, b. Shadwell, Goochland County, VA 13 April 1743, d. Charlottesville, VA 4 July 1826. Jefferson, our third President, was knowledgeable in music, architecture, astronomy and agriculture. At age 20 he began building his home, Monticello, on Carter's Mountain; it was completed in his 60th year. Jefferson died on the 15th anniversary of the signing of the Declaration of Independence. (Nos. 154-170 203-207, 1502-1505, 1548-1551 all small-size $2 notes and 5-cent encased postage)

Abraham Lincoln, b. Hodgenville, Harrison County, KY 12 Feb. 1809, d. Washington, DC 15 April 1865. In 1861, during the first administration of the 16th U.S. President, the first demand notes, or greenbacks, were issued. After George Washington and Alexander Hamilton, Abraham Lincoln is the most frequently portrayed person on United States currency. (Nos. 372, 380-382, 463-465, 1122-1136, 1359-1369, 1624-1625, and all small-size $5 notes)

William McKinley, b. Niles, OH 29 Jan. 1843, d. Buffalo, NY 14 Sept. 1901. The 25th U.S. President, he was shot at the Pan-American Exposition in Buffalo, New York and died soon thereafter. (Nos. 540-566 and 1372-1375)

James Madison, b. Port Conway, VA 16 Mar. 1751, d. Montpelier, VA 28 June 1836. Madison was a member of the Continental Congress (1780-1783, 1787-1788) and was elected as the fourth U.S. President. He did not favor government-issued paper money and voted against the establishment of the Bank of the United States. (Nos. 1435, 1446-1464)

James Monroe, b. Westmoreland County, VA 28 April 1758, d. New York City 4 July 1831. He studied law under Thomas Jefferson. He became Governor of Virginia, was appointed Secretary of State by President Madison, and became the fifth U.S. President. (Nos. 1212-1221)

Robert Morris, b. Liverpool, England 20 Jan. 1734, d. Philadelphia, PA 8 May 1806. Morris, United States Senator (1789-1795), was one of the signers of the Declaration of Independence. As Superintendent of Finance (1781-1784), he was instrumental in founding the Bank of North America. (Nos. 578-589 and 1376-1378)

George Washington, b. Pope's Creek, VA 22 Feb. 1732, d. Mt. Vernon, VA 14 Dec. 1799. President Washington was much involved in the production of the first U.S. coins. It is possible that the half dismes struck by Robert Birch in 1792 were minted with table silver from the Washington home. Although it remains controversial, it does seem that Washington financed the purchase of the silver bullion that was used. Washington rejected the idea that his portrait should appear on the new coinage. (Nos. 5028, 45-46, 59-61, 187-196, 300-315, 834-842, 953-986, 101301014, 1137-1140, 1340, 1343, 1393b, 1403-1404, 1461, 1499-1501, 1506-1509, 1514-1529, 1522-1558, 1568-1572, X110C, X113, X115A, X121A, all small-size $1 notes and 90-cent encased postage)

ANNOUNCEMENT OF SMALL-SIZE CURRENCY

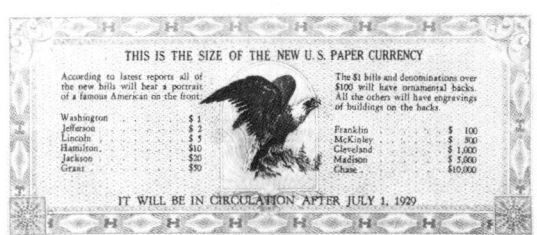

A few months before small-size currency entered circulation in 1929, circulars, the same size as the new notes, were distributed by banks and businesses. The backs of these provided a splendid opportunity for advertisement.

TEST PIECES

In January 1972 it was revealed that the Bureau of Engraving and Printing had sent experimental plates to Germany for a test run on new Giori presses, which were later purchased by the Bureau. An example from this test is illustrated here. One has black printing on the face and a reddish-brown back, another has green face printing and black back printing, a third, discovered in 1980, has black face printing and a light brown back.

At least four examples of these notes, the colors of three are unknown, bear serial numbers with an "A" prefix. The lowest is A000993??A, the highest is A99998109A on a black back.

In 1976 another test piece appeared; it had been printed in Geneva, New York on a Magna press. These pieces have green face designs and black backs. A portrait of George Washington replaced the one of Thomas Jefferson.

These test pieces should have been destroyed. However, they are now legal to hold as collectors' pieces.

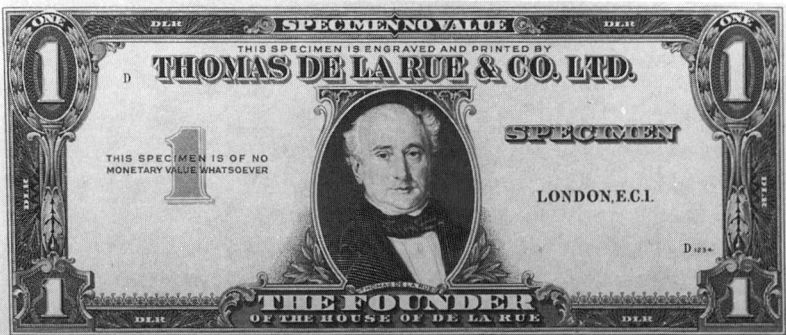

In the late 1980s a remarkable test piece surfaced. With the exception of the portrait of Thomas de la Rue, the founder of the company that undoubtedly provided for the test, the piece is exactly the same as the 1935-1957, $1 silver certificates. A plate of this type was indeed used to perform trial runs after the Giori presses were acquired by the Bureau of Engraving and Printing. Only four of these uniface test pieces with the de la Rue portrait are known to exist. The color of this piece is brown, green and blue.

Catalog of United States Paper Money

USING THE CATALOG

THE catalog is organized by denomination from $1 to $100,000. Within each denomination, the various issues are cataloged by major type. The system of numbering used here is the simplest possible: each piece has been numbered consecutively. Occasionally a letter follows the number; this usually coincides with a series change.

In the case of Federal Reserve notes the letters of the respective districts have been added to the number. In addition, another suffix letter is sometimes included to differentiate between the maximum five-signature combinations. At the end of each listing for Federal Reserve note denominations that are current ($1-$100), additional numbers have been left unassigned for future issues.

Any numbering system is only a type of shorthand reference. Unwieldy cataloging systems that try to include as much information in the catalog number as in the description itself sometimes become redundant and difficult. It should also be remembered that there is no necessity to use a number at all. It is simply a convenience and form of reference for those who wish to use it.

Written permission is required for the use of the numbering system used in this catalog if cited in any book, pamphlet or catalog. Publishers of magazines, newspapers, periodicals, journals and auction catalogs are free to cite this numbering system. Dealers in stamps, coins and currency who send price lists to customers are encouraged to use this system for identification provided reference is made to the book and author.

A Note About Grading

Few syngraphists agree completely when it comes to the grading of paper money. Notwithstanding, a grading scale must be included in any catalog of this type. The following descriptions of grades or conditions are merely guides.

Uncirculated (Unc). Notes can be described as uncirculated only when they are in the same condition as when issued; the paper must be firm and crisp. Any indication of mishandling or corners that are not sharp and square must be mentioned in a description.

About Uncirculated (AU). A note that appears to be in uncirculated condition, but after close observation minute signs of handling are visible, such as minor corner folds, but no hard creases.

Extra Fine (EFine). A note in this condition will still be crisp, although there might be evidence of handling, such as minor creases and folds. Corners might begin to lose their squared edges.

Very Fine (VFine). A moderately circulated note that retains some crispness, but with folds and creases. Signs of handling must be minimal with no tears on the edges; the corners begin to lose their sharpness.

Fine. Paper that feels soft with multiple folds, creases, smudges, minor tears, and colors that are beginning to fade identifies a note in this condition. Notes in this condition have sometimes been washed.

Very Good (VGood). Well circulated notes with tears, heavy smudges, faded colors, heavy creases and folds that might have created a separation of the paper in the center of the note. Notwithstanding the folds, the note must be in one piece.

Good. Notes in this condition will have blemishes as the preceding only more severe. Corners of the note might be missing from wear.

A Note About Valuations

Values listed throughout this catalog are suggested or average prices. These figures reflect numerous price lists consulted as well as prices realized from recent auctions. Supply and demand and varying degrees of interest will affect the price of any note. All prices listed for national bank notes are for the most common pieces in the R1 category. LARGE-SIZE NOTES THAT HAVE SURVIVED IN UNCIRCULATED CONDITION AND ARE WELL CENTERED WITH EVEN MARGINS COMMAND A PREMIUM HIGHER THAN THOSE LISTED FOR UNC NOTES.

Many notes listed here are extremely rare, occasionally unique. These pieces do not change hands often, and valuations are therefore difficult, if not impossible, to establish.

The appropriate terms to describe paper money or any type of fiscal document is FACE and BACK. Obverse and reverse are correct when applied to coins and medals. But, as any engraver of fiscal paper will confirm, it's FACE and BACK when one describes paper money and related material.

Miscellaneous Information

If more than one-half of a damaged piece of U.S. paper money is presented to a Federal Reserve Bank, it will be replaced with a new note of the same denomination.

If a note or a group of notes has been damaged or mutilated by fire or was immersed in water so that individual notes cannot be separated, do not attempt to isolate from purse or wallet. Send the note(s) and container to the Department of the Treasury, Bureau of Government Financial Operations, Room 132, Treasury Annex No. 1, DCS/BEPA, Washington, DC 20226. Every effort will be made to determine the amount of money in such a circumstance and you will receive a check for the deciphered amount.

The approximate life of U.S. paper money depends on the denomination: $1 and $10 notes 18 months; $5 notes 15 months; $20 notes two years; $50 and $100 notes 8½ years.

An estimated 9 billion notes will be printed for fiscal 1992 at a cost of $325.8 million; approximately one-half of this amount will be for $1 notes. The cost of printing one note of any denomination is about 3.5 cents.

Of the amount of currency in circulation in the United States, approximately one-tenth of one percent is counterfeit.

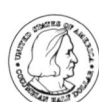
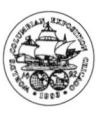
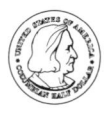
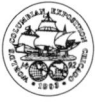

Act of 30 June 1812/One-year Notes/5 $^2/_8$%

No.	Denomination	Amount Authorized and Issued	Printer
X69	$100	$5,000,000	MDF&Co

Remarks: The design is the same as X74C.

Act of 25 February 1813/One-year notes/5 $^2/_8$%

No.	Denomination	Amount Authorized and Issued	Printer
X72	$100	$5,000,000	MDF&Co

Act of 4 March 1814/One-Year Notes/5 $^2/_8$%

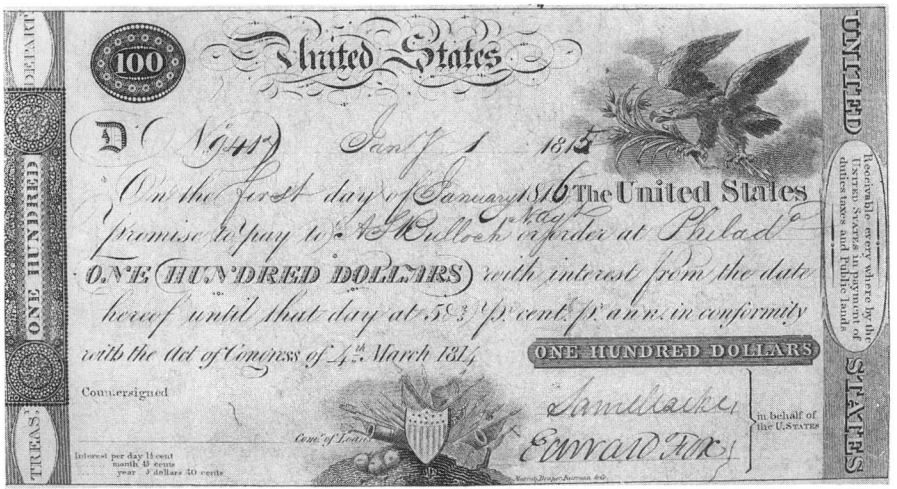

No.	Denomination	Amount Authorized and Issued	Printer
X74A	$20		
X74B	$50 (issue uncertain)	$10,000,000	MDF&Co
X74C	$100		

Act of 26 December 1814/One-year Notes/5 $^2/_5$%

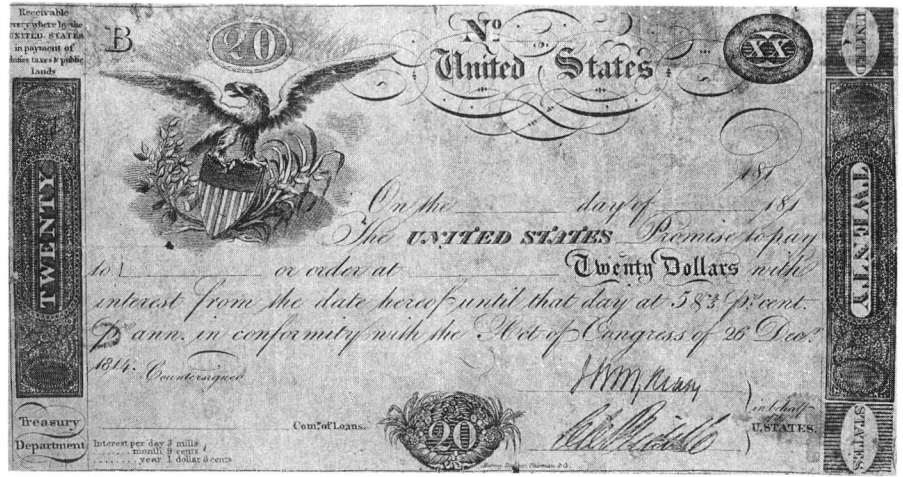

No.	Denomination	Amount Authorized	Amount Issued	Printer
X80A	$20			
X80B	$50	$10,500,000	$8,318,400	MDF&Co
X80C	$100			

Act of 24 February 1815

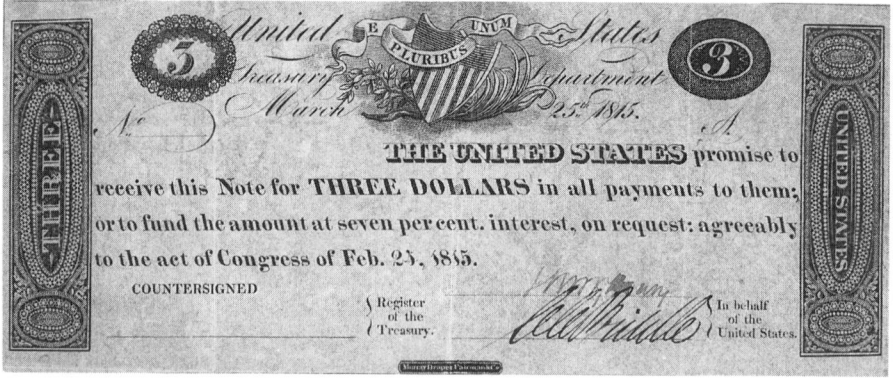

Act of 24 February 1815 *(continued)*

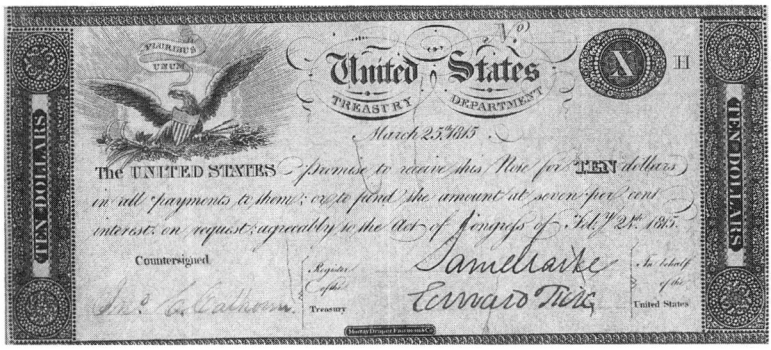

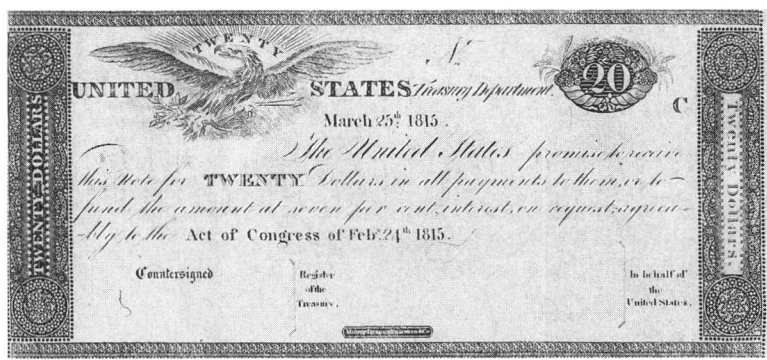

No.	Denomination	Amount Authorized	Amount Issued	Printer
X83A	$3			
X83B	$5			
X83C	$10	$25,000,000	$3,392,994	MDF&Co
X83D	$20			
X83E	$50			

Remarks: With no interest, these notes were redeemable at the pleasure of the government.

Act of 24 February 1815 (Section 3)/5 ²/₅%

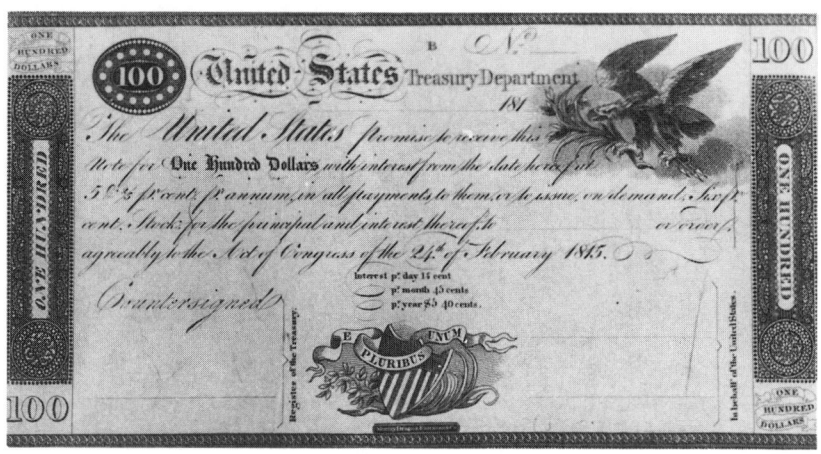

No.	Denomination	Amount Issued	Printer
X85	$100	$4,969,400	MDF&Co

Act of 12 October 1837

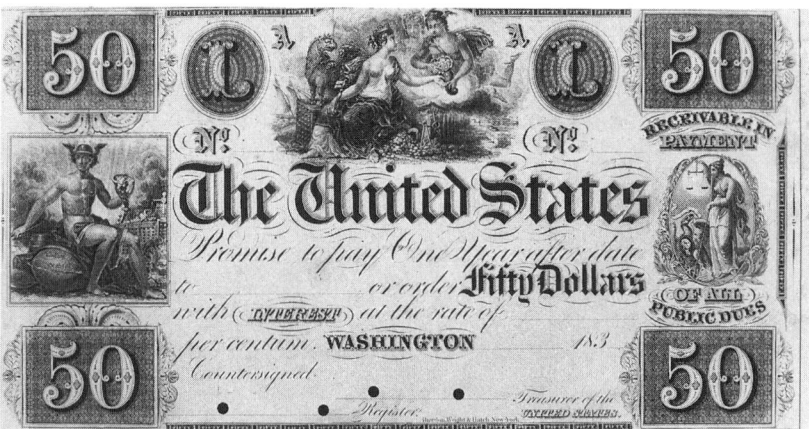

Mercury was drawn and engraved by George W. Hatch. *Wealth* was designed, drawn and engraved by Freeman Rawdon. *Justice* cannot be specifically attributed.

Remarks: No. X85 was redeemable at the pleasure of the government.

Act of 12 October 1837 *(continued)*

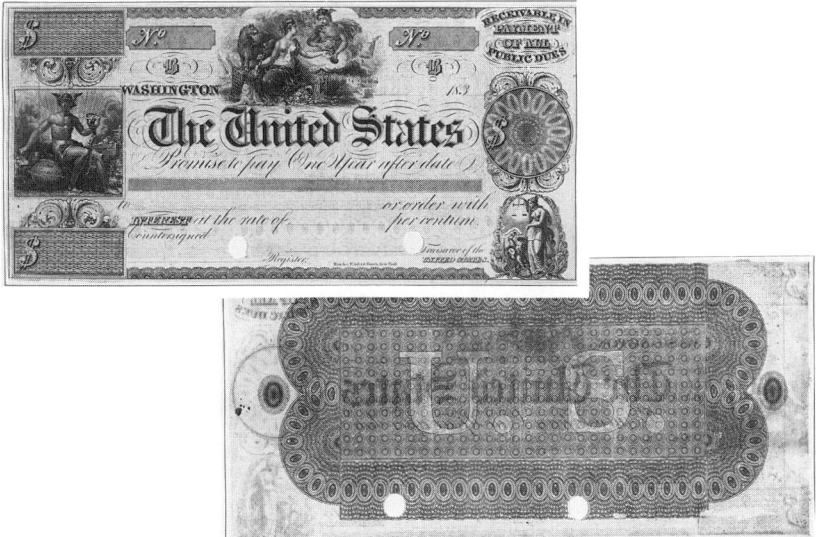

The amount was to be inserted on No. X99I.

The number of notes that were issued at these percentages.

No.	Denomination	1 mil%	2%	5%	6%
X99A	$50	3,445	4,465	–	–
X99B	$50*	2,912	2,490	12,523	1,588
X99C	$100	2,850	9,975	–	12
X99D	$100*	2,306	1,941	10,902	3,533
X99E	$500	–	–	–	–
X99F	$500*	622	151	3,027	794
X99G	$1,000	252	1,039	–	6
X99H	$1,000*	353	113	1,020	335
X99I	Blanks	59	109	–	–
X99J	Blanks*	43	73	–	–

Remarks: These one-year, two and one-half month notes were redeemable one year from date of issue. They are the first U.S. Treasury notes with back designs.

* Dated 1838.

Act of 21 May 1838/7⅓ Months/6%

No.	Denomination	Amount Authorized	Notes Issued	Printer
X100A	$50		12,172	
X100B	$100	$10,000,000	5,907	RW&H
X100C	$500		886	
X100D	$1,000		1,326	

Remarks: These notes were redeemable one year from date of issue.

Act of 2 March 1839

The number of notes that were issued at these percentages.

No.	Denom.	2%	6%	No.	Denom.	2%	6%
X101A	$50	80	423	**X101C**	$500	8	309
X101B	$100	50	821	**X101D**	$1,000	–	2,216

Remarks: The amount authorized for these four-month notes consisted of the remainder unissued under the Act of 21 May 1838; the issued amount was $3,857,276.21. (RW&H)

Act of 31 March 1840/One-year notes

The number of notes that were issued at these percentages.

No.	Denomination	2%	5%	5 ⅖%	6%
X102A	$50	1,279	2,121	–	–
X102B	$50*	695	1,017	–	2,077
X102C	$100	1,016	1,670	80	–
X102D	$100*	614	805	–	1.989
X102E	$500	174	540	1,212	–
X102F	$500*	126	104	–	555
X102G	$1,000	44	224	1,386	–
X102H	$1,000	6	–	–	–
X102I	$10,000	–	–	–	–
X102J	$10,000	–	–	–	–
X102K	Blanks	–	–	–	–
X102L	Blanks*	–	–	–	–

Remarks: The amount authorized and to be outstanding at any one time was $5,000,000; $7,114,251.31 was issued, including reissues. (RW&H)

* Dated 1841

Act of 15 February 1841/One-year Notes

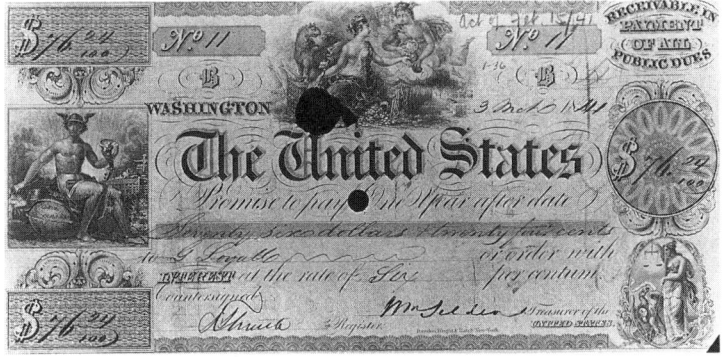

See No. X99 for designer and engraver information.

No.	Denomination	2%	5%	5 2/8%	5½%	6%
X103A	$50	2,254	–	973	–	1,700
X103B	$50*	–	–	–	–	3,601
X103C	$100	2,344	–	878	–	2,249
X103D	$100*	–	–	–	–	3,079
X103E	$500	925	–	980	300	1,515
X103F	$500*	–	–	–	–	661
X103G	$1,000	90	–	358	150	2,527
X103H	$1,000*	–	–	–	–	210
X103I	Blanks	20	–	20	–	88
X103J	Blanks*	–	–	–	–	153

Remarks: The amount authorized to be outstanding at any one time for these notes was $5,000,000; $7,529,062.75 was issued, including reissues. (RW&H)
* Dated 1841.

Act of 31 January 1842/One-year Notes 2 & 6%

No.	Denom.	Notes Issued	No.	Denom.	Notes Issued
X105A	$50	26,985	**X105D**	$1,000	915
X105B	$100	24,462	**X105E**	Blanks	426
X105C	$500	3,360			

Remarks: The amount authorized to be outstanding at any one time for these one-year notes was $5,000,000; $7,959,994.83 was issued. See No. 1139b for the same $100 design. (RW&H)

Act of 31 August 1842/7½ Months/2 & 6% *(continued)*

No.	Denomination	Amount Authorized	Amount Issued
X107A	$50		
X107B	$100		
X107C	$500	$6,000,000	$3,025,554.89
X107D	$1,000		
X107E	Blanks		

Act of 3 March 1843/Indefinite/1 mill & 4%

X108	$50	See X110A for the same design.

Act of 22 July 1846/One-year notes/1 mill & 5 ²/s%

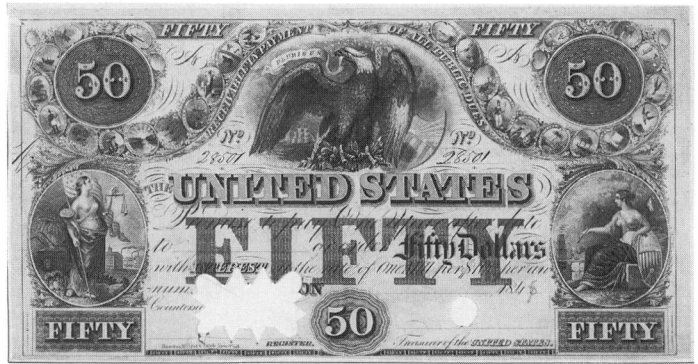

Justice, E Pluribus Unum and *Liberty.*

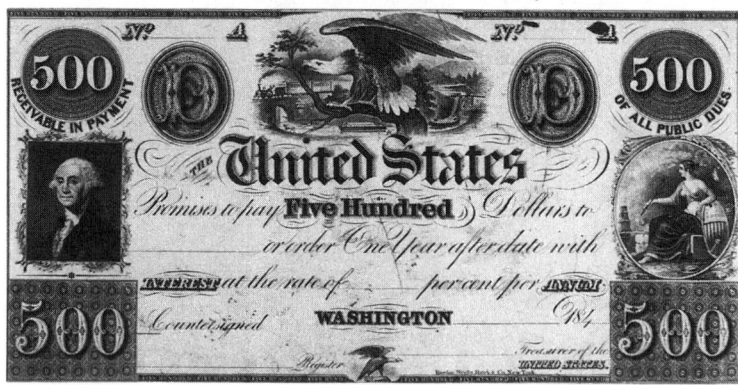

Washington, E Pluribus Unum and *Liberty.*

Act of 22 July 1846/One-year notes/1 mill & 5 ²/₅% *(continued)*

No.	Denomination	Amount Authorized	Amount Issued	Printer
X110A	$50			
X110B	$100			
X110C	$500	$10,000,000	$7,787,800	RW&H
X110D	$1,000			
X110E	Blanks			

Remarks: Nos. X107A-E do not bear the date of the act and therefore are indistinguishable from those notes issued under the preceding act. (RW&H) The amount authorized for No. X108 was indefinite. According to Bayley (p. 4) $1,806,950 was issued; Knox (p. 452) said $850,000.

Act of 28 January 1847, 5 ²/₅ & 6%

(X114–115)

The amount issued under this act was $23,000,000, with reissues the amount totaled $26,122,000. These six-month notes were redeemable one and two years after date of issue. (RW&H; RWH&E; TC)

One-Year Notes 5 ²/₅%

The following notes bear the same vignettes, although arranged differently on each. *Mercury* was drawn and engraved by George W. Hatch; *Wealth* was drawn and engraved by Freeman Rawdon; *Justice* cannot be specifically attributed. Back designs are similar to X114C. (RW&H)

X114A $50 See X99A for the same design.
X114B $100 See 1139b for the same design.

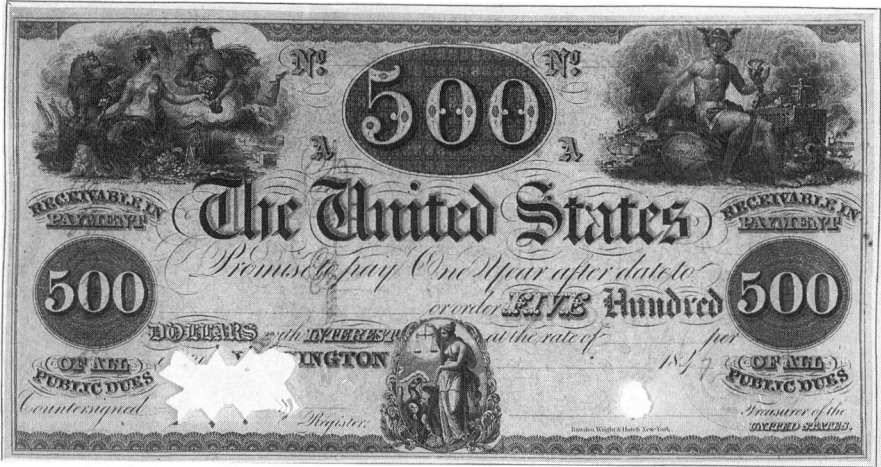

X114C $500 Face Design

Act of 28 January 1847/One-year Notes/5 ²/₅% *(continued)*

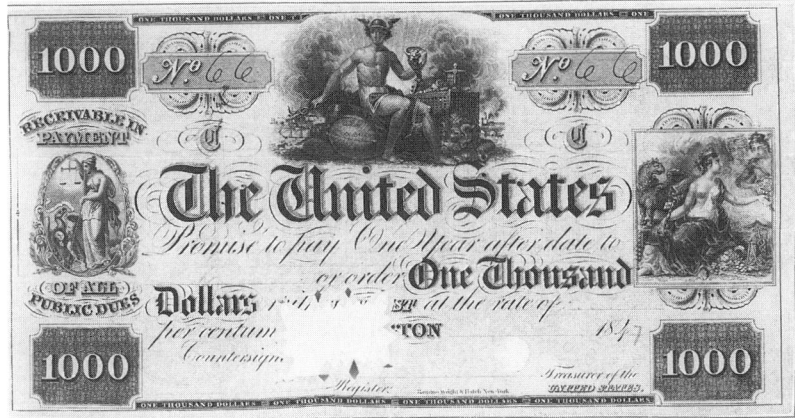

X114D $1,000 Face Design
X114E $5,000
X114F Blanks

Two-Year Notes 6%

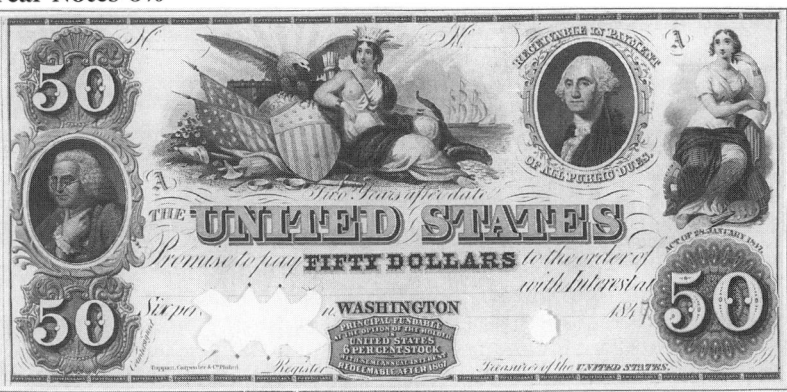

X115A $50 Benjamin Franklin, *Indian Maiden as America*, Washington, and female
representing *Industry, Music and Art*. (TC)
The back design has an interest table.

Act of 28 January 1847/Two-year Notes/6% *(continued)*

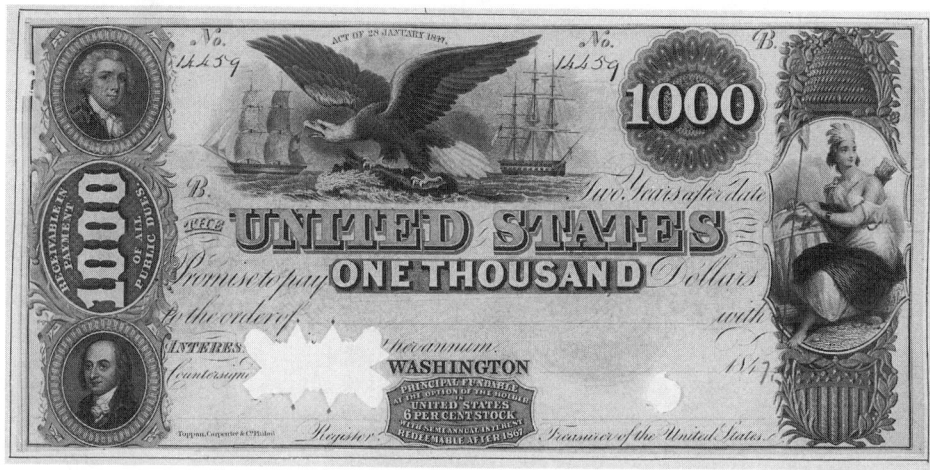

X115D $1,000 Portraits of Alexander Dallas and Albert Gallatin, eagle and ships, and an *Indian Maiden as America.* (TC) The back design has an interest table.

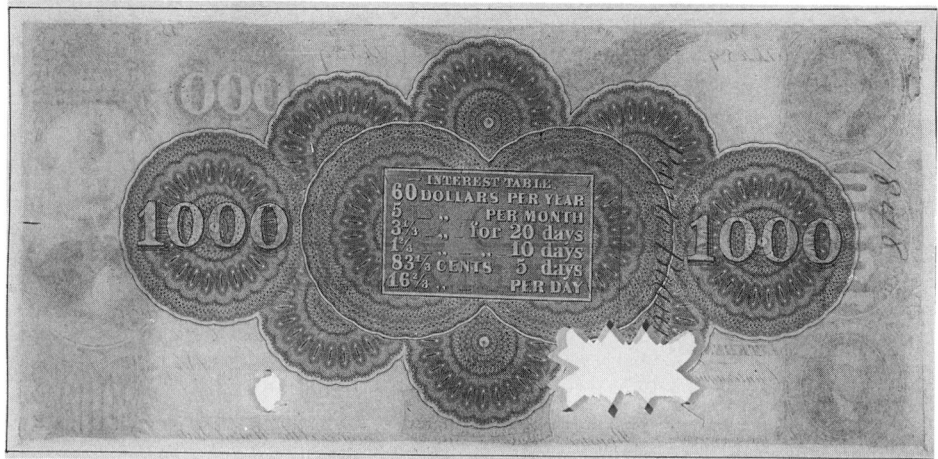

Act of 28 January 1847/Two-year Notes/6% *(continued)*

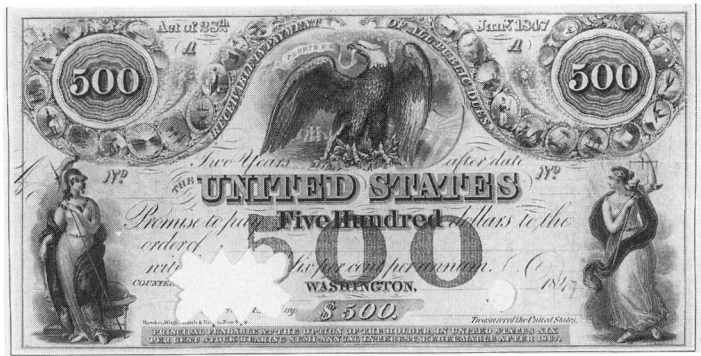

X115C $500 *Minerva, E Pluribus Unum* and *Justice.* (RWH&E)

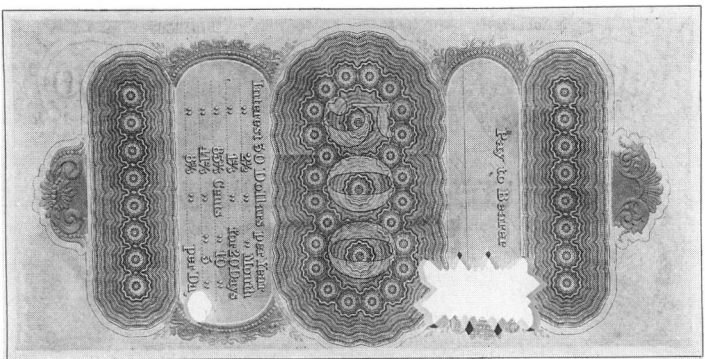

The back design has an interest table.

Act of 28 January 1847/Two-year Notes/6% *(continued)*

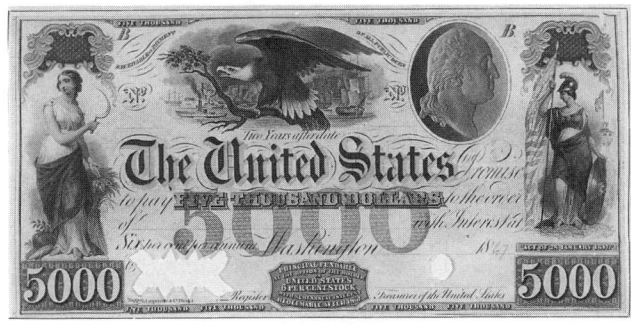

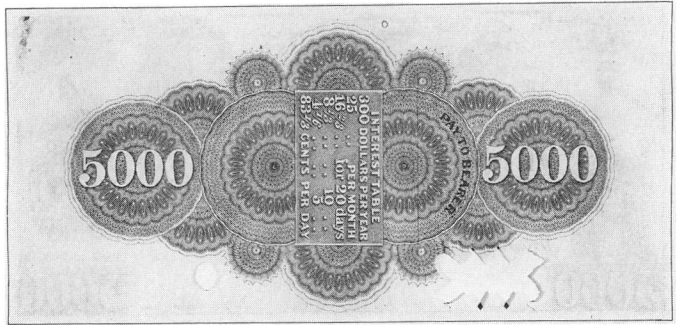

X115E $5,000 *Agriculture*, eagle and harbor scene, Washington medallion head and *Minerva as America*. (TC) R8 The back design has an interest table.

X115F Blanks

Act of 23 December 1857/One-year Notes/3 & 6%

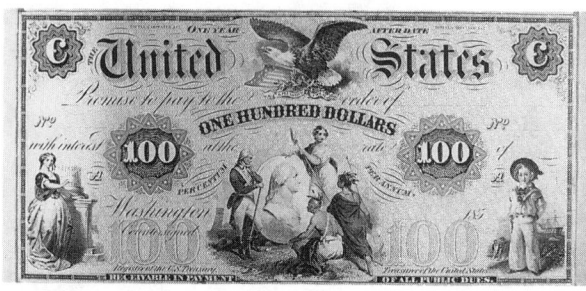

X121A $100 *E Pluribus Unum* as seen on the $10 demand and first United States notes (H463–465); *Union* and the *Prince of Wales* were both engraved by Alfred Jones. The Prince at age six was originally painted by F. Winterhalter. The central vignette depicts early *America contemplating a bust of Washington.* The color is rust (TC).

The back design is blue.

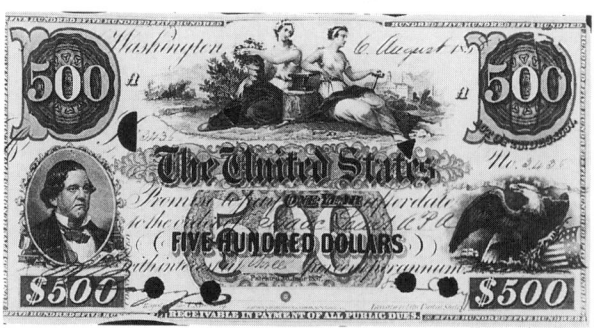

X121B $500 Green and black. At the left is a portrait of Secretary of the Treasury Howell Cobb. The color is green and black (RWH&E). Unique.

Act of 23 December 1857/One-year Notes/3 & 6% *(continued)*

The back design is green and black and is the same as H1340.

X121C $1,000 See X124D for face and back designs. (RWH&E)

Remarks: The amount authorized to be outstanding at any one time for these notes was $20,000,000; $52,778,900 was issued. (RWH&E; TC)

Act of 17 December 1860/One-year Notes/6–12%

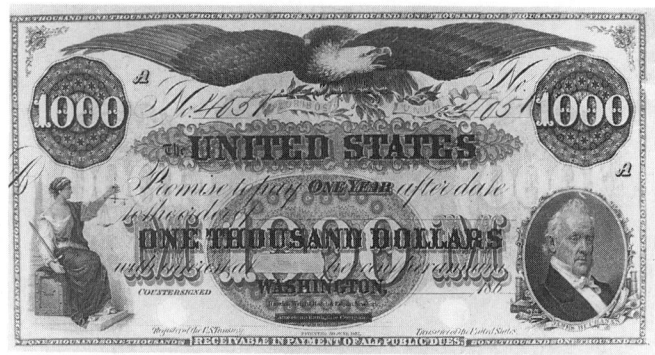

Justice, *E Pluribus Unum* and the portrait of James Buchanan on this proof are believed
to be the work of engraver Charles Burt. This note was altered from X121C and bears the
additional credit of American Bank Note Co. RWH&E was one of the seven firms that joined
together in 1858 to form ABNCo.

No.	Denomination		Amount Authorized and Issued
X124A	$50		
X124B	$100		$10,000,000
X124C	$500		
X124D	$1,000		

United States Notes/1862/Red Seal

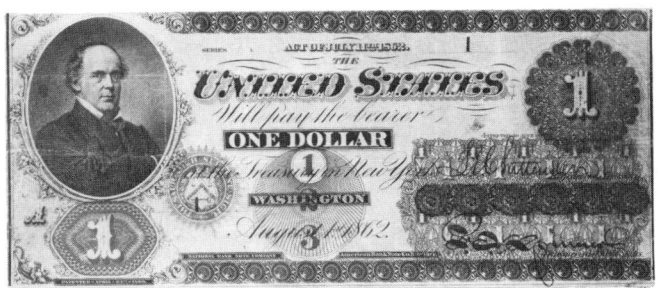

The portrait of Salmon P. Chase was engraved by Joseph P. Ourdan. The illustrated note with serial number "1" and plate position "A" from Series 1 was presented to Secretary of the Treasury Chase.

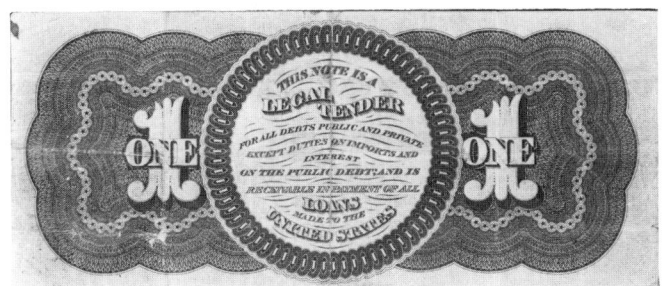

No.	Description	Fine	EFine	Unc
1	"National Bank Note Company – American Bank Note Company" on face at lower border	$135.	$400.	$1350.
2	as preceding with "American Bank Note Company" at upper right	115.	350.	1000.
3	"National Bank Note Company" printed twice at lower border	100.	250.	600.
4	as preceding with "American Bank Note Company" at upper right	100.	250.	600.

Remarks: The series designation is found at the upper left or right. A total of 28,351,348 notes were issued for Nos. 1 through 4; all have signatures of Chittenden-Spinner. For No. 2, Martin Gengerke has recorded serial number "1" for Series 7, 19 20 & 126.

United States Notes/Series 1869/Red Seal

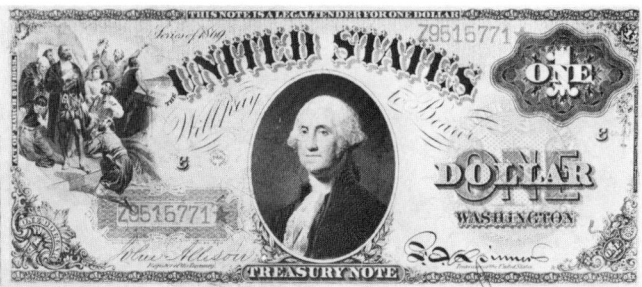

The portrait of George Washington was engraved by Alfred Sealey. *Columbus Discovery of Land,* a painting by Charles Schussele, was engraved by Joseph P. Ourdan.

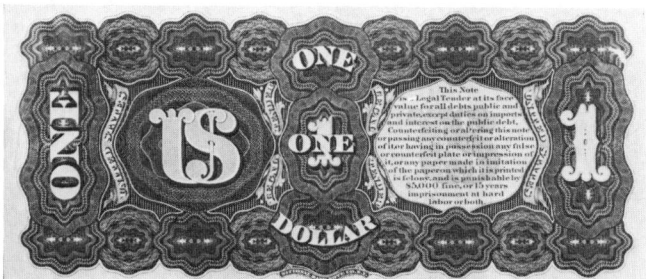

No.	Signatures	Notes Printed	Fine	EFine	Unc
5	Allison-Spinner	41,868,000	$125.	$325.	$1000.

Remarks: There were 42,456,812 notes issued. Reissues could account for the excess of the official figure above. An example of No. 5, printed on "US" watermarked paper intended for fractional currency, in fine to very fine condition appeared in the November 13, 1979 NASCA auction (see Nos. 154 and 245).

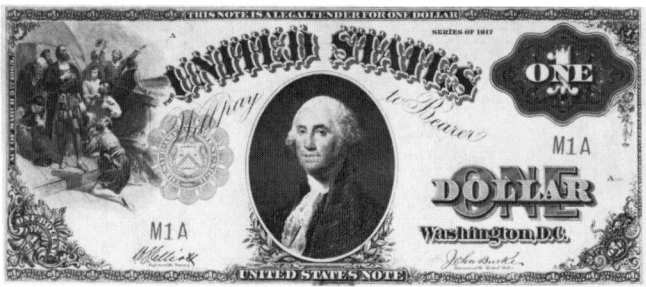

Face design for series 1917; back design is on the following page.

United States Notes/Series 1874–1917

The back has the legal ten-der and counterfeiting clause. The face design is on the preceding page.

No.	Series	Signatures		Notes Printed	Fine	EFine	Unc
	*Nos. 6–14 have a small red seal on the left and a red ornament that circles "ONE DOLLAR" on the right.*						
6	1874	Allison-Spinner		$18,988,000	$ 65.	$ 135.	$ 400.
7	1875A	Allison-New		1,000,000	250.	500.	1250.
8	1875B	Allison-New		1,000,000	300.	750.	1950.
9	1875C	Allison-New		1,000,000	250.	500.	1250.
10	1875D	Allison-New		1,000,000	100.	300.	1500.
11	1875E	Allison-New		1,000,000	300.	750.	1950.
12	1875	Allison-New		10,000,000	65.	115.	325.
13	1875	Allison-Wyman		11,212,000	65.	115.	325.
14	1878	Allison-Gilfillan		12,512,000	65.	115.	325.
	*Nos. 15–17 have red serial numbers and a large brown seal to the right.*						
15	1880	Scofield-Gilfillan		15,308,000	65.	115.	300.
16	1880	Bruce-Gilfillan		22,192,000	50.	100.	275.
17	1880	Bruce-Wyman		19,344,000	50.	100.	275.
	*Blue serial numbers*						
			Seal				
17a	1880	Bruce-Wyman	lg. red	1,636,000		delivered; not issued	
18	1880	Rosecrans-Huston	lg. red	–	185.	475.	1700.
19	1880	Rosecrans-Huston	lg. brn	420,000	185.	475.	1700.
20	1880	Rosecrans-Nebeker	lg. brn	200,000	200.	500.	1850.
21	1880	Rosecrans-Nebeker	sm. red	1,000,000	50.	75.	250.
22	1880	Tillman-Morgan	sm. red	2,000,000	40.	65.	225.
	*Red serial numbers*						
23	1917	Teehee-Burke	sm. red	269,684,000	30.	50.	125.
23☆	75 reported			–	–	–	–
24	1917	Elliott-Burke	sm. red	299,132,000	30.	50.	125.
24☆	92 reported			–	–	–	–
25	1917	Burke-Elliott	sm. red	included in No. 24	50.	150.	600.
26	1917	Elliott-White	sm. red	304,812,000	30.	50.	125.
26☆	30 reported			–	–	–	–
27	1917	Speelman-White	sm. red	92,740,000	35.	65.	150.
27☆	132 reported			–	–	–	–

Remarks: An unspecified number of No. 6, commencing with serial number E8347xxx, have been reported in a hoard. No. 17a was sent to the Treasury Department unsealed; all were apparently destroyed since none are known. The approximate serial numbers reported for No. 20 are A27983xx. The signatures for No. 26 were reversed in error on the plate.

United States Notes/Series 1923/Red Seal

The Gilbert Stuart portrait of George Washington was engraved by G.F.C. Smillie.

This back design was reduced and used as the model for small-size $1 notes first issued in 1928.

No.	Signatures	Notes Printed	Fine	EFine	Unc
28	Speelman-White	81,872,000	$40.	$100.	$200.
28☆	119 reported	–	50.	150.	275.

National Bank Notes/First Charter Period

Concordia, by artist T.A. Liebler, was engraved by Charles Burt.

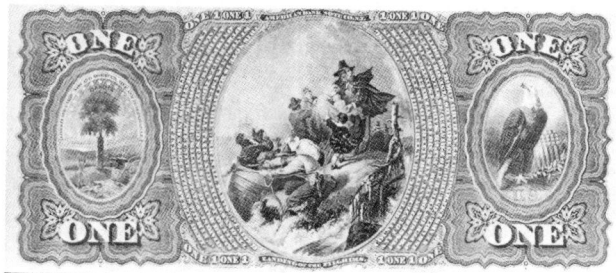

The *Landing of the Pilgrims*, by Edwin White, was also engraved by Charles Burt.

No.	Series	Signatures	Red Seal	VGood	VFine	Unc
29	orig.	Colby-Spinner	rays	$100.	$ 235.	$ 850.
30	orig.	Jeffries-Spinner	rays	750.	1350.	3500.
31	orig.	Allison-Spinner	rays	100.	235.	850.
32	1875	Allison-New	scallops	100.	225.	800.
33	1875	Allison-Wyman	scallops	100.	225.	800.
34	1875	Allison-Gilfillan	scallops	100.	225.	800.
35	1875	Scofield-Gilfillan	scallops	100.	235.	850.

Remarks: A total of 23,167,677 notes were printed; 339,723 notes are outstanding. The original series had no series date on the face.

Silver Certificates/Series 1886 & 1891

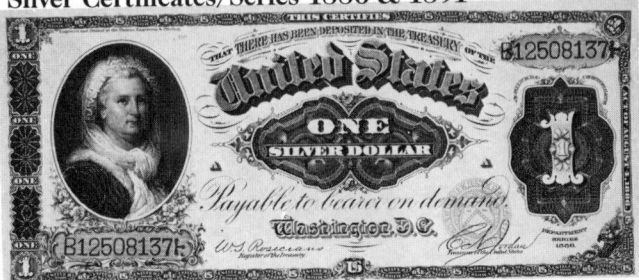

The Jalabert portrait of Martha Washington was engraved by Charles Burt. She is the only non-idealized woman to appear on U.S. currency.

No.	Signatures	Seal	Notes Printed	Fine	EFine	Unc
36	Rosecrans-Jordan	sm. red	14,000,000	$150.	$300.	$750.
37	Rosecrans-Hyatt	sm. red	7,000,000	150.	315.	775.
38	Rosecrans-Hyatt	lg. red	18,648,000	150.	300.	750.
39	Rosecrans-Huston	lg. red	14,648,000	150.	300.	750.
40	Rosecrans-Huston	lg. brn.	10,000,000	150.	300.	750.
41	Rosecrans-Nebeker	lg. brn.	4,200,000	175.	325.	800.
42	Rosecrans-Nebeker	sm. red	4,284,000	175.	325.	800.

The face design now dated 1891 is the same as Series 1886; the green back has been redesigned.

Series of 1891

43	Rosecrans-Nebeker	sm. red	13,000,000	$150.	$275.	$850.
44	Tillman-Morgan	sm. red	52,408,000	125.	200.	700.

Remarks: Delivery of this denomination, Series 1886 Notes began on September 20, 1886. A hoard of No. 37 in uncirculated condition exists with serial numbers B20601553–600.

Silver Certificates/Series 1896/Red Seal

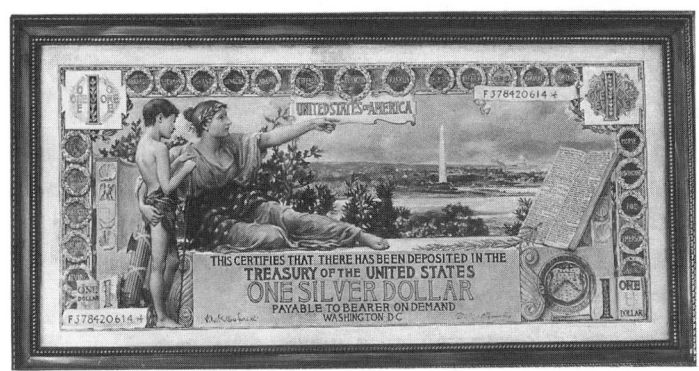

Will Low's original painting hangs in the Bureau of Engraving and Printing. This is the first note in the educational series (see Nos. 185 & 358).

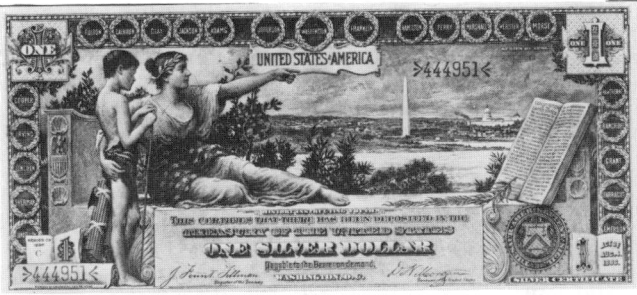

Thomas F. Morris made some design changes before Charles Schlecht engraved *History Instructing Youth.*

Thomas F. Morris designed this back. Alfred Sealey engraved the portrait of George Washington and Charles Burt engraved the portrait of Martha. Additional engravers for the face and back were L.F. Ellis, J. Kennedy, D.S. Ronaldson, G.U. Rose, Jr. and E.M. Hall.

No.	Signatures	Notes Printed	Fine	EFine	Unc
45	Tillman-Morgan	33,400,000	$125.	$350.	$850.
46	Bruce-Roberts	23,944,000	125.	375.	900.

Silver Certificates/Series 1899/Blue Seal

The *Eagle of the Capitol* spreads its wings over portraits of Lincoln and Grant; all three were engraved by G.F.C. Smillie. The Lincoln portrait was based on a photograph by Anthony Berger. The wreaths that surround the portraits were engraved by Marcus W. Baldwin.

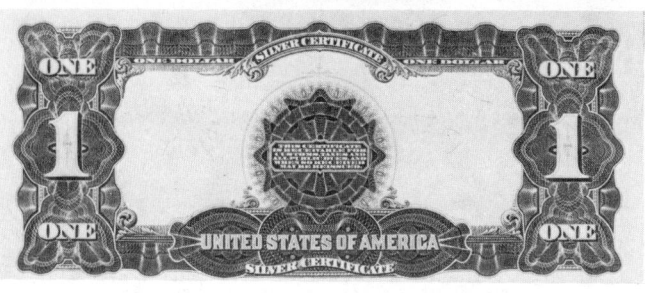

No.	Signatures	Notes Printed	Fine	EFine	Unc
		Series above serial number on the right			
47	Lyons-Roberts	500,000	$40.	$50.	$200.
		Series below serial number on the right			
48	Lyons-Roberts	included in above	30.	50.	150.
49	Lyons-Treat	117,112,000	30.	50.	150.
50	Vernon-Treat	316,887,600	25.	40.	135.
51	Vernon-McClung	251,404,000	30.	50.	150.
51☆	13 reported				
		Series vertically to the right of the seal			
51a	Vernon-McClung	included in above	30.	50.	150.
51a☆	2 reported		–	–	–
52	Napier-McClung	469,200,000	25.	40.	135.
52☆	17 reported		–	–	–
53	Napier-Thompson	6,740,000	125.	275.	500.
54	Parker-Burke	354,268,000	25.	40.	135.
54☆	21 reported		–	–	–
55	Teehee-Burke	790,444,000	25.	40.	135.
55☆	70 reported		–	–	–
56	Elliott-Burke	30,452,000	35.	50.	175.
56☆	24 reported		–	–	–
57	Elliott-White	326,536,000	25.	40.	135.
57☆	67 reported		–	–	–
58	Speelman-White	530,992,000	25.	40.	135.
58☆	70 reported				

Silver Certificates/Series 1923/Blue Seal

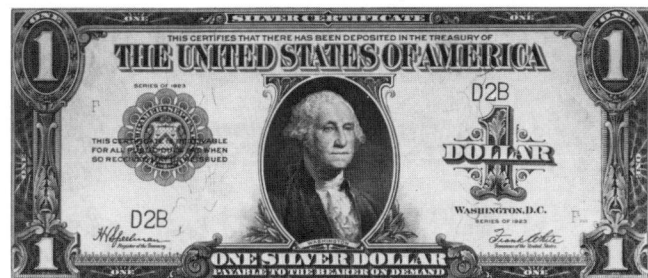

This design is similar to No. 28.

These notes have blue serial numbers.

No.	Signatures	Notes Issued	Fine	EFine	Unc
59	Speelman-White	2,431,837,347	$ 13.	$ 30.	$ 50.
59☆	482 reported	–	–	–	–
60	Woods-White	223,472,467	18.	40.	60.
60☆	156 reported	–	–	–	–
61	Woods-Tate	4,686,186	40.	125.	200.
61☆	7 reported	–	–	–	–

Remarks: The number of notes issued was compiled by Frank Nowak and printed in *PAPER MONEY*, Vol. 10, No. 1.

Treasury or Coin Notes/Series 1890

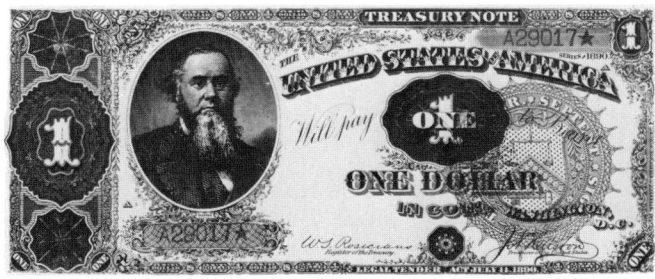

The designer of this note was George W. Casilear. The portrait of Edwin M. Stanton was engraved by Charles Burt. Stanton was Secretary of War under Presidents Lincoln and Johnson. The back design is on the following page.

Treasury or Coin Notes/Series 1890 (continued)

The engravers of the back were D.M. Cooper, W.A. Coppenhaver, W.H. Dougal, E.M. Hall, E.E. Myers and G.U. Rose, Jr.

No.	Signatures	Seal	Notes Printed	Fine	EFine	Unc
62	Rosecrans-Huston	brown	3,948,000	$185.	$400.	$1750.
63	Rosecrans-Huston	brown	802,000	200.	525.	2000.
64	Rosecrans-Nebeker	red	2,410,000	185.	400.	1750.

Treasury or Coin Notes/Series 1891/Red Seal

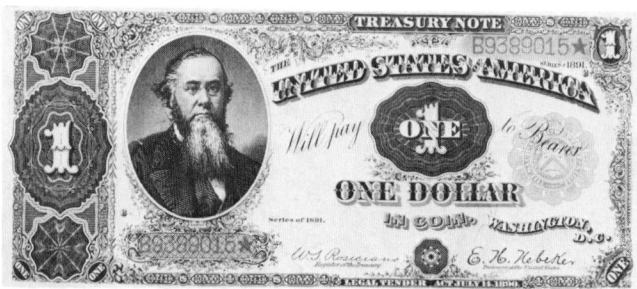

The face design is the same as the preceding note except for the smaller seal.

The engravers of the back were H.L. Chorlton, E.M. Hall, J. Kennedy and S.B. Many.

Treasury or Coin Notes/Series 1891/Red Seal *(Continued)*

No.	Signatures	Notes Printed	Fine	EFine	Unc
65	Rosecrans-Nebeker	14,000,000	$60.	$150.	$400.
66	Tillman Morgan	35,000,000	60.	150.	400.
67	Bruce-Roberts	8,544,000	65.	175.	475.

Federal Reserve Bank Notes/Series 1918

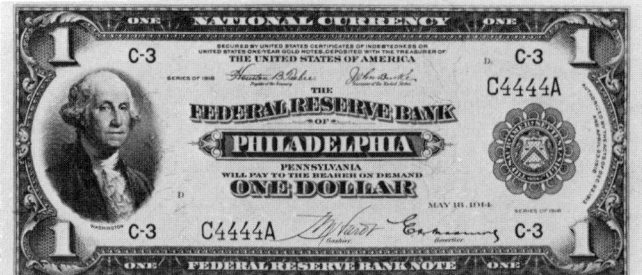

The portrait of George Washington was engraved by G.F.C. Smillie.

The *Eagle with Flag* was engraved by Robert Ponickau.

		Signatures				
No.	Bank	U.S.	Bank	Notes Issued	EFine	Unc
681A	Boston	T-B	Bullen-Morss		$50.	$135.
68A1 ☆	7 reported			39,600,000	–	–
68A2	Boston	T-B	Willet-Morss		100.	275.
68A3	Boston	T-B	Willet-Morss		50.	135.
68A3 ☆	12 reported				–	–
68B1	New York	T-B	Sailer-Strong		50.	135.
68B1 ☆	7 reported				–	–
68B2	New York	T-B	Hendricks-Strong	106,724,000	50.	135.
68B2 ☆	19 reported				–	–
68B3	New York	E-B	Hendricks-Strong		50.	135.
68B3 ☆	17 reported				–	–
68C1	Philadelphia	T-B	Hardt-Passmore		50.	135.
68C1 ☆	5 reported				–	–
68C2	Philadelphia	T-B	Dyer-Passmore	51,056,000	50.	135.
68C2 ☆	7 reported				–	–
68C3	Philadelphia	E-B	Dyer-Passmore		50.	135.
68C4	Philadelphia	E-B	Dyer-Norris		50.	135.
68C4 ☆	9 reported				–	–
68D1	Cleveland	T-B	Baxter-Fancher		50.	135.
68D1 ☆	12 reported				–	–
68D2	Cleveland	T-B	Davis Fancher		50.	135.
68D2 ☆	4 reported				–	–
68D3	Cleveland	E-B	Davis-Fancher		50.	135.
68D3 ☆	5 reported				–	–

U.S. government signatures: T(eehee)-B(urke); E(lliott)-B(urke).

Federal Reserve Bank Notes *(continued)*

No.	Bank	U.S.	Signatures Bank	Notes Issued	EFine	Unc	
68E1	Richmond	T-B	Keesee-Seay		$50.	$135.	
68E1 ☆	7 reported			23,384,000	–	–	
68E2	Richmond	E-B	Keesee-Seay		50.	135.	
68E2 ☆	6 reported				–	–	
68F1	Atlanta	T-B	Pike-McCord		50.	135.	
68F1 ☆	2 reported				–	–	
68F2	Atlanta	T-B	Bell-McCord		50.	135.	
68F2 ☆	1 reported				–	–	
68F3	Atlanta	T-B	Bell-Wellborn		50.	135.	
68F3 ☆	2 reported				–	–	
68F4	Atlanta	E-B	Bell-Wellborn		50.	135.	
68F4 ☆	4 reported				–	–	
68G1	Chicago	T-B	McCloud-McDougal		50.	135.	
68G1 ☆	11 reported			64,432,000	–	–	
68G2	Chicago	T-B	Cramer-McDougal		50.	135.	
68G3	Chicago	E-B	Cramer-McDougal		50.	135.	
68G3 ☆	11 reported				–	–	
68H1	St. Louis	T-B	Attebery-Wells		50.	135.	
68H1 ☆	8 reported				–	–	
68H2	St. Louis	T-B	Attebery-Biggs		50.	135.	
68H2 ☆	4 reported			27,908,000	–	–	
68H3	St. Louis	E-B	Attebery-Biggs		50.	135.	
68H4	St. Louis	E-B	White-Biggs		50.	135.	
68H4 ☆	4 reported				–	–	
68I1	Minneapolis	T-B	Cook-Wold		85.	165.	
68I1 ☆	2 reported				–	–	
68I2	Minneapolis	T-B	Cook-Young		700.	2000.	
68I2 ☆	2 reported				–	–	
68I3	Minneapolis	E-B	Cook-Young		100.	225.	
68I3 ☆	5 reported				–	–	
68J1	Kansas City	T-B	Anderson-Miller		50.	135.	
68J1 ☆	5 reported				–	–	
68J2	Kansas City	E-B	Anderson-Miller		50.	135.	
68J2 ☆	3 reported			24,820,000	–	–	
68J3	Kansas City	E-B	Helm-Miller		50.	135.	
68J3 ☆	2 reported				–	–	
68K1	Dallas	T-B	Talley-VanZandt		50.	135.	
68K1 ☆	7 reported				–	–	
68K2	Dallas	E-B	Talley-VanZandt		17,864,000	135.	600.
68K2 ☆	4 reported				–	–	
68K3	Dallas	E-B	Lawder-VanZandt		50.	135.	
68K3 ☆	7 reported				–	–	

Federal Reserve Bank Notes *(continued)*

No.	Bank	Signatures U.S.	Signatures Bank	Notes Issued	EFine	Unc
68L1	San Francisco	T-B	Clerk-Lynch		50.	135.
68L1 ☆	9 reported				–	–
68L2	San Francisco	T-B	Clerk-Calkins		50.	135.
68L2 ☆	2 reported			23,784,000	–	–
68L3	San Francisco	E-B	Clerk-Calkins		50.	135.
68L3 ☆	1 reported				–	–
68L4	San Francisco	E-B	Ambrose-Calkins		50.	135.
68L4 ☆	2 reported				–	–

U.S. government signatures: T(eehee)-B(urke); E(lliott)-B(urke).

United States Notes/Series 1928/Red Seal

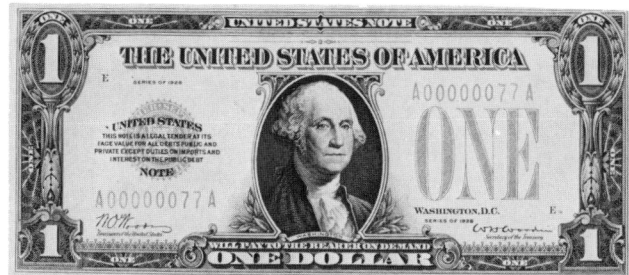

The Gilbert Stuart portrait of George Washington on all small-size $1 notes was engraved by G.F.C. Smillie in 1918.

No.	Signatures	Notes Printed	VFine	EFine	Unc
69	Woods-Woodin	1,872,012	$ 20.	$ 40.	$ 85.
69☆		–	500.	950.	2000.

Silver Certificates/Blue Seal/1928

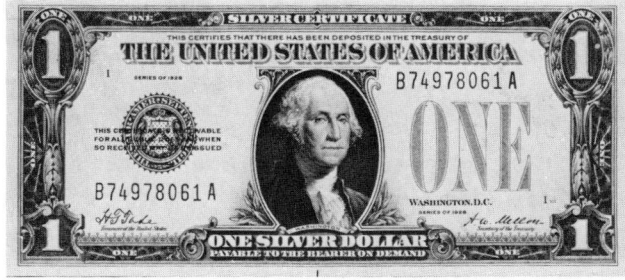

The back design is similar to No. 69.

Silver Certificate/Series 1928/1934/Blue Seal

No.	Series	Signatures	Notes Printed	VFine	EFine	Unc
70	1928	Tate-Mellon	638,296,908	$ 8.	$ 10.	$ 18.
70☆			–	–	–	–
71	1928A	Woods-Mellon	2,267,809,500	6.	8.	15.
71☆			–	–	–	–
72	1928B	Woods-Mills	674,597,808	8.	10.	20.
72☆			–	–	–	–
73	1928C	Woods-Woodin	5,364,348	100.	200.	400.
73☆			–	–	–	–
74	1928D	Julian-Woodin	14,451,372	40.	75.	185.
74☆			–	–	–	–
75	1928E	Julian-Morgenthau	3,519,324	200.	375.	1000.
75☆			–	– – – extremely rare – – – –		

Silver Certificate/Series 1934/Blue Seal

No.	Signatures	Notes Printed	VFine	EFine	Unc
	The seal, now blue, is on the right, and the large "1" is on the left.				
76	Julian-Morgenthau	682,176,000	$ 8.	$10.	$ 25.
76☆		7,680,000	30.	60.	150.

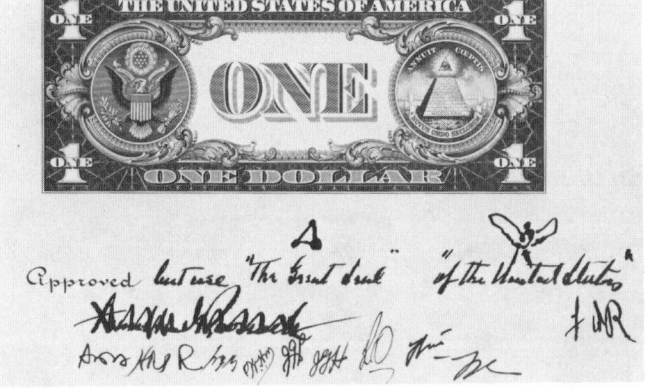

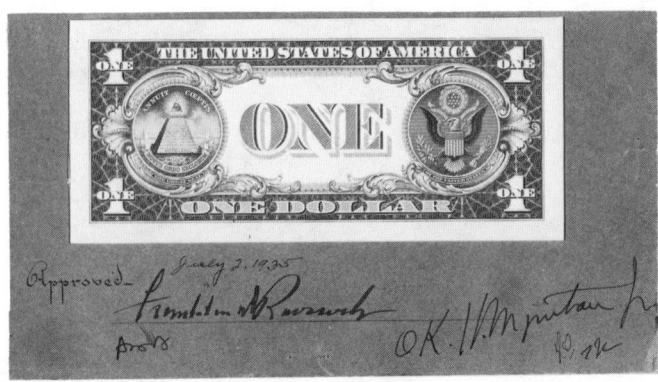

The proposed back design by E.M. Weeks for the 1935, $1 note shows a number of approval initials below the crossed out signature of Franklin D. Roosevelt, who after reconsidering, made changes as indicated. This change inappropriately placed the obverse of the Great Seal on the right. This was the first time both the obverse and reverse of the Great Seal appeared on one note. The engravers were J.C. Benzing, E.M. Hall, D.R. McLeod, R. Ponickau and W.B. Wells.

The revised design has the signatures of President F.D. Roosevelt and Secretary of the Treasury Henry Morgenthau, Jr.

Silver Certificates/Series 1935 & 1935A/Blue Seal

No.	Series	Notes Printed	VFine	EFine	Unc
77	1935	1,681,552,000	$ 3.	$ 5.	$ 8.
77☆		–	–	15.	75.
78	1935A	6,111,832,000	–	–	3.
78☆		–	–	–	15.
79	1935A	35,052,000	8.	10.	28.
79☆		–	50.	75.	300.
80	1935A	26,916,000	6.	10.	35.
80☆		–	50.	75.	300.

Remarks: All bear the signatures of Julian-Morgenthau. No. 79 bears the overprint "HAWAII" on the face and back. No. 80 bears a yellow seal for use in North Africa. Both were used during World War II.

EXPERIMENTAL NOTES
Series 1928 and 1928B

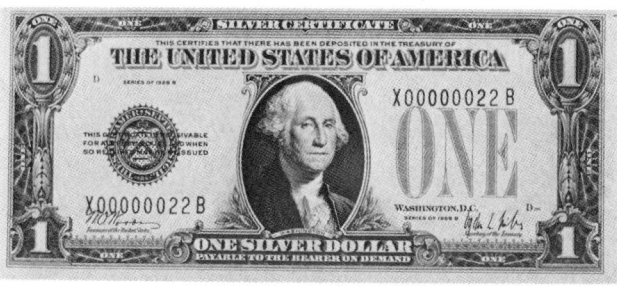

To test the durability of another type of paper, an experimental run of $1 silver certificates, series 1928A and 1928B was issued during the early 1930s. These extremely scarce notes have blocks X-B (10,728,000 printed), Y-B and Z-B (10,248,000 printed for each).

Series of 1935
The *Numismatic Scrapbook* (October 1964, p. 2664 and February 1968, p. 196) published the following letter from the Director of the Bureau of Engraving and Printing to R.H. Lloyd dated 23 December 1938:

> Dear Sir:
> Receipt is acknowledged of your letter of December 16, 1938, enclosing silver certificate No. C01263845B, and inquiring as to the reason for the suffix letter 'B.' Your certificate is one of the 3,300,000 $1 silver certificates, series 1935, delivered in the latter part of the calendar year 1937, numbered from C00000001B to C03300000B, which was regular work. At the same time there was delivered an equal number of $1 silver certificates, series 1935, numbered from B00000001B to B03300000B. This was platered by a new method. These two deliveries were made for the purpose of determining any objectionable condition due to the new method of platering. The silver certificate is returned herewith.
>
> Very Truly yours,
> A.W. Hall, Director

Remarks: The letter fails to mention that 6,180,000 pieces with A-B serial numbers were printed.

Silver Certificates/Series 1935A–1935G/Blue Seal

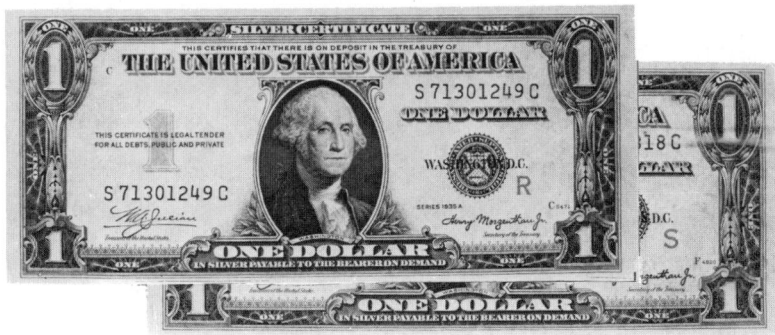

No.	Series	Signatures	Notes Printed	Fine	EFine	Unc
81	1935A(R)	Julian-Morgenthau	1,184,000	$14.	$35.	$ 135.
81☆			12,000	–	–	1500.
82	1935A(S)	Julian-Morgenthau	1,184,000	14.	35.	100.
82☆			12,000	–	–	1500.

Nos. 81 and 82 were issued as part of a paper experiment by the Bureau. The "R" signified the regular issue; the "S" identified the special paper.

No.	Series	Signatures	Notes Printed	Fine	EFine	Unc
83	1935B	Julian-Vinson	806,612,000	–	–	4.
83☆			–	13.	25.	50.
84	1935C	Julian-Snyder	3,088,108,000	–	–	4.
84☆			–	–	5.	20.
85	1935D	Clark-Snyder	4,656,968,000	–	–	3.
85☆			–	–	–	6.
86	1935D(ND)	Clark-Snyder	included in above	–	–	3.
86☆			–	–	–	6.
87	1935E	Priest-Humphrey	5,134,056,000	–	–	3.
87☆			–	–	–	6.
88	1935F	Priest-Anderson	1,173,360,000	–	–	3.
88☆			53,200,000	–	–	6.
89	1935G	Smith-Dillon	194,600,000	–	–	3.
89☆			8,640,000	–	–	6.

Remarks: During the printing of Series 1935D (No. 86) the back design was narrowed by about 1/16 of an inch. All subsequent $1 issues were printed with this narrow design. No. 89 is without the motto "IN GOD WE TRUST."

Silver Certificates/Series 1935G–1957B/Blue Seal

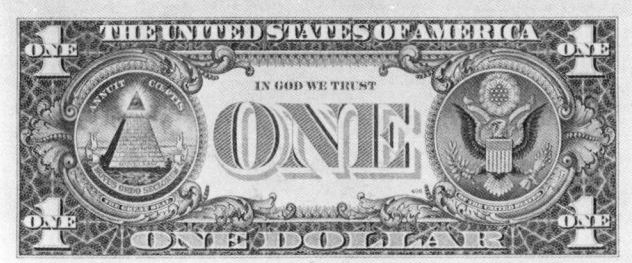

In addition to those who engraved Series 1935, C.A. Brooks, G.L. Huber and R.J. Jones engraved the back for Series 1957.

No.	Series	Signatures	Notes Printed	EFine	Unc
90	1935G	Smith-Dillon	31,320,000	$–	$ 5.
90☆			1,080,000	4.	10.
91	1935H	Granahan-Dillon	30,520,000	–	3.
91☆			1,436,000	3.	8.
92	1957	Priest-Anderson	2,609,600,000	–	3.
92☆			307,640,000	–	6.
93	1957A	Smith-Dillon	1,594,080,000	–	3.
93☆			94,720,000	–	4.
94	1957B	Granahan-Dillon	718,400,000	–	3.
94☆			49,280,000	–	6.

Remarks: During the printing of Series 1935G the motto "IN GOD WE TRUST" was added. The 1935G listings above are for notes with the motto.

Federal Reserve Notes/Series 1963, 1963A & 1963B/Green Seal

Series 1963, Granahan-Dillon

No.	Bank	Notes Printed	Unc
95A	Boston	87,680,000	$3.
95A☆		6,400,000	4.
95B	New York	219,200,000	3.
95B☆		15,360,000	4.
95C	Philadelphia	123,680,000	3.
95C☆		10,880,000	4.
95D	Cleveland	108,320,000	3.
95D☆		8,320,000	4.
95E	Richmond	159,520,000	3.
95E☆		12,160,000	4.
95F	Atlanta	221,120,000	3.
95F☆		19,200,000	4.
95G	Chicago	279,360,000	3.
95G☆		19,840,000	4.
95H	St. Louis	99,840,000	3.
95H☆		9,600,000	4.
95I	Minneapolis	44,800,000	3.
95I☆		5,120,000	4.
95J	Kansas City	88,760,000	3.
95J☆		8,960,000	4.
95K	Dallas	85,760,000	3.
95K☆		8,960,000	4.
95L	San Francisco	199,999,999	3.
95L☆		14,720,000	4.

Series 1963A, Granahan-Fowler

No.	Bank	Notes Printed	Unc
96A	Boston	319,840,000	$3.
96A☆		19,840,000	4.
96B	New York	657,600,000	3.
96B☆		48,800,000	4.
96C	Philadelphia	375,520,000	3.
96C☆		26,240,000	4.
96D	Cleveland	337,120,000	3.
96D☆		21,120,000	4.
96E	Richmond	532,000,000	3.
96E☆		41,600,000	4.
96F	Atlanta	636,480,000	3.
96F☆		40,960,000	4.
96G	Chicago	784,480,000	3.
96G☆		52,640,000	4.
96H	St. Louis	264,000,000	3.
96H☆		17,920,000	4.
96I	Minneapolis	112,160,000	3.
96I☆		7,040,000	4.
96J	Kansas City	219,200,000	3.
96J☆		14,720,000	4.
96K	Dallas	288,960,000	3.
96K☆		19,184,000	4.
96L	San Francisco	576,800,000	3.
96L☆		43,040,000	4.

Series 1963B, Granahan-Barr

No.	Bank	Notes Printed	Unc
97B	New York	123,040,000	$3.
97B☆		3,680,000	4.
97E	Richmond	93,600,000	3.
97E☆		3,200,000	4.
97G	Chicago	91,040,000	3.
97G☆		2,400,000	4.
97J	Kansas City	44,800,000	3.
97J☆		not printed	–
97L	San Francisco	106,400,000	3.
97L☆		3,040,000	4.

Federal Reserve Notes/Series 1969, 1969A, 1969B & 1969C/Green Seal

Series 1969, Elston-Kennedy

No.	Bank	Notes Printed	Unc
98A	Boston	99,200,000	$2.
98A☆		1,120,000	3.
98B	New York	269,120,000	2.
98B☆		14,080,000	3.
98C	Philadelphia	68,480,000	2.
98C☆		3,616,000	3.
98D	Cleveland	120,480,000	2.
98D☆		5,760,000	3.
98E	Richmond	250,560,000	2.
98E☆		10,880,000	3.
98F	Atlanta	85,120,000	2.
98F☆		7,680,000	3.
98G	Chicago	359,530,000	2.
98G☆		12,160,000	3.
98H	St. Louis	74,880,000	2.
98H☆		3,840,000	3.
98I	Minneapolis	48,000,000	2.
98I☆		1,920,000	3.
98J	Kansas City	95,360,000	2.
98J☆		5,760,000	4.
98K	Dallas	113,440,000	2.
98K☆		5,120,000	3.
98L	San Francisco	226,240,000	2.
98L☆		9,600,000	3.

Series 1969A, Kabis-Kennedy

No.	Bank	Notes Printed	Unc
99A	Boston	40,480,000	$2.
99A☆		1,120,000	3.
99B	New York	122,400,000	2.
99B☆		6,240,000	3.
99C	Philadelphia	44,960,000	2.
99C☆		1,760,000	3.
99D	Cleveland	30,080,000	2.
99D☆		1,280,000	3.
99E	Richmond	66,080,000	2.
99E☆		3,200,000	3.
99F	Atlanta	70,560,000	2.
99F☆		2,400,000	3.
99G	Chicago	75,680,000	2.
99G☆		4,480,000	3.
99H	St. Louis	41,420,000	2.
99H☆		1,280,000	3.
99I	Minneapolis	21,760,000	2.
99I☆		640,000	5.
99J	Kansas City	40,480,000	2.
99J☆		1,120,000	3.
99K	Dallas	27,520,000	2.
99K☆		not printed	–
99L	San Francisco	51,840,000	2.
99L☆		3,480,000	3.

Series 1969B, Kabis-Connally

No.	Bank	Notes Printed	Unc
100A	Boston	94,720,000	$2.
100A☆		1,920,000	3.
100B	New York	329,144,000	2.
100B☆		7,040,000	3.
100C	Philadelphia	133,280,000	2.
100C☆		3,200,000	3.
100D	Cleveland	91,520,000	2.
100D☆		4,480,000	3.
100E	Richmond	180,000,000	2.
100E☆		3,840,000	3.
100F	Atlanta	200,000,000	2.
100F☆		3,840,000	3.
100G	Chicago	204,480,000	2.
100G☆		4,480,000	3.
100H	St. Louis	59,520,000	2.
100H☆		1,920,000	3.
100I	Minneapolis	33,290,000	2.
100I☆		3,200,000	3.
100J	Kansas City	67,200,000	2.
100J☆		2,560,000	3.
100K	Dallas	116,640,000	2.
100K☆		5,120,000	3.
100L	San Francisco	208,960,000	2.
100L☆		5,760,000	3.

Series 1969C, Banuelos-Connally

No.	Bank	Notes Printed	Unc
101A	Boston	not printed	$–
101A☆		not printed	–
101B	New York	49,920,000	2.
101B☆		not printed	–
101C	Philadelphia	not printed	–
101C☆		not printed	–
101D	Cleveland	8,480,000	2.
101D☆		480,000	6.
101E	Richmond	61,600,000	2.
101E☆		480,000	6.
101F	Atlanta	61,360,000	2.
101F☆		3,680,000	3.
101G	Chicago	137,120,000	2.
101G☆		1,748,000	3.
101H	St. Louis	23,680,000	2.
101H☆		640,000	5.
101I	Minneapolis	25,600,000	2.
101I☆		3,200,000	3.
101J	Kansas City	98,560,000	2.
101J☆		1,120,000	3.
101K	Dallas	29,440,000	2.
101K☆		640,000	5.
101L	San Francisco	101,280,000	2.
101L☆		2,560,000	20.

Federal Reserve Notes/Series 1969D, 1974, 1977 & 1977A/Green Seal

Series 1969D, Banuelos-Schultz

No.	Bank	Notes Printed	Unc
102A	Boston	187,040,000	$2.
102A☆		1,120,000	3.
102B	New York	468,484,000	2.
102B☆		4,480,000	3.
102C	Philadelphia	218,560,000	2.
102C☆		4,320,000	3.
102D	Cleveland	161,440,000	2.
102D☆		2,400,000	3.
102E	Richmond	374,240,000	2.
102E☆		4,320,000	3.
102F	Atlanta	377,240,000	2.
102F☆		5,280,000	3.
102G	Chicago	378,080,000	2.
102G		5,280,000	3.
102H	St. Louis	168,480,000	2.
102H☆		1,760,000	3.
102I	Minneapolis	63,200,000	2.
102I☆		not printed	–
102J	Kansas City	185,760,000	2.
102J☆		3,040,000	3.
102K	Dallas	158,240,000	2.
102K☆		6,240,000	3.
102L	San Francisco	400,640,000	2.
102L☆		6,400,000	3.

Series 1974, Neff-Simon

No.	Bank	Notes Printed	Unc
103A	Boston	269,760,000	$2.
103A☆		2,400,000	3.
103B	New York	730,320,000	2.
103B☆		8,800,000	3.
103C	Philadelphia	308,960,000	2.
103C☆		1,760,000	3.
103D	Cleveland	240,960,000	2.
103D☆		1,120,000	3.
103E	Richmond	644,160,000	2.
103E☆		5,600,000	3.
103F	Atlanta	599,840,000	2.
103F☆		7,520,000	3.
103G	Chicago	473,600,000	2.
103G☆		6,880,000	3.
103H	St. Louis	291,520,000	2.
103H☆		3,040,000	3.
103I	Minneapolis	144,160,000	2.
103I☆		480,000	5.
103J	Kansas City	330,720,000	2.
103J☆		3,200,000	3.
103K	Dallas	330,720,000	2.
103K☆		1,760,000	3.
103L	San Francisco	737,120,000	2.
103L☆		4,320,000	3.

Series 1977, Morton-Blumenthal

No.	Bank	Notes Printed	Unc
104A	Boston	188,160,000	$2.
104A☆		3,072,000	3.
104B	New York	635,520,000	2.
104B☆		10,112,000	3.
104C	Philadelphia	216,960,000	2.
104C☆		4,480,000	3.
104D	Cleveland	213,120,000	2.
104D☆		3,328,000	3.
104E	Richmond	418,560,000	2.
104E☆		6,400,000	3.
104F	Atlanta	565,120,000	2.
104F☆		8,960,000	3.
104G	Chicago	615,680,000	2.
104G☆		9,472,000	3.
104H	St. Louis	199,680,000	2.
104H☆		2,048,000	3.
104I	Minneapolis	115,200,000	2.
104I☆		2,944,000	3.
104J	Kansas City	223,360,000	2.
104J☆		3,840,000	3.
104K	Dallas	289,280,000	2.
104K☆		4,608,000	3.
104L	San Francisco	516,480,000	2.
104L☆		8,320,000	3.

Series 1977A, Morton-Miller

No.	Bank	Notes Printed	Unc
105A	Boston	204,800,000	$2.
105A☆		2,432,000	3.
105B	New York	592,000,000	2.
105B☆		9,472,000	3.
105C	Philadelphia	196,480,000	2.
105C☆		2,688,000	3.
105D	Cleveland	174,120,000	2.
105D☆		2,560,000	3.
105E	Richmond	377,600,000	2.
105E☆		6,400,000	3.
105F	Atlanta	396,160,000	2.
105F☆		5,376,000	3.
105G	Chicago	250,880,000	2.
105G☆		2,560,000	3.
105H	St. Louis	103,680,000	2.
105H☆		1,664,000	3.
105I	Minneapolis	38,400,000	2.
105I☆		384,000	6.
105J	Kansas City	266,880,000	2.
105J☆		4,864,000	3.
105K	Dallas	313,600,000	2.
105K☆		6,016,000	3.
105L	San Francisco	433,280,000	2.
105L☆		5,888,000	3.

Federal Reserve Notes/Series 1981, 1981A, 1985 & 1988/Green Seal

Series 1981, Buchanan-Regan

No.	Bank	Notes Printed	Unc
106A	Boston	308,480,000	$ 2.
106A☆		3,200,000	3.
106B	New York	963,840,000	2.
106B☆		11,776,000	3.
106C	Philadelphia	359,680,000	2.
106C☆		1,536,000	10.
106D	Cleveland	295,680,000	2.
106D☆		1,792,000	3.
106E	Richmond	603,520,000	2.
106E☆		3,840,000	3.
106F	Atlanta	741,760,000	2.
106F☆		3,200,000	8.
106G	Chicago	629,760,000	2.
106G☆		5,184,000	8.
106H	St. Louis	163,840,000	2.
106H☆		1,056,000	5.
106I	Minneapolis	105,600,000	2.
106I☆		1,152,000	10.
106J	Kansas City	302,080,000	2.
106J☆		3,216,000	8.
106K	Dallas	385,920,000	2.
106K☆		1,920,000	10.
106L	San Francisco	677,760,000	2.
106L☆		4,992,000	8.

Series 1981A, Ortega-Regan

No.	Bank	Notes Printed	Unc
107A	Boston	204,800,000	$2.
107A☆		not printed	–
107B	New York	537,600,000	2.
107B☆		9,216,000	3.
107C	Philadelphia	99,200,000	2.
107C☆		not printed	–
107D	Cleveland	188,800,000	2.
107D☆		not printed	–
107E	Richmond	441,600,000	2.
107E☆		6,400,000	3.
107F	Atlanta	483,200,000	2.
107F☆		not printed	–
107G	Chicago	432,000,000	2.
107G☆		3,200,000	3.
107H	St. Louis	182,400,000	2.
107H☆		not printed	–
107I	Minneapolis	102,400,000	2.
107I☆		not printed	–
107J	Kansas City	176,000,000	2.
107J☆		not printed	–
107K	Dallas	188,800,000	2.
107K☆		3,000,000	6.
107L	San Francisco	659,200,000	2.
107L☆		3,200,000	3.

Series 1985, Ortega-Baker

No.	Bank	Notes Printed	Unc
108A	Boston	553,600,000	$ –
108A☆		not printed	–
108B	New York	1,795,200,000	–
108B☆		not printed	–
108C	Philadelphia	422,400,000	–
108C☆		not printed	–
108D	Cleveland	636,800,000	–
108D☆		not printed	–
108E	Richmond	1,190,400,000	–
108E☆		6,400,000	–
108F	Atlanta	1,414,400,000	–
108F☆		not printed	–
108G	Chicago	1,190,400,000	–
108G☆		5,120,000	–
108H	St. Louis	400,000,000	–
108H☆		640,000	3.
108I	Minneapolis	246,400,000	–
108I☆		2,560,000	–
108J	Kansas City	390,400,000	–
108J☆		not printed	–
108K	Dallas	697,600,000	–
108K☆		3,200,000	–
108L	San Francisco	1,881,600,000	–
108L☆		9,600,000	–

Series 1988, Ortega-Brady

No.	Bank	Notes Printed	Unc
109A	Boston	214,400,000	$ –
109A☆		3,200,000	–
109B	New York	921,600,000	–
109B☆		2,560,000	–
109C	Philadelphia	96,000,000	–
109C☆		not printed	–
109D	Cleveland	195,200,000	–
109D☆		not printed	–
109E	Richmond	728,800,000	–
109E☆		2,688,000	–
109F	Atlanta	390,400,000	–
109F☆		3,840,000	–
109G	Chicago	416,400,000	–
109G☆		not printed	–
109H	St. Louis	396,800,000	–
109H☆		not printed	–
109I	Minneapolis	124,800,000	–
109I☆		not printed	–
109J	Kansas City	137,600,000	–
109J☆		3,200,000	–
109K	Dallas	80,000,000	–
109K☆		1,248,000	3.
109L	San Francisco	585,600,000	–
109L☆		3,200,000	–

Federal Reserve Notes/Series 1988A & 1990/Green Seal

Series 1988A, Villalpando-Brady				Series 1990, Villalpando-Brady			
No.	Bank	Notes Printed	Unc	No.	Bank	Notes Printed	Unc
110A	Boston			111A	Boston		
110A☆				111A☆			
110B	New York			111B	New York		
110B☆				111B☆			
110C	Philadelphia			111C	Philadelphia		
110C☆				111C☆			
110D	Cleveland			111D	Cleveland		
110D☆				111D☆			
110E	Richmond			111E	Richmond		
110E☆				111E☆			
110F	Atlanta			111F	Atlanta		
110F☆				111F☆			
110G	Chicago			111G	Chicago		
110G☆				111G☆			
110H	St. Louis			111H	St. Louis		
110H☆				111H☆			
110I	Minneapolis			111I	Minneapolis		
110I☆				111I☆			
110J	Kansas City			111J	Kansas City		
110J☆				111J☆			
110K	Dallas			111K	Dallas		
110K☆				111K☆			
110L	San Francisco			111L	San Francisco		
110L☆				111L☆			

These series were in production when this catalog was printed.

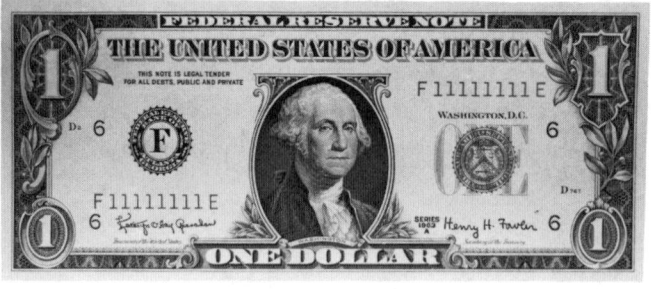

This page has been left blank for your personal notations.

This page has been left blank for your personal notations.

United States Notes/1862/Red Seal

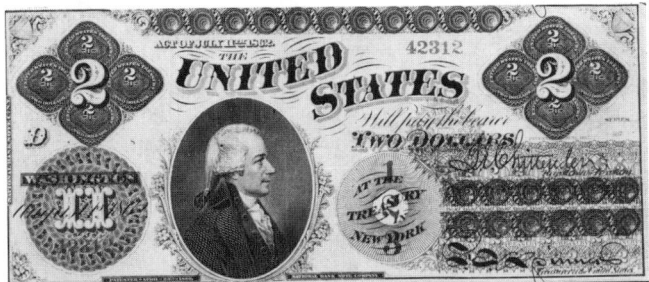

The portrait of Alexander Hamilton was engraved by Joseph P. Ourdan.

No.	Signatures	Notes Printed	Fine	EFine	Unc
153	Chittenden-Spinner; "American Bank Note Company" in left border	17,035,514	$175.	$475.	$1350.
153a	Chittenden-Spinner; "National Bank Note Company" in left border		175.	475.	1350.

Remarks: Both have "National Bank Note Company—Patented April 23, 1860" in lower face border.

United States Notes/Series 1869/Red Seal

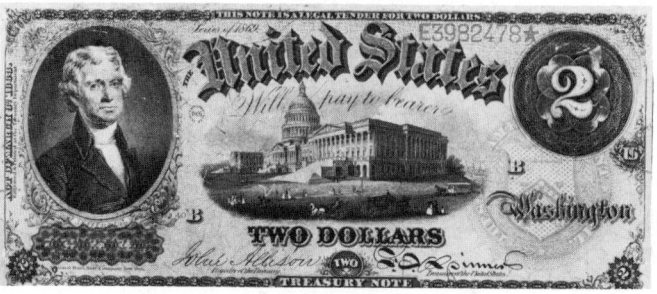

The portrait of Thomas Jefferson was engraved by Charles Burt. The *Capitol* was engraved by Louis Delnoce and William Chorlton.

No.	Signatures	Notes Printed	Fine	EFine	Unc
154	Allison-Spinner	24,796,000	$225.	$600.	$1900.

Remarks: There were 25,255,960 notes issued. Reissues could account for the excess of the the official figure above. A note of this type (U50336) in uncirculated condition, printed on paper watermarked "US" (intended for fractional currency) appeared in the November 13, 1979, NASCA auction (see Nos. 5 and 245).

United States Notes/Series 1874–1917

The face design is similar to No. 154 with a red ornament behind "Washington, D.C." The back design was changed as illustrated.

No.	Series	Signatures		Notes Printed	Fine	EFine	Unc
		Nos. 155–159 have red seals with rays.					
155	1874	Allison-Spinner		8,260,000	$125.	$275.	$ 625.
155A	1875A	Allison-New		1,000,000	150.	450.	1300.
155B	1875B	Allison-New		1,000,000	150.	450.	1300.
156	1875	Allison-New		4,160,000	125.	275.	600.
157	1875	Allison-Wyman		5,358,000	125.	275.	600.
158	1878	Allison-Gilfillan		4,676,000	125.	275.	600.
159	1878	Scofield-Gilfillan		included in above	750.	1850.	4500.
		Numbers 15–17 have red serial numbers and a large, brown seal on the right.					
160	1880	Scofield-Gilfillan		5,808,000	60.	135.	325.
161	1880	Bruce-Gilfillan		10,132,000	60.	135.	325.
162	1880	Bruce-Wyman		9,636,000	60.	135.	325.
		Nos. 162a-166 have blue serial numbers.					
			Seal				
162a	1880	Bruce-Wyman	lg. red	1,052,000	delivered; not issued		
163	1880	Rosecrans-Huston	lg. red	400,000	215.	650.	2100.
164	1880	Rosecrans-Huston	lg. brn	180,000	– – –8 known– – –		
165	1880	Rosecrans-Nebeker	lg. brn	920,000	65.	135.	300.
166	1880	Tillman-Morgan	sm. red	1,200,000	50.	100.	250.
		Nos. 167–170 have red serial numbers and red seals with scallops.					
167	1917	Teehee-Burke		69,072,000	25.	65.	175.
167☆	30 reported			–	–	–	–
168	1917	Elliott-Burke		57,136,000	25.	65.	200.
168☆	21 reported			–	–	–	–
169	1917	Elliott-White		17,792,000	35.	75.	225.
169☆	16 reported			–	–	–	–
170	1917	Speelman-White		173,416,000	25.	65.	150.
170☆	103 reported			–	–	–	–

Remarks: No. 162a was sent to the Treasury Department unsealed; all were apparently destroyed since none are known. Martin Gengerke has recorded ten notes for No. 163.

National Bank Notes/First Charter Period/Red Seals

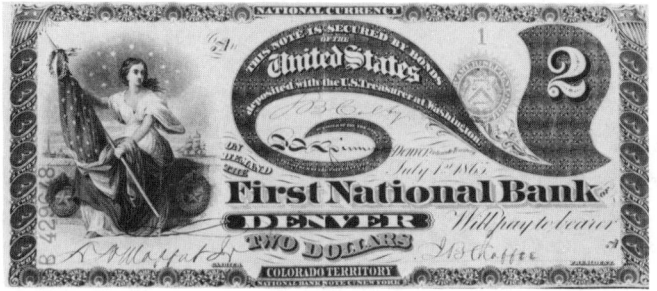

This design is generally referred to as the "Lazy Two." *Stars and Stripes* was engraved by Louis Delnoce. James B. Chaffee, whose signature is on this note, was the first president of the First National Bank of Denver founded in 1865.

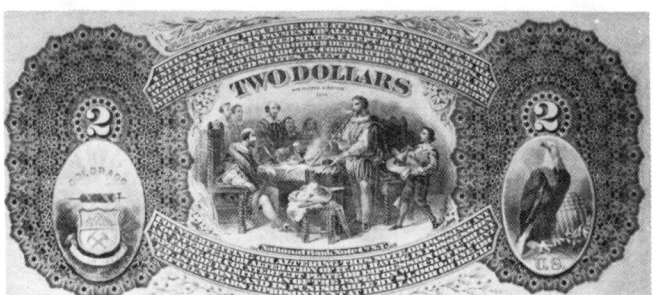

Louis Delnoce engraved *Sir Walter Raleigh Presenting Corn and Tobacco to the English.* Lettering on the face and back was engraved by W.D. Nichols and G.W. Thurber.

No.	Series	Signatures	Red Seal	VGood	VFine	Unc
171	orig.	Colby-Spinner	rays	$ 350.	$ 650.	$2350.
172	orig.	Jeffries-Spinner	rays	1650.	2750.	6500.
173	orig.	Allison-Spinner	rays	350.	650.	2350.
174	1875	Allison-New	scallops	350.	650.	2350.
175	1875	Allison-Wyman	scallops	350.	650.	2350.
176	1875	Allison-Gilfillan	scallops	350.	650.	2350.
177	1875	Scofield-Gilfillan	scallops	350.	650.	2350.

Remarks: A total of 7,747,519 notes were issued; 80,844 are outstanding. The original series had no series date printed on the face.

Silver Certificates/Series 1886

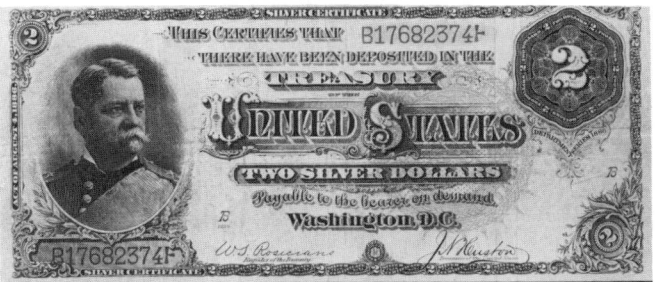

General Winfield Scott Hancock held the rank of Commanding General of the U.S. Army for 20 years. The portrait was engraved by Charles Schlecht. The back design was engraved by E.M. Hall, S.S. Hurlbut, D.M. Cooper and L. Delnoce.

No.	Signatures	Seal	Notes Printed	Fine	EFine	Unc
178	Rosecrans-Jordan	sm. red	5,000,000	$ 210.	$ 550.	$1250.
179	Rosecrans-Hyatt	sm. red	1,400,000	235.	600.	1400.
180	Rosecrans-Hyatt	lg. red	6,796,000	210.	550.	1250.
181	Rosecrans-Huston	lg. red	4,564,000	210.	550.	1250.
182	Rosecrans-Huston	lg. brn.	3,240,000	225.	575.	1300.

Remarks: A hoard of No. 179 in uncirculated condition exists commencing with B6117xxx. No. 180 in the same condition is also known in hoards: B10596xx, B6459xx, B77292xx, and B130550xx-B130552xx. Delivery of this $2 note began on November 27, 1886.

Silver Certificates/Series 1891/Red Seal

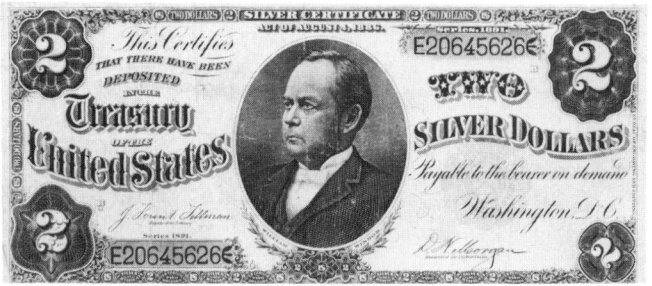

William Windom was born in Belmont, OH on May 10, 1827. He moved to Minnesota and served as United States senator. In 1881 Windom resigned to become Secretary of the Treasury; he died in 1891 holding that office. His portrait was engraved by W.G. Phillips.

No.	Signatures	Notes Printed	Fine	EFine	Unc
183	Rosecrans-Nebeker	6,148,000	$175.	$550.	$2850.
184	Tillman-Morgan	14,840,000	150.	450.	2300.

Remarks: *The New York Times* of August 15, 1897 reported that "Secret Service officers say that the reason why the Windom two, raised to a ten, was successfully passed was because the Windom note was not long enough in circulation to become well known to users."

Silver Certificates/Series 1896/Red Seal

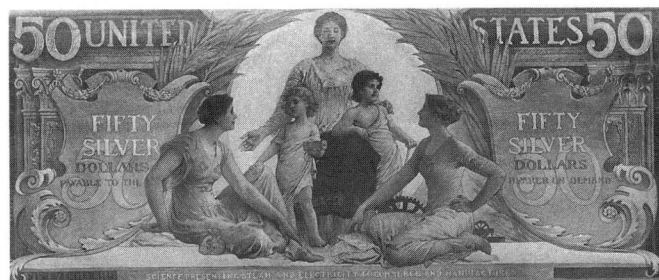

The painting of the original design, as a $50 note, hangs in the Bureau of Engraving and Printing.

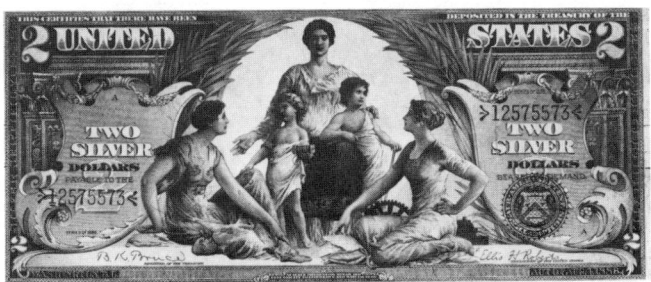

Science Presenting Steam and Electricity to Industry and Commerce was designed by Edwin H. Blashfield; it was engraved by Charles Schlecht and G.F.C. Smillie. The remainder of the face and the entire back was designed by Thomas F. Morris.

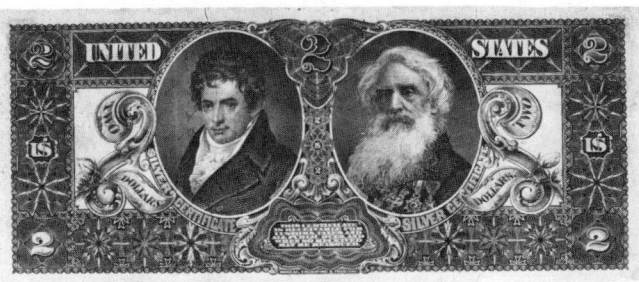

The portrait of R. Fulton, after a painting by Benjamin West, was engraved by Charles Burt. Charles Schlecht engraved the portrait of Samuel F.B. Morse.

This is the second note in the educational series (see Nos. 45 & 358).

No.	Signatures	Notes Printed	Fine	EFine	Unc
185	Tillman-Morgan	9,200,000	$275.	$700.	$3000.
186	Bruce-Roberts	11,452,000	265.	625.	2400.

Remarks: Observed serial numbers exceed the official figures listed above.

Silver Certificates/Series 1899/Blue Seal

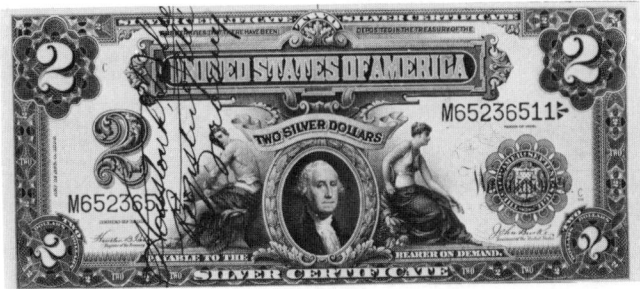

A portrait of Washington is flanked by *Mechanics and Agriculture*. The engravers were G.F.C. Smillie and M.W. Baldwin. The illustrated note has the autograph of Register of the Treasury Houston B. Teehee.

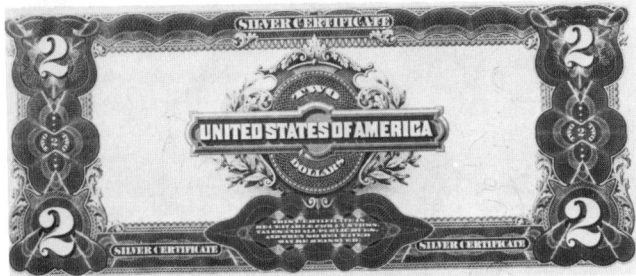

The back design was engraved by E.M. Hall, W.F. Lutz, J.P. Prender, R. Ponickau, D.S. Ronaldson and G.U. Rose.

No.	Signatures	Notes Printed	Fine	EFine	Unc
		Series above serial number on the right			
187	Lyons-Roberts	119,408,000	$55.	$115.	$325.
		Series below serial number on right			
188	Lyons-Treat	13,206,000	75.	165.	400.
189	Vernon-Treat	74,712,000	55.	115.	325.
190	Vernon-McClung	45,852,000	55.	125.	350.
190☆	5 reported	–	–	–	–
		Series vertically to the right of the seal			
191	Napier-McClung	78,936,000	55.	115.	325.
191☆	9 reported	–	–	–	–
192	Napier-Thompson	1,816,000	150.	500.	2000.
193	Parker-Burke	61,600,000	55.	115.	325.
193☆	4 reported	–	–	–	–
194	Teehee-Burke	93,284,000	55.	115.	325.
194☆	17 reported	–	–	–	–
195	Elliott-Burke	11,716,000	75.	165.	400.
195☆	4 reported	–	–	–	–
196	Speelman-White	38,204,000	55.	115.	325.
196☆	19 reported	–	–	–	–

Remarks: At least ten notes have been recorded for No. 192.

Treasury or Coin Notes/Series 1890

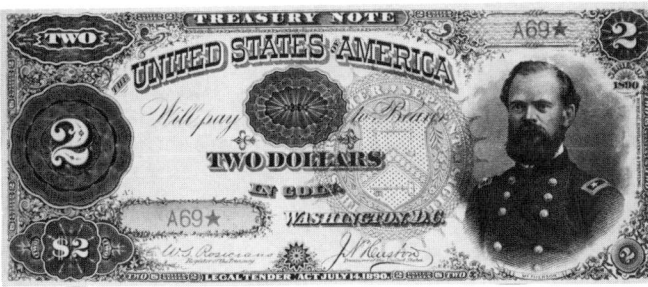

General James B. McPherson was born on November 14, 1828 in Sandusky, Ohio. He graduated from West Point and eleven years later, in 1864, was killed in an attack against Confederate troops. This portrait was engraved by Charles Burt. The back design was engraved by W.H. Dougal, E.M. Hall, A.L. Helm and G.U. Rose, Jr.

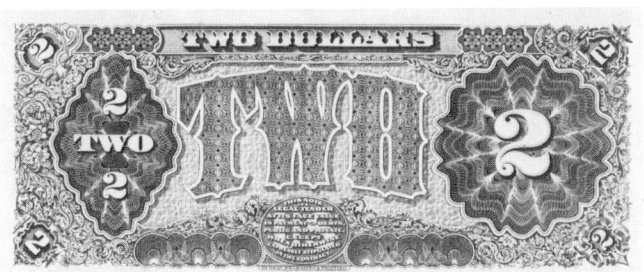

No.	Signatures	Seal	Notes Printed	Fine	EFine	Unc
197	Rosecrans-Huston	brown	2,650,000	$285.	$650.	$2500.
198	Rosecrans-Nebeker	brown	450,000	350.	725.	3250.
199	Rosecrans-Nebeker	red	1,832,000	300.	675.	2750.

Treasury or Coin Notes/Series 1891/Red Seal

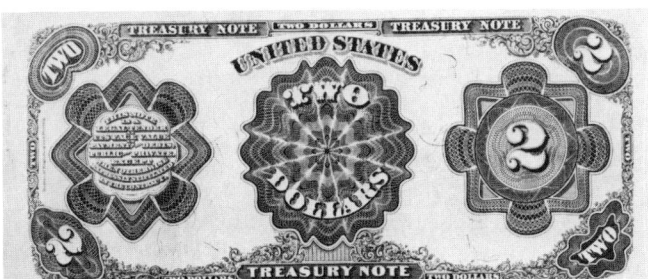

The face design is the same as the preceding type except with a smaller seal.

No.	Signatures	Notes Printed	Fine	EFine	Unc
200	Rosecrans-Nebeker	4,152,000	$135.	$300.	$850.
201	Tillman-Morgan	12,348,000	115.	275.	700.
202	Bruce-Roberts	3,472,000	135.	325.	900.

Federal Reserve Bank Notes/Series 1918/Blue Seal

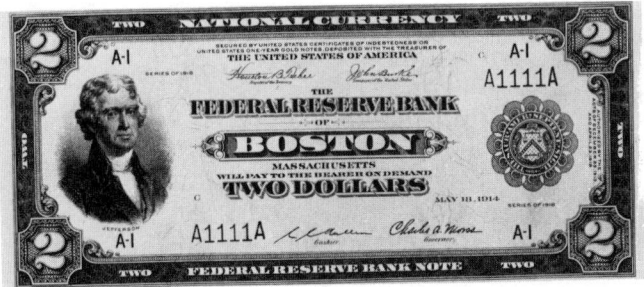

The portrait of Thomas Jefferson was engraved by Charles Burt. The "A-1" in the four corners indicates the first Federal Reserve District.

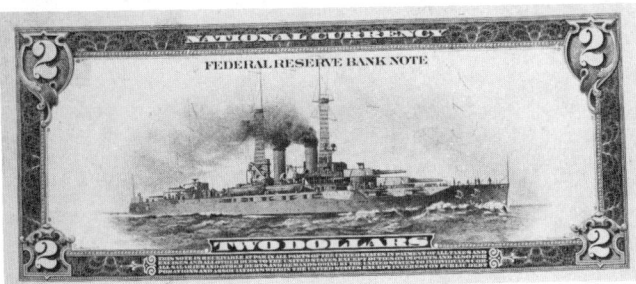

The World War I battleship *New York* was engraved by C.M. Chalmers.

No.	Bank	Signatures U.S.	Bank	Notes Issued	EFine	Unc
203A1	Boston	T-B	Bullen-Morss		$150.	$350.
203A1☆	2 reported				–	–
203A2	Boston	T-B	Willet-Morss	12,468,000	150.	350.
203A2☆	2 reported				–	–
203A3	Boston	T-B	Willet-Morss		150.	350.
203A3☆	5 reported				– –	–
203B1	New York	T-B	Sailer-Strong		150.	350.
203B1☆	5 reported				–	–
203B2	New York	T-B	Hendricks-Strong	15,216,000	150.	350.
203B2☆	3 reported				–	–
203B3	New York	E-B	Hendricks-Strong		150.	350.
203B3☆	1 reported				–	–
203C1	Philadelphia	T-B	Hardt-Passmore		150.	350.
203C2	Philadelphia	T-B	Dyer-Passmore	8,004,000	150.	350.
203C3	Philadelphia	E-B	Dyer-Passmore		185.	550.
203C4	Philadelphia	E-B	Dyer-Norris		150.	350.
203C4☆	2 reported				–	–
203D1	Cleveland	T-B	Baxter-Fancher		150.	350.
203D1☆	2 reported				–	–
203D2	Cleveland	T-B	Davis-Fancher		150.	350.
203D3	Cleveland	E-B	Davis-Fancher		150.	350.
203D3☆	1 reported				–	–
203E1	Richmond	T-B	Keesee-Seay		185.	550.
203E1☆	4 reported			3,736,000	–	–
203E2	Richmond	E-B	Keesee-Seay		150.	350.

U.S. government signatures: T(eehee)-B(urke); E(lliott)-B(urke).

Federal Reserve Notes/Series 1918/Blue Seal *(continued)*

No.	Bank	U.S.	Signatures Bank	Notes Issued	EFine	Unc
203F1	Atlanta	T-B	Pike-McCord	⎤	$150.	$350.
203F2	Atlanta	T-B	Bell-McCord	⎥	215.	625.
203F2☆	1 reported			2,300,000	–	–
203F3	Atlanta	T-B	Bell-Wellborn	⎥	185.	550.
203F4	Atlanta	E-B	Bell-Wellborn	⎦	185.	550.
203G1	Chicago	T-B	McCloud-McDougal	⎤	150.	350.
203G1☆	4 reported				150.	350.
203G2	Chicago	T-B	Cramer-McDougal	9,528,000	150.	350.
203G3	Chicago	E-B	Cramer-McDougal	⎥	150.	350.
203G3☆	3 reported			⎦	–	–
203H1	St. Louis	T-B	Attebery-Wells	⎤	165.	500.
203H2	St. Louis	T-B	Attebery-Biggs	3,300,000	185.	550.
203H3	St. Louis	E-B	Attebery-Biggs	⎥	215.	625.
203H4	St. Louis	E-B	White-Biggs	⎦	185.	550.
203I1	Minneapolis	T-B	Cook-Wold		185.	550.
203I1☆	2 reported				–	–
203I2	Minneapolis	T-B	Cook-Young		185.	550.
203I3	Minneapolis	E-B	Cook-Young		185.	550.
203J1	Kansas City	T-B	Anderson-Miller	⎤	185.	550.
203J1☆	2 reported			2,652,000	–	–
203J2	Kansas City	E-B	Anderson-Miller	⎥	185.	550.
203J3	Kansas City	E-B	Helm-Miller	⎦	185.	550.
203K1	Dallas	T-B	Talley-VanZandt	⎤	185.	550.
203K1☆	1 reported			1,252,000	–	–
203K2	Dallas	E-B	Talley-VanZandt	⎥	185.	550.
203K3	Dallas	E-B	Lawder-VanZandt	⎦	185.	550.
203L1	San Francisco	T-B	Clerk-Lynch	⎤	185.	550.
203L2	San Francisco	T-B	Clerk-Calkins	⎥	185.	550.
203L2☆	7 reported			3,188,000	–	–
203L3	San Francisco	E-B	Clerk-Calkins	⎥	185.	550.
203L3☆	7 reported			⎥	–	–
203L4	San Francisco	E-B	Ambrose-Calkins	⎦	185.	550.

U.S. government signatures: T(eehee)-B(urke); E(lliott)-B(urke).

United States Notes/Series 1928–1928G/Red Seal

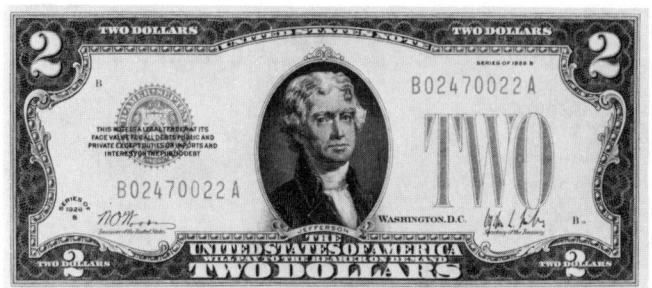

The portrait of Thomas Jefferson, based on a painting by Gilbert Stuart, was engraved by Charles Burt in 1867. A portrait of James Garfield was originally considered for this note.

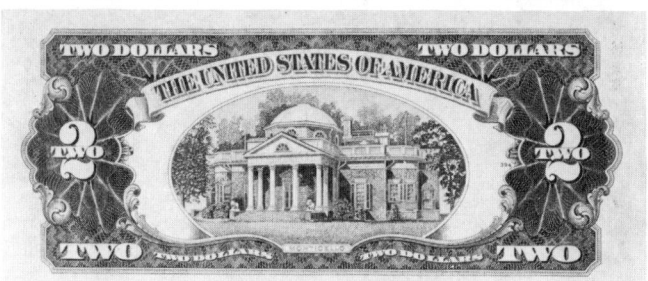

The engraving of *Monticello*, Jefferson's home, is the work of J.C. Benzing. *Monticello*, now a museum, houses numerous inventions by Jefferson, who was also an architect, a musician and lawyer.

No.	Series	Signatures	Notes Printed	VFine	EFine	Unc
204	1928	Tate-Mellon	55,889,424	$ 5.	$ 7.	$ 16.
204☆			–	25.	50.	150.
204A	1928A	Woods-Mellon	46,859,136	15.	30.	165.
204A☆			–	150.	265.	850.
204B	1928B	Woods-Mills	9,001,632	75.	135.	425.
204B☆			–	1200.	2500.	5000.
204C	1928C	Julian-Morgenthau	86,584,008	8.	18.	65.
204C☆			–	35.	65.	250.
204D	1928D	Julian-Morgenthau	146,381,364	5.	8.	12.
204D☆			–	10.	15.	65.
204E	1928E	Julian-Vinson	5,261,016	6.	12.	40.
204E☆			–	1200.	2000.	4000.
204F	1928F	Julian-Snyder	43,349,292	6.	8.	12.
204F☆			–	10.	20.	75.
204G	1928G	Clark-Snyder	52,208,000	6.	8.	10.
204G☆			–	10.	20.	75.

United States Notes/Series 1953–1963A/Red Seal

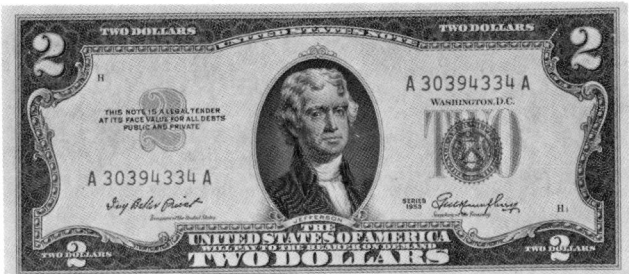

A grey "2" replaces the seal at the left, which is now on the right. "TWO" is also reduced in size.

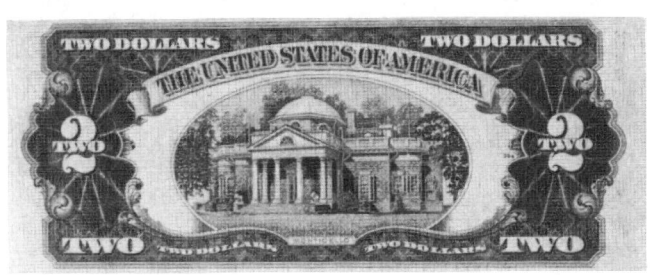

The back design, engraved by A. Dintaman and G.A. Payne, is the same as the preceding note.

No.	Series	Signatures	Notes Printed	VFine	EFine	Unc
205	1953	Priest-Humphrey	45,360,000	$ –	$ 5.	$ 7.
205 ☆			2,160,000	–	–	12.
205A	1953A	Priest-Anderson	18,000,000	–	4.	6.
205A ☆			720,000	2.	5.	25.
205B	1953B	Smith-Dillon	10,800,000	–	4.	7.
205B ☆			720,000	2.	5.	12.
205C	1953C	Granahan-Dillon	5,760,000	–	4.	7.
205C ☆			360,000	4.	7.	15.

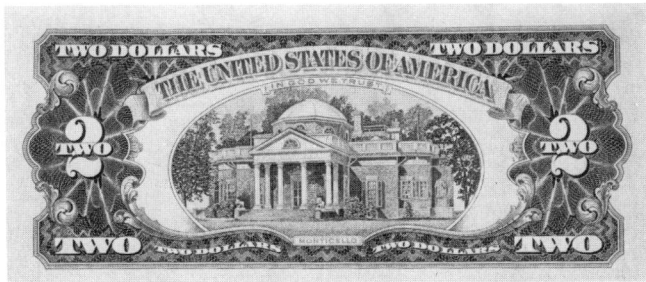

The face design is similar to Nos. 204 and 205. "IN GOD WE TRUST" was added to the back of Series 1963.

No.	Series	Signatures	Notes Printed	VFine	EFine	Unc
206	1963	Granahan-Dillon	15,360,000	–	$ –	$ 5.
206 ☆			640,000	–	5.	10.
206A	1963A	Granahan-Fowler	3,200,000	–	3.	5.
206A ☆			640,000	–	5.	10.

Federal Reserve Notes/Series 1976/Green Seal

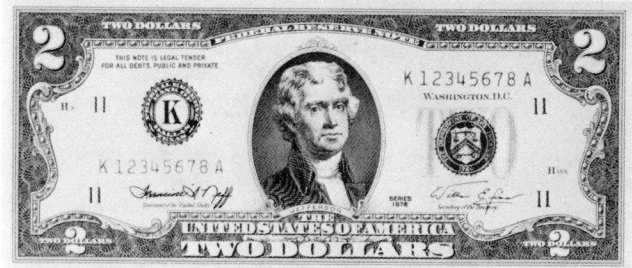

This issue is the first, small-size, $2 Federal Reserve note. The portrait of Thomas Jefferson is based on a painting by Gilbert Stuart, as are numbers 204–206.

The presentation of *The Declaration of Independence* by John Trumbull hangs in the Trumbull Gallery at Yale University (see No. 1151).

Series 1976, Neff-Simon					Series 1976, Neff-Simon			
No.	Bank	Notes Printed	Unc		No.	Bank	Notes Printed	Unc
207A	Boston	29,440,000	$4.		207G	Chicago	75,520,000	$4.
207A☆		1,280,000	5.		207G☆		1,280,000	5.
207B	New York	67,200,000	4.		207H	St. Louis	39,040,000	4.
207B☆		2,560,000	5.		207H☆		1,280,000	5.
207C	Philadelphia	33,280,000	4.		207I	Minneapolis	23,680,000	4.
207C☆		1,280,000	5.		207I☆		640,000	7.
207D	Cleveland	31,360,000	4.		207J	Kansas City	24,960,000	4.
207D☆		1,280,000	5.		207J☆		640,000	7.
207E	Richmond	59,960,000	4.		207K	Dallas	41,600,000	4.
207E☆		640,000	7.		207K☆		1,280,000	5.
207F	Atlanta	60,800,000	4.		207L	San Francisco	82,560,000	4.
207F☆		1,280,000	5.		207L☆		920,000	5.

Remarks: The following signed the *Declaration* but are not included in the original painting: Matthew Thornton, NH, John Hart, NJ, John Morton, James Smith, George Taylor and George Ross, PA, Caesar Rodney, DE, Thomas Stone, MD, Thomas Nelson, Jr, Francis Lightfoot Lee and Carter Braxton, VA, John Penn, NC, Button Gwinnett and Lyman Hall, GA.

The portraits of George Wythe, VA, William Whipple and Josiah Bartlet, NH, Thomas Lynch, SC, Thomas McKean, DE, and Philip Livingston, NY were deleted from the above engraving, however they appear on Nos. 1151–1162.

Demand Notes/1861

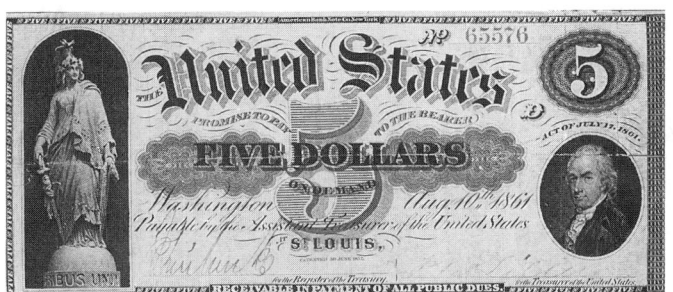

Freedom, which adorns the top of the Capitol in Washington, was created by Thomas Crawford. The statue as seen here was engraved by Owen G. Hanks. The engraved portrait of Alexander Hamilton is based on a painting by Archibald Robertson.

No.	Payable at	Notes Printed	Known	VGood	Fine	VFine
242A	Boston	1,340,000	52 (1)	$ 600.	$ 1250.	$ 1850.
242B	New York	1,500,000	59 (7)	600.	1250.	1850.
242C	Philadelphia	1,400,000	54	600.	1250.	1850.
242D	Cincinnati	44,000	5	6500.	8000.	15000.
242E	St. Louis	76,000	7	6000.	7500.	12000.

Remarks: A total of 4,360,000 notes were printed. According to records of 1931, 4,249½ notes were outstanding. These notes, all without the U.S. Treasury Seal, were signed by representatives of the U.S. Treasurer and the Register of the Treasury. "For the" was originally written as the signatures were inscribed (see No. 463 for an example). The number of these notes known, not included in the other total, are in parentheses above. These notes are extremely rare and command a higher premium. After a brief time "For the" was engraved into the plate. Serial number "1" notes are known for No. 242A Series 7, and No. 242C with no series.

United States Notes/1862 & 1863/Red Seal

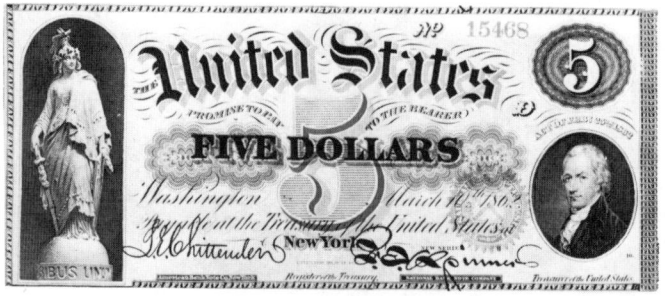

This issue is similar to the preceding with the addition of the U.S. Treasury Seal and the deletion of the words "ON DEMAND." (Photo courtesy of Jack H. Fisher)

Back with first obligation.

Back with second obligation.

Nos. 243 and 243a have the first obligation back, remaining notes have the second obligation.

No.	Date	Description	Notes issued	Fine	EFine	Unc
243	1862	"American Bank Note Company" in upper border, no "Series"	100,000			
243a	1862	"American Bank Note Company" with "Series" on face		$150.	$400.	$1250.
243b	1862	"American Bank Note Company" and "National Bank Note Company" in lower border		150.	400.	1250.
244	1863	"American Bank Note Company" twice in lower border; one serial number		135.	350.	1000.
244a	1863	as 243b; one serial number		135.	350.	1000.
244b	1863	as 244; two serial numbers		135.	350.	1000.

Remarks: All have signatures of Chittenden-Spinner. A total of 20,200,000 notes were printed; 19,332,714 were issued, and 99,726 were outstanding in 1889. Three of No. 243 have been reported.

United States Notes/Series 1869/Red Seal

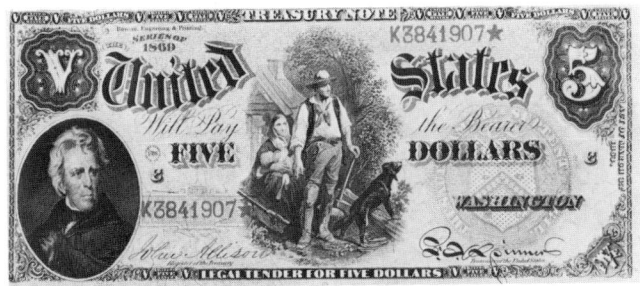

The portrait of Andrew Jackson, based on a painting by Thomas Sully, was engraved by Alfred Sealey. *The Pioneer* was engraved by Henry Gugler.

No.	Date	Signatures	Notes Printed	Fine	EFine	Unc
245	1869	Allison-Spinner	10,068,000	$225.	$600.	$2000.

Remarks: An example of No. 245, printed on paper watermarked "US" (intended for fractional currency) in new condition appeared in the November 13, 1979 NASCA auction (see Nos. 5 and 154).

United States Notes/Series 1875–1880

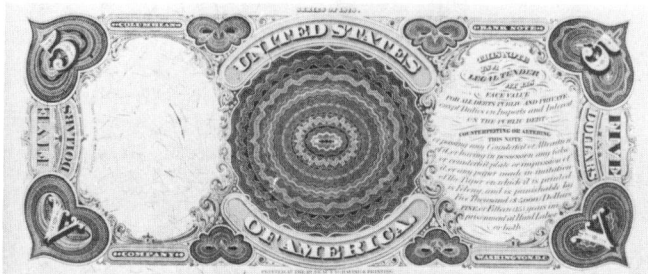

The face design is similar to the preceding note. This back design was engraved by G.L. Huber.

No.	Series	Signatures	Seal	Notes Printed	Fine	EFine	Unc
		Nos. 246A-249 have a red seal with rays.					
246A	1875A	Allison-New		1,000,000	$ 100.	$ 300.	$ 750.
246B	1875B	Allison-New		1,000,000	100.	300.	750.
247	1875	Allison-New		3,860,000	60.	135.	375.
248	1875	Allison-Wyman		3,436,000	60.	135.	375.
249	1878	Allison-Gilfillan		6,032,000	135.	200.	450.
		Series of 1880					
250		Scofield-Gilfillan	lg. brown	3,800,000	325.	900.	3000.
251		Bruce-Gilfillan	lg. brown	7,200,000	65.	125.	450.
252		Bruce-Wyman	lg. brown	6,600,000	65.	125.	450.
		Nos. 253–263 have blue serial numbers and a large seal.					
253		Bruce-Wyman	red	2,500,000	85.	175.	850.
254		Bruce-Wyman	red		none observed		
255		Rosecrans-Jordan	red	6,500,000	75.	175.	800.
256		Rosecrans-Hyatt	red	1,460,000	90	200.	1000.
257		Rosecrans-Huston	red	4,540,000	60.	250.	900.
258		Rosecrans-Huston	brown	4,000,000	60.	250.	900.
259		Rosecrans-Nebeker	brown	600,000	350.	1000.	1750.
		Nos. 260–263 have a small red seal with scallops.					
260		Rosecrans-Nebeker		8,992,000	65.	125.	375.
261		Tillman-Morgan		12,316,000	50.	75.	300.
262		Bruce-Roberts		7,000,000	65.	125.	375.
263		Lyons-Roberts		7,484,000	65.	125.	375.

Remarks: Only seven notes are known for No. 250; 13 are known for No. 259. The following hoards (by serial number) are known, all in uncirculated condition: No. 246A, unspecified number commencing with A7808xx; No. 246B, B257945–65 and B981331–83; No. 252, unspecified number commencing with Z12373xx; No. 262, unspecified number commencing with A435117xx

United States Notes/Series 1907

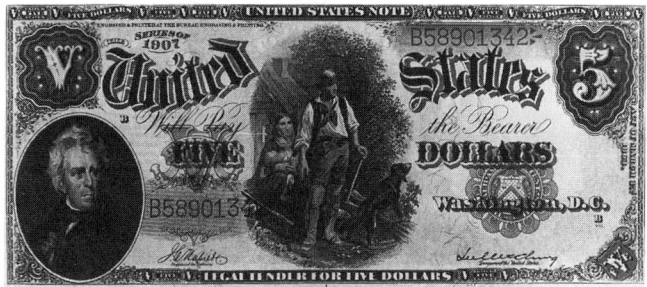

Nos. 264–273 have a red "V" and the word "Dollars" added; serial numbers are red, and the seals are red with scallops.

No.	Signatures	Notes Printed	Fine	EFine	Unc
264	Vernon-Treat	36,010,000	$35.	$65.	$200.
265	Vernon-McClung	32,120,000	35.	65.	200.
265☆	4 reported	–	–	–	–
266	Napier-McClung	54,004,000	35.	65.	200.
266☆	6 reported	–	–	–	–
267	Napier-Thompson	1,596,000	200.	425.	850.
267☆	not confirmed	–	–	–	–
268	Parker-Burke	47,116,000	35.	65.	200.
268☆	5 reported	–	–	–	–
269	Teehee-Burke	99,500,000	35.	65.	200.
269☆	19 reported	–	–	–	–
270	Elliott-Burke	4,300,000	50.	100.	300.
270☆	4 reported	–	–	–	–
271	Elliott-White	13,700,000	50.	90.	225.
271☆	3 reported	–	–	–	–
272	Speelman-White	155,384,000	35.	50.	185.
272☆	57 reported	–	–	–	–
273	Woods-White	18,304,000	50.	90.	225.
273☆	5 reported	–	–	–	–

Remarks: Martin Gengerke has recorded 17 examples for No. 267. The number printed for No. 272 could be higher or lower. "M" block, after M24796001, was printed concurrently with notes of Woods-White. It is possible that additional notes were printed for No. 273.

National Bank Notes/First Charter Period

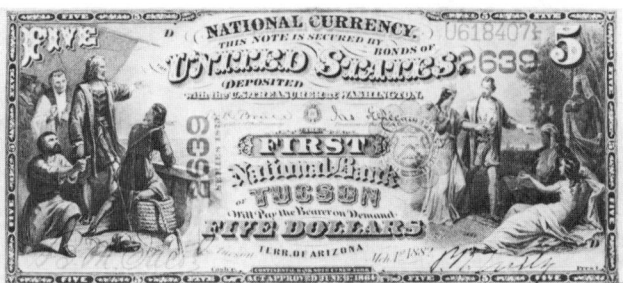

Columbus in Sight of Land, by artist Charles Fenton, was engraved by Louis Delnoce. *America Presented to the Old World,* by T.A. Liebler, was engraved by W.W. Rice.

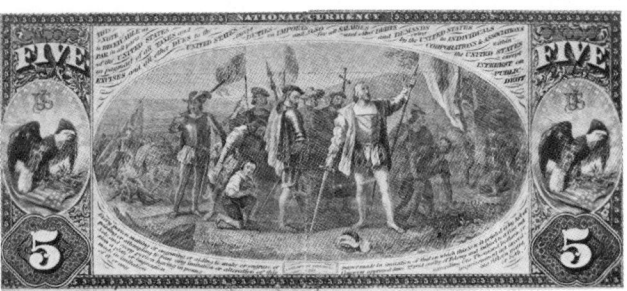

The Landing of Columbus is based on the painting by John Vanderlyn. James Bannister, Louis Delnoce and Walter Shirlaw each engraved a version for the Continental Bank Note Co.

No.	Series	Signatures	VGood	VFine	Unc
		Red seal with rays			
274	orig.	Chittenden-Spinner	$125.	$285.	$1250.
275	orig.	Colby-Spinner	125.	285.	1250.
276	orig.	Jeffries-Spinner	750.	1750.	5000.
277	orig.	Allison-Spinner	125.	285.	1250.
		Red seal with scallops			
278	1875	Allison-New	125.	285.	1100.
279	1875	Allison-Wyman	125.	285.	1100.
280	1875	Allison-Gilfillan	125.	285.	1100.
281	1875	Scofield-Gilfillan	125.	285.	1100.
282	1875	Bruce-Gilfillan	150.	325.	1500.
283	1875	Bruce-Wyman	165.	375.	2000.
284	1875	Bruce-Jordan	――――――― Rare ―――――――		
285	1875	Rosecrans-Jordan	165.	325.	2000.
286	1875	Rosecrans-Huston	165.	325.	2000.
286a	1875	Rosecrans-Nebeker	―――――――Extremely rare―――――――		
286b	1875	Tillman-Morgan	―――――――Unique―――――――		

Remarks: The original series had no series date on the face. For additional information concerning the varieties of the back design see Hessler (1979, 142–146).

National Bank Notes/Series 1882/Second Charter Period/First Issue/Brown Seal

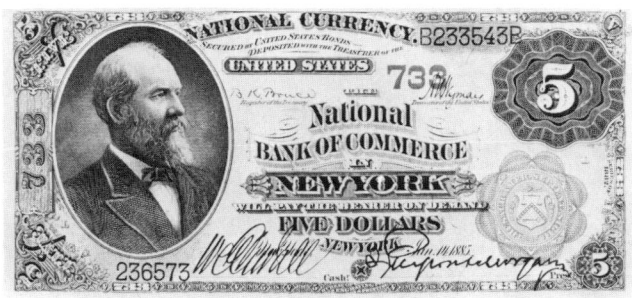

James A. Garfield was born in Orange, OH on November 18, 1831. After serving in the Ohio Senate he was elected to the presidency; Garfield was assassinated seven months later. This portrait, based on an autotype by Edward Bierstadt, was engraved by Lorenzo Hatch.

The back is brown.

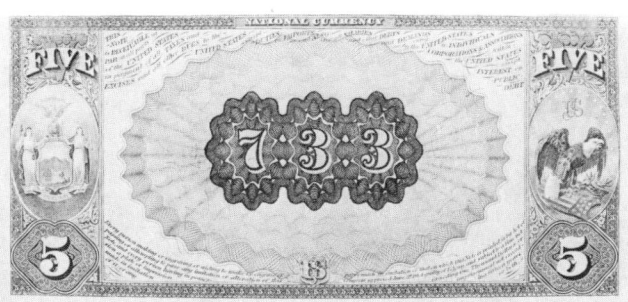

No.	Signatures	VGood	VFine	Unc
287	Bruce-Gilfillan	$ 75.	$125.	$ 600.
288	Bruce-Wyman	75.	125.	600.
289	Bruce-Jordan	75.	125.	600.
290	Rosecrans-Jordan	75.	125.	600.
291	Rosecrans-Hyatt	75.	125.	600.
292	Rosecrans-Huston	75.	125.	600.
293	Rosecrans-Nebeker	75.	125.	600.
294	Rosecrans-Morgan	150.	400.	1000.
295	Tillman-Morgan	75.	125.	600.
296	Tillman-Roberts	75.	125.	600.
297	Bruce-Roberts	75.	125.	600.
298	Lyons-Roberts	75.	125.	600.
299	Vernon-Treat	100.	275.	950.

National Bank Notes/Series 1882/Second Charter Period/Second Issue/Blue Seal

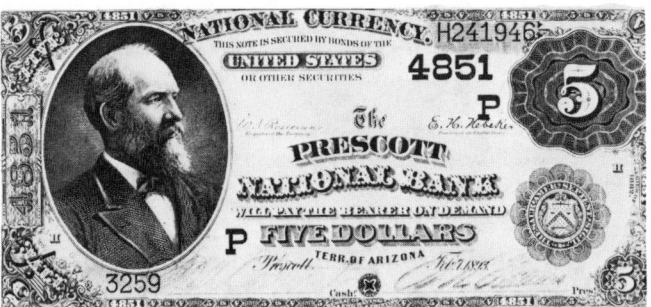

See preceding note for face design information.

The back is green.

No.	Signatures	VGood	VFine	Unc
300	Rosecrans-Huston	$ 75.	$ 135.	$ 600.
301	Rosecrans-Nebeker	75.	135.	600.
302	Rosecrans-Morgan	200.	500.	1250.
303	Tillman-Morgan	75.	135.	600.
304	Tillman-Roberts	75.	135.	650.
305	Bruce-Roberts	75.	135.	650.
306	Lyons-Roberts	75.	135.	600.
307	Vernon-Treat	75.	135.	700.
308	Napier-McClung	375.	750.	1500.

National Bank Notes/Series 1882/Second Charter Period/Third Issue/Blue Seal

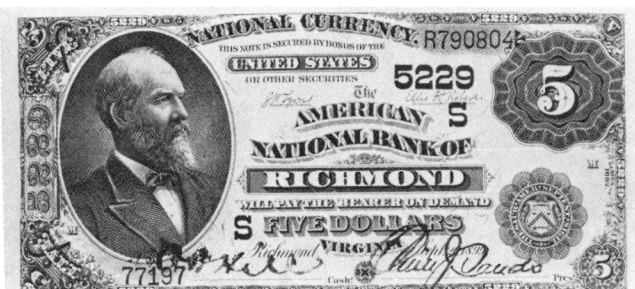

See No. 287 for face design information.

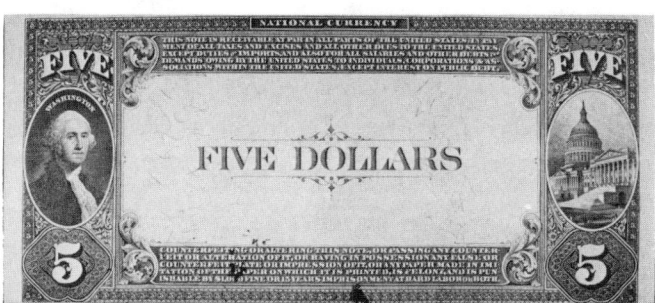

The back is green.

No.	Signatures	VGood	VFine	Unc
309	Tillman-Morgan	$100.	$250.	$1000.
310	Tillman-Roberts	150.	450.	1750.
311	Bruce-Roberts	150.	450.	1750.
312	Lyons-Roberts	135.	250.	1000.
313	Vernon-Treat	135.	450.	1250.
314	Napier-McClung	200.	450.	1500.
315	Teehee-Burke	———————— Rare ————————		

National Bank Notes/Series 1902/Third Charter Period

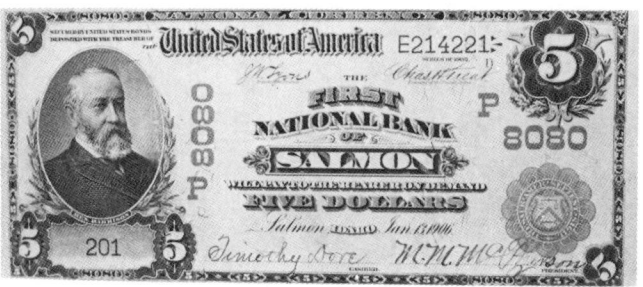

Benjamin Harrison, 23rd President of the U.S., was born on August 20, 1833. His great-grandfather was a signer of the Declaration of Independence; his grandfather was the ninth president, and his father served in the House of Representatives. The note was designed by Ostrander Smith and engraved by G.F.C. Smillie.

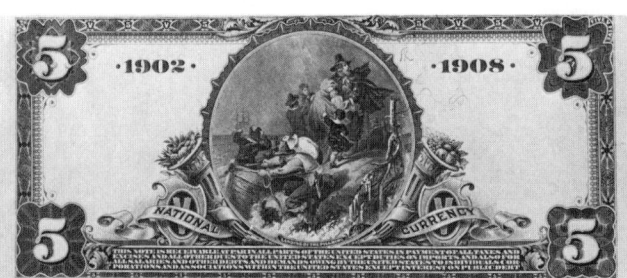

The green back design, with the *Landing of the Pilgrims* engraved by G.F.C. Smillie, is the same for all three issues, however, the second issue only has "1902–1908" added.

No.	Signatures	VGood	VFine	Unc
	First Issue—red seal			
316	Lyons-Roberts	$ 75.	$125.	$ 600.
317	Lyons-Treat	75.	175.	700.
318	Vernon-Treat	90.	200.	750.
	Second issue—blue seal			
319	Lyons-Roberts	25.	50.	300.
320	Lyons-Treat	25.	50.	300.
321	Vernon-Treat	25.	50.	300.
322	Vernon-McClung	25.	50.	300.
323	Napier-McClung 30.	60.	325.	
324	Napier-Thompson	40.	100.	400.
325	Napier-Burke	30.	60.	325.
326	Parker-Burke	30.	60.	325.
327	Teehee-Burke	50.	150.	425.
	Third issue—blue seal			
328	Lyons-Roberts	22.	40.	250.
329	Lyons-Treat	22.	40.	250.
330	Vernon-Treat	22.	40.	250.
331	Vernon-McClung	22.	40.	250.
332	Napier-McClung	22.	40.	250.
333	Napier-Thompson	35.	100.	350.
334	Napier-Burke	22.	40.	250.
335	Parker-Burke	22.	40.	250.
336	Teehee-Burke	22.	40.	250.
337	Elliott-Burke	22.	40.	250.
338	Elliott-White	22.	40.	250.
339	Speelman-White	22.	40.	250.
340	Woods-White	22.	40.	250.
341	Woods-Tate	35.	75.	300.
342	Jones-Woods	125.	400.	1250.

National Gold Bank Notes/Red Seal

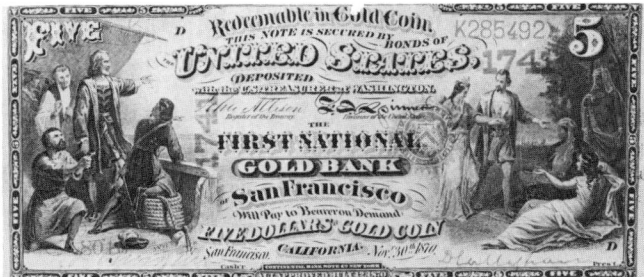

See Nos. 274–286 for face design information.

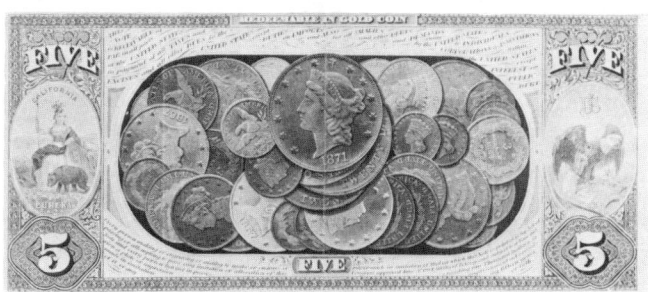

The gold coin vignette was engraved by James Smillie.

No.	Date	Issuing Bank	City	Notes Issued	Known	VGood	Fine
343	1870	First National Gold Bank	San Francisco	33,000	192	$ 900.	$1750.
344	1872	National Gold Bank and Trust Company	San Francisco	17,840	6	1400.	2250.
345	1872	National Gold Bank of D.O. Mills and Company	Sacramento	7,960	26	1250.	2000.
346	1873	First National Gold Bank	Santa Barbara	2,000	10	1400.	2250.
347	1873	First National Gold Bank	Stockton	4,000	12	1250.	2000.
348	1874	Farmers National Gold Bank	San Jose	8,028	28	1000.	1850.

Remarks: The signatures of Allison-Spinner appear on these notes. A total of 3,451 notes are outstanding.

Silver Certificates/Series 1886 & 1891

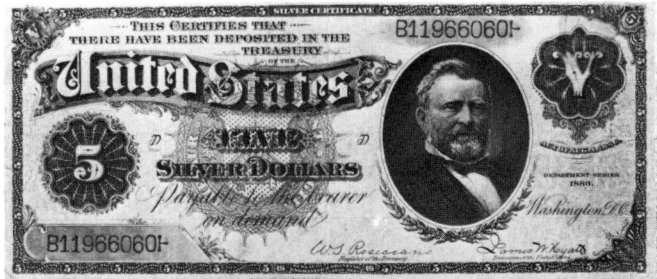

Lorenzo Hatch engraved the portrait of Ulysses S. Grant.

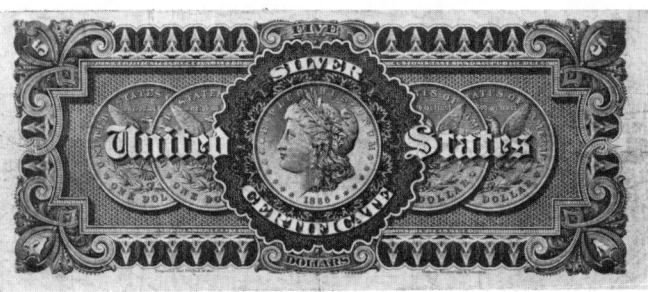

"In God We Trust," as seen on the reverses of the silver dollars, was not adopted for use on U.S. paper money until 1957.

No.	Signatures	Seal	Notes Printed	Fine	EFine	Unc
349	Rosecrans-Jordan	sm. red	1,500,000	$400.	$1100.	$3000.
350	Rosecrans-Hyatt	sm. red	7,345,800	325.	950.	2800.
351	Rosecrans-Hyatt	lg. red	12,171,000	300.	900.	2700.
352	Rosecrans-Huston	lg. red	3,548,000	350.	1000.	2900.
353	Rosecrans-Huston	lg. brown	7,400,000	325.	950.	2800.
354	Rosecrans-Nebeker	sm. red	1,000,000	400.	1100.	3000.
355	Rosecrans-Nebeker	lg. brown	880,000	450.	1200.	3250.

Series of 1891

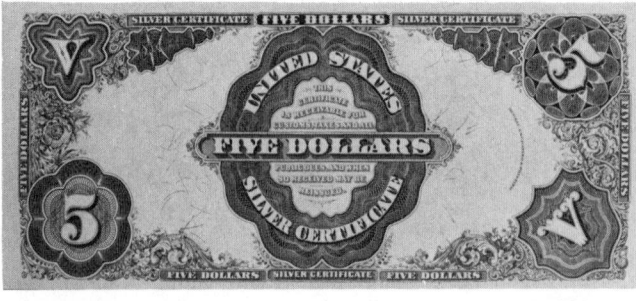

The back design has changed; the face design is similar to the preceding note.

No.	Signatures	Seal	Notes Printed	Fine	EFine	Unc
356	Rosecrans-Nebeker	red, scallops	6,464,000	$250.	$650.	$3000.
357	Tillman-Morgan	red	25,092,000	200.	550.	2350.

Remarks: Delivery for Nos. 349–355 began on Feb. 9, 1887. The following hoards have been reported: No. 351 (B8845901–15); No. 353 (unknown number commencing with B310794x); No. 357 (E2761001–34).

Silver Certificates/Series 1896/Red Seal

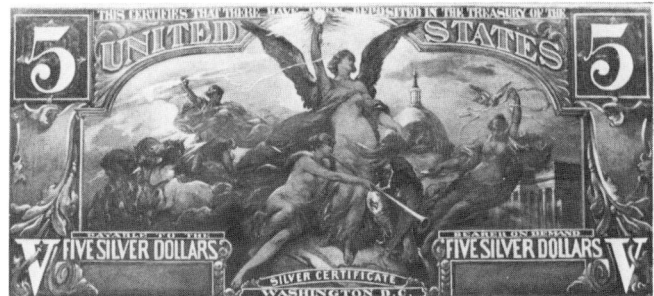

This painting by Walter Shirlaw, about four feet across, the original model for Nos. 358–360 hangs in the Bureau of Engraving and Printing. For this design the artist was paid $600.

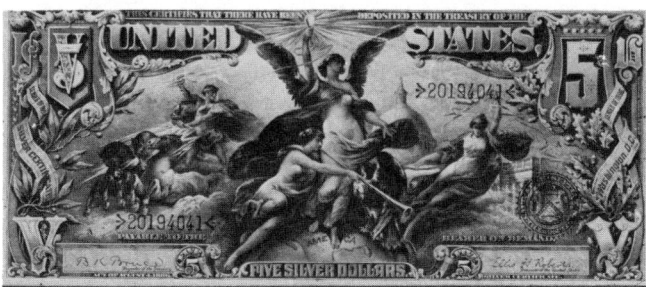

Mr. Shirlaw's central design, *Electricity Presenting Light to the World*, was retained; Thomas F. Morris redesigned the remaining portions. G.F.C. Smillie engraved the figures.

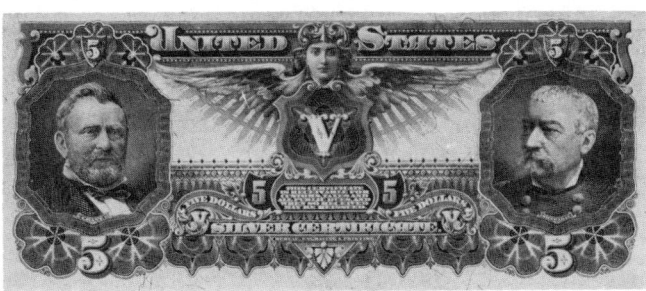

T.F. Morris designed the back; the female head, which greatly resembles the designer's wife, was engraved by G.F.C. Smillie. The portraits of U.S. Grant and Gen. Philip Sheridan were engraved by Lorenzo Hatch. This is the third note in the educational series (see Nos. 45 & 185).

No.	Signatures	Notes Printed	Fine	EFine	Unc
358	Tillman-Morgan	15,650,000	$400.	$1250.	$3250.
359	Bruce-Roberts	12,850,000	425.	1300.	3450.
360	Lyons-Roberts	6,432,000	500.	1400.	3750.

Remarks: A total of 35,012,000 notes were printed. This note is considered by many to be one of the most beautiful notes prepared by the Bureau of Engraving and Printing. It is possible that Anthony Comstock, Secretary of the Society for Suppression of Vice, pressured the U.S. Treasury to withdraw these "dirty dollars." An essay, dated 1897, with additional clothing on the central figure was prepared but not issued.

Silver Certificates/Series 1899/Blue Seal

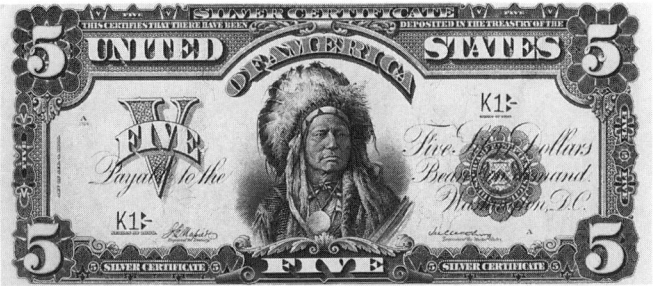

The model for this portrait was *Chief Running Antelope*, a Sioux. The headdress is a Pawnee war bonnet, which the model supposedly refused to wear. G.F.C. Smillie engraved this portrait.

Additional engravers were: W. Montgomery, E.M. Hall, E.E. Myers, R. Ponickau and G.U. Rose, Jr. who also engraved the back.

No.	Signatures	Notes Issued	Fine	EFine	Unc
361	Lyons-Roberts	154,276,000	$150.	$350.	$ 900.
362	Lyons-Treat	36,212,000	165.	375.	1000.
363	Vernon-Treat	94,282,000	150.	350.	900.
364	Vernon-McClung	46,020,000	165.	375.	1000.
364☆	3 reported	–	–	–	–
365	Napier-McClung	62,780,000	150.	350.	900.
365☆	4 reported	–	–	–	–
366	Napier-Thompson	2,234,000	200.	600.	2000.
367	Parker-Burke	40,572,000	165.	375.	1000.
367☆	6 reported	–	–	–	–
368	Teehee-Burke	47,804,000	165.	375.	1000.
368☆	8 reported	–	–	–	–
369	Elliott-Burke	18,520,000	175.	400.	1100.
369☆	8 reported	–	–	–	–
370	Elliott-White	32,212,000	165.	375.	1000.
370☆	13 reported	–	–	–	–
371	Speelman-White	30,952,000	165.	375.	1000.
371☆	34 reported	–	–	–	–

Remarks: A total of 556,054,000 notes were printed

Silver Certificates/Series 1923/Blue Seal

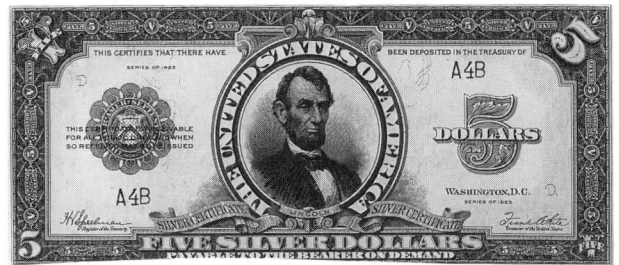

The "porthole" portrait of Lincoln was based on a photograph by Anthony Berger, a partner of Matthew Brady; it was engraved by Charles Burt.

The obverse of the *Great Seal of the United States*, as seen on the back, was engraved by Robert Ponickau.

No.	Signatures	Notes Printed	Fine	EFine	Unc
372	Speelman-White	6,316,000	$165.	$400.	$1150.
372☆	33 reported	–	195.	500.	1750.

Remarks: Other notes with nicknames include the "buffalo bill" (No. 483) and the "tombstone note" (No. 590).

Treasury or Coin Notes/Series 1890 & 1891

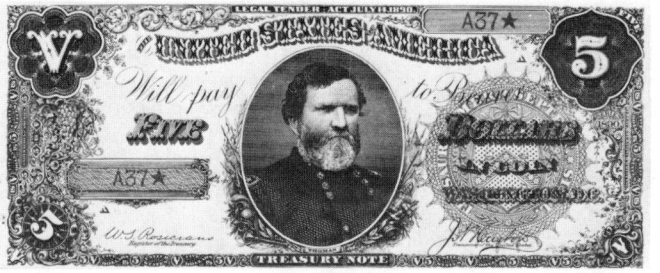

George W. Thomas was born in Southhampton, VA on July 11, 1816. He graduated from West Point where he served as an instructor from 1851 to 1854. He won numerous battles during the Civil War. The portrait of Thomas was engraved by Lorenzo Hatch.

No.	Signatures	Seal	Notes Printed	Fine	EFine	Unc
373	Rosecrans-Huston	brown	3,500,000	$210.	$525.	$1750.
374	Rosecrans-Nebeker	brown	300,000	300.	750.	3250.
375	Rosecrans-Nebeker	red	3,400,000	210.	525.	1750.

The face design is similar to the preceding note with the new back design

Series 1891/Red Seal

376	Rosecrans-Nebeker		2,700,000	150.	350.	1000.
377	Tillman-Morgan		11,344,000	135.	275.	750.
378	Bruce-Roberts		2,456,000	150.	350.	1000.
379	Lyons-Roberts		760,000	225.	700.	2000.

Remarks: The following serial numbers have been observed in uncirculated condition for No. 373: A2829002, −010, and −079. Many of the numbers between exist in the same condition. The following serial numbers have been observed in uncirculated condition for No. 375: A7192317, −330, −379, −399 and 400, indicating that many of the numbers between probably exist in the same condition. For the 1891 issue 16,948,000 notes were issued.

Federal Reserve Notes/Series of 1914/Red Seal

Charles Burt's engraving of the Lincoln portrait was based on a photograph by Anthony Berger, a partner of Matthew Brady.

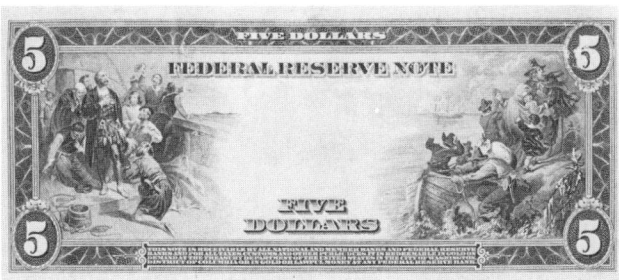

Columbus Discovery of Land and *Landing of the Pilgrims* were probably engraved by Joseph I. Pease.

No.	Bank	VFine	Unc	No.	Bank	VFine	Unc
380A	Boston	$50.	$300.	380G	Chicago	$50.	$300.
380B	New York	50.	300.	380H	St. Louis	50.	300.
380C	Philadelphia	50.	300.	380I	Minneapolis	50.	300.
380D	Cleveland	50.	300.	380J	Kansas City	50.	300.
380E	Richmond	50.	300.	380K	Dallas	50.	300.
380F	Atlanta	50.	300.	380L	San Francisco	65.	400.

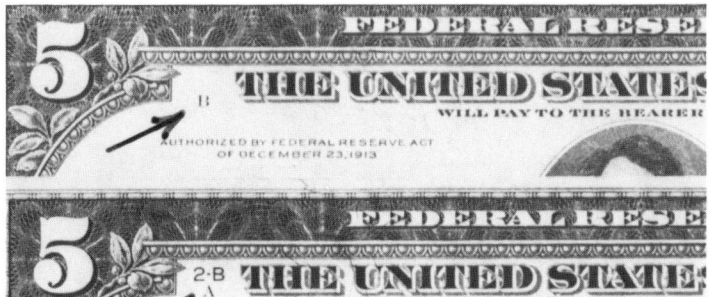

Remarks: The first day of issue was November 16, 1914. The signatures of Burke-McAdoo appear on these notes. Type I was printed for all 12 districts. Type II, with small district number and letter in upper left and lower right corners, was printed for all districts.

Federal Reserve Notes/Series 1914/Blue Seal

No.	Bank	Signatures	Notes Printed	Delivered	VFine	Unc
381A1	Boston	Burke-McAdoo			$25.	$ 80.
381A1☆	ᐟ 4 reported				–	–
381A2	Boston	Burke-Glass			25.	80.
381A2☆	1 reported		92,168,000	90,400,000	–	–
381A3	Boston	Burke-Houston			25.	80.
381A3☆	6 reported				–	–
381A4	Boston	White-Mellon (b,c)			25.	80.
381A4☆	11 reported		(872,000)		–	–
381B1	New York	Burke-McAdoo			25.	80.
381B1☆	4 reported				–	–
381B2	New York	Burke-Glass			25.	80.
381B2☆	3 reported		297,852,000		–	–
381B3	New York	Burke-Houston			25.	80.
381B3☆	13 reported				–	–
381B4	New York	White Mellon (b,c)			25.	80.
381B4☆	38 reported	(3 "b", 9 "c")	(2,400,000)		–	–
381C1	Philadelphia	Burke-McAdoo			25.	80.
381C1☆	2 reported				–	–
381C2	Philadelphia	Burke-Glass			25.	80.
381C2☆	1 reported		103,824,000		–	–
381C3	Philadelphia	Burke-Houston			25.	80.
381C3☆	8 reported				–	–
381C4	Philadelphia	White-Mellon (b,c)			25.	80.
381C4☆	17 reported	(1 "b", 4 "c")	(1,204,000)		–	–
381D1	Cleveland	Burke-McAdoo			25.	80.
381D1☆	1 reported				–	–
381D2	Cleveland	Burke-Glass			25.	80.
381D3	Cleveland	Burke-Houston	73,216,000		25.	80.
381D3☆	3 reported				–	–
381D4	Cleveland	White-Mellon (b,c)			25.	80.
381D4☆	15 reported	(1 "b", 4 "c")	(752,000)		–	–
381E1	Richmond	Burke-McAdoo			25.	80.
381E2	Richmond	Burke-Glass			25.	80.
381E3	Richmond	Burke-Houston			25.	80.
381E3☆	5 reported		49,444,000	45,932,000	–	–
381E4	Richmond	White-Mellon (b,c)			30.	100.
381E4☆	4 reported		(496,000)		–	–
381F1	Atlanta	Burke-McAdoo			25.	80.
381F2	Atlanta	Burke-Glass			40.	125.
381F3	Atlanta	Burke-Houston	55,000,000	54,476,000	25.	80.
381F3☆	5 reported				–	–
381F4	Atlanta	White-Mellon (b,c)			25.	80.
381F4☆	4 reported		(504,000)		–	–
381G1	Chicago	Burke-McAdoo			25.	80.
381G1☆	2 reported				–	–
381G2	Chicago	Burke-Glass			25.	80.
381G2☆	2 reported		164,876,000		–	–
381G3	Chicago	Burke-Houston			25.	80.
381G3☆	17 reported				–	–
381G4	Chicago	White-Mellon (b,c)			25.	80.
381G4☆	27 reported	(1 "b", 2 "c")	(1,524,000)		–	–

Federal Reserve Notes/Series 1914/Blue Seal *(continued)*

No.	Bank	Signatures	Notes Printed	Delivered	VFine	Unc
381H1	St. Louis	Burke-McAdoo			$25.	$80.
381H1 ☆	2 reported				–	–
381H2	St. Louis	Burke-Glass			25.	80.
381H2 ☆	4 reported	41,704,000			–	–
381H3	St. Louis	Burke-Houston			25.	80.
381H3 ☆	6 reported				–	–
381H4	St. Louis	White-Mellon (b)			25.	80.
381H4 ☆	3 reported		(476,000)		–	–
381I1	Minneapolis	Burke-McAdoo			25.	80.
381I1 ☆	1 reported				–	–
381I2	Minneapolis	Burke-Glass			25.	80.
381I3	Minneapolis	Burke-Houston	30,116,000	29,280,000	30.	100.
381I3 ☆	2 reported				–	–
381I4	Minneapolis	White-Mellon			25.	80.
381I4 ☆	5 reported		(244,000)		–	–
381J1	Kansas City	Burke-McAdoo			25.	80.
381J1 ☆	1 reported				25.	80.
381J2	Kansas City	Burke-Glass			25.	80.
381J2 ☆	2 reported		44,396,000	43,928,000	–	–
381J3	Kansas City	Burke-Houston			25.	80.
381J3 ☆	3 reported				–	–
381J4	Kansas City	White-Mellon (b)			25.	80.
381J4 ☆	9 reported		(372,000)		–	–
381K1	Dallas	Burke-McAdoo			40.	125.
381K2	Dallas	Burke-Glass			40.	125.
381K3	Dallas	Burke-Houston	29,416,000	28,526,000	25.	80.
381K3 ☆	1 reported				–	–
381K4	Dallas	White-Mellon (b,c)			25.	80.
381K4 ☆	6 reported		(272,000)		–	–
381L1	San Francisco	Burke-McAdoo			25.	80.
381L1 ☆	1 reported				–	–
381L2	San Francisco	Burke-Glass			25.	80.
381L3	San Francisco	Burke-Houston	92,168,000	91,848,000	25.	80.
381L3 ☆	1 reported				–	–
381L4	San Francisco	White-Mellon (b,c)			25.	80.
381L4 ☆	9 reported	(1 "b")	(892,000)		–	–

Type "a" Type "b" Type "c"

Remarks: The total for each district is for regular issues only. The figure in parenthesis, the last replacement serial number, is the total number of replacement notes of this denomination printed for that bank; the number printed by signatures is not available. White-Mellon plate variations, in parenthesis, exist for some districts, identified as type "b" (small district number and letter in lower left) and type "c" (space of 23 mm horizontal from left seal to the engraved border). Star replacement notes reported in the main listing above are type "a" if not identified by type.

Federal Reserve Bank Notes/Blue Seal

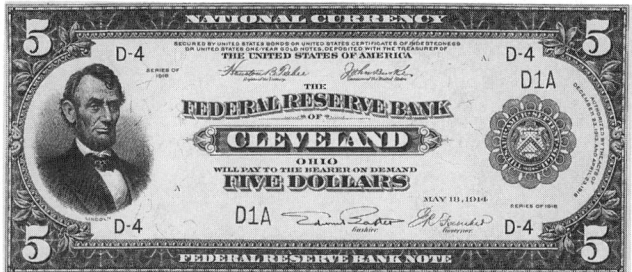

See No. 380 for portrait information. The "G-7" in the four corners indicates the seventh Federal Reserve District.

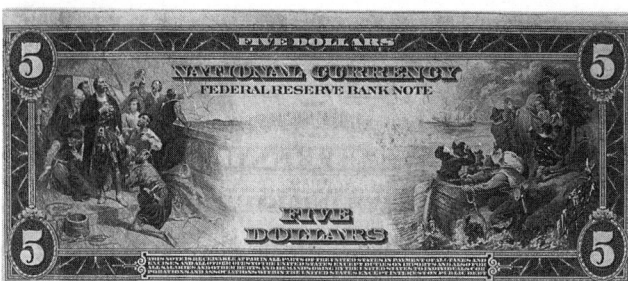

The back design is similar to No. 380.

No.	Bank	Date	Bank Signatures	Notes Issued	VFine	Unc
382A1	Boston	1918	Bullen-Morss	440,000	$800.	$2750.
382A1 ☆	1 reported			−	−	−
382B1	New York	1918	Hendricks-Strong	6,400,000	75.	400.
382C1	Philadelphia	1918	Hardt-Passmore	1,600,000	75.	400.
382C2	Philadelphia	1918	Dyer-Passmore	included in above	75.	400.
382D1	Cleveland	1918	Baxter-Fancher	−	75.	400.
382D1 ☆	2 reported			−	−	−
382D2	Cleveland	1918	Davis Fancher	−	85.	450.
382D3	Cleveland	1918	Davis-Fancher	−	85.	450.
382F1	Atlanta	1915	Bell-Wellborn	−	200.	625.
382F2	Atlanta	1915	Pike-McCord	−	150.	575.
382F3	Atlanta	1918	Pike-McCord	−	125.	500.
382F4	Atlanta	1918	Bell-Wellborn	−	125.	500.
382F5	Atlanta	1918	Bell-Wellborn	−	125.	500.
382G1	Chicago	1915	McLalllen-McDougal	−	85.	450.
382G2	Chicago	1918	McCloud-McDougal	−	75.	400.
382G2 ☆	3 reported			−	−	−
382G3	Chicago	1918	Cramer-McDougal	−	150.	600.
382H1	St. Louis	1918	Attebery-Wells	−	85.	450.
382H2	St. Louis	1918	Attebery-Biggs	51,524,000	75.	400.
382H3	St. Louis	1918	Attebery-Biggs	−	75.	400.
382I1	Minneapolis	1918	Cook-Wold	−	85.	450.

Federal Reserve Bank Notes/Blue Seal *(continued)*

No.	Bank	Date	Bank Signatures	Notes Issued	VFine	Unc
382J1	Kansas City	1915	Anderson-Miller		$150.	$ 600.
382J2	Kansas City	1915	Cross-Miller		125.	550.
382J3	Kansas City	1915	Helm-Miller	4,802,000	150.	550.
382J4	Kansas City	1918	Anderson-Miller	–	125.	550.
382J4 ☆	2 reported			–	–	–
382J5	Kansas City	1918	Helm-Miller@	–	150.	550.
382K1	Dallas	1915	Hoopes-VanZandt	128,000	125.	500.
382K2	Dallas	1915	Talley-VanZandt	included in above	175.	600.
382K3	Dallas	1918	Talley-VanZandt	500,000	225.	650.
382L1	San Francisco	1915	Clerk-Lynch	336,000	125.	550.
382L2	San Francisco	1918	Clerk-Lynch	500,000	125.	550.
382L3	San Francisco	1914	Clerk-Lynch	–	900.	3000.
382L3 ☆	7 reported			–	–	–
382L4	San Francisco	1918	Ambrose-Calkins@	incl. in No. 382L2	–	–

Remarks: For No. 382A, 375 pieces are outstanding. No. 382L3 has the incorrect date, May 18; it should be May 20. All have Teehee-Burke signatures except those with (@), which have Elliott-Burke signatures. Observed: 382J1 hand-signed; 382J2 Cross, hand-signed, as Acting Cashier; 382J5 Helm as Acting Cashier.

United States Notes/Series 1928–1928F/Red Seal

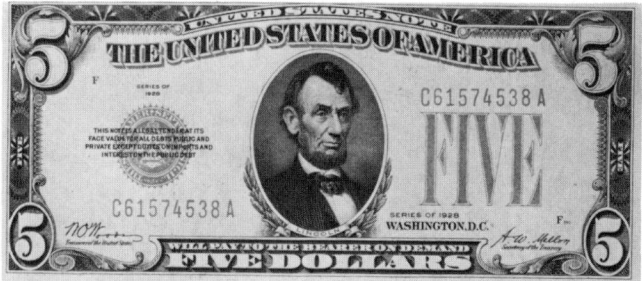

Charles Burt's 1869 engraving of Abraham Lincoln was based on a photograph by Anthony Berger, a partner of Matthew Brady.

The *Lincoln Memorial* on the back was engraved by J.C. Benzing. On May 30, 1922, 57 years after the idea was conceived, the memorial was dedicated; Henry Bacon was the architect. The 36 columns represent the 36 states of the Union in 1865. The 19–foot statue of Lincoln was carved by Daniel C. French.

No.	Series	Signatures	Notes Printed	VFine	EFine	Unc
383	1928	Woods-Mellon	267,209,616	$ –	$ 8.	$ 30.
383☆			–	15.	25.	200.
383A	1928A	Woods-Mills	58,194,600	8.	15.	50.
383A☆			–	150.	200.	1000.
383B	1928B	Julian-Morgenthau	147,827,340	–	10.	15.
383B☆			–	20.	35.	175.
383C	1928C	Julian-Morgenthau	214,735,765	–	10.	15.
383C☆			–	20.	35.	175.
383D	1928D	Julian-Vinson	9,297,120	25.	35.	150.
383D☆			–	40.	125.	600.
383E	1928E	Julian-Snyder	109,952,760	–	10.	15.
383E☆			–	10.	25.	75.
383F	1928F	Clark-Snyder	104,194,704	–	10.	15.
383F☆			–	10.	25.	75.

United States Notes/Series 1953–1963/Red Seal

A grey "5" replaces the seal, which is now on the left. "FIVE" is also reduced in size. The back design is the same as the preceding note.

No.	Series	Signatures	Notes Printed	VFine	EFine	Unc
384	1953	Priest-Humphrey	120,880,000	–	$–	$15.
384☆			5,760.000	–	25.	75.
384A	1953A	Priest-Anderson	90,760,000	–	–	10.
384A☆			5,400,000	–	–	25.
384B	1953B	Smith-Dillon	44,640,000	–	–	10.
384B☆			2,160,000	–	10.	20.
384C	1953C	Granahan-Dillon	8,640,000	–	–	10.
384C☆			320,000	–	10.	35.

"IN GOD WE TRUST" was added to the 1963 series.

385	1963	Granahan-Dillon	63,360,000	–	–	10.
385☆			3,840,000	–	–	15.

Silver Certificates/Blue Seal/ *None Extant* /Series 1934–1953C

No.	Series	Signatures	Notes Printed	VFine	EFine	Unc
386	1934	Julian-Morgenthau	393,088,368	$ –	$ 8.	$ 15.
386☆			3,960,000	10.	20.	50.
386A	1934A	Julian-Morgenthau	656,265,948	–	–	12.
386A☆				10.	20.	35.

Nos. 387 and 387A have yellow seals; they were issued for the North African invasion during World War II.

No.	Series	Signatures	Notes Printed	VFine	EFine	Unc
387	1934	Julian-Morgenthau			none reported	
387A	1934A	Julian Morgenthau	16,710,000	15.	25.	80.
387A☆			included in above	50.	75.	150.
387B	1934B	Julian-Vinson	59,128,500	8.	10.	30.
387B☆			–	20.	50.	135.
387C	1934C	Julian-Snyder	403,328,964	–	–	15.
387C☆			–	–	15.	25.
387D	1934D	Clark-Snyder	486,146,148	–	–	15.
387D☆			–	–	15.	25.

The "5" on the left is grey; the blue seal is smaller.

No.	Series	Signatures	Notes Printed	VFine	EFine	Unc
388	1953	Priest-Humphrey	339,600,000	–	–	10.
388☆			15,120,000	–	10.	25.
388A	1953A	Priest-Anderson	232,400,000	–	–	10.
388A☆			12,960,000	–	10.	25.
388B	1953B	Smith-Dillon	73,000,000	–	–	10.
388B☆			3,240,000	–	175.	600.
388C	1953C	Granahan-Dillon	90,640,000		never released	

Remarks: For No. 388B only 14,196,000 notes were released. The figure for No. 388C includes an uncut sheet of star notes at the BEP.

Federal Reserve Bank Notes/Series 1929/Brown Seal

Back design is similar to
No. 383.

Signatures of Jones-Woods

No.	Bank	Notes Printed	VFine	EFine	Unc
389A	Boston	3,180,000	$ 10.	$ 15.	$ 60.
389A☆		–	–	–	–
389B	New York	2,100,200	10.	15.	50.
389B☆		–	–	–	–
389C	Philadelphia	3,096,000	10.	15.	60.
389C☆		–	–	–	–
389D	Cleveland	4,236,000	8.	12.	45.
389D☆		–	–	–	–
389E	Richmond	not issued	–	–	–
389F	Atlanta	1,848,000	12.	20.	85.
389F☆		–	–	–	–
389G	Chicago	5,988,000	8.	12.	35.
389G☆		–	–	–	–
389H	St. Louis	276,000	75.	125.	450.
389H☆		–	–	–	–
389I	Minneapolis	684,000	20.	35.	125.
389J	Kansas City	2,460,000	10.	15.	60.
389J☆		–	–	–	–
389K	Dallas	996,000	15.	25.	60.
389L	San Francisco	360,000	350.	500.	1750.
389L☆		–	–	–	–

National Bank Notes/Series 1929/Brown Seal

Type I

Type II has the charter number printed a second time near the serial number.

		Type I			Type II		
No.	Rarity	VFine	EFine	Unc	VFine	EFine	Unc
	1	$ 15.	$ 20.	$ 40.	$ 20.	$ 30.	$ 50.
	2	18.	25.	50.	25.	35.	60.
	3	22.	35.	60.	30.	45.	85.
	4	30.	45.	75.	40.	60.	100.
390	5	40.	55.	100.	50.	75.	125.
	6	50.	80.	150.	60.	100.	165.
	7	75.	115.	200.	100.	165.	250.
	8	125.	200.	375.	225.	400.	500.
	9	500.	750.	1000.	650.	1000.	3500.

Remarks: A total of 170,229,387 notes were issued for both types; both bear the signatures of Jones-Woods. The Chase National Bank, now The Chase Manhattan Bank, issued 6,346,530 type I notes, the largest amount issued by any national bank.

Federal Reserve Notes/Series 1928 & 1928A/Green Seal

The number in the seal indicates the Federal Reserve district. The back design is similar to No. 383.

Series 1928, Tate-Mellon

No.	Bank	Notes Printed	Unc
391A	Boston	8,025,300	$30.
391A☆		not issued	–
391B	New York	14,701,884	30.
391B☆		not issued	–
391C	Philadelphia	123,680,000	20.
391C☆		not issued	–
391D	Cleveland	9,048,500	35.
391D☆			–
391E	Richmond	6,027,000	35.
391E☆			–
391F	Atlanta	10,964,000	30.
391F☆			–
391G	Chicago	12,326,052	30.
391G☆			–
391H	St. Louis	4,765,000	40.
391H☆			–
391I	Minneapolis	4,284,000	40.
391I☆		not issued	
391J	Kansas City	4,480,000	40.
391J☆			–
391K	Dallas	8,137,000	35.
391K☆			–
391L	San Francisco	9,792,000	35.
391L☆		not issued	–

Series 1928A, Woods-Mellon

No.	Bank	Notes Printed	Unc
392A	Boston	9,404,724	$30.
392A☆			–
392B	New York	42,878,196	30.
392B☆			–
392C	Philadelphia	10,806,012	30.
392C☆			–
392D	Cleveland	6,822,424	30.
392D☆		not issued	–
392E	Richmond	2,409,900	30.
392E☆		not issued	–
392F	Atlanta	13,386,420	30.
392F☆		not issued	–
392G	Chicago	37,882,176	30.
392G☆			–
392H	St. Louis	2,731,824	30.
392H☆		not issued	–
392I	Minneapolis	652,000	40.
392I☆		not issued	–
392J	Kansas City	3,572,400	30.
392J☆		not issued	–
392K	Dallas	2,564,400	30.
392K☆		not issued	–
392L	San Francisco	6,565,500	30.
392L☆			–

Federal Reserve Notes/Series 1928B, 1928C & 1928D/Green Seal

Series 1928B, Woods-Mellon

No.	Bank	Notes Printed	Unc
393A	Boston	28,430,724	$35.
393A☆			–
393B	New York	51,157,536	30.
393B☆		not issued	–
393C	Philadelphia	25,698,396	35.
393C☆			–
393D	Cleveland	28,874,272	35.
393D☆			–
393E	Richmond	15,151,932	40.
393E☆		not issued	–
393F	Atlanta	13,386,420	40.
393F☆			–
393G	Chicago	17,157,036	35.
393G☆		not issued	–
393H	St. Louis	20,251,716	30.
393H☆		not issued	–
393I	Minneapolis	6,954,060	40.
393I☆			–
393J	Kansas City	10,677,636	40.
393J☆		not issued	–
393K	Dallas	4,334,400	40.
393K☆		not issued	–
393L	San Francisco	28,840,080	30.
393L☆		not issued	–

Series 1928C, Woods-Mills

No.	Bank	Notes Printed	Unc
394D	Cleveland	3,293,640	$300.
394F	Atlanta	2,056,200	300.
394L	San Francisco	266,304	650.

Series 1928D, Woods-Woodin

No.	Bank	Notes Printed	Unc
395F	Atlanta	1,281,600	$650.

For Series 1928C and 1928D, $5 notes were printed only for the districts listed.

Federal Reserve Notes/Series 1934/Green Seal

Series 1934, Julian-Morgenthau				Series 1934, Julian Morgenthau			
No.	Bank	Notes Printed	Unc	No.	Bank	Notes Printed	Unc
396A	Boston	30,510,000	$30.	396G	Chicago	131,299,156	$25.
396A☆			–	396G☆			–
396B	New York	47,888,760	30.	396H	St. Louis	48,737,280	30.
396B☆			–	396H☆			–
396C	Philadelphia	47,327,760	30.	396I	Minneapolis	16,795,392	35.
396C☆			–	396I☆			–
396D	Cleveland	62,273,508	30.	396J	Kansas City	31,854,432	30.
396D☆			–	396J☆			–
396E	Richmond	62,128,452	30.	396K	Dallas	33,332,208	30.
396E☆			–	396K☆			–
396F	Atlanta	50,548,608	30.	396L	San Francisco	39,324,168	30.
396F☆			–	396L☆			–
396LL	Hawaii	3,000,000	100.	396LL☆			400.

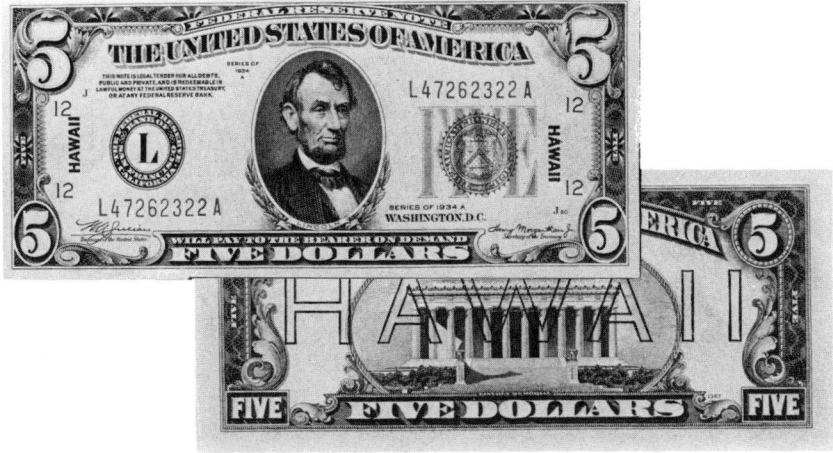

Remarks: No. 396LL was overprinted with "HAWAII" for use in the Pacific theater during World War II. Notes of $1 (No. 79), $5 (No. 397LL) $10 (No. 633LL) and $20 (No. 858LL) also bear this overprint.

Federal Reserve Notes/Series 1934A, 1934B, 1934C & 1934D/Green Seal

Series 1934A, Julian-Morgenthau				Series 1934B, Julian-Vinson			
No.	Bank	Notes Printed	Unc	No.	Bank	Notes Printed	Unc
397A	Boston	23,231,566	$ 25.	398A	Boston	3,457,000	$ 25.
397A☆		–	–	398A☆		not issued	–
397B	New York	143,199,336	20.	398B	New York	14,099,580	20.
397B☆		–	–	398B☆			–
397C	Philadelphia	30,691,632	25.	398C	Philadelphia	8,306,820	20.
397C☆		–	–	398C☆			–
397D	Cleveland	1,610,676	30.	398D	Cleveland	11,348,184	20.
397D☆		–	–	398D☆			–
397E	Richmond	6,555,168	25.	398E	Richmond	5,902,848	25.
397E☆		–	–	398E☆		not issued	–
397F	Atlanta	22,811,168	25.	398F	Atlanta	4,314,048	25.
397F☆		–	–	398F☆		not issued	–
397G	Chicago	88,376,376	25.	398G	Chicago	9,070,932	20.
397G☆		–	–	398G☆		not issued	–
397H	St. Louis	7,843,452	25.	398H	St. Louis	4,307,712	25.
397H☆		–	–	398H☆			–
397I	Minneapolis	not issued	–	398I	Minneapolis	2,482,000	25.
397I☆		not issued	–	398I☆			–
397J	Kansas City	not issued	–	398J	Kansas City	73,800	350.
397J☆		not issued	–	398J☆		not issued	–
397K	Dallas	not issued	–	398K	Dallas	not issued	–
397K☆		not issued	–	398K☆		not issued	–
397L	San Francisco	72,118,452	25.	398L	San Francisco	9,910,296	20.
397L☆		–	–	398L☆			–
397LL	(Hawaii ovpt)	6,416,000	100.				
397LL☆			250.				

Series 1934C, Julian-Snyder				Series 1934D, Clark-Snyder			
No.	Bank	Notes Printed	Unc	No.	Bank	Notes Printed	Unc
399A	Boston	14,463,600	$20.	400A	Boston	12,660,552	$20.
399A☆		–	–	400A☆		–	–
399B	New York	74,383,248	20.	400B	New York	50,976,676	15.
399B☆		–	–	400B☆		–	–
399C	Philadelphia	22,879,212	20.	400C	Philadelphia	12,106,740	20.
399C☆		–	–	400C☆		–	–
399D	Cleveland	19,898,256	20.	400D	Cleveland	8,969,052	20.
399D☆		–	–	400D☆		–	–
399E	Richmond	23,800,524	20.	400E	Richmond	13,333,032	20.
399E☆		–	–	400E☆		–	–
399F	Atlanta	23,572,968	20.	400F	Atlanta	9,599,352	20.
399F☆		not issued	–	400F☆		–	–
399G	Chicago	60,598,812	20.	400G	Chicago	36,601,680	20.
399G☆		–	–	400G☆		–	–
399H	St. Louis	20,393,340	20.	400H	St. Louis	8,093,412	20.
399H☆		–	–	400H☆		–	–
399I	Minneapolis	5,089,200	25.	400I	Minneapolis	3,594,900	25.
399I☆		not issued	–	400I☆		–	–
399J	Kansas City	8,313,504	20.	400J	Kansas City	6,538,740	20.
399J☆		not issued	–	400J☆		–	–
399K	Dallas	5,107,800	20.	400K	Dallas	4,139,016	25.
399K☆		not issued	–	400K☆		–	–
399L	San Francisco	9,451,944	20.	400L	San Francisco	11,704,200	20.
399L☆		–	–	400L☆		–	–

Federal Reserve Notes/Series 1950, 1950A, 1950B & 1950C/Green Seal

Series 1950, Clark-Snyder No.	Bank	Notes Printed	Unc	Series 1950A, Priest-Humphrey No.	Bank	Notes Printed	Unc
401A	Boston	30,672,000	$ 20.	402A	Boston	53,568,000	$15.
401A☆		408,000	75.	402A☆		2,808,000	20.
401B	New York	106,768,000	15.	402B	New York	186,472,000	15.
401B☆		1,464,000	75.	402B☆		9,216,000	20.
401C	Philadelphia	44,784,000	20.	402C	Philadelphia	69,616,000	15.
401C☆		600,000	100.	402C☆		4,320,000	20.
401D	Cleveland	54,000,000	20.	402D	Cleveland	45,360,000	15.
401D☆		744,000	45.	402D☆		2,376,000	20.
401E	Richmond	47,088,000	20.	402E	Richmond	76,672,000	15.
401E☆		684,000	45.	402E☆		5,400,000	20.
401F	Atlanta	52,416,000	20.	402F	Atlanta	86,464,000	15.
401F☆		696,000	45.	402F☆		5,040,000	20.
401G	Chicago	85,104,000	20.	402G	Chicago	129,296,000	15.
401G☆		1,176,000	40.	402G☆		6,264,000	20.
401H	St. Louis	36,864,000	20.	402H	St. Louis	54,936,000	15.
401H☆		552,000	115.	402H☆		3,384,000	20.
401I	Minneapolis	11,796,000	20.	402I	Minneapolis	11,232,000	15.
401I☆		144,000	115.	402I☆		864,000	25.
401J	Kansas City	25,428,000	20.	402J	Kansas City	29,952,000	15.
401J☆		360,000	70.	402J☆		1,088,000	20.
401K	Dallas	22,848,000	20.	402K	Dallas	24,984,000	15.
401K☆		372,000	50.	402K☆		1,368,000	20.
401L	San Francisco	55,008,000	20.	402L	San Francisco	90,712,000	15.
401L☆		744,000	50.	402L☆		6,336,000	20.

Series 1950B, Priest-Anderson No.	Bank	Notes Printed	Unc	Series 1950C, Smith-Dillon No.	Bank	Notes Printed	Unc
403A	Boston	30,880,000	$15.	404A	Boston	20,880,000	$15.
403A☆		2,520,000	20.	404A☆		720,000	20.
403B	New York	85,960,000	15.	404B	New York	47,440,000	15.
403B☆		4,680,000	20.	404B☆		2,880,000	20.
403C	Philadelphia	43,560,000	15.	404C	Philadelphia	29,520,000	15.
403C☆		2,880,000	20.	404C☆		1,800,000	20.
403D	Cleveland	38,800,000	15.	404D	Cleveland	33,840,000	15.
403D☆		2,880,000	20.	404D☆		1,800,000	20.
403E	Richmond	52,920,000	15.	404E	Richmond	33,460,000	15.
403E☆		2,008,000	20.	404E☆		1,160,000	20.
403F	Atlanta	80,560,000	15.	404F	Atlanta	54,360,000	15.
403F☆		3,960,000	20.	404F☆		3,240,000	20.
403G	Chicago	104,320,000	15.	404G	Chicago	56,880,000	15.
403G☆		6,120,000	20.	404G☆		3,240,000	20.
403H	St. Louis	25,840,000	15.	404H	St. Louis	22,680,000	15.
403H☆		1,440,000	20.	404H☆		720,000	20.
403I	Minneapolis	20,880,000	15.	404I	Minneapolis	12,960,000	15.
403I☆		792,000	25.	404I☆		720,000	20.
403J	Kansas City	32,400,000	15.	404J	Kansas City	24,760,000	15.
403J☆		2,520,000	20.	404J☆		1,800,000	20.
403K	Dallas	52,120,000	15.	404K	Dallas	3,960,000	15.
403K☆		3,240,000	20.	404K☆		360,000	25.
403L	San Francisco	56,080,000	15.	404L	San Francisco	25,920,000	15.
403L☆		3,600,000	20.	404L☆		1,440,000	20.

Federal Reserve Notes/Series 1950D, 1950E, 1963 & 1963A/Green Seal

Series 1950D, Granahan-Dillon

No.	Bank	Notes Printed	Unc
405A	Boston	25,200,000	$15.
405A☆		1,080,000	20.
405B	New York	102,160,000	15.
405B☆		5,040,000	20.
405C	Philadelphia	21,520,000	15.
405C☆		1,080,000	20.
405D	Cleveland	23,400,000	15.
405D☆		1,080,000	20.
405E	Richmond	42,400,000	15.
405E☆		1,080,000	20.
405F	Atlanta	35,200,000	15.
405F☆		1,800,000	20.
405G	Chicago	67,240,000	15.
405G☆		3,600,000	20.
405H	St. Louis	20,160,000	15.
405H☆		720,000	20.
405I	Minneapolis	7,920,000	15.
405I☆		360,000	25.
405J	Kansas City	11,160,000	15.
405J☆		720,000	20.
405K	Dallas	7,200,000	15.
405K☆		360,000	25.
405L	San Francisco	53,280,000	15.
405L☆		3,600,000	20.

Series 1950E, Granahan-Fowler

No.	Bank	Notes Printed	Unc
406B	New York	82,000,000	$15.
406B☆		6,678,000	20.
406G	Chicago	14,760,000	15.
406G☆		1,080,000	25.
406L	San Francisco	24,400,000	15.
406L☆		1,800,000	25.

"In God We Trust" was added to the back of Series 1963 and all subsequent $1 notes.

Series 1963, Granahan-Dillon

No.	Bank	Notes Printed	Unc
407A	Boston	4,480,000	$15.
407A☆		640,000	20.
407B	New York	12,160,000	15.
407B☆		1,280,000	18.
407C	Philadelphia	8,320,000	15.
407C☆		1,920,000	18.
407D	Cleveland	10,240,000	15.
407D☆		1,920,000	18.
407E	Richmond	not printed	–
407E☆		not printed	–
407F	Atlanta	17,920,000	15.
407F☆		2,560,000	18.
407G	Chicago	22,400,000	15.
407G☆		3,200,000	18.
407H	St. Louis	14,080,000	15.
407H☆		1,920,000	18.
407I	Minneapolis	not printed	–
407I☆		not printed	–
407J	Kansas City	1,920,000	18.
407J☆		640,000	20.
407K	Dallas	5,760,000	15.
407K☆		360,000	25.
407L	San Francisco	18,560,000	15.
407L☆		1,920,000	18.

Series 1963A, Granahan-Fowler

No.	Bank	Notes Printed	Unc
408A	Boston	77,440,000	$10.
408A☆		5,760,000	15.
408B	New York	98,080,000	10.
408B☆		7,680,000	15.
408C	Philadelphia	106,400,000	10.
408C☆		10,240,000	15.
408D	Cleveland	83,840,000	10.
408D☆		7,040,000	15.
408E	Richmond	118,560,000	10.
408E☆		10,880,000	15.
408F	Atlanta	117,920,000	10.
408F☆		9,600,000	15.
408G	Chicago	213,440,000	10.
408G☆		16,640,000	15.
408H	St. Louis	56,960,000	10.
408H☆		5,120,000	15.
408I	Minneapolis	32,640,000	10.
408I☆		3,200,000	15.
408J	Kansas City	55,040,000	10.
408J☆		5,760,000	15.
408K	Dallas	64,000,000	10.
408K☆		360,000	20.
408L	San Francisco	128,900,000	10.
408L☆		12,153,000	15.

Federal Reserve Notes/Series 1969, 1969A, 1969B & 1969C/Green Seal

Series 1969, Elston-Kennedy				Series 1969A, Kabis-Connally			
No.	Bank	Notes Printed	Unc	No.	Bank	Notes Printed	Unc
409A	Boston	51,200,000	$10.	410A	Boston	23,040,000	$10.
409A☆		1,920,000	15.	410A☆		1,280,000	12.
409B	New York	198,560,000	10.	410B	New York	62,240,000	10.
409B☆		8,960,000	12.	410B☆		2,394,000	12.
409C	Philadelphia	69,120,000	10.	410C	Philadelphia	41,160,000	10.
409C☆		2,560,000	15.	410C☆		1,920,000	12.
409D	Cleveland	56,320,000	10.	410D	Cleveland	21,120,000	10.
409D☆		2,560,000	15.	410D☆		640,000	15.
409E	Richmond	84 480,000	10.	410E	Richmond	37,920,000	10.
409E☆		3,200,000	12.	410E☆		1,120,000	12.
409F	Atlanta	84,480,000	10.	410F	Atlanta	25,120,000	10.
409F☆		3,840,000	15.	410F☆		480,000	15.
409G	Chicago	125,600,000	10.	410G	Chicago	60,800,000	10.
409G☆		5,120,000	12.	410G☆		1,920,000	12.
409H	St. Louis	27,520,000	10.	410H	St. Louis	15,360,000	10.
409H☆		1,280,000	15.	410H☆		640,000	15.
409I	Minneapolis	16,640,000	10.	410I	Minneapolis	8,960,000	10.
409I☆		640,000	20.	410I☆		640,000	12.
409J	Kansas City	48,640,000	10.	410J	Kansas City	17,920,000	10.
409J☆		3,292,000	12.	410J☆		640,000	15.
409K	Dallas	39,680,000	10.	410K	Dallas	21,120,000	10.
409K☆		1,920,000	15.	410K☆		640,000	15.
409L	San Francisco	103,840,000	10.	410L	San Francisco	44,800,000	10.
409L☆		4,480,000	12.	410L☆		1,920,000	15.

Series 1969B, Banuelos-Connally				Series 1969C, Banuelos-Shultz			
No.	Bank	Notes Printed	Unc	No.	Bank	Notes Printed	Unc
411A	Boston	5,040,000	$10.	412A	Boston	50,720,000	$10.
411A☆		not printed	–	412A☆		1,920,000	12.
411B	New York	34,560,000	10.	412B	New York	120,000,000	10.
411B☆		634,000	12.	412B☆		2,400,000	12.
411C	Philadelphia	5,120,000	10.	412C	Philadelphia	53,760,000	10.
411C☆		not printed	–	412C☆		1,280,000	12.
411D	Cleveland	12,160,000	10.	412D	Cleveland	43,680,000	10.
411D☆		not printed	–	412D☆		1,120,000	12.
411E	Richmond	15 360,000	10.	412E	Richmond	73,760,000	10.
411E☆		640,000	12.	412E☆		640,000	12.
411F	Atlanta	18,560,000	10.	412F	Atlanta	81,440,000	10.
411F☆		640,000	12.	412F☆		3,200,000	12.
411G	Chicago	27,040,000	10.	412G	Chicago	54,400,000	10.
411G☆		480,000	15.	412G☆		not printed	–
411H	St. Louis	5,120,000	10.	412H	St. Louis	37,760,000	10.
411H☆		not printed	–	412H☆		1,820,000	12.
411I	Minneapolis	8,320,000	10.	412I	Minneapolis	14,080,000	10.
411I☆		not printed	–	412I☆		not printed	–
411J	Kansas City	8,320,000	10.	412J	Kansas City	41,120,000	10.
411J☆		640,000	12.	412J☆		1,920,000	12.
411K	Dallas	12,160,000	10.	412K	Dallas	41,120,000	10.
411K☆		not printed	–	412K☆		1,920,000	12.
411L	San Francisco	23,160,000	10.	412L	San Francisco	80,800,000	10.
411L☆		640,000	12.	412L☆		3,680,000	12.

Federal Reserve Notes/Series 1974, 1977, 1977A & 1981/Green Seal

Series 1974, Neff-Simon				Series 1977, Morton-Blumenthal			
No.	Bank	Notes Printed	Unc	No.	Bank	Notes Printed	Unc
413A	Boston	58,240,000	$10.	414A	Boston	60,800,000	$ 8.
413A☆		1,920,000	12.	414A☆		1,664,000	10.
4013	New York	153,120,000	10.	414B	New York	163,040,000	8.
413B☆		3,200,000	12.	414B☆		3,072,000	10.
413C	Philadelphia	53,920,000	10.	414C	Philadelphia	78,720,000	8.
413C☆		3,200,000	12.	414C☆		1,280,000	10.
413D	Cleveland	78,240,000	10.	414D	Cleveland	72,960,000	8.
413D☆		1,920,000	12.	414D☆		1,152,000	10.
413E	Richmond	135,200,000	10.	414E	Richmond	110,720,000	8.
413E☆		1,920,000	12.	414E☆		1,816,000	10.
413F	Atlanta	127,520,000	10.	414F	Atlanta	127,360,000	8.
413F☆		3,200,000	12.	414F☆		1,920,000	10.
413G	Chicago	95,520,000	10.	414G	Chicago	177,920,000	8.
413G☆		3,200,000	12.	414G☆		2,816,000	10.
413H	St. Louis	64,800,000	10.	414H	St. Louis	46,080,000	8.
413H☆		1,920,000	12.	414H☆		128,000	25.
413I	Minneapolis	41,600,000	10.	414I	Minneapolis	21,760,000	8.
413I☆		1,560,000	12.	414I☆		not printed	–
413J	Kansas City	42,240,000	10.	414J	Kansas City	78,080,000	8.
413J☆		3,200,000	12.	414J☆		1,408,000	10.
413K	Dallas	23,680,000	10.	414K	Dallas	60,800,000	8.
413K☆		1,920,000	12.	414K☆		1,040,000	10.
413L	San Francisco	139,680,000	10.	414L	San Francisco	135,040,000	8.
413L☆		6,400,000	12.	414L☆		2,432,000	10.

Series 1977A, Morton-Miller				Series 1981, Buchanan-Regan			
No.	Bank	Notes Printed	Unc	No.	Bank	Notes Printed	Unc
415A	Boston	48,000,000	$ 8.	416A	Boston	73,600,000	$ 8.
415A☆		512,000	15.	416A☆		16,000	50.
415B	New York	113,920,000	8.	416B	New York	250,800,000	8.
415B☆		2,304,000	10.	416B☆		3,968,000	10.
415C	Philadelphia	55,680,000	8.	416C	Philadelphia	74,240,000	8.
415C☆		384,000	15.	416C☆		640,000	15.
415D	Cleveland	58,880,000	8.	416D	Cleveland	130,560,000	8.
415D☆		1,280,000	10.	416D☆		384,000	20.
415E	Richmond	77,440,000	8.	416E	Richmond	176,000,000	8.
415E☆		768,000	15.	416E☆		1,664,000	10.
415F	Atlanta	76,160,000	8.	416F	Atlanta	155,520,000	8.
415F☆		1,152,000	10.	416F☆		768,000	15.
415G	Chicago	80,640,000	8.	416G	Chicago	186,240,000	8.
415G☆		1,408,000	10.	416G☆		1,280,000	10.
415H	St. Louis	42,240,000	8.	416H	St. Louis	58,240,000	8.
415H☆		640,000	15.	416H☆		256,000	20.
415I	Minneapolis	10,240,000	8.	416I	Minneapolis	31,360,000	8.
415I☆		256,000	25.	416I☆		128,000	25.
415J	Kansas City	52,480,000	8.	416J	Kansas City	111,360,000	8.
415J☆		1,024,000	10.	416J☆		272,000	20.
415K	Dallas	76,160,000	8.	416K	Dallas	96,000,000	8.
415K☆		1,408,000	10.	416K☆		640,000	15.
415L	San Francisco	106,880,000	8.	416L	San Francisco	240,640,000	8.
415L☆		1,152,000	10.	416L☆		1,792,000	10.

Federal Reserve Notes/Series 1981A, 1985, 1988 & 1988A/Green Seal

Series 1981A, Ortega-Regan				Series 1985, Ortega-Brady			
No.	Bank	Notes Printed	Unc	No.	Bank	Notes Printed	Unc
417A	Boston	54,400,000	$ 8.	418A	Boston	192,000,000	$ –
417A☆		not printed	–	418A☆		not printed	–
417B	New York	112,000,000	8.	418B	New York	448,000,000	–
417B☆		1,920,000	10.	418B☆		128,000	10.
417C	Philadelphia	25,600,000	8.	418C	Philadelphia	169,600,000	–
417C☆		not printed	–	418C☆		4,608,000	–
417D	Cleveland	51,200,000	8.	418D	Cleveland	214,400,000	–
417D☆		not printed	–	418D☆		not printed	–
417E	Richmond	96,000,000	8.	418E	Richmond	332,800,000	–
417E☆		not printed	–	418E☆		256,000	10.
417F	Atlanta	102,400,000	8.	418F	Atlanta	352,000,000	–
417F☆		not printed	–	418F☆		3,840,000	–
417G	Chicago	115,200,000	8.	418G	Chicago	345,600,000	–
417G☆		not printed	–	418G☆		3,584,000	–
417H	St. Louis	32,000,000	8.	418H	St. Louis	128,000,000	–
417H☆		not printed	–	418H☆		not printed	–
417I	Minneapolis	19,200,000	8.	418I	Minneapolis	73,600,000	–
417I☆		not printed	–	418I☆		not printed	–
417J	Kansas City	48,000,000	8.	418J	Kansas City	134,400,000	–
417J☆		not printed	–	418J☆		not printed	–
417K	Dallas	35,200,000	8.	418K	Dallas	176,000,000	–
417K☆		not printed	–	418K☆		3,200,000	8.
417L	San Francisco	150,400,000	8.	418L	San Francisco	457,600,000	–
417L☆		3,200,000	10.	418L☆		2,560,000	8.

Series 1988, Ortega-Brady				Series 1988A, Villalpando-Brady			
No.	Bank	Notes Printed	Unc	No.	Bank	Notes Printed	Unc
419A	Boston	86,400,000	$ –	420A	Boston		
419A☆		768,000	8.	420A☆			
419B	New York	195,200,000	–	420B	New York		
419B☆		3,200,000	–	420B☆			
419C	Philadelphia	54,400,000	–	420C	Philadelphia		
419C☆		not printed	–	420C☆			
419D	Cleveland	111,200,000	–	420D	Cleveland		
419D☆		not printed	–	420D☆			
419E	Richmond	131,200,000	–	420E	Richmond		
419E☆		not printed	–	420E☆			
419F	Atlanta	137,200,000	–	420F	Atlanta		
419F☆		2,048,000	–	420F☆			
419G	Chicago	134,400,000	–	420G	Chicago		
419G☆		not printed	–	420G☆			
419H	St. Louis	51,200,000	–	420H	St. Louis		
419H☆		not printed	–	420H☆			
419I	Minneapolis	9,600,000	–	420I	Minneapolis		
419I☆		not printed	–	420I☆			
419J	Kansas City	44,800,000	–	420J	Kansas City		
419J☆		not printed	–	420J☆			
419K	Dallas	54,400,000	–	420K	Dallas		
419K☆		not printed	–	420K☆			
419L	San Francisco	70,400,000	–	420L	San Francisco		
419L☆		not printed	–	420L☆			

Series 1990, Villalpando-Brady

No.	Bank	Notes Printed	Unc

Series 1988A and 1990 were in production when this catalog was printed.

This page has been left blank for your personal notations.

This page has been left blank for your personal notations.

Demand Notes/1861

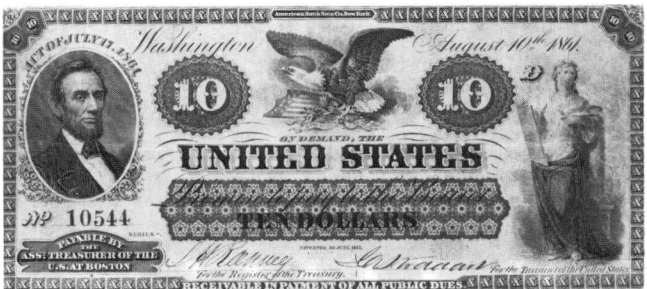

The Frederick Girsch engraving of Lincoln was based on a photograph by C.S. German. A symbolic figure of Art (or *Painting*), is on the right. The eagle, *E Pluribus Unum*, was originally engraved for Toppan Carpenter. (ABNCo)

Demand notes are the original "greenbacks."

No.	Payable at	Notes Printed	Known	VGood	Fine	VFine
463A	Boston	660,000	27 (1)	$1000.	$1750.	$3000.
463B	New York	640,000	27 (5)	1000.	1750.	3000.
463C	Philadelphia	580,000	28	1100.	2000.	3500.
463D	Cincinnati	75,000	5 (1)	– – – – –extremely rare – – – – –		
463E	St. Louis	48,000	4	– – – – – extremely rare – – – – –		

Remarks: A total of 2,003,000 (including 3,000 reissues) were printed. Records of 1931 indicate that 1,964 notes were outstanding. No. 463C with serial number "1," once held by S.P. Chase, is in a private collection. Recorded notes for No. 463E are: 31133, 35202, 41122 and 47760.

These notes, all without the U.S. Treasury Seal, were signed by representatives of the U.S. Treasurer and the Register of the Treasury. "For the" was originally written as the signatures were inscribed; the number of these notes known, not included in the other total, is in parentheses above. After a brief period, "For the" was engraved into the plate. Demand notes with the handwritten "For the" command a higher premium than the latter type.

"For the" as written. "For the" as engraved.

United States Notes/1862 & 1863/Red Seal

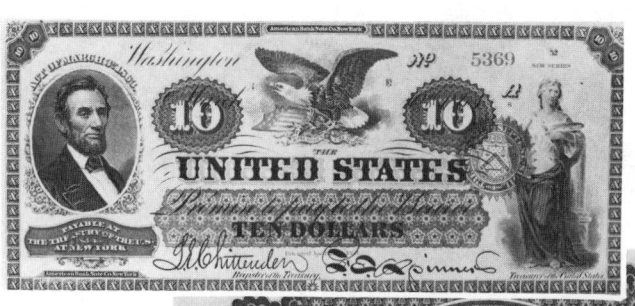

Face design is similar to the preceding note; the Treasury Seal has been added and "On Demand" has been deleted.

Back design with second obligation.

Back design with first obligation.

Back design with first obligation.

No.	Series	Description	Fine	EFine	Unc
464	1862	"American Bank Note Company" in upper border	$300.	$600.	$1850.
465	1862	"American Bank Note Company" in lower border	300.	600.	1750.
465a	1862	"American Bank Note Company" in upper border "National Bank Note Company" in lower border	300.	600.	1750.
465b	1863	"American Bank Note Company" in both borders	300.	600.	1750.
465c	1863	same as 465	300.	600.	1650.
465d	1863	same as 465a but two serial numbers	275.	500.	1500.
465e	1863	same as 465 but two serial numbers	300.	600.	1650.

Remarks: A total of 11,800,505 notes were printed; all except No. 464 bear the second obligation back. Signatures of Chittenden-Spinner appear on all notes.

United States Notes/Series 1869–1878

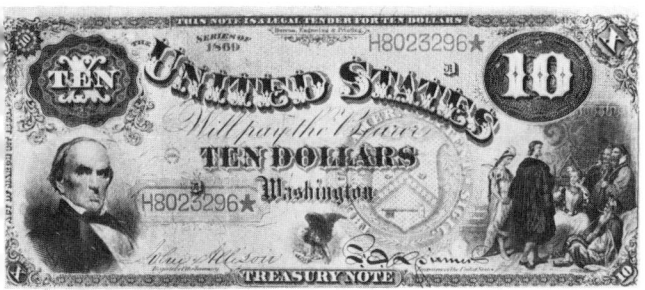

The portrait of Daniel Webster was engraved by Alfred Sealey. If the note is inverted, the small eagle engraved by Henry Gugler, takes on the appearance of a jackass, the name given to this note. The scene on the right is *Introduction of the Old World to the New World*, or *Pocahontas Presented at Court*; it is believed the artist and engraver are T.A. Liebler and W.W. Rice, respectively.

No.	Series	Signatures	Seal	Notes Printed	Fine	EFine	Unc
466	1869	Allison-Spinner	lg. red	8,376,000	$250.	$550.	$1800.
		The following have "TEN" in red on the right.					
467	1875	Allison-New	sm. red	1,500,000	300.	600.	1750.
467A	1875A	Allison-Gilfillan	sm. red	866,000	350.	700.	2300.
468	1878	Allison-Gilfillan	sm. red	2,600,000	250.	550.	1650.

Remarks: The back design for Nos. 467 and 468 is on the following page. There were 8,522,124 notes for No. 466 issued. Reissues could account for the excess of the official figure above. At least seven notes for No. 467 are known.

The following hoards of No. 466 in uncirculated condition have been observed by Gengerke: H42651xx-H42653xx, H42658xx-H42659xx, H68400xx-H68402xx, H71784xx-H71787xx, H73584xx-H73587xx.

United States Notes/Series 1880

The face design is similar
to No. 466. This back
design is for Nos. 467–482.

The red "TEN" is replaced with a large seal; serial numbers are red.

No.	Signatures	Seal	Notes Printed	Fine	EFine	Unc
469	Scofield-Gilfillan	lg. brown	1,560,000	$150.	$215.	$ 800.
470	Bruce-Gilfillan	lg. brown	1,872,000	150.	215.	800.
471	Bruce-Wyman	lg. brown	2,732,000	135.	200.	750.
		Serial numbers are blue				
472	Bruce-Wyman	lg. red	1,000,000	175.	350.	1000.
473	Rosecrans-Jordan	lg. red	1,084,000	175.	350.	1000.
474	Rosecrans-Hyatt	lg. red	1,616,000	175.	350.	1000.
475	Rosecrans-Hyatt	lg. red, spikes	2,552,000	150.	325.	900.
476	Rosecrans-Huston	lg. red, spikes	2,748,000	150.	325.	900.
478	Rosecrans-Nebeker	lg. brown	200,000	– – – – – Unique – – – – –		
479	Rosecrans-Nebeker	sm. red, scallops	3,792,000	115.	250.	850.
480	Tillman-Morgan	sm. red, scallops	9,900,000	115.	250.	850.
481	Bruce-Roberts	sm. red, scallops	960,000	200.	350.	1350.
482	Lyons-Roberts	sm. red, scallops	11,840,000	115.	250.	900.

Remarks: The following hoards (by serial number) are known, all in uncirculated condition: No. 471, Z26029506–85; No. 472, A289308–43; No. 475, A4093333–54.

United States Notes/Series 1901/Red Seal

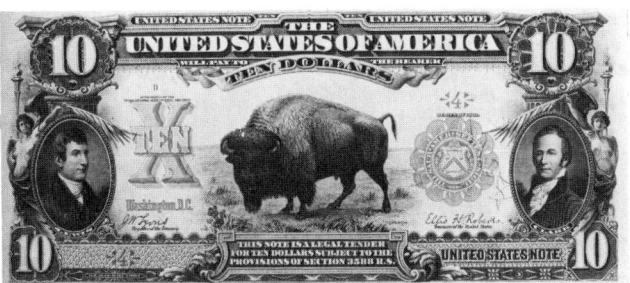

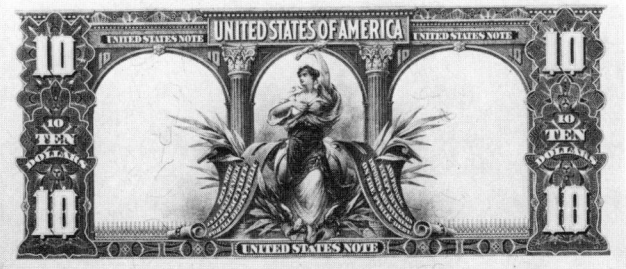

Ostrander Smith based his bison design of *Pablo* on a sketch by Charles Knight; M.W. Baldwin was the engraver. The portraits of Lewis and Clark were engraved by G.F.C. Smillie. This "buffalo bill" could have been designed to stimulate interest in the Lewis and Clark Centennial Exposition in 1905. The same bison appears on the 30-cent stamp of 1923 and the $1 military payment certificate Series 692.

No.	Signatures	Notes Issued	Fine	EFine	Unc
483	Lyons-Roberts	46,500,000	$215.	$525.	$1400.
484	Lyons-Treat	101,000,000	205.	475.	1350.
485	Vernon-Treat	17,030,000	215.	525.	1400.
486	Vernon-McClung	5,760,000	225.	525.	1500.
486☆	2 reported	–	–	–	–
487	Napier-McClung	8,476,000	225.	525.	1500.
487☆	1 reported	–	–	–	–
488	Parker-Burke	11,592,000	215.	525.	1400.
488☆	2 reported	–	–	–	–
489	Teehee-Burke	10,621,000	215.	525.	1400.
489☆	4 reported	–	–	–	–
490	Elliott-White	10,621,000	215.	525.	1400.
490☆	19 reported	–	–	–	–
491	Speelman-White	32,359,000	215.	525.	1400.
491☆	28 reported	–	–	–	–

Remarks: Plates with signatures of Napier-Thompson were prepared. Observed, uncirculated examples of No. 488 are known as E19477xx, and E98964xx-E98965xx.

United States Notes/Series 1923/Red Seal

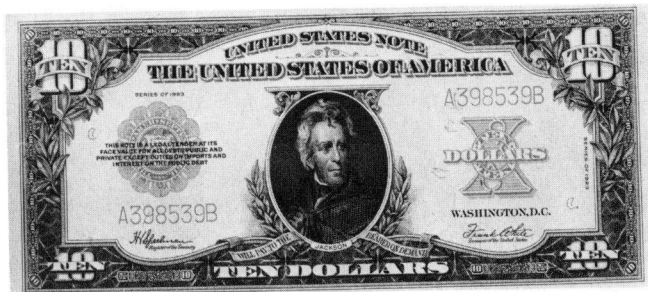

The portrait of Andrew Jackson was engraved by Alfred Sealey.

No.	Signatures	Notes Printed	Fine	EFine	Unc
492	Speelman-White	696,000	$375.	$1000.	$2850.
492 ☆	2 reported	—	—	—	—

Remarks: A minimum of 250 notes in new condition are known including the first note, A1B, and the last note, A696,000B, both in the same collection. Many of the observed notes have serial numbers within A387xxxB, A5023xxB, and A6958xxB to A6959xxB.

Compound Interest Treasury Notes/Red Seals

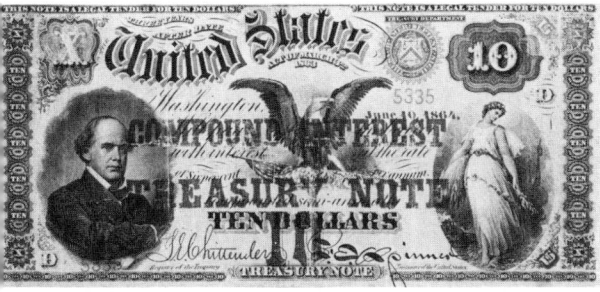

Charles Burt engraved the portrait of Salmon P. Chase; the *Eagle of the Capitol* was engraved by James Bannister. "COMPOUND INTEREST TREASURY NOTE" AND "10" in the center are in bronze.

Redemption values are listed in the center of the back.

No.	Signatures	Act of March 3, 1863 Dated	Printed	Issued	Outstanding	Fine
493	Chittenden-Spinner	June 10, 1864	92,420	84,940	164	rare
		Act of June 30, 1864				
494	Chittenden-Spinner	July 15, 1864	–	206,000	2007	$2000.
494a	Chittenden-Spinner	July 15, 1864	(error, Act of July 2, 1864)			2 known
495	Colby-Spinner	Aug. 15, 1864	–	210,500	–	1750.
495a	Colby-Spinner	Oct. 15, 1864	included in preceding			2250.
495b	Colby-Spinner	Dec. 15, 1864	–	176,500	–	2000.

Remarks: The following number of notes in parentheses are known: No. 493 (10); 494 (12); 495 (37); 495a (6); 495b (15). An extra fine example of No. 495 was advertised at $6250 in 1991. An unspecified number of No. 494 were issued with the incorrect Act of July 2, 1864 printed on the note. The two recorded serial numbers are 8275 and 9592.

Interest-Bearing Notes/5%

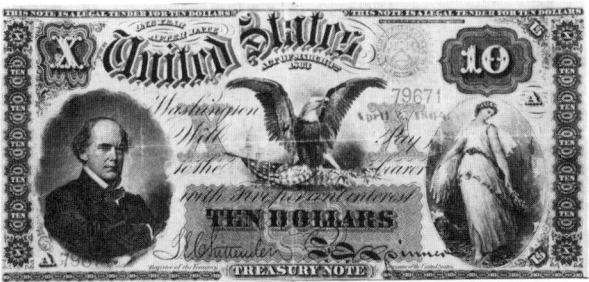

The face design is similar to the preceding note.

The back design includes the obligation and a warning to counterfeiters.

Signatures of Chittenden-Spinner

No.	Dated			Known	No.	Dated			Known
	Feb. 29,	1864	(ABNCo)	1		April 1,	1864	(ABNCo)	1
	March 1,	1864	(ABNCo)	1		April 4,	1864		1
	March 3,	1864		1		April 6,	1864		1
	March 9,	1864		1		April 8,	1864		2
496	March 15,	1864		1	496	April 9,	1864		1
	March 16,	1864		1		April 13,	1864		1
	March 23,	1864		2		April 16,	1864		1
	March 28,	1864		3		April 20,	1864		1
	March 30,	1864		3		May 28,	1864		1
	March 31,	1864	(ABNCo)	1		May 30,	1864		3

Remarks: A total of 620,000 notes were issued; 503½ remain outstanding. The dated portion of the note with serial number 156281 C5 is missing (Gengerke 47). An example dated March 31, 1864 in fine condition was advertised at $4750 in 1989.

National Bank Notes/First Charter Period

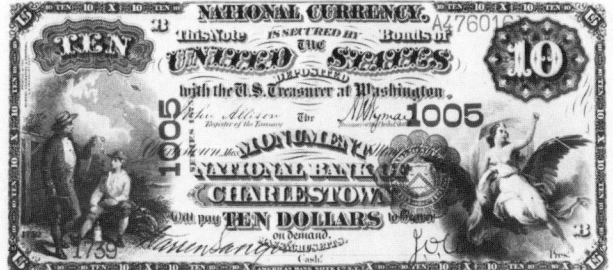

Franklin and Electricity, 1752 was engraved by Alfred Jones and James Smillie for ABNCo. T.A. Liebler's *America Seizing Lightning* was engraved by Charles Burt.

DeSoto Discovering the Mississippi was engraved by Frederick Girsch (see No. 1370).

No.	Series	Signatures	VGood	VFine	Unc
		The red seal has rays.			
497	orig.	Chittenden-Spinner	$225.	$ 450.	$2500.
498	orig.	Colby-Spinner	200.	425.	2000.
499	orig.	Jeffries-Spinner	450.	1250.	4000.
500	orig.	Allison-Spinner	200.	425.	2000.
		The red seal has scallops.			
501	1875	Allison-New	200.	425.	1850.
502	1875	Allison-Wyman	200.	425.	1850.
503	1875	Allison-Gilfillan	175.	400.	2500.
504	1875	Scofield-Gilfillan	175.	400.	2500.
505	1875	Bruce-Gilfillan	175.	400.	2500.
506	1875	Bruce-Wyman	175.	400.	2500.
507	1875	Rosecrans-Huston	200.	500.	2750.
508	1875	Rosecrans-Nebeker	225.	550.	3000.
508a	1875	Tillman-Morgan	— — — — — — — —	Rare	— — — — — — — —

Remarks: The original series had no series date on the face.

National Bank Notes/Second Charter Period/First Issue/Series 1882/Brown Seal

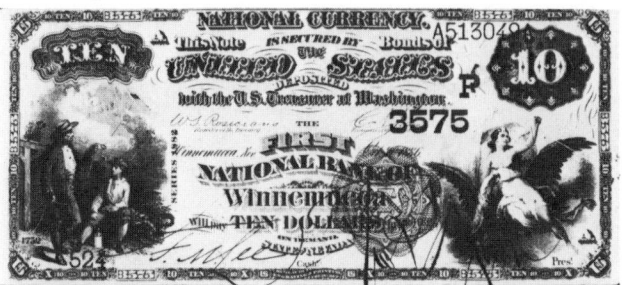

See preceding note for
design information.

The color of the back is
brown.

No.	Signatures	VGood	VFine	Unc
509	Bruce-Gilfillan	$ 85.	$165.	$ 750.
510	Bruce-Wyman	85.	165.	750.
511	Bruce-Jordan	100.	200.	1000.
512	Rosecrans-Jordan	85.	165.	750.
513	Rosecrans-Hyatt	85.	165.	750.
514	Rosecrans-Huston	85.	165.	750.
515	Rosecrans-Nebeker	85.	165.	750.
516	Rosecrans-Morgan	250.	500.	2000.
517	Tillman-Morgan	85.	165.	750.
518	Tillman-Roberts	100.	200.	1000.
519	Bruce-Roberts	85.	165.	750.
520	Lyons-Roberts	85.	165.	750.
521	Lyons-Treat	125.	300.	1400.
522	Vernon-Treat	125.	300.	1400.

National Bank Notes/Second Charter Period/Second Issue/Series 1882/Blue Seal

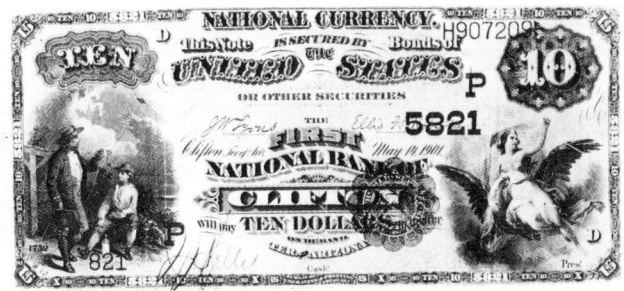

The design is the same as the preceding.

The portrait of William P. Fessenden, Secretary of the Treasury, was engraved by Charles Skinner. The figure on the right is *Mechanics*.

No.	Signatures	VGood	VFine	Unc
523	Rosecrans-Huston	$ 85.	$225.	$ 900.
524	Rosecrans-Nebeker	85.	225.	900.
525	Rosecrans-Morgan	250.	500.	1300.
526	Tillman-Morgan	85.	225.	900.
527	Tillman-Roberts	85.	225.	900.
528	Bruce-Roberts	85.	225.	900.
529	Lyons-Roberts	85.	225.	900.
530	Vernon-Treat	80.	225.	900.
531	Vernon-McClung	115.	300.	1100.
532	Napier-McClung	115.	300.	1100.

National Bank Notes/Second Charter Period/Third Issue/Series 1882/Blue Seal

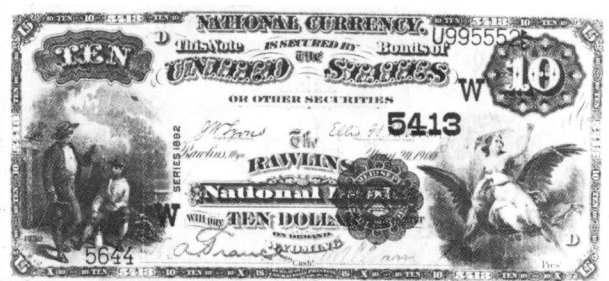

The design is the same as
the preceding.

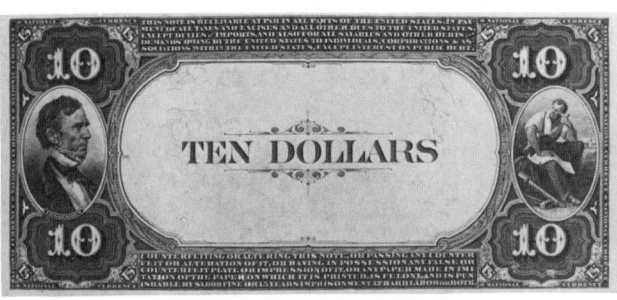

"TEN DOLLARS" replaces
"1882–1908" on the back.

No.	Signatures	VGood	VFine	Unc
533	Tillman-Morgan	$100.	$300.	$1250.
534	Tillman-Roberts	100.	300.	1250.
535	Bruce-Roberts	100.	300.	1250.
536	Lyons-Roberts	100.	300.	1250.
537	Vernon-Treat	175.	500.	1400.
538	Napier-McClung	100.	300.	1250.
539	Teehee-Burke	– – – – – – – – – – – – Rare – – – – – – – – – – – – –		

National Bank Notes/Third Charter Period/Series 1902

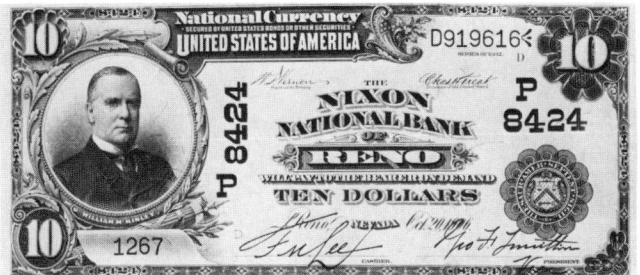

The Courtney photograph of William McKinley was engraved by G.F.C. Smillie.

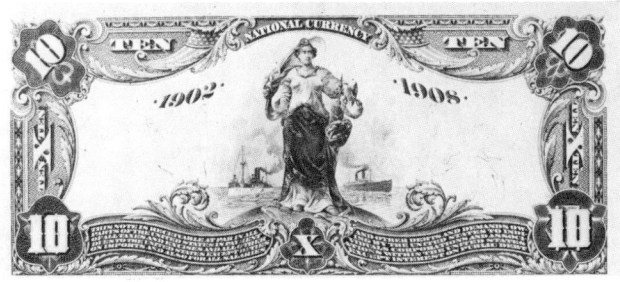

G.F.C. Smillie is also the engraver of Walter Shirlaw's *Liberty and Progress*. Only the back of the second issue has "1902–1908."

No.	Signatures	VGood	VFine	Unc
		First issue – red seal		
540	Lyons-Roberts	$110.	$165.	$700.
541	Lyons-Treat	110	185.	800.
542	Vernon-Treat	125.	225.	900.
		Second issue – blue seal		
		"1902–1908" on back		
543	Lyons-Roberts	30.	60.	325.
544	Lyons-Treat	30.	60.	325.
545	Vernon-Treat	30.	60.	325.
546	Vernon-McClung	30.	60.	325.
547	Napier-McClung	30.	60.	325.
548	Napier-Thompson	30.	100.	425.
549	Napier-Burke	30.	60.	325.
550	Parker-Burke	30.	60.	325.
551	Teehee-Burke	40.	125.	475.

National Bank Notes/Third Charter Period/Series 1902

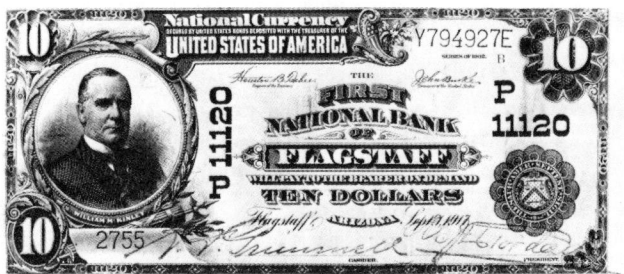

The face design is the same as the preceding note. The dates have been deleted from the back.

No.	Signatures	VGood	VFine	Unc
		Third issue—blue seal		
552	Lyons-Roberts	$ 30.	$ 50.	$ 250.
553	Lyons-Treat	30.	50.	250.
554	Vernon-Treat	30.	50.	250.
555	Vernon-McClung	30.	50.	250.
556	Napier-McClung	30.	50.	250.
557	Napier-Thompson	60.	115.	400.
558	Napier-Burke	35.	50.	250.
559	Parker-Burke	35.	50.	250.
560	Teehee-Burke	35.	50.	250.
561	Elliott-Burke	35.	50.	250.
562	Elliott-White	35.	50.	250.
563	Speelman-White	35.	50.	250.
564	Woods-White	40.	65.	300.
565	Woods-Tate	50.	150.	500.
566	Jones-Woods	115.	400.	1250.

National Gold Bank Notes

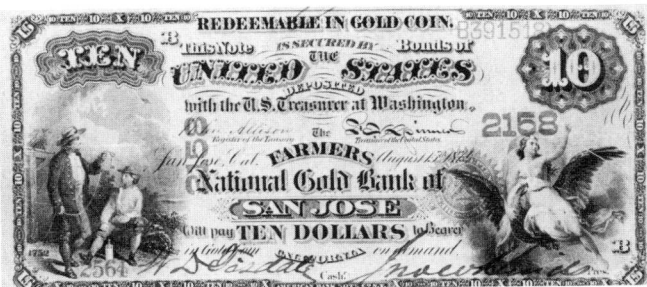

*Franklin and Electricity,
1752* was engraved by
Alfred Jones and Louis
Delnoce for ABNCo. T.A.
Liebler's *America Seizing
Lightning* was engraved by
Charles Burt.

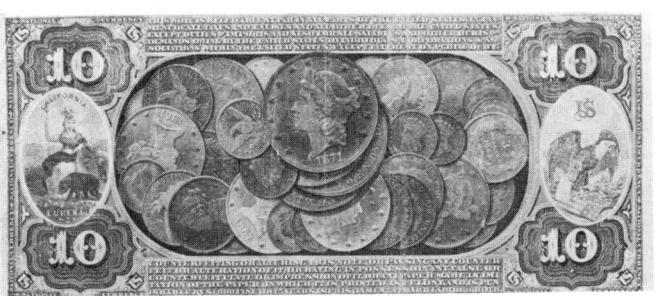

The gold coin vignette was
engraved by James Smillie.

No.	Date	Issuing Bank	City	Notes Issued	Known	Good	VGood
567	1870	First National Gold Bank	San Francisco	18,004	19	$ 850.	$1500.
568	1875	National Gold Bank & T Co.	San Francisco	12,669	9	900.	1650.
569	1872	National Gold Bank of D.O. Mills & Company	Sacramento	3,723	5	1000.	1750.
570	1873	First National Gold Bank	Stockton	15,000	14	850.	1500.
570a	1875	First National Gold Bank	Stockton	779	5	1000.	1750.
571	1873	First National Gold Bank	Santa Barbara	2,400	3	1200.	1850.
572	1874	Farmers National Gold Bank	San Jose	8,547	7	1000.	1600.
573	1874	First National Gold Bank	Petaluma	6,000	7	1000.	1600.
574	1875	First National Gold Bank	Petaluma	600	4	1000.	1750.
574a	1875	as preceding on white paper		489	2	1350.	1900.
575	1875	First National Gold Bank	Oakland	4,800	7	1000.	1650.
575a	1875	First National Gold Bank	Oakland	36	0	–	–
576	1875	Union National Gold Bank	Oakland	1,500	2	1350.	1900.
577	1875	First National Gold Bank	Stockton	779	5	1000	1750.

Remarks: The signatures of Allison-Spinner appear on these notes except for Nos. 575, 574a and 577, which have Scofield-Gilfillan signatures. A total of 2,481 notes are outstanding.

Silver Certificates/Series 1878 & 1880

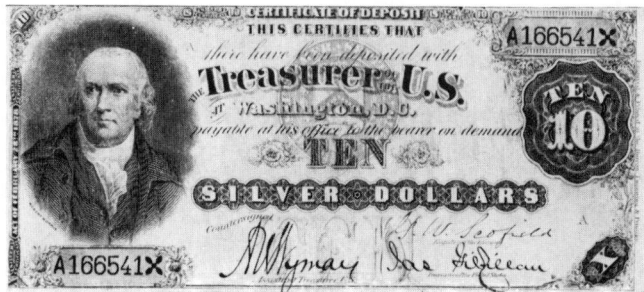

The portrait of Robert Morris, by Robert Edge Pine, was engraved by Charles Schlecht.

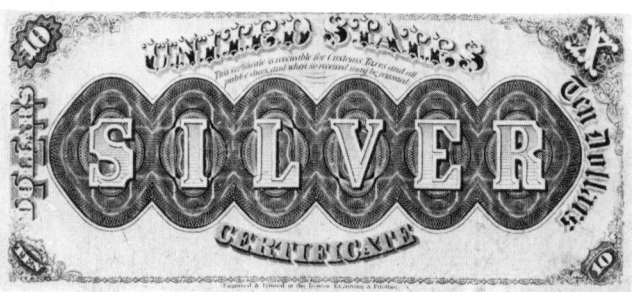

The back is black and brown.

The following bear the signatures of Scofield-Gilfillan.
Nos. 578–583a have red seals; 584 & 585 have brown seals.

No.	Series	Countersignatures	Payable at	Notes Issued	Known	VGood	VFine
578	1878	W.G. White	New York	20,000	1	$ –	$ –
579	1878	J.C. Hopper	New York	incl. in above	5	2500.	6000.
580	1878	T. Hillhouse*	New York	16,000	0		
581	1878	T. Hillhouse	New York	incl. in above	2	–	–
582	1878	T. Hillhouse*	San Francisco	3,400	0		
583	1878	A.U. Wyman*	Washington, DC	4,000	2	2500.	6000.
583a	1878	A.U. Wyman	Washington, DC	182,000	7	2500.	5000.
584	1880	T. Hillhouse	New York	196,000	12	2000.	4000.
585	1880	A.U. Wyman	Washington, DC	–	0		

Remarks: The (*) indicates autographed countersignatures. A total of 1,734 notes for Nos. 578–583a were outstanding in 1893. A private sale of No. 578 in fine condition has been recorded at $35,000. Robert Morris is one of five Americans of foreign birth to appear on U.S. paper money; the others are A. Hamilton, E.D. Baker (No. 1441), A. Gallatin (No. 1320) and G.G. Meade No. 1425).

Silver Certificates/Series 1880

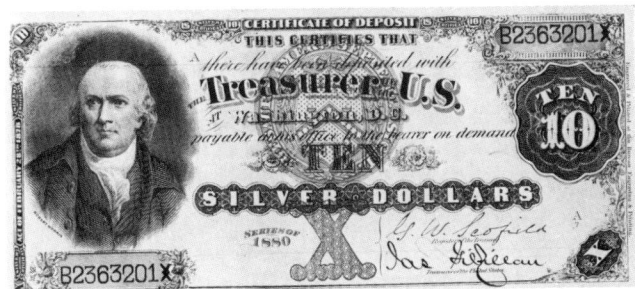

An "X" has been added to all but No. 589. The back design is the same as the preceding note.

No.	Signatures	Seal	Notes Issued	Fine	EFine	Unc
586	Scofield-Gilfillan	brown	2,772,000	$500.	$1100.	$2750.
587	Bruce-Gilfillan	brown	1,832,000	550.	1200.	3000.
588	Bruce-Wyman	brown	3,102,000	500.	1000.	2500.
589	Bruce-Wyman	red	304,000	650.	1400.	5000.

Remarks: For No. 589 the following notes, all with prefix "A," have been recorded by Martin Gengerke, Gene Hessler and John Isted: 405, 21743, 25516, 70527, 86781, 102773, 123539, 150793, 169487, 180193, 180312, 182034, 184755, 190529, 253920, 292447 and 297611.

A group of as many as 29 consecutively-numbered notes in uncirculated condition of No. 587, commencing with B34387xx has been reported. As many as 44 in the same condition of No. 588 commencing with B71133xx have been reported.

Silver Certificates/Series 1886

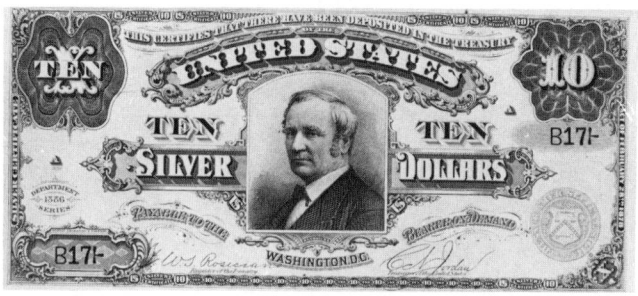

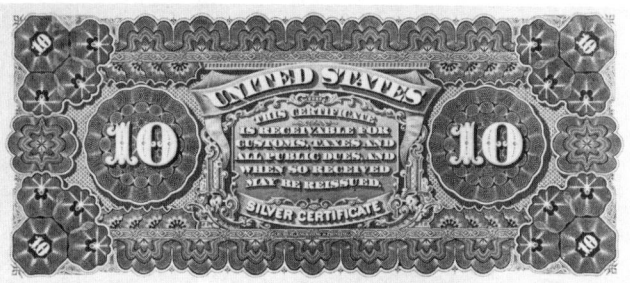

Thomas A. Hendricks was Vice-President of the U.S. for nine months; he died on November 25, 1865 in Indianapolis, where he spent most of his academic and political life. This portrait was engraved by Charles Schlecht. Due to the shape of the portrait frame, this bill is often called the "tombstone note."

No.	Signatures	Seal	Notes Printed	Fine	EFine	Unc
590	Rosecrans-Jordan	sm. red	400,000	$600.	$1200.	$8000.
591	Rosecrans-Hyatt	sm. red	2,560,000	450.	1000.	5000.
592	Rosecrans-Hyatt	lg. red	5,640,000	425.	900.	4000.
593	Rosecrans-Huston	lg. red	2,036,000	450.	1000.	5000.
594	Rosecrans-Huston	lg. brn	1,764,000	500.	1100.	5000.
595	Rosecrans-Nebeker	lg. brown	1,600,000	500.	1100.	5000.
596	Rosecrans-Nebeker	sm. red-scallops	204,000	650.	1300.	9000.

Remarks: The following notes have been recorded by Martin Gengerke, Gene Hessler and John Isted. No. 590: B17, B38846, B64039, B86401, B269550, B329327; No. 596: B13901943, B14098656, B14168131, B13977044, B14141794, B13977046 and B14167245.

Silver Certificates/Series 1891 & 1908

The face design is similar
to the preceding note.

No.	Series	Signatures	Seal	Notes Printed	Fine	EFine	Unc
597	1891	Rosecrans-Nebeker	red	3,500,000	$200.	$450.	$1500.
598	1891	Tillman-Morgan	red	16,500,000	175.	425.	1300.
599	1891	Bruce-Roberts	red	7,776,000	175.	425.	1300.
600	1891	Lyons-Roberts	red	6,644,000	175.	425.	1300.
		Blue "X" added to face					
601	1908	Vernon-Treat	blue	4,500,000	200.	450.	1500.
601a	1908	Vernon-McClung	blue	1,756,000	225.	475.	1650.
602	1908	Parker-Burke	blue	3,952,000	200.	450.	1300.
602 ☆	1 reported			–	–	–	–

Remarks: For No. 597, serial numbers E1, E3 through E7 and E9 are known. For No. 601 serial numbers A1, A2, A6, A7 and A10 are known. For No. 601a, 27 notes have been reported; most fall between B1056355 and B1705294; the lowest reported serial number is B5240.

Refunding Certificates

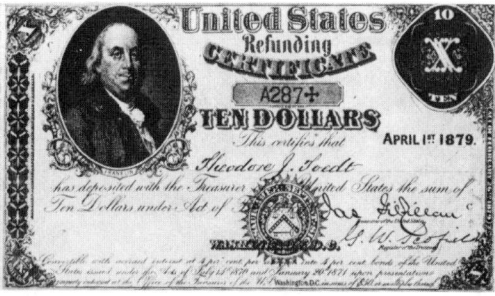

The portrait of Benjamin Franklin is based on the painting by James Barton Longacre.

No.	Notes Issued	Outstanding	Known	VGood	VFine	EFine
603	5,850	2	2	$ –	$ –	$ –
604	3,995,425	800	85	400.	900.	1250.

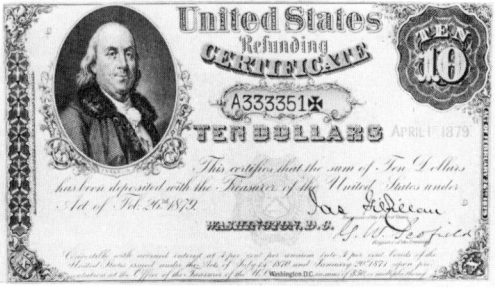

No. 604 is payable to bearer.

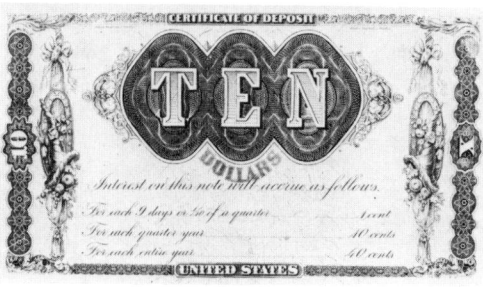

Gold Certificates/Series 1907 & 1922

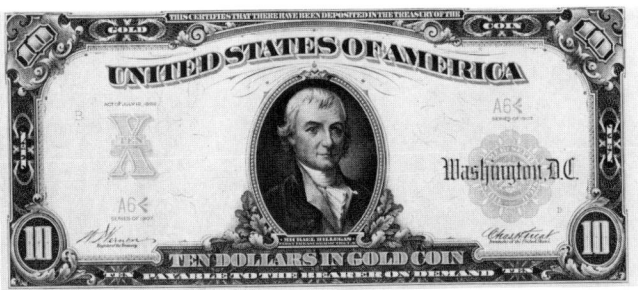

Michael Hillegas was born in Philadelphia on April 22, 1729; he died there on September 29, 1804. With George Clymer he held the office of co-Treasurer of the U.S. They were the first to hold this office. The portrait of Hillegas, originally painted by A.M. Archambault, was engraved by G.F.C. Smillie. The illustrated note has small serial numbers.

The bright yellow back was engraved by H.L. Chorlton, E.M. Hall and G.U. Rose, Jr.

No.	Series	Signatures	Notes Issued	VFine	EFine	Unc
605	1907	Vernon-Treat	21,366,800	$ 65.	$100.	$ 300.
606	1907	Vernon McClung	17,746,000	65.	125.	400.
606☆	1907	2 reported	–	–	–	–
607	1907	Napier-McClung	⎤	75.	150.	600.
607☆	1907	2 reported	33,436,000	75.	150.	600.
607a	1907	Napier-McClung	⎦	–	–	–
608	1907	Napier-Thompson	2,276,000	350.	750.	3000.
608a	1907	Napier-Thompson	incl. in above	350.	750.	3000.
609	1907	Parker-Burke	16,176,000	65.	125.	400.
609☆	1907	2 reported	–	–	–	–
610	1907	Teehee-Burke	44,364,000	65.	100.	300.
610☆	1907	6 reported	–	–	–	–
611	1922	Speelman-White (sm. sn)	13,504,000	75.	150.	500.
611☆	1922	5 reported	–	–	–	–
611a	1922	Speelman-White (lg. sn)	147,100,000	60.	85.	285.
611a☆	1922	97 reported	–	–	–	–

Remarks: "Act of July 12, 1882" appears on Nos. 607 and 608; "Act of March 4, 1907" is on Nos. 607a and 608a (sn = serial number). See Nos. 1042 and 1042a for examples of large and small s(erial) n(umbers).

Treasury or Coin Notes/Series 1890

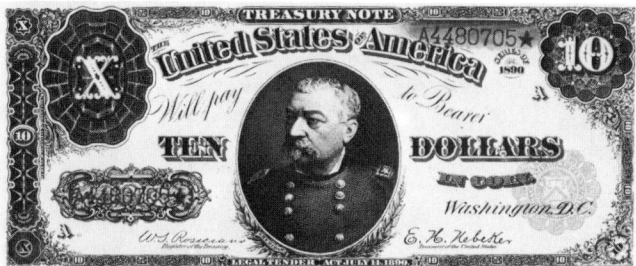

General Philip Sheridan was born in Albany, NY on March 6, 1831, He graduated from West Point in 1853 and fought in the Civil War. This portrait was engraved by Lorenzo Hatch.

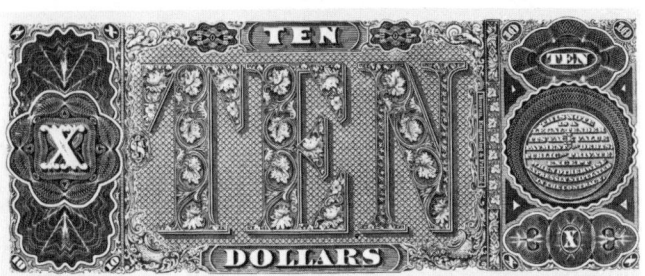

The back was engraved by D.M. Cooper, W.A. Copenhaver, W.H. Hall, A.L. Helm, W.G. Phillips and D.M. Russell.

No.	Signatures	Seal	Notes Printed	Fine	EFine	Unc
612	Rosecrans-Huston	brown	2,876,000	$300.	$700.	$2850.
613	Rosecrans-Nebeker	brown	324,000	500.	900.	4000.
614	Rosecrans-Nebeker	red	1,400,000	400.	800.	3250.

Series of 1891

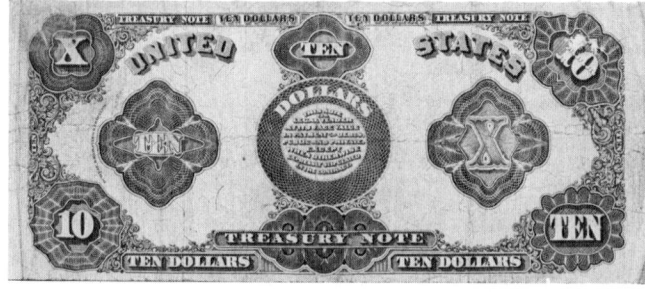

The face design is similar to the preceding note. This back was engraved by J.A. Allen, D.M. Cooper, W.H. Dougal, E.M. Hall, A.L. Helm, J.R. Hill, E.E. Myers, E.G. Rose and G.U. Rose, Jr.

No.	Signatures	Seal	Notes Issued	Fine	EFine	Unc
615	Rosecrans-Nebeker	red	976,000	$300.	$550.	$1500.
616	Tillman-Morgan	red	4,552,000	250.	475.	1450.
617	Bruce-Roberts	red	500,000	350.	650.	1600.

Remarks: Six notes (four in uncirculated condition) are known for No. 613. No. 614 could exist as a hoard; Nos. A4483529, −568, 569 and −585 have been observed in uncirculated condition. No. 615 could also exist as a hoard; B543627, −636, −660, −678 and 683 have been observed in uncirculated condition. Martin Gengerke has recorded 10 notes for No. 617.

Federal Reserve Notes/Series 1914/Red Seal

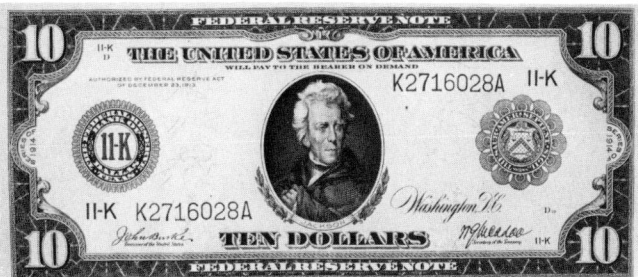

The portrait of Andrew Jackson was engraved by G.F.C. Smillie

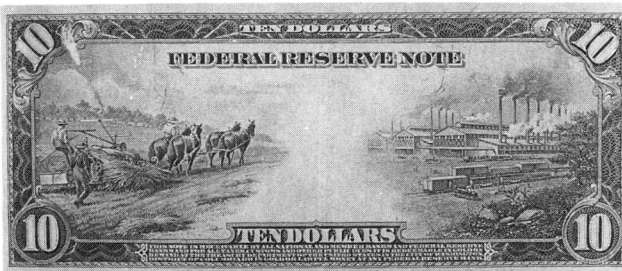

The back design is the same as No. 620.

Signatures of Burke-McAdoo

No.	Bank	VGood	VFine	Unc
618A	Boston	$50.	$100.	$525.
618B	New York	40.	75.	425.
618C	Philadelphia	40.	75.	425.
618D	Cleveland	40.	75.	425.
618E	Richmond	40.	75.	425.
618F	Atlanta	40.	75.	425.
618G	Chicago	40.	75.	425.
618H	St. Louis	40.	75.	425.
618I	Minneapolis	40.	75.	425.
618J	Kansas City	40.	75.	425.
618K	Dallas	50.	100.	525.
618L	San Francisco	50.	100.	525.

Remarks: The first day of issue was November 16, 1914. Type I and type II were printed for all districts. Type II has the small district number and letter in the upper left and lower right corners. See No. 380 for illustrations.

Federal Reserve Notes/Series 1914/Blue Seal

No.	Bank	Signatures	Notes Printed	Delivered	VFine	Unc
619A1	Boston	Burke-McAdoo	⌝		$25.	$100.
619A2	Boston	Burke-Glass			30.	115.
619A3	Boston	Burke-Houston			25.	100.
619A3☆	6 reported		69,756,000	69,756,000	–	–
619A4	Boston	White-Mellon (b)			25.	100.
619A4☆	6 reported	(1 "b") ⌟	(568,000)		–	–
619B1	New York	Burke-McAdoo ⌝			25.	100.
619B1☆	1 reported				–	–
619B2	New York	Burke-Glass			30.	115.
619B2☆	4 reported		176,728,000	176,728,000	–	–
619B3	New York	Burke-Houston			25.	100.
619B3☆	7 reported				–	–
619B4	New York	White Mellon (b,c)			25.	100.
619B4☆	8 reported	(4 "b", 6 "c") ⌟	(1,396,000)		–	–
619C1	Philadelphia	Burke-McAdoo ⌝			25.	100.
619C2	Philadelphia	Burke-Glass			30.	115.
619C2☆	1 reported				–	–
619C3	Philadelphia	Burke-Houston	56,616,000	56,616,000	25.	100.
619C3☆	5 reported				–	–
619C4	Philadelphia	White-Mellon (c)			25.	100.
619C4☆	6 reported	(1 "c") ⌟	(476,000)		–	–
619D1	Cleveland	Burke-McAdoo ⌝			25.	100.
619D1☆	1 reported				–	–
619D2	Cleveland	Burke-Glass			30.	115.
619D2☆	2 reported		43,856,000	43,856,000	–	–
619D3	Cleveland	Burke-Houston			25.	100.
619D3☆	4 reported				–	–
619D4	Cleveland	White-Mellon (b,c)			25.	100.
619D4☆	10 reported	⌟	(360,000)		–	–
619E1	Richmond	Burke-McAdoo ⌝			25.	100.
619E2	Richmond	Burke-Glass			30.	115.
619E2☆	2 reported				–	–
619E3	Richmond	Burke-Houston	27,528,000	27,528,000	25.	100.
619E3☆	3 reported				–	–
619E4	Richmond	White-Mellon			25.	100.
619E4☆	1 reported	⌟	(236,000)		–	–
619F1	Atlanta	Burke-McAdoo ⌝			25.	100.
619F1☆	2 reported				–	–
619F2	Atlanta	Burke-Glass	31,400,000	31,400,000	30.	115.
619F3	Atlanta	Burke-Houston			25.	100.
619F4	Atlanta	White-Mellon (b) ⌟	(228,000)		25.	100.
619G1	Chicago	Burke-McAdoo ⌝			25.	100.
619G1☆	1 reported				–	–
619G2	Chicago	Burke-Glass			30.	115.
619G2☆	4 reported		84,804,000	84,804,000	–	–
619G3	Chicago	Burke-Houston			25.	100.
619G3☆	21 reported				–	–
619G4	Chicago	White-Mellon (b,c)			25.	100.
619G4☆	17 reported	(3 "b") ⌟	(680,000)		–	–

Federal Reserve Notes/Series 1914/Blue Seal *(continued)*

No.	Bank	Signatures	Notes Printed	Delivered	VFine	Unc
619H1	St. Louis	Burke-McAdoo			$25.	$100.
619H1 ☆	5 reported				–	–
619H2	St. Louis	Burke-Glass			30.	115.
619H2 ☆	1 reported		21,508,000	21,508,000	–	–
619H3	St. Louis	Burke-Houston			25.	100.
619H3 ☆	7 reported				–	–
619H4	St. Louis	White-Mellon	(236,000)		25.	100.
619I1	Minneapolis	Burke-McAdoo			25.	100.
619I1 ☆	1 reported				–	–
619I2	Minneapolis	Burke-Glass			30.	115.
619I2 ☆	3 reported		14,376,000	14,376,000	–	–
619I3	Minneapolis	Burke-Houston			25.	100.
619I3 ☆	6 reported				–	–
619I4	Minneapolis	White-Mellon			25.	100.
619I4 ☆	3 reported	(124,000)			–	–
619J1	Kansas City	Burke-McAdoo			25.	100.
619J1 ☆	1 reported				–	–
619J2	Kansas City	Burke-Glass	16,448,000	16,448,000	30.	115.
619J3	Kansas City	Burke-Houston			25.	100.
619J3 ☆	8 reported				–	–
619J4	Kansas City	White-Mellon	(144,000)		25.	100.
619K1	Dallas	Burke-McAdoo			25.	100.
619K1 ☆	3 reported				–	–
619K2	Dallas	Burke-Glass	13,400,000	12,988,000	30.	115.
619K3	Dallas	Burke-Houston			25.	100.
619K3 ☆	3 reported				–	–
619K4	Dallas	White-Mellon	(112,000)		25.	100.
619L1	San Francisco	Burke-McAdoo			25.	100.
619L2	San Francisco	Burke-Glass			30.	115.
619L2 ☆	1 reported		41,432,000	41,432,000	–	–
619L3	San Francisco	Burke-Houston			25.	100.
619L4	San Francisco	White-Mellon (b,c)			25.	100.
619L4 ☆	3 reported	(352,000)			–	–

Remarks: The totals are for regular issues. The figures in parenthesis, the last replacement serial number, is the total number of replacement notes of this denomination printed for that bank; the number printed by signatures is not available. White-Mellon plate variations, in parenthesis, exist for some districts, identified as type "b" (small district number and letter in lower left) and type "c" (space of 20 mm horizontal from left seal to the engraved border). Star, replacement notes reported in the main listing above are type "a" or notes not identified by type. See $5 Federal Reserve notes for examples.

Federal Reserve Bank Notes/Series 1915 & 1918/Blue Seal

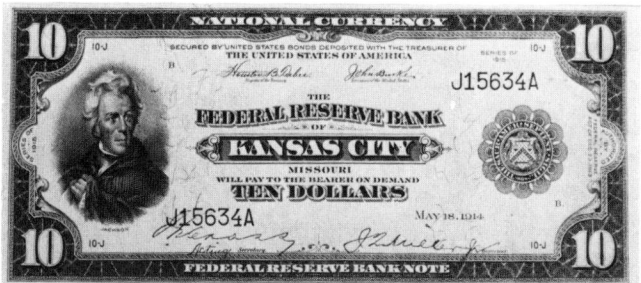

The portrait of Andrew Jackson was engraved by G.F.C. Smillie.

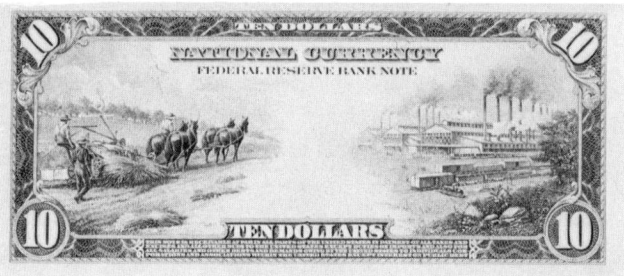

The back was designed by C.A. Huston. *Farming* was engraved by Marcus W. Baldwin; *Industry*, a mill in Joliet, Illinois, was engraved by H.L. Chorlton.

No.	Bank	Series	Bank Signatures	Issued	VFine	EFine	Unc
620B	New York	1918	Hendricks-Strong	200,000	$400.	$750.	$3000.
620F1	Atlanta	1918	Bell-Wellborn	300,000	300.	500.	2500.
620F2	Atlanta	1918	Bell-Wellborn	incl. in above	300.	500.	2500.
620G1	Chicago	1915	McLallen-McDougal	300,000	300.	500.	2500.
620G2	Chicago	1918	McCloud-McDougal	incl. in above	300.	500.	2500.
620H	St. Louis	1918	Attebery-Wells	100,000	400.	950.	4000.
620H☆	1 reported			–	–	–	–
620J1	Kansas City	1915	Anderson-Miller		350.	750.	3000.
620J2a	Kansas City	1915	Cross-Miller		300.	425.	2750.
620J2b	as above with large signatures				300.	425.	2750.
620J4	Kansas City	1915	Helm-Miller	504,000	300.	500.	–
620K1	Dallas	1915	Hoopes-VanZandt		350.	750.	3000.
620K2	Dallas	1915	Gilbert-VanZandt		300.	475.	2850.
620K3	Dallas	1915	Talley-VanZandt		300.	425.	2750.

Remarks: Government signatures of Teehee-Burke appear on all except No. 620F2, which has Elliott-Burke. On 620J2b, Cross is "Acting Secretary." Respectively, 343 and 237 notes are outstanding for Nos. 620B and 620H. For the latter, six notes are known.

Silver Certificate/Series 1933–1934A/Blue Seal

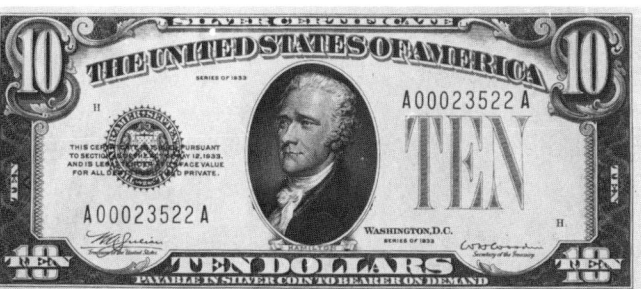

John Trumbull's portrait of Alexander Hamilton was engraved in 1906 by G.F.C. Smillie.

The U.S. Treasury Building.

No.	Series	Signatures	Notes Printed	VFine	EFine	Unc
621	1933	Julian-Woodin	216,000			
			(156,000 released)	$1100.	$1600.	$4000.
621A	1933A	Julian-Morgenthau	336,000			
			(28,000 released)	– – – – –	Unique	– – – – –

Series 1934
The seal is moved to the right; a blue "10" is on the left. The back design is the same as No. 621.

No.	Series	Signatures	Notes Printed	VFine	EFine	Unc
622	1934	Julian-Morgenthau	88,692,000	15.	25.	40.
622☆			–	–	–	75.

Yellow seals for the invasion of North Africa

No.	Series	Signatures	Notes Printed	VFine	EFine	Unc
623	1934	Julian-Morgenthau	21,860,000	1250.	2750.	6500.
623☆			–	– – – – –	Rare	– – – – –
623A	1934A	Julian-Morgenthau	included in above	20.	35.	85.
623☆			–	40.	100.	200.

Silver Certificates/Series 1934A-1953D/Blue Seal

No.	Series	Signatures	Notes Printed	VFine	EFine	Unc
624A	1934A	Julian-Morgenthau	42,346,428	$ 15.	$ 25.	$ 40.
624A☆			–	–	–	–
624B	1934B	Julian-Vinson	337,740	85.	150.	750.
624B☆			–	200.	300.	1000.
624C	1934C	Julian-Snyder	20,032,632	–	18.	30.
624C☆			–	–	–	–
624D	1934D	Clark-Snyder	11,801,112	–	18.	35.
624D☆			–	–	30.	75.

Series 1953

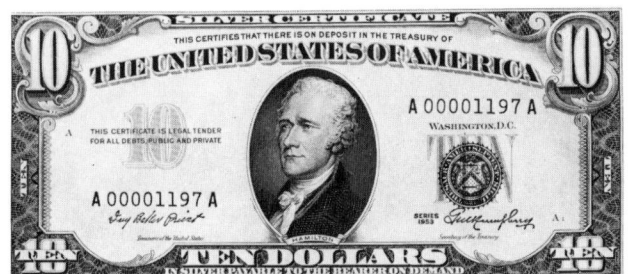

The "10" on the left is now grey. The back design is the same as No. 621.

No.	Series	Signatures	Notes Printed	VFine	EFine	Unc
625	1953	Priest-Humphrey	10,440,000	–	25.	40.
625☆			576,000	–	35.	65.
625A	1953A	Priest-Anderson	1,080,000	15.	30.	100.
625A☆			144,000	20.	35.	125.
625B	1953B	Smith-Dillon	720,000	15.	30.	50.

Federal Reserve Bank Notes/Series 1929/Brown Seal

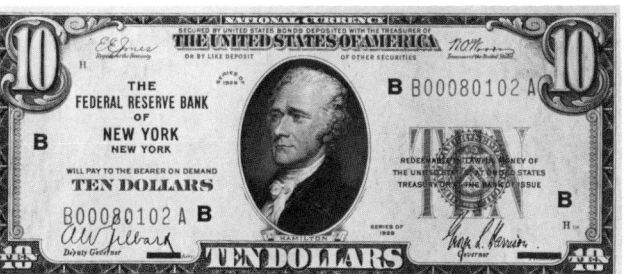

John Trumbull's portrait of Alexander Hamilton was engraved in 1906 by G.F.C. Smillie. The back design is the same as No. 621.

Signatures of Jones-Woods

No.	Bank	Notes Printed	VFine	EFine	Unc
626A	Boston	1,680,000	$15.	$35.	$ 60.
626A☆	1 reported	–	–	–	–
626B	New York	5,556,000	12.	15.	30.
626B☆	8 reported	–	–	–	75.
626C	Philadelphia	1,416,000	15.	35.	50.
626C☆	2 reported	–	–	–	100.
626D	Cleveland	2,412,000	15.	25.	35.
626D☆	3 reported	–	–	–	75.
626E	Richmond	1,356,000	15.	35.	60.
626E☆	2 reported	–	–	–	100.
626F	Atlanta	1,056,000	15.	35.	60.
626F☆	2 reported	–	–	–	100.
626G	Chicago	3,156,000	12.	15.	30.
626G☆	1 reported	–	–	–	–
626H	St. Louis	1,584,000	15.	35.	60.
626H☆	4 reported	–	–	–	100.
626I	Minneapolis	588,000	25.	50.	225.
626I☆	2 reported	–	–	–	300.
626J	Kansas City	1,284,000	15.	35.	60.
626J☆	5 reported	–	–	–	100.
626K	Dallas	504,000	25.	50.	250.
626K☆	2 reported	–	–	–	300.
626L	San Francisco	1,080,000	25.	50.	300.
626L☆	3 reported	–	–	–	350.

National Bank Notes/Series 1929/Brown Seal

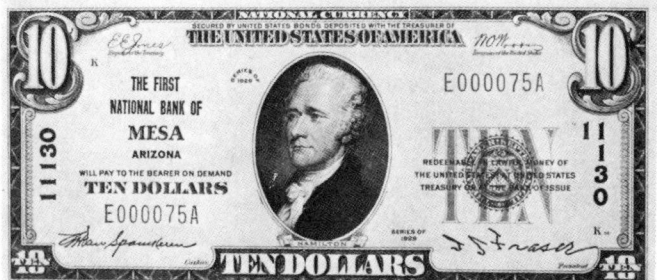

Type I with the G.F.C. Smillie portrait of Alexander Hamilton.

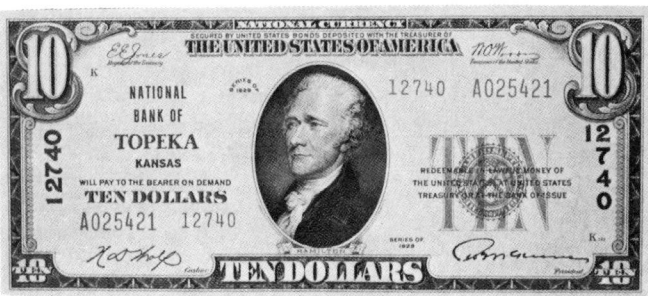

Type II has the bank charter number printed a second time near the serial number. The back design is the same as No. 621.

Signatures of Jones-Woods

No.	Rarity	Type I			Type II		
		VFine	EFine	Unc	VFine	EFine	Unc
	1	$ 15.	$ 25.	$ 50.	$ 20.	$ 35.	$ 60.
	2	20.	30.	60.	25.	40.	70.
	3	25.	40.	75.	30.	50.	90.
	4	30.	60.	90.	35.	70.	110.
627	5	40.	75.	115.	50.	85.	140.
	6	50.	90.	135.	65.	100.	175.
	7	80.	140.	225.	100.	150.	275.
	8	125.	350.	500.	200.	375.	600.
	9	1250.	1850.	3500.	1400.	2000.	–

Remarks: The total issue for both types was 124,236,394 notes.

Federal Reserve Notes/Series 1928, 1928A, 1928B & 1928C/Green Seal

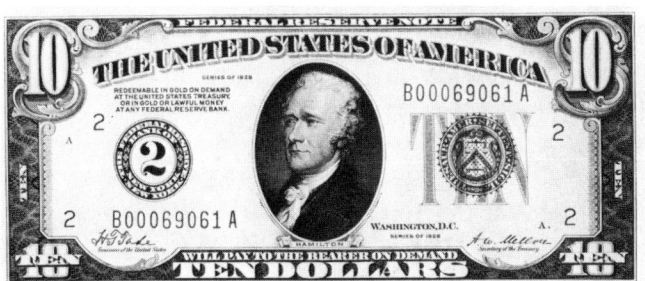

The numeral in the seal represents the second Federal Reserve district. The back design is the same as No. 621.

Series 1928, Tate-Mellon

No.	Bank	Notes Printed	Unc
628A	Boston	9,804,552	$30.
628A☆			–
628B	New York	11,295,000	30.
628B☆			–
628C	Philadelphia	8,114,412	30.
628C☆			–
628D	Cleveland	7,570,000	30.
628D☆		not printed	–
628E	Richmond	4,534,800	35.
628E☆			–
628F	Atlanta	6,807,720	30.
628F☆			–
628G	Chicago	8,130,000	30.
628G☆			–
628H	St. Louis	4,124,100	35.
628H☆			–
628I	Minneapolis	3,874,440	35.
628I☆			–
628J	Kansas City	3,620,400	35.
628J☆			–
628K	Dallas	4,855,500	35.
628K☆			–
628L	San Francisco	7,086,900	30.
628L☆			–

Series 1928A, Woods-Mellon

No.	Bank	Notes Printed	Unc
629A	Boston	2,893,440	$35.
629A☆			–
629B	New York	18,631,056	30.
629B☆			–
629C	Philadelphia	2,710,680	35.
629C☆		not printed	
629D	Cleveland	5,610,000	30.
629D☆			–
629E	Richmond	552,300	75.
629E☆			–
629F	Atlanta	3,033,480	35.
629F☆		not printed	–
629G	Chicago	8,715,000	30.
629G☆			–
629H	St. Louis	531,000	75.
629H☆			–
629I	Minneapolis	102,600	90.
629I☆		not printed	–
629J	Kansas City	410,400	75.
629J☆		not printed	–
629K	Dallas	410,400	75.
629K☆		not printed	–
629L	San Francisco	2,547,900	35.
629L☆		not printed	–

Series 1928B, Woods-Mellon

No.	Bank	Notes Printed	Unc
630A	Boston	33,216,088	$30.
630B	New York	44,458,308	30.
630C	Philadelphia	22,689,216	30.
630D	Cleveland	17,418,024	30.
630D☆			–
630E	Richmond	12,714,504	30.
630E☆			–
630F	Atlanta	5,246,700	35.
630G	Chicago	38,035,000	30.
630G☆			–
630H	St. Louis	10,814,664	30.
630I	Minneapolis	5,294,460	35.
630I☆			–
630J	Kansas City	7,748,040	35.

Series 1928C, Woods-Mills

No.	Bank	Notes Printed	Unc
631B	New York	2,902,678	$ 50.
631D	Cleveland	4,230,428	40.
631D☆		1 reported	
631E	Richmond	304 800	100.
631F	Atlanta	688,380	85.
631G	Chicago	2,423,400	50.
630K	Dallas	3,396,096	35.
630L	San Francisco	22,695,300	35.
630L☆		1 reported	–

Series 1928C $10 notes were printed for these districts only.

Federal Reserve Notes/Series 1934, 1934A, 1934B & 1934C/Green Seal

Series 1934, Julian-Morgenthau				Series 1934A, Julian-Morgenthau			
No.	Bank	Notes Printed	Unc	No.	Bank	Notes Printed	Unc
632A	Boston	46,276,152	$25.	633A	Boston	104,540,088	$ 15.
632A☆			–	633A☆			–
632B	New York	177,298,000	20.	633B	New York	281,940,996	15.
632B☆			–	633B☆			–
632C	Philadelphia	34,770,768	25.	633C	Philadelphia	95,338,032	20.
632C☆			–	633C☆			–
632D	Cleveland	28,764,108	25.	633D	Cleveland	93,332,048	20.
632D☆				633D☆			–
632E	Richmond	16,437,252	25.	633E	Richmond	101,037,912	15.
632E☆			–	633E☆			–
632F	Atlanta	20,656,872	25.	633F	Atlanta	85,478,160	20.
632F☆			–	633F☆			–
632G	Chicago	69,962,064	20.	633G	Chicago	177,285,960	15.
632G☆			–	633G☆			–
632H	St. Louis	22,593,204	25.	633H	St. Louis	50,694,312	20.
632H☆			–	633H☆			–
632I	Minneapolis	16,840,000	25.	633I	Minneapolis	16,340,000	25.
632I☆			–	633I☆			–
632J	Kansas City	22,627,824	25.	633J	Kansas City	31,069,978	25.
632J☆			–	633J☆			–
632K	Dallas	21,403,488	25.	633K	Dallas	28,263,156	25.
632K☆			–	633K☆		not printed	–
632L	San Francisco	37,402,308	25.	633L	San Francisco	125,537,592	15.
632L☆			–	633LL	(HAWAII ovpt.)	10,424,000	200.
				633LL☆			750.

Series 1934B, Julian-Vinson				Series 1934C, Julian-Snyder			
No.	Bank	Notes Printed	Unc	No.	Bank	Notes Printed	Unc
634A	Boston	3,999,600	$25.	635A	Boston	42,431,404	$20.
634A☆			–	635A☆			–
634B	New York	34,815,948	20.	635B	New York	115,675,644	15.
634B☆			–	635B☆			–
634C	Philadelphia	10,339,020	20.	635C	Philadelphia	46,874,760	20.
634C☆			–	635C☆			–
634D	Cleveland	1,394,700	35.	635D	Cleveland	332,400	75.
634D☆			–	635D☆			–
634E	Richmond	4,018,272	25.	635E	Richmond	37,422,600	20.
634E☆		not printed	–	635E☆			–
634F	Atlanta	6,764,076	25.	635F	Atlanta	44,838,264	20.
634F☆		not printed	–	635F☆			–
634G	Chicago	18,130,836	20.	635G	Chicago	105,875,412	15.
634G☆			–	635G☆			–
634H	St. Louis	6,849,348	25.	635H	St. Louis	36,541,404	20.
634H☆			–	635H☆			–
634I	Minneapolis	2,254,800	35.	635I	Minneapolis	11,944,848	20.
634I☆		not printed	–	635I☆			–
634J	Kansas City	3,835,200	25.	635J	Kansas City	10,874,072	20.
634J☆		not printed	–	635J☆			–
634K	Dallas	3,085,200	30.	635K	Dallas	25,642,620	20.
634K☆		not printed	–	635K☆		not printed	–
634L	San Francisco	9,076,800	20.	635L	San Francisco	49,164,480	20.
634L☆			–	635L☆			–

Federal Reserve Notes/Series 1934D, 1950, 1950A & 1950B/Green Seal

Series 1934D, Clark-Snyder				Series 1950, Clark-Snyder			
No.	Bank	Notes Printed	Unc	No.	Bank	Notes Printed	Unc
636A	Boston	19,917,900	$20.	637A	Boston	70,992,000	$20.
636A☆			25.	637A☆		1,008,000	25.
636B	New York	64,067,904	20.	637B	New York	218,567,000	20.
636B☆			25.	637B☆		2,568,000	25.
636C	Philadelphia	18,432,000	20.	637C	Philadelphia	76,320,000	20.
636C☆			25.	637C☆		1,008,000	25.
636D	Cleveland	20,291,316	20.	637D	Cleveland	76,032,000	20.
636D☆		not printed	–	637D☆		1,008,000	25.
636E	Richmond	18,090,312	20.	637E	Richmond	61,776,600	20.
636E☆			25.	637E☆		876,000	30.
636F	Atlanta	17,064,816	20.	637F	Atlanta	63,792,000	20.
636F☆			25.	637F☆		864,000	30.
636G	Chicago	55,943,844	20.	637G	Chicago	161,056,000	20.
636G☆			25.	637G☆		2,088,000	25.
636H	St. Louis	15,828,048	20.	637H	St. Louis	47,808,000	20.
636H☆			25.	637H☆		648,000	30.
636I	Minneapolis	5,237,220	25.	637I	Minneapolis	18,864,000	20.
636I☆			25.	637I☆		252,000	40.
636J	Kansas City	7,992,500	20.	637J	Kansas City	36,332,000	20.
636J☆			25.	637J☆		456,000	30.
636K	Dallas	7,178,196	20.	637K	Dallas	33,264,000	20.
636K☆		not printed	–	637K☆		480,000	30.
636L	San Francisco	23,956,584	20.	637L	San Francisco	76,896,000	20.
636L☆		not printed	–	637L☆		1,152,000	25.

Series 1950A, Priest-Humphrey				Series 1950B, Priest-Anderson			
No.	Bank	Notes Printed	Unc	No.	Bank	Notes Printed	Unc
638A	Boston	104,248,000	$20.	639A	Boston	49,240,000	$20.
638A☆		5,112,000	25.	639A☆		2,880,000	25.
638B	New York	356,664,000	15.	639B	New York	170,840,000	15.
638B☆		16,992,000	20.	639B☆		8,280,000	20.
638C	Philadelphia	71,920,000	20.	639C	Philadelphia	66,880,000	20.
638C☆		3,672,000	25.	639C☆		3,240,000	25.
638D	Cleveland	75,088,000	20.	639D	Cleveland	55,360,000	20.
638D☆		3,672,000	25.	639D☆		2,880,000	25.
638E	Richmond	82,144,000	20.	639E	Richmond	51,120,000	20.
638E☆		no record	–	639E☆		2,880,000	25.
638F	Atlanta	73,288,000	20.	639F	Atlanta	66,520,000	20.
638F☆		3,816,000	25.	639F☆		2,880,000	25.
638G	Chicago	235,064,000	20.	639G	Chicago	165,080,000	15.
638G☆		11,160,000	25.	639G☆		6,480,000	25.
638H	St. Louis	46,512,000	20.	639H	St. Louis	33,040,000	20.
638H☆		2,880,000	25.	639H☆		1,800,000	25.
638I	Minneapolis	8,136,000	20.	639I	Minneapolis	13,320,000	20.
638I☆		432,000	35.	639I☆		720,000	30.
638J	Kansas City	25,448,000	20.	639J	Kansas City	33,480,000	20.
638J☆		2,304,000	25.	639J☆		2,520,000	25.
638K	Dallas	21,816,000	20.	639K	Dallas	26,280,000	20.
638K☆		1,584,000	25.	639K☆		1,440,000	25.
638L	San Francisco	101,584,000	20.	639L	San Francisco	55,000,000	20.
638L☆		6,408,000	25.	639L☆		2,880,000	25.

Federal Reserve Notes/Series 1950C, 1950D, 1950E & 1963/Green Seal

Series 1950C, Smith-Dillon				Series 1950D, Granahan-Dillon			
No.	Bank	Notes Printed	Unc	No.	Bank	Notes Printed	Unc
640A	Boston	52,120,000	$18.	641A	Boston	38,800,000	$18.
640A☆		2,160,000	20.	641A☆		1,800,000	20.
640B	New York	126,520,000	15.	641B	New York	150,320,000	15.
640B☆		6,840,000	20.	641B☆		6,840,000	20.
640C	Philadelphia	22,200,000	18.	641C	Philadelphia	19,080,000	18.
640C☆		720,000	30.	641C☆		1,808,000	20.
640D	Cleveland	33,120,000	18.	641D	Cleveland	24,120,000	18.
640D☆		1,640,000	20.	641D☆		720,000	30.
640E	Richmond	46,640,000	18.	641E	Richmond	33,840,000	18.
640E☆		1,800,000	20.	641E☆		720,000	30.
640F	Atlanta	38,880,000	18.	641F	Atlanta	36,000,000	18.
640F☆		1,800,000	20.	641F☆		1,440,000	20.
640G	Chicago	69,400,000	18.	641G	Chicago	115,480,000	15.
640G☆		3,600,000	20.	641G☆		5,040,000	20.
640H	St. Louis	23,040,000	18.	641H	St. Louis	10,440,000	18.
640H☆		1,080,000	20.	641H☆		720,000	30.
640I	Minneapolis	9,000,000	18.	641I	Minneapolis	no record	–
640I☆		720,000	30.	641I☆		not printed	–
640J	Kansas City	23,320,000	18.	641J	Kansas City	15,480,000	18.
640J☆		800,000	30.	641J☆		1,080,000	20.
640K	Dallas	17,640,000	18.	641K	Dallas	18,280,000	18.
640K☆		720,000	30.	641K☆		800,000	25.
640L	San Francisco	35,640,000	18.	641L	San Francisco	62,560,000	18.
640L☆		1,800,000	20.	641L☆		3,600,000	20.

Series 1950E, Granahan-Fowler				Series 1963, Granahan-Dillon			
No.	Bank	Notes Printed	Unc	No.	Bank	Notes Printed	Unc
642A	Boston	not printed	$–	643A	Boston	5,760,000	$18.
642A☆		not printed	–	643A☆			20.
642B	New York	12,600,000	15.	643B	New York	24,960,000	15.
642B☆		2,621,000	20.	643B☆			20.
642G	Chicago	65,080,000	12.	643C	Philadelphia	6,400,000	18.
642G☆		4,320,000	20.	643C☆			20.
642L	San Francisco	17,280,000	15.	643D	Cleveland	7,040,000	18.
642L☆				643D☆			20.
				643E	Richmond	4,480,000	18.

Series 1950E $10 notes were printed for these districts only.

643E☆			20.
643F	Atlanta	10,880,000	18.
643F☆			20.
643G	Chicago	35,200,000	15.
643G☆			20.
643H	St. Louis	13,440,000	18.
643H☆			20.
643I	Minneapolis	not printed	–
643I☆		not printed	–
643J	Kansas City	3,120,000	18.
643J☆			20.
643K	Dallas	5,120,000	18.
643K☆			20.
643L	San Francisco	14,080,000	18.
643L☆			20.

"IN GOD WE TRUST" added to back of Series 1963 and all subsequent notes.

Federal Reserve Notes/Series 1963A, 1969, 1969A & 1969B/Green Seal

Series 1963A, Granahan-Fowler				Series 1969, Elston-Kennedy			
No.	Bank	Notes Printed	Unc	No.	Bank	Notes Printed	Unc
644A	Boston	131,360,000	$15.	645A	Boston	74,880,000	$15.
644A☆		6,400,000	18.	645A☆		2,560,000	18.
644B	New York	199,360,000	15.	645B	New York	247,560,000	12.
644B☆		9,600,000	18.	645B☆		10,240,000	15.
644C	Philadelphia	100,000,000	15.	645C	Philadelphia	56,960,000	15.
644C☆		4,480,000	18.	645C☆		2,560,000	18.
644D	Cleveland	72,960,000	15.	645D	Cleveland	57,620,000	15.
644D☆		3,840,000	18.	645D☆		2,560,000	18.
644E	Richmond	114,720,000	15.	645E	Richmond	56,960,000	15.
644E☆		5,120,000	18.	645E☆		2 560,000	18.
644F	Atlanta	80,000,000	15.	645F	Atlanta	53,760,000	15.
644F☆		3,840,000	18.	645F☆		2,560,000	18.
644G	Chicago	195,520,000	15.	645G	Chicago	142,240,000	15.
644G☆		9,600,000	18.	645G☆		6,400,000	18.
644H	St. Louis	43,520,000	15.	645H	St. Louis	22,400,000	15.
644H☆		1,920,000	20.	645H☆		640,000	25.
644I	Minneapolis	16,640,000	15.	645I	Minneapolis	12,800,000	15.
644I☆		640,000	25.	645I☆		280,000	40.
644J	Kansas City	31,360,000	15.	645J	Kansas City	31,360,000	15.
644J☆		1,920,000	20.	645J☆		1,280,000	18.
644K	Dallas	51,200,000	15.	645K	Dallas	30,800,000	15.
644K☆		1,920,000	20.	645K☆		1,280,000	18.
644L	San Francisco	87,200,000	15.	645L	San Francisco	56,320,000	15.
644L☆		5,120,000	18.	645L☆		3,185,000	18.

Series 1969A, Kabis-Connally				Series 1969B, Banuelos-Connally			
No.	Bank	Notes Printed	Unc	No.	Bank	Notes Printed	Unc
646A	Boston	41,120,000	$15.	647A	Boston	16,640,000	$15.
646A☆		1,920,000	18.	647A☆		not printed	–
646B	New York	111,840,000	12.	647B	New York	60,320,000	12.
646B☆		3,840,000	18.	647B☆		1,920,000	18.
646C	Philadelphia	24,320,000	15.	647C	Philadelphia	16,880,000	15.
646C☆		1,920,000	18.	647C☆		not printed	–
646D	Cleveland	23,680,000	15.	647D	Cleveland	12,800,000	15.
646D☆		1,276,000	18.	647D☆		not printed	–
646E	Richmond	26,600,000	15.	647E	Richmond	12,160,000	15.
646E☆		640,000	25.	647E☆		640,000	20.
646F	Atlanta	20,480,000	15.	647F	Atlanta	13,440,000	15.
646F☆		640,000	25.	647F☆		640,000	20.
646G	Chicago	80,160,000	15.	647G	Chicago	32,640,000	12.
646G☆		3,560,000	18.	647G☆		1,268,000	18.
646H	St. Louis	15,360,000	15.	647H	St. Louis	8,960,000	15.
646H☆		640,000	25.	647H☆		1,280,000	18.
646I	Minneapolis	8,320,000	15.	647I	Minneapolis	3,200,000	15.
646I☆		not printed	–	647I☆		not printed	–
646J	Kansas City	10,880,000	15.	647J	Kansas City	5,120,000	15.
646J☆		not printed	–	647J☆		640,000	20.
646K	Dallas	20,480,000	15.	647K	Dallas	5,760,000	15.
646K☆		640,000	25.	647K☆		not printed	–
646L	San Francisco	27,520,000	15.	647L	San Francisco	23,840,000	15.
646L☆		1,280,000	18.	647L☆		640,000	20.

Federal Reserve Notes/Series 1969C, 1974, 1977 & 1977A/Green Seal

Series 1969C, Banuelos-Shultz				Series 1974, Neff-Simon			
No.	Bank	Notes Printed	Unc	No.	Bank	Notes Printed	Unc
648A	Boston	44,800,000	$15.	649A	Boston	104,480,000	$12.
648A☆		640,000	20.	649A☆		2,560,000	15.
648B	New York	203,200,000	12.	649B	New York	239,040,000	12.
648B☆		7,040,000	18.	649B☆		4,480,000	15.
648C	Philadelphia	69,920,000	15.	649C	Philadelphia	69,280,000	12.
648C☆		1,280,000	18.	649C☆		2,560,000	15.
648D	Cleveland	46,880,000	15.	649D	Cleveland	82,080,000	12.
648D☆		2,400,000	18.	649D☆		1,920,000	15.
648E	Richmond	45,600,000	15.	649E	Richmond	105,760,000	12.
648E☆		1,120,000	18.	649E☆		3,220,000	15.
648F	Atlanta	46,240,000	15.	649F	Atlanta	75,680,000	12.
648F☆		1,920,000	18.	649F☆		3,200,000	15.
648G	Chicago	55,200,000	15.	649G	Chicago	104,480,000	12.
648G☆		880,000	20.	649G☆		5,120,000	15.
648H	St. Louis	29,800,000	15.	649H	St. Louis	46,240,000	12.
648H☆		128,000	35.	649H☆		1,280,000	15.
648I	Minneapolis	11,520,000	15.	649I	Minneapolis	27,520,000	12.
648I☆		640,000	20.	649I☆		2,560,000	15.
648J	Kansas City	23,040,000	15.	649J	Kansas City	34,032,000	12.
648J☆		640,000	20.	649J☆		640,000	18.
648K	Dallas	24,960,000	15.	649K	Dallas	39,840,000	12.
648K☆		640,000	20.	649K☆		1,920,000	15.
648L	San Francisco	56,960,000	15.	649L	San Francisco	70,560,000	12.
648L☆		640,000	20.	649L☆		1,920,000	15.

Series 1977, Morton-Blumenthal				Series 1977A, Morton-Miller			
No.	Bank	Notes Printed	Unc	No.	Bank	Notes Printed	Unc
650A	Boston	96,640,000	$12.	651A	Boston	83,840,000	$12.
650A☆		2,688,000	15.	651A☆		1,792,000	15.
650B	New York	277,440,000	–	651B	New York	252,800,000	–
650B☆		7,296,000	15.	651B☆		6,016,000	12.
650C	Philadelphia	83,200,000	12.	651C	Philadelphia	96,000,000	12.
650C☆		896,000	15.	651C☆		2,048,000	12.
650D	Cleveland	83,200,000	12.	651D	Cleveland	60,160,000	12.
650D☆		768,000	15.	651D☆		2,176,000	12.
650E	Richmond	71,040,000	12.	651E	Richmond	113,280,000	12.
650E☆		1,920,000	15.	651E☆		3,072,000	12.
650F	Atlanta	88,960,000	12.	651F	Atlanta	49,280,000	12.
650F☆		1,536,000	15.	651F☆		1,024,000	12.
650G	Chicago	174,720,000	–	651G	Chicago	122,240,000	12.
650G☆		3,968,000	15.	651G☆		3,200,000	12.
650H	St. Louis	46,720,000	12.	651H	St. Louis	27,520,000	12.
650H☆		896,000	15.	651H☆		768,000	15.
650I	Minneapolis	10,240,000	12.	651I	Minneapolis	7,680,000	12.
650I☆		256,000	20.	651I☆		128,000	20.
650J	Kansas City	50,560,000	12.	651J	Kansas City	41,600,000	12.
650J☆		1,024,000	15.	651J☆		2,048,000	12.
650K	Dallas	53,760,000	12.	651K	Dallas	60,160,000	12.
650K☆		640,000	15.	651K☆		3,712,000	12.
650L	San Francisco	73,600,000	12.	651L	San Francisco	68,480,000	12.
650L☆		1,792,000	15.	651L☆		2,048,000	12.

Federal Reserve Notes/Series 1981, 1981A, 1985 & 1988/Green Seal

Series 1981, Buchanan-Regan				Series 1981A, Ortega-Regan			
No.	Bank	Notes Printed	Unc	No.	Bank	Notes Printed	Unc
652A	Boston	172,160,000	$12.	653A	Boston	112,000,000	$12.
652A☆		1,280,000	15.	653A☆		not printed	–
652B	New York	381,440,000	–	653B	New York	259,200,000	–
652B☆		1,920,000	15.	653B☆		24,000	75.
652C	Philadelphia	94,720,000	12.	653C	Philadelphia	48,000,000	12.
652C☆		384,000	20.	653C☆		not printed	–
652D	Cleveland	68,480,000	12.	653D☆	Cleveland	80,000,000	12.
652D☆		896,000	15.	653D☆		not printed	–
652E	Richmond	122,080,000	12.	653E	Richmond	92,800,000	12.
652E☆		2,576,000	15.	653E☆		3,200,000	15.
652F	Atlanta	72,960,000	12.	653F	Atlanta	83,200,000	12.
652F☆		1,536,000	15.	653F☆		4,736,000	15.
652G	Chicago	179,840,000	12.	653G	Chicago	99,200,000	12.
652G☆		1,280,000	15.	653G☆		not printed	–
652H	St. Louis	55,680,000	12.	653H	St. Louis	25,600,000	12.
652H☆		not printed	–	653H☆		not printed	–
652I	Minneapolis	23,680,000	12.	653I	Minneapolis	19,200,000	12.
652I☆		256,000	25.	653I☆		not printed	–
652J	Kansas City	53,120,000	12.	653J	Kansas City	48,000,000	12.
652J☆		not printed	–	653J☆		not printed	–
652K	Dallas	50,560,000	12.	653K	Dallas	48,000,000	12.
652K☆		not printed	–	653K☆		not printed	–
652L	San Francisco	144,000,000	12.	653L	San Francisco	115,200,000	12.
652L☆		1,280,000	15.	653L☆		not printed	–

Series 1985, Ortega-Baker				Series 1988A, Villalpando-Brady			
No.	Bank	Notes Printed	Unc	No.	Bank	Notes Printed	Unc
654A	Boston	380,800,000	$–	655A	Boston		
654A☆		7,296,000	–	655A☆			
654B	New York	1,027,200,000	–	655B	New York		
654B☆		not printed	–	655B☆			
654C	Philadelphia	163,200,000	–	655C	Philadelphia		
654C☆		not printed	–	655C☆			
654D	Cleveland	304,000,000	–	655D	Cleveland		
654D☆		not printed	–	655D☆			
654E	Richmond	211,200,000	–	655E	Richmond		
654E☆		not printed	–	655E☆			
654F	Atlanta	297,600,000	–	655F	Atlanta		
654F☆		384,000	15.	655F☆			
654G	Chicago	358,400,000	–	655G	Chicago		
654G☆		not printed	–	655G☆			
654H	St. Louis	131,200,000	–	655H	St. Louis		
654H☆		3,200,000	–	655H☆			
654I	Minneapolis	64,000,000	–	655I	Minneapolis		
654I☆		not printed	–	655I☆			
654J	Kansas City	86,400,000	–	655J	Kansas City		
654J☆		not printed	–	655J☆			
654K	Dallas	115,200,000	–	655K	Dallas		
654K☆		3,136,000	–	655K☆			
654L	San Francisco	300,800,000	–	655L	San Francisco		
654L☆		2,688,000	–	655L☆			

Federal Reserve Notes/Series 1990/Green Seal

Series 1990, Villalpando-Brady

No.	Bank	Notes Printed	Unc

No Series 1988 $20 notes were printed. Series 1988A and Series 1990 were in production when this catalog was printed.

This page has been left blank for your convenience.

Gold Certificate/Series 1928 & 1928A

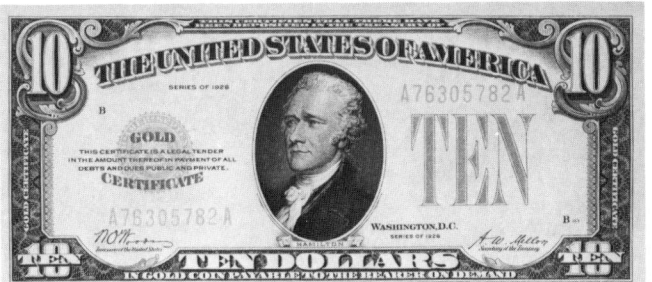

The Hamilton portrait was engraved by G.F.C. Smillie. Additional engravers were H.K. Earle, H.S. Nutter, F. Pauling and W.B. Wells. The back design is the same for all small-size $10 notes.

No.	Series	Signatures	Notes Printed	VFine	EFine	Unc
699	1928	Woods-Mellon	130,812,000	$30.	$ 50.	$200.
699☆			–	65.	135.	600.
699A	1928A	Woods-Mills	2,544,000		never released	

Demand Notes/1861

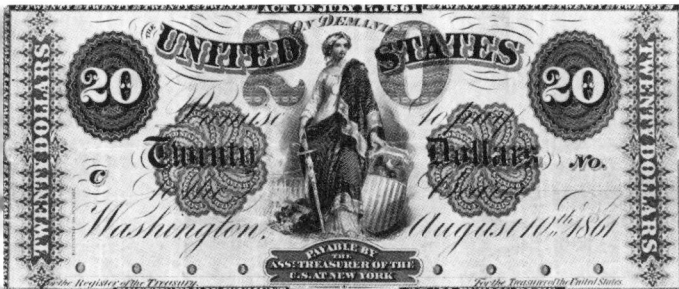

America was engraved by
Alfred Jones.

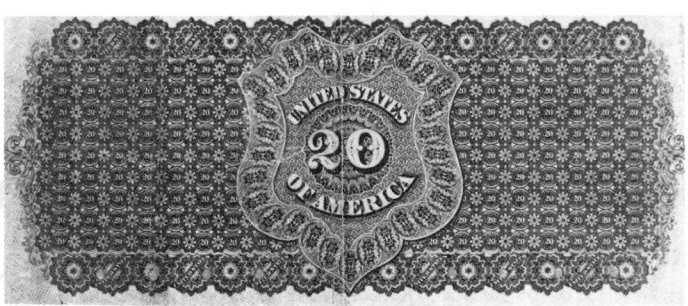

No.	Payable at	Notes Printed	Known	VGood	VFine
700A	Boston	300,000	4	$8000.	$16,000.
700B	New York	320,000	7	7500.	14,000.
700C	Philadelphia	240,000	6	8000.	15,000.
700D	Cincinnati	25,000	1	–	–
700E	St. Louis	25,000	0	–	–

Remarks: Records of 1931 indicate that 606 notes are outstanding; 10 are known in collections. Treasurer F.E. Spinner was presented with the first sheet of second emission $20 demand notes; unsigned and canceled, the sheet was cut. Spinner gave two notes to government officials and retained the illustrated note and the remaining one.

These notes, all without the U.S. Treasury Seal, were signed by representatives of the U.S. Treasurer and the Register of the Treasury. "For the" was originally written as the signatures were inscribed. These notes are extremely rare, and command a higher premium, because after a brief time "For the" was engraved on the plate (see No. 463 for an example).

United States Notes/1862 & 1863/Red Seal

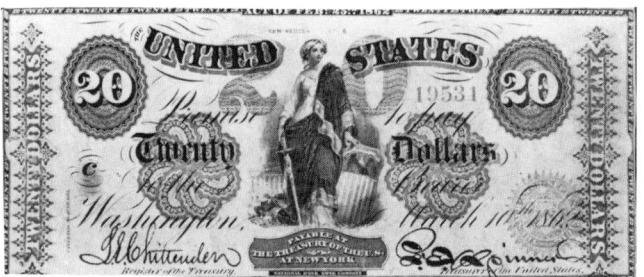

The face design is similar to the preceding note with the addition of the U.S. Treasury Seal; "On Demand" has been deleted.

First obligation back on No. 701, remaining have second obligation.

Second obligation back.

No.	Date	Description	Fine	EFine	Unc
701	1862	"American Bank Note Company" in lower border	$550.	$1100.	$3250.
701a	1862	as preceding with "National Bank Note Company in border	600.	1200.	3500.
701b	1862	"American Bank Note Company" and "National Bank Note Company" in lower border	600.	1200.	3500.
701c	1863	"American Bank Note Company" in upper border, one serial number	650.	1300.	3750.
701d	1863	same as 701 but two serial numbers	550.	1100.	3250.
702	1863	same as 701a but two serial numbers	550.	1100.	3250.

Remarks: A total of 5,146,000 notes were printed; all bear signatures of Chittenden-Spinner. Examples of Nos. 701c and 702 in uncirculated condition have been recorded between serial numbers 28655–28775 and 41634–41758; remaining unobserved notes within this range could also be in similar condition.

United States Notes/Series 1869/Red Seal

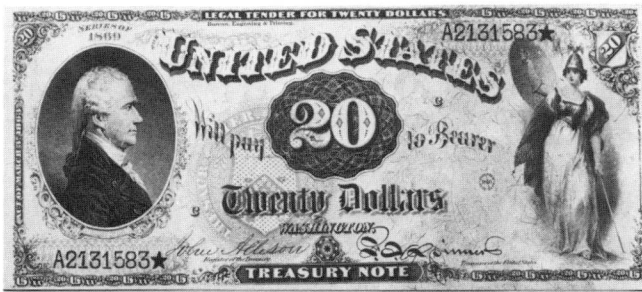

The portrait of Alexander Hamilton was engraved by Charles Burt. *Liberty*, sketched by John W. Casilear, was engraved by Alfred Jones.

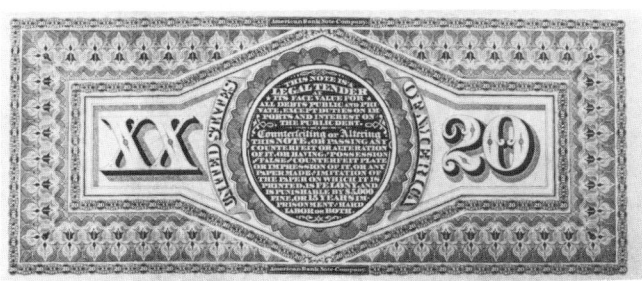

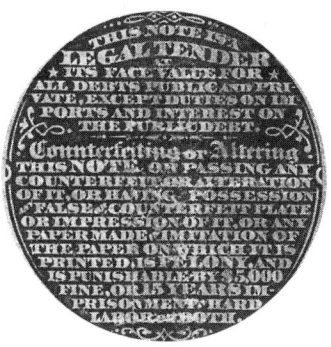

An enlarged portion of the back.

No.	Signatures	Notes Printed	Fine	EFine	Unc
703	Allison-Spinner	3,648,000	$600.	$1500.	$4500.

United States Notes/Series 1875 & 1878/Red Seal

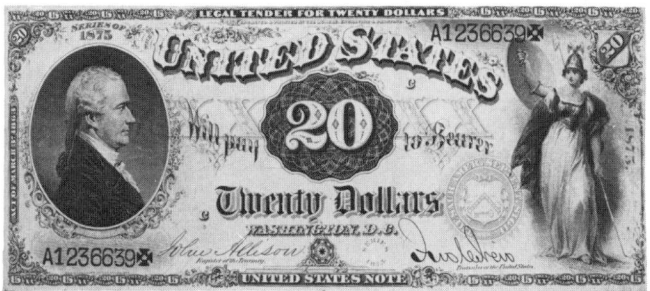

The face design is similar to No. 703 with the addition of "XX" on either side of "20."

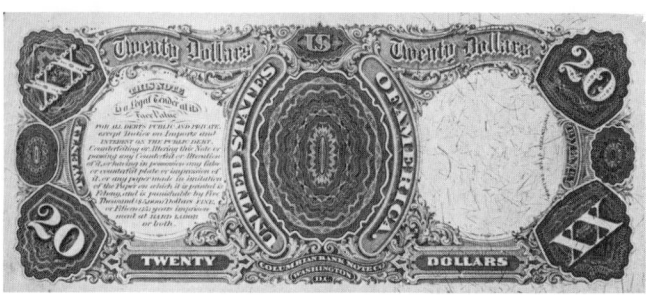

The back bears the imprint of the Columbian Bank Note Company.

No.	Series	Signatures	Notes Printed	Fine	EFine	Unc
704	1875	Allison-New	1,240,000	$500.	$800.	$2250.
705	1878	Allison-Gilfillan	1,740,000	400.	750.	2100.

Remarks: Numerous examples of No. 705 between A1013651 and A1013988, and an unspecified number commencing with A682xxx, all in new condition have been observed; these could represent hoards. No. 705 with serial number 1013688 on "US" watermarked paper, intended for fourth issue fractional currency, was in Stack's, March 14, 1989 sale.

United States Notes/Series 1880

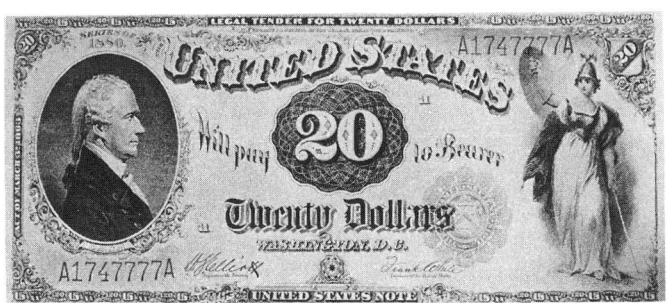

The "XX" has been deleted. The back design is the same as Nos. 704 & 705.

Serial numbers for Nos. 706–721 are blue; red for Nos. 722 & 723.

No.	Signatures	Seal	Notes Printed	Fine	EFine	Unc
706	Scofield-Gilfillan	lg. brown	316,000	$200.	$600.	$2000.
707	Bruce-Gilfillan	lg. brown	484,000	200.	600.	2000.
708	Bruce-Wyman	lg. brown	640,000	185.	550.	1900.
	Serial numbers are blue except for Nos. 722 & 723 which have red numbers.					
709	Bruce-Wyman	lg. red	500,000	200.	600.	2000.
710	Rosecrans-Jordan	lg. red	550,000	200.	600.	2000.
711	Rosecrans-Hyatt	lg. red	810,000	150.	425.	1500.
712	Rosecrans-Hyatt	lg. red, spikes	1,890,000	150.	425.	1400.
713	Rosecrans-Huston	lg. red, spikes	1,700,000	150.	425.	1400.
714	Rosecrans-Huston	lg. brown	1,050,000	150.	425.	1450.
715	Rosecrans-Nebeker	lg. brown	120,000	300.	750.	–
	Numbers 716–723 have small red seals with scallops.					
716	Rosecrans-Nebeker		1,380,000	175.	450.	1200.
717	Tillman-Morgan		2,500,000	150.	400.	1100.
718	Bruce-Roberts		2,500,000	150.	400.	1100.
719	Lyons-Roberts		1,560,000	175.	450.	1200.
720	Vernon-Treat		404,000	200.	600.	2000.
721	Vernon-McClung		408,000	200.	600.	2000.
722	Teehee-Burke		400,000	200.	600.	2000.
722 ☆	3 reported		–	–	–	–
723	Elliott-White		4,580,000	125.	300.	850.
723 ☆	14 reported		–	–	–	–

Remarks: The official total of notes issued is 20,792,000. However, higher serial numbers have been recorded by Walter Breen, who believes the total could be 21,252,000.

Numbers of notes known in parentheses have been recorded by Martin Gengerke: Nos. 706 (6), 707 (9), 709 (8), 711 (16) & 715 (8). Numerous examples of No. 716 between A768005 and A768072, in uncirculated condition, have been observed and recorded; more within this range could exist. As many as 78 consecutively numbered examples of No. 717, commencing with A9652xx, might exist. As many as 35 examples of No. 718, in uncirculated condition, starting with A119041xx, might exist. The 400,000 for No. 722 could prove to be incomplete.

Compound Interest Treasury Notes/6%/Red Seal

Act of March 3, 1863
The design of this note is similar to the following note.

No.	Signatures	Notes Printed	Notes Issued
724	Chittenden-Spinner	152,000	0

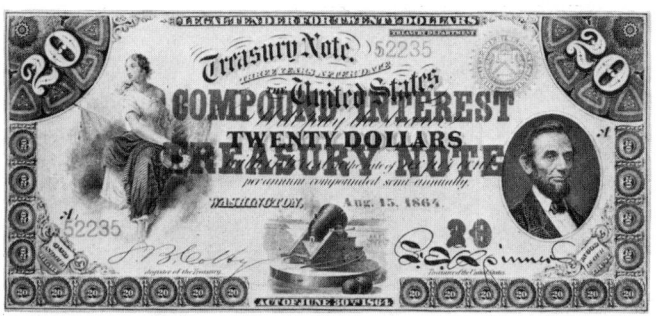

The portrait of Abraham Lincoln was engraved by Henry Gugler. The two vignettes are entitled *Victory* and *Mortar Firing*; the latter was engraved by James Smillie.

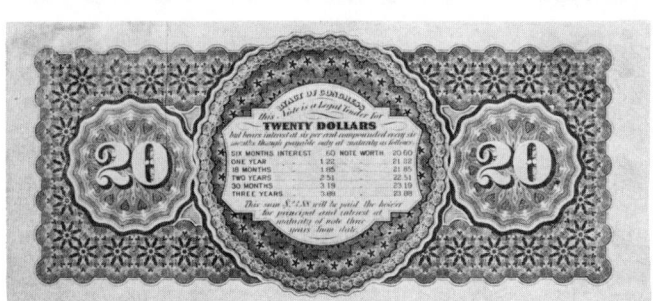

The back design includes an interest-rate table.

No.	Signatures	Act of June 30, 1864 Dated	Printed	Issued	Outstanding	VFine
725	Chittenden-Spinner	July 15, 1864	696,000	677,600	1,715	3 known
725a	Chittenden-Spinner	July 15, 1864	(error, Act of July 2, 1864)			unknown
726	Colby-Spinner	Aug. 15, 1864	194,000	included in above		$ 4,500.
726a	Colby-Spinner	Oct. 15, 1864		included in above		10,000.
726b	Colby-Spinner	Dec. 15, 1864	–	90,400	–	7,000.
726c	Colby-Spinner	Aug. 1, 1865	–	41,000	–	3 known
726d	Colby-Spinner	Sept. 1, 1865	–	–	–	unique
726e	Colby-Spinner	Sept. 15, 1865	–	55,600	–	2 known
726f	Colby-Spinner	Oct. 15, 1865	–	–	–	unknown

Remarks: The number of notes known are in parentheses: No. 726 (20); 726a (4); 726b (12). For No. 725a two $10 notes are known with this incorrect date, and the July 7, 1885 edition of *The New York Times* confirms that $50 notes were issued. It is therefore possible that $20 notes could also bear this incorrect date.

Interest-bearing Notes/One-year/5%/Red Seal

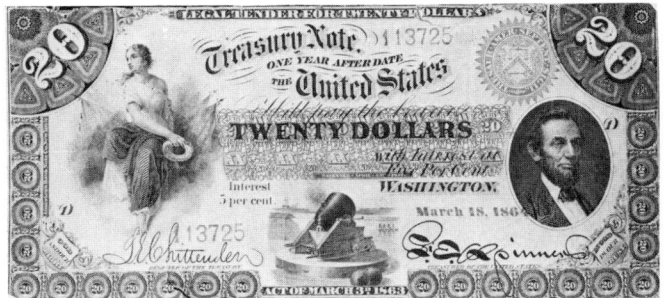

The face design, without the overprint, is similar to the preceding note. A counterfeiting clause appears on the back.

Act of March 3, 1863
Signatures of Chittenden-Spinner

No.	Dated		Known	No.	Dated		Known
	Feb.	15, 1864 (ABNCo)	1		March	23, 1864	1
	Feb.	13, 1864 (ABNCo)	1		March	30, 1864	2
	Feb.	26, 1864	1		April	5, 1864	2
	March	3, 1864 (ABNCo)	1		April	7, 1864	1
	March	5, 1864	1		April	9, 1864	1
727	March	7, 1864	2	**727**	April	14, 1864	1
	March	12, 1864	1		May	14, 1864	1
	March	15, 1864	1		April	15, 1864	3
	March	16, 1864	1		April	18, 1864 (ABNCo)	2*
	March	18, 1864 (ABNCo)	2		May	24, 1864	1
	March	19, 1864	1				

Remarks: A total of 822,000 notes were issued; 602 remain outstanding. The note dated May 14, 1864 was dated in error; it should have been April 14; only a few entered circulation. Serial number 75168 has been recorded, but not the date and variety. One of the notes with the (*) bears the imprint of ABNCo [Gengerke, 48].

National Bank Notes/First Charter Period/Red Seal

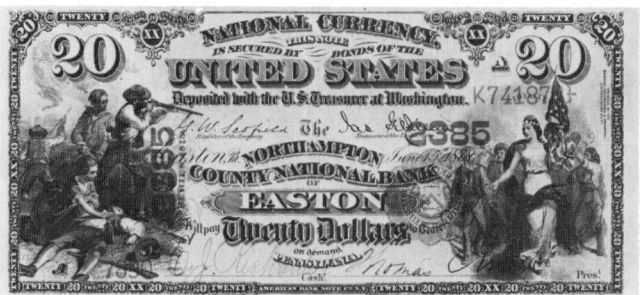

Felix O.C. Darley's painting of the *Battle of Lexington, 1775* was engraved by Joseph I. Pease; *Loyalty* was engraved by Alfred Jones. (ABNCo)

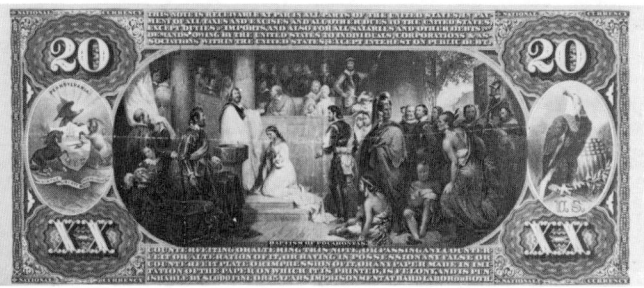

The *Baptism of Pocahontas*, by John G. Chapman, was engraved by Charles Burt.

No.	Series	Signatures	VGood	VFine	Unc
		Red seals with rays			
728	orig.	Chittenden-Spinner	$ 450.	$ 850.	$3250.
729	orig.	Colby-Spinner	450.	850.	3250.
730	orig.	Jeffries-Spinner	1000.	2400.	−
731	orig.	Allison-Spinner	450.	850.	3250.
		Red seals with scallops			
732	1875	Allison-New	450.	750.	3000.
733	1875	Allison-Wyman	450.	750.	3000.
734	1875	Allison-Gilfillan	450.	750.	3000.
735	1875	Scofield-Gilfillan	450.	750.	3000.
736	1875	Bruce-Gilfillan	450.	750.	3000.
737	1875	Bruce-Wyman	450.	800.	3200.
738	1875	Rosecrans-Huston	500.	850.	3400.
739	1875	Rosecrans-Nebeker	600.	1000.	4000.
740	1875	Tillman-Morgan	− − − − − − − − extremely rare − − − − − − − − −		

Remarks: The original series had no series date on the face. A total of 340,082 notes are outstanding.

National Bank Notes/Second Charter Period/First Issue/Series 1882/Brown Seal

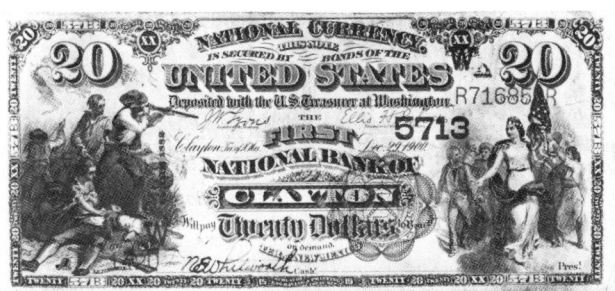

The face design is similar to the preceding note.

The back design is brown.

No.	Signatures	VGood	VFine	Unc
		First issue—brown seal		
741	Bruce-Gilfillan	$135.	$250.	$ 900.
742	Bruce-Wyman	135.	250.	900.
743	Bruce-Jordan	150.	300.	1000.
744	Rosecrans-Jordan	135.	250.	900.
745	Rosecrans-Hyatt	135.	250.	900.
746	Rosecrans-Huston	135.	250.	900.
747	Rosecrans-Nebeker	135.	250.	900.
748	Rosecrans-Morgan	350.	850.	2250.
749	Tillman-Morgan	135.	250.	900.
750	Tillman-Roberts	150.	300.	1000.
751	Bruce-Roberts	135.	250.	900.
752	Lyons-Roberts	135.	250.	900.
753	Lyons-Treat	185.	500.	1300.
754	Vernon-Treat	150.	300.	1000.

National Bank Notes/Second Charter Period/Second Issue/Series 1882/Blue Seal

The back design now includes "1882–1908." The face design is similar to the preceding note.

No.	Signatures	VGood	VFine	Unc
	Second issue – blue seal			
755	Rosecrans-Huston	$100.	$250.	$1000.
756	Rosecrans-Nebeker	100.	250.	1000.
757	Rosecrans-Morgan	275.	600.	1800.
758	Tillman-Morgan	100.	250.	1000.
759	Tillman-Roberts	100.	250.	1000.
760	Bruce-Roberts	125.	275.	1200.
761	Lyons-Roberts	100.	250.	1000.
762	Vernon-Treat	125.	275.	1000.
763	Napier-McClung	175.	500.	1750.

Third issue – blue seal

The back design now includes "TWENTY DOLLARS." The face design is similar to the preceding note.

No.	Signatures	VGood	VFine	Unc
764	Tillman-Morgan	$150.	$400.	$2000.
765	Tillman-Roberts		Rare, no recent sale.	
766	Bruce-Roberts		Rare, no recent sale.	
767	Lyons-Roberts	135.	350.	1900.
768	Lyons-Treat	175.	450.	2100.
769	Vernon-Treat	175.	450.	2100.
770	Napier-McClung	135.	350.	1900.
771	Parker-Burke		Rare, no recent sale.	
772	Teehee-Burke	135.	350.	1900.

National Bank Notes/Third Charter Period/Series 1902

Hugh McCulloch held the office of Secretary of the Treasury twice, 1865–1869 and 1884–1885. Ostrander Smith designed this note; Alfred Sealey engraved the portrait.

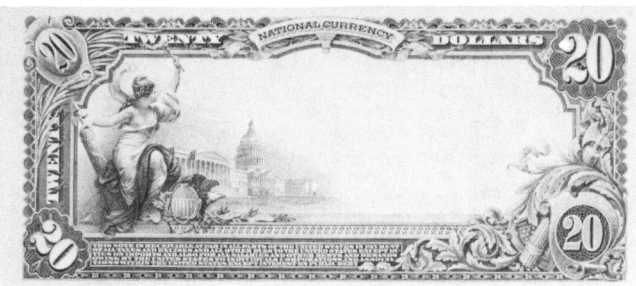

The back design is the same for all three issues; only the second issue has "1902–1908." *Union and Civilization* was engraved by G.F.C. Smillie. *The Capitol* was engraved by Marcus W. Baldwin.

No.	Signatures	VGood	VFine	Unc
		First Issue – red seal		
773	Lyons-Roberts	$150.	$235.	$1000.
774	Lyons-Treat	165.	275.	1150.
775	Vernon-Treat	165.	300.	1150.
		Second issue – blue seal		
		"1902–1908" on back		
776	Lyons-Roberts	50.	75.	400.
777	Lyons-Treat	50.	75.	400.
778	Vernon-Treat	50.	75.	400.
779	Vernon-McClung	50.	75.	400.
780	Napier-McClung	50.	85.	450.
781	Napier-Thompson	65.	115.	500.
782	Napier-Burke	50.	85.	450.
783	Parker-Burke	50.	75.	400.
784	Teehee-Burke	65.	115.	500.

National Bank Notes/Third Charter Period/Series 1902 *(continued)*

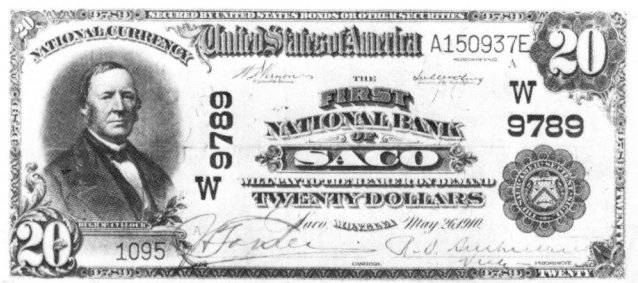

The face and back designs are the same as the preceding note.

Third issue—blue seal

Third issue—blue seal

No.	Signatures	VGood	VFine	Unc
785	Lyons-Roberts	$ 50.	$ 75.	$300.
786	Lyons-Treat	50.	75.	300.
787	Vernon-Treat	50.	75.	300.
788	Vernon-McClung	50.	75.	300.
789	Napier-McClung	50.	75.	300.
790	Napier-Thompson	75.	135.	400.
791	Napier-Burke	50.	90.	350.
792	Parker-Burke	50.	90.	350.
793	Teehee-Burke	50.	75.	300.
794	Elliott-Burke	50.	75.	300.
795	Elliott-White	50.	75.	300.
796	Speelman-White	50.	75.	300.
797	Woods-White	100.	200.	500.
798	Woods-Tate	135.	300.	650.
798a	Jones-Woods	Rare, no recent sale.		

National Gold Bank Notes/Red Seal

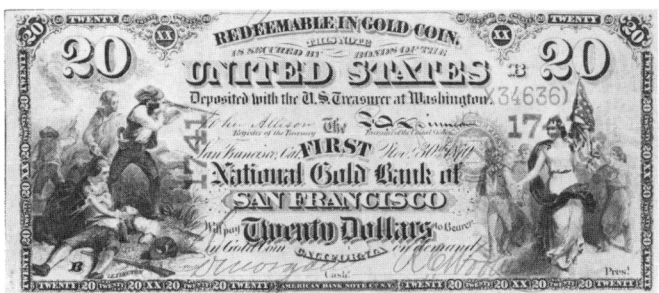

The face design is similar to Nos. 728–754.

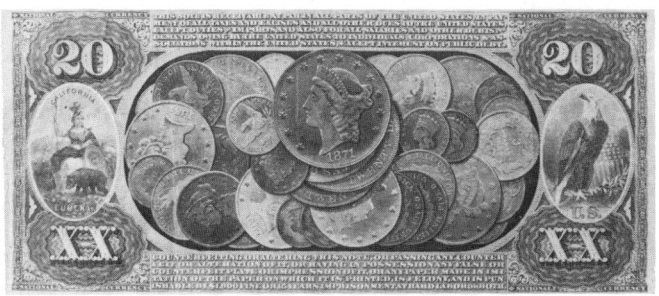

The gold coin vignette was engraved by James Smillie. The signatures of Bruce-Gilfillan appear on No. 800; Scofield-Gilfillan on Nos. 802a, 804a and 804b. Remaining notes have signatures of Allison-Spinner.

No.	Date	Issuing Bank	City	Issued	Known	VGood	Fine
799	1870*	First Nat'l Gold Bank	San Francisco	11,248	20	$3000.	$4700.
800	1875	First Nat'l Gold Bank	San Francisco	3,600	7	3000.	6000.
800a	1875	as preceding on white paper		–	4	3500.	6500.
801	1872	National Gold Bank of D.O. Mills & Company	Sacramento	3,641	3	3500.	6500.
802	1873*	First Nat'l Gold Bank	Stockton	5,000	5	3500.	6250.
802a	1875	First Nat'l Gold Bank	Stockton	293	1	–	–
803	1874	Farmers Nat'l Gold Bank	San Jose	2,849	5	3500.	6250.
804	1874*	First Nat'l Gold Bank	Petaluma	2,000	1	–	–
804a	1875	First Nat'l Gold Bank	Petaluma	200	0		
804b	1875	as preceding on white paper		163	1	–	–
805	1875*	First Nat'l Gold Bank	Oakland	1,600	6	3500.	6250.
805a	1875	First Nat'l Gold Bank	Oakland	12	0		
806	1875	Union Nat'l Gold Bank	Oakland	500	2	–	–
807	1873*	First Nat'l Gold Bank	Santa Barbara	800	1	–	–

Remarks: The (*) indicates the note is from the original series. A total of 506 notes is outstanding.

Silver Certificates/Series 1878 & 1880

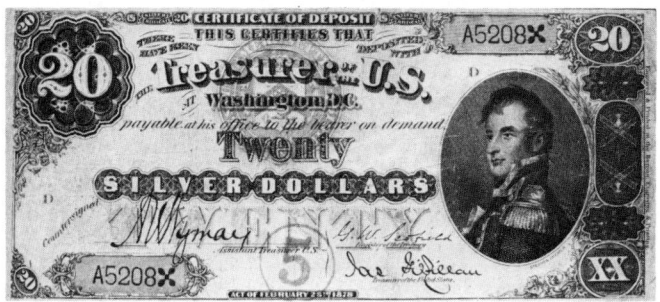

The portrait of U.S. Naval Commander Stephen Decatur was engraved by Charles Schlecht. Decatur was killed in 1820 in a duel with James Baron.

Nos. 808–813 have the signatures of Scofield-Gilfillan; they have red seals with the exception of No. 813, which has a brown seal. On Nos. 808–812 the key is reversed in the Treasury seal.

No.	Series	Countersignatures	Payable at	Issued	Known	VGood	Fine
808	1878	W.G. White*	New York	20,000	0	$ –	$ –
809	1878	J.C. Hopper*	New York	incl. in above	3	–	20000.
809a	1878	T. Hillhouse	New York	–	4	–	28000.
810	1878	R.M. Anthony*	San Francisco	3,300	0	–	–
811	1878	A.U. Wyman*	Washington, DC	4,000	2	–	–
812	1878	A.U. Wyman	Washington, DC	88,000	14	1500.	8000.
813	1880	T. Hillhouse	New York	182,000	6	3500.	9000.

			Series 1880				
No.	Signatures	Seal	Notes Issued	Known	VGood	VFine	Unc
814	Scofield-Gilfillan	brown	1,216,000	21	450.	1000.	5000.
815	Bruce-Gilfillan	brown	556,000	22	600.	1100.	7500.
816	Bruce-Wyman	brown	1,960,000	65	450.	1000.	5000.
817	Bruce-Wyman	red	124,000	17	750.	1750.	10000.

Remarks: The (*) indicates autographed countersignatures. For No. 810, 40,000 notes were printed; all but 3,300 were burned on October 19, 1881. A "XX" appears in the center of Nos. 813–816. Plates were made for the No. 814–817 type with signatures of Rosecrans-Jordan.

Silver Certificates/Series 1886 & 1891

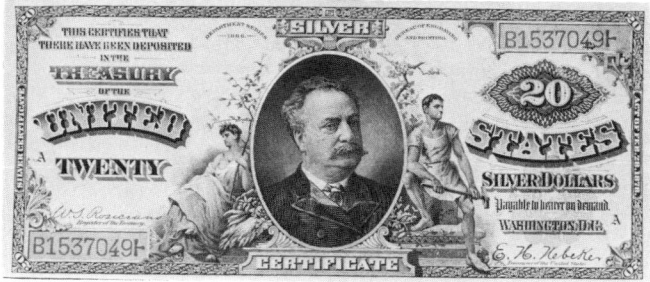

Daniel Manning was Secretary of the Treasury, 1865–1887. His portrait was engraved by Lorenzo Hatch. The two allegorical figures represent *Agriculture* and *Industry*.

The back design was engraved by D.M. Cooper and G.U. Rose.

No.	Signatures	Seal	Notes Printed	Known	Fine	EFine	Unc
818	Rosecrans-Hyatt	lg. red	12,000	8	$1800.	$6250.	$ —
819	Rosecrans-Huston	lg. brown	616,000	29	1500.	4250.	9000.
820	Rosecrans-Nebeker	lg. brown	872,000	11	1400.	4000.	8000.
821	Rosecrans-Nebeker	sm. red	212,000	14	1600.	5000.	—

Series 1891

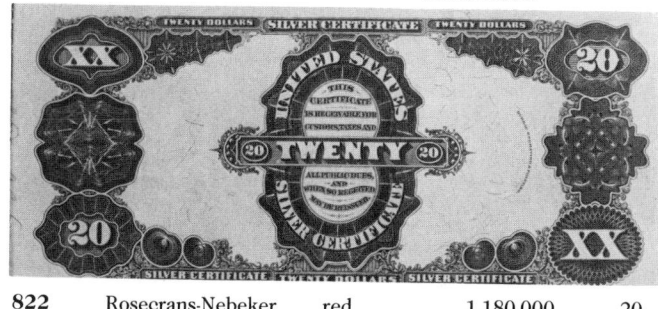

The face design is similar to the preceding note.

822	Rosecrans-Nebeker	red	1,180,000	20	350.	650.	2600.
823	Tillman-Morgan	red	5,920,000	39	250.	500.	2350.
824	Bruce-Roberts	red	1,500,000	17	350.	650.	2500.
825	Lyons-Roberts	red	504,000	20	400.	750.	—
826	Parker-Burke	blue	1,500,000	74	300.	650.	2600.
826☆				3	no recent sale		
827	Teehee-Burke	blue	424,000	29	400.	750.	—

Remarks: Nos. 826 and 827 have "XX" in blue on the face. As many as 24 of No. 825 exist in uncirculated condition commencing with E86814xx. As many as 34 consecutively numbered notes of No. 826 exist in uncirculated condition commencing with H14412xx. E1, the first No. 822 note is known.

Gold Certificates/Act of March 3, 1863/First Issue

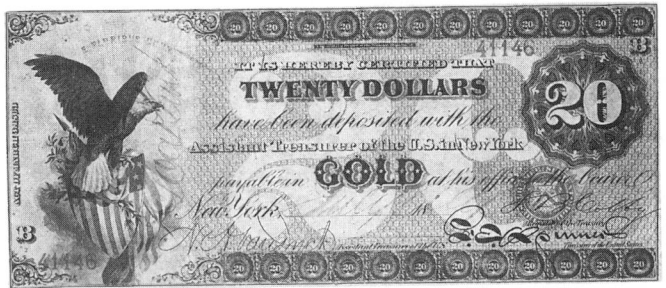

E Pluribus Unum was engraved by Charles Skinner.

The back design is gold.

No.	Signatures	Payable at	Printed	Issued	Outstanding	Known
827a	Colby-Spinner	New York	100,000	48,000	9	1
827b	Colby-Spinner	New York	included in above		–	3

Remarks: No. 827a has an autographed countersignature. No. 827b has a printed countersignature. Serial number 36621 is at the Bureau of the Public Debt; 41146 was sold in 1979 for $100,000; 48545 is at the Smithsonian Institution.

Gold Certificates/Series 1882

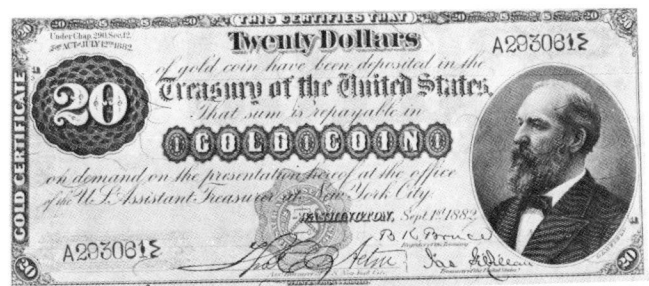

The portrait of President James Garfield was engraved by Charles Burt.

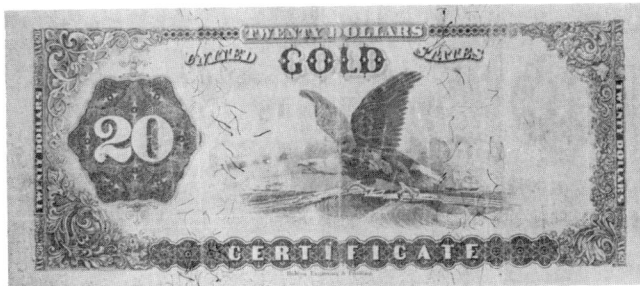

Ocean Telegraph, which commemorated the completion of the Atlantic Cable in 1858, was engraved by George D. Baldwin. The back design is gold.

No.	Signatures	Seal	Notes Printed	Known	VGood	VFine	Unc
828	Bruce-Gilfillan	brown	14,000	2		no recent sale	
829	Bruce-Gilfillan	brown	586,000	18	$2000.	$4500.	$9250.
830	Bruce-Gilfillan	brown	448,000	4		no recent sale	
831	Bruce-Wyman	brown	232,000	14	2250.	4750.	9750.
832	Rosecrans-Huston	lg. brown	200,000	16	1850.	4250.	9500.
833	Lyons-Roberts	sm. red	16,344,000	–	100.	350.	1750.

Remarks: Both No. 828 & 829, payable at New York, are countersigned by Thomas C. Acton; No. 828 bears the autographed countersignature. Martin Gengerke has recorded the following serial numbers for No. 828 (A1 and A2205), and No. 830 (A337644, A338121, A370769 and A399371).

Gold Certificates/Series 1905–1922

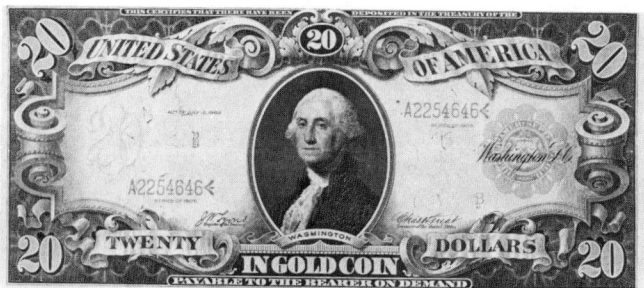

The portrait of George Washington was engraved by Alfred Sealey.

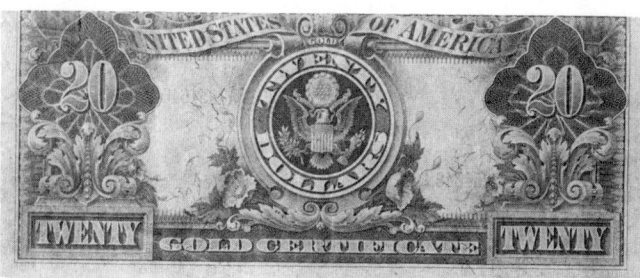

The Great Seal of the U.S. on this gold back was engraved by Robert Ponickau.

No.	Series	Signatures	Notes Issued	VFine	EFine	Unc
834	1905	Lyons-Roberts	1,664,000	$750.	$2400.	$7250.
835	1905	Lyons-Treat	3,012,000	600.	2250.	6000.
836	1906	Vernon-Treat	12,176,000	75.	150.	475.
837	1906	Vernon McClung	6,924,000	85.	185.	525.
838	1906	Napier-McClung	8,248,000	85.	185.	525.
838☆	1906	8 reported	—	400.	800.	1850.
839	1906	Napier-Thompson	2,276,000	100.	200.	750.
840	1906	Parker-Burke	8,316,000	85.	185.	525.
840☆	1906	5 reported	—	500.	900.	2000.
841	1906	Teehee-Burke	10,064,000	75.	165.	475.
842	1922	Speelman-White	87,120,000	75.	125.	400.
842☆	1922	64 reported	—	200.	450.	950.

Remarks: Serial number 1 has been recorded for No. 834; serial numbers A1, A7 and A8 for No. 835. No. 840 exists as a hoard, H567728–800.

Treasury or Coin Notes/Series 1890

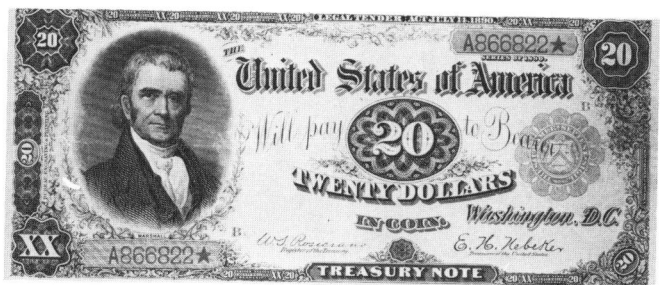

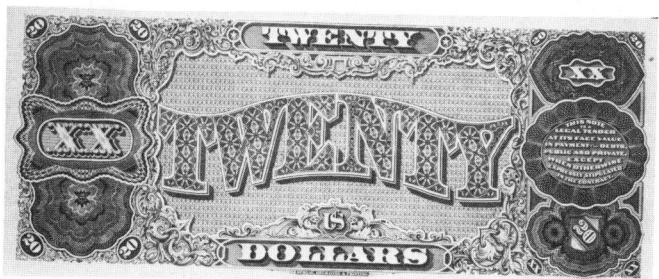

John Marshall served as Secretary of State and Chief Justice of the Supreme Court. He was born in Virginia in 1755 and died in Philadelphia in 1835. The Henry Inman portrait of Marshall was engraved by Charles Schlecht.

No.	Signatures	Seal	Notes Printed	Known	Fine	EFine	Unc
843	Rosecrans-Huston	brown	488,000	25	$1250.	$3750.	$10000.
844	Rosecrans-Nebeker	brown	100,000	7		no recent sale	
845	Rosecrans-Nebeker	red	704,000	60	1000.	3500.	9500.

Known notes have been compiled by Martin Gengerke, Gene Hessler and John Isted:

No. 843					No. 844
A3	A1590	A45439	A107812	A284998	A539883
A4	A11136	A54623	A172211	A405549	A560825
A5	A16604	A67796	A187146	A405833	A571751
A6	A24619	A76133	A189910	A434346	
A31	A25124	A101595	A247517	A468886	

Treasury or Coin Notes/Series 1891

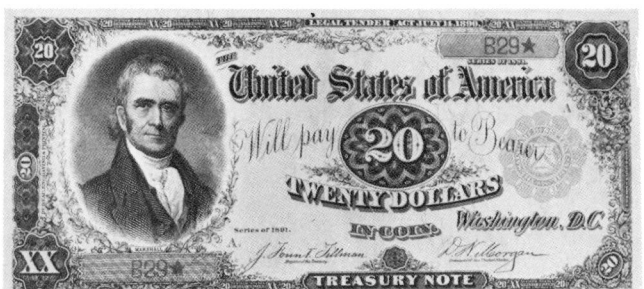

The face design is similar
to the preceding note.

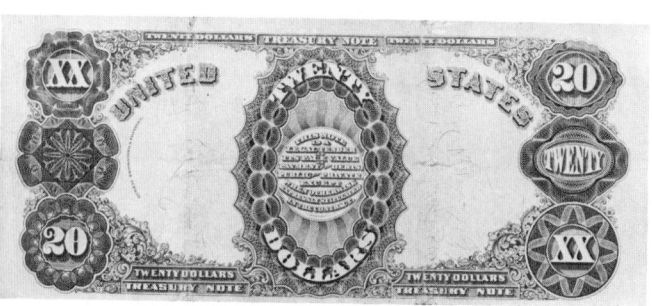

No.	Signatures	Seal	Printed	Notes Issued	Notes Known	Fine	EFine	Unc
846	Tillman-Morgan	red	820,000	496,000	52	$1750.	$5250.	$14500.
847	Bruce-Roberts	red	328,000	incl. in above	2	no recent sale		

Known notes for No. 846 have been compiled by Martin Gengerke, Gene Hessler and John Isted:

B1	B30148	B91298	B229061	B311956	B446071
B2	B33406	B104454	B230939	B329537	B466423
B27	B33885	B106881	B239622	B334014	B466494
B29	B40830	B124853	B243015	B346450	B490627
B30	B50753	B181342	B249642	B383719	
B33	B63742	B181368	B287025	B407411	
B5319	B77874	B208353	B290649	B420175	
B28634	B81070	B208586	B300155	B443244	

Federal Reserve Notes/Series 1914/Red Seal

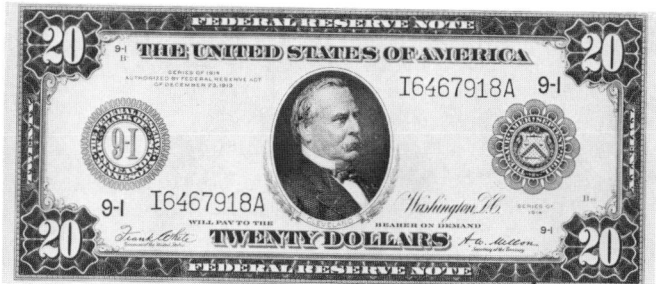

The portrait of Grover Cleveland was engraved by G.F.C. Smillie. *Land, Sea and Air,* which represents the four methods of transportation, was engraved by Marcus W. Baldwin.

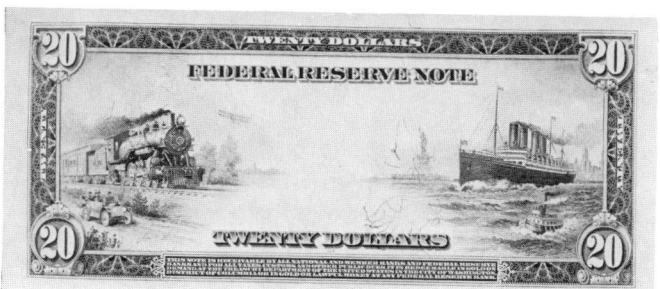

Signatures of Burke-McAdoo

No.	Bank	VFine	Unc	No.	Bank	VFine	Unc
848A	Boston	$175.	$800.	848G	Chicago	$150.	$750.
848B	New York	150.	750.	848H	St. Louis	150.	750.
848C	Philadelphia	150.	750.	848I	Minneapolis	150.	750.
848D	Cleveland	150.	750.	848J	Kansas City	150.	750.
848E	Richmond	150.	750.	848K	Dallas	150.	750.
848F	Atlanta	150.	750.	848L	San Francisco	175.	800.

Remarks: The first day of issue for this issue was November 16, 1914. Type II, as illustrated with small district number and letter in the upper left and lower right corners, was printed for all districts except Atlanta and Dallas. See No. 380 for additional illustrations.

Federal Reserve Notes/Series 1914/Blue Seal

No.	Bank	Signatures	Printed	Delivered	VFine	Unc
849A1	Boston	Burke-McAdoo			$40.	$150.
849A1☆	1 reported				–	–
849A2	Boston	Burke-Glass			45.	175.
849A2☆	2 reported		26,024,000	25,760,000	–	–
849A3	Boston	Burke-Houston			40.	150.
849A3☆	5 reported		(200,000)		–	–
849A4	Boston	White-Mellon			40.	150.
849B1	New York	Burke-McAdoo			40.	150.
849B1☆	1 reported				–	–
849B2	New York	Burke-Glass			45.	175.
849B2☆	2 reported		59,848,000	58,704,000	–	–
849B3	New York	Burke-Houston			40.	150.
849B3☆	8 reported				–	–
849B4	New York	White Mellon (b,c)			40.	150.
849B4☆	11 reported		(472,000)		–	–
849C1	Philadelphia	Burke-McAdoo			40.	150.
849C1☆	2 reported				–	–
849C2	Philadelphia	Burke-Glass			45.	175.
849C3	Philadelphia	Burke-Houston	30,088,000	30,088,000	40.	150.
849C3☆	8 reported				–	–
849C4	Philadelphia	White-Mellon			40.	150.
849C4☆	4 reported		(216,000)		–	–
849D1	Cleveland	Burke-McAdoo			40.	150.
849D1☆	1 reported				–	–
849D2	Cleveland	Burke-Glass			45.	175.
849D2☆	1 reported		38,544,000	38,544,000	–	–
849D3	Cleveland	Burke-Houston			40.	150.
849D3☆	5 reported				–	–
849D4	Cleveland	White-Mellon (b)			40.	150.
849D4☆	4 reported		(280,000)		–	–
849E1	Richmond	Burke-McAdoo			40.	150.
849E1☆	1 reported				–	–
849E2	Richmond	Burke-Glass			45.	175.
849E3	Richmond	Burke-Houston	17,336,000	16,944,000	40.	150.
849E3☆	1 reported				–	–
849E4	Richmond	White-Mellon (b)	(136,000)		40.	150.
849E4☆	1 reported				–	–
849F1	Atlanta	Burke-McAdoo			40.	150.
849F1☆	5 reported				–	–
849F2	Atlanta	B-G, not printed			45.	175.
849F3	Atlanta	Burke-Houston	16,384,000	15,956,000	40.	150.
849F3☆	3 reported				–	–
849F4	Atlanta	White-Mellon (b)			40.	150.
849G1	Chicago	Burke-McAdoo			40.	150.
849G2	Chicago	Burke-Glass			45.	175.
849G2☆	4 reported				–	–
849G3	Chicago	Burke-Houston	46,776,000	46,776,000	40.	150.
849G3☆	16 reported				–	–
849G4	Chicago	White-Mellon (b,c)			40.	150.
849G4☆	5 reported		(364,000)		–	–

Federal Reserve Notes/Series 1914/Blue Seal *(continued)*

No.	Bank	Signatures	Notes Printed	Delivered	VFine	Unc
849H1	St. Louis	Burke-McAdoo			$40.	$150.
849H1 ☆	6 reported				–	–
849H2	St. Louis	Burke-Glass			45.	175.
849H2 ☆	1 reported		10,748,000	10,748,000	–	–
849H3	St. Louis	Burke-Houston			40.	150.
849H3 ☆	8 reported				–	–
849H4	St. Louis	White-Mellon	(144,000)		40.	150.
849I1	Minneapolis	Burke-McAdoo			40.	150.
849I1 ☆	3 reported				–	–
849I2	Minneapolis	Burke-Glass	6,872,000	6,600,000	45.	175.
849I3	Minneapolis	Burke-Houston			40.	150.
849I3 ☆	2 reported				–	–
849I4	Minneapolis	White-Mellon	(76,000)		40.	150.
849J1	Kansas City	Burke-McAdoo			40.	150.
849J2	Kansas City	B-G, not printed			45.	175.
849J3	Kansas City	Burke-Houston	9,172,000	9,172,000	40.	150.
849J3 ☆	6 reported				–	–
849J4	Kansas City	White-Mellon	(56,000)		40.	150.
849K1	Dallas	Burke-McAdoo			40.	150.
849K1 ☆	9 reported				–	–
849K2	Dallas	Burke-Glass	7,064,000	6,872,000	45.	175.
849K3	Dallas	Burke-Houston			40.	150.
849K4	Dallas	White-Mellon	(76,000)		40.	150.
849L1	San Francisco	Burke-McAdoo			40.	150.
849L1 ☆	2 reported				–	–
849L2	San Francisco	Burke-Glass			45.	175.
849L2 ☆	1 reported		35,756,000	35,756,000	–	–
849L3	San Francisco	Burke-Houston			40.	150.
849L3 ☆	4 reported				–	–
849L4	San Francisco	White-Mellon (b,c)			40.	150.
849L4 ☆	8 reported		(296,000)		–	–

Remarks: The figure in parenthesis, the last replacement serial number, is the total number of replacement notes of this denomination printed for that bank; the number printed by signatures is not available. White-Mellon plate variations in parenthesis exist for some districts identified as type "b" (small district number and letter in lower left) and type "c" (space of 18 mm horizontal from left seal to the engraved border). Star, replacement notes reported in the main listing above are type "a."

Federal Reserve Bank Notes/Series 1915 & 1918/Blue Seal

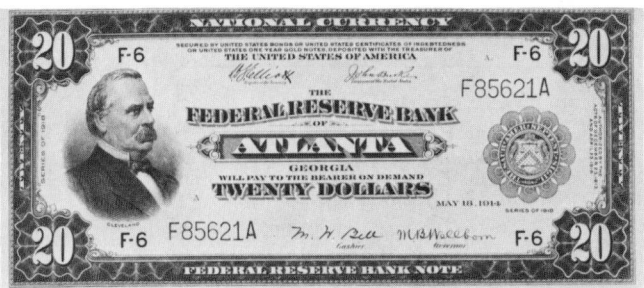

The portrait of Grover Cleveland was engraved by G.F.C. Smillie.

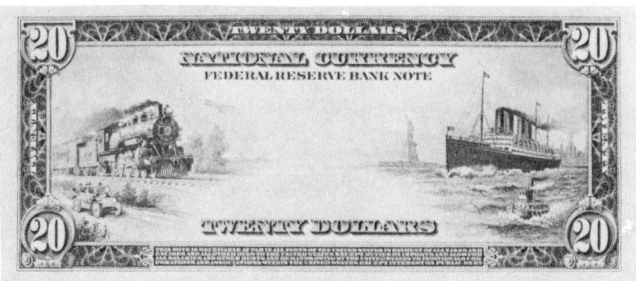

The back design is the same as No. 848.

No.	Bank	Series	Bank Signatures	Issued	Fine	EFine	Unc
850F1	Atlanta	1915	Bell-Wellborn (Bell as cashier)		– – – –	Unique	– – – –
850F1a	Atlanta	1918	Bell-Wellborn (Bell as secretary)	24,000			
850F3	Atlanta	1915	Pike-McCord		– – – –	Unique	– – – –
850F4	Atlanta	1918	Bell-Wellborn	96,000	$375.	$700.	$2000.
850G1	Chicago	1915	McLallen-McDougal	84,000	375.	700.	2000.
850H1	St. Louis	1918	Attebery-Wells	24,000	450.	925.	2500.
850J1	Kansas City	1915	Anderson-Miller		375.	800.	2200.
850J2	Kansas City	1915	Cross Miller	180,000	375.	800.	2200.
850J2a	Kansas City	1915	Cross-Miller		375.	800.	2200.
850K1	Dallas	1915	Hoopes-Van Zandt		– – – –	5 known	– – – –
850K2	Dallas	1915	Gilbert-Van Zandt	100,000	– – – –	4 known	– – – –
850K3	Dallas	1915	Talley-Van Zandt		– – – –	2 known	– – – –

Remarks: Government signatures are Teehee-Burke except for No. 850F4, which has Elliott-Burke. On No. 850J2a signatures are large; Cross is "Acting Secretary." For Nos. 850G, H and K, respectively, 170, 93 and 230 notes are outstanding.

Federal Reserve Bank Notes/Series 1929/Brown Seal

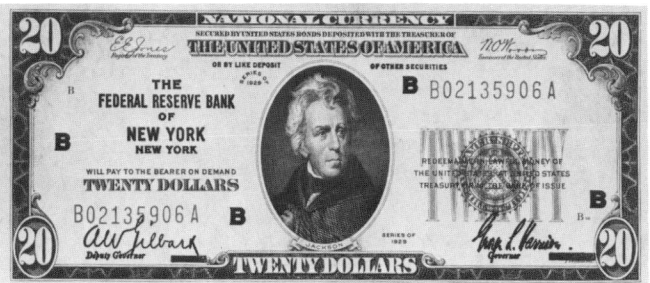

The portrait of Andrew Jackson was engraved by Alfred Sealey in 1867.

The White House.

Signatures of Jones-Woods

No.	Bank	Notes Printed	VFine	EFine	Unc
851A	Boston	927,000	$25.	$35.	$ 65.
851B	New York	2,568,000	–	25.	50.
851B☆		–	–	–	–
851C	Philadelphia	1,008,000	22.	30.	60.
851C☆		–	–	–	–
851D	Cleveland	1,020,000	22.	30.	60.
851D☆		–	–	–	–
851E	Richmond	1,632,000	22.	35.	65.
851E☆		–	–	–	–
851F	Atlanta	960,000	25.	35.	80.
851G	Chicago	2,028,000	–	25.	50.
851H	St. Louis	444,000	30.	50.	100.
851H☆		–	–	–	–
851I	Minneapolis	864,000	25.	35.	65.
851I☆		–	–	–	–
851J	Kansas City	612,000	30.	50.	90.
851J☆		–	–	–	–
851K	Dallas	468,000	30.	50.	100.
851K☆		–	–	–	–
851L	San Francisco	888,000	25.	35.	75.
851L☆		–	–	–	–

National Bank Notes/1929/Brown Seal

Type I with the Alfred Sealey portrait of Andrew Jackson.

Type II has the bank charter number printed a second time near the serial number.

		Type I			Type II		
No.	Rarity	VFine	EFine	Unc	VFine	EFine	Unc
	1	$ 25.	$ 35.	$ 60.	$ 30.	$ 50.	$ 75.
	2	30.	40.	70.	35.	55.	80.
	3	35.	50.	80.	40.	65.	100.
	4	45.	60.	90.	55.	80.	120.
852	5	60.	75.	115.	70.	100.	150.
	6	75.	100.	140.	100.	135.	180.
	7	90.	125.	200.	135.	180.	275.
	8	125.	200.	300.	275.	425.	–
	9	500.	–	–	–	–	–

Remarks: The total issue for both types was 124,236,394 notes; both have the signatures of Jones-Woods.

Federal Reserve Notes/Series 1928, 1928A, 1928B & 1928C/Green Seal

The back design is similar
to No. 851.

Series 1928, Tate-Mellon No.	Bank	Notes Printed	Unc	Series 1928A, Woods-Mellon No.	Bank	Notes Printed	Unc
853A	Boston	3,790,880	$40.	854A	Boston	1,293,900	$40.
853A☆		not printed	–	854A☆			–
853B	New York	12,797,000	30.	854B	New York	1,055,800	40.
853B☆			–	854B☆		1 reported	
853C	Philadelphia	3,787,200	40.	854C	Philadelphia	1,717,200	40.
853C☆			–	854C☆		not printed	
853D	Cleveland	10,626,900	30.	854D	Cleveland	625,200	40.
853D☆		not printed	–	854D☆			–
853E	Richmond	4,119,600	40.	854E	Richmond	1,534,500	40.
853E☆			–	854E☆		1 reported	
853F	Atlanta	3,842,000	40.	854F	Atlanta	1,442,400	40.
853F☆			–	854F☆		not printed	–
853G	Chicago	10,891,740	30.	854G	Chicago	822,000	40.
853G☆			–	854G☆			–
853H	St. Louis	2,523,300	40.	854H	St. Louis	573,300	40.
853H☆			–	854H☆			–
853I	Minneapolis	2,633,100	40.	854I	Minneapolis	not printed	–
853I☆			–	854I☆		not printed	–
853J	Kansas City	2,584,500	40.	854J	Kansas City	113,400	65.
853J☆			–	854J☆		not printed	–
853K	Dallas	1,568,500	40.	854K	Dallas	1,032,000	40.
853K☆			–	854K☆		not printed	–
853L	San Francisco	8,404,800	30.	854L	San Francisco	9,689,124	30.
853L☆			–	854L☆			–

Series 1928B, Woods-Mellon No.	Bank	Notes Printed	Unc	Series 1928B, Woods-Mellon (cont'd) No.	Bank	Notes Printed	Unc
855A	Boston	7,749,636	$30.	855H	St. Louis	3,834,600	$35.
855A☆			–	855I	Minneapolis	3,298,920	35.
855B	New York	19,448,436	30.	855J	Kansas City	4,941,252	35.
855B☆			–	855K	San Francisco	8,404,800	30.
855C	Philadelphia	8,095,548	30.				
855D	Cleveland	11,648,196	30.	**Series 1928C, Woods-Mills**			
855E	Richmond	4,413,900	35.	No.	Bank	Notes Printed	Unc
855F	Atlanta	2,390,240	35.				
855G	Chicago	17,220,276	30.	856G	Chicago	3,363,300	200.
855G☆			–	856L	San Francisco	1,420,000	200.

Federal Reserve Notes/Series 1934, 1934A & 1934B/Green Seal

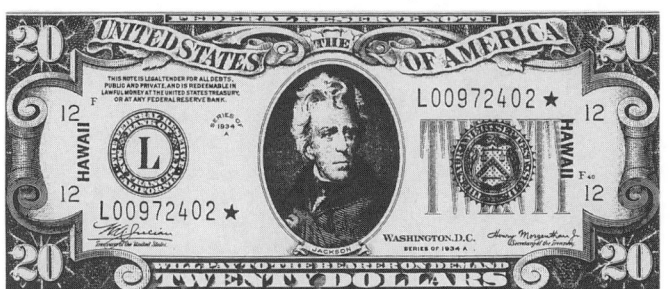

The back design is similar to No. 851.

Series 1934, Julian-Morgenthau

No.	Bank	Notes Printed	Unc
857A	Boston	27,673,000	$35.
857A☆			–
857B	New York	27,573,264	35.
857B☆			–
857C	Philadelphia	53,209,968	35.
857C☆			–
857D	Cleveland	48,301,416	35.
857D☆			–
857E	Richmond	36,259,224	35.
857E☆			–
857F	Atlanta	41,547,660	35.
857F☆			–
857G	Chicago	20,777,832	35.
857G☆			–
857H	St. Louis	27,174,552	35.
857H☆			–
857I	Minneapolis	16,795,000	40.
857I☆			–
857J	Kansas City	20,852,160	35.
857J☆			–
857K	Dallas	20,852,160	35.
857K☆			–
857L	San Francisco	32,203,956	35.
857L☆			–
857LL	(HAWAII)	incl. in 858LL	750.
857LL☆			1800.

Series 1934A, Julian-Morgenthau

No.	Bank	Notes Printed	Un
858A	Boston	3,202,416	$4(
858A☆			-
858B	New York	102,555,538	3!
858B☆			-
858C	Philadelphia	3,371,316	4(
858C☆			-
858D	Cleveland	23,475,108	3!
858D☆			-
858E	Richmond	46,816,224	3!
858E☆			-
858F	Atlanta	6,756,816	4(
858F☆			-
858G	Chicago	91,141,452	3!
858G☆			-
858H	St. Louis	3,701,568	4(
858H☆			-
858I	Minneapolis	1,162,500	4(
858I☆			-
858J	Kansas City	3,221,184	4(
858J☆			-
858K	Dallas	2,531,700	4(
858K☆			-
858L	San Francisco	94,454,112	3!
858L☆			-
858LL	(HAWAII)	11,246,000	32!
858LL☆			200(

Series 1934B, Julian-Vinson

No.	Bank	Notes Printed	Unc	No.	Bank	Notes Printed	Un
859A	Boston	3,904,800	$35.	859G	Chicago	9,084,600	$3(
859A☆			–	859G☆			-
859B	New York	14,876,436	30.	859H	St. Louis	5,817,300	3(
859B☆			–	859H☆			-
859C	Philadelphia	3,271,452	35.	859I	Minneapolis	2,817,300	3!
859C☆			–	859I☆		not printed	-
859D	Cleveland	2,814,600	35.	859J	Kansas City	3,524,244	3!
859D☆			–	859J☆			-
859E	Richmond	9,451,632	30.	859K	Dallas	2,807,388	3!
859E☆			–	859K☆			-
859F	Atlanta	6,887,640	30.	859L	San Francisco	5,289,540	3(
859F☆			–	859L☆			-

Federal Reserve Notes/Series 1934C & 1934D/Green Seal

On 20 July 1948 an altered version of the *White House* was first used on backs of $20 notes, Series 1934C; consequently, this series can be found with the old and new version. The plate, engraved by Charles Brooks, shows two additional chimneys, a second floor balcony and larger trees and shrubbery. All subsequent $20 notes bear this altered back design.

Series 1934C, Julian-Snyder				Series 1934D, Clark-Snyder			
No.	Bank	Notes Printed	Unc	No.	Bank	Notes Printed	Unc
860A	Boston	7,397,352	$35.	861A	Boston	4,520,000	$35.
860A☆		–		861A☆		not printed	–
860B	New York	18,668,148	35.	861B	New York	27,894,260	30.
860B☆		–		861B☆			–
860C	Philadelphia	11,590,752	35.	861C	Philadelphia	6,022,428	35.
860C☆		–		861C☆			–
860D	Cleveland	17,912,424	35.	861D	Cleveland	8,981,688	35.
860D☆		–		861D☆			–
860E	Richmond	22,526,568	35.	861E	Richmond	14,055,984	35.
860E☆		–		861E☆		not printed	–
860F	Atlanta	18,858,568	35.	861F	Atlanta	7,495,440	35.
860F☆		–		861F☆			–
860G	Chicago	26,031,660	35.	861G	Chicago	15,187,596	35.
860G☆		–		861G☆			–
860H	St. Louis	13,276,984	35.	861H	St. Louis	5,923,248	35.
860H☆		–		861H☆			–
860I	Minneapolis	3,490,200	35.	861I	Minneapolis	2,422,000	35.
860I☆		not printed	–	861I☆		not printed	–
860J	Kansas City	9,675,468	35.	861J	Kansas City	4,211,904	35.
860J☆		–		861J☆		not printed	–
860K	Dallas	10,205,364	35.	861K	Dallas	3,707,364	35.
860K☆		–		861K☆		not printed	–
860L	San Francisco	20,580,828	35.	861L	San Francisco	12,015,228	35.
860L☆		–		861L☆		not printed	–

Federal Reserve Notes/Series 1950, 1950A, 1950B & 1950C/Green Seal

Series 1950, Clark-Snyder				Series 1950A, Priest-Humphrey			
No.	Bank	Notes Printed	Unc	No.	Bank	Notes Printed	Unc
862A	Boston	23,184,000	$30.	863A	Boston	19,656,000	$30.
862A☆			–	863A☆			–
862B	New York	80,064,000	30.	863B	New York	82,568,000	30.
862B☆			–	863B☆			–
862C	Philadelphia	29,520,000	30.	863C	Philadelphia	16,560,000	30.
862C☆			–	863C☆			–
862D	Cleveland	51,120,424	30.	863D	Cleveland	50,320,000	30.
862D☆			–	863D☆			–
862E	Richmond	67,536,000	30.	863E	Richmond	69,544,000	30.
862E☆			–	863E☆			–
862F	Atlanta	39,312,000	30.	863F	Atlanta	27,648,000	30.
862F☆			–	863F☆			–
862G	Chicago	70,464,000	30.	863G	Chicago	73,720,000	30.
862G☆			–	863G☆			–
862H	St. Louis	27,352,000	30.	863H	St. Louis	22,680,000	30.
862H☆			–	863H☆			–
862I	Minneapolis	9,216,000	35.	863I	Minneapolis	5,544,000	35.
862I☆			–	863I☆			–
862J	Kansas City	22,752,000	35.	863J	Kansas City	22,968,000	30.
862J☆			–	863J☆			–
862K	Dallas	22,658,000	35.	863K	Dallas	10,728,000	30.
862K☆			–	863K☆			–
862L	San Francisco	70,272,000	30.	863L	San Francisco	85,528,000	30.
862L☆			–	863L☆			–

Series 1950B, Priest-Humphrey				Series 1950C, Smith-Dillon			
No.	Bank	Notes Printed	Unc	No.	Bank	Notes Printed	Unc
864A	Boston	5,040,000	$35.	865A	Boston	7,200,000	$35.
864A☆			–	865A☆		not printed	–
864B	New York	49,960,000	30.	865B	New York	43,200,000	30.
864B☆			–	865B☆		not printed	–
864C	Philadelphia	7,920,000	35.	865C	Philadelphia	7,560,000	35.
864C☆			–	865C☆		not printed	–
864D	Cleveland	38,160,424	30.	865D	Cleveland	28,440,000	30.
864D☆			–	865D☆		not printed	–
864E	Richmond	42,120,000	30.	865E	Richmond	37,004,000	30.
864E☆			–	865E☆		not printed	–
864F	Atlanta	40,240,000	30.	865F	Atlanta	19,080,000	30.
864F☆			–	865F☆		not printed	–
864G	Chicago	80,560,000	30.	865G	Chicago	29,160,000	30.
864G☆			–	865G☆			–
864H	St. Louis	19,440,000	30.	865H	St. Louis	12,960,000	30.
864H☆			–	865H☆			–
864I	Minneapolis	12,240,000	30.	865I	Minneapolis	6,480,000	35.
864I☆			–	865I☆			–
864J	Kansas City	28,440,000	30.	865J	Kansas City	18,360,000	30.
864J☆			–	865J☆			–
864K	Dallas	11,880,000	30.	865K	Dallas	9,000,000	35.
864K☆			–	865K☆			–
864L	San Francisco	51,040,000	30.	865L	San Francisco	45,360,000	30.
864L☆			–	865L☆			–

Federal Reserve Notes/Series 1950D, 1950E & 1963/Green Seal

Series 1950D, Granahan-Dillon

No.	Bank	Notes Printed	Unc
866A	Boston	9,320,000	$35.
866A☆			–
866B	New York	64,280,000	30.
866C	Philadelphia	5,400,000	35.
866C☆			–
866D	Cleveland	23,760,000	30.
866D☆			–
866E	Richmond	30,240,000	30.
866F	Atlanta	22,680,000	30.
866G	Chicago	67,960,000	30.
866H	St. Louis	6,120,000	35.
866I	Minneapolis	3,240,000	35.
866J	Kansas City	8,200,000	35.
866J☆		not printed	–
866K	Dallas	6,480,000	35.
866K☆			–
866L	San Francisco	69,400,000	30.

Series 1950E, Granahan-Fowler

No.	Bank	Notes Printed	Unc
867B	New York	8,640	$85.
867B☆			–
867G	Chicago	9,360,000	30.
867G☆			–
867L	San Francisco	8,640,000	30.
867L☆			–

Series 1963, Granahan-Fowler

No.	Bank	Notes Printed	Unc
868A	Boston	2,560,000	$35.
868A☆			–
868B	New York	16,640,000	30.
868B☆			–
868C	Philadelphia	not printed	–
868C☆		not printed	–
868D	Cleveland	7,680,000	30.
868D☆			–
868E	Richmond	4,480,000	35.
868E☆			–
868F	Atlanta	10,240,000	30.
868F☆			–
868G	Chicago	2,560,000	35.
868G☆			–
868H	St. Louis	3,200,000	35.
868H☆			–
868I	Minneapolis	not printed	–
868I☆		not printed	–
868J	Kansas City	3,840,072	35.
868J☆			–
868K	Dallas	2,560,000	35.
868K☆			–
868L	San Francisco	7,040,000	30.
868L☆			–

"IN GOD WE TRUST" was added to No. 868 and all subsequent $20 notes.

Federal Reserve Notes/Series 1963A, 1969, 1969A & 1969B/Green Seal

Series 1963A, Granahan-Fowler				Series 1969, Elston-Kennedy			
No.	Bank	Notes Printed	Unc	No.	Bank	Notes Printed	Unc
869A	Boston	23,680,000	$30.	870A	Boston	19,200,000	$30.
869A☆		1,280,000	35.	870A☆		1,280,000	35.
869B	New York	96,600,000	30.	870B	New York	106,400,000	25.
869B☆		3,840,000	30.	870B☆		5,106,000	30.
869C	Philadelphia	17,920,000	30.	870C	Philadelphia	10,880,000	30.
869C☆		640,000	40.	870C☆		1,280,000	35.
869D	Cleveland	68,480,424	30.	870D	Cleveland	60,160,000	30.
869D☆		2,560,000	30.	870D☆		2,560,000	35.
869E	Richmond	128,800,000	30.	870E	Richmond	66,560,000	30.
869E☆		5,760,000	30.	870E☆		2,560,000	35.
869F	Atlanta	42,880,000	30.	870F	Atlanta	36,480,000	30.
869F☆		1,920,000	35.	870F☆		1,280,000	35.
869G	Chicago	156,320,000	25.	870G	Chicago	107,680,000	25.
869G☆		7,040,000	30.	870G☆		3,202,000	35.
869H	St. Louis	34,400,000	30.	870H	St. Louis	19,200,000	30.
869H☆		1,920,000	35.	870H☆		640,000	40.
869I	Minneapolis	10,240,000	30.	870I	Minneapolis	12,160,000	30.
869I☆		640,000	40.	870I☆		640,000	40.
869J	Kansas City	37,120,000	30.	870J	Kansas City	39,040,000	30.
869J☆		1,920,000	35.	870J☆		1,280,000	35.
869K	Dallas	38,400,000	30.	870K	Dallas	25,600,000	30.
869K☆		1,280,000	35.	870K☆		640,000	40.
869L	San Francisco	169,120,000	25.	870L	San Francisco	103,840,000	25.
869L☆		8,320,000	30.	870L☆		5,120,000	30.

Series 1969A, Kabis-Connally				Series 1969B, Banuelos-Connally			
No.	Bank	Notes Printed	Unc	No.	Bank	Notes Printed	Unc
871A	Boston	13,440,000	$30.	872A	Boston	not printed	$–
871A☆		not printed	–	872A☆		not printed	–
871B	New York	69,760,000	30.	872B	New York	39,200,000	30.
871B☆		2,460,000	35.	872B☆		not printed	–
871C	Philadelphia	13,440,000	30.	872C	Philadelphia	not printed	–
871C☆		not printed	–	872C☆		not printed	–
871D	Cleveland	29,440,424	30.	872D	Cleveland	6,400,000	35.
871D☆		640,000	40.	872D☆		not printed	–
871E	Richmond	42,400,000	30.	872E	Richmond	27,520,000	30.
871E☆		1,920,000	35.	872E☆		not printed	–
871F	Atlanta	13,440,000	30.	872F	Atlanta	14,080,000	30.
871F☆		not printed	–	872F☆		640,000	40.
871G	Chicago	81,640,000	30.	872G	Chicago	14,240,000	30.
871G☆		1,920,000	35.	872G☆		1,112,000	35.
871H	St. Louis	14,080,000	30.	872H	St. Louis	5,120,000	35.
871H☆		640,000	40.	872H☆		not printed	–
871I	Minneapolis	7,040,000	30.	872I	Minneapolis	2,560,000	35.
871I☆		640,000	40.	872I☆		not printed	–
871J	Kansas City	16,040,000	30.	872J	Kansas City	3,840,000	35.
871J☆		not printed	–	872J☆		not printed	–
871K	Dallas	14,720,000	30.	872K	Dallas	12,160,000	30.
871K☆		640,000	40.	872K☆		not printed	–
871L	San Francisco	50,560,000	30.	872L	San Francisco	26,000,000	30.
871L☆		1,280,000	35.	872L☆		640,000	40.

Federal Reserve Notes/1969C, 1974, 1977 & 1981/Green Seal

Series 1969C, Banuelos-Shultz				Series 1974, Neff-Simon			
No.	Bank	Notes Printed	Unc	No.	Bank	Notes Printed	Unc
873A	Boston	17,280,000	$30.	874A	Boston	57,120,000	$25.
873A☆		640,000	35.	874A☆		1,280,000	30.
873B	New York	135,200,000	25.	874B	New York	296,800,000	22.
873B☆		1,640,000	35.	874B☆		8,320,000	25.
873C	Philadelphia	40,960,000	30.	874C	Philadelphia	59,680,000	25.
873C☆		640,000	35.	874C☆		1,920,000	30.
873D	Cleveland	57,760,424	30.	874D	Cleveland	148,460,000	25.
873D☆		480,000	40.	874D☆		4,480,000	30.
873E	Richmond	80,160,000	30.	874E	Richmond	149,920,000	25.
873E☆		1,920,000	35.	874E☆		5,120,000	30.
873F	Atlanta	35,840,000	30.	874F	Atlanta	53,280,000	25.
873F☆		640,000	35.	874F☆		480,000	35.
873G	Chicago	78,720,000	30.	874G	Chicago	250,080,000	22.
873G☆		640,000	35.	874G☆		6,880,000	25.
873H	St. Louis	33,920,000	30.	874H	St. Louis	73,120,000	25.
873H☆		640,000	35.	874H☆		1,280,000	30.
873I	Minneapolis	14,080,000	30.	874I	Minneapolis	39,040,000	25.
873I☆		640,000	35.	874I☆		1,280,000	30.
873J	Kansas City	32,000,000	30.	874J	Kansas City	74,400,000	25.
873J☆		640,000	35.	874J☆		1,760,000	30.
873K	Dallas	31,360,000	30.	874K	Dallas	68,640,000	25.
873K☆		1,920,000	35.	874K☆		1,120,000	30.
873L	San Francisco	62,080,000	30.	874L	San Francisco	128,800,000	25.
873L☆		1,120,000	35.	874L☆		5,760,000	30.

Series 1977, Morton-Blumenthal				Series 1981, Buchanan-Regan			
No.	Bank	Notes Printed	Unc	No.	Bank	Notes Printed	Unc
875A	Boston	94,720,000	$25.	876A	Boston	191,360,000	$22.
875A☆		2,688,000	30.	876A☆		1,024,000	30.
875B	New York	569,600,000	22.	876B	New York	559,360,000	22.
875B☆		12,416,000	25.	876B☆		5,312,000	25.
875C	Philadelphia	117,760,000	25.	876C	Philadelphia	101,760,000	22.
875C☆		2,816,000	30.	876C☆		256,000	40.
875D	Cleveland	189,632,000	25.	876D	Cleveland	146,500,000	22.
875D☆		5,632,000	30.	876D☆		1,280,000	30.
875E	Richmond	257,280,000	22.	876E	Richmond	296,320,000	22.
875E☆		6,272,000	30.	876E☆		1,280,000	30.
875F	Atlanta	70,400,000	25.	876F	Atlanta	93,440,000	22.
875F☆		2,688,000	30.	876F☆		3,200,000	30.
875G	Chicago	358,400,000	22.	876G	Chicago	361,600,000	22.
875G☆		7,552,000	30.	876G☆		2,688,000	30.
875H	St. Louis	98,560,000	25.	876H	St. Louis	76,160,000	22.
875H☆		1,792,000	30.	876H☆		1,536,000	30.
875I	Minneapolis	15,360,000	25.	876I	Minneapolis	23,040,000	22.
875I☆		512,000	35.	876I☆		256,000	40.
875J	Kansas City	148,480,000	25.	876J	Kansas City	147,840,000	22.
875J☆		4,864,000	30.	876J☆		1,280,000	30.
875K	Dallas	163,840,000	25.	876K	Dallas	95,360,000	22.
875K☆		6,656,000	30.	876K☆		896,000	30.
875L	San Francisco	263,680,000	22.	876L	San Francisco	404,480,000	22.
875L☆		6,528,000	30.	876L☆		1,424,000	30.

Federal Reserve Notes/1981A, 1985, 1988 & 1988A/Green Seal

Series 1981A, Ortega-Regan				Series 1985, Ortega-Brady			
No.	Bank	Notes Printed	Unc	No.	Bank	Notes Printed	Unc
877A	Boston	156,800,000	$22.	878A	Boston	416,000,000	$22.
877A☆		not printed	–	878A☆		not printed	–
877B	New York	352,000,000	22.	878B	New York	1,728,000,000	22.
877B☆		not printed	–	878B☆		not printed	–
877C	Philadelphia	57,600,000	25.	878C	Philadelphia	224,000,000	22.
877C☆		not printed	–	878C☆		not printed	–
877D	Cleveland	160,000,424	22.	878D	Cleveland	585,600,000	22.
877D☆		3,840,000	30.	878D☆		not printed	–
877E	Richmond	214,400,000	22.	878E	Richmond	860,800,000	22.
877E☆		not printed	–	878E☆		not printed	–
877F	Atlanta	140,800,000	22.	878F	Atlanta	313,600,000	22.
877F☆		3,200,000	30.	878F☆		not printed	–
877G	Chicago	211,200,000	22.	878G	Chicago	729,600,000	22.
877G☆		not printed	–	878G☆		not printed	–
877H	St. Louis	73,600,000	22.	878H	St. Louis	230,400,000	22.
877H☆		not printed	–	878H☆		not printed	–
877I	Minneapolis	19,200,000	25.	878I	Minneapolis	112,000,000	22.
877I☆		not printed	–	878I☆		not printed	–
877J	Kansas City	86,400,000	22.	878J	Kansas City	204,800,000	22.
877J☆		not printed	–	878J☆		not printed	–
877K	Dallas	99,200,000	22.	878K	Dallas	192,000,000	22.
877K☆		not printed	–	878K☆		not printed	–
877L	San Francisco	457,600,000	22.	878L	San Francisco	1,129,600,000	22.
877L☆		6,400,000	25.	878L☆		not printed	–

Series 1988A, Villalpando-Brady				Series 1990, Villalpando-Brady			
No.	Bank	Notes Printed	Unc	No.	Bank	Notes Printed	Unc

These two series were in production when this catalog was printed. No Series 1988 $20 notes were printed.

This page has been left blank for your personal notations.

Gold Certificate/Series 1928 & 1928A

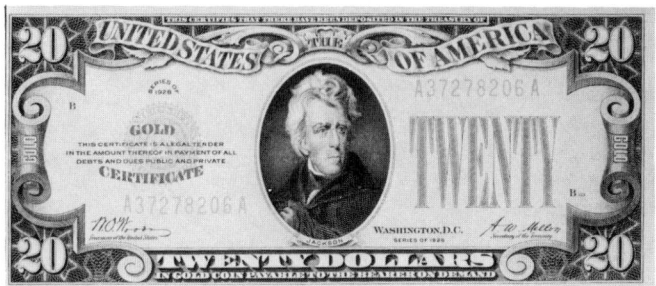

The back design is the same as No. 851.

No.	Series	Signatures	Notes Printed	VFine	EFine	Unc
925	1928	Woods-Mellon	66,204,000	$ 40.	$ 60.	$200.
925☆	1928☆	Woods-Mellon	–	125.	275.	450.
925A	1928A	Woods-Mills	1,500,000		never released	

United States Notes/1862 & 1863/Red Seal

The portrait of Alexander Hamilton was engraved by Joseph P. Ourdan.

No. 926 has the first obligation back; the remaining have the second obligation.

Second obligation back.

No.	Date	Description	Printed	VGood	Fine	Unc
926	1862	"American Bank Note Company" upper border	260,000	$2150.	$4200.	–
926a	1862	as above with "National Bank Note Company" added		– – – – Unique – – – –		
926b	1862	"National Bank Note Company" upper border	341,104	2150.	4200.	–
927	1863	as 926a		2150.	4200.	–
927a	1863	as 926b		2150.	4200.	–

Remarks: A total of 601,104 notes were printed, all with Chittenden-Spinner signatures. For 927 and 927a a group of nine consecutively numbered notes in uncirculated condition has been reported; these commence with 133xx with the implication that there could be more. About 10,000 counterfeit notes of this design circulated.

United States Notes/Series 1869/Red Seal

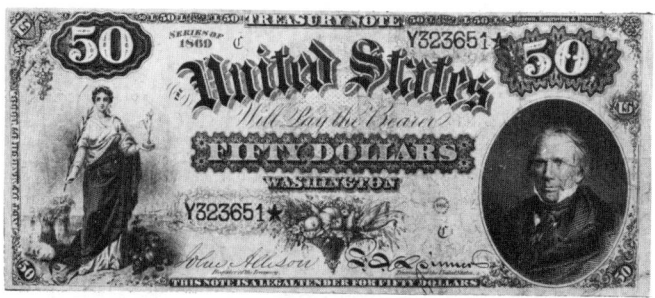

Henry Clay, self-educated, was admitted to the bar in VA, where he was born in 1777. He was twice elected to the Senate; he also served as Secretary of State from 1825–1829. This portrait of Clay was engraved by Alfred Sealey. *Return of Peace*, on the left, was engraved by Charles Smith.

No.	Series	Signatures	Notes Printed	VGood	VFine	Unc
928	1869	Allison-Spinner	604,000	$4000.	$8000.	$20,000.

Remarks: At least 46 notes have been recorded. This issue was recalled because of an abundance of counterfeits with plate letter "B." All of these counterfeits lack a flourish between "SERIES OF" and "1869"; and there is no engraving behind the portrait of Clay. The following counterfeits have been recorded by Martin Gengerke: Y29597, Y32790, Y37566 and Y37569.

United States Notes/Series 1874–1880

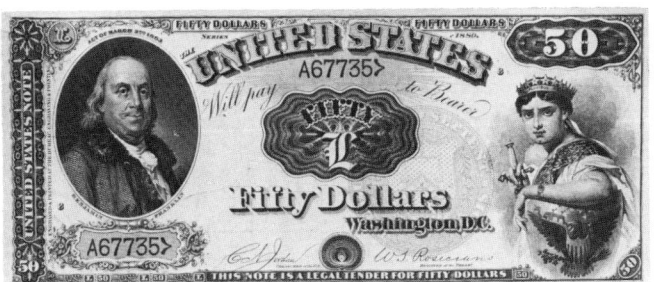

America, with a crown bearing *E Pluribus Unum*, was engraved by Charles Burt, who probably engraved the Duplessis portrait of Benjamin Franklin.

No.	Series	Signatures	Seal	Notes Printed	Fine	EFine	Unc
"L" in red on left and right; seal is red.							
929	1874	Allison-Spinner	rays	489,200	$1650.	$3850.	$ 9500.
930	1875	Allison-Wyman	rays	40,000	– – – –	3 known	– – – –
931	1878	Allison-Gilfillan	rays	210,000	1650.	4200.	10000.
"L" is deleted; serial numbers are blue; red seals except for Nos. 932 & 933.							
932	1880	Bruce-Gilfillan	brown	80,000	950.	2000.	6000.
933	1880	Bruce-Wyman	brown	160,000	850.	1600.	4250.
934	1880	Rosecrans-Jordan	large	80,000	950.	2000.	6000.
935	1880	Rosecrans-Hyatt	plain	80,000	950.	2000.	6000.
936	1880	Rosecrans-Hyatt	spikes	160,000	850.	1600.	4250.
937	1880	Rosecrans-Huston	spikes	80,000	950.	2000.	6000.
938	1880	Rosecrans-Huston	large	100,000	750.	1750.	4750.
939	1880	Tillman-Morgan	scallops	212,000	750.	1750.	4500.
940	1880	Bruce-Roberts	scallops	28,000	– – – –	5 known	– – – –
941	1880	Lyons-Roberts	scallops	300,000	650.	1500.	4250.

Remarks: Only uncirculated notes between E78416–E78588 have been observed and recorded for No. 929; this suggests that more exist in similar condition. As many as 46 consecutively numbered notes of No. 938 have been reported; all commence with A4485xx. Figures in parentheses represent the number known for: Nos. 929 (22); 931 (12); 932 (6); 933 (8); 934 (7); 935 (6); 936 (10); 937 (9); 938 (41); 939 (14); & 941 (63).

Compound Interest Treasury Notes/6%

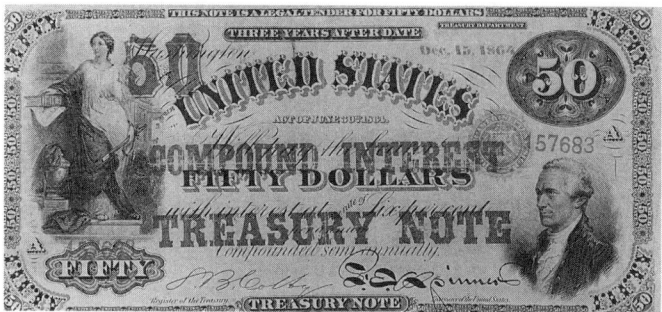

To the left of the Alexander Hamilton portrait, engraved by Owen G. Hanks, is a symbolic figure of *Loyalty* engraved by Charles Burt. (RWH&E-ABNCo)

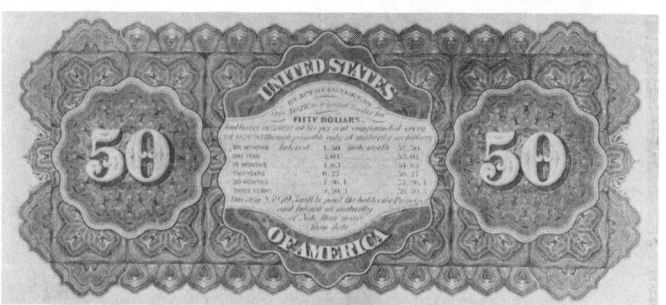

No.	Signatures	Dated	Notes Printed	Notes Issued	Outstanding	Known	VFine
		Act of March 3, 1863					
942	Chittenden-Spinner	10 June 1864	55,580	40,180	95	1	–
943	Colby-Spinner	–	208,000	0	0	0	–
		Act of June 30, 1864					
943a	Chittenden-Spinner	July 15, 1864	(error, Act of July 2, 1864)				unknown
944	Chittenden-Spinner	July 15, 1864	880,500	851,200	1213	1	–
944a	Colby-Spinner	Aug. 15, 1864	612,000	306,000	incl above	2	$17,500.
944b	Colby-Spinner	Oct. 15, 1864	–	–	–	3	17,500.
944c	Colby-Spinner	Dec. 15, 1864	–	–	–	4	17,500.
944d	Colby-Spinner	May 15, 1865	–	–	–	1	–
944e	Colby-Spinner	Sep. 15, 1865	–	–	–	1	–

Remarks: Nos. 942 and 944 have signatures of Chittenden-Spinner; all others have Colby-Spinner. The issued figure for 944a is an estimate. Martin Gengerke has recorded the following counterfeits for No. 944: 12639, 16239, 16450, 16823, 31407, 39345 and 91239. The July 7, 1885 edition of *The New York Times* confirmed that as much as $15,000,000 in notes bearing the erroneous Act of July 2, 1864 was issued. Two $10 notes have been recorded.

Interest-bearing Notes/6%/Act of March 2, 1861

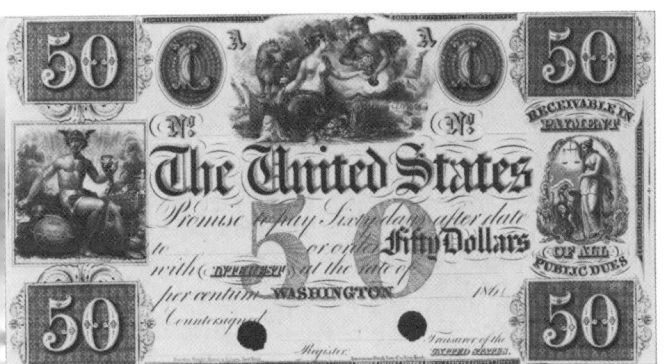

Rawdon, Wright, Hatch & Edson prepared this "old style" uniface note. *Mercury* was drawn and engraved by George W. Hatch; *Wealth* was designed and engraved by Freeman Rawdon; *Justice*, on the right, was probably engraved by Hatch or Rawdon.

| | | Notes Issued | |
No.	Term	Old Plates	New Plates
945	60-days	Unknown	30,113

Act of March 3, 1863
One-Year Notes — 5%

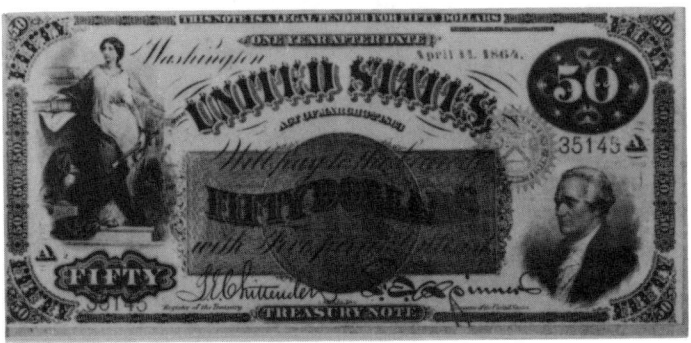

The back of this note, similar to Nos. 942–944e, has an interest table.

No.	Signatures	Dated	Notes Issued	Out	Known
945a	Chittenden-Spinner	March 15, 1864	164,800	131	1
	Chittenden-Spinner	April 14, 1864	included in above		2

Remarks: No.945, as illustrated, sold for $4,500 in Christie's April 2, 1982 auction. Serial numbers for known notes are 8525, 35145 and 38161.

Interest-bearing Notes/6%/Two Years/Act of March 2, 1861

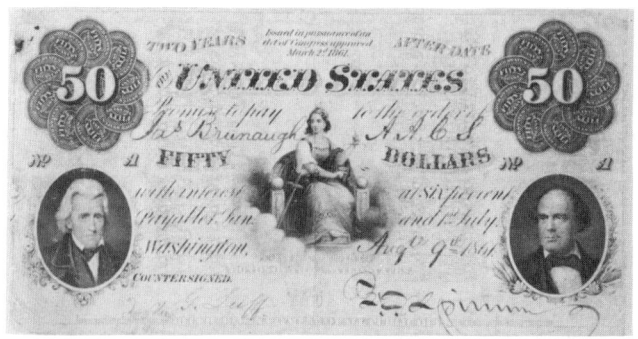

The John Wood Dodge portrait of Andrew Jackson (also used on the $1,000 Confederate note in 1861) was probably engraved by Charles Burt. Frederick Girsch is believed to have engraved *Justice* and the portrait of Salmon P. Chase. The note is black and red. (NBNCo)

No.	Signatures	Dated	Notes Issued Old Plates	New Plates	Known
945b	Chittenden-Spinner	9 Aug. 1861	7,624	73,316	2

Remarks: Additional notes could have been printed and issued.

G. Luff, H.G. Root and other authorized clerks signed "For the" Register and the Treasurer. "For the" was probably engraved on the new plates. The only circulated note in the hands of a collector is from an old plate and bears plate position "A"; the faded serial number could be 17662C. The second circulated note, with serial number 17119A, is canceled and held by the Bureau of the Public Debt. There are three additional examples: one specimen and two plate proofs. The illustrated specimen was in the Christie's auction of September 17, 1982. One proof bears plate position "B," the other "C." There is no example of this note at the Bureau of Engraving and Printing.

Interest-bearing Notes/5%/Two Years/Act of March 3, 1863

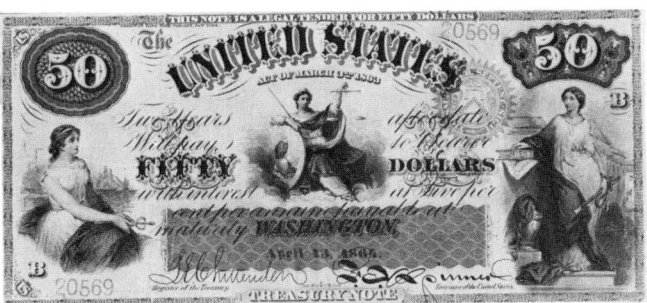

Caduceus, on the left, was sketched by John W. Casilear and engraved by Alfred Jones. *Justice with Shield*, by engraver Charles Burt, occupies the center; *Loyalty*, by Alfred Jones, was engraved by W.W. Rice. (ABNCo)

No.	Dated	Signatures of Chittenden-Spinner				
		Coupons	Printed	Issued	Out	Known
945c	April 1, 1864 April 13, 1864 April 20, 1864 April 22, 1864 May 27, 1864	none	148,000	136,000	115	5
945d		3	199,112	118,112	38	−

Remarks: Serial numbers for No. 945c are 10174, 12114, 20569, 26198, 29419 and 32596 (Gengerke 49).

Interest-bearing Notes/7.30%/Three-Year Notes

Act of July 17,1861

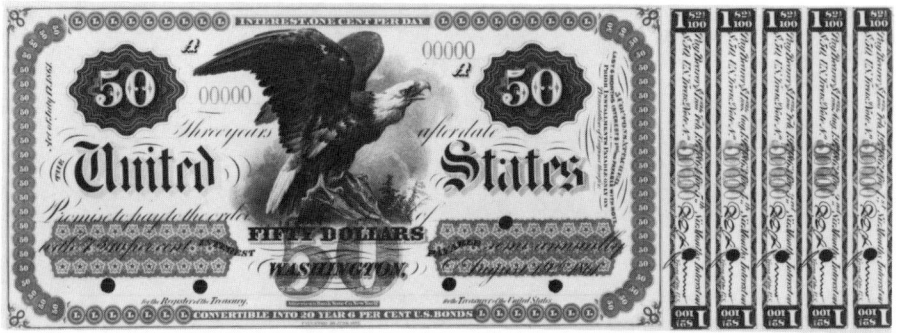

The *Great Eagle* by W. Croome was engraved by Alfred Jones. (ABNCo)

No.	Dated	Serial Numbers	Issued	Outstanding
946	Aug. 19, 1861	red	71,641	108
947	Oct. 1, 1861	red	82,365	17
948	Oct. 1, 1861	blue	527	10

Act of June 30, 1864

The face and back of this note are similar to the following note.

No.	Dated	Printed	Issued	Outstanding
949	Aug. 15, 1864	623,408	363,952	270
950	Mar. 3, 1865	42,268	included in above	

Interest-bearing Notes/7.30%/Three-Year Notes

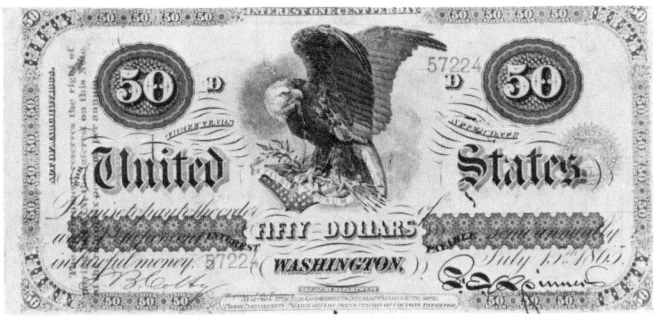

This large eagle is similar to the small eagle by Henry Gugler on No. 466. (ABNCo & BEP)

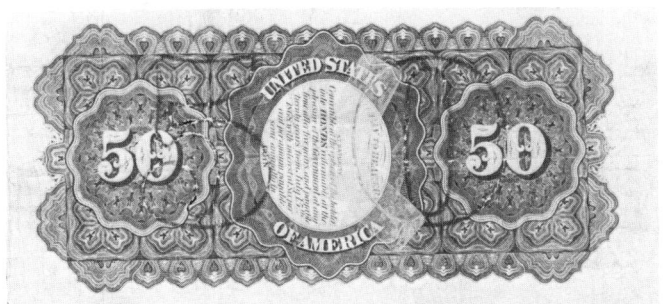

Act of March 3, 1865

No.	Dated	Serial Numbers	Printed	Issued	Out	Known
951	June 15, 1865	blue	226,324	182,324	56	1
952	July 15, 1865	red	368,000	343,320	211	5

Remarks: The following serial numbers have been recorded by Martin Gengerke, Gene Hessler and John Isted. No. 951: 89959; No. 952: 57224, 126378, 142145, 161643 and 196081.

National Bank Notes/First Charter Period/Red Seal

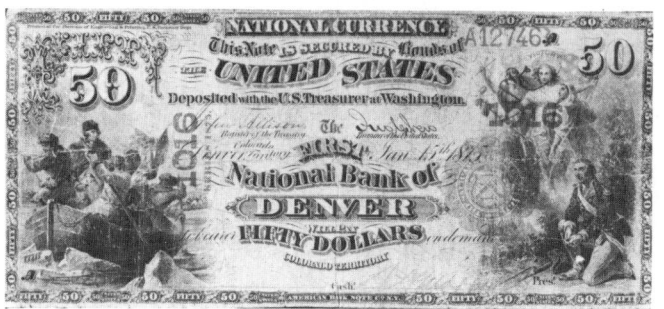

J.P. Major designed the face of this note. *Washington Crossing the Delaware* was engraved by Alfred Jones. *Prayer for Victory* was engraved by Louis Delnoce; his daughters were the models for the three figures above the soldier. The *Embarkation of the Pilgrims* by Robert W. Weir was engraved by W.W. Rice. (ABNCo)

No.	Series	Signatures	VGood	VFine
		The red seal has rays.		
953	orig.	Chittenden-Spinner	$2150.	$4750.
954	orig.	Colby-Spinner	2150.	4500.
955	orig.	Allison-Spinner	2150.	4500.
		The red seal has scallops		
956	1875	Allison-New	2100.	4500.
957	1875	Allison-Wyman	– – – – – –Unique – – – – – –	
958	1875	Allison-Gilfillan	2300.	5800.
959	1875	Scofield-Gilfillan	2300.	5800.
960	1875	Bruce-Gilfillan	2500.	5800.
961	1875	Bruce-Wyman	2500.	5800.
962	1875	Rosecrans-Huston	2600.	6000.
963	1875	Rosecrans-Nebeker	2600.	6000.
964	1875	Tillman-Morgan	2600.	6000.

Remarks: The original series had no series date on the faces. A total of 23,871 notes are outstanding for both types; about 60 actually exist.

National Bank Notes/Second Charter Period/First Issue/Series 1882/Brown Seal

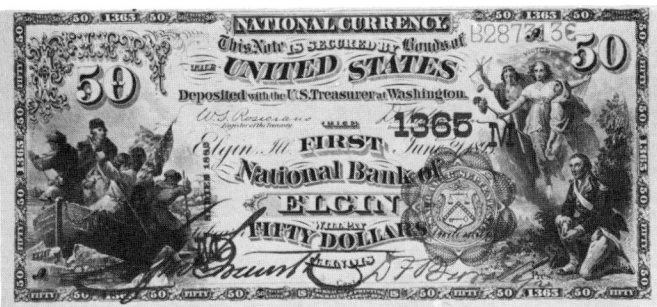

See preceding note for engraver information.

The back is brown.

No.	Signatures	VGood	VFine	Unc
965	Bruce-Gilfillan	$525.	$1250.	$4000.
966	Bruce-Wyman	525.	1250.	4000.
967	Bruce-Jordan	525.	1250.	4250.
968	Rosecrans-Jordan	525.	1250.	4000.
969	Rosecrans-Hyatt	525.	1250.	4000.
970	Rosecrans-Huston	525.	1250.	4000.
971	Rosecrans-Nebeker	525.	1250.	4000.
972	Rosecrans-Morgan	700.	1500.	5250.
973	Tillman-Morgan	525.	1250.	4000.
974	Tillman-Roberts	550.	1250.	4250.
975	Bruce-Roberts	525.	1250.	4000.
976	Lyons-Roberts	525.	1250.	4000.
977	Vernon-Treat	750.	1700.	5750.

National Bank Notes/Second Charter Period/Series 1882/Blue Seal

The back design now has "1882–1908." The face design is similar to the preceding note.

No.	Signatures	VGood	VFine	Unc
978	Rosecrans-Huston	$500.	$1000.	$3500.
979	Rosecrans-Nebeker	500.	1000.	3500.
980	Tillman-Morgan	500.	1000.	3500.
981	Tillman-Roberts	500.	1000.	3500.
982	Bruce-Roberts	500.	1000.	3500.
983	Lyons-Roberts	500.	1000.	3500.
984	Vernon-Treat	550.	1100.	3750.
985	Napier-McClung	600.	1200.	4000.

Third issue – blue seal

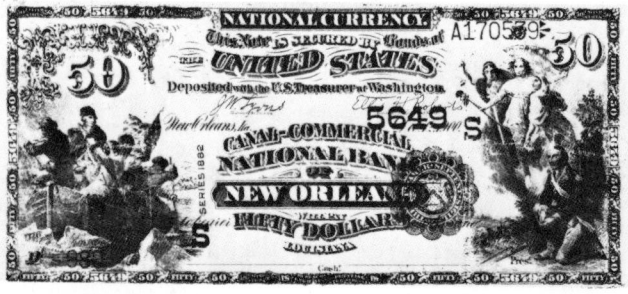

The face design is similar to the preceding note.

Th back design now includes "FIFTY DOLLARS."

No.	Signatures	Printed	Issued	Known	VFine
986	Lyons-Roberts	9,300	8,571	3	$25,000.

National Bank Notes/Third Charter Period/Series 1902

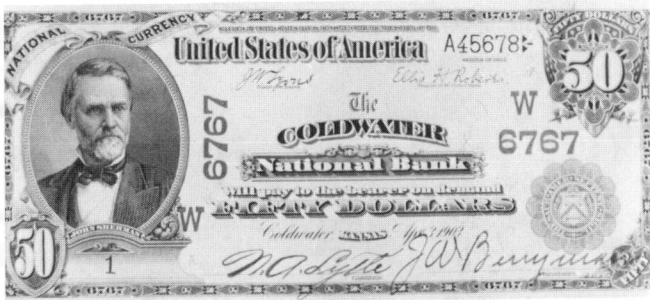

The back design is the same for all three issues; only the second issue has "1902–1908 on the back." *Mechanics and Navigation* was engraved by G.F.C. Smillie.

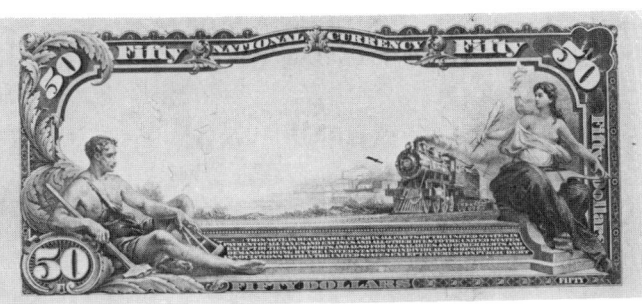

No.	Signatures	VGood	VFine	Unc
		First Issue – red seal		
987	Lyons-Roberts	$500.	$1350.	$4000.
988	Lyons-Treat	500.	1350.	4500.
989	Vernon-Treat	600.	1350.	5000.
		Second issue – blue seal		
		"1902–1908" on back		
990	Lyons-Roberts	250.	500.	2000.
991	Lyons-Treat	250.	500.	2000.
992	Vernon-Treat	250.	500.	2000.
993	Vernon-McClung	250.	500.	2000.
994	Napier-McClung	250.	500.	2200.
995	Napier-Thompson	250.	500.	2250.
996	Napier-Burke	250.	500.	2000.
997	Parker-Burke	250.	500.	2000.
998	Teehee-Burke	325.	625.	2400.
		Third issue – blue seal		
999	Lyons-Roberts	200.	450.	1850.
1000	Lyons-Treat	200.	450.	1850.
1001	Vernon-Treat	200.	450.	1850.
1002	Vernon-McClung	200.	450.	1850.
1003	Napier-McClung	200.	450.	1850.
1004	Napier-Thompson	200.	525.	1850.
1005	Napier-Burke	200.	450.	1850.
1006	Parker-Burke	200.	450.	1850.
1007	Teehee-Burke	200.	450.	1850.
1008	Elliott-Burke	200.	450.	1850.
1009	Elliott-White	200.	450.	1850.
1010	Speelman-White	200.	450.	1850.
1011	Woods-White	250.	600.	2250.
1012	Woods-Tate	No examples are known.		

National Gold Bank Notes/Red Seal

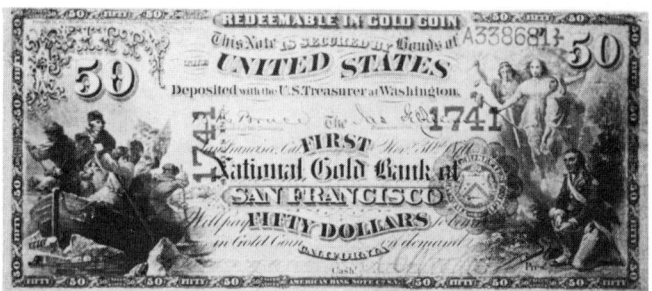

The face design is similar to Nos. 953–986. (ABNCo)

The back design is similar to Nos. 799–807.

No.	Date	Issuing Bank	City	Issued	Good	VGood
1013	1870	First National Gold Bank of	San Francisco	2000	$7000.	$18,000.
1013a	1875	First National Gold Bank of	San Francisco			
		as No. 1013 on white paper		620	8000.	20,500.
1014	1872	Farmers Nat'l Gold Bank	San Jose	400	–	–
1014a	1872	Nat'l Gold Bank & Trust Co.	San Francisco	2856	–	–
1014b	1872	Nat'l GB of D.O. Mills Co.	Sacramento	604	–	–
1014c	1873	First National Gold Bank of	Stockton	867	–	–
1014d	1873	First National Gold Bank of	Santa Barbara	200	–	–
1014e	1874	First National Gold Bank of	Petaluma	400	–	–
1014f	1875	Union National Gold Bank	Oakland	100	–	–

Remarks: A total of 113 notes are outstanding. Listed are recorded serial numbers with bank serial numbers in parentheses:

No. 1013				No. 1013a		No. 1014	
321280	(1392)	321558	(1670)	A338681	(20)	43486	(386)
321504	(1616)	321772	(1884)				

Silver Certificates/Series 1878 & 1880

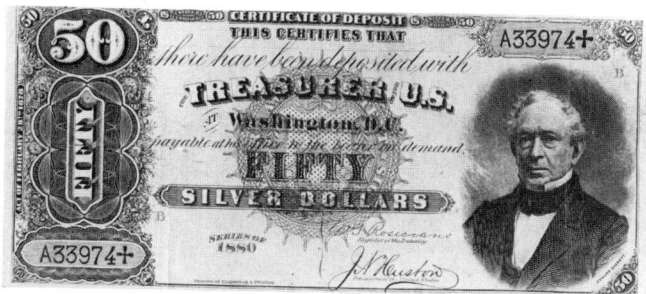

Edward Everett was Professor of Greek at Harvard at age 21. He served in the House of Representatives and as Secretary of State. In 1835 Everett became Governor of Massachusetts. His portrait was engraved by Charles Schlecht.

The back is black and brown.

Series of 1878 notes have large red seals, signatures of Scofield-Gilfillan and "L" below the series. Countersignatures on Nos. 1016 & 1017 are handwritten.

No.	Series	Countersigned by	Payable at	Issued	Known
1014g	1878	W.G. White	New York	8,000	0
1014h	1878	J.C. Hopper	New York	included in above	0
1015	1878	T. Hillhouse	New York	8,000	2
1016	1878	R.M. Anthony	San Francisco	1,000	1
1017	1878	A.U. Wyman	Washington, DC	4,000	0
1017a	1878	A.U. Wyman	Washington, DC	38,000	3

Series 1880
Seals are brown except for No. 1022.

No.	Signatures	Seal	Notes Printed	Known	VGood	VFine	Unc
1018	Scofield-Gilfillan	rays	16,000	1	$ —	$ —	$ —
1019	Bruce-Gilfillan	rays	80,000	3	—	—	—
1020	Bruce-Wyman	rays	100,000	9	3500.	9000.	—
1021	Rosecrans-Huston	spikes	100,000	27	2000.	7500.	16,000.
1022	Rosecrans-Nebeker	red	120,000	16	3000.	10000.	—

Silver Certificates/Series 1891

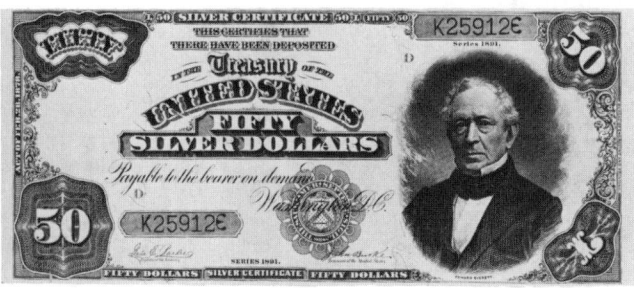

The face design is similar to the preceding note.

The back design was engraved by W.H. Dougal, E.M. Hall, A.L. Helm and G.U. Rose, Jr.

No.	Signatures	Seal	Notes Printed	Known	Fine	EFine	Unc
1023	Rosecrans-Nebeker	red	120,000	5	$3000.	$6000.	$ —
1024	Tillman-Morgan	red	380,000	10	750.	1800	4250.
1025	Bruce-Roberts	red	384,000	11	750.	1800.	4250.
1026	Lyons-Roberts	red	220,000	14	750.	1800.	4000.
1027	Vernon-Treat	blue	200,000	25	700.	1650.	3800.
1028	Parker-Burke	blue	812,000	59	525.	1400.	3600.

Remarks: As many as 13 consecutively numbered notes are known for No. 1027. They commence with H1662xx. In addition, at least three uncirculated notes are known. At least four notes in uncirculated condition are known for No. 1028.

Gold Certificates/Series 1882

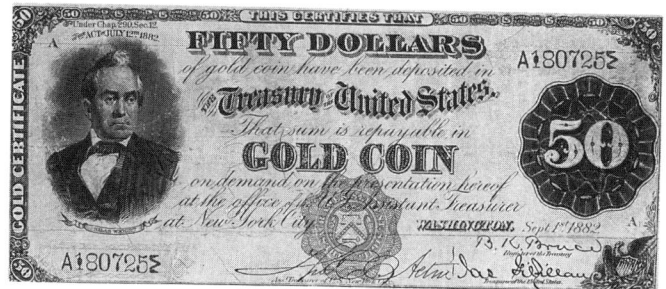

Silas Wright was born in Amherst, Massachusetts on May 24, 1795. He was a state and U.S. Senator, and was governor of New York. He died on August 27, 1847 in Canton, New York. Charles Burt's engraving of Wright's portrait was based on a painting by Alonzo Chappell.

The back is yellow.

No.	Signatures	Seal	Notes Printed	Known	VGood	VFine	Unc
1029	Bruce-Gilfillan	brown	9,000	1	$ –	$ –	$ –
1030	Bruce-Gilfillan	brown	191,000	10	2000.	3250.	12,000.
1031	Bruce-Gilfillan	brown	96,000	7	3000.	10000.	–
1032	Bruce-Wyman	brown	40,000	5	2000.	3250.	–
1033	Rosecrans-Hyatt	lg. red	40,000	3	no recent sale		
1034	Rosecrans-Huston	lg. brn	100,000	6	2000.	3250.	–
1034a	Rosecrans-Huston	red	incl. in above	1	no recent sale		
1035	Lyons-Roberts	red	1,724,000	24	300.	500.	3,000.
1036	Lyons-Treat	red	400,000	12	350.	600.	4,250.
1037	Vernon-Treat	red	400,000	16	325.	550.	4,000.
1038	Vernon-McClung	red	400,000	11	325.	550.	4,000.
1039	Napier-McClung	red	1,204,000	42	300.	500.	3,000.

Remarks: Nos. 1029 & 1030 are payable at New York; both are countersigned by Thomas C. Acton. No. 1029 bears an autographed countersignature and No. 1029 sold for $5,700 in 1974.

Gold Certificates/Series 1913–1922

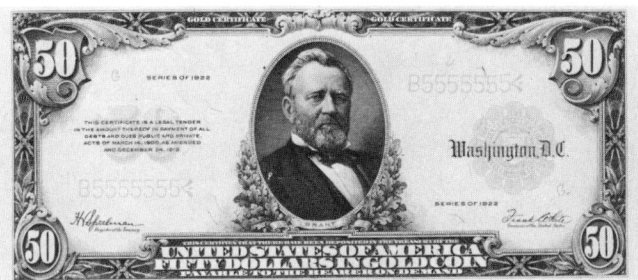

The portrait of Ulysses S. Grant was engraved by G.F.C. Smillie.

The back is yellow.

No.	Series	Signatures	Notes Issued	VFine	EFine	Unc
1040	1913	Parker-Burke	400,000	$500.	$750.	$2750.
1041	1913	Teehee-Burke	1,224,000	350.	600.	1900.
1042	1922	Speelman-White (sm. numbers)	800,000	450.	700.	2250.
1042a	1922	Speelman-White (lg. numbers)	5,184,000	325.	525.	1750.
1042a☆	1922	10 reported				

Remarks: Martin Gengerke has recorded 15 notes for No. 1040. They are: A1, A1930, A5118, A23686, A93058, A115916, A127020, A211745, A245396, A318661, A338536, A343998, A343999, A369927, and A375803.

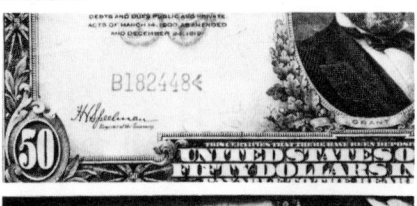

No. 1042

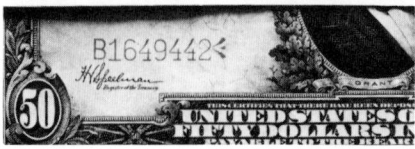

No. 1042a

Treasury or Coin Notes/Series 1891/Red Seal

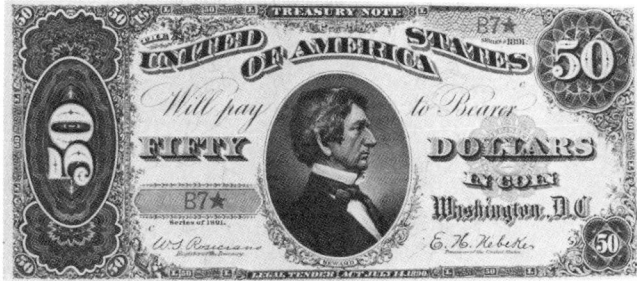

The portrait of William H. Seward (1801–1872) was engraved by Charles Schlecht. As Secretary of State (1860–1869), Seward negotiated for foreign land purchases; only the Alaska purchase was successful.

The back design was engraved by D.M. Cooper, W.H. Hall, E.E. Myers and G.U. Rose, Jr.

No.	Signatures	Printed	Issued	Outstanding	Known	VGood	VFine
1043	Rosecrans-Nebeker	80,000	23,500	23	18	$7500.	$27,500.

Remarks: Of the notes outstanding, six are in new condition including the first note, B1, at the American Numismatic Association Museum. Notes with the following serial numbers have been recorded: B1, B2, B3, B7, B8, B2137, B5082, B12916, B13890, B14535, B15233, B16876, B17501, B17508, B17510, B17532 and B20726. A private sale of the uncirculated, illustrated note was reported at more than $100,000.

Federal Reserve Notes/Series 1914/Red Seal

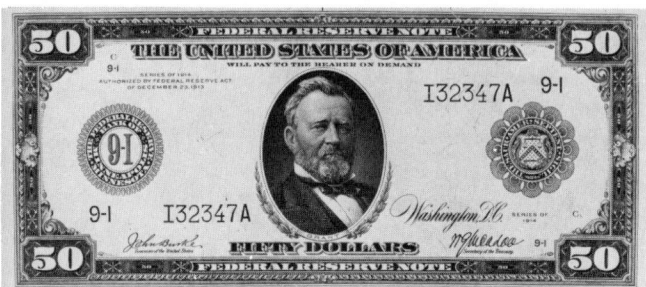

The portrait of U.S. Grant was engraved by John Eissler.

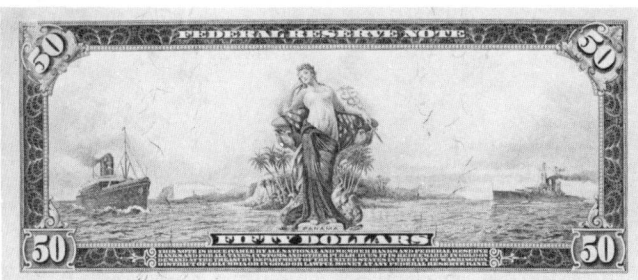

The symbolic figure of *Panama* was engraved by Marcus W. Baldwin. This note was issued in the year the Panama Canal opened.

Signatures of Burke-McAdoo

No.	Bank	VFine	Unc	No.	Bank	VFine	Unc
1044A	Boston	$350.	$2000.	1044G	Chicago	$350.	$2000.
1044B	New York	350.	2000.	1044H	St. Louis	350.	2000.
1044C	Philadelphia	350.	2000.	1044I	Minneapolis	350.	2000.
1044D	Cleveland	350.	2000.	1044J	Kansas City	350.	2000.
1044E	Richmond	350.	2000.	1044K	Dallas	350.	2000.
1044F	Atlanta	350.	2000.	1044L	San Francisco	350.	2000.

Remarks: The first day of issue for this issue was November 16, 1914. Type I was printed for all districts. Type II, with small district number and letter in the upper left and lower right corners, was printed for all districts except Atlanta and Dallas. See No. 380 for illustrations.

Federal Reserve Notes/Series 1918/Blue Seal

No.	Bank	Signatures	Notes Printed	Delivered	VFine	Unc	
1045A1	Boston	Burke-McAdoo	⎤		$185.	$ 950.	
1045A2	Boston	Burke-Glass	⎤		200.	1000.	
1045A3	Boston	Burke-Houston	1,072,000	1,072,000	185.	950.	
1045A4	Boston	White-Mellon	⎦		185.	950.	
1045B1	New York	Burke-McAdoo	⎤		185.	950.	
1045B2	New York	Burke-Glass			200.	1000.	
1045B3	New York	Burke-Houston	5,264,000	5,264,000	185.	950.	
1045B3 ☆	2 reported				–	–	
1045B4	New York	White Mellon (b)	⎦		185.	950.	
1045C1	Philadelphia	Burke-McAdoo	⎤		185.	950.	
1045C2	Philadelphia	Burke-Glass			200.	1000.	
1045C3	Philadelphia	Burke-Houston			185.	950.	
1045C3 ☆	1 reported		3,720,000	3,720,000			
1045C4	Philadelphia	White-Mellon			185.	950.	
1045C4 ☆	1 reported		⎦		–		
1045D1	Cleveland	Burke-McAdoo	⎤		185.	950.	
1045D2	Cleveland	Burke-Glass			200.	1000.	
1045D3	Cleveland	Burke-Houston	6,136,000	6,012,000	185.	950.	
1045D4	Cleveland	White-Mellon (b)			185.	950.	
1045D4 ☆	8 reported		⎦		–	–	
1045E1	Richmond	Burke-McAdoo	⎤		185.	950.	
1045E2	Richmond	Burke-Glass			200.	1000.	
1045E3	Richmond	Burke-Houston	1,688,000	1,664,000	185.	950.	
1045E3 ☆	2 reported				–	–	
1045E4	Richmond	White-Mellon	⎦		185.	950.	
1045F1	Atlanta	Burke-McAdoo	⎤		185.	950.	
1045F2	Atlanta	Burke-Glass			200.	1000.	
1045F3	Atlanta	Burke-Houston	1,060,000	868,000	185.	950.	
1045F4	Atlanta	White-Mellon	⎦		185.	950.	
1045G1	Chicago	Burke-McAdoo	⎤		185.	950.	
1045G2	Chicago	Burke-Glass			200.	1000.	
1045G2 ☆	1 reported		3,988,000	3,988,000	–	–	
1045G3	Chicago	Burke-Houston			185.	950.	
1045G3 ☆	2 reported				–	–	
1045G4	Chicago	White-Mellon	⎦		185.	950.	
1045H1	St. Louis	Burke-McAdoo	⎤		185.	950.	
1045H2	St. Louis	Burke-Glass			200.	1000.	
1045H2 ☆	1 reported		584,000	572,000	–	–	
1045H3	St. Louis	Burke-Houston			185.	950.	
1045H4	St. Louis	White-Mellon	⎦		185.	950.	
1045I1	Minneapolis	Burke-McAdoo	⎤		185.	950.	
1045I3	Minneapolis	Burke-Houston	164,000	160,000	185.	950.	
1045I4	Minneapolis	White-Mellon	⎦		185.	950.	
1045J1	Kansas City	Burke-McAdoo		424,000	372,000	185.	950.
1045J4	Kansas City	White-Mellon		included in above		185.	950.

Federal Reserve Notes/Series 1918/Blue Seal *(continued)*

			Notes			
No.	Bank	Signatures	Printed	Delivered	VFine	Unc
1045K1	Dallas	Burke-McAdoo			185.	950.
1045K3	Dallas	Burke-Houston	216,000	204,000	185.	950.
1045K4	Dallas	White-Mellon			185.	950.
1045L1	San Francisco	Burke-McAdoo			185.	950.
1045L3	San Francisco	Burke-Houston	1,356,000	1,356,000	185.	950.
1045L4	San Francisco	White-Mellon			185.	950.

Remarks: Doug Murray reports that no plates were made for Nos. 1045I2, 1045J2 & 3, 1045K2 and 1045L2. For each of the following districts, A, F, H, I, J, K and L, 4,000 replacement notes were printed; for B, 12,000 notes; C, 28,000; D, 36,000; E & G, 8,000 each. White-Mellon plate variation, in parenthesis, exist for two districts, identified as type "b" (small district number and letter in lower left). Star, replacement notes reported in the main listing above are type "a" notes. See $5 Federal Reserve notes for examples.

Federal Reserve Bank Notes/Series 1918/Blue Seal

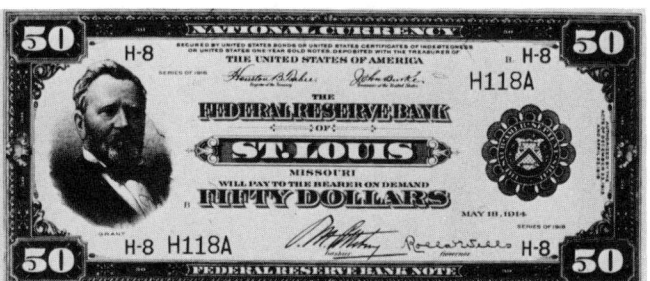

The portrait of Ulysses S. Grant was engraved by John Eissler. The back design is similar to No. 1044.

		Signatures				
No.	Bank	Government	Bank	Issued	VFine	Unc
1046	St. Louis	Teehee-Burke	Attebery-Wells	4000	$4000.	$9000.

Remarks: Although plates were prepared for all 12 Federal Reserve Banks, St. Louis was the only bank to issue this denomination. In 1956, 64 notes were outstanding. The serial numbers of the known 47 notes are provided by Michael A. Crabb, Jr. and Martin Gengerke. Each note has the "H" prefix and "A" suffix: 46, 103, 110, 115, 117, 118, 122, 138, 140, 151, 153, 161, 168, 176, 608, 649, 656, 671, 674, 678, 682, 683, 689, 741, 751, 753, 768, 770, 774, 797, 821, 898, 991, 1813, 2128, 2320, 2923, 2933, 3213, 3299, 3396, 3402, 3458, 3800, 3862, 3887 and 3917.

Federal Reserve Bank Notes/Series 1929/Brown Seal

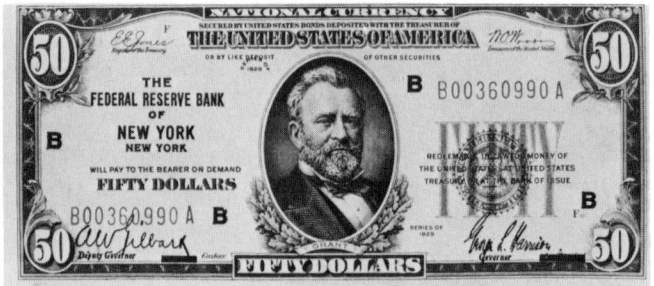

This portrait of U.S. Grant was engraved by John Eissler.

An engraving of the *U.S. Capitol* occupies the back.

Signatures of Jones-Woods

No.	Bank	Notes Printed	VFine	EFine	Unc
1047A	Boston	not printed	$ –	$ –	$ –
1047B	New York	636,000	65.	90.	115.
1047B☆		24,000	–	–	–
1047C	Philadelphia	not printed	–	–	–
1047D	Cleveland	684,000	65.	90.	115.
1047D☆		12,000	–	–	–
1047E	Richmond	not printed	–	–	–
1047F	Atlanta	not printed	–	–	–
1047G	Chicago	300,000	65.	90.	150.
1047G☆		4,000	–	–	–
1047H	St. Louis	not printed	–	–	–
1047I	Minneapolis	132,000	75.	100.	175.
1047J	Kansas City	276,000	65.	90.	135.
1047J☆		–	–	–	–
1047K	Dallas	168,000	65.	90.	150.
1047L	San Francisco	576,000	65.	90.	115.

National Bank Notes/Series 1929/Brown Seal

Signatures of Jones-Woods

Type I

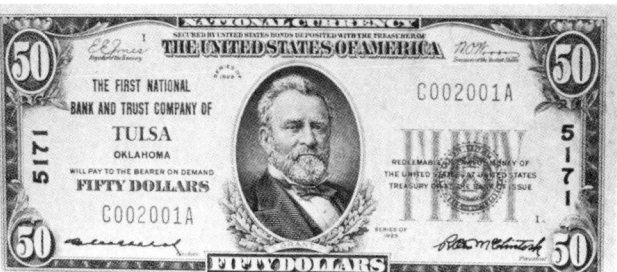

Type II has the bank
charter number printed a
second time near the serial
number.

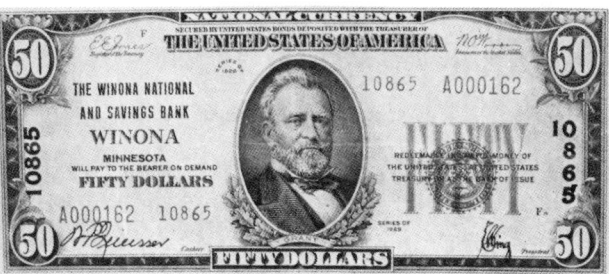

		Type I			Type II		
No.	Rarity	VFine	EFine	Unc	VFine	EFine	Unc
	1	$ 80.	$110.	$165.	$ 90.	$120.	$ 475.
	2	85.	120.	175.	95.	130.	500.
	3	90.	130.	200.	100.	150.	525.
	4	100.	155.	225.	120.	165.	550.
1048	5	140.	175.	250.	160.	190.	600.
	6	165.	210.	285.	200.	250.	675.
	7	190.	250.	350.	225.	300.	1000.
	8	325.	450.	750.	415.	600.	–
	9	–	–	–	–	–	–

Remarks: The total issue for both types was 1,160,812. Banks in Alabama, Alaska, Arizona, Arkansas, Georgia, Maine, New Mexico and South Carolina did not issue this denomination.

Federal Reserve Notes/Series 1928 & 1928A/Green Seal

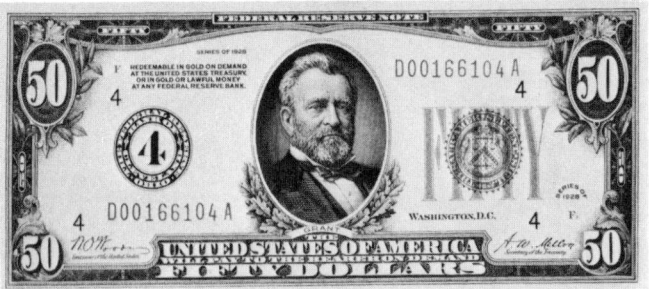

The district letter replaces the numeral in the seal on the Series 1928A. The back design is the same as No. 1047.

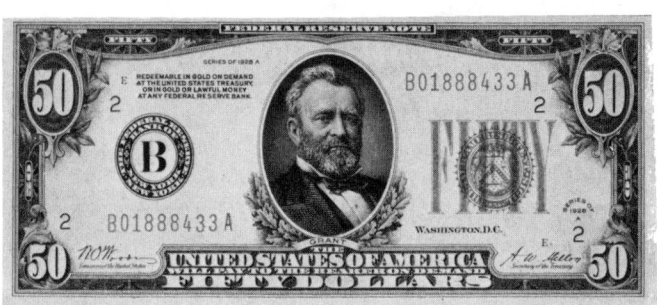

Series 1928, Woods-Mellon				Series 1928A, Woods-Mellon			
No.	**Bank**	**Notes Printed**	**Unc**	**No.**	**Bank**	**Notes Printed**	**Unc**
1049A	Boston	265,000	$125.	1050A	Boston	1,834,989	$100.
1049A☆		–		1050A☆		not printed	–
1049B	New York	1,351,800	100.	1050B	New York	3,392,329	100.
1049B☆		–		1050B☆		not printed	–
1049C	Philadelphia	997,560	115.	1050C	Philadelphia	3,078,944	100.
1049C☆		–		1050C☆		not printed	–
1049D	Cleveland	1,161,900	100.	1050D	Cleveland	2,453,364	100.
1049D☆		–		1050D☆		not printed	–
1049E	Richmond	539,400	120.	1050E	Richmond	1,516,500	100.
1049E☆		not printed	–	1050E☆		not printed	–
1049F	Atlanta	538,800	120.	1050F	Atlanta	338,400	125.
1049F☆		–		1050F☆		not printed	–
1049G	Chicago	1,348,620	100.	1050G	Chicago	5,263,956	100.
1049G☆		–		1050G☆		not printed	–
1049H	St. Louis	627,300	120.	1050H	St. Louis	880,500	115.
1049H☆		–		1050H☆		not printed	–
1049I	Minneapolis	106,200	130.	1050I	Minneapolis	780,240	115.
1049I☆		–		1050I☆		not printed	–
1049J	Kansas City	252,600	125.	1050J	Kansas City	791,064	115.
1049J☆		–		1050J☆		not printed	–
1049K	Dallas	109,920	130.	1050K	Dallas	701,496	115.
1049K☆		–		1050K☆		not printed	–
1049L	San Francisco	447,600	120.	1050L	San Francisco	1,522,000	100.
1049L☆		not printed	–	1050L		not printed	–

Federal Reserve Notes/Series 1934, 1934A, 1934B, 1934C & 1934D/Green Seal

Series 1934, Julian-Morgenthau No.	Bank	Notes Printed	Unc	Series 1934A, Julian-Morgenthau No.	Bank	Notes Printed	Unc
1051A	Boston	2,265,000	$100.	1052A	Boston	406,200	$115.
1051A☆			–	1052A☆		not printed	–
1051B	New York	17,894,676	85.	1052B	New York	4,710,648	85.
1051B☆			–	1052B☆		not printed	–
1051C	Philadelphia	5,833,200	90.	1052C	Philadelphia	not printed	–
1051C☆			–	1052C☆		not printed	–
1051D	Cleveland	8,817,720	90.	1052D	Cleveland	864,164	100.
1051D☆			–	1052D☆		not printed	–
1051E	Richmond	4,826,628	90.	1052E	Richmond	2,235,372	85.
1051E☆		not printed	–	1052E☆		not printed	–
1051F	Atlanta	3,069,348	90.	1052F	Atlanta	416,100	115.
1051F☆		not printed	–	1052F☆			–
1051G	Chicago	8,675,940	90.	1052G	Chicago	1,014,600	85.
1051G☆			–	1052G☆		not printed	–
1051H	St. Louis	1,497,144	100.	1052H	St. Louis	361,944	115.
1051H☆		not printed	–	1052H☆		not printed	–
1051I	Minneapolis	539,700	115.	1052I	Minneapolis	93,300	125.
1051I☆		not printed	–	1052I☆		not printed	–
1051J	Kansas City	1,133,520	100.	1052J	Kansas City	189,300	115.
1051J☆			–	1052J☆		not printed	–
1051K	Dallas	1,194,876	100.	1052K	Dallas	266,700	115.
1051K☆		not printed	–	1052K☆		not printed	–
1051L	San Francisco	8,101,200	90.	1052L	San Francisco	162,000	115.
1051L☆			–	1052L☆		not printed	–

Series 1934B, Julian-Vinson No.	Bank	Notes Printed	Unc	Series 1934C, Julian-Snyder No.	Bank	Notes Printed	Unc
1053A	Boston	not printed	$ –	1054A	Boston	117,600	$115.
1053B	New York	not printed	–	1054B	New York	1,556,400	90.
1053C	Philadelphia	509,100	100.	1054C	Philadelphia	107,283	115.
1053D	Cleveland	359,100	100.	1054D	Cleveland	374,400	110.
1053E	Richmond	596,700	100.	1054E	Richmond	1,821,960	90.
1053F	Atlanta	416,710	100.	1054F	Atlanta	107,640	115.
1053G	Chicago	306,000	100.	1054G	Chicago	294,432	110.
1053H	St. Louis	306,000	100.	1054H	St. Louis	535,200	110.
1053I	Minneapolis	120,000	115.	1054I	Minneapolis	118,800	115.
1053J	Kansas City	221,340	100.	1054J	Kansas City	303,600	110.
1053J☆		reported	–	1054J☆		none reported	–
1053K	Dallas	120,108	115.	1054K	Dallas	429,900	110.
1053L	San Francisco	441,000	100.	1054L	San Francisco	not printed	–

Series 1934D, Clark Snyder No.	Bank	Notes Printed	Unc	No.	Bank	Notes Printed	Unc
1055A	Boston	279,000	$ 85.	1055G	Chicago	494,016	$ 85.
1055A☆			–	1055G☆			–
1055B	New York	898,776	85.	1055H	St. Louis	not printed	–
1055C	Philadelphia	699,000	85.	1055I	Minneapolis	not printed	–
1055D	Cleveland	not printed	–	1055J	Kansas City	not printed	–
1055E	Richmond	156,000	100.	1055K	Dallas	103,200	100.
1055F	Atlanta	216,000	90.	1055L	San Francisco	not printed	–
1055F☆			–				

Federal Reserve Notes/Series 1950, 1950A, 1950B & 1950C/Green Seal

Series 1950, Clark-Snyder				Series 1950A, Priest-Humphrey			
No.	Bank	Notes Printed	Unc	No.	Bank	Notes Printed	Unc
1056A	Boston	1,248,000	$75.	1057A	Boston	720,000	$85.
1056A☆			–	1057A☆			–
1056B	New York	10,236,000	65.	1057B	New York	6,480,000	70.
1056B☆			–	1057B☆			–
1056C	Philadelphia	2,353,000	75.	1057C	Philadelphia	1,728,000	75.
1056C☆			–	1057C☆			–
1056D	Cleveland	6,180,000	75.	1057D	Cleveland	1,872,000	75.
1056D☆			–	1057D☆			–
1056E	Richmond	5,064,000	75.	1057E	Richmond	2,016,000	75.
1056E☆			–	1057E☆			–
1056F	Atlanta	1,812,000	75.	1057F	Atlanta	288,000	90.
1056F☆			–	1057F☆			–
1056G	Chicago	4,212,000	75.	1057G	Chicago	2,016,000	75.
1056G☆			–	1057G☆			–
1056H	St. Louis	892,000	75.	1057H	St. Louis	576,000	85.
1056H☆			–	1057H☆			–
1056I	Minneapolis	384,000	90.	1057I	Minneapolis	not printed	–
1056J	Kansas City	696,000	85.	1057J	Kansas City	144,000	90.
1056J☆			–	1057J☆			–
1056K	Dallas	1,100,000	75.	1057K	Dallas	664,000	85.
1056K☆			–	1057K☆			–
1056L	San Francisco	3,996,000	75.	1057L	San Francisco	576,000	85.
1056L☆			–	1057L☆			–

Series 1950B, Priest-Anderson				Series 1950C, Smith-Dillon			
No.	Bank	Notes Printed	Unc	No.	Bank	Notes Printed	Unc
1058A	Boston	664,000	$75.	1059A	Boston	720,000	$75.
1058A☆			–	1059A☆			–
1058B	New York	8,352,000	65.	1059B	New York	5,328,000	65.
1058B☆			–	1059B☆			–
1058C	Philadelphia	2,592,000	70.	1059C	Philadelphia	1,296,000	65.
1058C☆			–	1059C☆			–
1058D	Cleveland	1,728,000	70.	1059D	Cleveland	1,296,000	65.
1058D☆			–	1059D☆			–
1058E	Richmond	1,584,000	70.	1059E	Richmond	1,296,000	65.
1058E☆			–	1059E☆			–
1058F	Atlanta	not printed	–	1059F	Atlanta	not printed	–
1058F☆		not printed	–	1059F☆		not printed	–
1058G	Chicago	4,320,000	70.	1059G	Chicago	1,728,000	65.
1058G☆			–	1059G☆			–
1058H	St. Louis	576,000	75.	1059H	St. Louis	576,000	75.
1058H☆			–	1059H☆			–
1058I	Minneapolis	not printed	–	1059I	Minneapolis	144,000	85.
1058I☆		not printed	–	1059I☆			–
1058J	Kansas City	1,008,000	70.	1059J	Kansas City	432,000	75.
1058J☆			–	1059J☆			–
1058K	Dallas	1,008,000	70.	1059K	Dallas	720,000	75.
1058K☆			–	1059K☆			–
1058L	San Francisco	1,872,000	70.	1059L	San Francisco	1,152,000	65.
1058L☆			–	1059L☆			–

Federal Reserve Notes/Series 1950D, 1950E, 1963A & 1969/Green Seal

Series 1950D, Granahan-Dillon

No.	Bank	Notes Printed	Unc
1060A	Boston	1,728,000	$65.
1060A☆			–
1060B	New York	7,200,000	60.
1060B☆			–
1060C	Philadelphia	2,736,000	60.
1060C☆			–
1060D	Cleveland	2,880,000	60.
1060D☆			–
1060E	Richmond	2,016,000	60.
1060E☆			–
1060F	Atlanta	576,000	75.
1060F☆			–
1060G	Chicago	4,176,000	60.
1060G☆			–
1060H	St. Louis	1,440,000	65.
1060H☆			–
1060I	Minneapolis	288,000	75.
1060I☆			–
1060J	Kansas City	720,000	75.
1060J☆			–
1060K	Dallas	1,296,000	65.
1060K☆			–
1060L	San Francisco	2,160,000	60.
1060L☆			–

Series 1950E, Granahan-Fowler

No.	Bank	Notes Printed	Unc
1061B	New York	3,024,000	$60.
1061B☆		reported	–
1061G	Chicago	1,008,000	60.
1061L	San Francisco	1,296,000	60.

notes were printed for these districts only.

"IN GOD WE TRUST" added to Series 1963A and all subsequent $50 notes.

Series 1963A, Granahan-Fowler

No.	Bank	Notes Printed	Unc
1062A	Boston	1,536,000	$60.
1062A☆		320,000	70.
1062B	New York	11,008,000	55.
1062B☆		1,408,000	60.
1062C	Philadelphia	3,328,000	60.
1062C☆		704,000	70.
1062D	Cleveland	3,584,000	60.
1062D☆		256,000	75.
1062E	Richmond	3,072,000	60.
1062E☆		704,000	70.
1062F	Atlanta	768,000	65.
1062F☆		384,000	75.
1062G	Chicago	6,912,000	55.
1062G☆		768,000	75.
1062H	St. Louis	512,000	65.
1062H☆		128,000	85.
1062I	Minneapolis	512,000	65.
1062I☆		128,000	85.
1062J	Kansas City	512,000	65.
1062J☆		64,000	90.
1062K	Dallas	1,536,000	60.
1062K☆		128,000	85.
1062L	San Francisco	4,352,000	60.
1062L☆		704,000	70.

Series 1969, Elston-Kennedy

No.	Bank	Notes Printed	Unc
1063A	Boston	2,048,000	$60.
1063A☆		not printed	–
1063B	New York	12,032,000	55.
1063B☆		384,000	70.
1063C	Philadelphia	3,548,000	60.
1063C☆		128,000	80.
1063D	Cleveland	3,584,000	60.
1063D☆		192,000	75.
1063E	Richmond	2,560,000	60.
1063E☆		64,000	85.
1063F	Atlanta	256,000	70.
1063F☆		not printed	–
1063G	Chicago	9,728,000	55.
1063G☆		256,000	70.
1063H	St. Louis	256,000	70.
1063H☆		not printed	–
1063I	Minneapolis	512,000	65.
1063I☆		not printed	–
1063J	Kansas City	1,280,000	60.
1063J☆		64,000	85.
1063K	Dallas	1,536,000	60.
1063K☆		64,000	85.
1063L	San Francisco	6,912,000	55.
1063L☆		256,000	70.

Federal Reserve Notes/Series 1969A, 1969B, 1969C & 1974/Green Seal

Series 1969A, Kabis-Connally

No.	Bank	Notes Printed	Unc
1064A	Boston	1,536,000	$55.
1064A☆		128,000	75.
1064B	New York	9,728,000	55.
1064B☆		704,000	65.
1064C	Philadelphia	2,560,000	55.
1064C☆		704,000	65.
1064D	Cleveland	2,816,000	55.
1064D☆		not printed	–
1064E	Richmond	2,304,000	55.
1064E☆		64,000	85.
1064F	Atlanta	256,000	70.
1064F☆		64,000	85.
1064G	Chicago	3,584,000	55.
1064G☆		192,000	70.
1064H	St. Louis	256,000	70.
1064H☆		not printed	–
1064I	Minneapolis	512,000	65.
1064I☆		not printed	–
1064J	Kansas City	256,000	70.
1064J☆		not printed	–
1064K	Dallas	1,024,000	55.
1064K☆		128,000	75.
1064L	San Francisco	5,120,000	55.
1064L☆		256,000	70.

Series 1969B, Banuelos-Connally

No.	Bank	Notes Printed	Unc
1065A	Boston	1,024,000	$55.
1065A☆		not printed	–
1065B	New York	2,560,000	55.
1065B☆		not printed	–
1065C	Philadelphia	2,048,000	55.
1065C☆		not printed	–
1065E	Richmond	1,536,000	55.
1065F	Atlanta	512,000	65.
1065G	Chicago	1,134,000	55.
1065K	Dallas	1,024,000	55.

$50 notes were printed for these districts only.

Series 1969C, Banuelos-Shultz

No.	Bank	Notes Printed	Unc
1066A	Boston	1,792,000	$55.
1066A☆		64,000	65.
1066B	New York	7,040,000	55.
1066B☆		192,000	65.
1066C	Philadelphia	3,584,000	55.
1066C☆		256,000	65.
1066D	Cleveland	5,120,000	55.
1066D☆		192,000	65.
1066E	Richmond	2,304,000	55.
1066E☆		64,000	65.
1066F	Atlanta	256,000	65.
1066F☆		64,000	65.
1066G	Chicago	6,784,000	55.
1066G☆		576,000	65.
1066H	St. Louis	2,688,000	55.
1066H☆		64,000	65.
1066I	Minneapolis	256,000	65.
1066I☆		64,000	65.
1066J	Kansas City	1,280,000	55.
1066J☆		128,000	65.
1066K	Dallas	3,456,000	55.
1066K☆		64,000	65.
1066L	San Francisco	4,608,000	55.
1066L☆		256,000	65.

Series 1974, Neff-Simon

No.	Bank	Notes Printed	Unc
1067A	Boston	3,840,000	$55.
1067A☆		256,000	65.
1067B	New York	38,400,000	55.
1067B☆		768,000	65.
1067C	Philadelphia	7,040,000	55.
1067C☆		384,000	65.
1067D	Cleveland	21,120,000	55.
1067D☆		640,000	65.
1067E	Richmond	14,400,000	55.
1067E☆		576,000	65.
1067F	Atlanta	1,280,000	55.
1067F☆		64,000	65.
1067G	Chicago	30,720,000	55.
1067G☆		1,536,000	55.
1067H	St. Louis	1,920,000	55.
1067H☆		128,000	65.
1067I	Minneapolis	3,200,000	55.
1067I☆		192,000	65.
1067J	Kansas City	4,480,000	55.
1067J☆		192,000	65.
1067K	Dallas	8,320,000	55.
1067K☆		128,000	65.
1067L	San Francisco	8,320,000	55.
1067L☆		64,000	65.

Federal Reserve Notes/Series 1977, 1981, 1981A & 1988/Green Seal

Series 1977, Morton-Blumnenthal				Series 1981, Buchanan-Regan			
No.	Bank	Notes Printed	Unc	No.	Bank	Notes Printed	Unc
1068A	Boston	15,360,000	$55.	1069A	Boston	18,500,000	$55.
1068A☆		1,088,000	60.	1069A☆		not printed	–
1068B	New York	49,920,000	55.	1069B	New York	78,080,000	55.
1068B☆		2,112,000	55.	1069B☆		768,000	65.
1068C	Philadelphia	5,112,000	55.	1069C	Philadelphia	1,280,000	55.
1068C☆		128,000	65.	1069C☆		not printed	–
1068D	Cleveland	23,040,000	55.	1069D	Cleveland	28,160,000	55.
1068D☆		1,024,000	55.	1069D☆		256,000	65.
1068E	Richmond	24,320,000	55.	1069E	Richmond	25,600	85.
1068E☆		896,000	65.	1069E☆		not printed	–
1068F	Atlanta	2,560,000	55.	1069F	Atlanta	14,080,000	55.
1068F☆		128,000	65.	1069F☆		not printed	–
1068G	Chicago	47,360,000	55.	1069G	Chicago	67,200,000	55.
1068G☆		2,304,000	55.	1069G☆		128,000	65.
1068H	St. Louis	3,840,000	55.	1069H	St. Louis	4,480,000	55.
1068H☆		512,000	65.	1069H☆		not printed	–
1068I	Minneapolis	3,840,000	55.	1069I	Minneapolis	5,760,000	55.
1068I☆		128,000	65.	1069I☆		128,000	65.
1068J	Kansas City	7,680,000	55.	1069J	Kansas City	18,560,000	55.
1068J☆		256,000	65.	1069J☆		896,000	65.
1068K	Dallas	14,080,000	55.	1069K	Dallas	19,840,000	55.
1068K☆		576,000	65.	1069K☆		not printed	–
1068L	San Francisco	19,200,000	55.	1069L	San Francisco	35,200,000	55.
1068L☆		768,000	65.	1069L☆		256,000	65.

Series 1981A, Ortega-Regan				Series 1988, Ortega-Brady			
No.	Bank	Notes Printed	Unc	No.	Bank	Notes Printed	Unc
1070A	Boston	9,600,000	$55.	1071A	Boston	9,600,000	$55.
1070A☆		not printed	–	1071A☆		not printed	–
1070B	New York	28,800,000	55.	1071B	New York	214,400,000	–
1070B☆		3,200,000	55.	1071B☆		not printed	–
1070C	Philadelphia	not printed	–	1071C	Philadelphia	not printed	–
1070C☆		not printed	–	1071C☆		not printed	–
1070D	Cleveland	12,800,000	55.	1071D	Cleveland	32,000,000	–
1070D☆		not printed	–	1071D☆		not printed	–
1070E	Richmond	12,800,000	55.	1071E	Richmond	12,800,000	–
1070E☆		688,000	65.	1071E☆		not printed	–
1070F	Atlanta	3,200,000	55.	1071F	Atlanta	not printed	–
1070F☆		not printed	–	1071F☆		not printed	–
1070G	Chicago	28,800,000	55.	1071G	Chicago	80,000,000	–
1070G☆		not printed	–	1071G☆		not printed	–
1070H	St. Louis	3,200,000	55.	1071H	St. Louis	not printed	–
1070H☆		not printed	–	1071H☆		not printed	–
1070I	Minneapolis	3,200,000	55.	1071I	Minneapolis	not printed	–
1070I☆		not printed	–	1071I☆		not printed	–
1070J	Kansas City	6,400,000	55.	1071J	Kansas City	6,400,000	55.
1070J☆		not printed	–	1071J☆		not printed	–
1070K	Dallas	6,400,000	55.	1071K	Dallas	not printed	–
1070K☆		not printed	–	1071K☆		not printed	–
1070L	San Francisco	22,400,000	55.	1071L	San Francisco	12,800,000	55.
1070L☆		640,000	65.	1071L☆		not printed	–

Federal Reserve Notes/Series 1988A & 1990/Green Seal

Series 1988A, Villalpando-Brady				Series 1990, Villalpando-Brady			
No.	Bank	Notes Printed	Unc	No.	Bank	Notes Printed	Unc

No Series 1985 and 1988A $50 notes were printed.
Series 1990 were in production when this catalog was printed.

This page has been left blank for your personal notations.

Gold Certificate/Series 1928

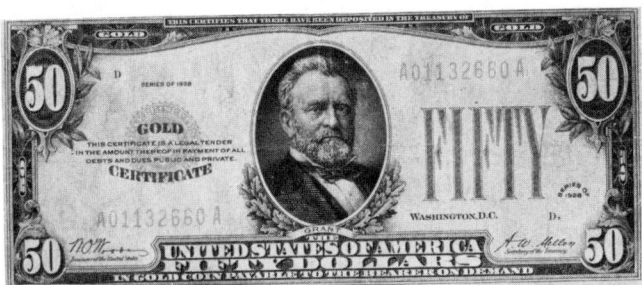

The portrait of U.S. Grant was engraved by John Eissler. The back design is similar to No. 1047.

No.	Signatures	Notes Printed	VFine	EFine	Unc
1119	Woods-Mellon	5,520,000	$ 90.	$125.	$550.
1119☆	Woods-Mellon	—	300.	500.	800.

United States Notes/1862 & 1863/Red Seal

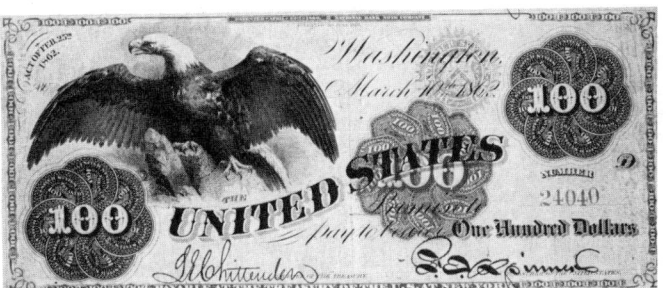

Spread Eagle was engraved by Joseph P. Ourdan.

First obligation back on Nos. 1120 & 1120a.

Second obligation back.

No.	Date	Description	VGood	VFine	Unc
1120	1862	"American Bank Note Company" upper border	$2350.	$6000.	$22,000.
1120a	1862	without above monogram	2350.	6000.	22,000.
1120b	1863	"National Bank Note Company" upper border		2 notes reported	
1121	1863	"National" and "American Bank Note Company" in upper border; one serial number		2 notes known	
1121a	1863	as preceding; two serial numbers	2250.	5800.	20,000.

Remarks: A total of 400,000 notes were printed, all with signatures of Chittenden-Spinner. For Nos. 1120–1120a, an estimated 130,000 notes bearing the first obligation were printed. The remaining 270,000 notes bear the second obligation. Recorded serial numbers suggest that as many as 64 notes in uncirculated condition could exist. The number of notes known are in parentheses: Nos. 1120 (11), 1120a (10), 1121a (24). These catalog numbers have been changed from the 1983 edition.

United States Notes/Series 1869/Red Seal

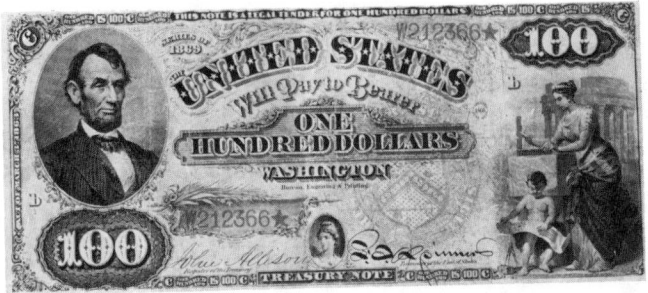

The portrait of Abraham Lincoln, based on a photograph by Anthony Berger, was engraved by Charles Burt, who also engraved the head of *Liberty* (see No. 1341). *Reconstruction* was engraved by Louis Delnoce

No.	Signatures	Notes Printed	Known	Fine	EFine	Unc
1122	Allison-Spinner	364,000	18	$7500.	$11,000.	$25,000.

Remarks: According to Walter Breen, as many as 371,040 notes were issued; this exceeds the official total. About five of the known notes are in uncirculated condition. The following serial numbers, all with "A" prefix, have been recorded by Martin Gengerke, Gene Hessler and John Isted: 45508, 68701, 68705, 71287, 72701, 88855, 110033, 167928, 175693, 204590, 204599, 211085, 212120, 212366, 213113, 266223, 266227, 277696, 282739, 291200, 329434 & 346542.

United States Notes/Series 1875–1880

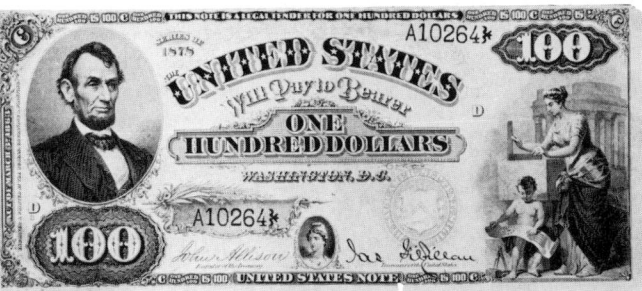

Face design is similar to preceding note.

No.	Series	Signatures	Seal	Notes Printed	Fine	EFine	Unc
		Nos. 1123A-1125 have red floral patterns and red seals.					
1123	1875	Allison-New	rays	122,000	$3350.	$8750.	$ –
1124	1875A	Allison-Wyman	rays	40,000	– – – –	4 known	– – – –
1125	1878	Allison-Gilfillan	rays	202,000	3150.	9000.	–
		Black floral patterns. All have red seals except for Nos. 1126, 1127 & 1132.					
1126	1880	Bruce-Gilfillan	brown	60,000	2250.	5750.	10500.
1127	1880	Bruce-Wyman	brown	80,000	2250.	5750.	10500.
1128	1880	Rosecrans-Jordan	large	80,000	2250.	5750.	10750.
1129	1880	Rosecrans-Hyatt	large	20,000	– – – –	2 known	– – – –
1130	1880	Rosecrans-Hyatt	lg. spikes	80,000	2250.	5750.	10750.
1131	1880	Rosecrans-Huston	spikes	60,000	2250.	5750.	10500.
1132	1880	Rosecrans-Huston	brown	80,000	2250.	5750.	10500.
1133	1880	Tillman-Morgan	scallops	172,000	1750.	4250.	9500.
1134	1880	Bruce-Roberts	scallops	24,000	– – – –	6 known	– – – –
1135	1880	Lyons-Roberts	scallops	180,000	1750.	4250.	9500.
1136	1880	Napier-McClung	scallops		existence doubtful		

Remarks: Figures in parentheses represent the number of notes known for Nos. 1123 (10); 1125 (13); 1126 (8); 1127 (6); 1128 (12); 1130 (6); 1131 (15); 1132 (13); 1133 (21); & 1135 (35).

Compound Interest Treasury Notes/6%/Red Seal

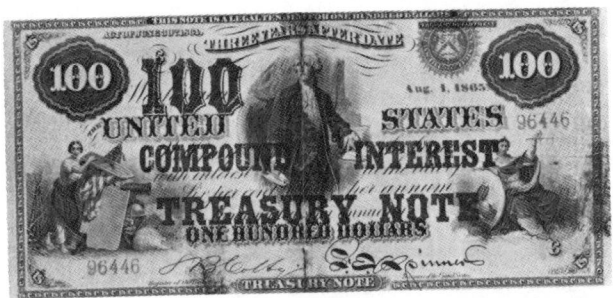

The *Lansdowne Portrait of Washington* was engraved by Owen G. Hanks. *Justice and Shield* on the right was engraved by Charles Burt; the *Guardian* is on the left.

The interest-rate table is on the back.

No.	Signatures	Dated	Notes Printed	Notes Issued	Outstanding	Known
		Act of March 3, 1863				
1137	Chittenden-Spinner	June 10, 1864	40,032	39,176	59	1
		Act of June 30, 1864				
1138	Chittenden-Spinner	July 15, 1864	272,480	260,140	278	2
1139	Colby-Spinner	Aug. 15, 1864	266,800	243,600	incl. above	2
1139a	Colby-Spinner	Dec. 15, 1864	−	−	−	1
1139b	Colby-Spinner	May 15, 1865	−	−	−	6
1139c	Colby-Spinner	Aug. 1, 1865	−	−	−	2
1139d	Colby-Spinner	Sept. 1, 1865	−	−	−	1

Remarks: These notes, especially No. 1139b, were counterfeited extensively. See "A Superb Counterfeit" by W.P. Koster in *PAPER MONEY*, Vol. XIV, No. 1. 1975, p. 7. As much as $15,000,000 in notes, of all denominations, bearing the erroneous Act of 2 July 1864 was issued with the date of 15 July 1864. To date only two $10 notes have been recorded.

Interest-bearing Notes 6%/Act of March 2, 1861

Wealth was designed and engraved by Freeman Rawdon; *Mercury* was drawn and engraved by G.W. Hatch; *Justice*, on the right, is probably the work of Rawdon or Hatch. Rawdon, Wright, Hatch & Edson prepared this "old-style," uniface note. This illustrated note sold for $4,500 in Christie's April 2, 1982 auction.

		Notes issued		
No.	Term	Old Plates	New Plates	Known
1139g	60 days	Unknown	30,152	1

One-year Notes, Act of March 3, 1863

The face design is similar to Nos. 1137–1139d.

The back design includes a counterfeit clause.

	Signatures of Chittenden-Spinner			
No.	Dated	Notes Issued	Outstanding	Known
1140	Feb. 17, 1864	136,400	62	1
	March 25, 1864			1
	June 10, 1864			1

Interest-bearing Notes/6%/Two-year Notes

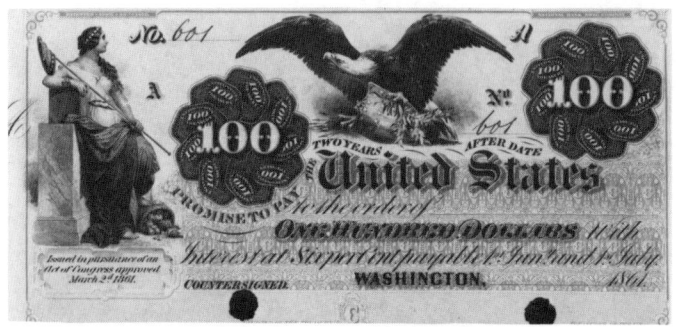

This is the only example on which this version of *Liberty* and this *Eagle* appear on U.S. federal currency (NBNCo).

Act of March 2, 1861

| No. | Signatures | Notes Issued | | Known |
		Old Plates	New Plates	
1141	Chittenden-Spinner	8,719	95,848	1

Remarks: In addition to the illustration of No. 1141, complete with face and back, there is a uniface, face proof with plate "C" known. This version of *Liberty* is based on a reversed image that is part of the *Hemicycle* by Paul Delaroche, completed in 1841 for the École des Beaux Arts. See "Liberty" by R. Horstman in *The Essay Proof Journal*, Vol. 45, No. 3, p. 110.

The head of *Liberty* was used on an essay for a Confederate 5¢ stamp, 200E-C. "For the" was probably written on notes from old plates by clerks who were authorized to sign for U.S. Treasury officials. Notes from new plates probably had "For the" engraved in the plate. At least 97,390 notes from new plates were printed; additional notes could have been printed and issued.

Interest-bearing Notes/6%/Act of March 3, 1863/Two-year Notes

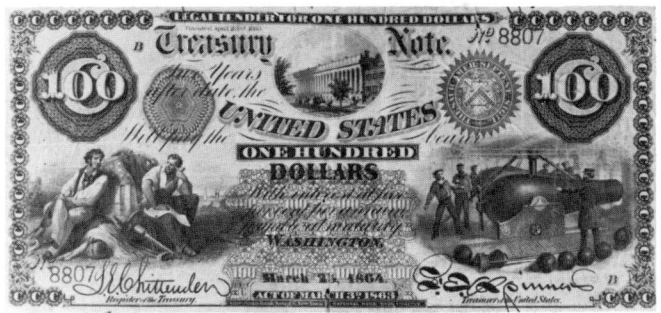

The vignettes on either side of the U.S. Treasury building are entitled *Farmer and Mechanics* and *In the Turret.* (ABNCo & NBNCo)

The back design includes a counterfeit clause.

| | | | Notes | | |
No.	Signatures	Coupons	Printed	Issued	Outstanding
1142	Chittenden-Spinner	0	96,800	96,800	19
1143	Chittenden-Spinner	3	144,800	144,800	80

Remarks: In 1961 this heretofore unknown note was discovered at the Citizens National Bank of Lexington, KY; the illustrations are courtesy of the bank. In addition to the illustrated note another is known with serial number 18114.

Interest-bearing Notes, Three-year Notes/7.30%

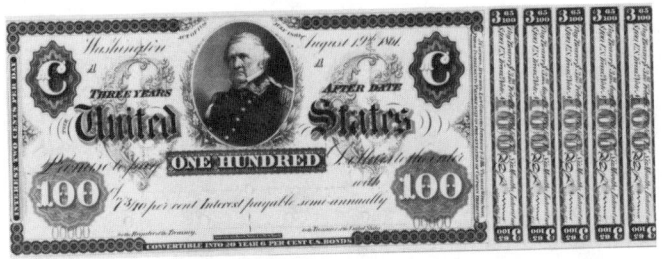

The portrait of General Winfield Scott was engraved by Alfred Jones. This illustrated note, on India paper, is unique in that uniface face and back are mounted as a complete note. (ABNCo)

The back design is green.

Act of July 17, 1861
Signatures of Chittenden-Spinner

No.	Dated	Serial Numbers	Notes Issued	Outstanding
1144	Aug. 19, 1861	red	90,000	73
1145	Oct. 1, 1861	red	103,074	37
1146	Oct. 1, 1861	blue	1,066	0

Act of June 30, 1864
Signatures of Colby-Spinner

No.	Dated	Printed	Notes Issued	Outstanding
1147	Aug. 15, 1864	550,400	556,039	219
1148	Mar. 3, 1865	86,552	included in above	

Remarks: The coupons attached to these notes were redeemed at six-month intervals; the note was redeemed after the last interval. These notes are known as proofs only. (ABNCo & BEP)

Interest-bearing Notes, Three-year Notes/7.30%

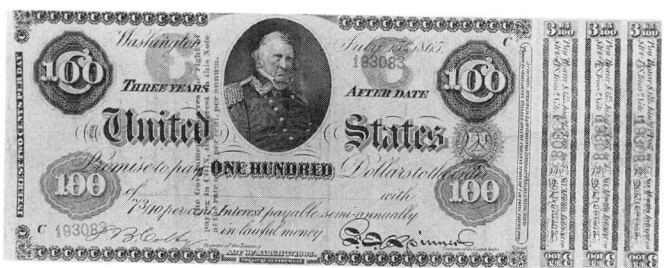

This portrait of General Winfield Scott was engraved by George D. Baldwin. Scott, Supreme Commander of the U.S. Army from July 1841 to Nov. 1861, was, due to his vanity, called "Old Fuss'n Feathers." (ABNCo & BEP)

Act of March 3, 1865
Signatures of Colby-Spinner

No.	Dated	Notes Printed	Issued	Outstanding	Known
1149	June 15, 1865	401,048	338,227	122½	1
1150	July 15, 1865	500,000	472,080	215½	2

Remarks: The recorded serial number for No. 1149 is 272963; the number for the other known No. 1150 is 194009.

National Bank Notes/First Charter Period

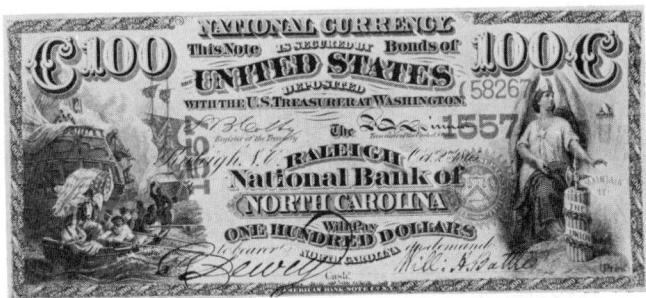

The *Battle of Lake Erie*, by W.H. Powell, was engraved by Louis Delnoce. *Union*, at the right, was engraved by James Bannister. (ABNCo)

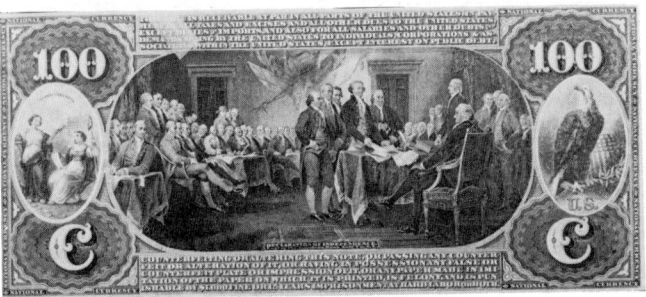

The presentation of the *Declaration of Independence*, by John Trumbull, was engraved by Frederick Girsch.

No.	Series	Signatures	VGood	VFine
		Red seals have rays.		
1151	orig.	Chittenden-Spinner	$2850.	$6000.
1152	orig.	Colby-Spinner	2650.	5500.
1153	orig.	Allison-Spinner	2650.	5500.
		Red seals have scallops.		
1154	1875	Allison-New	2850.	5500.
1155	1875	Allison-Wyman	–––––Unique–––––	
1156	1875	Allison-Gilfillan	2750.	5500.
1157	1875	Scofield-Gilfillan	2750.	5500.
1158	1875	Bruce-Gilfillan	2750.	5500.
1159	1875	Bruce-Wyman	2750.	5500.
1160	1875	Rosecrans-Huston	2750.	5500.
1161	1875	Rosecrans-Nebeker	3250.	7500.
1162	1875	Tillman-Morgan	–	–

Remarks: The original series had no series date on the face. A total of 16,309 notes for both types are outstanding; about 60 actually exist.

National Bank Notes/Second Charter Period/First Issue/Series 1882/Brown Seal

The face design is similar to Nos. 1151–1162. The back design is similar to Nos. 287–299.

No.	Signatures	VGood	VFine	Unc
1163	Bruce-Gilfillan	$650.	$1500.	$5000.
1164	Bruce-Wyman	650.	1500.	5000.
1165	Bruce-Jordan	650.	1500.	5000.
1166	Rosecrans-Jordan	650.	1500.	5000.
1167	Rosecrans-Hyatt	650.	1500.	5000.
1168	Rosecrans-Huston	650.	1500.	5000.
1169	Rosecrans-Nebeker	650.	1500.	5000.
1170	Rosecrans-Morgan	850.	1750.	5750.
1171	Tillman-Morgan	650.	1500.	5000.
1172	Tillman-Roberts	650.	1500.	5000.
1173	Bruce-Roberts	650.	1500.	5000.
1174	Lyons-Roberts	650.	1500.	5000.
1174a	Vernon-Treat	– – – – – – – –	extremely rare	– – – – – – – –

Second Charter Period/Second Issue/Series 1882/Blue Seal

Face design is similar to Nos. 1151–1162. The *Eagle* on the left was engraved by Harry L. Chorlton.

No.	Signatures	VGood	VFine	Unc
1175	Rosecrans-Huston	$600.	$1300.	$5000.
1176	Rosecrans-Nebeker	625.	1350.	5250.
1177	Tillman-Morgan	625.	1350.	5250.
1178	Tillman-Roberts	625.	1350.	5250.
1179	Bruce-Roberts	625.	1350.	5250.
1180	Lyons-Roberts	600.	1300.	5000.
1181	Vernon-Treat	700.	1450.	5750.
1182	Napier-McClung	– – – – – – – –	extremely rare	– – – – – – – –

National Bank Notes/Second Charter Period/Series 1882

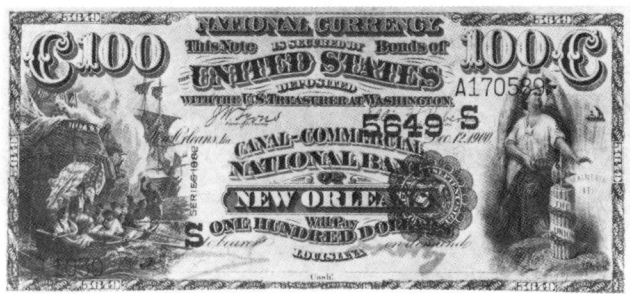

The face design is similar to No. 1151.

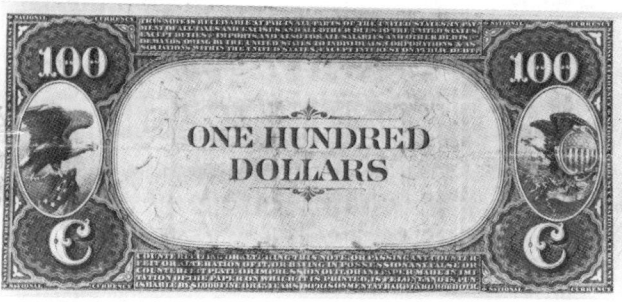

(These illustrations courtesy of John Hickman and Dean Oakes)

Third Issue – Blue Seal

No.	Signatures	Notes Printed	Issued	Known
1183	Lyons-Roberts	3,100	2,857	4

Remarks: The Winters National Bank of Dayton, Ohio and the Canal-Commercial National Bank of New Orleans were the only two banks to issue this denomination. The illustrated note was purchased for $25,000 in 1974; it was sold for $52,500 in 1991.

National Bank Notes/Third Charter Period/Series 1902

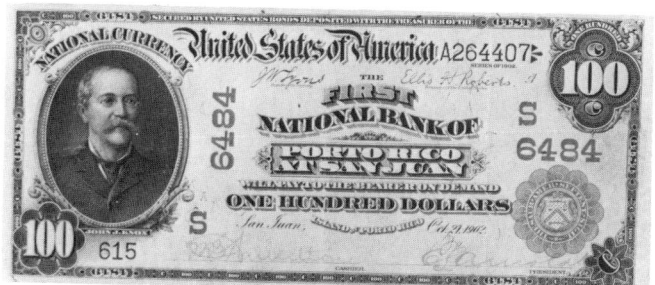

John Knox (1826–1892) served as Comptroller of the Currency (1872–1884). Ostrander Smith designed this note; G.F.C. Smillie engraved the portrait.

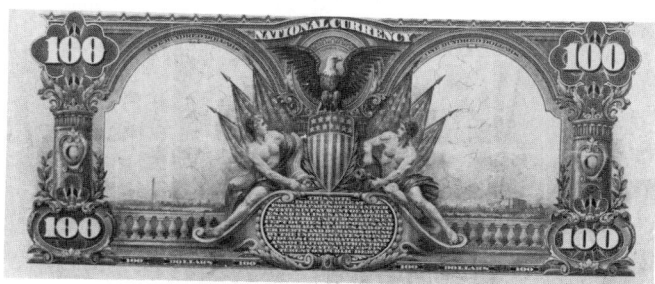

The back design is the same for all three issues; only the second issue has "1902–1908."

No.	Signatures	VGood	VFine	Unc
		First Issue – red seal		
1184	Lyons-Roberts	$700.	$1300.	$3750.
1185	Lyons-Treat	700.	1300.	3750.
1186	Vernon-Treat	800.	1400.	4000.
		Second issue – blue seal		
		"1902–1908"		
1187	Lyons-Roberts	300.	550.	2000.
1188	Lyons-Treat	300.	550.	2000.
1189	Vernon-Treat	300.	550.	2000.
1190	Vernon-McClung	300.	550.	2000.
1191	Napier-McClung	300.	550.	2000.
1192	Napier-Thompson	325.	550.	2150.
1193	Napier-Burke	300.	550.	2000.
1194	Parker-Burke	300.	550.	2000.
1195	Teehee-Burke	325.	550.	2150.

National Bank Notes/Third Charter Period/Series 1902 *(continued)*

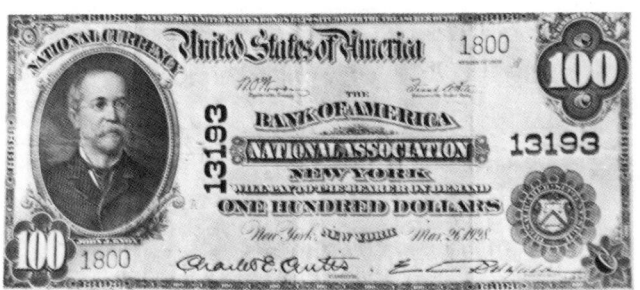

The face design is similar
to the preceding note.

Third issue – blue seal

No.	Signatures	VGood	VFine	Unc
1196	Lyons-Roberts	$275.	$550.	$1850.
1197	Lyons-Treat	275.	550.	1850.
1198	Vernon-Treat	275.	550.	1850.
1199	Vernon-McClung	275.	550.	1850.
1200	Napier-McClung	275.	550.	1850.
1201	Napier-Thompson	300.	575.	2000.
1202	Parker-Burke	275.	575.	1950.
1203	Teehee-Burke	275.	575.	1850.
1204	Elliott-Burke	275.	575.	1850.
1205	Elliott-White	275.	575.	1850.
1206	Speelman-White	275.	575.	1850.
1206a	Woods-White	――――――― 2 known ―――――――		

National Gold Bank Notes/Red Seal

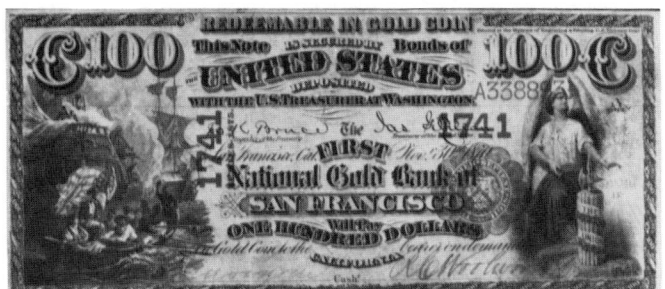

The face design is similar to No. 1151.

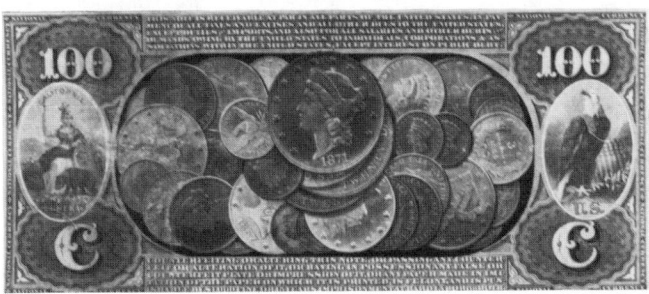

The gold coin vignette was engraved by James Smillie.

No.	Date	Issuing Bank	City	Issued	Known
1207	1870	First National Gold Bank of	San Francisco	2000	2
1208	1875	as above on white paper	San Francisco	620	2
1209	1873	First National Gold Bank of	Santa Barbara	200	1
1210	1874	First National Gold Bank of	Petaluma	400	2
1211	1875	Union National Gold Bank	Oakland	100	1
1211a	1872	Nationlal Gold Bank & Trust Co.	San Francisco	2856	0
1211b	1872	National Gold Bank of D.O. Mills Co.	Sacramento	604	0
1211c	1873	First National Gold Bank of	Stockton	867	0
1211d	1874	Farmers' National Gold Bank	San Jose	400	0

Remarks: A total of 84 notes are outstanding. No. 1207 (321148) in fine condition was advertised at $14,000. No. 1209 (375737) in very good condition sold for $59,000 in 1989. No. 1210, in fine condition, sold for $10,500 in 1973. No. 1211 sold for $18,000 in 1979. One of the two known for No. 1208 is in new condition.

Silver Certificates/Series 1878

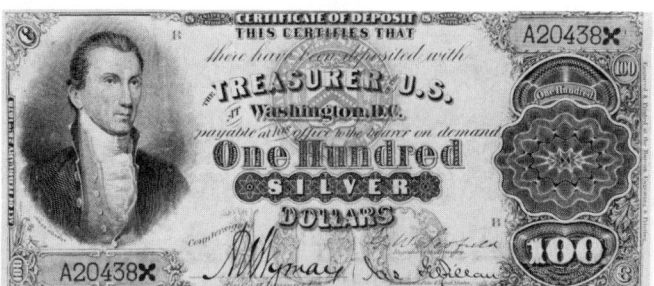

The portrait of James Monroe (1758–1831), fifth President of the U.S., was engraved by Louis, Delnoce; it is based on a portrait by John Vanderlyn.

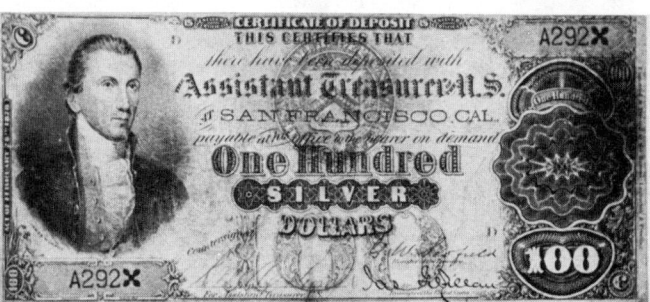

No. 1213

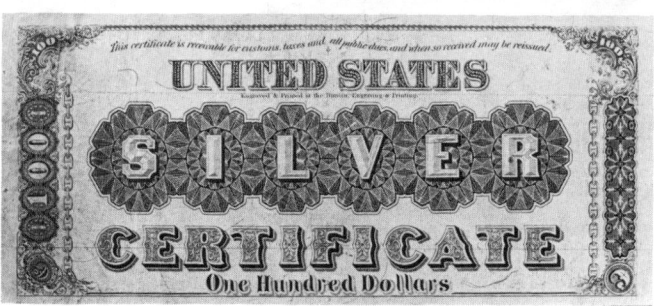

The back is brown and black.

Series of 1878 notes have large red seals, signatures of Scofield-Gilfillan and "100" below series. Countersignatures on Nos. 1213 & 1214 are handwritten.

No.	Countersigned by	Payable at	Issued	Known
1212	W.G. White	New York ⎤	–	1
1212a	J.C. Hopper	New York ⎥	5,000	0
1211b	T. Hillhouse	New York ⎦	–	0
1213	R.M. Anthony	San Francisco	2,400	1
1214	A.U. Wyman	Washington, DC	4,000	1
1214a	A.U. Wyman	Washington, DC	24,000	4

Remarks: For No. 1212, 8,000 notes were printed; 6,800 probably had autographed countersignatures. The remaining 1,200 could have had the engraved countersignature of T. Hillhouse. See "Series 1878 silver certificates . . . " by W. Breen, *Numismatic News*, May 24, 1975. No. 1214a, in very fine condition, was advertised by Stack's in 1989 for $59,000.

Silver Certificates/Series 1880 & 1891

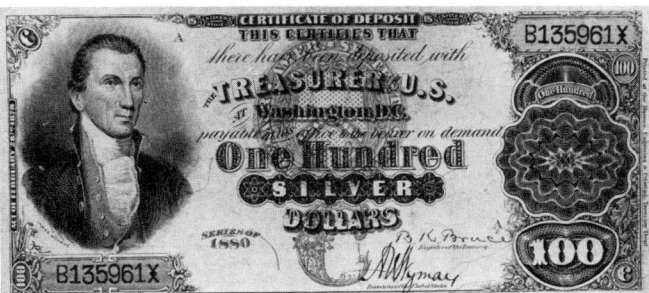

The face design is similar to the preceding note. The back design is the same as the following note.

Series of 1880

Seals are brown except for No. 1219; large "C" in center except for No. 1218.

No.	Signatures	Seal	Notes Printed	Known	VGood	VFine	Unc
1215	Scofield-Gilfillan	rays	16,000	0	$ –	$ –	$ –
1216	Bruce-Gilfillan	rays	40,000	5	3500.	6500.	15,500.
1217	Bruce-Wyman	rays	80,000	8	3250.	6000.	14,000.
1218	Rosecrans-Huston	spikes	100,000	14	3000.	6000.	12,500.
			Small seal at lower right				
1219	Rosecrans-Nebeker	red	40,000	8	3250.	6250.	14,000.

Series of 1891

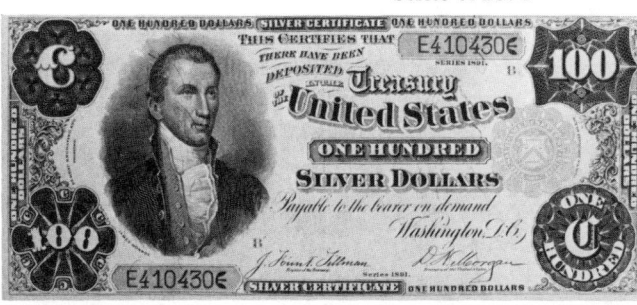

The face design is similar to the preceding note. In addition to the portrait, engraving is by D.M. Cooper, W.H. Dougal, J.R. Hall, E.E. Myers, W.G. Phillips and G.U. Rose, Jr. The seal is at right-center.

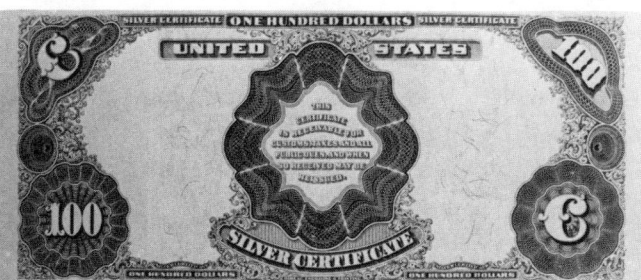

The back design was engraved by D.M. Cooper, W.H. Dougal, E.M. Hall, W.F. Lutz and G.U. Rose, Jr.

No.	Signatures	Seal	Notes Printed	Known	Fine	EFine	Unc
1220	Rosecrans-Nebeker	red	192,000	13	$2250.	$6250.	$9250.
1221	Tillman-Morgan	red	312,000	16	2000.	5850.	8750.

Remarks: In 1897 there was an attempt to recall all of No. 1221 due to superb counterfeits by W.M. Jacobs. In early January 1898 four eastern cities reported counterfeits that began with serial number 326. In addition, Cincinnati reported counterfeits that began with serial number 323.

Gold Certificates/Series 1863–1875

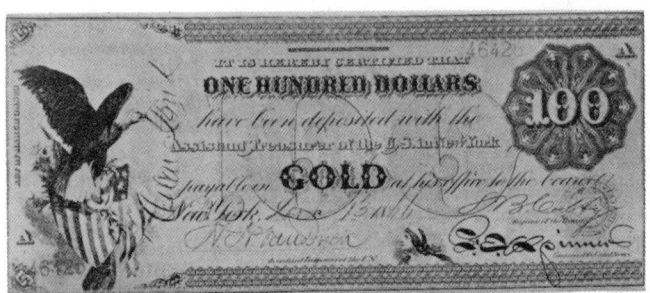

E Pluribus Unum was engraved by Charles Skinner. For the complete figure of the *Altar of Liberty,* in lower border, see No. 1435a.

Only the first issue had this back design.

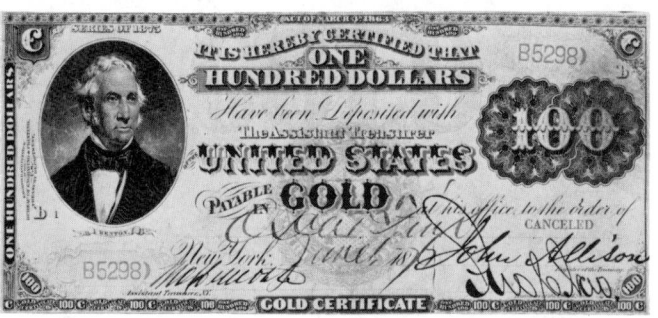

Thomas H. Benton (1782–1858), whose portrait appears on the second and third issues, served in the U.S. Senate and the House of Representatives. Benton favored Western development and spoke out against slavery

No.	Issue	Date	Signatures	Printed	Issued	Out	Known
1222	First	1863	Colby-Spinner	118,000	116,449	–	3
1222a	First	1863	Colby-Spinner	included in above		44	1
1223	Second	1870	(There is a proof with no signatures at the BEP.)			–	–
1224	Second	1871	Colby-Spinner	50,000	48,000	27	–
1225	Third	1875	Allison-New	56,894	35,984	8	2
1225a	Third	1875	Allison-Gilfillan	included in above		–	1

Remarks: No. 1222 has an autographed countersignature; serial number 11811 is at the Smithsonian Institution, 46425 is in private hands. No. 1222a, with serial number 112853, at the Smithsonian Institution, is payable at Washington, others are payable at New York. Nos. 1225 with serial numbers B5298 and B13104 are at the Smithsonian; No. 1225a with serial number B56887 is at the Bureau of the Public Debt. All three are uniface.

Gold Certificates/Series 1882

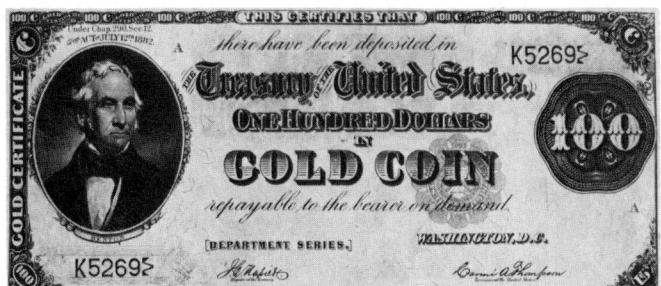

The portrait of Thomas H. Benton on this and the preceding note was engraved by Charles Burt.

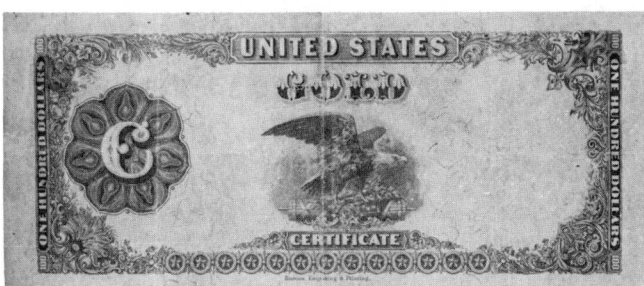

The *Eagle* on the gold back was engraved by Joseph P. Ourdan.

No.	Signatures	Notes Printed	Known	VGood	VFine	Unc
		Nos. 1226–1229 have brown seals.				
1226	Bruce-Gilfillan	9,000	2			
1227	Bruce-Gilfillan	71,000	2		no recent sales	
1228	Bruce-Gilfillan	80,000	8			
1229	Bruce-Wyman	40,000	3			
		Seal is larger; No. 1230 is red; No. 1231 is brown				
1230	Rosecrans-Hyatt	40,000	4	$600.	$1250.	$ –
1231	Rosecrans-Huston	60,000	6	500.	1000.	–
		All have a small red seal				
1232	Lyons-Roberts	1,160,000	14	275.	475.	2850.
1233	Lyons-Treat	296,000	6	375.	750.	4000.
1234	Vernon-Treat	320,000	7	375.	750.	4000.
1235	Vernon-McClung	402,000	12	375.	750.	3750.
1236	Napier-McClung	202,000	8	375.	750.	4000.
1237	Napier-Thompson	198,000	23	350.	700.	3500.
1238	Napier-Burke	200,000	15	375.	750.	3750.
1239	Parker-Burke	200,000	11	375.	750.	3750.
1240	Teehee-Burke	1,020,000	66	275.	475.	2850.
1241	Speelman-White	2,444,000	–	225.	375.	2000.
1241 ☆	14 reported					

Remarks: Nos. 1226 & 1227 are payable at New York; both are countersigned by Thomas C. Acton. No. 1226 bears an autographed countersignature. No. 1241 is dated 1922.

Treasury or Coin Notes/Series 1890 & 1891

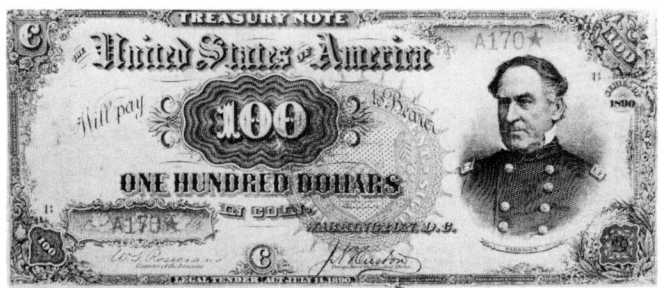

David G. Farragut (1811–1870) was the first man to hold the rank of admiral in the U.S. Navy. Although he was born in Tennessee, he served in the Union Navy during the Civil War. His portrait was engraved by Charles Schlecht.

The back design was engraved by W.A. Copenhaver, W.H. Dougal, G.U. Rose, Jr. and J.A. Rueff. The shape and color of the zeros prompt collectors to call this the watermelon note. (See No. 1425)

No.	Series	Signatures	Seal	Printed	Known	VGood	VFine	Unc
1242	1890	Rosecrans-Huston	brown	120,000	28	$6,000.	$16,500.	—

The face design is similar to the preceding note; the seal is smaller. The back design was engraved by D.M. Cooper, W.H. Dougal, E.M. Hall and E.E. Myers.

No.	Series	Signatures	Seal	Printed	Known	VGood	VFine	Unc
1243	1891	Rosecrans-Nebeker	red	80,000	9	$10,000.	$20,000.	—

Remarks: For No. 1242, 298 notes are outstanding. For No. 1243, 60,000 were issued. The nine known notes are: B3958, B6388, B7296, B10662, B14471, B17039, B47137, B55602 and B79901.

Federal Reserve Notes/Series 1914/Red Seal

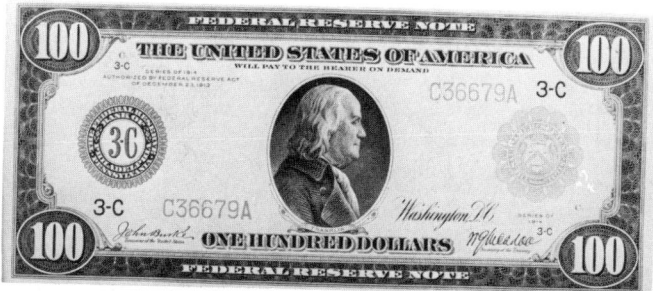

The portrait of Benjamin Franklin was engraved by Marcus W. Baldwin.

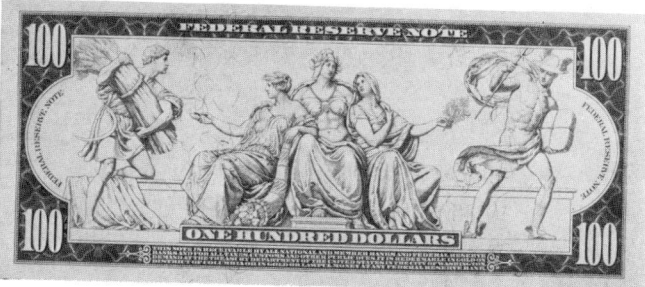

Labor, Plenty, America, Peace and Commerce by Kenyon Cox was engraved by G.F.C. Smillie. This design was originally intended for all denominations of U.S. small-size currency.

Signatures of Burke-McAdoo

No.	Bank	VGood	VFine	Unc	No.	Bank	VGood	VFine	Unc
1244A	Boston	$275.	$500	$2000.	1244G	Chicago	$275.	$500.	$2000.
1244B	New York	275.	500.	2000.	1244H	St. Louis	275.	500.	2000.
1244C	Philadelphia	275.	500.	2000.	1244I	Minneapolis	300.	500.	2000.
1244D	Cleveland	275.	500.	2000.	1244J	Kansas City	275.	500.	2000.
1244E	Richmond	275.	500.	2000.	1244K	Dallas	275.	500.	2000.
1244F	Atlanta	275.	500.	2000.	1244L	San Francisco	275.	500.	2000.

Remarks: The first day of issue was November 16, 1914. About 500 notes are probably outstanding; Frank Nowak has recorded 240. Type I and type II were printed for all districts. Type II has the small district number and letter in the upper left and lower right corners. See No. 380 for illustrations.

Federal Reserve Notes/Series 1914/Blue Seal

No.	Bank	Signatures	Notes Printed	Delivered	VFine	Unc
1245A1	Boston	Burke-McAdoo			$200.	$700.
1245A2	Boston	Burke-Glass	728,000	728,000	225.	800.
1245A4	Boston	White-Mellon			200.	700.
1245B1	New York	Burke-McAdoo			200.	700.
1245B1 ☆	1 reported				200.	700.
1245B2	New York	Burke-Glass			225.	800.
1245B3	New York	Burke-Houston	3,084,000	3,084,000	200.	700.
1245B3 ☆	1 reported				–	–
1245B4	New York	White Mellon			200.	700.
1245C1	Philadelphia	Burke-McAdoo	666,000	636,000	200.	700.
1245C4	Philadelphia	White-Mellon	included in above		200.	700.
1245D1	Cleveland	Burke-McAdoo			200.	700.
1245D2	Cleveland	Burke-Glass			225.	800.
1245D3	Cleveland	Burke-Houston	668,000	668,000	200.	700.
1245D3 ☆	1 reported				–	–
1245D4	Cleveland	White-Mellon			200.	700.
1245E1	Richmond	Burke-McAdoo			200.	700.
1245E1 ☆	1 reported		504,000	416,000	–	–
1245E2	Richmond	Burke-Glass			225.	800.
1245E4	Richmond	White-Mellon			200.	700.
1245F1	Atlanta	Burke-McAdoo			200.	700.
1245F1 ☆	1 reported		540,000	476,000	–	–
1245F3	Atlanta	Burke-Houston			200.	700.
1245F4	Atlanta	White-Mellon			200.	700.
1245G1	Chicago	Burke-McAdoo			200.	700.
1245G1 ☆	1 reported		888,000	888,000	–	–
1245G3	Chicago	Burke-Houston			200.	700.
1245G4	Chicago	White-Mellon			200.	700.
1245H1	St. Louis	Burke-McAdoo	188,000	188,000	200.	800.
1245H4	St. Louis	White-Mellon	included in above		200.	700.
1245I1	Minneapolis	Burke-McAdoo	124,000	120,000	200.	700.
1245I4	Minneapolis	White-Mellon	included in above		200.	700.
1245J1	Kansas City	Burke-McAdoo			200.	700.
1245J1 ☆	1 reported		256,000	256,000	–	–
1245J4	Kansas City	White-Mellon			200.	700.
1245K1	Dallas	Burke-McAdoo			200.	700.
1245K1 ☆	1 reported		256,000	256,000	–	–
1245K4	Dallas	White-Mellon			200.	700.
1245L1	San Francisco	Burke-McAdoo			200.	700.
1245L1 ☆	1 reported		1,064,000	1,064,000	–	–
1245L3	San Francisco	Burke-Houston			200.	700.
1245L4	San Francisco	White-Mellon			200.	700.

Remarks: Doug Murray reports that no plates were made for Nos. 1245A3, 1245C2, & 3, 1245E3, 1245F2, 1245G2, 1245H2 & 3, 1245I2 & 3, 1245J2 & 3, 1245 K2 & 3, and 1245L2. A total of 4,000 replacement notes were printed for each district except New York, which had 8,000 printed.

United States Notes/Series 1966 & 1966A/Red Seal

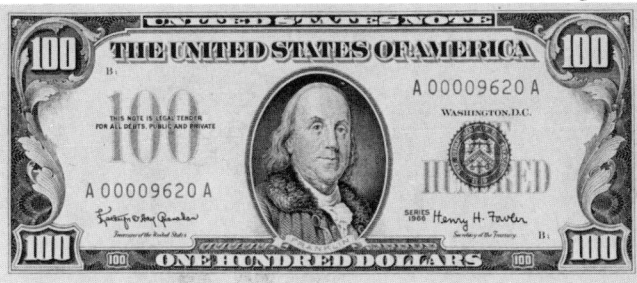

The portrait of Benjamin Franklin, engraved by John Eissler, appears on all small-size $100 notes.

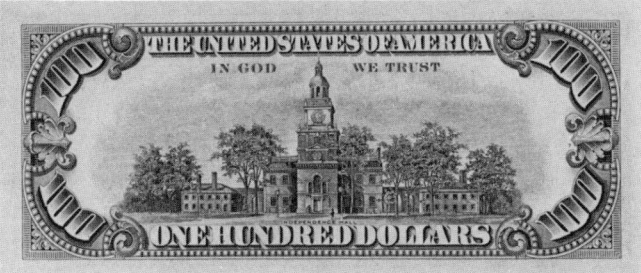

Independence Hall in Philadelphia.

No.	Series	Signatures	Notes Printed	VFine	Unc
1246	1966	Granahan-Fowler	768,000	$ –	$250.
1246☆			128,000	–	900.
1247	1966A	Elston-Kennedy	512,000	150.	650.

Remarks: As many as 700,000, for both issues, might have entered circulation. These $100 notes were intended to replace the $2 and $5 red seal notes. In October 1976 they were first released in Washington, DC, New York City and perhaps Puerto Rico; remaining $100 notes were held by Federal Reserve Banks. These notes are now being withdrawn as they come into banks.

Federal Reserve Bank Notes/Series 1929/Brown Seal

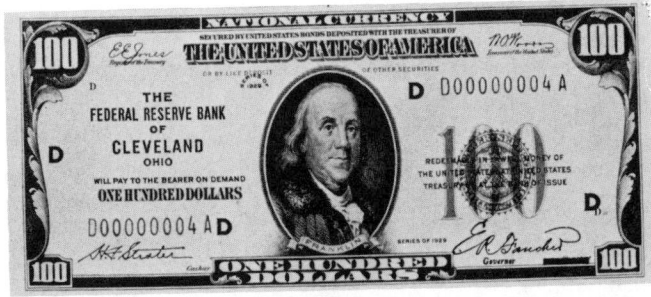

See No. 1247 for descriptive information.

| | | Signatures of Jones-Woods | | |
No.	Bank	Notes Printed	EFine	Unc
1248A	Boston	not printed	$ —	$ —
1248B	New York	480,000	115.	175.
1248C	Philadelphia	not printed	—	—
1248D	Cleveland	276,000	115.	175.
1248D ☆		—	—	—
1248E	Richmond	192,000	125.	185.
1248E ☆		—	—	—
1248F	Atlanta	not printed	—	—
1248G	Chicago	384,000	115.	175.
1248H	St. Louis	not printed	—	—
1248I	Minneapolis	144,000	125.	185.
1248J	Kansas City	96,000	135.	200.
1248J ☆		—	—	—
1248K	Dallas	36,000	150.	300.
1248L	San Francisco	not printed	—	—

National Bank Notes/Series 1929/Brown Seal

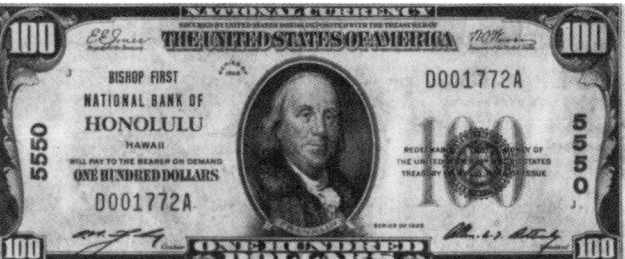

Type I

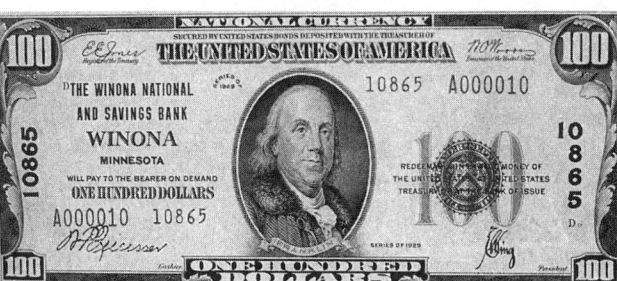

Type II has the bank
charter number printed a
second time near the serial
number.

		Type I		
No.	Rarity	VFine	EFine	Unc
	1	$135	$175.	$200.
	2	145.	195.	250.
	3	175.	210.	275.
	4	200.	235.	315.
1249	5	225.	275.	325.
	6	235.	315.	375.
	7	275.	365.	500.
	8	350.	425.	700.
	9	none were issued		

Remarks: A total of 456,915 notes were issued for both types. Type II notes command a premium of up to 50% more. Banks in the following states did not issue this denomination: Alabama, Alaska, Arizona, Arkansas, Georgia, Maine, New Mexico, South Carolina and Utah.

Federal Reserve Notes/Series 1928, 1928A & 1934/Green Seal

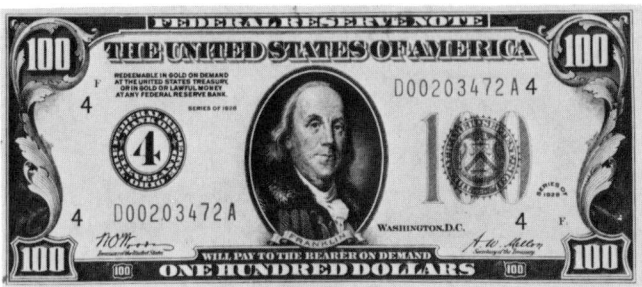

The district number appears in the seal. The district letter replaces the number.

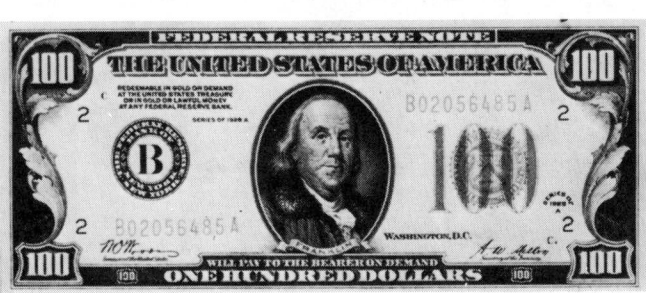

Series 1928, Woods-Mellon

No.	Bank	Notes Printed	Unc
1250A	Boston	376,000	$175.
1250B	New York	755,400	175.
1250B☆		–	–
1250C	Philadelphia	389,000	175.
1250D	Cleveland	542,400	175.
1250E	Richmond	364,416	175.
1250F	Atlanta	no record	–
1250G	Chicago	783,000	175.
1250G☆		–	–
1250H	St. Louis	187,200	185.
1250H☆		not printed	–
1250I	Minneapolis	102,000	185.
1250J	Kansas City	234,000	175.
1250K	Dallas	80,140	190.
1250L	San Francisco	486,000	175.
1250L☆		–	–

Series 1928A, Woods-Mellon

No.	Bank	Notes Printed	Unc
1251A	Boston	980,400	$175.
1251B	New York	2,938,000	165.
1251B☆		not printed	–
1251C	Philadelphia	1,496,000	165.
1251D	Cleveland	993,436	175.
1251E	Richmond	621,364	175.
1251F	Atlanta	371,400	175.
1251G	Chicago	4,010,424	165.
1251G☆		not printed	–
1251H	St. Louis	749,424	175.
1251H☆		reported	–
1251I	Minneapolis	503,040	175.
1251J	Kansas City	681,804	175.
1251K	Dallas	594,456	175.
1251L	San Francisco	1,228,032	165.
1251L☆		not printed	–

Series 1934, Julian-Morgenthau

No.	Bank	Notes Printed	Unc	No.	Bank	Notes Printed	Unc
1252A	Boston	3,710,000	$165.	1252G☆		–$	–
1252B	New York	3,086,000	165.	1252H	St. Louis	2,106,192	165.
1252C	Philadelphia	2,776,000	165.	1252I	Minneapolis	852,600	175.
1252D	Cleveland	3,447,108	165.	1252J	Kansas City	1,932,900	165.
1252E	Richmond	4,317,600	165.	1252J☆		–	–
1252F	Atlanta	3,264,000	165.	1252K	Dallas	1,506,516	–
1252G	Chicago	7,075,000	165.	1252L	San Francisco	6,521,940	–

Federal Reserve Notes/Series 1934A–1950A/Green Seal

Series 1934A, Julian-Morgenthau				Series 1934B, Julian-Vinson			
No.	Bank	Notes Printed	Unc	No.	Bank	Notes Printed	Unc
1253A	Boston	102,000	$175.	1254A	Boston	41,400	$185.
1253B	New York	15,278,892	150.	1254B	New York	not printed	–
1253B☆		–	–	1254B☆		not printed	–
1253C	Philadelphia	588,000	175.	1254C	Philadelphia	39,600	185.
1253D	Cleveland	645,300	175.	1254D	Cleveland	61,200	185.
1253E	Richmond	770,100	175.	1254E	Richmond	877,400	175.
1253F	Atlanta	589,896	175.	1254F	Atlanta	645,000	175.
1253G	Chicago	3,328,800	165.	1254F☆		–	–
1253G☆		–	–	1254G	Chicago	396,000	175.
1253H	St. Louis	434,208	175.	1254H	St. Louis	672,200	175.
1253I	Minneapolis	153,000	175.	1254I	Minneapolis	377,000	175.
1253J	Kansas City	455,100	175.	1254J	Kansas City	364,500	175.
1253K	Dallas	226,164	175.	1254K	Dallas	392,700	175.
1253L	San Francisco	1,130,000	175.	1254K☆		reported	–
1253L☆		–	–	1254L	San Francisco	not printed	–

Series 1934C, Julian-Snyder				Series 1934D, Clark-Snyder			
No.	Bank	Notes Printed	Unc	No.	Bank	Notes Printed	Unc
1255A	Boston	13,800	$200.	1256A	Boston	no record	$ –
1255B	New York	1,556,000	160.	1256B	New York	3,908,000	150.
1255C	Philadelphia	13,200	200.	1256C	Philadelphia	1,332,000	150.
1255D	Cleveland	1,473,200	160.	1256C☆		–	–
1255E	Richmond	no record	–	1256D	Cleveland	1,632,000	150.
1255F	Atlanta	493,900	175.	1256E	Richmond	4,076,000	150.
1255G	Chicago	612,000	175.	1256G	Chicago	4,428,000	150.
1255H	St. Louis	957,000	175.	1256H	St. Louis	1,284,000	150.
1255H☆		–	–	1265H☆		–	–
1255I	Minneapolis	392,904	175.	1256I	Minneapolis	564,000	165.
1255J	Kansas City	401,100	175.	1256J	Kansas City	864,000	165.
1255K	Dallas	280,700	175.	1256K	Dallas	1,216,000	150.
1255L	San Francisco	432,600	175.	1256K☆		not printed	–
1255L☆		not printed	–	1256L	San Francisco	no record	–

Series 1950, Clark-Snyder				Series 1950A, Priest-Humphrey			
No.	Bank	Notes Printed	Unc	No.	Bank	Notes Printed	Unc
1257A	Boston	768,000	$150.	1258A	Boston	1,008,000	$135.
1257B	New York	3,908,000	135.	1258B	New York	2,880,000	135.
1257C	Philadelphia	1,332,000	135.	1258B☆		–	–
1257C☆		–	–	1258C	Philadelphia	720,000	150.
1257D	Cleveland	1,632,000	135.	1258D	Cleveland	432,000	150.
1257E	Richmond	4,076,000	135.	1258E	Richmond	1,008,000	135.
1257F	Atlanta	1,824,900	135.	1258F	Atlanta	576,000	150.
1257G	Chicago	4,428,000	135.	1258G	Chicago	2,592,000	135.
1257H	St. Louis	1,284,000	135.	1258G☆		–	–
1257H☆		–	–	1268H	St. Louis	1,152,000	135.
1257I	Minneapolis	564,000	150.	1258I	Minneapolis	288,000	160.
1257J	Kansas City	864,000	150.	1258J	Kansas City	720,000	150.
1257K	Dallas	1,216,000	135.	1258K	Dallas	1,728,000	135.
1257L	San Francisco	2,524,000	135.	1258K☆		–	–
1257L☆		not printed	–	1258L	San Francisco	2,880,000	135.

Federal Reserve Notes/1950B, 1950C, 1950D, 1950E & 1963A/Green Seal

Series 1950B, Priest-Anderson

No.	Bank	Notes Printed	Unc
1259A	Boston	720,000	$150.
1259B	New York	6,636,000	130.
1259C	Philadelphia	720,000	150.
1259D	Cleveland	432,000	150.
1259E	Richmond	1,008,000	130.
1259F	Atlanta	576,000	150.
1259G	Chicago	2,592,000	130.
1259G☆		–	–
1259H	St. Louis	1,152,000	130.
1259I	Minneapolis	288,000	165.
1259J	Kansas City	720,000	150.
1259K	Dallas	1,728,000	130.
1259K☆		–	–
1259L	San Francisco	2,880,000	135.

Series 1950C, Smith-Dillon

No.	Bank	Notes Printed	Unc
1260A	Boston	864,000	$135.
1260B	New York	2,448,000	125.
1260C	Philadelphia	576,000	135.
1260D	Cleveland	576,000	135.
1260E	Richmond	1,440,000	125.
1260F	Atlanta	1,296,000	125.
1260G	Chicago	1,584,000	125.
1260H	St. Louis	720,000	135.
1260G☆		–	–
1260I	Minneapolis	288,000	150.
1260J	Kansas City	432,000	135.
1260K	Dallas	720,000	135.
1260K☆		not printed	
1260L	San Francisco	2,160,000	125.

Series 1950D, Granahan-Dillon

No.	Bank	Notes Printed	Unc
1261A	Boston	1,872,000	$125.
1261B	New York	7,632,000	125.
1261C	Philadelphia	1,872,000	125.
1261D	Cleveland	1,584,000	125.
1261D☆		–	150.
1261E	Richmond	2,880,000	125.
1261E☆		–	150.
1261F	Atlanta	1,872,000	125.
1261G	Chicago	4,608,000	125.
1261H	St. Louis	1,440,000	135.
1261I	Minneapolis	432,000	135.
1261J	Kansas City	864,000	135.
1261K	Dallas	1,728,000	125.
1261L	San Francisco	3,312,000	125.

Series 1963A, Granahan-Fowler

No.	Bank	Notes Printed	Unc
1263A	Boston	1,536,000	$125.
1263A☆		128,000	140.
1263B	New York	12,544,000	125.
1263B☆		1,536,000	125.
1263C	Philadelphia	1,440,000	125.
1263C☆		192,000	135.
1263D	Cleveland	2,304,000	125.
1263D☆	Chicago	192,000	135.
1263E	Richmond	2,816,000	125.
1263E☆		192,000	135.
1263F	Atlanta	1,280,000	125.
1263F☆		128,000	140.
1263G	Chicago	4,352,000	125.
1263G☆		512,000	135.
1263H	St. Louis	1,536,000	125.
1263H☆		256,000	135.
1263I	Minneapolis	512,000	135.
1263I☆		128,000	140.
1263J	Kansas City	1,024,000	125.
1263J☆		128,000	140.
1263K	Dallas	1,536,000	125.
1263K☆		192,000	135.
1263L	San Francisco	6,400,000	125.
1263L☆		832,000	135.

Series 1950E, Granahan-Fowler

No.	Bank	Notes Printed	Unc
1262B	New York	3,024,000	$125.
1262B☆		reported	–
1262G	Chicago	576,000	135.
1262L	San Francisco	2,736,000	125.
1262L☆		–	–

"IN GOD WE TRUST" added to the back of 1963A and all subsequent notes.

Federal Reserve Notes/1969, 1969A, 1969C & 1974/Green Seal

Series 1969, Elston-Kennedy				Series 1969A, Kabis-Connally			
No.	Bank	Notes Printed	Unc	No.	Bank	Notes Printed	Unc
1264A	Boston	2,048,000	$120.	1265A	Boston	1,280,000	$120.
1264A☆		128,000	135.	1265A☆		320,000	130.
1264B	New York	11,520,000	120.	1265B	New York	11,264,000	120.
1264B☆		192,000	135.	1265B☆		640,000	130.
1264C	Philadelphia	2,560,000	120.	1265C	Philadelphia	2,048,000	120.
1264C☆		128,000	135.	1265C☆		448,000	130.
1264D	Cleveland	768,000	125.	1265D	Cleveland	1,280,000	120.
1264D☆		64,000	140.	1265D☆		192,000	135.
1264E	Richmond	2,560,000	120.	1265E	Richmond	2,304,000	120.
1264E☆		192,000	135.	1265E☆		192,000	135.
1264F	Atlanta	2,304,000	120.	1265F	Atlanta	2,304,000	120.
1264F☆		128,000	135.	1265F☆		649,000	130.
1264G	Chicago	5,888,000	120.	1265G	Chicago	5,376,000	120.
1264G☆		256,000	135.	1265G☆		320,000	130.
1264H	St. Louis	1,280,000	120.	1265H	St. Louis	1,024,000	120.
1264H☆		64,000	140.	1265H☆		664,000	130.
1264I	Minneapolis	512,000	135.	1265I	Minneapolis	1,024,000	120.
1264I☆		64,000	140.	1265I☆		not printed	–
1264J	Kansas City	1,792,000	120.	1265J	Kansas City	512,000	130.
1264J☆		384,000	135.	1265J☆		not printed	–
1264K	Dallas	2,048,000	120.	1265K	Dallas	3,328,000	120.
1264K☆		1,048,000	120.	1265K☆		128,000	135.
1264L	San Francisco	7,168,000	120.	1265L	San Francisco	4,352,000	120.
1264L☆		320,000	135.	1265L☆		576,000	130.

Series 1969B $20 notes were not printed.

Series 1969C, Banuelos-Shultz				Series 1974, Neff-Simon			
No.	Bank	Notes Printed	Unc	No.	Bank	Notes Printed	Unc
1267A	Boston	2,048,000	$115.	1268A	Boston	19,200,000	$110.
1267A☆		64,000	130.	1268A☆		320,000	125.
1267B	New York	15,616,000	110.	1268B	New York	166,400,000	–
1267B☆		256,000	125.	1268B☆		1,664,000	110.
1267C	Philadelphia	2,816,000	115.	1268C	Philadelphia	5,120,000	110.
1267C☆		64,000	130.	1268C☆		128,000	125.
1267D	Cleveland	3,456,000	115.	1268D	Cleveland	16,640,000	110.
1267D☆		64,000	130.	1268D☆		192,000	125.
1267E	Richmond	7,296,000	115.	1268E	Richmond	24,320,000	110.
1267E☆		128,000	125.	1268E☆		384,000	125.
1267F	Atlanta	2,432,000	115.	1268F	Atlanta	3,840,000	110.
1267F☆		64,000	130.	1268F☆		704,000	120.
1267G	Chicago	6,016,000	115.	1268G	Chicago	39,680,000	110.
1267G☆		320,000	125.	1268G☆		704,000	120.
1267H	St. Louis	5,376,000	115.	1268H	St. Louis	15,120,000	110.
1267H☆		64,000	130.	1268H☆		448,000	125.
1267I	Minneapolis	512,000	125.	1268I	Minneapolis	5,120,000	110.
1267I☆		64,000	130.	1268I☆		192,000	125.
1267J	Kansas City	4,736,000	115.	1268J	Kansas City	20,480,000	110.
1267J☆		192,000	125.	1268J☆		640,000	120.
1267K	Dallas	2,944,000	115.	1268K	Dallas	38,400,000	110.
1267K☆		64,000	130.	1268K☆		640,000	120.
1267L	San Francisco	10,240,000	115.	1268L	San Francisco	39,680,000	110.
1267L☆		512,000	125.	1268L☆		448,000	125.

Federal Reserve Notes/1977, 1981, 1981A & 1988/Green Seal

Series 1977, Morton-Blumenthal No.	Bank	Notes Printed	Unc	Series 1981, Buchanan-Regan No.	Bank	Notes Printed	Unc
1269A	Boston	19,200,000	$110.	1270A	Boston	8,560,000	$110.
1269A☆		320,000	120.	1270A☆		not printed	–
1269B	New York	166,400,000		1270B	New York	95,600,000	–
1269B☆		1,664,000	115.	1270B☆		not printed	–
1269C	Philadelphia	5,120,000	110.	1270C	Philadelphia	12,800,000	–
1269C☆		128,000	125.	1270C☆		not printed	–
1269D	Cleveland	16,640,000	110.	1270D	Cleveland	8,960,000	–
1269D☆		192,000	125.	1270D☆		not printed	–
1269E	Richmond	24,320,000	110.	1270E	Richmond	23,680,000	–
1269E☆		384,000	120.	1270E☆		1,280,000	115.
1269F	Atlanta	3,840,000	110.	1270F	Atlanta	not printed	–
1269F☆		704,000	115.	1270F☆		not printed	–
1269G	Chicago	39,680,000	110.	1270G	Chicago	33,280,000	–
1269G☆		704,000	115.	1270G☆		not printed	–
1269H	St. Louis	15,120,000	125.	1270H	St. Louis	5,760,000	115.
1269H☆		448,000	120.	1270H☆		not printed	–
1269I	Minneapolis	5,120,000	110.	1270I	Minneapolis	not printed	–
1269I☆		192,000	125.	1270I☆		not printed	–
1269J	Kansas City	20,480,000	110.	1270J	Kansas City	23,680,000	–
1269J☆		640,000	115.	1270J☆		not printed	–
1269K	Dallas	38,400,000	110.	1270K	Dallas	23,680,000	–
1269K☆		640,000	115.	1270K☆		not printed	–
1269L	San Francisco	39,680,000	115.	1270L	San Francisco	24,960,000	–
1269L☆		448,000	120.	1270L☆		not printed	–

Series 1981A, Ortega-Regan No.	Bank	Notes Printed	Unc	Series 1988 Ortega-Brady No.	Bank	Notes Printed	Unc
1271A	Boston	16,000,000	$ –	1272A	Boston	9,600,000	$ –
1271A☆		not printed	–	1272A☆		not printed	–
1271B	New York	64,000,000	–	1272B	New York	505,600,000	–
1271B☆		not printed	–	1272B☆		4,480,000	–
1271C	Philadelphia	3,200,000	110.	1272C	Philadelphia	9,600,000	–
1271C☆		not printed	–	1272C☆		not printed	–
1271D	Cleveland	6,400,000	110.	1272D	Cleveland	35,200,000	–
1271D☆		not printed	–	1272D☆		not printed	–
1271E	Richmond	12,800,000	–	1272E	Richmond	19,200,000	–
1271E☆		not printed	–	1272E☆		not printed	–
1271F	Atlanta	12,800,000	–	1272F	Atlanta	not printed	–
1271F☆		not printed	–	1272F☆		not printed	–
1271G	Chicago	22,400,000	–	1272G	Chicago	51,2200,000	–
1271G☆		not printed	–	1272G☆		not printed	–
1271H	St. Louis	12,800,000	–	1272H	St. Louis	not printed	–
1271H☆		not printed	–	1272H☆		not printed	–
1271I	Minneapolis	3,200,000	110.	1272I	Minneapolis	not printed	–
1271I☆		not printed	–	1272I☆		not printed	–
1271J	Kansas City	not printed	–	1272J	Kansas City	9,600,000	–
1271J☆		not printed	–	1272J☆		not printed	–
1271K	Dallas	3,200,000	110.	1272K	Dallas	not printed	–
1271K☆		not printed	–	1272K☆		not printed	–
1271L	San Francisco	19,200,000	–	1272L	San Francisco	19,200,000	–
1271L☆		640,000	115.	1272L☆		not printed	–

Federal Reserve Notes/1990/Green Seal

Series 1990, Villalpando-Brady

No.	Bank	Notes Printed	Unc

Series 1985 and Series 1988A $100 notes were not printed. Series 1990 was in production when this catalog was printed.

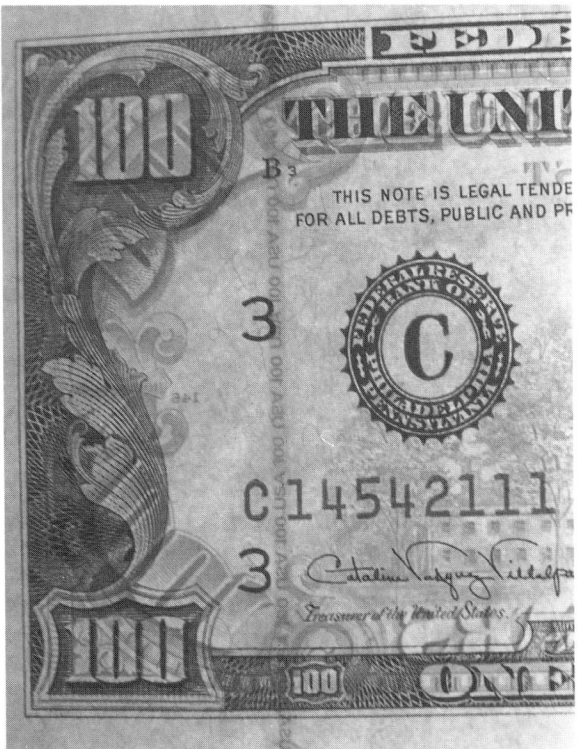

Security strip made its appearance with series 1990 Federal Reserve notes.

Micro-printing as a security device on Federal Reserve notes.

Gold Certificate/Series 1928 & 1928A

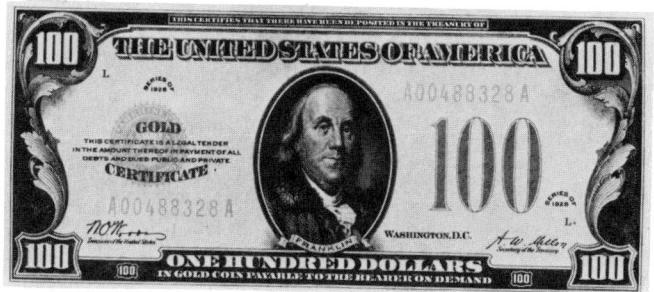

The portrait of Benjamin Franklin was engraved by Joseph Eissler. Other engravers were E.M. Hall and F. Lamasure.

The back design is similar to No. 1248.

No.	Series	Signatures	Notes Printed	VFine	Unc
1319	1928	Woods-Mellon	3,240,000	$165.	$650.
1319☆			–	–	–
1319A	1928A	Woods-Mills	120,000	not issued	

SOCIETY
OF
PAPER MONEY
COLLECTORS
INC.

It would be to your advantage to join the Society of Paper Money Collectors, organized in 1961 to further the following objectives:

1. Encourage the collecting and study of paper money.
2. Cultivate fraternal collector relations with opportunities for discussion trading, etc.
3. Furnish information and knowledge through experts, particularly through the Society's *PAPER MONEY* magazine.
4. Encourage research about paper money and publication of the resultant findings.
5. Promote legislation favorable to collectors, providing it is in accord with the general welfare.
6. Advance the prestige of the hobby.
7. Promote exhibits at numismatic and syngraphic meetings.
8. Encourage realistic and consistent market valuations.

PAPER MONEY, the society bimonthly journal, is sent to all members. In addition to informative articles, it lists new members, the collecting specialty of each, and identifies each as a collector or dealer. Member are encouraged to submit articles for publication.

BOOKS that catalog the obsolete currency of individual states are available to members at reduced prices.

MEETINGS, national and regional, take place throughout the year.

DUES are $20 per year and are payable in U.S. funds. Members who join the Society prior to October 1 receive the magazines already issued in the year in which they join. Members who join after October 1 will have their dues paid through December of the following year. They will also receive, as a bonus, a copy of the magazine issued in November of the year in which they join.

Dues: $20 per year; $25 for members in Canada and Mexico; $30 for other countries; $300 for life membership. Send application and U.S. funds, payable to SPMC to: Ronald Horstman, SPMC, P.O. Box 6011, St. Louis, MO 63139.

United States Notes/Series 1862 & 1863/Red Seal

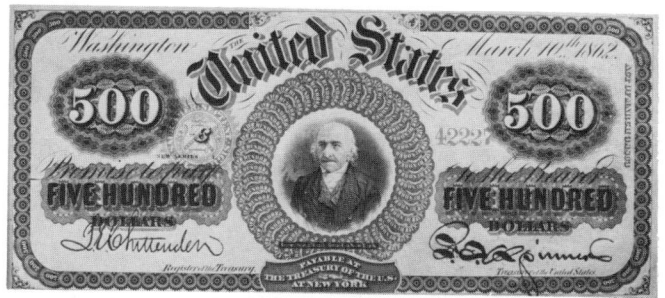

Albert Gallatin was elected to the U.S. Senate from Pennsylvania in 1793, 13 years after he arrived in America from Switzerland, where he was born in 1761. He served as Secretary of the Treasury and Minister to England and France. From 1832–1839 Gallatin was president of the National Bank of New York. This portrait was altered by Alfred Jones.

Signatures of Chittenden-Spinner

No.	Series	Obligation	Notes Printed	Notes Issued	Notes Outstanding	Known
1320	1862	First				2
1320a	1862	Second	118,072	117,972	451	0
1321	1863	Second				4
1321a	1863	Second				1

Remarks: The following serial numbers have been recorded: for No. 1320, 23956; No. 1321, 42223, 42227, 49519, and 64984. No. 1321a has duplicate serial numbers. A. Gallatin is one of five Americans of foreign birth to appear on U.S. paper money. The others are A. Hamilton, E.D. Baker (No. 1441), R. Morris (No. 578) and G.G. Meade (No. 1425).

United States Notes/Series 1869

Charles Burt engraved the portrait of John Quincy Adams (1735–1826), sixth president of the U.S. Adams was appointed Minister to Holland in 1794, Berlin in 1809, and England in 1815. Following his presidency he was elected to Congress. Adams assembled a nice collection of coins. *Justice* was engraved by S.A. Schoff.

No.	Series	Signatures	Seal	Notes Printed	Issued	Notes Outstanding	Known
1322	1869	Allison-Spinner	lg. red	89,360	87,980	499	5

Enlargement of the center of the back.

Remarks: These notes were withdrawn due to deceptive counterfeits. Martin Gengerke reports that one of the known notes, N32610, is questionable. The serial numbers of other known notes are: N16035, N16051, N31963, and N48792.

United States Notes/Series 1874–1880

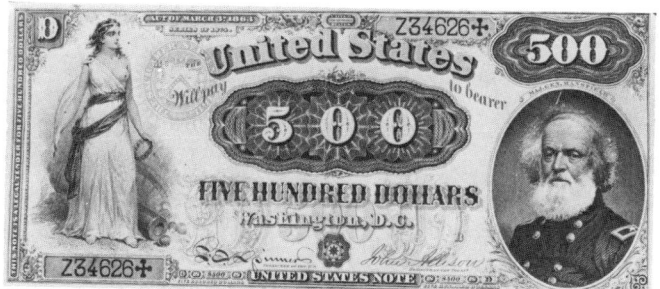

Joseph King Mansfield (1803–1862), a West Point graduate, was born in New Haven, Connecticut. Early in the Civil War he was made a brigadier general and was killed at the Battle of Antietam. His portrait and the figure of *Victory* were engraved by Charles Burt.

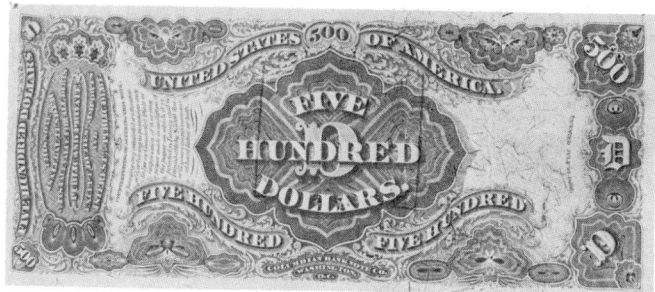

No.	Series	Signatures	Seal	Notes Printed	Known
		Nos. 1123A-1125 have large "D" twice, and red seals.			
1323	1874	Allison-Spinner	rays	56,000	5
1324	1875	Allison-New	rays	32,000	1
1325	1875	Allison-Wyman	rays	24,000	1
1326	1878	Allison-Gilfillan	rays	24,000	6
		All but Nos. 1327, 1328 & 1332 have red seals.			
1327	1880	Scofield-Gilfillan	brown	–	0
1328	1880	Bruce-Wyman	brown	12,000	0
1329	1880	Rosecrans-Jordan	large	8,000	0
1330	1880	Rosecrans-Hyatt	plain	20,000	0
1331	1880	Rosecrans-Huston	lg. spikes	–	3
1332	1880	Rosecrans-Nebeker	brown	16,000	2
1333	1880	Tillman-Morgan	scallops	20,000	6
1334	1880	Bruce-Roberts	scallops	8,000	5
1335	1880	Lyons-Roberts	scallops	12,000	5
1336	1880	Napier-McClung	scallops	existence doubtful	

Remarks: In 1983 No. 1323 (Z5381) sold for $44,500; No. 1326 (A4026) sold for $55,000. In 1985 No. 1335 sold for $23,000. All were in EFine condition.

Compound Interest Treasury Notes/6%/Act of March 3, 1863

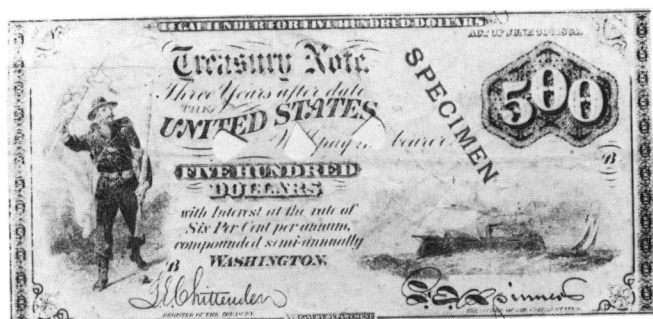

The Standard Bearer was engraved by George D. Baldwin. James Smillie engraved *New Ironsides.*

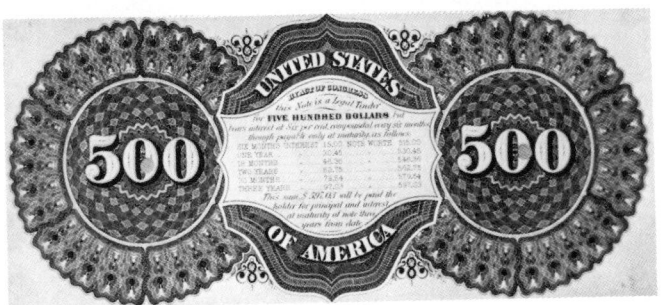

The back design includes an interest table.

Act of March 3, 1863

No.	Signatures	Dated	Notes Printed	Notes Issued	Notes Outstanding	Notes Known
1337	Chittenden-Spinner	June 10, 1864	–	16,468	1	1
1338	Colby-Spinner	June 10, 1864	–	0	0	0

Act of June 30, 1864

No.	Signatures	Dated	Notes Printed	Notes Issued	Notes Outstanding	Notes Known
1339	Chittenden-Spinner	July 15, 1864	84,612	76,000	22	1
1339a	Colby-Spinner	Oct. 1, 1865	included in above		included in above	

Interest-bearing Notes/6%/Act of March 2, 1861

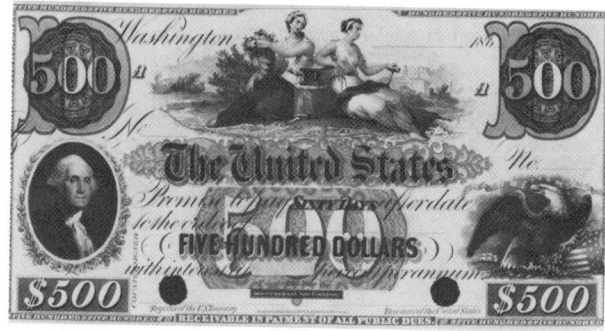

In addition to the portrait of George Washington there are two vignettes titled *Prosperity,* probably engraved by George W. Hatch, and *E Pluribus Unum.* (ABNCo)

As the back shows this note was payable to bearer.

No.	Term	Notes Issued		Known
		Old Plates	New Plates	
1340	60 days	Unknown	18,254	1

Act of March 3, 18635%

1340a	One year	(Similar to No. 1339, unknown in any collection)

Two-year Notes/6%/Act of March 2, 1861

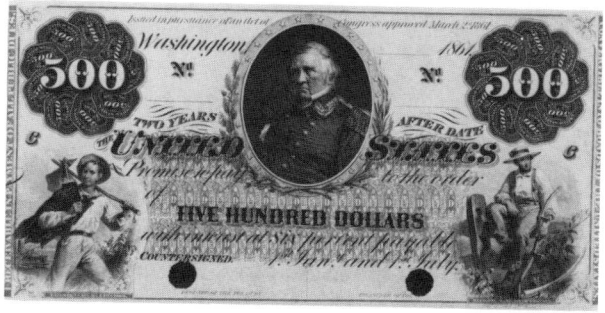

The portrait of General Winfield Scott was engraved by Joseph P. Ourdan. The *Man With a Scythe* was engraved by Frederick Girsch. *The Traveler* cannot be attributed. (NBNCo)

Back design is on following page.

No.	Old Plates	Notes issued	Known
		New Plates	
1340b	4,291	44,157	1

Interest-bearing Notes/6%/Act of March 2, 1861 *(continued)*

Back design for No. 1340b
is brown.

Interest-bearing Notes/5%/Act of March 3, 1863

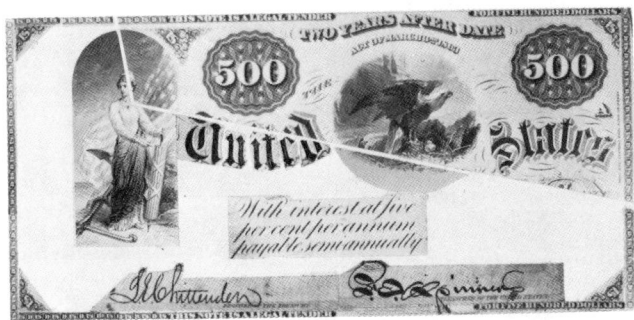

Liberty and Union was engraved by Charles Burt. *The Eagle's Nest*, also used on Nos. 1446–1460, was engraved by Louis Delnoce. This reconstruction was made from the upper and only portion visible in a frame of notes sold by Christie's on September 28, 1988, lot 435; the price was $80,000.

The back design includes an anti-counterfeiting clause.

No.	Signatures	Coupons	Notes Issued	Outstanding
1341	Chittenden-Spinner	0	0	0
1342	Chittenden-Spinner	3	80,604	3

Remarks: In addition to the illustrated specimen of No. 1340b, which sold for $7,000 in 1982, there is a uniface plate proof that bears plate position "C" in a private collection. No circulated notes are known. At least 46,709 notes from new plates were printed. Additional notes could have been issued and printed.

"For the" was probably written on notes from old plates by clerks who were authorized to sign for U.S. Treasury officials. Notes from new plates probably had "For the" engraved in the plate.

Interest-bearing Notes/7.30%/Act of July 17, 1861

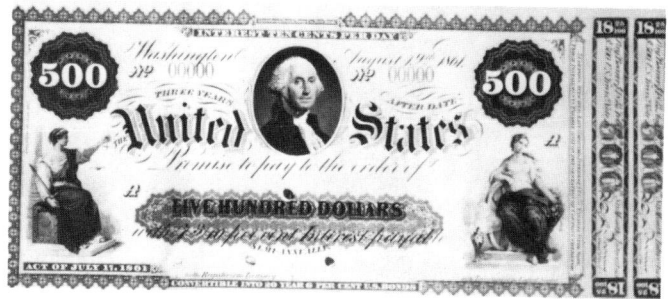

This unique note, with *Justice*, G. Washington and *Transportation*, was prepared by ABNCo.

Uniface face and back are mounted as a complete note.

No.	Signatures	Dated	Serial Numbers	Issued	Notes Outstanding
1343	Chittenden-Spinner	Aug. 19, 1861	red	24,200	6
1344	Chittenden-Spinner	Oct. 1, 1861	red	46,391	8
1345	Chittenden-Spinner	Oct. 1, 1861	blue	1,117	0

Remarks: No. 1343 with serial number 1 is canceled at the Bureau of the Public Debt.

Interest-bearing Three-year Notes/7.30%

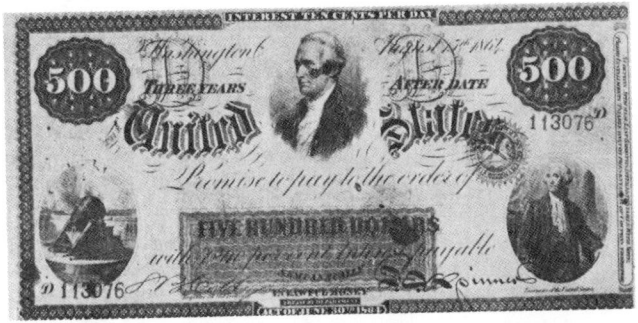

Mortar Firing was engraved by James Smillie. The portraits of Alexander Hamilton and George Washington (see No. 1140) were engraved by Owen G. Hanks. (Courtesy of the Coin and Currency Institute, Inc.)

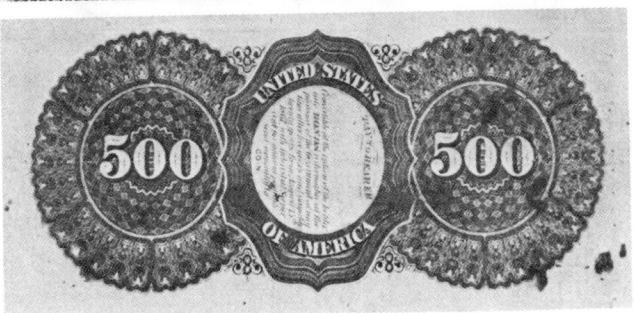

The back design is similar to No. 1342; a "pay to bearer" clause replaces the counterfeit warning.

No.	Dated	Act of June 30, 1864 Notes Printed	Notes Issued	Notes Outstanding
1346	Aug. 15, 1864	154,250	171,668	17
1347	Mar. 3, 1865	45,887	included in above	
		Act of March 3, 1865		
1348	June 15, 1865	181,813	175,682	28
1349	July 15, 1865	115,000	108,654	12

Remarks: All notes had the signatures of Colby-Spinner. In addition to the illustrated example of No. 1346, serial number 7811 is recorded for No. 1348.

National Bank Notes/First Charter Period/Red Seal

James D. Smillie engraved *Civilization. The Arrival of the Sirius, 1838* is on the right.

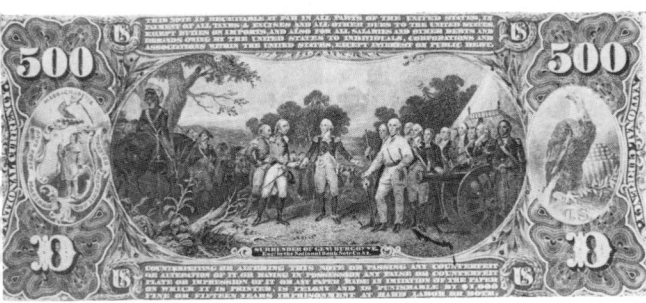

John Trumbull's *Surrender of General Gates at Saratoga* was engraved by Frederick Girsch. Lettering on the face and back was engraved by W.D. Nichols and G.W. Thurber.

No.	Series	Signatures	Notes Printed	Issued	Outstanding
1350	orig.	Chittenden-Spinner	21,645	19,523⌐	
1350a	orig.	Colby-Spinner	included in above		
1350b	1875	Allison-Spinner	⌐		
1350c	1875	Allison-New			
1350d	1875	Allison-Wyman	6,368	4,371	17
1350e	1875	Scofield-Gilfillan			
1350f	1875	Bruce-Gilfillan			
1350g	1875	Bruce-Wyman	⌐	⌐	

Numbers of $500 national bank notes issued in each state:

State	Orig.	1875	State	Orig.	1875
Alabama	0	292	Massachusetts	10031	842
Louisiana	720	0	New York	5767	2843
Maine	560	9	Pennsylvania	1175	230
Maryland	860	50	Rhode Island	410	105

Remarks: Catalog numbers have been changed in this edition. The original series has no series date on the face. Two notes are known for No. 1350a one is known for No. 1351c. The number of $50 national bank notes issued in each state was compiled by Peter Huntoon. See "The United States $50 & $1,000 National Bank Notes," *PAPER MONEY*, Vol. XXVII, No. 4, p. 103.

National Gold Bank Notes/Red Seal

The face design is similar to the preceding note.

The back design is similar to other national gold bank note denominations.

No.	Date	Issuing Bank	City	Issued
1351	1870	First National Gold Bank	San Francisco	300
1351a	1872	National Gold Bank & Trust Co.	San Francisco	250
1351b	1872	National Gold Bank of D.O. Mills & Co.	Sacramento	60

Remarks: A total of four notes are outstanding. Catalog numbers have been changed in this edition.

Silver Certificates/Series 1878 & 1880

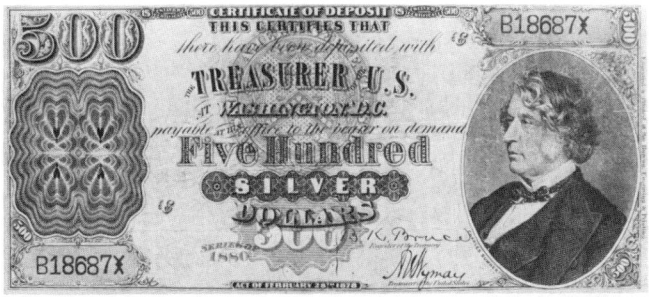

Bostonian Charles Sumner (1811–1874) graduated from Harvard Law School in 1834. In 1852 he was elected to the U.S. Senate by a margin of one vote. This portrait, based on a photograph by Allen and Rowell, was engraved by Charles Burt.

No.	Series	Countersigned by	Payable at	Issued	Known
1352	1878	W.G. White*	New York	⎤	0
1352a	1878	J.C. Hopper*	New York	400	0
1352b	1878	T. Hillhouse*	New York	⎦	0
1353	1878	R.M. Anthony	San Francisco	4,900	0
1354	1878	A.U. Wyman	Washington, DC	4,000	1
1354a	1878	A.U. Wyman	Washington, DC	included in above	0

No.	Series	Signatures	Seal	Issued	Known
1355	1880	Scofield-Gilfillan	brown	0	0
1356	1880	Bruce-Gilfillan	brown	16,000	5
1357	1880	Bruce-Wyman	brown	8,000	2

Remarks: The (*) indicates autographed countersignatures. Nos. 1352–1354a have signatures of Scofield-Gilfillan and red seals.

Gold Certificates/Series 1863–1875

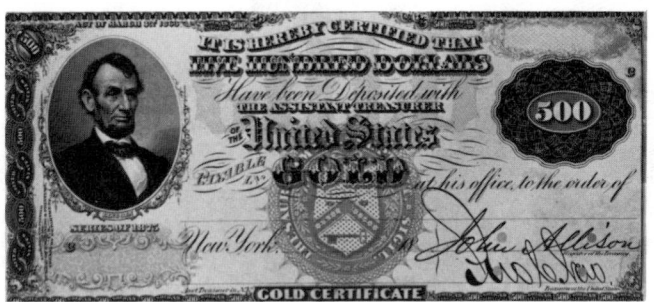

The portrait of Abraham
Lincoln was engraved by
Charles Burt.

Only the first issue has
this back design.

No.	Issue	Series	Signatures	Payable at	Printed	Issued	Out	Known
1358	First	1863	Colby-Spinner	New York	18,00	15,000	0	0
1359	Second	1870	Allison-Spinner	New York	40,00	36,000	11	1
1360	Third	1875	Allison-New	New York	11,28	11,628	0	0

Remarks: No. 1359, a uniface note with serial number A25770, is at the Bureau of the Public Debt.

Gold Certificates/Series 1882 & 1922

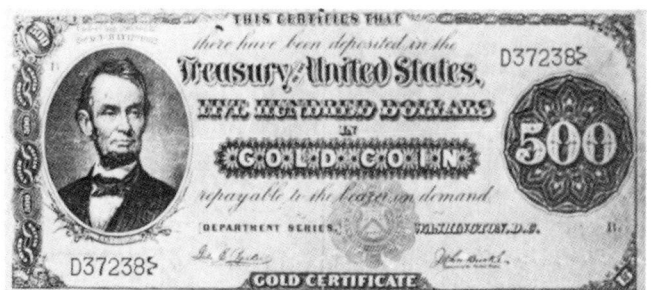

The portrait of Abraham Lincoln was engraved by Charles Burt.

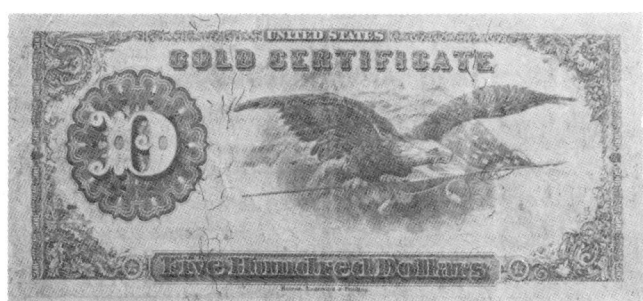

The *Eagle with Flag* was originally engraved for the Baldwin Bank Note Co.

No.	Date	Signatures	Seal	Notes Printed	Known
1361	1882	Bruce-Gilfillan	brown	20,000	0
		Department Series, payable at Washington			
1362	1882	Bruce-Gilfillan	brown	8,000	0
1363	1882	Bruce-Wyman	brown	20,000	1
1364	1882	Rosecrans-Hyatt	lg. red	16,000	1
1365	1882	Lyons-Roberts	sm. red	128,000	21
1366	1882	Lyons-Treat*	–	–	0
1366a	1882	Napier-McClung*	–	–	0
1367	1882	Parker-Burke	sm. red	40,000	22
1368	1882	Teehee-Burke	sm. red	40,000	31
1369	1922	Speelman-White	sm. red	84,000	33

Remarks: The (*) indicates plate proofs at the Bureau of Engraving and Printing; there is no record of issue. No. 1361 has the autographed countersignature of Thomas C. Acton and is payable in New York. No. 1365, in VFine-EFine condition, was auctioned by Stack's in Oct. 1988 for $3,300.

Federal Reserve Notes/Series 1918/Blue Seal

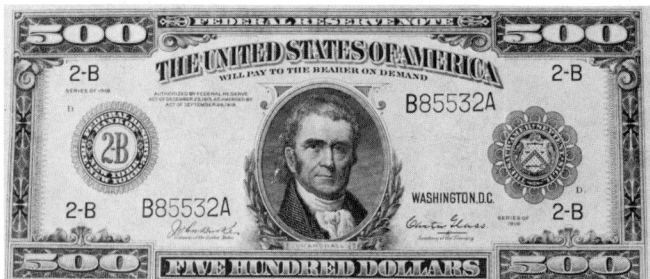

The portrait of John Marshall, originally painted by Henry Inman, was engraved by Charles Schlecht.

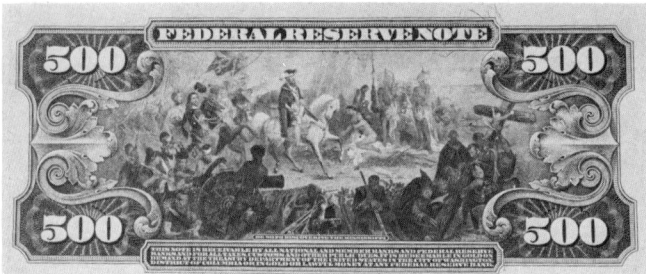

W.H. Powell's *DeSoto Discovering the Mississippi in 1541* was engraved by Frederick Girsch. The back is green.

| | | | Notes | | |
No.	Bank	Signatures	Printed	Issued	Known
1370A2	Boston	Burke-Glass	17,000	13,000	2
1370B2	New York	Burke-Glass	125,000	125,000	30
1370B4	New York	White-Mellon	125,000	125,000	2
1370C2	Philadelphia	Burke-Glass	24,000	6,000	4
1370D2	Cleveland	Burke-Glass	15,600	15,000	11
1370E	Richmond	unknown	23,200	4,000	–
1370F2	Atlanta	Burke-Glass	34,000	26,800	7
1370G1	Chicago	Burke-McAdoo	38,000	30,000	–
1370G2	Chicago	Burke-Glass	included in above		19
1370H2	St. Louis	Burke-Glass	14,400	6,800	3
1370I	Minneapolis	unrecorded	7,200	4,000	1
1370J2	Kansas City	Burke-Glass	16,000	7,200	12
1370K2	Dallas	Burke-Glass	6,000	4,400	3
1370L2	San Francisco	Burke-Glass	24,000	20,400	13
1370L3	San Francisco	Burke-Houston	–	–	2

Remarks: Although the above figures include all signature combinations, only those that have actually been observed are listed. Four consecutively-numbered pieces of No. 1370F exist in uncirculated condition. In 1991 No. 1370F2 sold for $10,000; in 1979 No. 1370K2 sold for $8,250; both were uncirculated.

Federal Reserve Notes/1928 & 1934/Green Seal

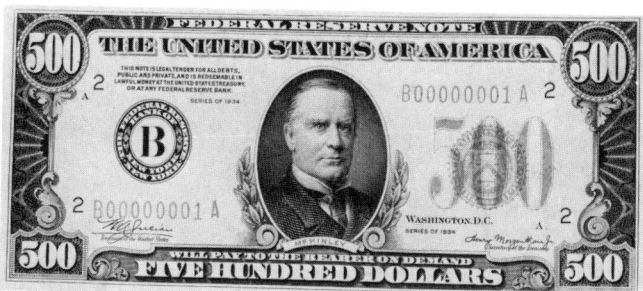

The portrait of William McKinley was engraved by John Eissler.

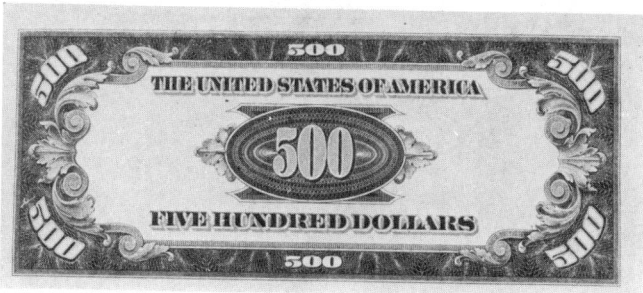

Series 1928, Woods-Mellon

No.	Bank	Notes Printed
1372A	Boston	69,120
1372B	New York	299,400
1372C	Philadelphia	135,120
1372D	Cleveland	166,440
1372E	Richmond	84,720
1372F	Atlanta	69,360
1372G	Chicago	573,600
1372H	St. Louis	66,180
1372I	Minneapolis	34,680
1372J	Kansas City	510,720
1372K	Dallas	70,560
1372L	San Francisco	64,080

Series 1934, Julian-Morgenthau

No.	Bank	Notes Printed
1373A	Boston	56,628
1373B	New York	288,000
1373B☆		–
1373C	Philadelphia	31,200
1373D	Cleveland	39,000
1373E	Richmond	40,000
1373F	Atlanta	46,200
1373F☆		–
1373G	Chicago	212,000
1373G☆		–
1373H	St. Louis	24,000
1373H☆		–
1373I	Minneapolis	24,000
1373J	Kansas City	40,800
1373J☆		–
1373K	Dallas	31,200
1373K☆		–
1373L	San Francisco	63,400
1373L☆		–

Federal Reserve Notes/Series 1934A, 1934B & 1934C/Green Seal

Series 1934A, Julian-Morgenthau

No.	Bank	Notes Printed
1374A	Boston	276,000
1374B	New York	45,300
1374C	Philadelphia	28,800
1374D	Cleveland	36,000
1374E	Richmond	36,000
1374F	Atlanta	confirmed
1374G	Chicago	214,800
1374G☆		confirmed
1374H	St. Louis	57,600
1374I	Minneapolis	14,400
1374J	Kansas City	55,200
1374K	Dallas	34,800
1374L	San Francisco	93,000

Series 1934B, Julian-Vinson

No.	Bank	Notes Printed
1374F-1	Atlanta	2,472

Series 1934C, Julian-Snyder

No.	Bank	Notes Printed
1374A-1	Boston	1,440
1374B-1	New York	204

Gold Certificate/Series 1928

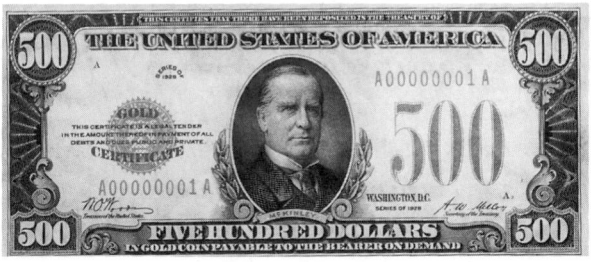

The portrait of William McKinley was engraved by John Eissler.

The back design is similar to the preceding note.

No.	Signatures	Notes Printed
1375	Woods-Mellon	420,000

United States Notes/1862 & 1863/Red Seal

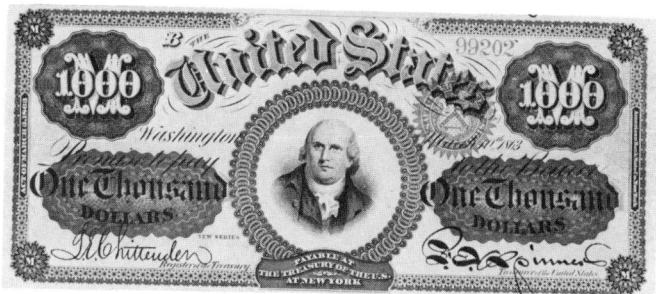

Charles Schlecht engraved the portrait of Robert Morris, patriot, U.S. Senator and our first Superintendent of Finance.

The back bears the second obligation.

Signatures of Chittenden-Spinner

No.	Date	Obligation	Printed	Notes Outstanding	Known
1376	1862	first			0
1377	1862	second			0
1378	1863	second, one serial number, "American Bank Note Co." at right "National Bank Note Co." at left	155,928	201	1
1378a	1863	second, one serial number, "American Bank Note Co." at right			2
1378b	1863	second, two serial numbers, "American Bank Note Co." at right			1

United States Notes/Series 1869/Red Seal

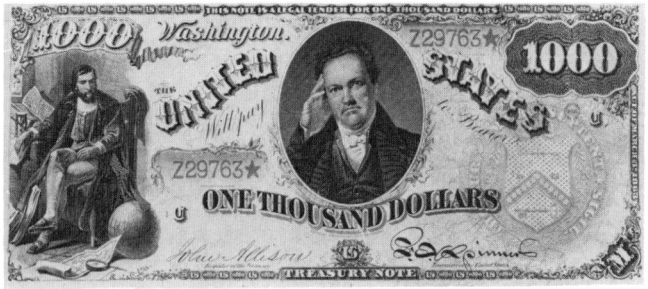

DeWitt Clinton (1769–1828) graduated from Columbia U. at age 17. He served as a U.S. Senator, as mayor of New York City and governor of New York. His portrait, based on a painting by C.C. Ingham, was engraved by Charles Burt. *Columbus in His Study* was engraved by Henry Gugler.

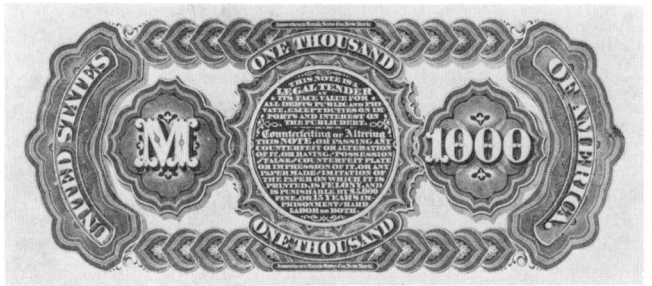

No.	Series	Signatures	Seal	Notes Issued	Outstanding	Known
1379	1869	Allison-Spinner	lg. red	87,100	499	2

An enlargement of the central portion of the back

Remarks: The official number printed is 74,400; reissued notes probably account for the above figure.

United States Notes/Series 1878 & 1880

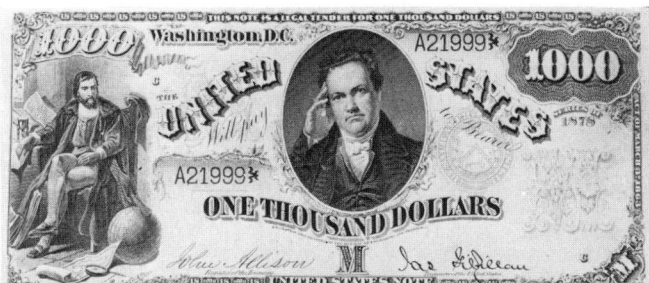

The face design is similar
to the preceding note.

No.	Series	Signatures	Seals	Notes Printed	Known
		All have red seals except for Nos. 1381 & 1385.			
1380	1878	Allison-Gilfillan	rays	24,000	2
1381	1880	Bruce-Wyman	brown	12,000	1
1382	1880	Rosecrans-Jordan	large	24,800	1
1383	1880	Rosecrans-Hyatt	plain	12,000	1
1384	1880	Rosecrans-Huston	lg. spike	– –	1
1385	1880	Rosecrans-Nebeker	brown	28,000	1
1386	1880	Tillman-Morgan	scallops	56,000	1
1387	1880	Tillman-Roberts	scallops	– –	1
1388	1880	Bruce-Roberts	scallops	24,000	1
1389	1880	Lyons-Roberts	scallops	32,000	12
1390	1880	Vernon-Treat	scallops	20,000	4
1391	1880	Napier-McClung	scallops	existence doubtful	

Compound Interest Treasury Notes/6%

Three-year Notes—Act of June 30, 1864

No.	Signatures	Dated	Notes Printed	Issued	Notes Outstanding
1392	Chittenden-Spinner	July 15, 1864	24,000	20,000	4
1392a	Colby-Spinner	Aug. 15, 1865	39,200	37,400	
1392b	Colby-Spinner	Sep. 15, 1865	included in above		

Interest-bearing Notes/6%

Act of March 2, 1861

No.	Term	Notes Printed Old Plates	New Plates	Issued
1393	60-days	Unknown	9,333	8,597

Act of March 3, 1863—5%

The subjects are entitled *Justice, Eagle with Shield,* and *Liberty.* The back design for this uniface proof is unknown.

No.	Term	Dated	Known
1393a	One-year	Oct. 1, 1863	1

Remarks: At least 9,333 notes from new plates were printed for No. 1393. Printed and issued figures are approximate. Notes from old plates probably had "For the" written by the signers who signed for the Treasury officials. "For the" was probably engraved on new plates.

Interest-bearing Notes/Two-year/6%

Act of March 2, 1861

George Washington, *America*, and the *U.S. Treasury Building* adorn this note. *America* is the central figure in *The Progress of Civilization* by Thomas Crawford, the pediment above the Senate Wing of the U.S. Capitol. The green overprint was accidentally inverted on this specimen.

The color of the back is rust.

No.	Signatures	Notes Issued Old Plates	New Plates	Known
1393b	Chittenden-Spinner	3,068	24,509	2

Remarks: "For the" was probably written by the clerks who signed for the U.S. Treasury officials on notes from old plates. The National Bank Note Co., who also printed the first Confederate issue, used the same version of *Columbia* on the $1,000 note dated 6 May 1861.

In addition to the illustrated specimen, there is one plate proof, position "A," known in a private collection; no circulated notes are known. There is no example of this note at the Bureau of Engraving and Printing.

Interest-bearing Notes/Two-year/5% Act of March 3, 1863

The *Naval Engagement Between the Guerriere and the Constitution,* and the *Discovery of the Mississippi by De Soto* appear on this unknown note. At least some of No. 1395 were prepared by the ContBNCo.

No.	Signatures	Coupons	Notes Issued	Outstanding
1394	Chittenden-Spinner	0	not issued	–
1395	Chittenden-Spinner	3	89,308	19

Three-year Notes – 7.30% Act of July 17, 1861

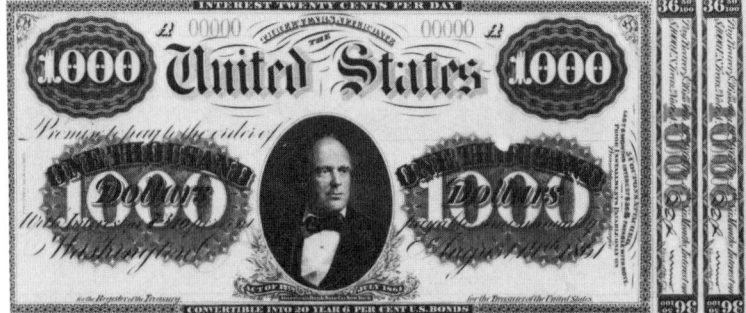

The portrait of Salmon P. Chase was engraved by Alfred Sealey.

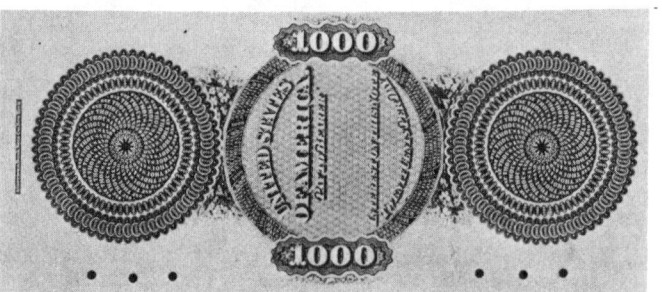

No.	Signatures	Dated	Serial Nos.	Printed	Notes Issued	Outstanding
1396	Chittenden-Spinner	Aug. 19, 1861	red	–	22,922	3
1397	Chittenden-Spinner	Oct. 1, 1861	red	–	37,998	3
1398	Chittenden-Spinner	Oct. 1, 1861	blue	–	1,380	0
		Act of June 30, 1864				
1399	Colby-Spinner	Aug. 15, 1864		114,540	118,528	5
1400	Colby-Spinner	Mar. 3, 1865		3,460	–	–

Interest-bearing Notes

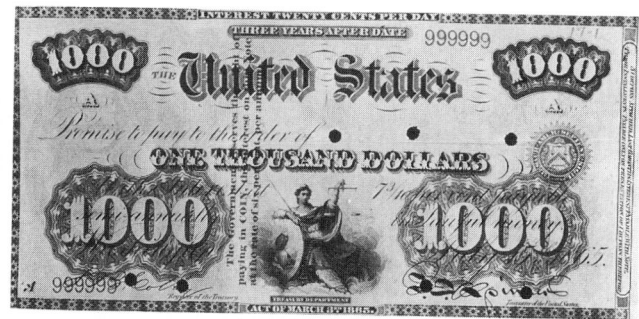

Justice occupies the center of this note; the five coupons are not shown.

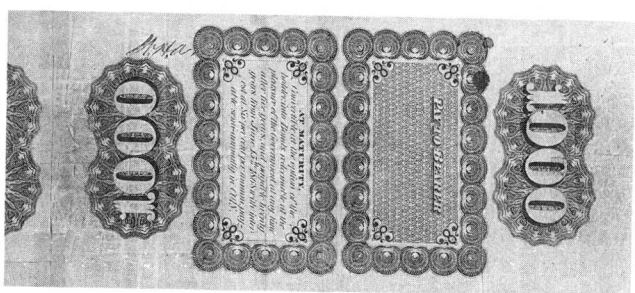

The back design indicates that these notes were payable to the bearer.

Act of March 3, 1865 – 7.30%

No.	Signatures	Dated	Printed	Notes Issued	Outstanding
1401	Colby-Spinner	June 15, 1865	189,200	179,965	3
1402	Colby-Spinner	July 15, 1865	81,000	71,879	8

Remarks: The Bureau of the Public Debt has two canceled notes, No. 1401 serial number 102997 (with four coupons) and No. 1402, serial number 999999 (with five coupons). William E. "Long Bill" Brockway (Col. W.E. Spencer) was the brains behind the counterfeiting of this note. The admitted counterfeiter was Charles H. Smith (*Underwood's Counterfeit Detector*, March 1881). Counterfeit notes reported by 12 October 1867 had plates A or B.

National Bank Notes/First Charter Period/Red Seal

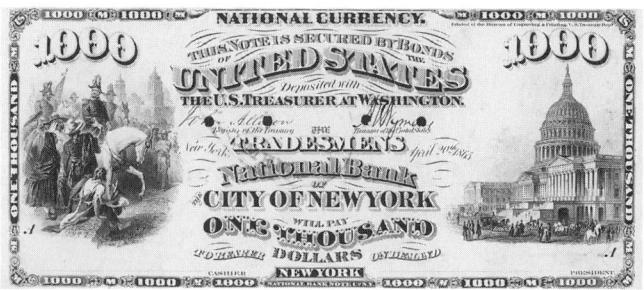

General Scott's Entrance into Mexico, by John Trumbull, was engraved by Alfred Jones and James Smillie; the latter also engraved the *U.S. Capitol*.

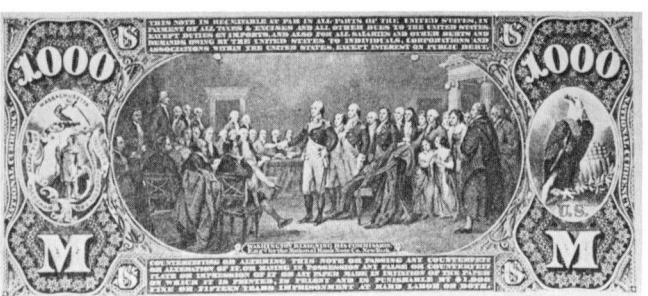

Washington Resigning his Commission, another mural by Trumbull, was engraved by Louis Delnoce and Frederick Girsch. Lettering on face and back was engraved by W.D. Nichols and G.W. Thurber.

No.	Date	Signatures	Notes Printed	Issued
1403	orig.	Chittenden-Spinner	5,888	5,743
1404	orig.	Colby-Spinner	included in above	
1404a	1875	Allison-Spinner		
1404b	1875	Allison-Wyman	2,402	1,636
1404c	1875	Scofield-Gilfillan		
1404d	1875	Bruce-Gilfillan		

Numbers of $1,000 national bank notes issued in each state

State	Orig.	1875
Maryland	142	0
Massachusetts	1332	160
New York	3902	1465
Pennsylvania	237	11
Rhode Island	130	0

Remarks: The original series has no series date on the notes. A total of 21 notes are outstanding. The number of $1,000 national bank notes issued in each state was compiled by Peter Huntoon. (See "The United States $500 & $1,000 National Bank Notes," *PAPER MONEY*, Vol. XXVII, No. 4, p. 103.)

Silver Certificates/Series 1878 & 1880

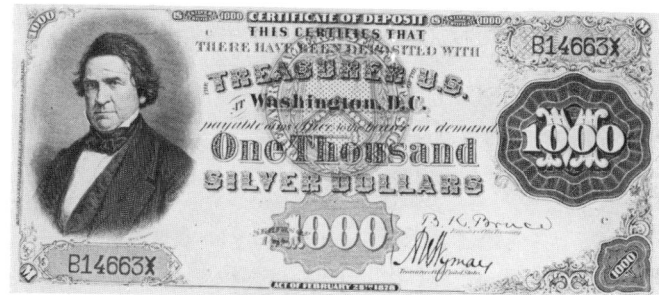

The portrait of William L. Marcy (1786–1857) was engraved by Charles Schlecht. Following his graduation from Brown University, Marcy held numerous political positions; the most notable was Secretary of State.

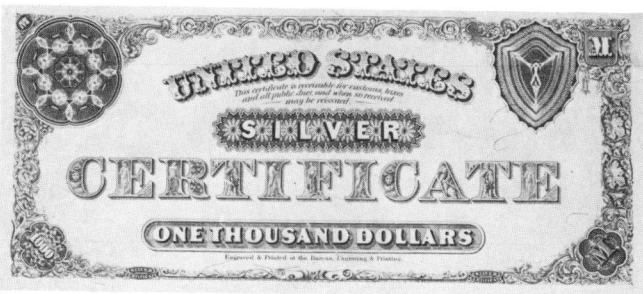

No.	Series	Countersigned by	Seal	Payable at	Issued
1405	1878	T. Hillhouse	red	New York	90
1406	1878	R.M. Anthony	red	San Francisco	10,400
1407	1878	A.U. Wyman	red	Washington, DC	2,000
1407a	1878	A.U. Wyman*	red	Washington, DC	2,000

No.	Series	Signatures	Seal	Issued	Known
1408	1880	Scofield-Gilfillan	brown	doubtful	0
1409	1880	Bruce-Gilfillan	brown	8,000	0
1410	1880	Bruce-Wyman	brown	8,000	5

Remarks: The (*) indicates autographed countersignatures. Nos. 1405–1407a were all redeemed or destroyed. A portion of No. 1406 could have autographed countersignatures. The number issued for No. 1407 is based on conjecture. No. 1407a has the signatures of Scofield-Gilfillan. See "Series 1878 silver certificates . . . " by W. Breen, *Numismatic News*, May 24, 1975.) Recorded notes for No. 1410 include B11437, B12623, and B12638.

Silver Certificates/Series 1891

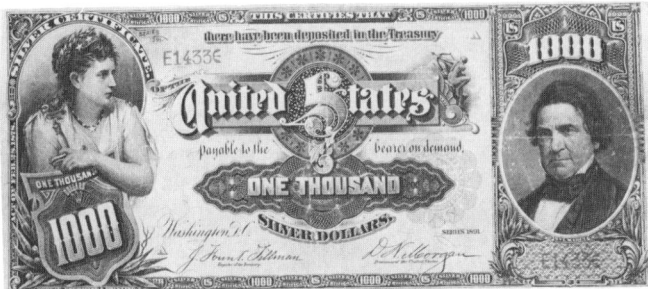

The face and back of this note were designed by Thomas F. Morris. Nonportrait engravers were D.M. Cooper, J. Kennedy, S.B. Many, W. Ponickau and G.U. Rose, Jr.

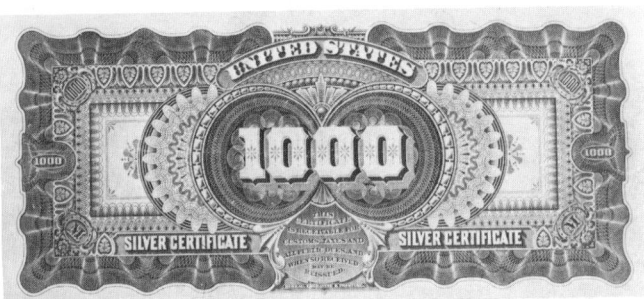

The back was engraved by D.M. Cooper, E.M. Hall, W.F. Lutz, R. Ponickau and G.U. Rose, Jr.

No.	Series	Signatures	Notes Printed	Issued	Known
1411	1891	Tillman-Morgan	8,000	5,600	5

Remarks: A total of ten notes are outstanding for Nos. 1405–1411. The following appeared in the July 29, 1894 edition of *The New York Times*: "According to U.S. Treasury gossip, the female portrait was taken from a photograph of Josie Mansfield" (the mistress of James Fisk). In 1877 Charles Burt engraved an image of *Liberty* that was used on a $1,000 bond (X170D, Hessler 1988). It seems that G.F.C. Smillie re-engraved the image as it appears on No. 1411.

Gold Certificates/Series 1863–1875

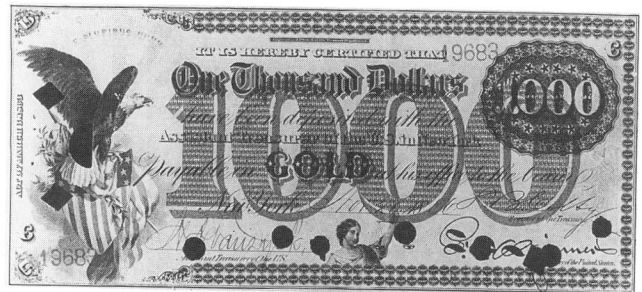

E Pluribus Unum was engraved by Charles Skinner. The complete figure of *Justice* can be seen on No. 1393a.

The first issue has this back design, one of the first plates produced at the Bureau of Engraving and Printing.

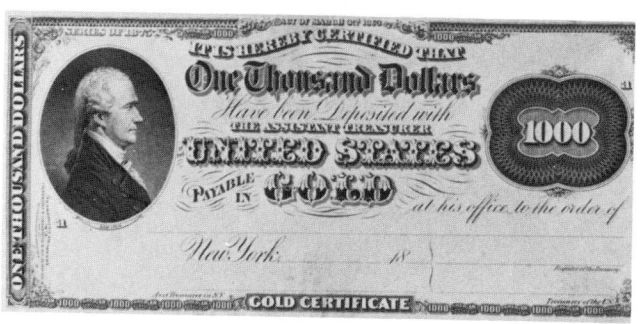

Nos. 1413 and 1414, uniface, have portraits of Alexander Hamilton engraved by Charles Burt.

No.	Issue	Date	Signatures	Payable at	Printed	Issued	Out	Known
1412	First	1863	Colby-Spinner	New York	117,000	60,000	7	1
1413	Second	1870	Allison-Spinner	New York	50,000	47,500	16	1
1414	Third	1875	Allison-New	New York	14,371	14,371	0	0

Remarks: No. 1412, with serial number 19683, and No. 1413, with serial number A38887, are at the Bureau of the Public Debt.

Gold Certificates/Series 1882 & 1922

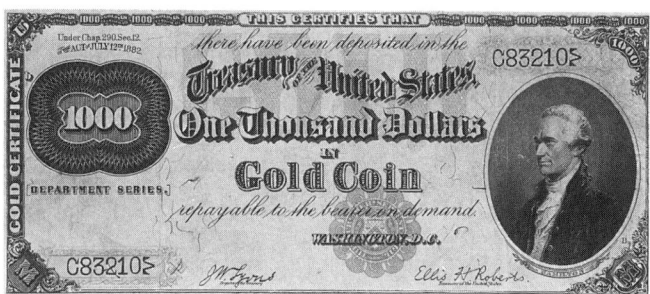

The portrait of Alexander Hamilton is at the right.

The back design is yellow.

No.	Series	Signatures	Seal	Notes Printed	Known
1415	1882	Bruce-Gilfillan	brown	12,000	2
		Department Series, payable at Washington			
1416	1882	Bruce-Gilfillan	brown	8,000	0
1417	1882	Bruce-Wyman	brown	20,000	1
1418	1882	Rosecrans-Hyatt	lg. red	16,000	1
1419	1882	Rosecrans-Huston	lg. brn	8,000	3
1420	1882	Rosecrans-Nebeker	lg. red	8,000	3
1421	1882	Lyons-Roberts	sm. red	96,000	7
1422	1922	Lyons-Treat	sm. red	16,000	4

Remarks: Number 1415 has the autographed countersignature of Thomas C. Acton, and is payable at New York. No. 1421, in fine condition, with serial number C58223, was auctioned by NASCA in November 1979 for $6,600. In 1991 the same note was sold by Stack's for $9,500. The following notes are at the Smithsonian: No. 1416, A10199; No. 1418, A18818; No. 1419, C6477; No. 1420, C23847; No. 1422, D15131. In addition, Martin Gengerke has recorded the following notes: No. 1419, C22708; No. 1421; C58223, C63993, C74741, C83210, C100258, and C119261; No. 1422; D10213 and D14752.

Gold Certificates/Series 1907 & 1922

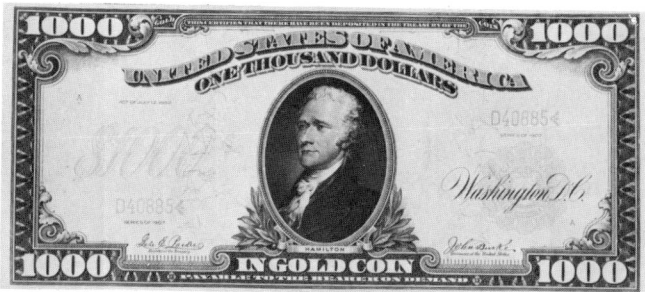

The C.L. Ransom portrait of Alexander Hamilton was engraved by G.F.C. Smillie.

The *Great Seal of the U.S.* on the gold back was engraved by R. Ponickau. Additional engravers were E.M. Hall, G.U. Rose, Jr. and R.H. Warren.

No.	Series	Signatures	Notes Printed	Known
1423	1907	Vernon-Treat	32,000	6
1423a	1907	Vernon-McClung	12,000	0
1423b	1907	Napier-McClung	12,000	1
1423c	1907	Napier Burke	12,000	3
1423d	1907	Parker-Burke	48,000	6
1423e	1907	Teehee-Burke	112,000	26
1424	1922	Speelman-White	80,000	25

Remarks: These notes have been renumbered. In 1988 No. 1423e in uncirculated condition, with serial number D142760, sold for $13,750. In addition to the illustrated note the following notes have been recorded. No. 1423: A9050, A2258, A13296, A26707 & A31075; No. 1423b: B19908; No. 1423c: D2626, D3953, D5936; No. 1423d: D40834, D40835, D40885, D40886, D44933 & D46670.

Treasury or Coin Notes/Series 1890 & 1891

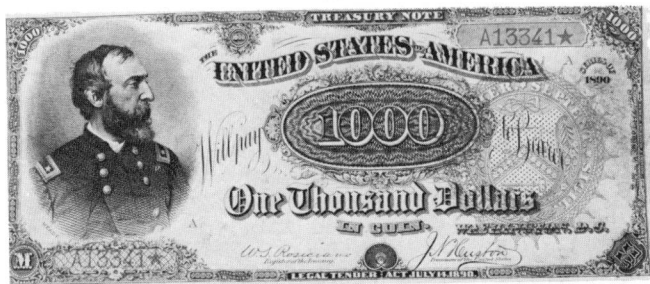

George Gordon Meade (1815–1872) was born in Cadiz, Spain of American parents. After serving in the Union army during the Civil War, he rose to major-general. His portrait was engraved by Charles Burt.

The green back design was engraved by W.H. Dougal, E.M. Hall, G.U. Rose, Jr. and D.M. Russell.

No.	Series	Signatures	Seal	Notes Printed	Known
1425	1890	Rosecrans-Huston	brown	16,000	6
1426	1890	Rosecrans-Nebeker	red	12,000	2
1427	1891	Rosecrans-Nebeker	red	8,000	0
1428	1891	Tillman-Morgan	red	24,000	2

Series 1891

The face design is similar to the preceding note. The back was engraved by D. M. Cooper, W.H. Dougal, E.M. Hall, A.L. Helm and G.U. Rose, Jr.

Remarks: G.G. Meade is one of five Americans of foreign birth to appear on U.S. paper money. The others are Alexander Hamilton, Robert Morris (Nos. 578 & 1376), A. Gallatin (No. 1320) and E.D. Baker (No. 1441). The 1890 note is often called the grand watermelon note due to the shape and color of the zeros on the back (see No. 1242).

Federal Reserve Notes/Series 1918/Blue Seal

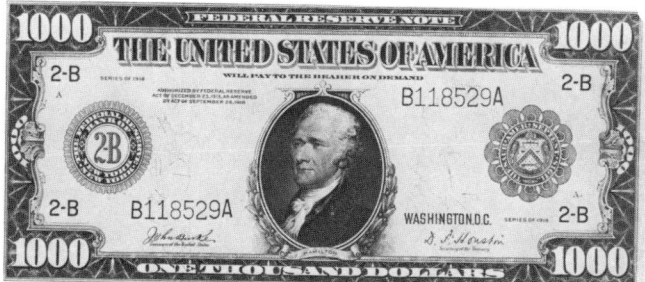

The C.L. Ransom portrait
of Alexander Hamilton was
engraved by G.F.C. Smillie.

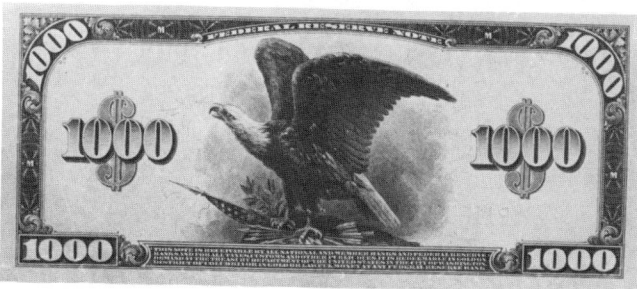

The *Eagle,* on the back,
was engraved by Marcus W.
Baldwin.

No.	Bank	Signatures	Notes Printed	Issued	Known
1429A2	Boston	Burke-Glass	39,600	20,800	1
1429B2	New York	Burke-Glass			10
1429B3	New York	Burke-Houston	124,800	124,800	3
1429B4	New York	White-Mellon			0
1429C2	Philadelphia	White-Mellon	16,400	12,800	11
1429D2	Cleveland	Burke-Glass	8,800	8,800	6
1429E2	Richmond	Burke-Glass	17,600	8,400	0
1429F2	Atlanta	Burke-Glass	43,200	43,200	4
1429F4	Atlanta	White-Mellon	included in above		4
1429G2	Chicago	Burke-Glass	23,600	19,600	14
1429H2	St. Louis	Burke-Glass	8,400	4,400	5
1429I2	Minneapolis	Burke-Glass	7,600	2,800	2
1429J2	Kansas City	Burke-Glass	15,200	4,400	4
1429K2	Dallas	Burke-Glass	6,000	4,400	3
1429L2	San Francisco	Burke-Glass	22,400	22,000	30
1429L4	San Francisco	White-Mellon	included in above		3

Remarks: Although the above figures include all signature combinations, only those that have actually
been observed thus far are listed. The figures for No. 1429H2 might be incomplete. No. 1429L4, in uncir-
culated condition, with serial number L19268, sold for $8,800 in 1988.

Federal Reserve Notes/Series 1928/Green Seal

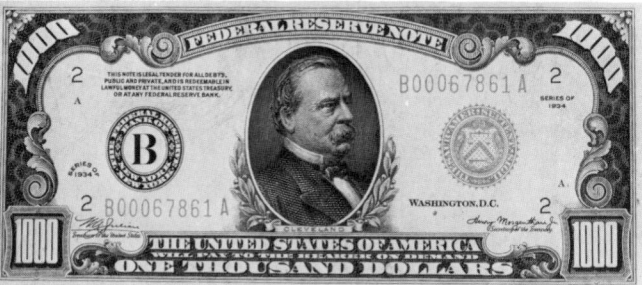

The portrait of Grover
Cleveland was engraved by
John Eissler.

Series 1928, Woods-Mellon

No.	Bank	Notes Printed
1430A	Boston	58,320
1430B	New York	139,200
1430C	Philadelphia	96,708
1430D	Cleveland	79,680
1430D☆		reported
1430E	Richmond	66,840
1430F	Atlanta	47,400
1430G	Chicago	355,800
1430G☆		–

Series 1928, Woods-Mellon

No.	Bank	Notes Printed
1430H	St. Louis	60,000
1430I	Minneapolis	26,640
1430J	Kansas City	62,172
1430K	Dallas	42,960
1430L	San Francisco	67,920
1430L☆		–

Federal Reserve Notes/Series 1934, 1934A & 1934C/Green Seal

Series 1934, Julian-Morgenthau

No.	Bank	Notes Printed
1431A	Boston	46,200
1431B	New York	332,784
1431C	Philadelphia	33,000
1431D	Cleveland	35,400
1431E	Richmond	19,560
1431F	Atlanta	67,800
1431G	Chicago	167,040
1431H	St. Louis	22,440
1431I	Minneapolis	12,000
1431J	Kansas City	51,840
1431K	Dallas	46,800
1431L	San Francisco	90,600

Series 1934A, Julian-Morgenthau

No.	Bank	Notes Printed
1432A	Boston	30,000
1432B	New York	174,348
1432C	Philadelphia	78,000
1432D	Cleveland	28,800
1432E	Richmond	16,800
1432F	Atlanta	80,964
1432G	Chicago	134,400
1432H	St. Louis	39,600
1432I	Minneapolis	4,800
1432J	Kansas City	21,600
1432K	Dallas	not printed
1432L	San Francisco	36,600

Series 1934C, Julian-Snyder

No.	Bank	Notes Printed
1433A	Boston	1,200
1433B	New York	168

Gold Certificates/Series 1928 & 1934

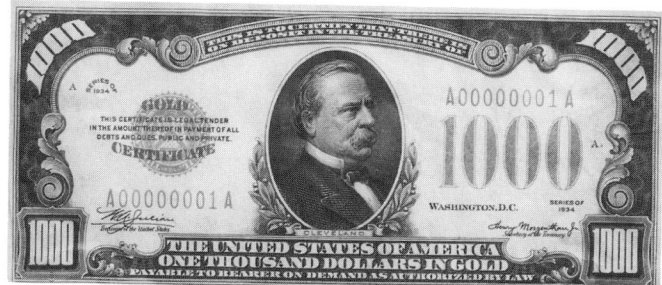

In addition to John Eissler, who engraved the portrait of Grover Cleveland, additional engravers were O. Benzing and W.B. Wells.

The back design is the same as No. 1430.

No.	Series	Signatures	Notes Printed
1434	1928	Woods-Mellon	288,000
1434a	1934	Julian-Morgenthau	84,000

United States Notes

The portrait of James Madison was engraved by Alfred Sealey. "Specimen Furnished the Chinese Government By the United States Treasury Department," at lower right, identifies this as an example of specimens sent to foreign governments for comparison purposes.

The *Eagle* was engraved by William Chorlton.

No.	Series	Signatures	Seal	Notes Printed	Outstanding
1435	1878	Scofield-Gilfillan	lg. brown	4,000	0

Interest-bearing Notes/6%

60-Day Notes/Act of March 2, 1861

		Notes Issued		Known
No.	Term	Old plates	New plates	
1435a	60-days	Unknown	1,466	0

The face design of this unknown note bears the *Altar of Liberty*. The designer was T.A. Liebler. The back design included a vignette entitled *Eagle and Stars*.

One-Year Notes/5%/Act of March 3, 1863

No.	Signatures	
1435b	Chittenden-Spinner	No data available on this unknown note.

Remarks: Additional notes could have been printed and issued for No. 1435a. Notes from old plates probably had "For the" written in by authorized clerks who signed for U.S. Treasury officials. "For the" was probably engraved in new plates.

Interest-Bearing, Three-Year Notes/7.3%

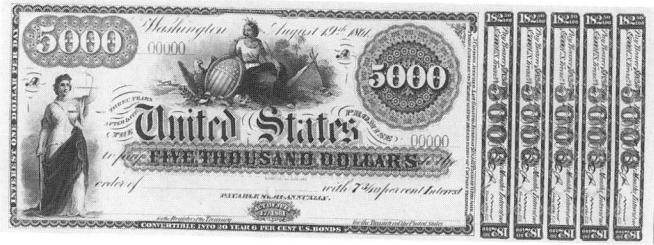

Justice, by T.A. Liebler, on the left, was engraved by Louis Delnoce; *America* was engraved by Charles Burt.

Act of July 17, 1861

No.	Signatures	Dated	Printed	Issued
1436	Chittenden-Spinner	Aug. 19, 1861	–	1,089
1437	Chittenden-Spinner	Oct. 1, 1861	–	1,871
		Act of June 30, 1864		
1438	Colby-Spinner	Aug. 15, 1864	6,145	4,166
1439	Colby-Spinner	Mar. 3, 1865	1,020	incl. in above
		Act of March 3, 1865		
1440	Colby-Spinner	June 15, 1865	4,430	4,045
1440a	Colby-Spinner	July 15, 1865	2,800	1,684

Remarks: All notes have been redeemed.

Currency Certificates of Deposit/Act of June 8, 1872

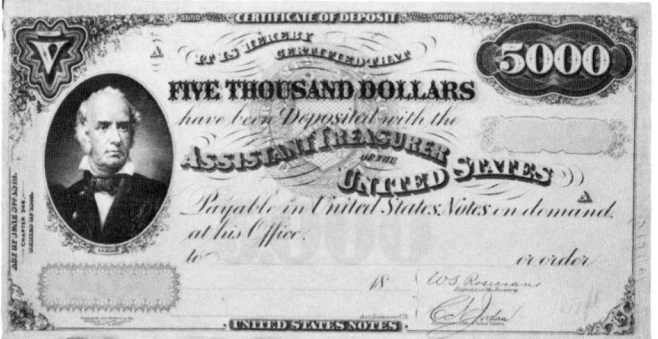

Five years after his birth in London, England, E.D. Baker (1811–1861) came to the U.S. He studied and practiced law in Springfield, Illinois, served as state senator in 1840 and was elected to Congress in 1844. This portrait was engraved by Charles Burt.

No.	Series	Signatures	Seal	Notes Printed
1441	1872	Allison-Spinner	red	8,000
1442	1875	Various	red	10,002

Remarks: Two additional sheets of three subjects each were prepared in 1889, one each for the Chinese and Japanese governments. Baker is one of five Americans of foreign birth to appear on U.S. paper money. The others are Alexander Hamilton, A. Gallatin (No. 1320), G.G. Meade (No. 1425) and R. Morris (Nos. 578 & 1376).

Gold Certificates/Series 1863–1875

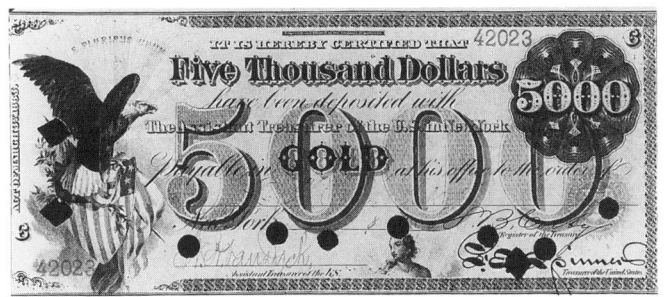

E Pluribus Unum was engraved by Charles Skinner. The complete figure of Victory can be seen on No. 726.

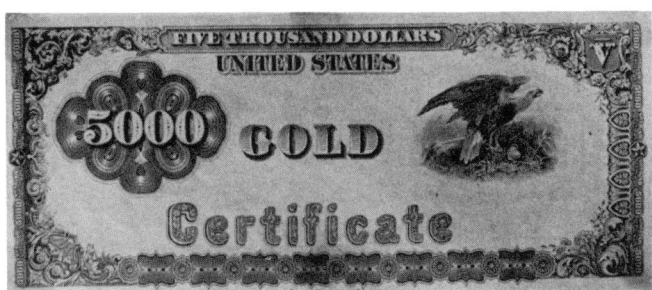

The first issue had this back design, one of the first plates produced at the Bureau of Engraving and Printing.

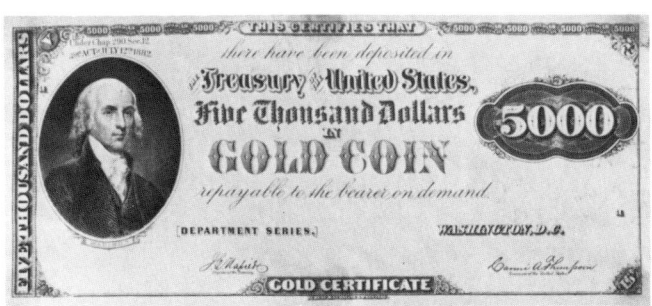

Nos. 1444–1445 are uniface and have portraits of James Madison engraved by Alfred Sealey. The illustrated proof, the only example known, is at the Bureau of Engraving and Printing. The back design is similar to Nos. 1446–1451.

No.	Issue	Date	Signatures	Payable at	Printed	Issued
1443	First	1863	Colby-Spinner	New York	94,600	64,600
1444	Second	1870	Allison-Spinner	New York	40,000	21,000
1444a	Second	1870	Allison-Gilfillan		(There is a proof at the BEP.)	
1445	Third	1875	Allison-New	New York	5,977	5,977

Remarks: No. 1443 with serial number 42023, is at the Bureau of the Public Debt. Three notes are outstanding for No. 1444. No other notes are known.

Gold Certificates/Series 1882

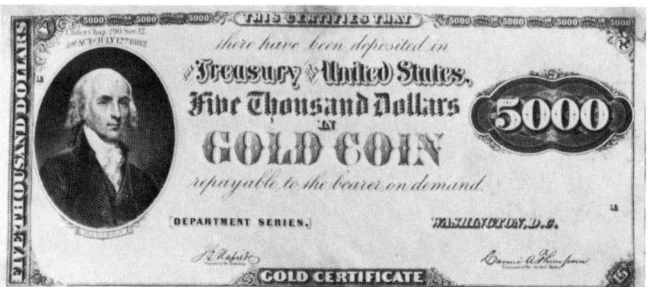

The portrait of James Madison was engraved by Alfred Sealey.

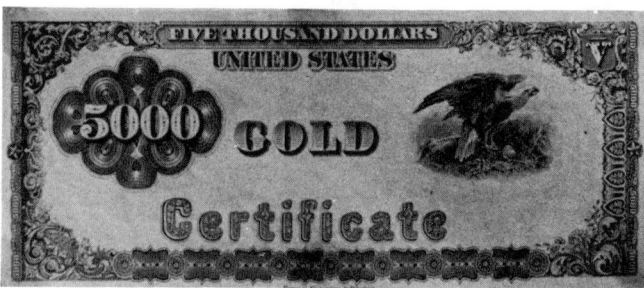

The Eagle's Nest is based on a painting by Gilbert Stuart.

No.	Signatures	Seal	Notes Printed
1446	Bruce-Gilfillan	brown	4,000
	Department Series, payable at Washington		
1447	Bruce-Gilfillan	brown	500
1448	Bruce-Wyman	brown	3,500
1449	Rosecrans-Hyatt	lg. red	4,000
1450	Rosecrans-Nebeker	sm. red	4,000
1451	Lyons-Roberts	sm. red	16,000
1451a	Lyons-Treat*	sm. red	–
1452	Vernon-Treat	sm. red	4,000
1453	Vernon-McClung	sm. red	26,500 (estimate)
1453a	Napier-McClung	sm. red	included in above
1453b	Napier-Thompson*	sm. red	–
1453c	Parker-Burke	sm. red	–
1453d	Teehee-Burke	sm. red	2 known

Remarks: The (*) indicates a plate proof at the Bureau of Engraving and Printing; there is no record of issue. No. 1446 has the autographed countersignature of Thomas C. Acton and is payable at New York. Ten pieces are outstanding for Nos. 1446–1453d.

Gold Certificates/Series of 1888

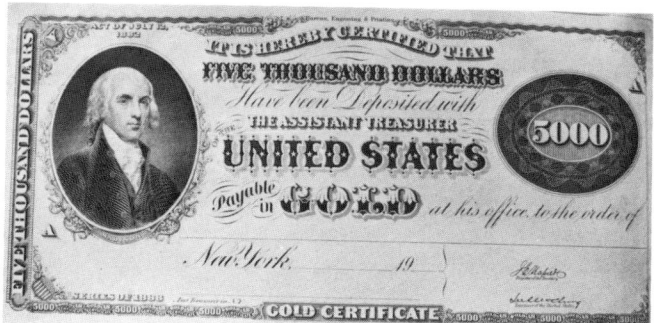

This proof note bears a portrait of James Madison engraved by Alfred Sealey.

No.	Payable at	Notes Issued	Notes Printed	Outstanding
1454	Baltimore	512		
1455	Chicago	974		
1456	New York	6,388		
1457	Philadelphia ✦	1,600	9,000	0
1458	St. Louis	48		
1459	San Francisco	1,736		
1460	Washington, DC	75		

Remarks: Signatures of Rosecrans-Hyatt appeared on 6,000 notes, and Rosecrans-Nebeker on 3,000. These official figures are from Final Receipts for Notes and Certificates of the Bureau of Engraving and Printing. Nevertheless, the issued figures supplied by Walter Breen total 11,333. Some notes could have been reissued.

Federal Reserve Notes/Series 1918/Green Seal

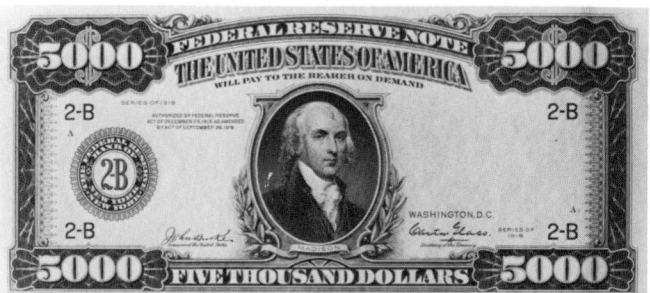

James Barton Longacre's portrait of James Madison was engraved by Alfred Sealey.

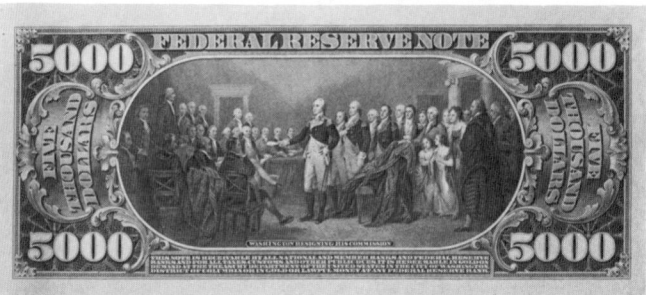

John Trumbull's *Washington Resigning his Commission* was engraved by Frederick Girsch and Louis Delnoce.

No.	Bank	Printed	Issued	Known
1461A	Boston	2,800	800	0
1461B	New York	5,200	1,600	3
1461C	Philadelphia	2,000	none	0
1461D	Cleveland	800	400	1
1461E	Richmond	1,600	400	0
1461F	Atlanta	400	none	0
1461G	Chicago	2,800	400	1
1461H	St. Louis	1,200	400	0
1461I	Minneapolis	none	–	–
1461J	Kansas City	none	–	–
1461K	Dallas	1,200	none	–
1461L	San Francisco	3,600	2,800	1

Remarks: Only 13 notes are outstanding. In addition to the illustrated plate proof, three notes are known: two at the Smithsonian and one at the Federal Reserve Bank of Chicago. The issued figures for Chicago and St. Louis might prove to be incomplete.

Federal Reserve Notes/Series 1928, 1934, 1934A & 1934B/Green Seal

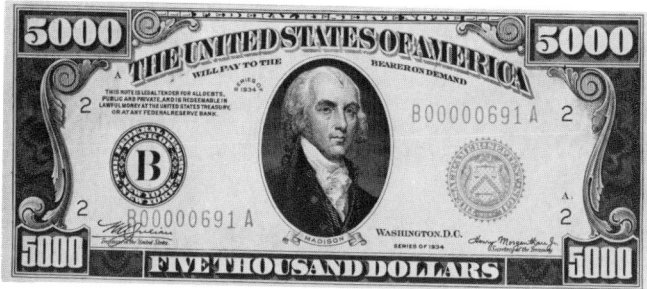

The portrait of James Madison was engraved by Alfred Sealey in 1869.

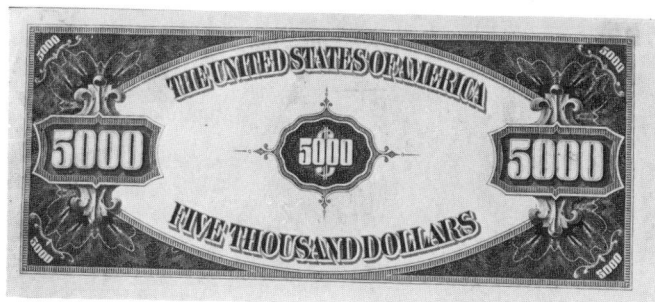

Series 1928, Woods-Mellon

No.	Bank	Notes Printed
1462A	Boston	1,320
1462B	New York	2,640
1462C	Philadelphia	not printed
1462D	Cleveland	3,000
1462E	Richmond	3,984
1462F	Atlanta	1,440
1462G	Chicago	3,480
1462H	St. Louis	not printed
1462I	Minneapolis	not printed
1462J	Kansas City	720
1462K	Dallas	360
1462L	San Francisco	51,300

Series 1934, Julian-Morgenthau

No.	Bank	Notes Printed
1463A	Boston	9,480
1463B	New York	11,520
1463C	Philadelphia	3,000
1463D	Cleveland	1,680
1463E	Richmond	2,400
1463F	Atlanta	3,600
1463G	Chicago	6,600
1463H	St. Louis	2,400
1463I	Minneapolis	not printed
1463J	Kansas City	2,400
1463K	Dallas	2,400
1463L	San Francisco	6,000

Series 1934A, Julian-Morgenthau

No.	Bank	Notes Printed
1463aH	St. Louis	1,440

Series 1934B, Julian-Vinson

No.	Bank	Notes Printed
1463bA	Boston	1,200
1463bB	New York	12

Gold Certificate/Series 1928

The face and back designs are similar to No. 1463 except for the seal and obligation.

No.	Series	Signatures	Notes Printed
1464	1928	Woods-Mellon	24,000

United States Notes/Brown Seal

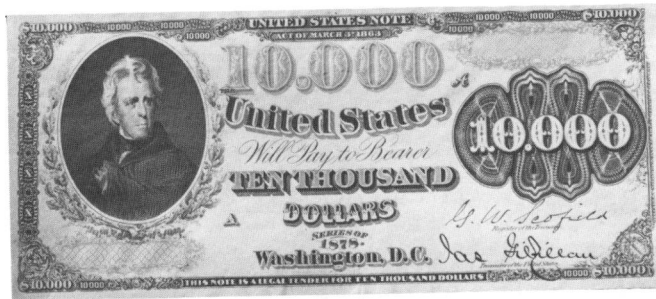

The Thomas Sully portrait of Andrew Jackson was engraved by Alfred Sealey.

No.	Series	Signatures	Notes Printed	Outstanding
1465	1878	Scofield-Gilfillan	4,000	0

The portrait enlarged.

Gold Certificates/Series 1863–1875

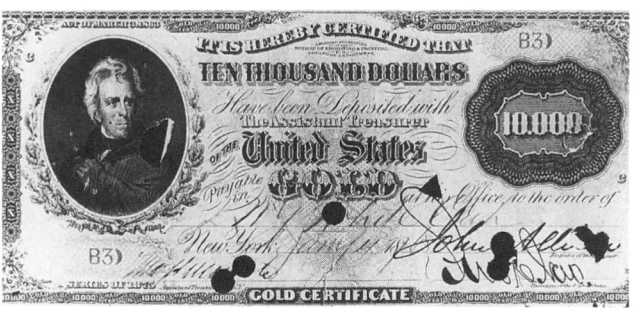

The portrait of Andrew Jackson, on No. 1468, was engraved by Alfred Sealey. This canceled note at the Bureau of the Public Debt is the only example known. No. 1466 probably resembled Nos. 1412 and 1443.

The first issue had this back design, one of the first plates produced at the Bureau of Engraving and Printing.

No.	Issue	Date	Signatures	Payable at	Printed & Issued
1466	First	1863	Colby-Spinner	New York	2,500
1467	Second	1870	Allison-New	New York	20,000
1468	Third	1875	Allison-New	New York	8,933

Remarks: Nos. 1467 and 1468 are uniface. All notes have been redeemed.

Gold Certificates/Series of 1882

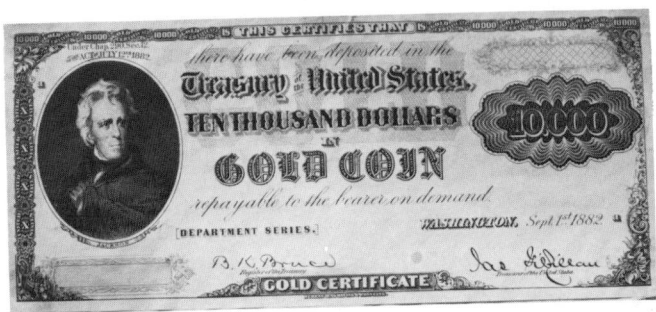

The portrait of Andrew Jackson was engraved by Alfred Sealey.

The *Eagle of the Capitol* was engraved by James Bannister.

No.	Signatures	Seal	Notes Printed
1470	Bruce-Gilfillan	brown	8,000
		Department Series, payable at Washington	
1471	Bruce-Gilfillan	brown	500
1472	Bruce-Wyman	brown	4,000
1473	Rosecrans-Hyatt	lg. red	4,000
1474	Rosecrans-Nebeker	lg. brown	4,000
1475	Lyons-Roberts	sm. red	7,000
1475a	Lyons-Treat*	sm. red	—
1476	Vernon-Treat	sm. red	4,000
1476a	Vernon-McClung	sm. red	4,000
1476b	Napier-Burke	sm. red	4,000
1476c	Parker-Burke	sm. red	12,000
1477	Teehee-Burke	sm. red	108,000

Remarks: The (*) indicates a plate proof at the Bureau of Engraving and Printing; there is no record of issue. No. 1470 has the autographed countersignature of Thomas C. Acton and is payable at New York. A total of eight pieces are outstanding for Nos. 1470–1477; two notes are known for No. 1477.

Gold Certificates/Series of 1888

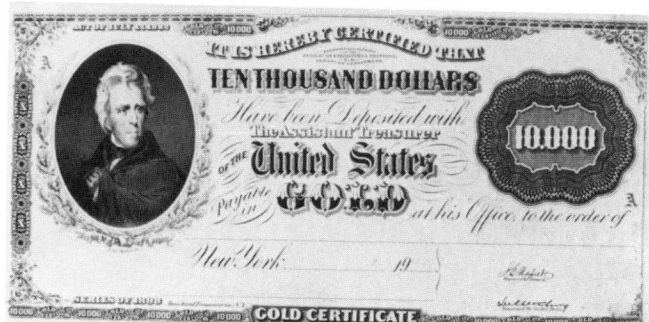

The portrait of Andrew
Jackson was engraved by
Alfred Sealey.

No.	Payable at	Notes Issued	Notes Printed	Outstanding
1478	Baltimore	523		
1479	Chicago	952		
1480	New York	6,592		
1481	Philadelphia	2,665	9,000	0
1482	St. Louis	320		
1483	San Francisco	1,700		
1484	Washington, DC	149		

Remarks: Signatures of Rosecrans-Hyatt appeared on 6,000 notes and Rosecrans-Nebeker on 3,000. These
official figures are from Final Receipts for Notes and Certificates of the Bureau of Engraving and Printing.
Nevertheless, the issued figures supplied by Walter Breen total 13,304. No. 1482 bore the signatures of
Lyons-Roberts; the illustrated proof shows signatures of Napier-McClung. Notes with other signatures may
have been issued.

Gold Certificates/Series of 1900

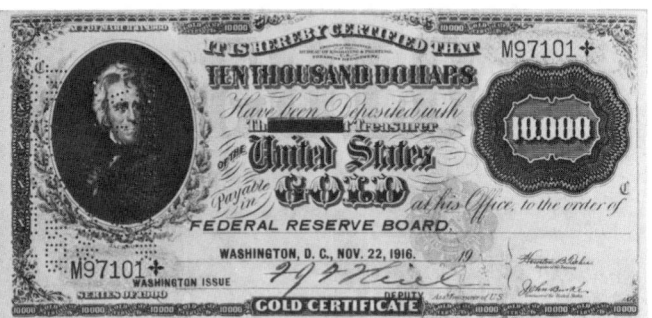

The portrait of Andrew Jackson was engraved by Alfred Sealey. The cancellation on the left reads "Payable to the Treasurer of the U.S. or a Federal Reserve Bank."

No.	Payable to Order In	Notes Issued
1485	Baltimore	17,265
1485a	Boston	9,803
1486	Chicago	9,916
1487	Cincinnati	2,790
1488	New Orleans	986
1489	New York	73,701
1490	Philadelphia	67,397
1491	St. Louis	7,097
1492	San Francisco	12,714
1492a	Washington, DC	75,581

Remarks: A total of 363,000 notes were printed. Notes still outstanding from the above came from the December 13, 1935 fire at the U.S. Post Office at 12th and Pennsylvania Avenue in Washington, DC. In a fruitless attempt to keep the fire from gutting the building, waste paper was thrown out of the windows. This paper included some of these canceled $10,000 notes that were carried by the wind to the hands of surprised passers-by. Even though these canceled notes are not redeemable they are illegal to hold. John Isted has recorded the following number of signature combinations for the above:

Lyons-Roberts	36,000	Napier-McClung	18,000
Lyons-Treat	6,000	Napier-Burke	6,000
Vernon-Treat	36,000	Parker-Burke	30,000
Vernon-McClung	18,000	Teehee-Burke	213,000

Currency Certificates of Deposit/Act of June 8, 1872

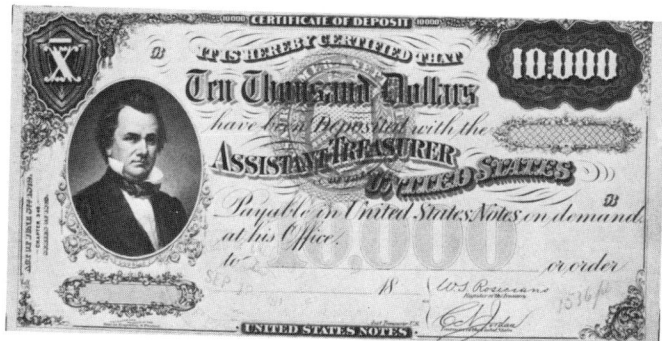

Stephen A. Douglas (1813–1861), son of a cabinet-maker, was elected to Congress at age 21. He was the Democratic nominee for President of the U.S. in 1860. This portrait was engraved by Charles Burt.

No.	Series	Signatures	Seal	Notes Printed
1492b	1872	Allison-Spinner	red	20,000
1492c	1875	Various	red	114,000

Remarks: Two additional three-subject sheets were prepared in 1889, one each for the Chinese and Japanese governments.

Federal Reserve Notes/Series 1918/Green Seal

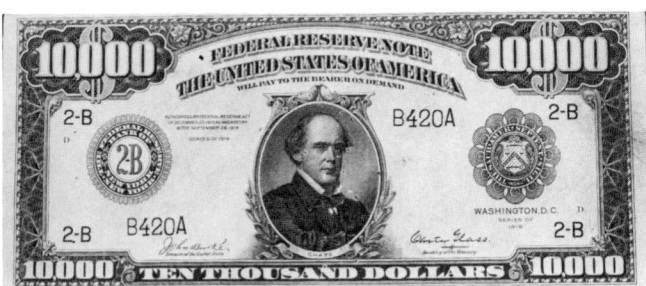

Salmon P. Chase, Secretary of the Treasury (1861–1864).

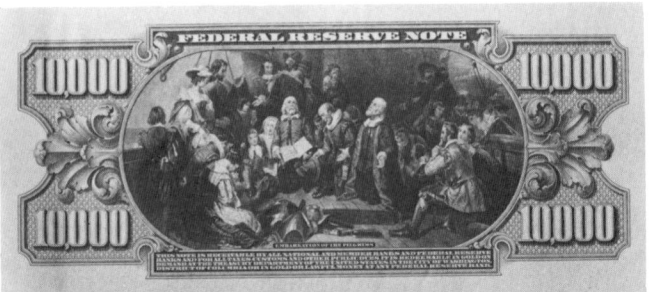

The *Embarkation of the Pilgrims* (see Nos. 953–964).

No.	Bank	Notes Printed	Notes Issued	No.	Bank	Notes Printed	Notes Issued
1493A	Boston	2,000	800	1493G	Chicago	1,200	none
1493B	New York	5,600	1,600	1493H	St. Louis	1,200	400
1493C	Philadelphia	2,400	none	1493I	Minneapolis	none	none
1493D	Cleveland	800	400	1493J	Kansas City	none	none
1493E	Richmond	800	400	1493K	Dallas	1,200	none
1493F	Atlanta	400	none	1493L	San Francisco	2,800	2,000

Remarks: Although ten notes are outstanding, the illustrated note is the only example known outside the Smithsonian Institution, where serial numbers B1A and D1A are located. The number listed as issued for St. Louis could prove incomplete.

Federal Reserve Notes/Series 1928, 1934, 1934A & 1934B/Green Seal

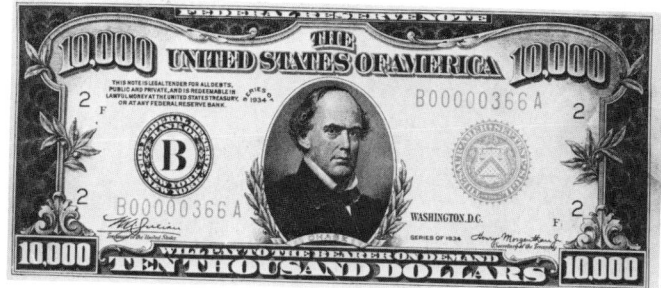

Salmon P. Chase, Secretary
of the Treasury
(1861–1864).

Series 1928, Woods-Mellon

No.	Bank	Notes Printed
1494A	Boston	1,320
1494B	New York	4,680
1494C	Philadelphia	not printed
1494D	Cleveland	960
1494E	Richmond	3,024
1494F	Atlanta	1,440
1494G	Chicago	1,880
1494H	St. Louis	480
1494I	Minneapolis	480
1494J	Kansas City	480
1494K	Dallas	360
1494L	San Francisco	1,824

Series 1934A, Julian-Morgenthau

No.	Bank	Notes Printed
1495aG	Chicago	1,560

Series 1934, Julian-Morgenthau

No.	Bank	Notes Printed
1495A	Boston	8,720
1495B	New York	11,520
1495C	Philadelphia	6,000
1495D	Cleveland	1,480
1495E	Richmond	1,200
1495F	Atlanta	2,400
1495G	Chicago	3,840
1495H	St. Louis	2,040
1495I	Minneapolis	not printed
1495J	Kansas City	1,200
1495K	Dallas	1,200
1495L	San Francisco	3,600

Series 1934B, Julian-Vinson

No.	Bank	Notes Printed
1495bB	New York	24

Gold Certificates/Series of 1928 & 1934

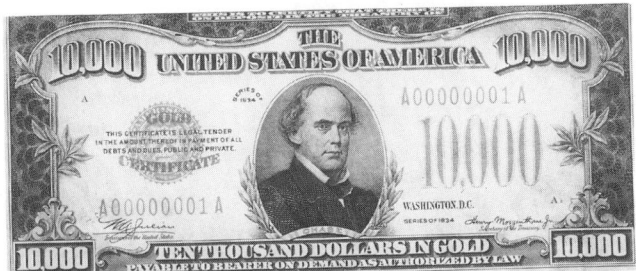

*The face and back
designs are similar to No.
1494 except for the seal
and obligation.*

No.	Series	Signatures	Notes Printed
1496	1928	Woods-Mellon	48,000
1497	1934	Julian-Morgenthau	36,000

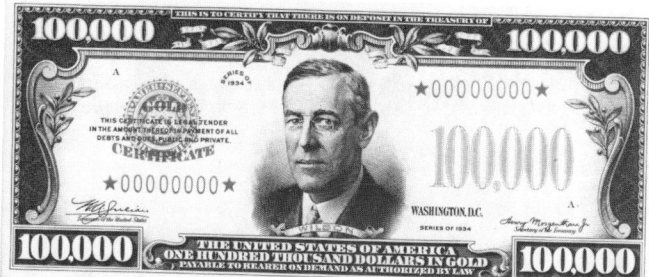

G.F.C. Smillie engraved the portrait of Woodrow Wilson, the twenty-eighth president of the U.S. The remainder of the face and back of this note was engraved by O. Benzing, W.B. Wells and F. Pauling.

No.	Series	Signatures	Notes Issued
1498	1934	Julian-Morgenthau	42,000

Remarks: This is the highest denomination bank note to be printed by the Bureau of Engraving and Printing. It was not meant for general circulation but was to be used in transactions between Federal Reserve Banks.

346

ANA CONVENTIONS
COMING SOON-
TO A CITY NEAR YOU!

1996
DENVER

1993
COLORADO SPRINGS
March 11-13, 1993

1999
CHICAGO

1997
NEW YORK

1998
PORTLAND

1994
DETROIT
July 27-31, 199●
PNG July 26

1993
BALTIMORE
July 28 - Aug. 1, 1993
PNG July 27

1995
ANAHEIM

1992
ORLANDO
Aug. 12 - 16, 1992
PNG Aug. 11

American Numismatic Association Future Convention Dates

For more information contact:
Convention Office, 818 North Cascade Ave., Colorado Springs, CO 80903-3279
Telephone 719/632-2646 • FAX 719/634-4085

At one time a limited number of patterns, essay, and trial pieces were struck before a new coin design was accepted. The recipients were usually government officials who would give an opinion or vote on these proposed designs. These pieces sometimes found their way into the numismatic marketplace. Unissued paper money designs, to the contrary, rarely left the Treasury Department. During the last century, designers and engravers were occasionally permitted to keep a few examples of their work, often in the form of die proofs in various stages of completion. Some of these designs have since found their way into private collections. The syngraphist is left to wonder what the remaining essays and rejected designs looked like.

Just as the final manuscript for the first edition of this catalog was approaching completion, 12 paper money essays were observed at the Bureau of Engraving and Printing; they were illustrated in that edition. After five more years of research, additional essays and information about them were presented in U.S. *Essay Proof and Specimen Notes.* Some of the designs from this book are illustrated on the following pages.

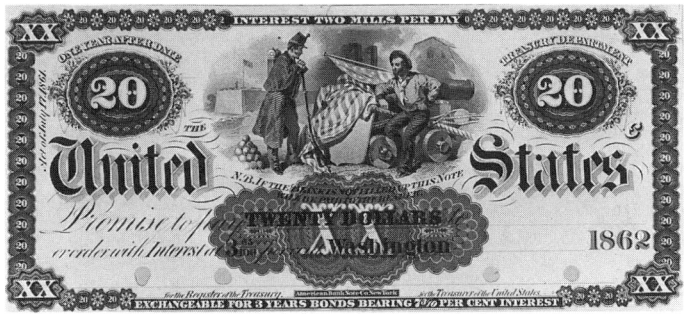

The Acts of July 17 and August 5, 1861 authorized 3.65% interest-bearing treasury notes in denominations of $5, $10 and $20. After ABNCo prepared designs for each, the company was instructed to alter these designs so they could be issued as $1, $2 and $3 United States (legal tender) notes.

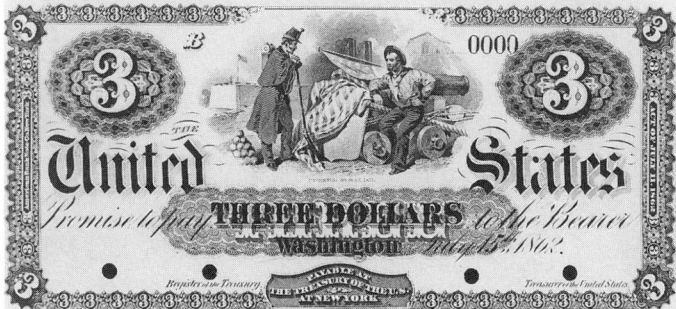

This illustration demonstrates how the engraved plate for the $20 note was altered. Nevertheless, none of these notes were issued. *Army and Navy,* by Henry Herrick, was engraved by Louis Delnoce. This subject was used on at least two state-issued notes: the Mt. Holly Bank, New Jersey $1.50; and the Harrisburg Bank, Pennsylvania $3.

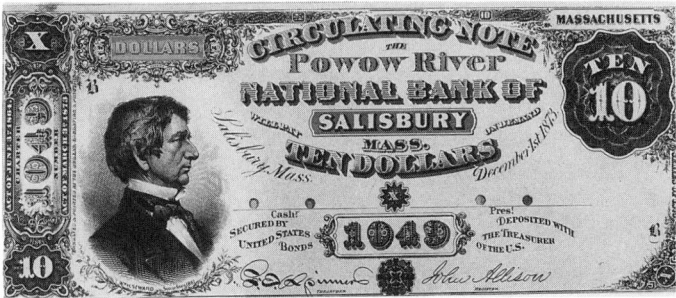

In 1873 there was a plan to issue national circulating notes that would replace worn and mutilated national bank notes. Engraved plates were made for most denominations. There are $10 proof impressions for thirteen different national banks at the Bureau of Engraving and Printing. In 1875 the Secretary of the Treasury announced that new notes would not be issued. Instead, original national bank notes would have the date 1875 added to the original designs. The portrait of William H. Seward was engraved by Charles Schlecht.

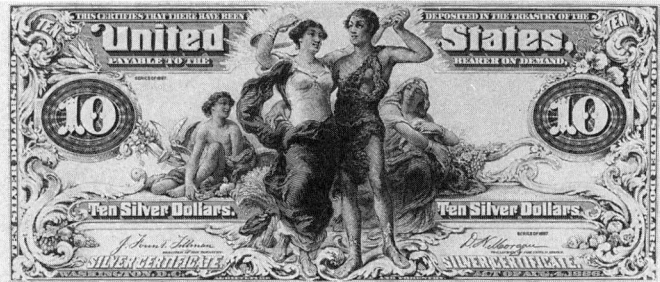

Along with the $1, $2 and $5 1896 silver certificates, a $10 design was to be included. Although these notes continue to be considered exquisite designs, they were not accepted, primarily by bankers. The plates for all four denominations were altered to "simplify" the notes; the altered designs had the date of 1897. Nevertheless, none were issued with the latter date; the $10 note was not issued with either date.

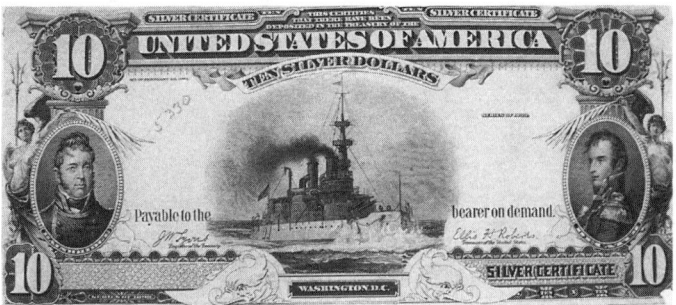

The 1901 $10 note (No. 483) was originally prepared as a silver certificate with this image of the battleship *Massachusetts* engraved by Marcus W. Baldwin. The portraits of William Bainbridge and Stephen Decatur were engraved by G.F.C. Smillie.

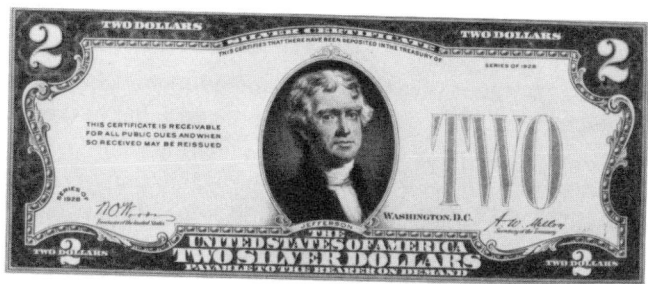

Series of 1928 small-size silver certificates were issued in denominations of $1 and $5 only. However, as this illustration demonstrates, a $2 note was considered. The portrait of Thomas Jefferson was engraved by Charles Burt.

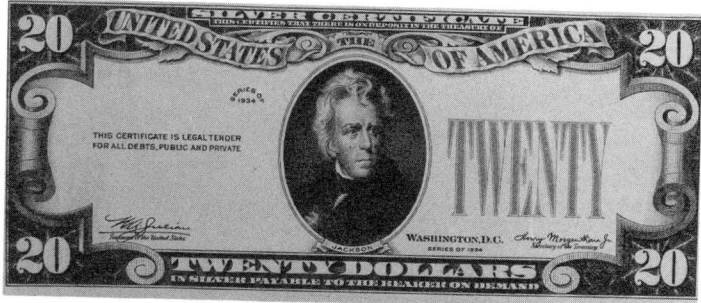

Series of 1934 small-size silver certificates were issued in denominations of $1, $5 and $10 only. This illustration indicates that a $20 note was planned. The portrait of Andrew Jackson was engraved by Alfred Sealey.

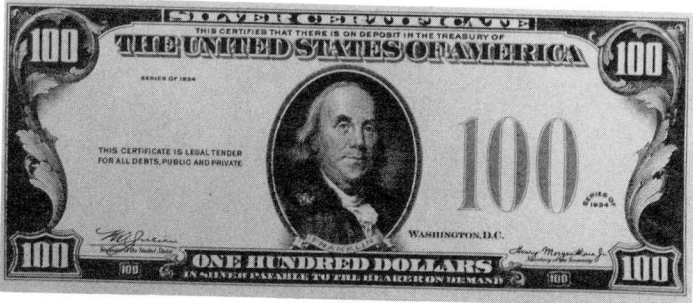

This $100 silver certificate series of 1934 was not issued. The portrait of Benjamin Franklin was engraved by John Eissler.

There is a relationship between the U.S. Postal Service and the Treasury that is not generally known. Until 1829 the U.S. Postal Service was part of the U.S. Treasury. Thirty years later there was a symbolic relationship.

As the Civil War got under way, the value of essential metals began to rise rapidly. The intrinsic value of coinage soon exceeded the face value of the coins. The coins in circulation began to disappear, either into the hoarder's chest or into the melting pot. Commerce was handicapped because ordinary daily transactions were impeded by the lack of small denomination coins. Change for a sale was often taken in merchandise. Merchants were forced to issue tokens and scrip in denominations less than one dollar in value, and these would be redeemed only by the issuing firm. Many state and privately issued bank notes were discounted with the hope of putting some of the coins back into circulation.

On July 17, 1862, at the suggestion of Salmon P. Chase, President Abraham Lincoln signed into law a bill authorizing the acceptance of stamps as currency. Post office supplies of regular stamps were exhausted before special stamps without gum could be prepared.

In a few of the larger northern cities merchants quickly had stationers print small envelopes with the merchant's name and address. These envelopes were meant to hold a specified number of postage stamps. Approximately 100 different types of these collectible envelopes from a possible 500 have been recorded. With the exception of a few pieces from Albany, Brooklyn, Boston Cincinnati, Jersey City and Philadelphia, the majority of recorded envelopes originated in New York City. Everyone did not have access to nor did they take advantage of these containers. Almost immediately the

Treasury Department had a sticky problem on its hands – the redemption of millions of soiled stamps, many of which had adhered to other stamps.

The Treasury Department began to issue small notes with designs that resembled postage stamps, but these had no legal backing because the law of July 17 applied only to genuine postage stamps. This defect in the law was corrected by the Act of March 3, 1863, which clearly stated that the government would issue fractional currency notes. At the request of the federal government, four private bank note companies printed notes for 3, 5, 10, 15, 25 and 50 cents.

There were five issues of fractional currency in these denominations. As the normal metal coinage slowly returned to circulation, Acts of Congress of January 14, 1875 and April 17, 1876 allowed for coin redemption of all these notes.

A total of $368,720,000 in these small notes was issued between 1862 and 1876; $2,000,000 worth are still unredeemed, many of which are in the hands of collectors.

The American Bank Note Company and the National Bank Note Company printed notes for the first and fourth issue while the Columbian Bank Note Company and Joseph R. Carpenter printed the backs of the fifth issue. The Bureau of Engraving and Printing printed the second and third issues, but only the face of the fifth issue.

Issue	Denominations	Periods of Circulation
First*	– 5, 10, – 25 and 50 cents	August 21, 1862–May 27, 1863
Second	– 5, 10, – 25 and 50 cents	October 10, 1863–February 23, 1867
Third	3, 5, 10, – 25 and 50 cents	December 5, 1864–August 16, 1869
Fourth	– – 10, 15, 25 and 50 cents	July 14, 1869–February 16, 1875
Fifth	– – 10, – 25 and 50 cents	February 26, 1874–February 15, 1876

* The first issue is usually referred to as postage currency because of the stamp facsimile designs.

Three-Cent Notes/Third Issue

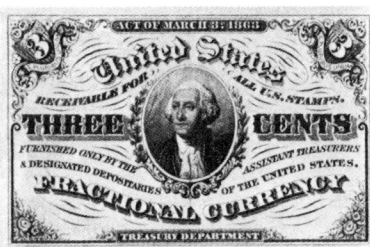

Portrait of George Washington

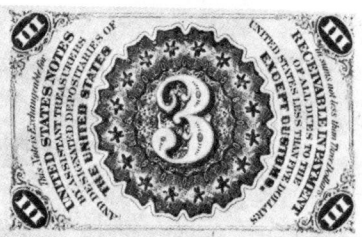

Back

No.	Description	Notes Issued	Fine	EFine	Unc
1500	portrait has light background	20,064,130	$15.	$20.	$50.
1501	portrait has dark background	included in above	15.	25.	85.

Remarks: There were 20,175,000 pieces printed for No. 1500.

Five-Cent Notes/First Issue

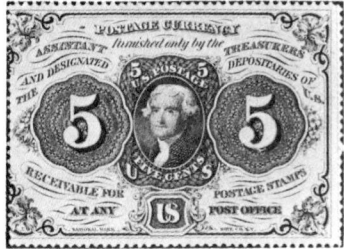

Face: brown. The portrait of Thomas Jefferson is on the 5–cent stamp of 1861 (Scott 75). The design was prepared under the direction of James MacDonough; the lettering is probably the work of William D. Nichols. The portrait was engraved by W. Marshall.

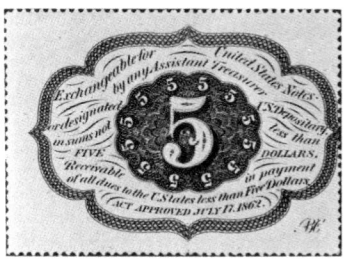

Back: black. The design was prepared under the direction of James P. Major and Nathaniel Jocelyn.

No.	Descriptions		Notes Printed	Fine	EFine	Unc
1502	perforated edges; "ABC" on back.		44,857,780	$15.	$30.	$110.
1503	perforated edges; without "ABC"	⎤	–	15.	35.	150.
1504	straight edges; "ABC" on back		included in above	12.	20.	50.
1505	straight edges; without "ABC"	⎦	–	15.	35.	150.

Remarks: Lot 406 of the Julian S. Marks collection, sold in 1971, was a canceled cover with No. 1504 used as postage. "ABC" stands for American Bank Note Co.

Five-Cent Notes/Second Issue

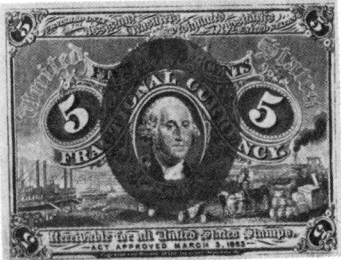

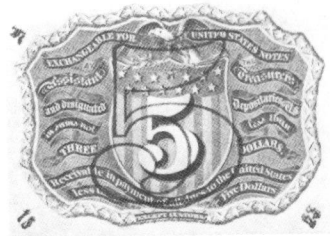

Face: brown. The portrait of George Washington, within the bronze oval, was engraved by J.P. Ourdan; the background was engraved by James Duthie.

Back: brown. George W. Casilear is the designer. The large "5" is bronze.

No.	Description	Notes Printed	Fine	EFine	Unc
1506	without surcharge on back	55,250,097	$10.	$15.	$40.
1507	surcharge "18 63" on back		10.	15.	50.
1508	surcharge "S" and "18 63"		12.	20.	70.
1509	surcharge "R 1" and "18 63"	296,425	30.	75.	200.

Five-Cent Notes/Third Issue

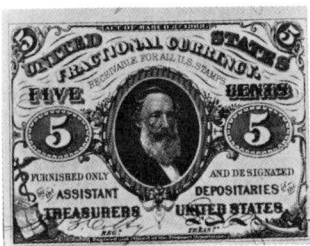

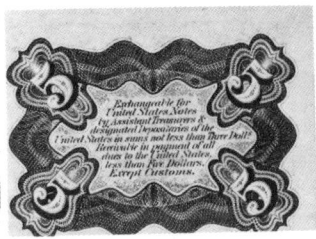

Placement of letter "a."

Face: black. Spencer M. Clark was Superintendent of the National Currency Bureau under Abraham Lincoln. Clark was responsible for designing the U.S. Treasury seal, a variation of which is still used. When this note appeared, Congress immediately moved to ban the portrait of a living person on bank notes and other obligations (Act of April 7, 1866, Chap. XXVIII, Sec. 1, and Act of March 3, 1873, Chap. CCLXVIII, Sec. 3576).

No.	Description	Notes Issued	Fine	EFine	Unc
1510	green back	13,400,000	$12.	$20.	$100.
1511	"a" on face, green back		15.	25.	125.
1512	red back		15.	30.	125.
1513	"a" on face, red back		20.	35.	150.

Ten-Cent Notes/First Issue

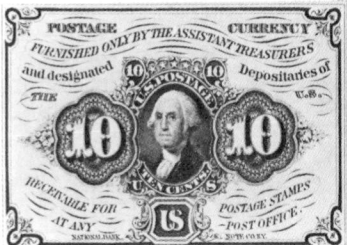

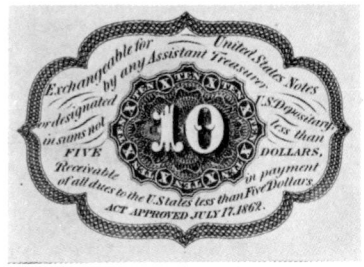

Face: green. The portrait of George
Washington, as seen on the 10–cent
stamp of 1861 (Scott 68) was engraved
by W. Marshall; it was based on the
painting by Gilbert Stuart.

Back: black. The design was prepared
under the direction of James P. Major
and Nathaniel Jocelyn.

No.	Description	Notes Printed	Fine	EFine	Unc
1514	perforated edges; "ABC" on back		$15.	$35.	$115.
1515	perforated edges; without "ABC"	41,153,780	15.	40.	150.
1516	plain edges; "ABC" on back		10.	25.	55.
1517	plain edges; without "ABC"		20.	40.	175.

Remarks: The monogram "ABC" stands for American Bank Note Co.

Ten-Cent Notes/Second Issue

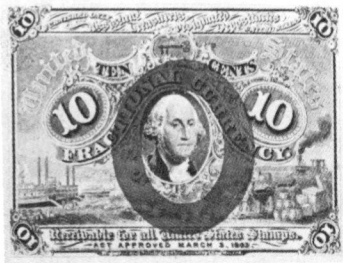

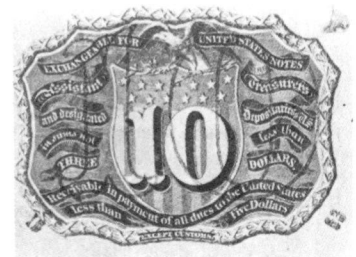

Face: slate-gray. The portrait of George
Washington, within the bronze oval,
was engraved by J.P. Ourdan; the back-
ground was engraved by James Duthie.

Back: green.

No.	Descriptions	Notes Issued	Fine	EFine	Unc
1518	no surcharge on back		$ 10.	$ 20.	$ 60.
1519	surcharge "18 63" on back		10.	20.	65.
1520	surcharge "S" and "18 63" on back	61,803,393	12.	25.	75.
1521	surcharge "1" and "18 63" on back		12.	25.	75.
1522	surcharge "0" and "63" on back		350.	800.	1850.
1523	surcharge "T1" and "18 63" on back	427,450	15.	35.	200.

Ten-Cent Notes/Third Issue

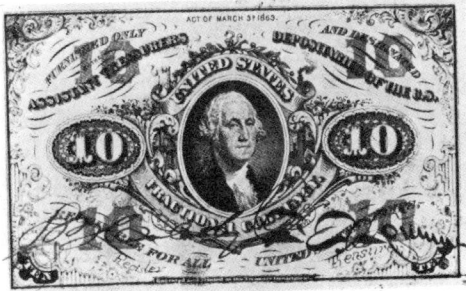

Face: black. Portrait of George Washington

Placement of "1".

Back: green or red

No.	Description	Notes Issued	Fine	EFine	Unc
1524	printed signatures of Colby-Spinner; green back		$10.	$20.	$ 50.
1525	as above with "1" near left margin on face		12.	25.	70.
1526	printed signatures of Colby-Spinner; red back		15.	35.	100.
1527	as above with "1" near left margin on face	169,761,345	20.	40.	125.
1528	autographed signatures of Colby-Spinner; red back		25.	50.	150.
1528a	autographed signatures of Colby-Spinner; green back		----- 2 known -----		
1529	autographed signatures of Jeffries-Spinner; red back		35.	75.	225.

Remarks: Although "cents" did not appear on these notes, they circulated, as intended, as 10–cent pieces. Of the 169,761,345 pieces issued, 18,000 have red backs.

Ten-Cent Notes/Fourth Issue

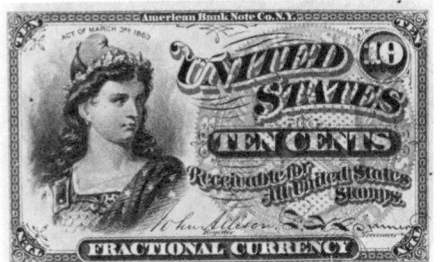

Face: black. The model for the bust of *Liberty* is said to have been Mary Hull. It was designed by Charles Burt and engraved by Frederick Girsch.

Back: green. The printer was the National Bank Note Co.

No.	Description	Seal	Notes Issued	Fine	EFine	Unc
1530	watermarked paper	lg. red		$10.	$15.	$55.
1531	pink fibers in paper	lg. red		10.	20.	60.
1532	pink fibers/blue ends	lg. red	179,097,600	10.	15.	40.
1533	previous listing inaccurate			–	–	–
1534	pink fibers/blue ends	sm. red		10.	25.	60.

Remarks: The large seal is 40 mm in diameter; the small seal is 38 mm.

Ten-Cent Notes/Fifth Issue

Face: black. The portrait of William Meredith, Secretary of the Treasury (1849–1850) is by Thomas Knollwood; it was engraved by Charles Burt.

Back: green. The printer was the Columbian Bank Note Co.

No.	Description	Notes Issued	Fine	EFine	Unc
1535	long thin key in green seal ⎤		$10.	$15.	$50.
1536	long thin key in red seal ⎟	199,899,000	8.	12.	20.
1537	short thick key in red seal ⎦		8.	12.	20.

Fifteen-Cent Notes/Fourth Issue

Face: black. The bust of *Columbia* is by designer C. Romerson; it was engraved by Charles Burt. The National Bank Note Co. prepared the plates.

Back: green. American Bank Note Co. prepared the plates. The letter engraving on both the face and back is by W.D. Nichols.

No.	Description	Seal	Notes Issued	Fine	EFine	Unc
1539	watermarked paper; pink fibers	lg. red ⎤		$20.	$30.	$100.
1540	plain paper; pink fibers	lg. red ⎟	27,240,040	20.	35.	115.
1541	violet fibers; blue ends	lg. red ⎦		25.	40.	165.
1542	as above	sm. red	8,121,400	25.	35.	150.

Twenty-Five Cent Notes/First Issue

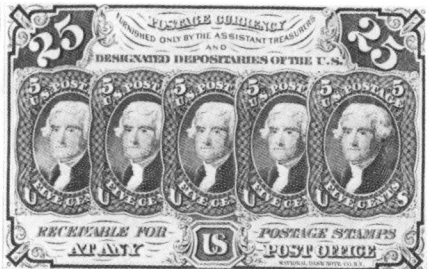

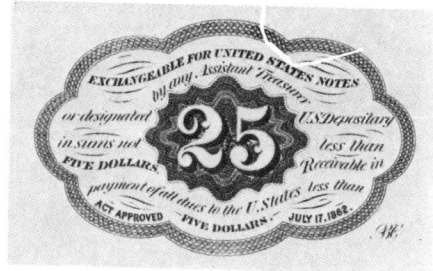

Face: brown. The portrait of Thomas Jefferson was engraved by W. Marshall.

Back: black. The monogram "ABC" stands for American Bank Note Co.

No.	Description	Notes Issued	Fine	EFine	Unc
1548	perforated edges; "ABC" on back		$20.	$40.	$165.
1549	perforated edges; without "ABC"	20,902,768	20.	45.	225.
1550	plain edges; "ABC" on back		10.	15.	75.
1551	plain edges; without "ABC"		25.	60.	300.

Twenty-Five Cent Notes/Second Issue

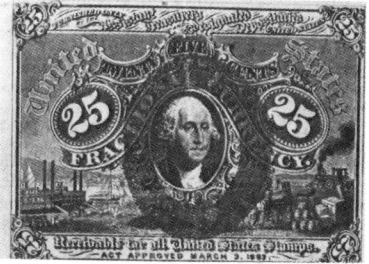

Face: slate-gray. The portrait of George Washington in the bronze oval was engraved by J.P. Ourdan; the background is by James Duthie. George W. Casilear is the designer.

Back: purple.

No.	Description	Notes Issued	Fine	EFine	Unc
1552	value only on back		$15.	$30.	$100.
1552a	surcharge "18 63" on back		20.	40.	150.
1553	surcharge "A" and "18 63" on back	29,299,585	15.	30.	100.
1554	surcharge "2" and "63" on back		20.	30.	100.
1555	surcharge "S" and "18 63" on back		20.	30.	100.
1556	surcharge "T-1" and "18 63" on back; fiber paper		30.	60.	150.
1557	surcharge "T-2" and "18 63", fiber paper	1,173,780	30.	60.	150.
1558	previous listing inaccurate		–	–	–

Twenty-Five-Cent/Third Issue

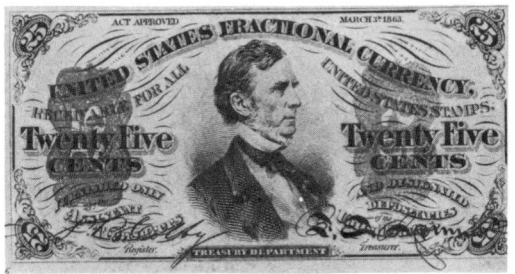

Face: black. Charles Skinner engraved the portrait of William P. Fessenden, Secretary of the Treasury in 1864.

Back: Nos. 1559–1560a red; Nos. 1561–1567 green.

Normal position of "a".

Large "a" on No. 1567.

No.	Description	Notes Issued	Fine	EFine	Unc
1559	red back		$ 75.	$125.	$ 200.
1560	"a" lower left; minor	16,000			
	variations in size of "a"		90.	150.	275.
1561	solid bronze on fiber				
	paper; "M 2 6 5" surcharge		300.	600.	1500.
1562	as above; small "a"		500.	900.	3000.
1563	outline bronze on fiber				
	paper; "M 2 6 5" surcharge	124,566,755	60.	100.	200.
1564	as above with "a"		75.	150.	300.
1565	outline bronze; no surcharge		20.	40.	100.
1566	as above; size of "a" varies		25.	50.	125.
1567	as above; large "a"		500.	800.	1600.

Remarks: The 7,107 notes issued on March 22, 1865 probably account for No. 1564. This issue violated the ban against portraits of living persons on U.S. currency (see Nos. 1510–1513).

Twenty-Five-Cent Notes/Fourth Issue

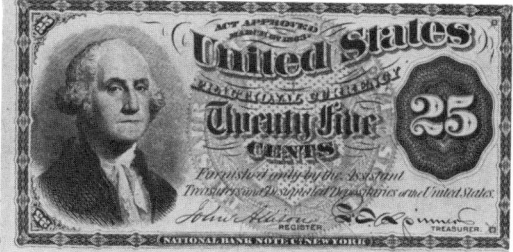

Face: black. Printed by the National Bank
Note Co., the face was designed by Douglas
C. Romerson and engraved by Frederick
Girsch.

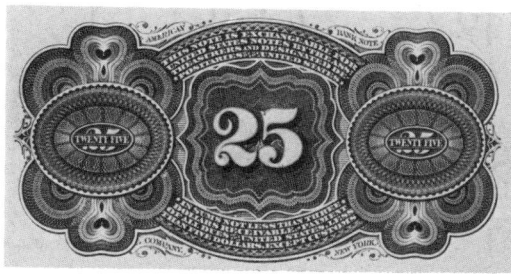

Back: green. Printed by American Bank
Note Co.

No.	Description	Seal	Notes Issued	Fine	EFine	Unc
1568	watermarked paper	lg. red		$15.	$25.	$100.
1569	plain white paper	lg. red		15.	25.	100.
1570	pink fibers, blue ends in paper	lg. red	235,689,024	15.	25.	100.
1571	violet fibers, blue ends	sm. red		20.	40.	125.
1572	as above	lg. brn		20.	40.	125.

Remarks: The large seal is 40 mm in diameter, the small is 39 mm. For No. 1571 32,516,256 were issued.

Twenty-Five-Cent Notes/Fifth Issue

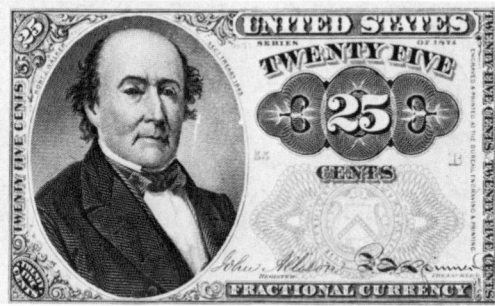

Face: black. The portrait of Robert Walker, Secretary of the Treasury (1845–1849), was engraved by Charles Burt.

Back: green. Printed by the Columbian Bank Note Co.

No.	Description	Notes Issued	Fine	EFine	Unc
1573	long thin key in red seal	144,368,000	$15.	$20.	$60.
1574	short thick key in red seal	included in above	15.	20.	60.

Remarks: The ink from the red seal occasionally bled through giving the face a pink color.

Fifty-Cent Notes/First Issue

Face: green. The portrait of George Washington as it appears on the ten-cent stamp, Scott A27.

Back: black. Printed by American Bank Note Co.

No.	Description	Notes Issued	Fine	EFine	Unc
1575	12 perforations per 20 mm; "ABC" on back		$35.	$ 60.	$125.
1575a	14 perforations per 20 mm; "ABC" on back	17,263,344		12–15 known	
1576	perforated; without "ABC"		75.	125.	400.
1577	plain edges; "ABC" on back		25.	50.	200.
1578	plain edges; without "ABC" on back		75.	125.	350.

Fifty-Cent Notes/Second Issue

Face: slate-gray. The portrait of George Washington, within the bronze oval, was engraved by J.P. Ourdan; the background was engraved by James Duthie.

Back: red.

No.	Description	Notes Issued	Fine	EFine	Unc
1579	no surcharge on back		no authentic examples known		
1580	surcharge "18 63" on back	11,844,464	$50.	$ 75.	$175.
1581	"A" and "18 63" on back		35.	60.	150.
1582	"1" and "18 63" on back		50.	100.	350.
1583	"0–1" & "18 63" on back; fiber paper		60.	125.	200.
1584	"R-2" & "18 63" on back; fiber paper	1,246,000	75.	150.	300.
1585	"T-1" & "18 63" on back; fiber paper		50.	100.	175.

Fifty-Cent Notes/Third Issue

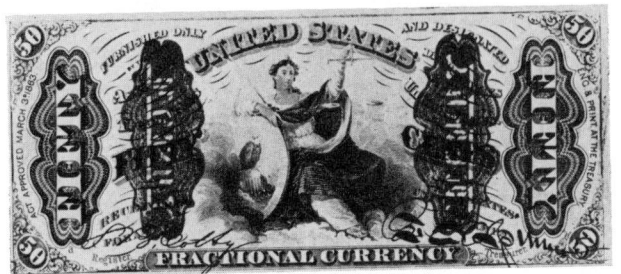

Face: black. The vignette is entitled *Justice with Scales*. See Nos. 1609–1619a for back design. Nos. 1586 through 1596 have red backs; the surcharge is "A-2–6–5."

No.	Description	Fine	EFine	Unc
1586	no design figure on face; no surcharge	$ 30.	$ 75.	$ 225.
1586a	as above with surcharge	30.	75.	225.
1587	"1" and "a" on face; no surcharge	125.	275.	700.
1587a	as above with surcharge	125.	275.	700.
1588	"1" only on face; no surcharge	40.	80.	275.
1588a	as above with surcharge	40.	80.	275.
1589	"a" only on face; no surcharge	50.	90.	325.
1589a	as above with surcharge	50.	90.	325.
	The following have autographed signatures of Colby-Spinner and red backs.			
1590	no design features on face; no surcharge	−	−	150.
1591	with surcharge	−	−	175.
1592	with surcharge "S-2–6–4", fiber paper	−	250.	450.
	The following have printed signatures on fiber paper and a "S-2–6–4" surcharge.			
1593	no design figures on face	− − − − −	8 known	− − − − −
1594	"1" and "a" on face	− − − − −	2 known	− − − − −
1595	"1" only on face, 5 known	−	−	−
1596	"a" only on face, 6 known, none better than EFine	−	3200.	−
	The following have green backs with no surcharge.			
1597	no design figures on face	25.	60.	125.
1598	"1" and "a" on face	75.	175.	750.
1599	"1" only on face	50.	125.	150.
1600	"a" only on face	50.	125.	150.
	The following have wide or narrow "A-2–6–5" surcharges.			
1601	no design figures on face; narrow surcharge	−	−	125.
1601a	no design figures on face; wide surcharge	−	−	175.
1602	"1" and "a" on face; narrow surcharge	−	−	275.
1602a	as preceding; wide surcharge	−	−	1000.
1603	"1" only on face; narrow surcharge	−	−	150.
1603a	as preceding; wide surcharge	−	−	250.
1604	"a" only on face; narrow surcharge	−	−	175.
1604a	as preceding; wide surcharge	−	−	300.
	The following, with green backs, have a "A-2-6–5" surcharge on fiber paper.			
1605	no design figures on face	50.	75.	225.
1606	"1" and "a" on face	200.	350.	1000.
1607	"1" only on face	100.	150.	300.
1608	"a" only on face	100.	175.	300.
1608a	surcharge "S-2–6–4"	− − − − −	8 known	− − − − −

Fifty-Cent Notes/Third Issue

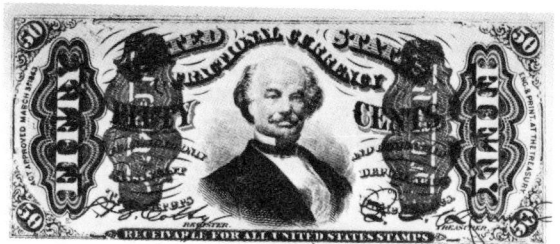

Face: black. F.E. Spinner,
U.S. Treasurer (1861–1875).
This issue appeared during
the lifetime of F.E. Spinner
(see Nos. 1510–1513).

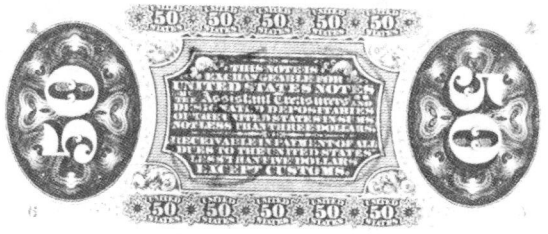

Back: green or red.

Position of "a" and "1" on face.

No.	Description	Fine	EFine	Unc
	Red backs; "A-2-6-5" surcharge			
1609	no design figures on face	$ 30.	$ 50.	$ 125.
1610	"1" and "a" on face	75.	150.	450.
1611	"1" only on face	35.	55.	175.
1612	"a" only on face	40.	65.	200.
1613	autographed signatures of Colby-Spinner	40.	80.	150.
1614	autographed signatures of Allison-Spinner	75.	120.	250.
1615	autographed signatures of Allison-New	600.	1200.	2250.
	Green backs; "A-2-6-5" surcharge			
1616	no design figures on face; no surcharge	25.	40.	100.
1616a	as preceding with surcharge	40.	80.	150.
1617	"1" and "a" on face; no surcharge	50.	100.	275.
1617a	as preceding with surcharge	150.	350.	900.
1618	"1" only on face; no surcharge	30.	50.	125.
1618a	as preceding with surcharge	60.	100.	250.
1619	"a" only on face; no surcharge	35.	70.	150.
1619a	as preceding with surcharge	65.	110.	325.

Remarks: One sheet of No. 1615 remained unsigned during the term of F.E. Spinner, and was signed by John Allison in 1869 or later; in 1875 or 1876 John C. New added his signature. (Walter Breen, "New look at old notes," *Numismatic News*, August 15, 1971, p. 28.) Based on reconstructed figures, 52,866,690 notes were issued for Nos. 1609–1619a; this figure is part of the third issue total of 73,471,853.

Fifty-Cent Notes/Third Issue

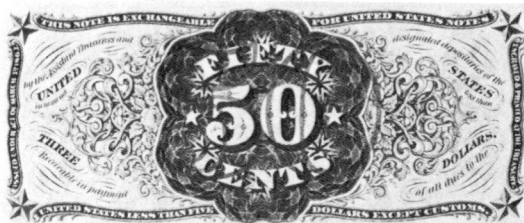

Back: green. The face design is similar to No. 1619.

No.	Description	Notes Issued	Fine	EFine	Unc
1620	no design figure on face		$ 30.	$ 65.	$ 175.
1621	"1" and "a" on face	10,868,028	65.	150.	500.
1622	"1" only on face		35.	70.	225.
1623	"a" only on face		40.	75.	250.

Remarks. The reconstructed figure above is part of the third issue total of 73,471,853.

Fifty-Cent Notes/Fourth Issue

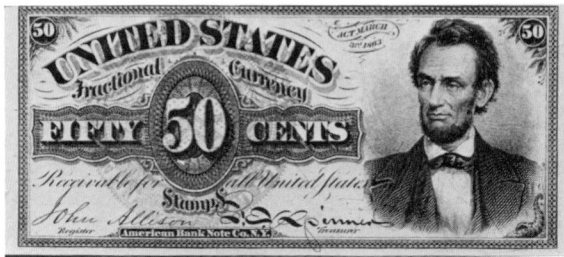

Face: black. The portrait of Abraham Lincoln, based on a photograph by Anthony Berger, was engraved by Charles Burt; it was printed by American Bank Note Co.

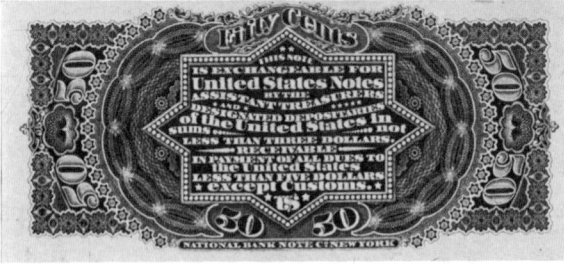

The green back was printed by the National Bank Note Co.

No.	Description	Seal	VFine	EFine	Unc
1624	watermarked paper; pink fibers	lg. red	$50.	$ 100.	$ 300.
1625	previously listing inaccurate				

Fifty-Cent Notes/Fourth Issue

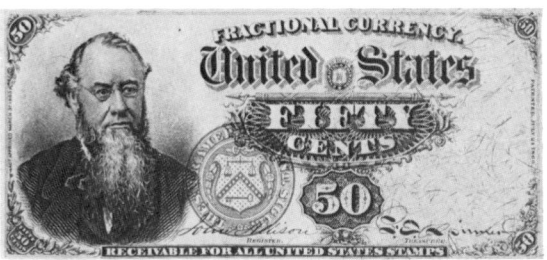

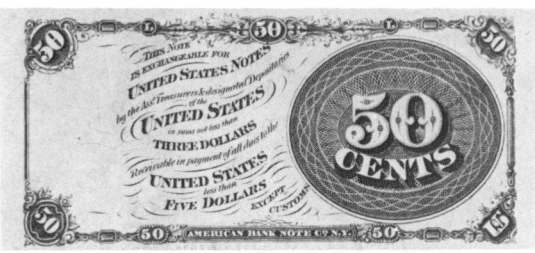

Face: black. George W. Casilear is the probable designer of this note, which bears a bust of E.M. Stanton, Lincoln's Secretary of War. Charles Burt received $600 for this engraved portrait. This note was issued in January 1870; Stanton died on Dec. 24, 1869. Apparently the note was in production while Stanton was alive. See Nos. 1510–1513 for the restriction of images of living people on U.S. currency.

The green back was printed by American Bank Note Co.

No.	Description	Seal	Notes Issued	VFine	EFine	Unc
1626	violet fibers with blue ends	sm. red	86,048,000	$ 25.	$40.	$ 125.
1627	violet fibers with blue ends	sm. brn	incl. in above	25.	40.	125.

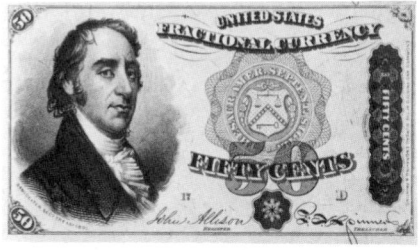

Face: black. George W. Casilear is the probable designer of this note, which bears a bust of Samuel Dexter, Secretary of War and the Treasury (1800–1802). Charles Burt engraved this portrait.

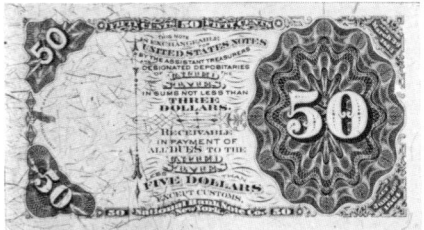

The green back was printed by the National Bank Note Co.

No.	Description	Seal	Notes Issued	VFine	EFine	Unc
1628	violet fibers, blue ends,	green	49,599,200	$20.	$35.	$100.

Fifty-Cent Notes/Fifth Issue/Red Seal

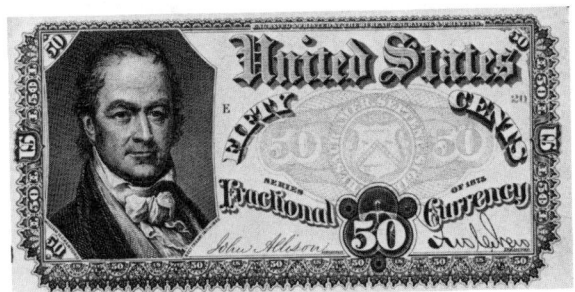

Face: black. The bust of William H. Crawford, originally painted by John W. Jarvis, was engraved by Charles Burt.

The green back was printed by Joseph R. Carpenter.

No.	Description	Notes Issued	VFine	EFine	Unc
1629	pink paper, pink fibers	13,160,000	$ 20.	$30.	$90.
1630	white paper, violet fibers, blue ends	incl. in above	20.	30.	90.

President Andrew Johnson selected members of the cabinet and certain legislators as the recipients of the first proof and specimen notes. Soon thereafter similar uniface notes, printed with both wide and narrow margins, were sold to the public. Some specimen notes were also used to make up fractional currency shields. By soaking, some of these notes were later removed by collectors.

Most specimen and proof notes were printed from adopted designs. Only wide margin examples and types not adopted will be illustrated here. The numbering system is the same as for regular issues with the addition of an "S".

On April 27, 1862 Union vessels seized the *Bermuda*, a ship returning from England with a cargo destined for the Confederate coast. Part of the cargo included bank note paper prepared for the Confederate States of America. This paper watermarked "CSA" was later purchased by the United States Treasury Department and used for proof and specimen fractional currency. Three separate purchases were made; the average price was about $2 per ream. The third purchase included 35 reams of foolscap at $6 per ream.

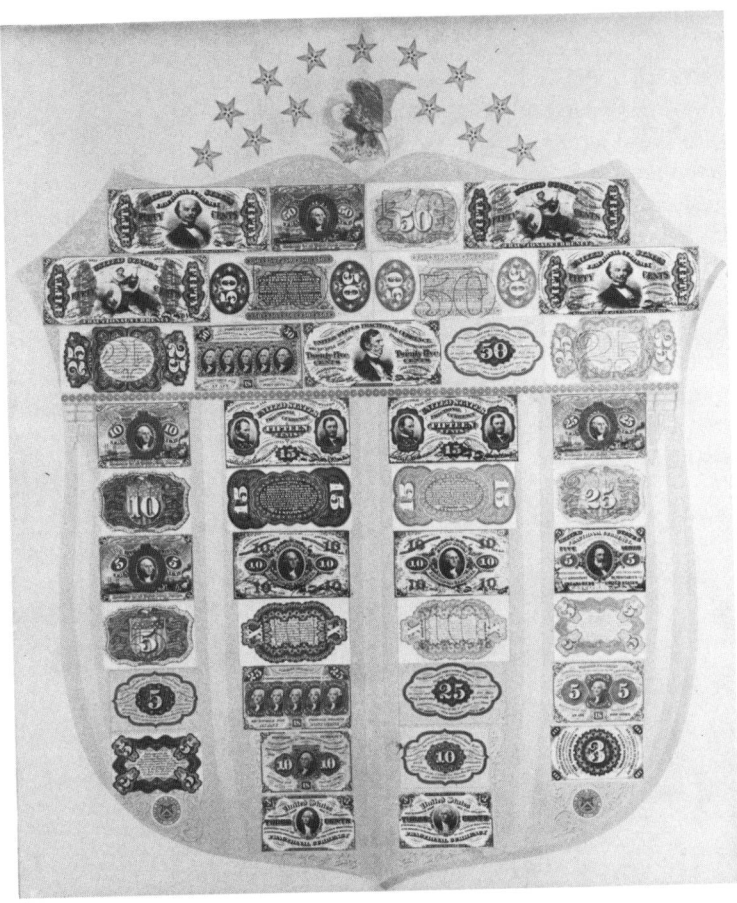

The dimensions of the shield are 20×25 inches.

Fractional currency shields, as illustrated here, were prepared before the release of the fourth and fifth issues. Each shield consisted of 39 uniface specimen notes. Banks and merchants could purchase a shield for $4.50 for the purpose of comparison if a note was thought to be counterfeit. The demand for the shields did not meet the expectations of the Treasury Department. In 1869 the remaining shields were dismantled; the uniface specimen notes were sold to collectors. Some shields were probably destroyed.

No.	Description	Degree of Rarity
1633	shield with grey background	rare
1634	shield with pink background	very rare
1635	shield with green background	extremely rare

Three-Cent Notes

No.	Description	Pieces Issued	Narrow Margin	Wide Margin
1500S	Face, portrait has light background	7,000	$150.	2 known
	Back	7,000	25.	$150.
1501S	Face, portrait has dark background	7,000	40.	200.
	Back	7,000	25.	150.

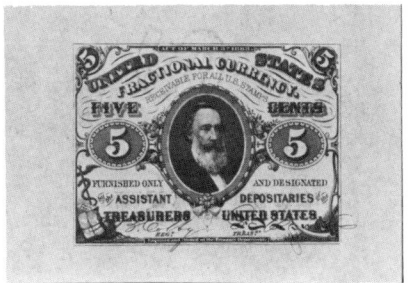 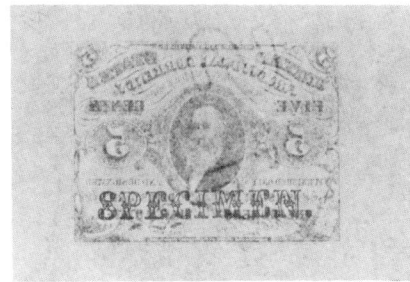

Proof and Specimen Five Cent Notes

No.	Description	Pieces Issued	Narrow Margin	Wide Margin
1505S	Face with plain edges	5,445	$25.	$150.
	Back	5,445	25.	150.
1506S	Face	3,058	25.	100.
	Back; no surcharge	3,058	25.	100.
1510S	Face	10,500	25.	125.
	Back	10,500	25.	100.
1512S	Face	10,500	25.	125.
	Back; red	10,500	25.	100.

Remarks: The figures for No. 1506 are probably for wide margin pairs issued as of October 31, 1867; additional pairs could have been issued later.

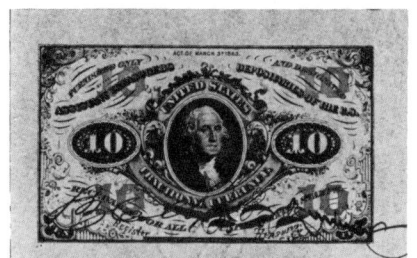

Ten-Cent Notes

No.	Description	Pieces Issued	Narrow Margin	Wide Margin
1517S	Face with plain edges	33,780	$25.	$150.
	Back	incl in above	25.	150.
1518S	Face	–	25.	125.
	Back; no surcharges	–	25.	125.
1524S	Back; green	⎫	25.	100.
1526S	Face; printed signatures of Colby-Spinner	⎪ 54,250	35.	150.
1528S	Face; written signatures of Colby-Spinner	⎪	30.	125.
	Back; red	⎭	25.	100.
1529S	Face; written signatures of Jeffries-Spinner	–	50.	ex. rare
	Back; red	10,000	25.	100.

Fifteen Cent Notes

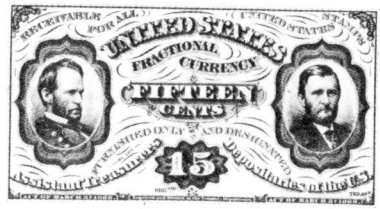

Portraits of Gen. W.T. Sherman and U.S. Grant.

No.	Description	Pieces Issued	Narrow Margin	Wide Margin
1543S	Face; printed signatures of Colby-Spinner		$75.	$175.
	Back; green		60.	125.
1544S	Face; written signatures of Colby Spinner		600.	unknown
	Back; red		60.	125.
1545S	Face; written signatures of Jeffries-Spinner		150.	400.
	Back; red	9,016	60.	125.
1546S	Face; written signatures of Allison-Spinner		175.	450.
	Back; red		60.	125.
1547S	Face without signatures		2 known	unknown
	Back; red	10,000	60.	125.

Remarks: Of the 9,016 pieces issued for No. 1543S, 3,513 were outstanding in 1884.

Twenty-five Cent Notes

No.	Description	Pieces Issued	Narrow Margin	Wide Margin
1551S	Face with plain edges	15,672	$30.	$175.
	Back without "ABC"	included in above	30.	175.
1552S	Face	–	30.	150.
	Back; no surcharges	–	30.	150.
1559S	Face	8,600	40.	175.
	Back; red, no surcharges	8,600	30.	150.
1563S	Face	8,600	40.	175.
1565S	Back; green	8,600	40.	150.

Fifty-Cent Notes

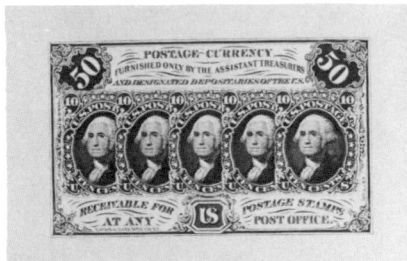

No.	Description	Pieces Issued	Narrow Margin	Wide Margin
1578S	Face with plain edges	10,872	$30.	$200.
	Back	10,872	30.	200.
1579S	Face	6,385	40.	175.
	Back without "ABC" or surcharges	6,365	40.	175.

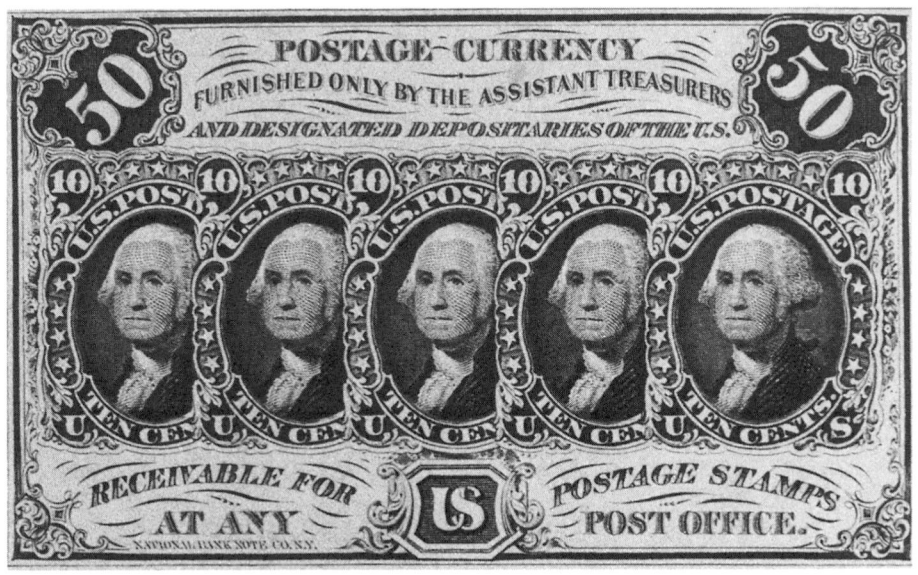

Enlargement of face portion

Fifty-Cent Notes

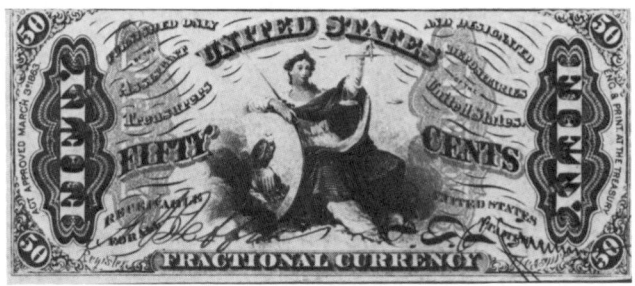

No.	Description	Narrow Margin	Wide Margin
1586S	Face; printed signatures of Colby-Spinner	$ 50.	$ 150.
	Back	40.	125.
1590S	Face; written signatures of Colby-Spinner	60.	150.
	Back; no surcharges	40.	125.
1592S	Face; written signatures of Jeffries-Spinner	150.	rare
	Back; no surcharges	40.	125.
1593S	Back; green, no surcharges	1000.	7500.

Remarks: No. 1592 is known only as a specimen.

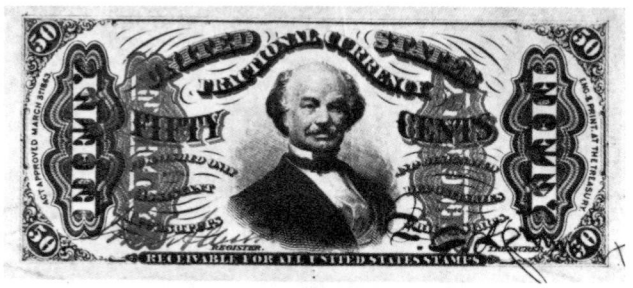

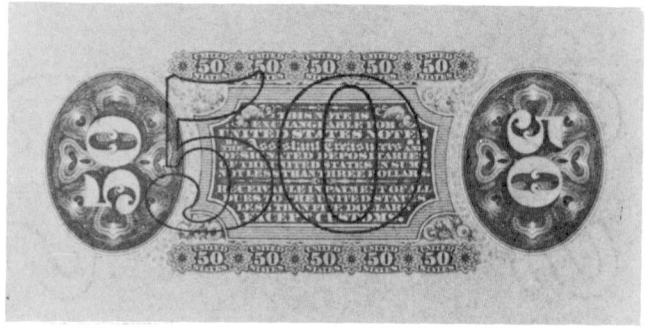

Fifty-Cent Notes

No.	Description	Narrow Margin	Wide Margin
1609S	Face; printed signatures of Colby-Spinner	$ 50.	$ 150.
1613S	Face; written signatures of Colby-Spinner	60.	200.
1614S	Face; written signatures of Allison-Spinner	7,000.	10,000.
1615S	Face; written signatures of Jeffries-Spinner	150.	rare
	Back; red, no surcharges	40.	125.
1616S	Back; green, no surcharges	40.	125.
1620S	Back; green, no surcharges	40.	125.

Remarks: No. 1615 is known in specimen form only. This note bears the Jeffries-Spinner signatures, not Allison-New. A total of 50,584 notes were printed for Nos. 1586S through 1620S. Specimens of these issues were printed but not sold to the public. A few were presented to VIPs; all examples are rare.

Inverted Printing

Second issue.

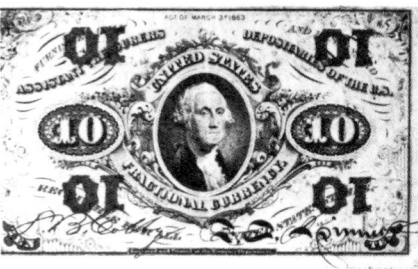

Third issue.

There are many examples of printing irregularities throughout the issuing period of fractional currency. The most common is an inverted printing. These range from the inversion of the entire back to pieces that have only a portion of the surcharge inverted. Advanced fractional currency collectors have demonstrated a substantial interest in these error printings. Inversions that have been observed by or reported are summarized here.

INVERTED BACK

No.	Entire Back	Surcharge	Engraving	Other
1500	observed	–	–	
1501	observed	–	–	
1502	reported	–	–	
1503	observed	–	–	without vertical perforations
1504	observed	–	–	
1505	observed	–	–	
1506	reported	observed	reported	with back of No. 1580, reported
1506	–	–	–	with back of No. 1583, observed
1507	reported	observed	–	
1510	observed	–	–	
1511	observed	–	–	
1515	observed	–	–	
1516	observed	–	–	
1517	observed	–	–	
1518	observed	–	–	
1519	–	observed	–	
1520	–	reported	observed	
1521	–	observed	–	
1523	–	reported	–	
1524	–	reported	–	face & back surcharge inverted. observed; face design inverted reported.
1524S	–	–	–	back has denom surcharge inverted observed.
1525	–	–	–	face & back surcharge inverted. observed without vertical perforations
1549	reported	–	–	
1550	observed	–	–	
1551	reported	–	–	
1552	–	observed	–	back with surcharge of No. 1552 and engraved design of No. 1579 observed
1552a	reported	–		
1554a	–	reported	–	
1555	–	reported	reported	"S" of back surcharge. inverted. observed
1556	–	reported	–	
1557	–	reported	–	
1559	–	–	reported	
1565	–	–	–	
1566	reported	observed	reported	
1567	–	–	observed	
1575	reported	–	–	
1576	observed	–	–	
1577	observed	–	–	
1578	reported	–	–	
1579S	–	–	–	back has denom. surcharge inverted to the engraving, observed
1580	reported	–	reported	
1581	–	observed	reported	
1582	–	observed	observed	
1584	reported	–	–	
1585	–	observed	–	
1592	–	–	observed	
1601	–	reported	–	
1602	–	reported	–	
1603	–	observed	observed	
1603a	–	–	–	
1604	observed	–	–	
1605	–	–	–	
1606	reported	–	–	
1608	–	–	–	
1616	reported	–	–	
1616S	–	–	–	back has denomination surcharge inverted, observed
1616a	–	observed	–	
1617	–	observed	–	
1620	observed	–	–	
1623	–	observed	–	

Philately, or stamp collecting, and syngraphics share a group of collectible pieces — encased postage. As stated in the preceding section on fractional currency, coins became scarce during the Civil War and substitutes were created; postage stamps were just one of many.

The U.S. Treasury estimated that about $27 million in silver coins was in circulation in January 1862. As a result of suspension of specie payment in December 1861, coins of all types but especially silver coins began to disappear from circulation in early 1862.

As you probably know from experience, a stamp, when exposed to moisture, can become a messy item, especially when handed from one person to another. Some New York firms adopted Horace Greeley's suggestion and pasted postage stamps on a piece of paper, the bottom of which was folded over to protect the stamps.

On August 12, 1862 Mr. J. Gault solved the problem by patenting a small brass disc with a mica window that covered an encased stamp. In that year the Scovill Button Works in Waterbury, Connecticut began a massive production of Mr. Gault's invention. These cases served as much of the nation's small change. Not only did the cases keep the stamp intact, but the brass backings soon became a convenient medium for advertising.

The stamps of 1861 were issued in denominations of 1 (*Scott* 63), 2 (not a regular issue), 3 (*S*65), 5 (*S*75), 10 (*S*68), 12 (*S*69), 24 (*S*70), 30 (*S*71) and 90 cents (*S*72). For about one year the public accepted postage currency in windowed discs. However the beleaguered federal government never issued enough of the postage stamps to satisfy the need. Notwithstanding, by the summer of 1863 U.S. fractional currency proved to be the better solution.

These encased postage stamps are not only of special interest to collectors of stamps and paper money, but collectors of coins as well. Do encased postage stamps belong to the field of numismatics, philately or syngraphics? They belong to all three and are unique in collecting history.

The prices listed are for pieces in VFine condition. The mica covering is expected to be clear, without any cracks or breaks. One should make certain there is no sign of tampering with the lip of the enclosure. For a thorough coverage of this subject see the *Standard Catalog of Encased Postage Stamps* by Michael J. Hodder and Q. David Bowers.

One-cent Stamps: portrait of Benjamin Franklin

No.	Issuer	VFine	EFine
1637	Aerated Bread Co., New York	$ 500.	$ 725.
1638	Ayer's Cathartic Pills [Lowell, MA] (short arrows)	250.	375.
1638a	as preceding (long arrows)	unique	
1639	"Take Ayer's Pills" [Lowell, MA]	200.	425.
1640	Ayer's Sarsaparilla [Lowell, MA] (small "AYER'S")	350.	475.

No.	Issuer	VFine	EFine
1641	as preceding (medium "AYER'S")	$ 250.	$ 375.
1642	Bailey & Co., Philadelphia	600.	725.
1643	Joseph L. Bates, "FANCY GOODS," Boston	400.	575.
1644	as preceding, "FANCYGOODS" as one word	350.	525.
1645	Brown's Bronchial Troches [Boston]	600.	725.
1646	F. Buhl & Co., Detroit	600.	750.
1647	Burnett's Cocoaine Kalliston [Boston]	425.	575.
1648	Burnett's Standard Cooking Extracts [Boston]	450.	625.
1649	Arthur M. Claflin, Hopkinton [Massachusetts]	–	6000.
1650	Dougan, New York	900.	1250.
1651	Drake's Plantation Bitters [New York City]	225.	325.
1652	Ellis, McAlpin & Co., Cincinnati	issue uncertain	
1653	G.G. Evans, Philadelphia	550.	775.
1654	Gage Brother & Drake, Tremont House [Chicago]	750.	950.
1655	J. Gault [Boston and New York] (plain frame)	400.	575.
1656	as preceding (ribbed frame)	rare	
1657	L.C. Hopkins & Co., Cincinnati	unique	
1658	Hunt & Nash, Irving House [New York City] (plain frame)	rare	
1658a	as preceding (ribbed frame)	rare	
1659	Kirkpatrick & Gault, New York	rare	
1660	Lord & Taylor, New York	rare	
1661	Mendum's Family Wine Emporium, New York City	500.	675.
1662	B.F. Miles, Peoria	unique	
1663	John W. Norris, Chicago	925.	1850.
1664	North American Life Insurance Company, New York ("INSURANCE" straight)	450.	575.
1665	as preceding ("INSURANCE" curved)	550.	750.
1666	Pearce Tolle & Holton, Cincinnati	unique	
1667	Schapker & Bussing, Evansville, Indiana	rare	
1668	John Shillito & Co., Cincinnati	rare	
1669	S. Steinfeld, New York	1500.	2000.
1670	N. & G. Taylor, Philadelphia	900.	1250.
1671	Weir & Larminie, Montreal	rare	
1672	White the Hatter, New York	950.	1600.

Two-cent stamps, portrait of Andrew Jackson

No.	Issuer	VFine	EFine
1673	J. Gault (not a regular issue)	3 known	

Three-cent stamps, portrait of George Washington

No.	Issuer	VFine	EFine
1674	Ayer's Cathartic Pills [Lowell, MA] (short arrows)	$ 200.	$ 325.
1675	as preceding (long arrows)	250.	375.
1676	"Take Ayer's Pills" [Lowell, MA]	200.	325.
1677	Ayer's Sarsaparilla [Lowell, MA] (small "AYER'S")	350.	475.
1678	as preceding (medium "AYER'S")	250.	375.
1679	as preceding (ribbed frame)	500.	625.
1680	Ayer's Sarsaparilla (large "AYER'S" in plain frame)	450.	800.

No.	Issuer	VFine	EFine
1681	Bailey & Co., Philadelphia	$ 500.	$ 825.
1682	Joseph L. Bates, "FANCY GOODS," Boston	350.	550.
1683	as preceding, "FANCYGOODS" as one word	rare	
1684	Brown's Bronchial Troches [Boston]	350.	500.
1685	F. Buhl & Co., Detroit	rare	
1686	Burnett's Cocoaine Kalliston [Boston]	425.	575.

No.	Issuer	VFine	EFine
1687	Burnett's Standard Cooking Extracts [Boston]	350.	475.
1688	Arthur M. Claflin, Hopkinton [Massachusetts]	unique	
1689	Dougan, New York	900.	1250.
1690	Drake's Plantation Bitters [New York City]	225.	325.
1691	Ellis, McAlpin & Co., Cincinnati	rare	
1692	G.G. Evans, Philadelphia	600.	825.
1693	Gage Brother & Drake, Tremont House [Chicago]	rare	
1694	J. Gault [Boston and New York] (plain frame)	600.	775.
1695	as preceding (ribbed frame)	rare	
1696	L.C. Hopkins & Co., Cincinnati	750.	1150.
1697	Hunt & Nash, Irving House [New York City] (plain frame)	rare	
1698	as preceding (ribbed frame)	rare	
1699	Kirkpatrick & Gault, New York	rare	
1700	Lord & Taylor, New York	850.	1150.
1701	Mendum's Family Wine Emporium, New York City	rare	
1702	John W. Norris, Chicago	rare	
1703	North American Life Insurance Company, New York ("INSURANCE" straight)	550.	700.
1704	as preceding ("INSURANCE" curved)	550.	750.
1705	Pearce Tolle & Holton, Cincinnati	925.	1,300.
1706	Schapker & Bussing, Evansville, Indiana	625.	750.
1707	John Shillito & Co., Cincinnati	425.	550.
1708	N. & G. Taylor, Philadelphia	1125.	1500.
1709	Weir & Larminie, Montreal	2 known	
1710	White the Hatter, New York	1425.	1800.

No.	Issuer	VFine	EFine
1711	Ayer's Cathartic Pills [Lowell, MA] (short arrows)	$ 250.	$ 550.
1712	as preceding (long arrows)	300.	425.
1713	"Take Ayer's Pills" [Lowell, MA] (plain frame)	250.	325.
1714	as preceding (ribbed frame)	450.	725.
1715	Ayer's Sarsaparilla [Lowell, MA] (large "AYER'S")	400.	500.
1716	as preceding (medium "AYER'S")	300.	375.
1717	Bailey & Co., Philadelphia	725.	925.
1718	Joseph L. Bates, "FANCY GOODS," Boston	350.	550.
1719	as preceding, "FANCYGOODS" as one word	rare	
1720	as preceding, "FANCYGOODS" in ribbed frame	350.	500.
1721	Brown's Bronchial Troches [Boston]		
1722	F. Buhl & Co., Detroit	rare	
1723	Burnett's Cocoaine Kalliston [Boston]	425.	575.
1724	Burnett's Standard Cooking Extracts [Boston]	350.	475.
1725	Arthur M. Claflin, Hopkinton [Massachusetts]	rare	
1726	H.A. Cook, Evansville, Indiana	850.	1125.
1727	Dougan, New York	rare	
1728	Drake's Plantation Bitters [New York City]	325.	425.
1729	as above (ribbed frame)	rare	
1730	Ellis, McAlpin & Co., Cincinnati	4 known	
1731	G.G. Evans, Philadelphia	unique	
1732	Gage Brothers & Drake, Tremont House [Chicago]	rare	
1733	J. Gault [Boston and New York] (plain frame)	250.	375.
1734	as preceding (ribbed frame)	450.	625.
1735	L.C. Hopkins & Co., Cincinnati	850.	1,275.
1736	Hunt & Nash, Irving House [New York City] (plain frame)	650.	975.
1737	as preceding (ribbed frame)	475.	850.
1738	Kirkpatrick & Gault, New York	325.	425.
1739	Lord & Taylor, New York	950.	1,400.
1740	Mendum's Family Wine Emporium, New York City	550.	775.
1741	B.F. Miles, Peoria	6 known	
1742	John W. Norris, Chicago	rare	
1743	North American Life Insurance Company, New York ("INSURANCE" straight)	rare	
1743a	as preceding ("INSURANCE" curved)	rare	
1743b	as preceding ("INSURANCE" straight; ribbed frame)	rare	
1744	Pearce Tolle & Holton, Cincinnati	1250.	1575.
1745	Sand's Ale [Milwaukee]	rare	
1746	Schapker & Bussing, Evansville, Indiana	650.	1,000.
1747	John Shillito & Co., Cincinnati	425.	625.
1748	S. Steinfeld, New York	unique	
1749	N. & G. Taylor, Philadelphia	rare	
1750	Weir & Larminie, Montreal	unique	
1751	White the Hatter, New York	1 or 2 known	

Nine-cent (three, three-cent) stamps, portrait of George Washington

No.	Issuer	VFine	EFine
1752	Feuchtwanger back (a fantasy piece in a rectangular frame)	–	–

Ten-cent stamps, portrait of George Washington

No.	Issuer	VFine	EFine
1753	Ayer's Cathartic Pills [Lowell, MA] (short arrows)	$ 225.	$ 525.
1754	as preceding (long arrows)	300.	425.
1755	"Take Ayer's Pills" [Lowell, MA] (plain frame)	250.	325.
1755a	as preceding (ribbed frame)	unique	
1756	Ayer's Sarsaparilla [Lowell, MA] (small "AYER'S")	450.	550.
1717	as preceding (medium "AYER'S")	450.	555.
1718	as preceding (ribbed frame)	500.	675.
1719	as preceding (large "AYER'S" in plain frame)	450.	575.
1760	Bailey & Co., Philadelphia	825.	950.
1761	Joseph L. Bates, "FANCY GOODS," Boston	600.	775.
1762	as preceding, "FANCYGOODS" as one word	550.	725.
1763	as preceding, "FANCYGOODS" in ribbed frame	575.	875.
1764	Brown's Bronchial Troches [Boston]	600.	725.
1765	F. Buhl & Co., Detroit	625.	900.
1766	Burnett's Cocoaine Kalliston [Boston]	425.	575.
1767	Burnett's Standard Cooking Extracts [Boston]	350.	475.
1768	as preceding (ribbed frame)	850.	975.
1769	Arthur M. Claflin, Hopkinton [Massachusetts]	rare	
1770	H.A. Cook, Evansville, Indiana	650.	975.
1771	Dougan, New York	rare	
1772	Drake's Plantation Bitters [New York City]	500.	675.
1773	as above (ribbed frame)	rare	
1774	Ellis, McAlpin & Co., Cincinnati	6 known	
1775	G.G. Evans, Philadelphia	unique	
1776	Gage Brothers & Drake, Tremont House [Chicago]	600.	850.
1777	as preceding (ribbed frame)	rare	
1778	J. Gault [Boston and New York] (plain frame)	250.	350.
1779	as preceding (ribbed frame)	450.	625.
1780	L.C. Hopkins & Co., Cincinnati	rare	
1781	Hunt & Nash, Irving House [New York City] (plain frame)	625.	775.
1782	as preceding (ribbed frame)	800.	975.
1783	Kirkpatrick & Gault, New York	450.	650.
1784	Lord & Taylor, New York	850.	1250.
1785	Mendum's Family Wine Emporium, New York City	600.	825.
1786	as preceding (ribbed frame)	rare	
1787	John W. Norris, Chicago	1150.	2000.
1788	North American Life Insurance Company, New York ("INSURANCE" straight)	1000.	1500.
1789	as preceding ("INSURANCE" curved)	1200.	1800.
1790	as preceding ("INSURANCE" straight; ribbed frame)	rare	

No.	Issuer	VFine	EFine
1790a	as preceding ("INSURANCE" curved; ribbed frame)	rare	
1791	Pearce Tolle & Holton, Cincinnati	unique	
1792	Sand's Ale [Milwaukee]	rare	
1793	Schapker & Bussing, Evansville, Indiana	$ 800.	$ 1100.
1794	John Shillito & Co., Cincinnati	750.	1125.
1795	S. Steinfeld, New York	unique	
1796	N. & G. Taylor, Philadelphia	rare	
1797	Weir & Larminie, Montreal	1000.	1450.
1798	White the Hatter, New York	rare	

Twelve-cent stamps, portrait of George Washington

No.	Issuer	VFine	EFine
1799	Ayer's Cathartic Pills [Lowell, MA] (short arrows)	$400.	$625.
1800	as preceding (long arrows)	rare	
1801	"Take Ayer's Pills" [Lowell, MA]	550.	650.
1802	Ayer's Sarsaparilla [Lowell, MA] (small "AYER'S")	450.	550.
1803	as preceding (medium "AYER'S")	450.	555.
1803a	as preceding (large "AYER'S")	450.	575.
1804	Bailey & Co., Philadelphia	825.	950.
1805	Joseph L. Bates, "FANCY GOODS," Boston	600.	775.
1806	Brown's Bronchial Troches [Boston]	750.	925.
1807	F. Buhl & Co., Detroit	rare	
1808	Burnett's Cocoaine Kalliston [Boston]	725.	925.
1809	Burnett's Standard Cooking Extracts [Boston]	800.	925.
1810	Arthur M. Claflin, Hopkinton [Massachusetts]	rare	
1811	Drake's Plantation Bitters [New York City]	800.	950.
1812	Ellis, McAlpin & Co., Cincinnati	rare	
1813	Gage Brothers & Drake, Tremont House [Chicago]	2 known.	
1814	J. Gault [Boston and New York] (plain frame)	700.	850.
1815	as preceding (ribbed frame)	rare	
1816	Hunt & Nash, Irving House [New York City] (plain frame)	rare	
1817	as preceding (ribbed frame)	rare	
1818	Kirkpatrick & Gault, New York	650.	850.
1819	Lord & Taylor, New York	rare	
1820	Mendum's Family Wine Emporium, New York City	600.	775.
1821	North American Life Insurance Company, New York ("INSURANCE" straight)	rare	
1821a	as preceding ("INSURANCE" curved)	unique	
1822	Pearce Tolle & Holton, Cincinnati	unique	
1823	Sand's Ale [Milwaukee]	issue uncertain	
1824	Schapker & Bussing, Evansville, Indiana	unique.	
1825	John Shillito & Co., Cincinnati	unique	
1826	S. Steinfeld, New York	unique	
1827	N. & G. Taylor, Philadelphia	unique	

Twenty-four-cent stamps, portrait of George Washington

No.	Issuer	VFine	EFine
1828	Ayer's Cathartic Pills [Lowell, MA] (short arrows)	$ 600.	$ 825.
1828a	as preceding (long arrows)		unique
1828b	"Take Ayer's Pills" [Lowell, MA]		unique
1829	Joseph L. Bates, "FANCY GOODS," Boston		unique

No.	Issuer	VFine	EFine
1830	Brown's Bronchial Troches		issue uncertain
1831	F. Buhl & Co., Detroit		rare
1832	Burnett's Cocoaine Kalliston [Boston]		rare
1833	Burnett's Standard Cooking Extracts [Boston]		rare
1834	Drake's Plantation Bitters [New York City]		rare
1835	Ellis, McAlpin & Co., Cincinnati	800.	1,300.
1836	J. Gault [Boston and New York] (plain frame)	1175.	1800.
1837	as preceding (ribbed frame)		rare
1838	Hunt & Nash, Irving House [New York City] (plain frame)		rare
1839	as preceding (ribbed frame)		rare
1840	Kirkpatrick & Gault, New York	750.	1,250.
1841	Lord & Taylor, New York		rare
1842	Pearce Tolle & Holton, Cincinnati		issue uncertain

Thirty-cent stamps, portrait of Benjamin Franklin

No.	Issuer	VFine	EFine
1843	Ayer's Cathartic Pills [Lowell, MA] (short arrows)		unique
1844	as preceding (long arrows)	$ 600.	$ 925.
1844a	"Take Ayer's Pills" [Lowell, MA]		unique
1844b	Ayer's Sarsaparilla [Lowell, MA] (medium "AYER'S)		unique
1845	Brown's Bronchial Troches		issue uncertain
1846	Burnett's Cocoaine Kalliston [Boston]		rare
1847	Burnett's Standard Cooking Extracts [Boston]		rare
1848	Drake's Plantation Bitters [New York City]		3 known
1849	J. Gault [Boston and New York] (plain frame)	1375.	1950.
1850	as preceding (ribbed frame)		rare
1851	Hunt & Nash, Irving House [New York City] (plain frame)		rare
1852	Kirkpatrick & Gault, New York	1225.	1750.
1853	Lord & Taylor, New York		rare
1854	Sand's Ale [Milwaukee]		rare

Ninety-cent stamps, portrait of George Washington

No.	Issuer	VFine	EFine
1855	"Take Ayer's Pills" [Lowell, MA]	issue uncertain	
1855a	Ayer's Sarsaparilla [Lowell, MA] (medium "AYER'S)	$1750.	$3200.
1856	Joseph L. Bates, "FANCY GOODS" Boston	unique	
1857	Burnett's Cocoaine Kalliston [Boston]	unique	
1857a	Burnett's Standard Cooking Extracts [Boston]	unique	
1858	Drake's Plantation Bitters [New York City]	rare	
1859	J. Gault [Boston and New York] (plain frame)	$1775.	$2500.
1859a	as preceding (ribbed frame)	unique	
1860	Kirkpatrick & Gault, New York	unique	
1861	Lord & Taylor, New York	unique	

United States postal notes were a creation that descended from and filled the void after fractional currency was withdrawn in the mid-1870s after the need for low denomination notes had passed.

In addition to the need for small-change notes in daily use during the post-Civil War crisis, fractional currency was also convenient for sending small amounts through the mail. And, although there was a risk of postal theft, fractional notes were often inserted in a folded letter and usually went undetected. Postal notes were created from the public demand for a replacement.

Then, as now, the wheels of government moved slowly. Awakened by the American Express Co., which initiated a money order system in 1882, the U.S. Congress passed H.R. 5661 and introduced postal notes for a fee of 3 cents, 2 cents less than that charged by American Express.

Postal notes were to be issued by post offices in sums less than $5; they were to be issued without notification to the paying office; they would be payable at a specific city; they were to be printed on thin bank note-like paper from engraved plates.

Issuance was restricted to the largest 63,000 post offices that would have sufficient funds to cash these notes. More notes were issued in the highest populated ares, i.e., New England, the mid-Atlantic and mid-Western states.

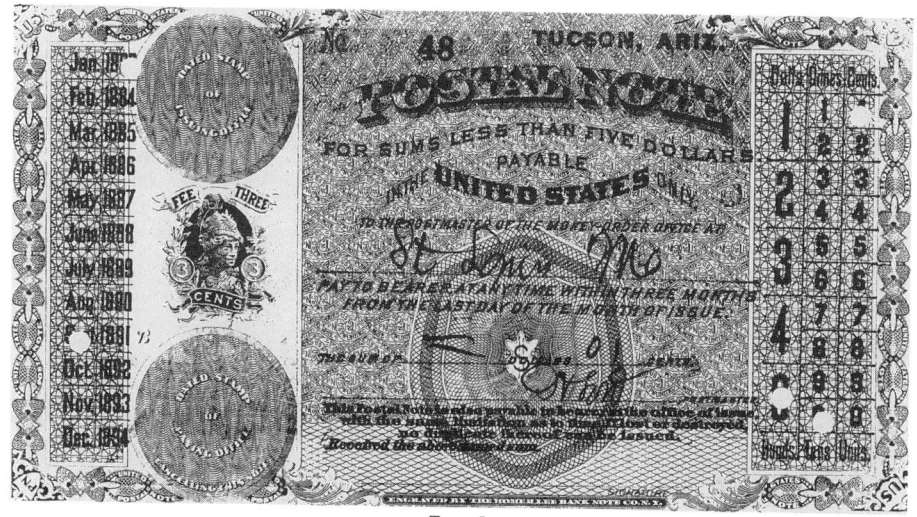

Type I

The first four-year contract (1883–1887) to design, engrave and print U.S. postal notes was awarded to the Homer Lee Bank Note Co. in New York City. The first notes, significantly larger than later ones, were printed on yellow paper. On the left portion of these notes was the date and fee shield; the notes were payable in a designated city only.

Type II

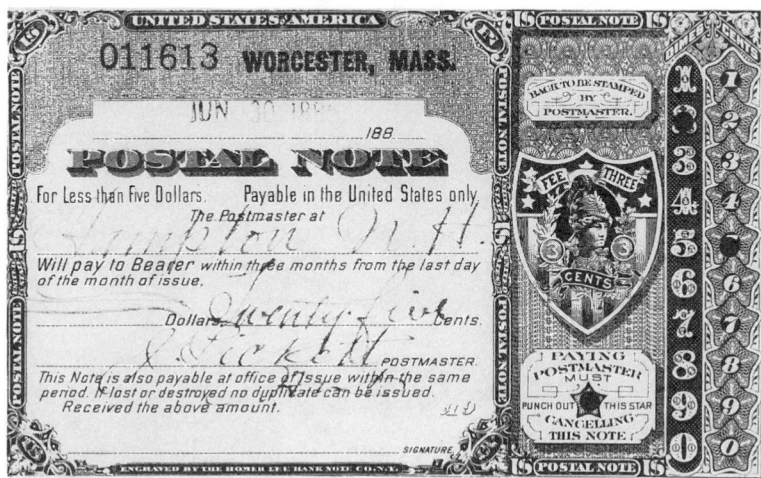

In 1884 the design was altered and the notes were printed on ivory-white paper.

Type II-A. To simplify cashing the notes, in early 1887 postal notes were individually rubber-stamped so they were payable at "ANY MONEY ORDER OFFICE."

Type III

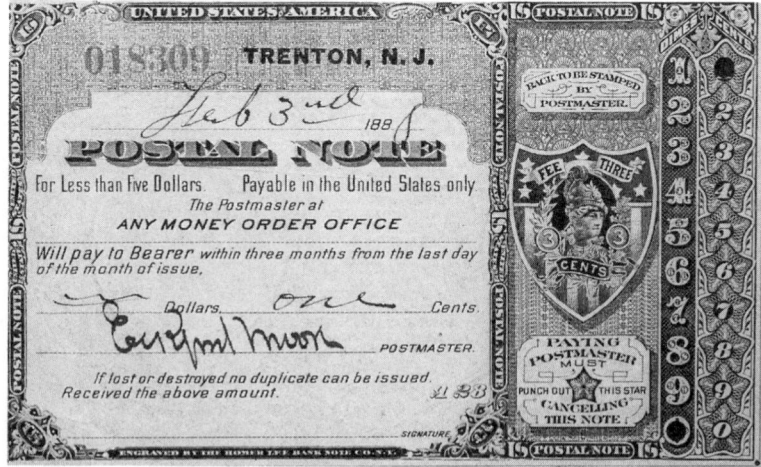

Toward the end of the contract with Homer Lee, postal notes were printed with "ANY MONEY ORDER OFFICE" engraved into the plates; this is the scarcest type.

Type IV

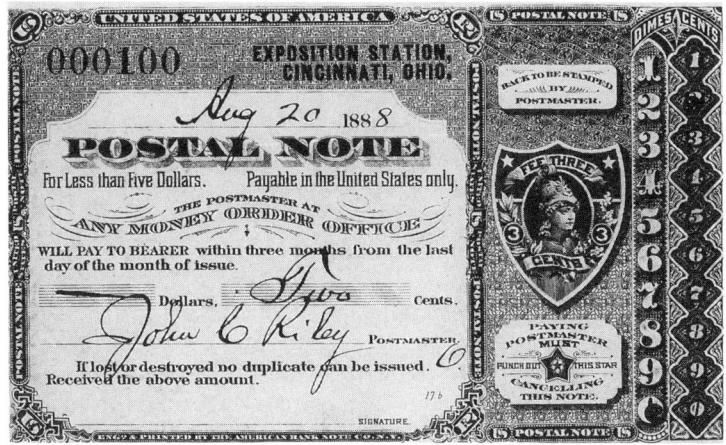

In 1887 the new contract was awarded to American Bank Note Co. Thomas F. Morris, Chief Designer at ABNCo, followed the basic Homer Lee format. The most noticeable design change was the style and placement of "ANY MONEY ORDER OFFICE."

The illustrated note, with serial number 100, was issued during the 100–day Centennial Exposition of the Ohio Valley and Central States in 1888. This note, issued at a mobile office, is the only known surviving note from the Centennial.

Type V. In September 1891 the final contract was awarded to Dunlap & Clarke in Philadelphia. This company merely produced a plate with the same design and added their name in the lower border. There are minor differences in the portrait.

Identification Guide by Type*

Type	Company	Identifying Characteristics
I	Homer Lee	yellow paper
II	Homer Lee	white paper and handwritten paying city
IIA	Homer Lee	rubber-stamped "ANY MONEY ORDER OFFICE"
III	Homer Lee	"ANY MONEY ORDER OFFICE" engraved in straight line
IV	ABNCo	American Bank Note Co. in lower face border
V	Dunlap & Clarke	Dunlap & Clarke in lower face border

Members of the American Numismatic Association (ANA) may borrow a postal note slide set and transcript from the ANA. This material, provided by U.S. postal note specialists Charles Surasky and Nicholas Bruyer, serves as an educational tool.

Remarks: A total of 70.8 million notes were issued; the total face value exceeded $126 million; the average postal note was issued for less than $2.

* *Identifying the Postal Notes of 1883 to 1894*, Charles Surasky, published by the author in 1985.

Current Federal Reserve notes are printed on 32-subject sheets. Most often, large-size notes were printed on 4-subject sheets.

Since the 1830s U.S. security paper has been printed from intaglio-engraved plates. With the exception of fractional currency, other circulating notes, issued during the Civil War were printed from 4-subject sheets; some interest-bearing notes were printed from 3-subject plates. In 1918, 8-subject plates were put into use. Prior to 1898 only single-plate hand presses were in use, which yielded one sheet per impression. Steam presses were able to accommodate up to four plates simultaneously.

The reduction of the size of U.S. paper money in 1928, and the need for more circulating money, brought printing improvements to the Bureau of Engraving and Printing. One such improvement in productivity involved the use of presses that would accommodate large engraved plates and print more subjects per sheet.

Among the notes produced by the older methods, some of the most interesting are the national bank notes. Large-size national bank notes were usually printed on sheets of 4 subjects, although some plates were prepared with only 2-subjects. For some $500 and $1,000 national bank notes, 1-subject plates were prepared. Surviving sheets represent only a small fraction of known subject combinations: ten sheets of the first charter period, each sheet comprised of $1-1-1-2; two sheets of $5-5-5-5; one sheet of $10-10-10-20. As for brown backs there are at least 20 sheets of $5-5-5-5; nine sheets of $10-10-10-20; one sheet of $10-10-10-10; one sheet of $50-$100.

There are four sheets of $5 subjects, all with second charter date backs and two sheets of $10-10-10-20. Only one sheet each with denomination backs is known for sheets with $5-5-5-5, the other with $10-10-10-20. There are dozens of third charter sheets; the vast majority are sheets of $5-5-5-5 with blue seals. Combinations such as $50-50-50-100 and $10-10-20-50 were made, but none have been preserved. Thus it is not always possible to determine the combination of the sheet from which any given national bank note was cut.

Uncut fractional currency sheets were shipped to post offices and banks and sold directly to the public. National bank notes were also shipped uncut to the issuing banks and were occasionally saved as souvenirs. Other sheets—with few exceptions—were separated and trimmed into single notes at the Bureau; the exceptions were a few sheets of 1896 silver certificates, several $1, $2 and $5 silver certificates of 1899, and two sheets of $5 United States notes of 1907, all of which appear to have been presented uncut to VIPs. A.A. Grinnell also had a pair of uncut Chicago 1915 Federal Reserve Bank note sheets in denominations of $10 and $20. Five $5 sheets are known—all from Atlanta. Even some of the presentation sheets were separated, as were their small-size counterparts dated 1928-1934.

Small-size notes, first printed in 12-subject sheets on August 6, 1928, were sold in sheet form to the general public beginning in 1935. The 1928-1934 sheets were presentation items; from six to a few dozen were made. When the 18-subject sheets of $1 notes were introduced in 1952, followed by higher denominations in May 1953, a few hundred sheets of each were distributed uncut. The Treasury Department then discontinued the practice. No 32-subject sheets were issued to the public until 1981, though presentation pieces cannot be ruled out. It is possible that many 18-subject sheets were subsequently separated, since they are more scarce than the 12-subject sheets.

Small-size national bank notes, like their big brothers, were shipped uncut to 6,994 issuing banks in panels of six. They were printed in 12–subject sheets, as were all other small-size notes, Series 1928 through 1953. The national bank notes were printed minus the bank information and then were stored and overprinted with logotypes as orders arrived from individual banks. At present over 850 such sheets have been recorded, the vast majority with serial number 1 (Type I) or 1–6 (Type II). Over half are $5 notes. Among the rest, $10 notes outnumber $20s by 3 to 1; the $50 and $100 sheets are exceedingly rare.

Uncut sheets are usually collected by states. Texas, Michigan and New York are the most common. The rarities are the sheets from Delaware, Washington, DC, Arizona, Idaho and Wyoming. Sheets are not known for Alaska or Hawaii.

SUMMARY OF SMALL-SIZE CURRENCY SHEET SUBJECTS

	Denomination	12 Subjects	18 Subjects	32 Subjects
United States Notes	1	1928	none	none
	2	1928–1928G	1953–1953C	1963–1963A
	5	1928–1928F	1953–1953C	1963
	100	none	none	1966–1966A
Silver Certificates	1	1928–1935D	1935D-1935H	1957–1957B
	5	1934–1934D	1953–1953C	none
	10	1933–1934D	1953–1953B	none
Federal Reserve Notes	1	none	none	1963–
	2	none	none	1976
	5, 10, 20	1928–1950	1950A-1950E	1963–
	50, 100	1928–1950	1950A-1950E	1963–

Gold certificates, national bank notes, Federal Reserve Bank notes and Federal Reserve notes above $100 were all printed in sheets of 12 subjects.

United States Notes/Series 1880–1917/Sheets of Four

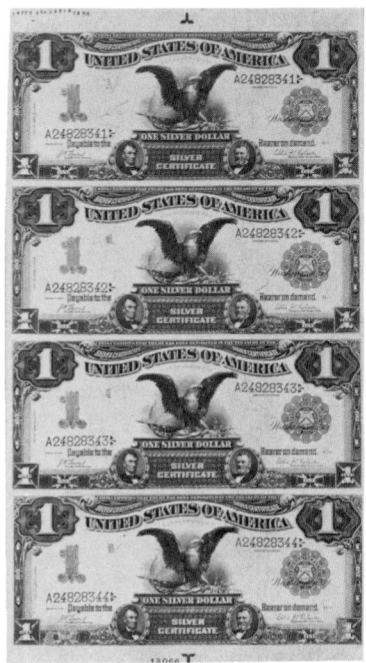

No.	Denomination	Series	Signatures	Value
26	$1	1917	Elliott-White	$ –
169	$2	1917	Elliott-White	–
263	$5	1880	Lyons-Roberts	–
271	$5	1907	Elliott-White	–
490	$10	1901	Elliott-White	–
723	$20	1880	Elliott-White	–

Remarks: There has been no recent sales of the above.

Silver Certificates/Series 1896 & 1899/Sheets of Four

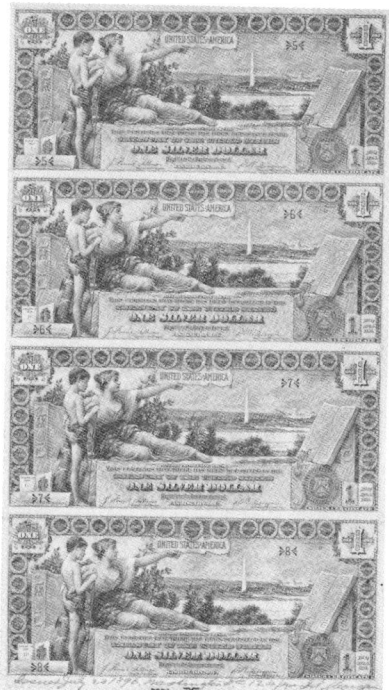 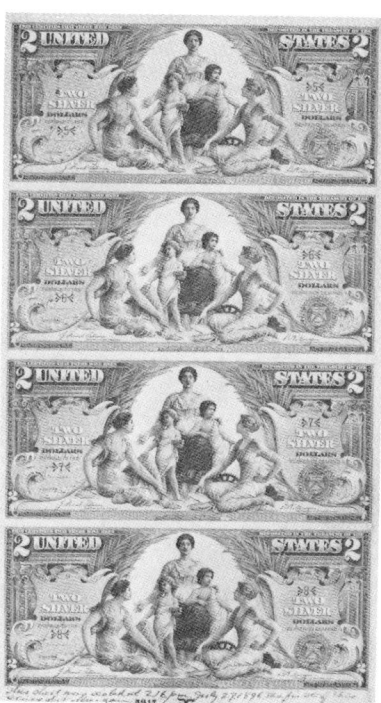

No.	Series	Signatures	Value	No.	Series	Signatures	Value		
45	$1	1896	Tillman-Morgan	$ –	187	$2	1899	Lyons-Roberts	$ –
46	$1	1896	Bruce-Roberts	–	190	$2	1899	Vernon-McClung	Unique
48	$1	1899	Lyons-Roberts	3500.	193	$2	1899	Parker-Burke	–
51	$1	1899	Vernon-McClung	3750.	196	$2	1899	Speelman-White	–
54	$1	1899	Parker-Burke	3750.	359	$5	1896	Bruce-Roberts	–
57	$1	1899	Elliott-White	3250.	360	$5	1896	Lyons-Roberts	3500.
185	$2	1896	Tillman-Morgan	3 known	367	$5	1899	Parker-Burke	–
186	$2	1896	Bruce-Roberts	–	371	$5	1899	Speelman-White	–

Treasury (or Coin) Notes/One Dollar/Sheets of Four

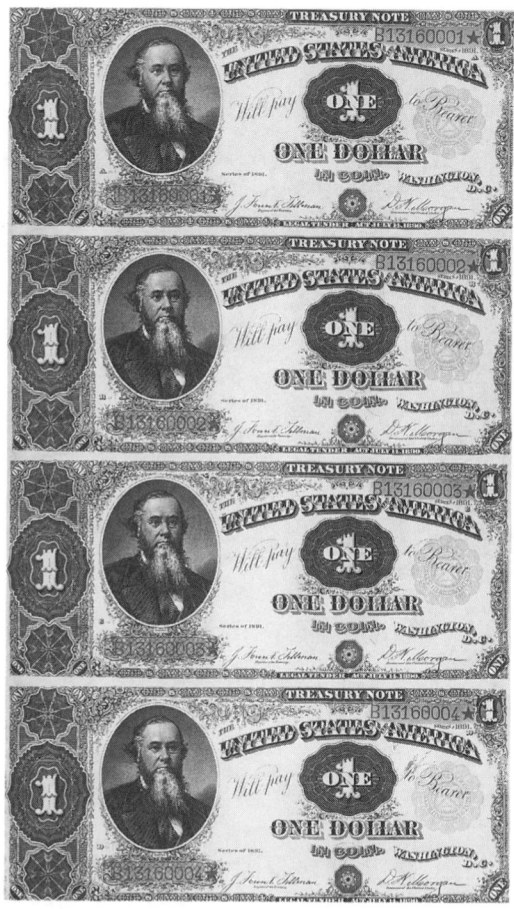

No.	Denomination	Series	Signatures	Value
62	$1	1890	Rosecrans-Huston	Unique
63	$1	1891	Tillman-Morgan	Unique

Remarks: No. 62 bears the following inscription on the bottom margin: "This sheet of four $1 Treasury Notes, being the designer, as a courtesy and at my request, were delivered to me through the Treasurer of the United States, by paying $4.00 without separation. Geor. W. Casilear, Chief Engraver."

National Bank Notes/Sheets of Four

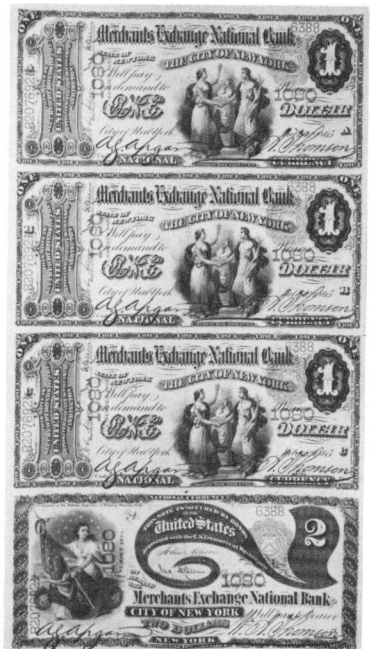 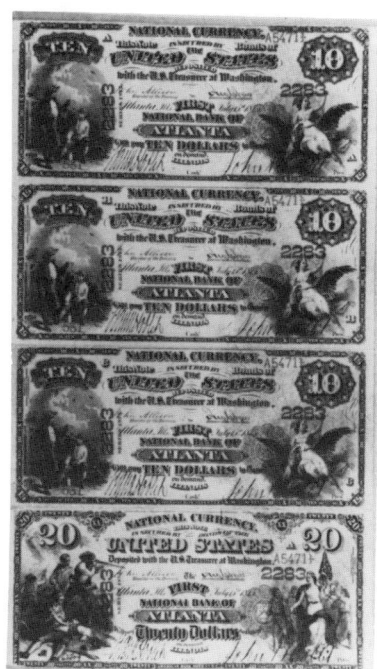

No.	Denomination	Signatures	Value
		Series 1865	
29&171	$1-1-1-2	Colby-Spinner	$ –
31&173	$1-1-1-2	Allison-Spinner	7,500.
33&175	$1-1-1-2	Allison-Wyman	–
34&176	$1-1-1-2	Allison-Gilfillan	7,500.
		Series 1875	
282	$5-5-5-5	Bruce-Gilfillan	–
501&732	$10-10-10-20	Allison-New	14,000.
		Series 1882-First Issue	
288	$5-5-5-5	Bruce-Wyman	–
291	$5-5-5-5	Rosecrans-Hyatt	–
292	$5-5-5-5	Rosecrans-Huston	–
293	$5-5-5-5	Rosecrans-Nebeker	–
298	$5-5-5-5	Lyons-Roberts	–
512&744	$10-10-10-20	Rosecrans-Jordan	–
514&746	$10-10-10-20	Rosecrans-Huston	–
515&747	$10-10-10-20	Rosecrans-Nebeker	–
520&752	$10-10-10-20	Lyons-Roberts	–

National Bank Notes/Second Charter Period/Sheets of Four

No.	Denomination	Signatures	Value
		Series 1882-Second Issue	
303	$5-5-5-5	Tillman-Morgan	$ –
524&756	$10-10-10-20	Rosecrans-Nebeker	–
527&759	$10-10-10-20	Tillman-Roberts	–
		Series 1882-Third Issue	
311	$5-5-5-5	Lyons-Roberts	–
536&767	$10-10-10-20	Lyons-Roberts	–

National Bank Notes/Third Charter Period/Series 1902/Sheets of Four

No.	Denomination	Signatures	Value
	Except for No. 542 & 775, all are $5 notes.		
		First Issue	
316		Lyons-Roberts	$ –
317		Lyons-Treat	–
318		Vernon-Treat	–
542&775	$10-10-10-20	Vernon-Treat	2200.
		Second Issue	
319		Lyons-Roberts	2000.
321		Vernon-Treat	2000.
322		Vernon-McClung	2000.
		Third Issue	
328		Lyons-Roberts	2000.
331		Vernon-McClung	2000.
332		Napier-McClung	2150.
333		Napier-Thompson	2250.
335		Parker-Burke	2000.
336		Teehee-Burke	2000.
337		Elliott-Burke	2000.
338		Elliott-White	2000.
339		Speelman-White	2000.
341		Woods-Tate	2250.

National Bank Notes/Third Charter Period/Sheets of Four

Series 1902-Third Issue
$10-10-10-20

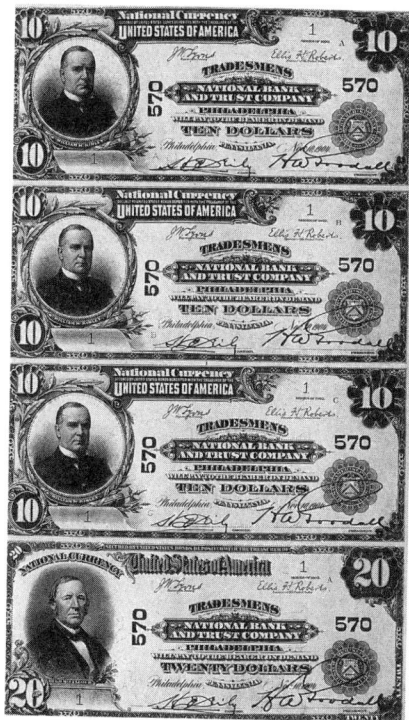

No.	Denomination	Signatures	Value
552&785		Lyons-Roberts	$2500.
554	($10-10-10-10)	Vernon—Treat	2500.
554&787		Vernon-Treat	2500.
555&788		Vernon-McClung	2500.
556&789		Napier-McClung	2500.
558&791		Napier-Burke	2500.
559&792		Parker-Burke	2500.
560&793		Teehee-Burke	2500.
561&794		Elliott-Burke	2500.
563&796		Speelman-White	2500.
565&798		Woods-Tate	3000.

Federal Reserve Bank Notes/Series 1915/Sheets of Four

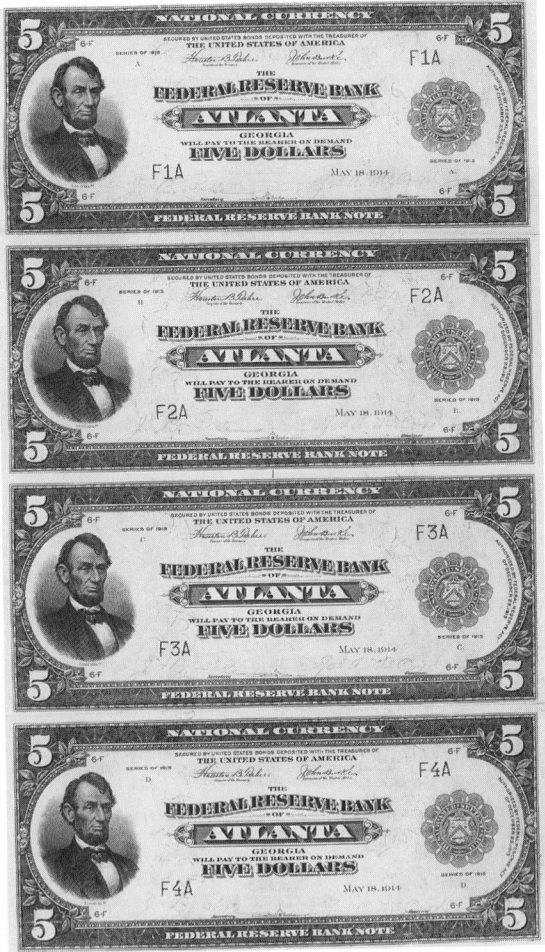

No.	Bank	Denomination	Signatures	Known
382F2	Atlanta	$5	T-B, Pike-McCord	5
620G1	Chicago	$10	T-B, McLallen-McDougal	Unique
850G	Chicago	$20	T-B, McLallen-McDougal	Unique

Remarks: Nos. 620G1 and 850G were included in the Grinnell sale in 1945 & 1946. Five sheets of No. 382F2 were sold by Christie's in September 1991, the first public sale of this denomination. The sheet numbered F1A to F4A sold for $9,350.

United States Notes/One Dollar/Series 1928/Sheets of Twelve

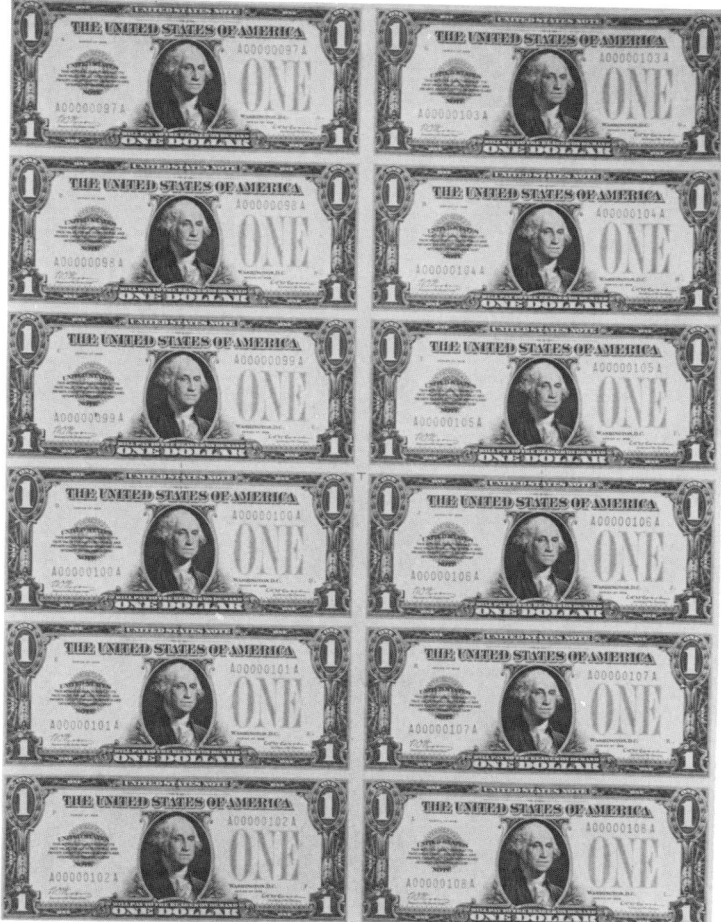

No.	Signatures	Delivered	Known	Value
69	Woods-Woodin	11	8	$13,000.

Remarks: A sheet presented to James W. Wade, now owned by Aubrey and Adeline Bebee, has the autograph of W.H. Woodin on each note.

United States Notes

Two Dollar—Sheets of Twelve

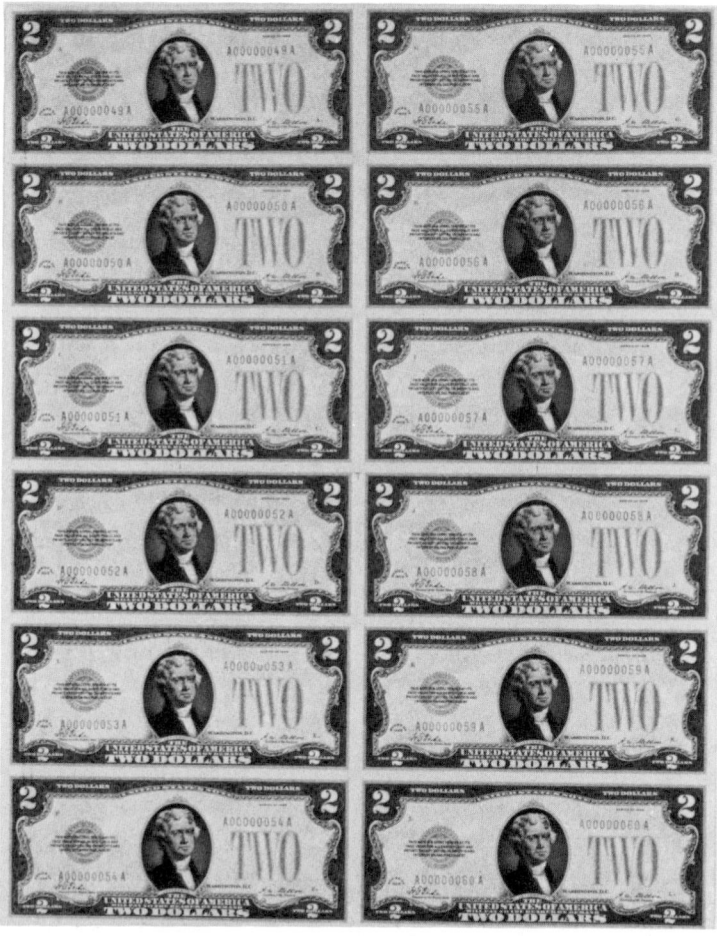

No.	Series	Signatures	Delivered	Known	Value
204	1928	Tate-Mellon	no record	0	$ —
204A	1928A	Woods-Mellon	no record	0	—
204B	1928B	Woods-Mills	no record	0	—
204C	1928C	Julian-Morgenthau	25	25	1500.
204D	1928D	Julian-Morgenthau	50	9	1850.
204E	1928E	Julian-Vinson	50	26	1500.
204F	1928F	Julian-Snyder	100	23	1000.
204G	1928G	Clark-Snyder	100	28	1000.

Two Dollar—Sheets of Eighteen

No.	Series	Signatures	Delivered	Known	Value
205	1953	Priest-Humphrey	100	26	$1100.

Remarks: One sheet of No. 204C was autographed by Julian and Morgenthau.

United States Notes/Five Dollars/Series 1928–1953

Five Dollar–Sheets of Twelve

No.	Series	Signatures	Delivered	Known	Value
383	1928	Woods-Mellon	5	1	$ –
383A	1928A	Woods-Mills	no record	0	–
383B	1928B	Julian-Morgenthau	no record	0	–
383C	1928C	Julian-Morgenthau	no record	0	–
383D	1928D	Julian-Vinson	25	13	2000.
383E	1928E	Julian-Snyder	100	18	1200.
383F	1928F	Clark-Snyder	no record	0	–

Five Dollar–Sheets of Eighteen

No.	Series	Signatures	Delivered	Known	Value
384	1953	Priest-Humphrey	100	13	2000.

Remarks: The delivered figure for No. 383D is an estimate.

Silver Certificates/One Dollar/Series 1928–1935D/Sheets of Twelve

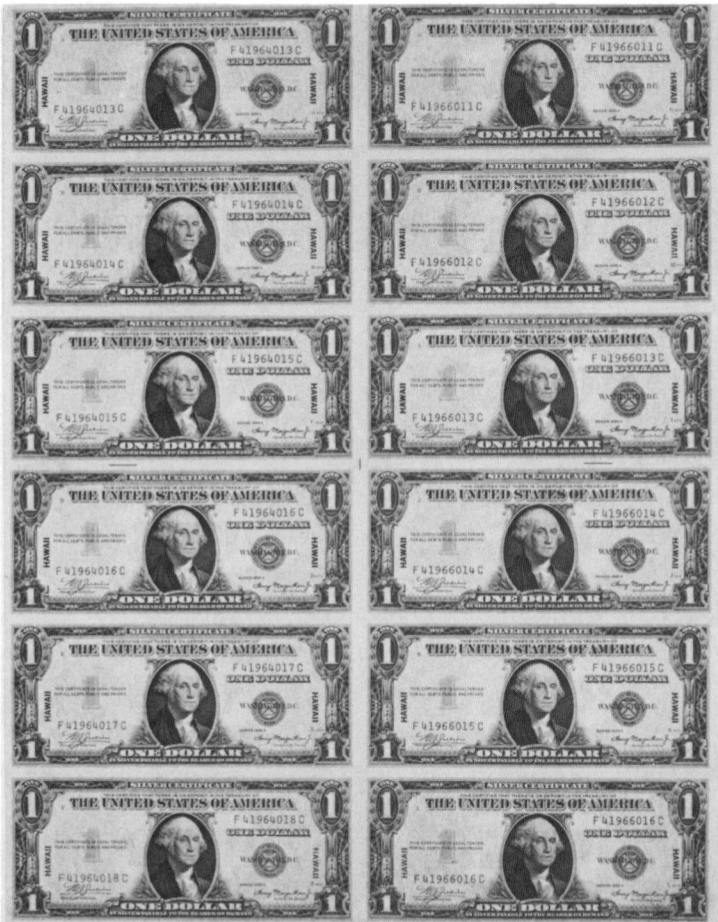

No.	Series	Signatures	Delivered	Known	Value
70	1928	Tate-Mellon	no record	14	$ 3,200.
71	1928A	Woods-Mellon	no record	0	–
72	1928B	Woods-Mills	6	0	–
73	1928C	Woods-Woodin	11	7	8,500.
74	1928D	Julian-Woodin	60	23	4,500.
75	1928E	Julian-Morgenthau	25	8	17,500.
76	1934	Julian-Morgenthau	25	10	5,000.
77	1935	Julian-Morgenthau	100	28	4,000.
78	1935A	Julian-Morgenthau	100	20	2,250.
79	1935A	Julian-Morgenthau (HAWAII)	25	20	3,000.
80	1935A	Julian-Morgenthau (N. Africa)	25	14	3,250.
83	1935B	Julian-Vinson	100	28	1,500.
84	1935C	Julian-Snyder	100	28	1,250.
85	1935D	Clark-Snyder	300	50	1,000.

Remarks: At least one sheet of Nos. 75 & 85 was autographed by the signers.

Silver Certificates/One Dollar/Series 1935D & 1935E

Sheets of Eighteen

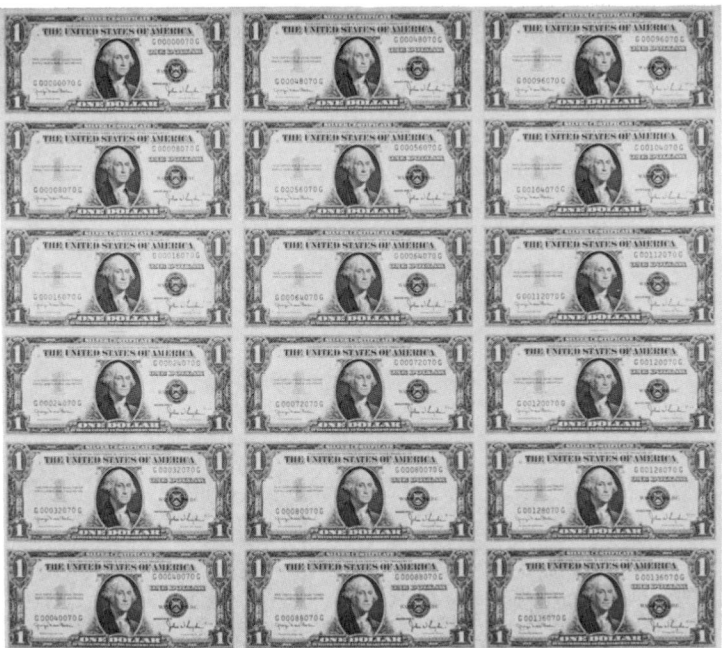

No.	Series	Signatures	Delivered	Known	Value
86	1935D	Clark-Snyder	102	33	$1,250.
87	1935E	Priest-Humphrey	400	53	1,000.

Silver Certificates/Series 1934–1953

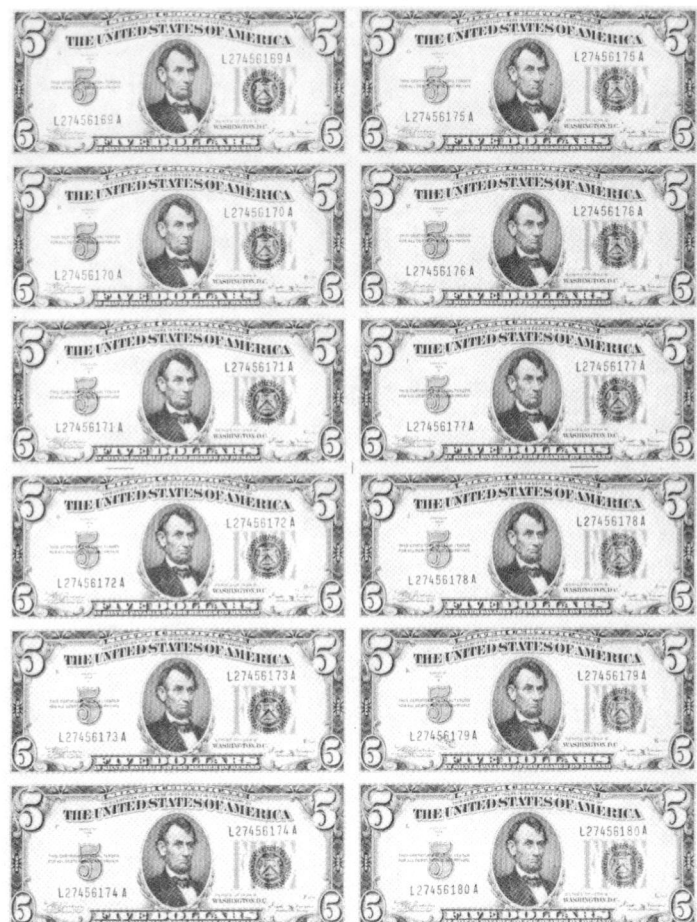

Five Dollar – Sheets of Twelve

No.	Series	Signatures	Delivered	Known	Value
386	1934	Julian-Morgenthau	25	12	$1,500.
386A	1934A	Julian-Morgenthau	no record	0	–
386B	1934B	Julian-Vinson	no record	10	1,500.
386C	1934C	Julian-Snyder	100	10	1,500.
386D	1934D	Clark-Snyder	100	26	1,000.
		Five Dollar – Sheets of Eighteen			
388	1953	Priest-Humphrey	100	21	2,500.
		Ten Dollar – Sheets of Twelve			
621	1933	Julian-Woodin	1	0	–
621A	1933A	Julian-Morgenthau	1	0	–
622	1934	Julian-Morgenthau	10	7	4,000.
		Ten Dollar – Sheets of Eighteen			
625	1953	Priest-Humphrey	100	10	4,000.

Federal Reserve Notes/Series 1928

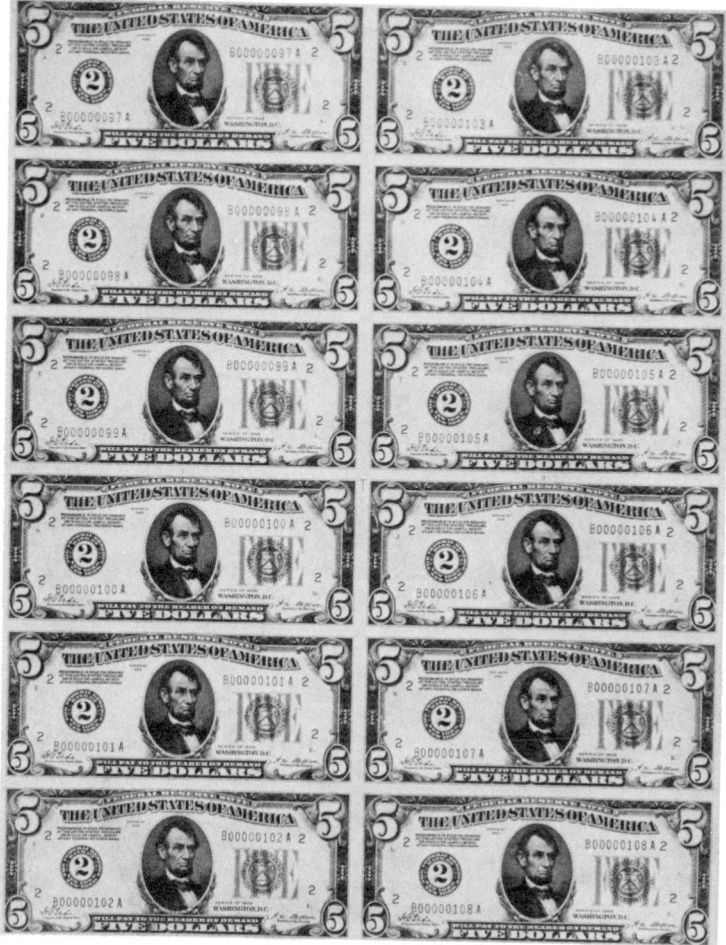

No.	Bank	Denomination	Signatures	Delivered	Known
391A	Boston	$5	Tate-Mellon	10	0
		$10	Tate-Mellon	10	0
		$20	Tate-Mellon	10	1
		$50	no record	no record	1
391B	New York	$5	Tate-Mellon	12	0
		$10	Tate-Mellon	12	0
		$20	Woods-Mellon	12	0
		$20	Tate-Mellon	no record	1
		$50	no record	1	0

Federal Reserve Notes/Series 1928

No.	Bank	Denom.	Signatures	Delivered	Known
391C	Philadelphia	$5	Tate-Mellon	5	1
		$10	Tate-Mellon	5	2
		$20	Tate-Mellon	5	2
		$50	Woods-Mellon	5	0
391D	Cleveland	$5	Tate or Woods-Mellon	2	0
		$10	Tate or Woods-Mellon	2	2
		$20	Woods-Mellon	2	0
		$50	Woods-Mellon	2	0
391E	Richmond	$5	Tate or Woods-Mellon	1	0
		$10	Tate or Woods-Mellon	1	0
		$20	Woods-Mellon	1	0
		$50	Woods-Mellon	1	0
391G	Chicago	$5	Tate-Mellon	5	1
		$10	Tate-Mellon	5	1
		$20	Tate-Mellon	5	1
391I	Minneapolis	$5	Tate-Mellon	5	0
		$5	Woods-Mellon	–	1
		$10	Woods-Mellon	5	2
		$20	Tate-Mellon	1	
391J	Kansas City	$5	Tate or Woods-Mellon	5	0
		$10	Tate or Woods-Mellon	5	0
		$20	Tate or Woods-Mellon	5	0
391K	Dallas	$5	Woods-Mellon & Tate-Mellon	5	2
		$10	Woods-Mellon & Tate-Mellon	5	1
391L	San Francisco	$5	Tate-Mellon	2	0
		$10	Tate-Mellon	2	0
		$50	Woods-Mellon	2	0

Remarks: The No. 391G delivered figures are estimates. No. 391G $5 notes and No. 391I $10 notes were sold at the 1977 American Numismatic Association auction. The No. 391I $5 note (Woods-Mellon, Series 1928B) was in the 1945 & 1946 Grinnell sale.

National Bank Notes/Series 1929/Sheets of Six

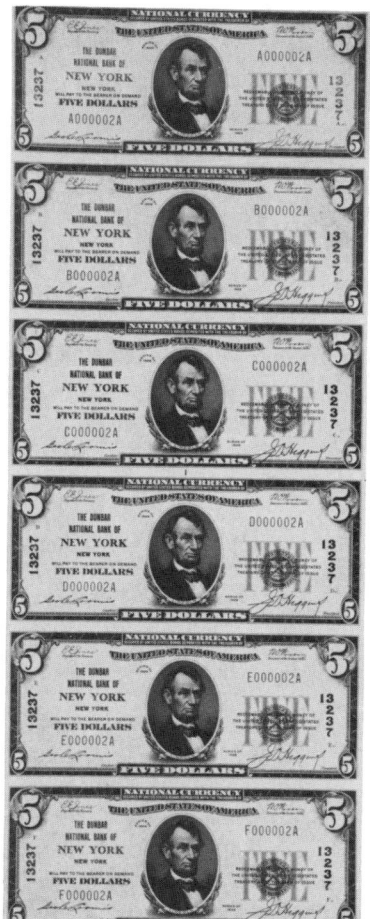
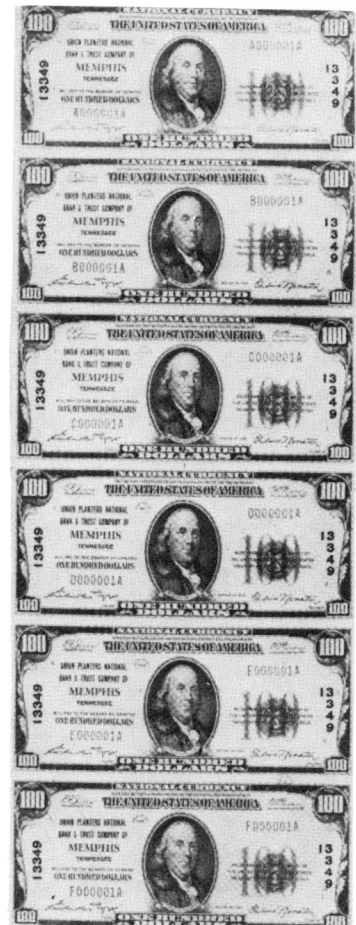

No.	Denomination	Rarity 1 & 2	Rarity 3 & 4	Rarity 5	Rarity 6	Rarity 7	Rarity 8
390	$5	$700.	$ 800.	–	–	–	–
627	$10	735.	875.	–	–	–	–
852	$20	825.	950.	–	–	–	–
1048	$50	4000.	5000.	–	–	–	–
1249	$100	5250.	6000.	–	–	–	–

Remarks: The above figures are for Type I notes; Type II notes command additional premiums, as much as twice the amount. See rarity table in chapter two. All small-size national bank notes and Federal Reserve Bank notes were printed in sheets of twelve, cut in half and delivered to the issuing banks in sheets of six.

Federal Reserve Bank Notes

Series 1929

No.	Bank	Denomination	Signatures	Notes Per Sheet	Known
626B	New York	$10	Jones-Woods	12	1
851C	Philadelphia	$20	Jones-Woods	12	2
851G	Chicago	$20	Jones-Woods	12	1
851I	Minneapolis	$20	Jones-Woods	12	1

Federal Reserve Notes/Series 1976–1990

Commencing with Series 1981 uncut sheets of $1 notes have been made available to collectors. Each series was offered in sheets of 32, 16 and 4. Sheets were not prepared for all 12 Federal Reserve Districts. Uncut sheets of $2 notes, Series of 1976, are also available. To purchase $2 sheets and current $1 sheets, write to the Bureau of Engraving and Printing, Public Sales Program, Room 602–11A, 14th and C Streets, SW, Washington, DC 20228.

No.	Signatures	Series	Denomination
106	Buchanan-Regan	1981	$1
107	Ortega-Regan	1981A	$1
108	Ortega-Baker	1985	$1
109	Ortega-Brady	1988	$1
110	Villalpando-Brady	1988A	$1
111	Villalpando-Brady	1990	$1
207☆	Neff-Simon	1976☆	$2

There are numerous avenues one can follow to assemble a collection of paper money. One can collect all the signature combinations or all denominations within a particular series. One of the most popular methods of collecting is to acquire one example of each type of note design; this is usually limited to one denomination. Notes executed by a particular engraver is another collecting possibility.

A fascinating path to follow is that of seeking unusual notes. On the following pages a few notes are illustrated that any collector would consider to be of special interest. There are many more.

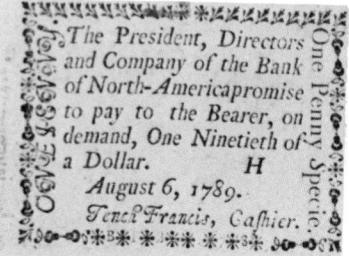

When this note circulated in the American Colonies, the Spanish Milled Dollar, exchangeable at 7 shillings 6 pence, or 90 pence, was the standard unit of currency.

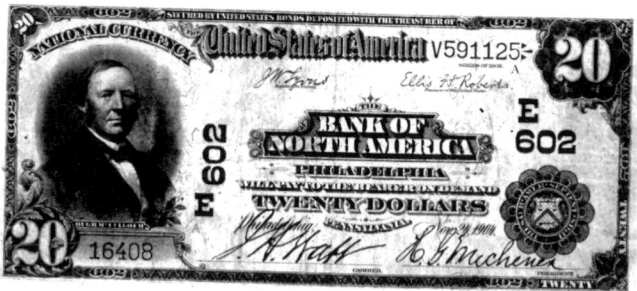

The Bank of North America, chartered by the Continental Congress on December 31, 1781, was the only national bank to receive the privilege of deleting the word "national" from its title. The man responsible for the charter was Robert Morris, the first Superintendent of Finance. The bank's charter was allowed to expire in 1811. A second Bank of North America was later formed and became nationalized on December 4, 1864. The members of Congress at that time thought it fitting that the only bank to be chartered by the Continental Congress should retain its original title.

The Bank of North America was liquidated on February 28, 1923, and therefore issued only large-size notes. All are scarce and of great historical interest.

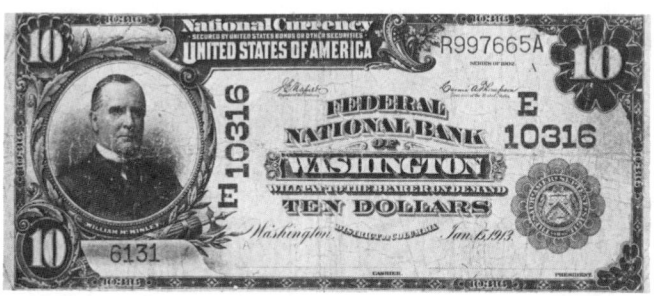

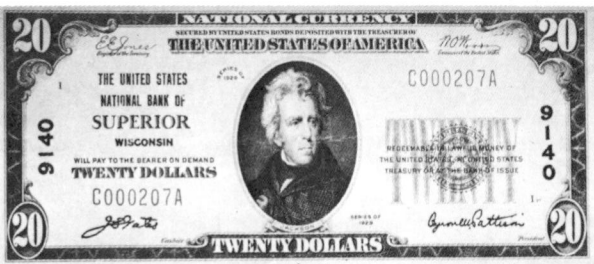

Forbidden Titles

National bank notes that used "United States," "Federal," or "Reserve" as part of their title were discouraged by the passage of the Federal Reserve Act of 1913. Titles that included these words were forbidden altogether by the Act of May 24, 1926. Nevertheless 33 banks were chartered with "United States" in their titles between 1863 and 1926; 19 issued notes. Six banks used "Federal," and four used "Federal Reserve" in their titles. All notes with forbidden titles are extremely desirable and very scarce.

Racketeer Note

The National Bank of the Republic of New York had 1000 as its charter number. The first notes issued by this bank under its second charter, with "1000" on the back, were sought after by swindlers, who tried to pass them to illiterate people as $1000 bills.

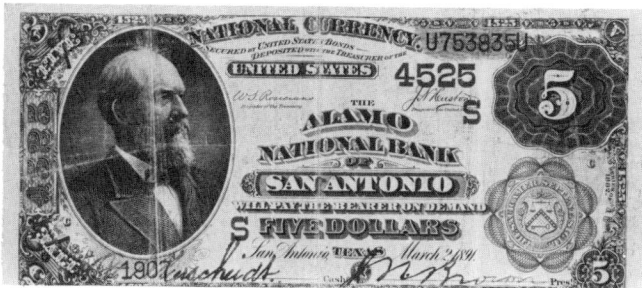

This $5 note from the historic city of the Alamo is a popular one.

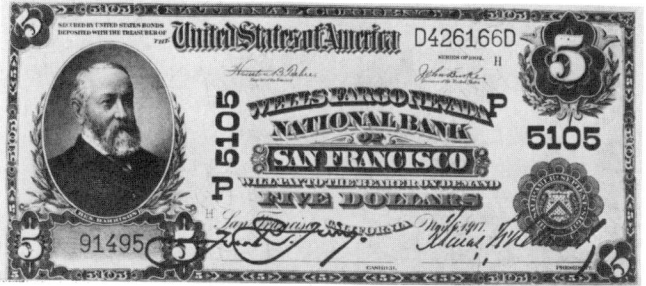

The Wells Fargo Nevada National Bank in San Francisco reminds us of stage-coach days.

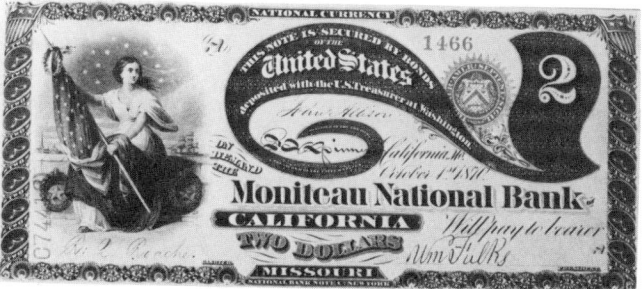

This note was issued in the colorful location of California, Missouri.

Jackson's Disappearing Fingers

Andrew Jackson made his first appearance on U.S. federal paper money on the $5 United States note, Series 1869. The portrait was engraved by Alfred Sealey.

A $10 note, Series 1923, bears a modified portrait of Jackson. The oval in which the portrait is framed is smaller and therefore covers part of the hand.

Prior to the printing of $20 notes, Series 1950E in 1957, wet paper had been used on flatbed presses. A certain amount of shrinkage took place as the mill-wet paper dried after being impressed with the printing plate, which were somewhat larger than the plates currently in use. To allow for this shrinkage, a new engraving of a larger portrait was prepared.

In order to retain the necessary size of Jackson's portrait on bills printed on dry paper, a retouched portrait was prepared. The most obvious change is the missing fingers.

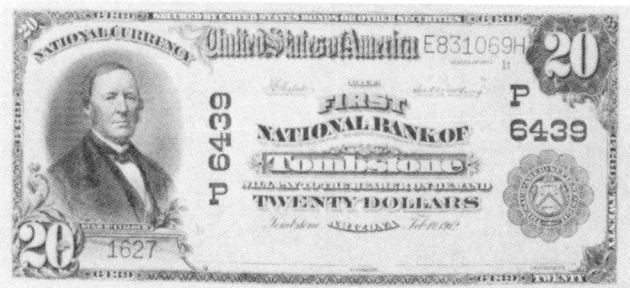

Tombstone, Arizona, the town too tough to die, was the scene of the gunfight at the O.K. Corral where Wyatt Earp and "Doc" Holiday fought the Clantons.

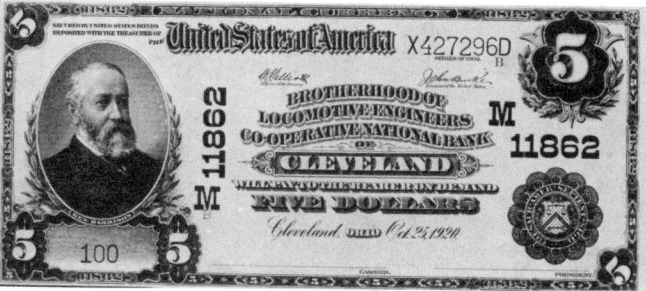

This note bears what is probably the longest title for any national bank note. For some notes with interesting serial numbers see the following numbers in this catalog: 1, 47, 68, 202 and 483.

The entire printing, cutting and banding of notes at the Bureau of Engraving and Printing is automated, including the process that checks for errors; in addition a minimal amount of examination is done. Nevertheless, mistakes occasionally slip through the system.

In order to understand how errors occur, it might be advisable to review just how currency is printed. Until recently sheets large enough to receive 32 impressions were fed into the presses to receive the back design. Stacks of these sheets were put aside for about 24 hours before they were turned over and again fed into the presses to imprint the face design. Following another 24–hour period, both sides of each sheet were inspected for errors. Next came the third or overprinting of treasury seal, district indicators and serial numbers. Stacks of 32–subject sheets were then cut in half, inspected, and cut again, ultimately into individual notes.

Now, face and back are printed simultaneously and sheets proceed on a journey of overprinting, cutting, examination and banding, all by COPE PAK. Nevertheless, to repeat, mistakes occasionally slip through the system. No two errors are exactly alike, but they may generally be categorized as being errors in one of the three basic processes described above: face or back printing, overprinting, or cutting. Many different errors are possible within each category. For example, mismatched serial numbers and missing seals are both overprinting errors, while ink smudges and double denomination notes are both the result of errors in the basic printing.

The values for different types of errors will depend largely upon the type and degree of the error. The values listed here for the errors are for low denomination notes. High denomination errors command a higher premium. Due to the nature of the error, many errors never circulate; consequently, these will only be priced in one condition.

Beware, some error notes can be fabricated. One common fake is a note with an off-color back, either blue or yellow. Such a note has never left the Bureau. These notes have been chemically treated by accident or design.

Notes from current uncut sheets of currency now sold by the Bureau of Engraving and Printing can be separated in a way to simulate a cutting error. Authenticity can be verified by submitting the serial number to the Bureau.

Many of the illustrations in this section were provided by Harry Jones, a paper money dealer who specializes in error notes.

Ink Smudge

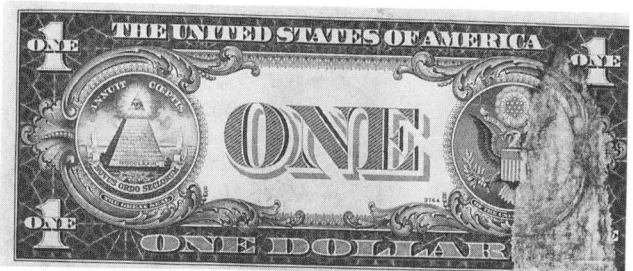

Either a portion of the plate lacked sufficient ink or a floating piece of debris caused these smudges. Both notes, showing the complete smudge, were found in the same pack.

The inked plate was not properly wiped; the result is a smudge across the portrait.

This printing plate was not sufficiently inked, the result was a ghostlike image of George Washington.

Description	EFine	Unc
Ink smudge (modest)	$15.	$25.
Insufficient ink	35.	90.

Offset Prints

The press probably started without the paper in position. The impression roller touched the entire engraved plate, and the sheet that followed received the full face impression of the back in retrograde. Subsequent printings will bear less and less of this error, and after a few impressions it will disappear.

This note received only a portion of the face offset onto the back.

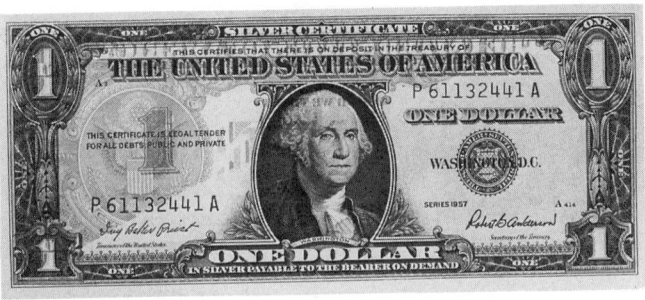

This face design received only a portion of the back offset onto the face.

Description	VFine	EFine	Unc
Offset prints (total)	$100.	$150.	$200.
Offset prints (partial)	65.	90.	150.

Paper Folds

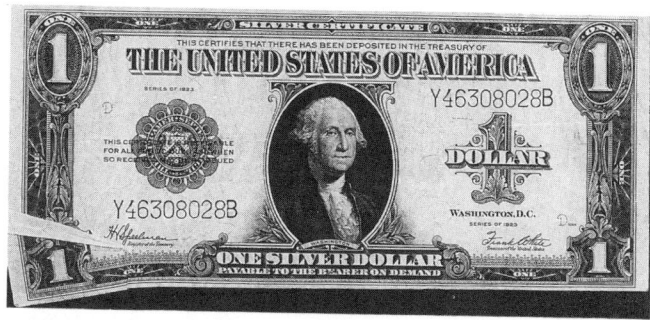

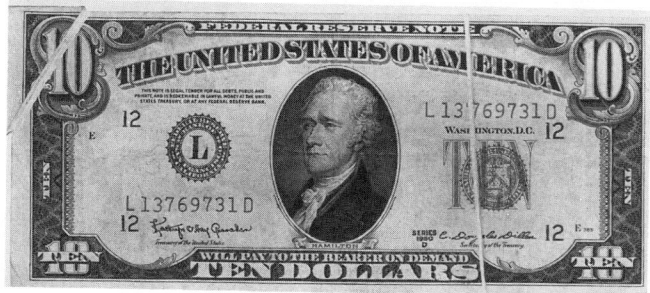

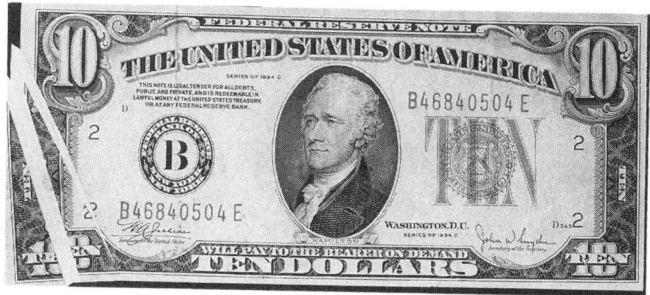

These notes, with folds in place, went through the printing operation undetected. Only after the notes entered circulation did the paper unfold.

Description	VFine	EFine	Unc
Fold (single)	$35.	$60.	$115.
Fold (multiple)	50.	90.	190.

Paper Fold with Faulty Overprint

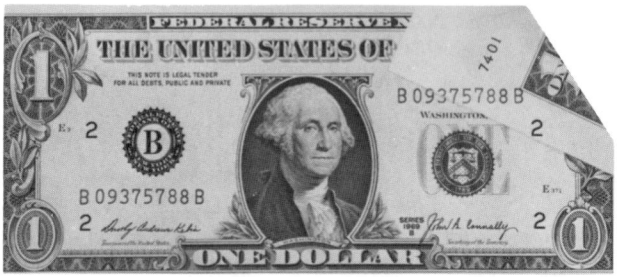

These photographs show the note as it received the initial printing and after the corner was unfolded. Normally the plate number on the outer edge is trimmed away. This type of error would probably be found only in uncirculated condition. The premium would be about $350.

$1.50 Origami Note

This unique error was discovered in a pack of new notes as it appears in the first photograph; there are three distinct folds.

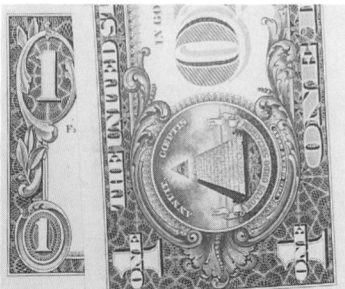

As the fold is undone, a partial face and portions of two backs are revealed.

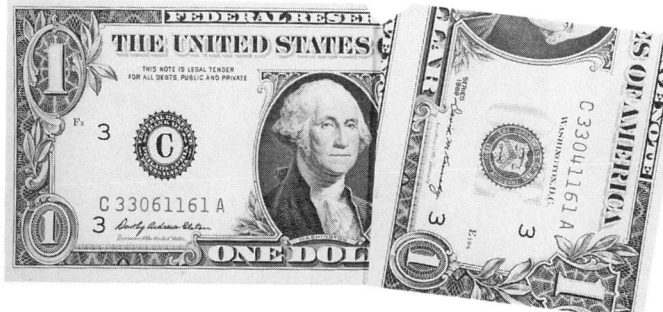

As the note is unfolded further, three-fourths of one face and one-half of a second is visible. The second illustration shows the back.

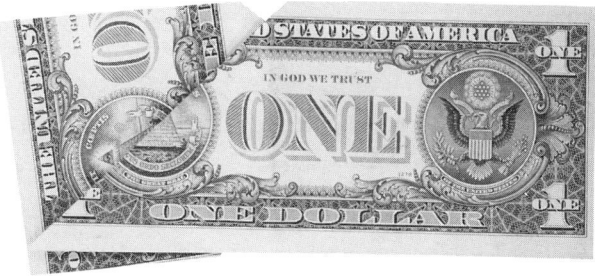

When totally unfolded, one-and-a-half notes are the result. As the sheet was being ejected, it became folded in an origami fashion and remained sandwiched between other sheets. The approximate value in uncirculated condition is about $850.

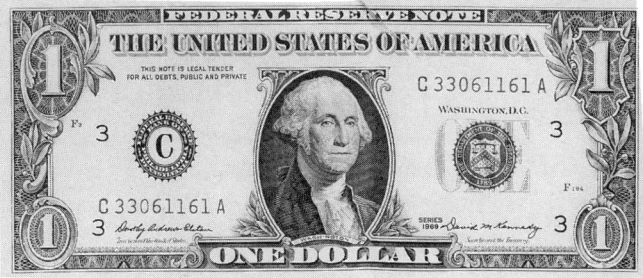

Overprint on Folded Note

The sheet from which this note came was folded when it was fed into the press for the overprint of seals and serial numbers. The second and third photographs show the note when unfolded. Value in uncirculated condition $1,000.

Paper Fold on Torn Sheet

Following normal face and back printing, the sheet from which this $20 note came developed a tear. The tear continued through the "W" in "TWENTY" on the face. The torn sheet became folded and received the overprinting of seal and serial numbers. Following the overprinting, the sheet straightened out and was properly cut. It entered circulation in two pieces. The note was found taped together.

Overprint only

This note completely lacks the initial, intaglio face printing. Two sheets probably adhered to one another but became separated before the overprinting of seals, serial numbers and Federal Reserve District number. This same error has been observed from other districts.

Description	Unc
Paper fold on torn sheet	$750.
Overprint only	300.

Double Denominations

After the backs were printed, sheets of one denomination were inadvertently placed with those of another denomination for the face printing.

Description	EFine	Unc
Double denomination	$3,500.	$5,000.

Adhering Loose Paper

Prior to 1957, when notes were wet-printed, paper dividers and tickets were inserted in counted stacks of paper destined for the Bureau of Engraving and Printing. Occasionally these tickets or another loose piece of paper would go unnoticed and adhere to the paper, sometimes throughout the entire printing and cutting operations. Only the adhering paper on the $1 note became separated.

Description	EFine	Unc
Adhering loose paper	$600.	$750.

Adhering Loose Paper

Immediately after this note received the serial number imprint and just before the overprint of the Federal Reserve seal was made, a tear-off section of a Band-Aid found its way onto the sheet, or was carefully placed there. This note entered circulation and most certainly is unique. Value about $1,000.

Mismatched Serial Number Prefix

The "A" and "Q" prefix suggest a serious malfunction with the numbering cylinder.

Mismatched Serial Numbers

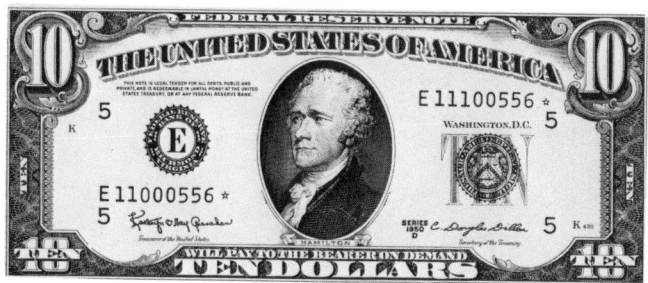

This star note was meant to replace an error note, yet it also bears an error, a mismatched serial number.

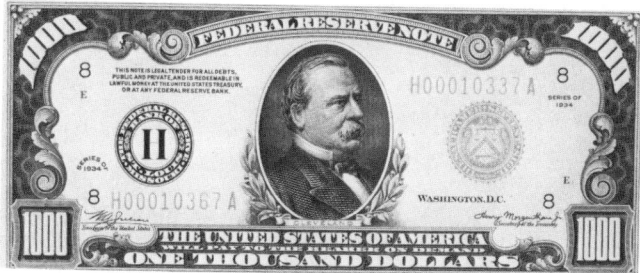

High denomination errors are rare. (Premiums do not include face value.)

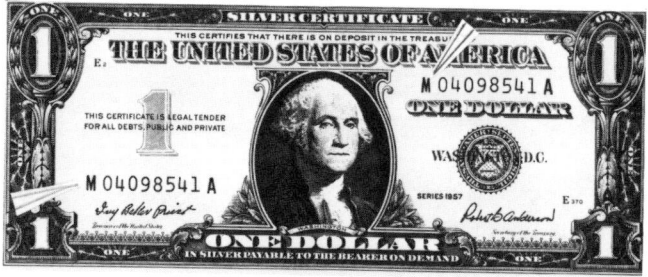

This error was noticed and marked with the correct number. It nevertheless entered circulation.

Description	VFine	EFine	Unc
Mismatched prefix or suffix	$50.	$ 75.	$200.
Mismatched replacement number	85.	150.	375.

Numbering Cylinder Malfunction

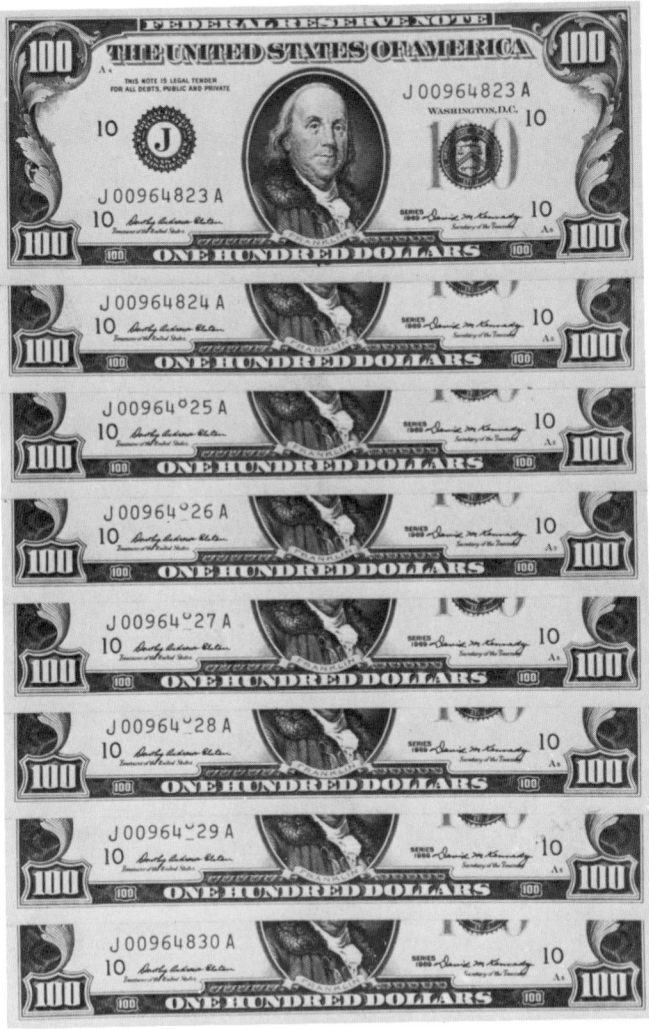

The numbering cylinder malfunctioned as the top note illustrates. It gradually corrected itself. The value for the sheet is $3,000.

Misaligned Overprint

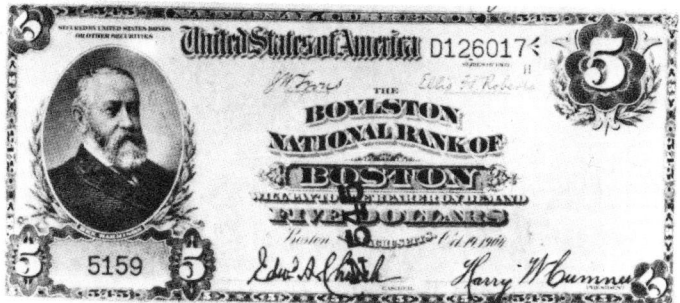

The overprint of seals and serial numbers are too far to the right.

Inverted Overprint

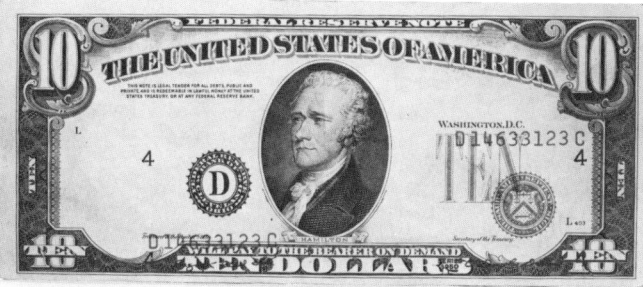

Both seal and serial numbers have been inverted.

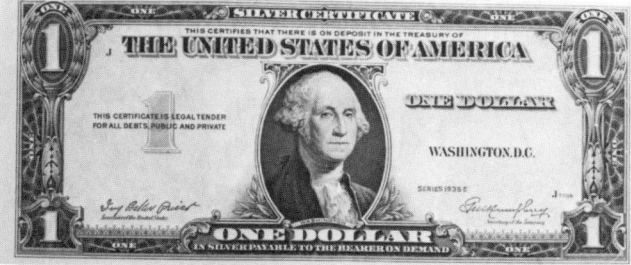

The entire overprint is missing on this gold certificate.

Description	VFine	EFine	Unc
Misaligned overprint	$50.	$ 90.	$150.
Inverted overprint	50.	100.	175.
Missing overprint	50.	100.	200.

Off-Center Notes

Faulty alignment during the cutting operation produced these errors. Notes are always cut and trimmed with the face showing. Nevertheless, the $1 is the most common off-center note to be found.

Description	EFine	Unc
Off-center, 10%	$ 50.	$125.
Off-center, 20%	85.	175.
Off-center, 30%	125.	250.

Modern-day souvenir cards usually commemorate an event, and most often are issued at a numismatic or philatelic meeting or convention; here we are concerned only with the former. There are forerunner cards, those issued prior to 1960. Nevertheless, it was at this time that cards specifically intended for collectors were created.

In the United States, "official" souvenir cards are issued regularly by the Bureau of Engraving and Printing. The bank note designs on these cards are printed from the original, intaglio-engraved plates. They are often the only way one can obtain notes that are either uncollectible or extremely rare. "Semi-official" cards are offered irregularly by American Bank Note Company (ABNCo) and the unions and guilds that make up the artisans who are employed by the Bureau and ABNCo. Due to the subject matter in this catalog only the official cards that portray U.S. paper money subjects are listed. The one exception to this is the 1981 International Plate Printers, Die Stampers and Engravers Union of North America card that features the unissued $2 design for the 1861 United States note.

Souvenir cards prepared and issued by ABNCo are no less beautiful, but the notes they portray are U.S. obsolete notes or those originally printed for foreign governments and banks. All official and semi-official cards are listed in *The Souvenir Card Collectors Society Numbering System.*

Souvenir cards, usually lithographed, are offered by the host organization to raise money or cover expenses incurred by a local numismatic club. These cards should never be compared to those prepared by the aforementioned sources.

A brisk secondary market has been established for all engraved official and semi-official souvenir cards, the earliest of which originally sold for only a few dollars. The Souvenir Card Collector Society (SCCC), established in 1981, issues a quarterly journal devoted to all types of souvenir cards. The secretary of the society is Dana M. Marr, who can be reached at P.O. Box 4155, Tulsa, OK 74159–0155. Annual dues are $20.

The numbering system used here is the one adopted by the SCCC and is used with the society's permission. The number in parenthesis is the one that relates to that design in this catalog; the number in italics represents a back design.

No.		Printed	Sold	Current $ Value	No.		Printed	Sold	Current $ Value
F1981B	(953)	unknown		40.	B103	(TN)	unknown	10,454	10.
PS1	(274)	unknown	10,391	300.	B104	(316)	unknown	7,409	12.
B2	(951)	12,400	12,347	65.	B105	(842)	unknown	7,259	10.
B7	(collage)	12,017	12,013	95.	B106	(178)	unknown	8,069	10.
B12	(45)	54,721	54,694	4.	B108	(605)	7,500	5,309	10.
B18	(185)	74,172	69,078	4.	B109	(seals)	2,500	2,365	10.
B24	(358)	49,544	49,530	7.	B111	(372)	7,500	5,317	10.
B29	(SE21*)	72,000	41,591	10.	B112	(1629)	7,500	unknown	10.
B31	(36)	28,039	28,022	22.	B114	(1470)	10,000	unknown	10.
B32	(45)	54,981	45,593	10.	B115	(361)	10,000	unknown	10.
B35	(1246)	55,380	50,000	10.	B116	(203)	10,000	unknown	10.
B38	(185)	unknown	38,636	8.	B119	(620)	10,000	unknown	10.
B41	(361)	69,556	57,806	4.	B121	(1043)	10,000	unknown	10.
B44	(497)	53,615	28,004	5.	B124	(1435)	10,000	unknown	10.
B46	(358)	25,638	21,933	18.	B125	(1461)	unknown		10.
B47	(483)	35,792	30,907	12.	B126	(269)	unknown		10.
B53	(834)	22,000	19,482	15.	B129	(1411)	unknown		10.
B54	(349)	26,100	19,417	10.	B130	(1151)	unknown		35.
B56	(1163)	26,300	10,385	10.	B132	(S103)	unknown		12.
B57	(90)	20,690	9,195	15.	B133	(SE19*)	5,800	5,800	10.
B59	(1242)	28,900	8,521	20.	B135	($2)	5,800	5,800	10.
B61	(850)	unknown	9,072	18.	B136	(SE3*)	5,800	5,800	10.
B64	(15)	unknown	6,874	20.	B139	(612)	9,500	unknown	10.
B69	(1465)	unknown	15,446	20.	B140	(1411)	unknown		10.
B71	(1361)	unknown	10,580	10.	B143	(197)	unknown		10.
B75	(827a)	unknown	6,024	10.	B144	(929)	8,500	unknown	12.
B77	(987)	unknown	6,447	10.	B145	(704)	8,500	unknown	10.
B79	(1044)	unknown	5,551	10.	B146	(243)	3,000	unknown	35.
B81	(1465)	unknown	7,465	10.	B147	(167)	8,500	unknown	8.
B82	(1361)	unknown	8,749	10.	B148	(843)	8,500	unknown	8.
B84	(533)	unknown	6,723	10.	B149	(1435)	8,500	unknown	8.
B87	(1242)	unknown	6,791	10.	B150	(243)	3,000	unknown	35.
B88	(483)	unknown	6,557	10.	B153	(LE5*)	3,000	unknown	6.
B93	(316)	unknown	7,264	10.	B154	(5)	unknown		6.
B94	(1506)	unknown	5,187	10.	B155	(1380)	unknown		6.
B98	(605)	unknown	7,537	10.	B157	(243)	3,000	unknown	35.
B99	(1628)	unknown	6,460	10.	B158	(380)	unknown		6.
B100	(1493)	unknown	7,278	10.	B159	(274)	unknown		6.
B102	(5)	unknown	7,654	10.	B160	(243)	3,000	unknown	35.

Remarks: No. B103 is a $500,000,000 treasury note. No. B132 has an engraving of *Chief Hollow Horn Bear* as seen on the $10 military payment certificate Series 692. No. B133 is an altered design for No. 185 in this catalog. Nos. B150, B157 & B160 bear the same design; each is printed in a different color.

* This is illustrated in Hessler (1979).

TERRITORIES AND POSSESSIONS

Numerous paper money issues have circulated in territories and possessions of the United States. The territories and possessions and the paper money that circulated there are all important to the history of the United States.

ALASKA

"Seward's Folly" was the name given to the $7.2 million purchase of Alaska from the Imperial Russian Government in 1867. William H. Seward, who negotiated the purchase as Secretary of State, took much abuse for his "icebox," but he has since been vindicated a thousand times over. Alaska became the 49th state of the Union in 1958.

Alaska and its outlying islands were surveyed by explorers James Cook, George Vancouver, Alexander MacKenzie and Vitus Bering under the auspices of the Czar's Imperial Russian government. In 1790 a joint venture was formed by royal charter, called the Russian-American Company, to exploit the natural resources of Alaska. Trading in furs, skins and ivory was brisk. The company issued an unusual currency printed on walrus skin between 1818 and 1825. The notes, called seal skin notes, were in denominations of 10, 25 and 50 kopecks as well as 1 and 25 rubles.

Before 1938 privately issued tokens and scrip circulated in Alaska in addition to regular U.S. currency. Large- and small-size national bank notes for Alaska are extremely scarce and in great demand.

No. 316.

No. 390.

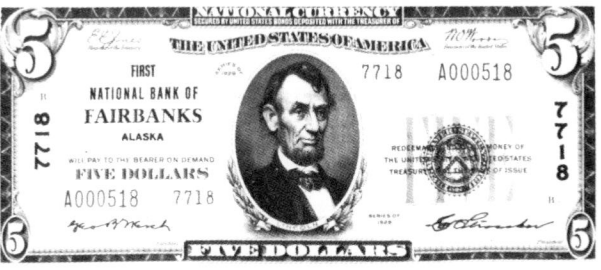

HAWAII

Today, tourists who visit Hawaii are welcomed with a lei, a wreath of friendship. Captain James Cook, who sailed to the Hawaiian Islands in 1778, received a shower of spears as a welcome; his death site is marked by a monument.

Christian missionaries arrived in Hawaii in large enough numbers to discourage such a hostile reception. In 1840 the missionaries persuaded King Kamehameha III to declare his kingdom a constitutional monarchy. In 1893, with the deposition of Queen Liliuokalani, a provisional government was formed under American control. In 1898 Hawaii was annexed to the United States. It became a territory in 1900 and a state in 1959.

The first paper money to be issued by American authority for Hawaii was the second charter national bank notes. A few large- and small-size national currency notes are scarce, but most are extremely rare. Bank notes that bore a "HAWAII" overprint were used during World War II, to insure identification should they fall into enemy hands. These notes are listed under $1 silver certificates and $5, $10 and $20 Federal Reserve notes.

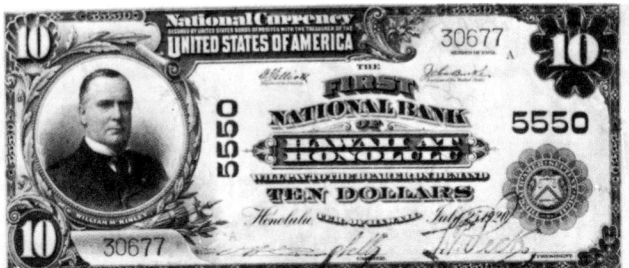

No. 561

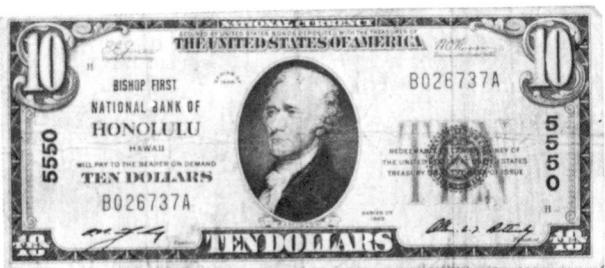

No. 627

THE PHILIPPINES

As a spoil of the 1898 Spanish-American War, the United States took control of Spanish possessions in the Caribbean and the Pacific. The war ended with the destruction of the Spanish battleships in Manila Harbor. By 1901 the American government had successfully replaced Spanish rule. On July 4, 1946 the Philippine Islands gained their independence when they became the Republic of the Philippines.

Spanish-Philippine currency is dated as early as 1852. In 1903 the first bank notes under American rule were issued. Four types of notes circulated from 1903 until independence: silver certificates, Philippine National Bank circulating notes and Bank of the Philippine Islands notes. All four were printed by the United States Bureau of Engraving and Printing.

Fearful that new Philippine silver certificates would be confused with those of the United States (two Philippine pesos equalled a U.S. dollar), notes smaller in size were prepared. The size of current U.S. currency grew out of this concept. However it took 25 years to be put into effect. For more information on all Philippine issues see *A Guide Book of Philippine Paper Money* by Neil Shafer.

Silver Certificates (1903–1918)

In 1906 the redemption clause was changed, whereby silver certificates were redeemable "in silver pesos or in gold coin of the United States of equivalent value." Originally these notes were redeemable only in silver pesos.

Series	Peso Notes Issued	Series	Peso Notes Issued
1903	2, 5 and 10	1910	5
1905	20, 50, 100 and 500	1912	10
1906	2 and 500	1916	50 and 100
1908	20		

THE PHILIPPINES

Silver Certificates

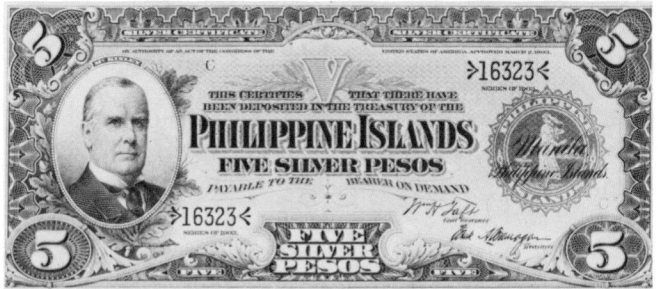

Series 1903 with a portrait of William McKinley.

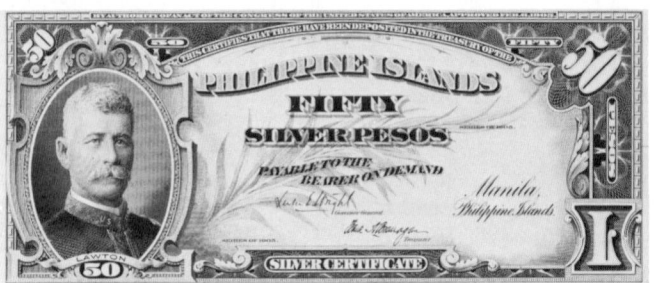

Series 1905. This specimen note bears the portrait of General Henry W. Lawton engraved by G.F.C. Smillie.

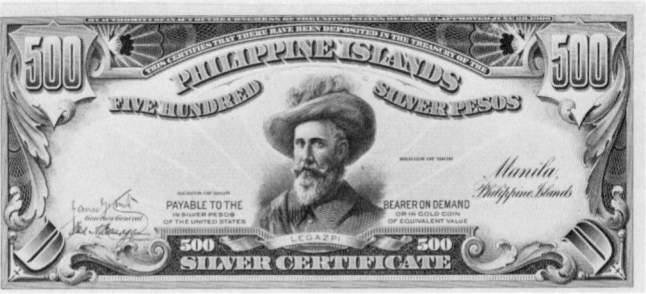

Series 1906. The illustrated specimen note bears the G.F.C. Smillie portrait engraving of the first Spanish Colonial Governor, Miguel Lopez de Legazpi.

Back for the preceding.

THE PHILIPPINES

Treasury Certificates

Treasury certificates replaced silver certificates on August 1, 1918. The 1936 notes reflected the Commonwealth status, which had come in 1935. "Philippines" replaced the legend "Philippine Islands" on earlier notes; a new seal was also introduced. The 1944 issue was overprinted "VICTORY" for General MacArthur's return.

Series	Peso Notes Issued	Series	Peso Notes Issued
1918	1, 2, 5, 10, 20, 50, 100 & 500	1936	1, 2, 5, 10, 20, 50, 100 & 500
1924	1, 2, 5, 10 & 100	1941	1, 2, 5, 10 & 20
1929	1, 2, 5, 10, 20, 50, 100 & 500	1944	1, 2, 5, 10, 20, 50, 100 & 500

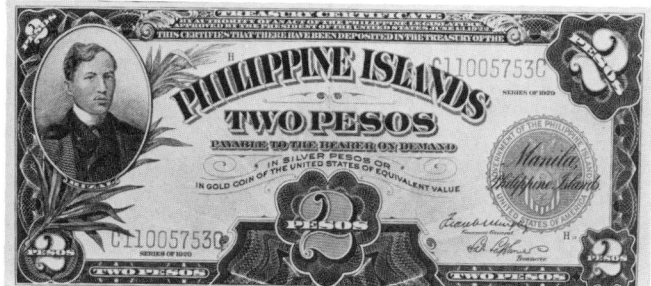

Series 1929. The portrait of José Rizal was engraved by G.F.C. Smillie.

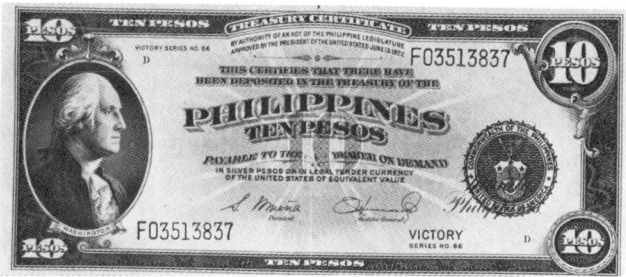

Series 66 (1944). C.A. Huston designed this note; John Eissler engraved the Washington portrait.

Back for the preceding.

THE PHILIPPINES

Philippine National Bank Circulating Notes

The Philippine National Bank came into existence through the effort of William A. Jones, whose portrait appears on the 20 peso note. Charles Conant, the man who was instrumental in setting up the Philippine currency system is depicted on the 1 peso note. These national bank circulating notes were used until they were withdrawn on June 1, 1948. They were redeemable for one additional year.

Series	Peso Notes Issued	Series	Peso Notes Issued
1916	2, 5 & 10	1920	50 & 100
1917*	10, 20 & 50 centavos, & 1 peso	1921	1, 2, 5, 10 & 20
1918	1	1924	1
1919	20	1937	5, 10 & 20

* These emergency notes were printed in the Philippines.

Series 1918. The portrait of C.A. Conant was engraved by M.W. Baldwin.

Back for the preceding.

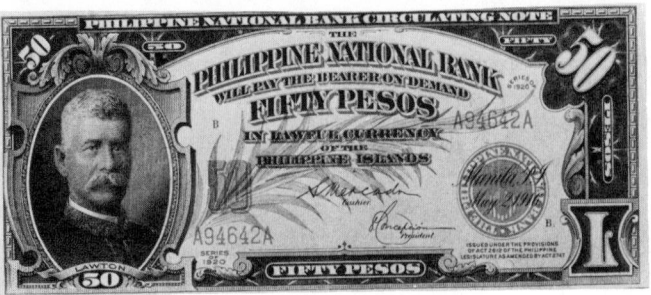

Series 1920. The portrait of Henry W. Lawton was engraved by G.F.C. Smillie

THE PHILIPPINES

Philippine National Bank Circulating Notes

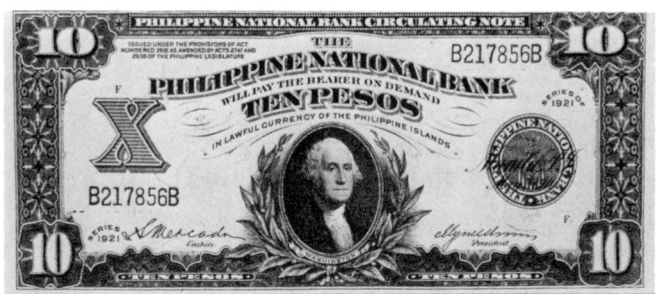

Series 1921 with a portrait of George Washington.

Back for the preceding.

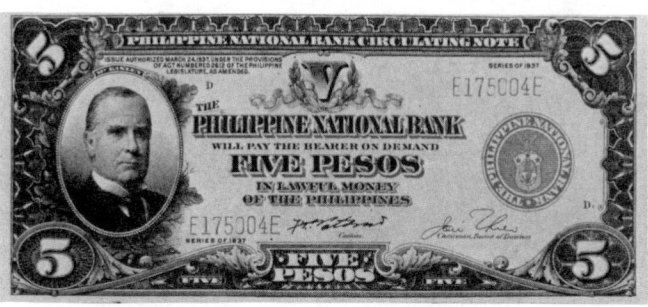

Series 1937 with a portrait of William McKinley.

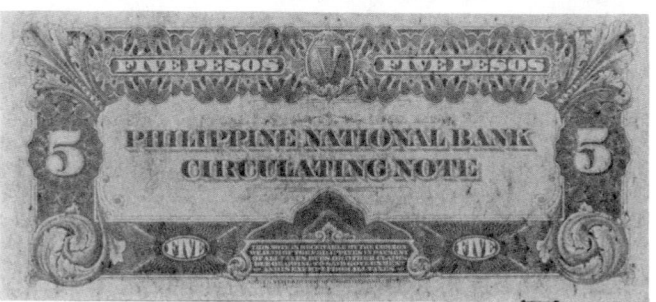

Back for the preceding.

THE PHILIPPINES

Bank of the Philippine Islands

In 1852 the Banco Español-Filipino was established; in 1908 the Spanish title was changed to the Bank of the Philippine Islands. When World War II began these notes were withdrawn from circulation.

Series	Peso Notes Issued	Series	Peso Notes Issued
1908*	5, 10, 20, 50, 100 & 200	1928	5, 10, 20, 50, 100 & 200
1912	5, 10, 20, 50, 100 & 200	1933	5, 10 & 20
1920	5, 10 & 20		

* This issue bears the original Spanish title.

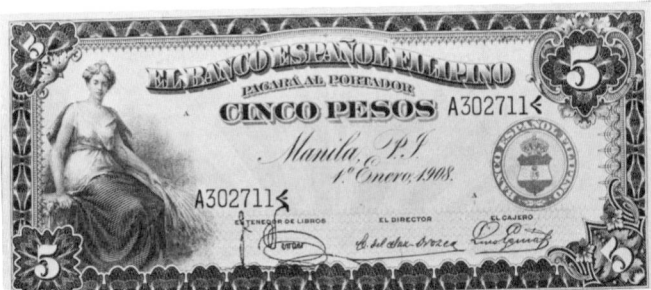

Series 1908.

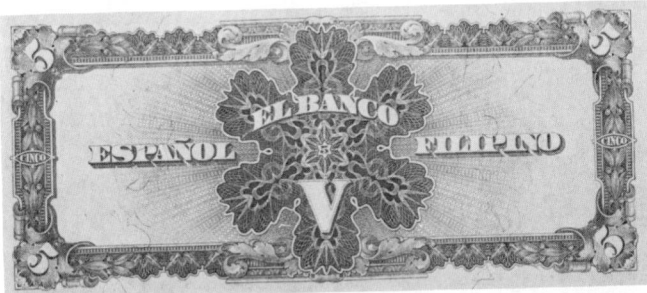

The back for the preceding.

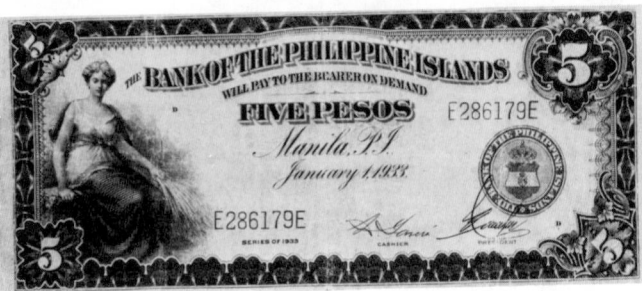

Series 1933.

PUERTO RICO

Puerto Rico, the "rich port" of the West Indies, was claimed as a territory of the United States after the Spanish-American War in 1898. The tropical island had become a province of the Spanish Empire after Columbus landed there in 1493. In 1590 Juan Ponce de León became Puerto Rico's first governor.

Paper money was issued by the Spanish authorities in Puerto Rico as early as 1813. In 1900, after Puerto Rico had become an American possession by the terms of the Treaty of Paris, notes with that date were overprinted as "MONEDA AMERICANA." These overprinted notes are sometimes collected along with the special notes issued by the United States for the territory. National bank notes were printed for use in "Porto Rico," but these large-size notes are extremely rare.

Beginning on January 1, 1899, United States coins and currency became the official money of Puerto Rico. The Spanish 25 peseta and French 20 franc gold pieces had been the only money acceptable for customs, taxes and postage. The native Puerto Rican coinage, which closely resembled that of Spain, was gradually withdrawn and melted. Today, the Territory of Puerto Rico uses U.S. coins and currency.

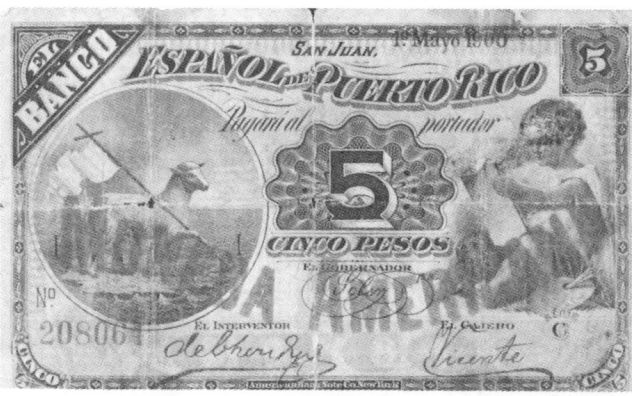

The 5 peso note dated 1900, overprinted "MONEDA AMERICANA," was printed by American Bank Note Co.

Back for the preceding.
(Courtesy of David Tang)

PUERTO RICO

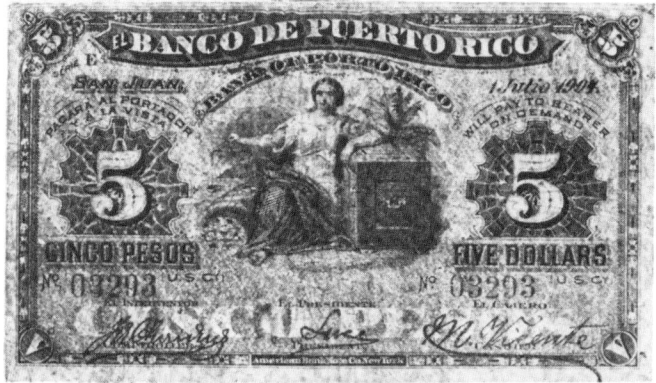

Moneta, the goddess of money, appears on this 1904 issue printed by American Bank Note Co.

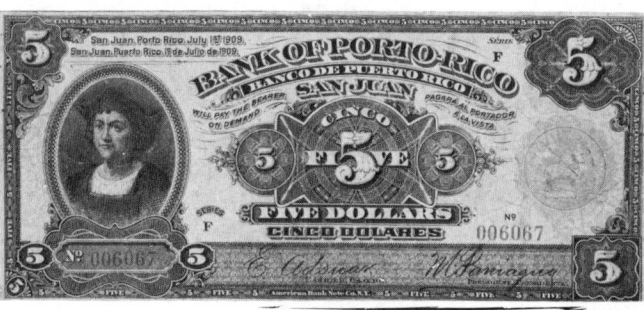

The Versailles portrait of Christopher Columbus appears on this 1909 issue printed by American Bank Note Co.

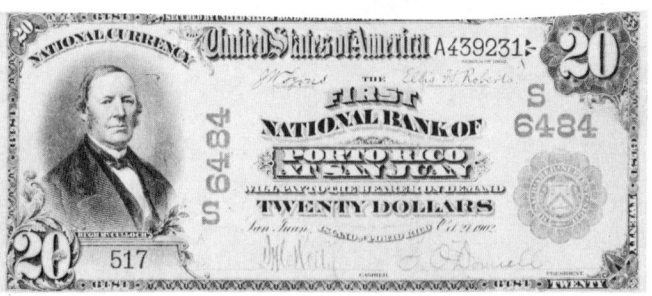

U.S. national bank notes issued in "Porto Rico" are extremely rare. (See No. 773)

THE UNITED STATES VIRGIN ISLANDS

On his second voyage to the New World in 1493, Christopher Columbus sailed to a group of islands that he named after the Virgin Mary. The Virgin Islands group consists of Saint Thomas, Saint John and Saint Croix, plus a number of smaller islands.

In 1671 the Danish West India Company claimed the islands in the midst of Spanish possessions. After the close of the Civil War, the United States realized the need for a strategic base in the West Indies. Negotiations for the purchase of the islands began in 1867 and ended in 1917. When World War I had begun and the concern about German submarines and raiders made the need for a naval base even more necessary.

The National Bank of the Danish West Indies had been in existence since 1905. Under the new American rule, the bank was granted permission to continue to issue 5, 10, 20 and 100 franc gold certificates; all were withdrawn in 1934. These notes are especially desirable to some collectors. They are printed in two languages (Danish and English), bear the portrait of a foreign monarch (King Christian IX of Denmark) and were legal tender in the United States.

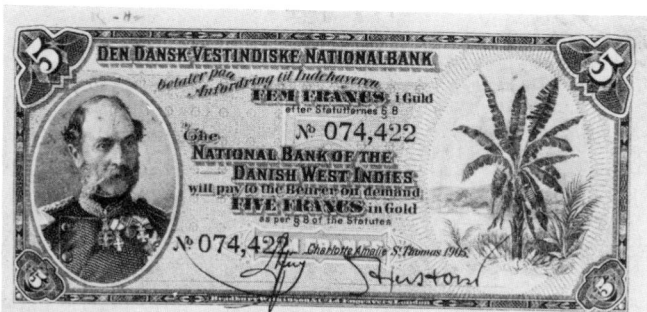

The portrait of King Christian IX of Denmark appears on all 1905 gold certificates printed by Bradbury Wilkinson & Co. Ltd.

A new world of collecting was opened to the syngraphist after World War II. The victorious United States found itself occupying large areas of countries whose economies were in a state of collapse. At that time United States overseas military personnel were being paid in local currencies, which could later be changed into American dollars. This system resulted in the conversion to dollars of vast amounts of francs and marks. Some United States servicemen added to their supply of convertible currency by doing a brisk business in cigarettes, silk stockings, candy bars, etc.

The need for new currency was fulfilled by United States military payment certificates, valid only in specified areas under the complete control of the occupying military authority. These certificates were issued to American military and civilian personnel. The first issue, Series 461, was released on September 16, 1946.

These new notes differed from regular United States bills in that they were not printed by engraved plates at the Bureau of Engraving and Printing. Instead, they were lithographed by private printing firms on a paper different from that used for regular currency from plates prepared at the BEP. The paper was imbedded with planchettes of small, colored discs rather than with colored threads. Thus, there is a similarity to the first printing of the federal greenbacks, in that both the military payment certificates and the first greenbacks were printed by private firms rather than by the government itself. Tudor Press,Inc. of Boston printed Series 461, 471, 472 and 541; Forbes Lithographic Co., also located in Boston, printed Series 481, 521 and 591. Series 611, issued on January 6, 1964, and those that followed, were printed by the Bureau of Engraving and Printing.

As with regular United States paper money, certain notes are prepared to replace defective ones. Military payment certificate replacement notes have a separate numbering sequence and are easily identified since the suffix letter is deleted.

It was periocically necessary to recall all circulating military payment certificates and issue a new series. Change-over, or C-Day, was quietly put into operation and completed within a 24–hour period. Counterfeiters, black market operators, and unauthorized holders of these military certificates were thereby caught off guard. Although two Series, 691 and 701, have been printed and are in storage for a time of need, military payment certificates are no longer in circulation anywhere in the world.

See the bibliography for the S(chwan) number reference.

Size of Certificates

5¢ through 50¢: 110×55 mm.
$1: 112×66 mm.
$5, Series 461 through 481: 156×66 mm.
$5, Series 521 and subsequent issues: 136×66 mm.
$10 and $20: 156×66 mm.

Series 461, issued September 16, 1946, withdrawn March 10, 1947.

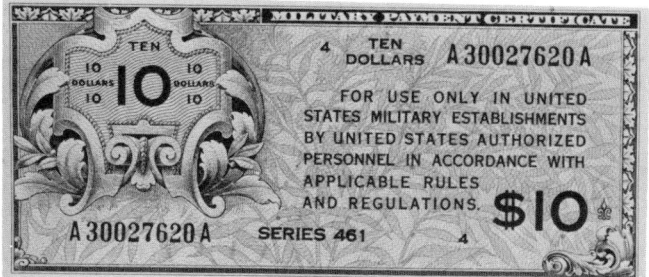

Face: grey, aqua and black.

Back: reddish-tan.

S No.	Denomination	Certificates Printed	VFine	EFine	Unc
11	.05	7,616,000	$ 4.	$10.	$ 60.
11☆		16 reported	–	–	–
12	.10	8,064,000	4.	10.	60.
12☆		16 reported	–	–	–
13	.25	4,704,000	6.	15.	80.
13☆		4 reported	–	–	–
14	.50	4,032,000	8.	15.	100.
14☆		5 reported	–	–	–
15	1.00	14,566,000	5.	12.	85.
15☆		12 reported	–	–	–
16	5.00	5,400,000	20.	40.	160.
16☆		7 reported	–	–	–
17	10.00	40,800,000	20.	40.	155.
17☆		8 reported	–	–	–

Series 471, issued March 10, 1947, withdrawn March 22, 1948.

Face: aqua and red.

Back: blue and red.

S No.	Denomination	Certificates Printed	VFine	EFine	Unc
18	.05	2,288,000	$ 8.	$ 18.	$ 65.
18☆		3 reported	–	–	–
19	.10	7,616,000	10.	30.	65.
19☆		8 reported	–	–	–
20	.25	4,480,000	10.	30.	125.
20☆		4 reported	–	–	–
21	.50	4,032,000	20.	35.	160.
21☆		2 reported	–	–	–
22	1.00	14,560,000	25.	40.	190.
22☆		7 reported	–	–	–
23	5.00	5,400,000	750.	1,800.	5,500.
23☆		2 reported	–	–	–
24	10.00	13,600,000	275.	400.	1,500.
24☆		2 reported	–	–	–

Series 472, issued March 22, 1948, withdrawn June 20, 1951.

Face: aqua and black.

Back: violet and brown.

S No.	Denomination	Certificates Printed	VFine	EFine	Unc
25	.05	7,968,000	$ 1.	$ 2.	$ 5.
25☆		26 reported	–	–	–
26	.10	7,960,000	1.	6.	40.
26☆		21 reported	–	–	–
27	.25	4,824,000	3.	12.	80.
27☆		none reported	–	–	–
28	.50	4,232,000	8.	15.	120.
28☆		6 reported	–	–	–
29	1.00	11,760,000	10.	25.	150.
29☆		14 reported	–	–	–
30	5.00	4,200,000	95.	200.	1,200.
30☆		1 reported	–	–	–
31	10.00	11,600,000	30	100.	1,000.
31☆		3 reported	–	–	–

Series 481, issued June 20, 1951, withdrawn May 25, 1954.

Face 50¢: aqua and black. *Commerce* was engraved by Marcus W. Baldwin.

Back: purple and blue.

Face $1: pale blue-green and brown. The allegorical figures of *Composition and Reflection* by Bela Lyon Pratt can be seen on the Tradition Door of the Library of Congress.

Back: deep blue and purple

Series 481 *(continued)*

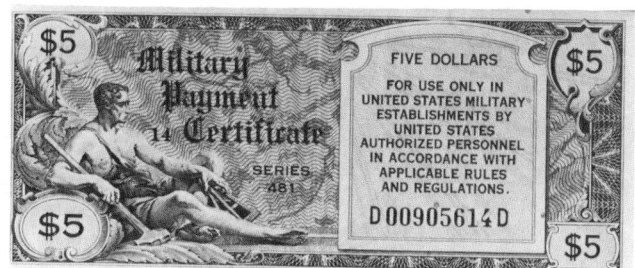

Face, $5, Series 481: pale blue-green and brown. (See No. 987.) The back is blue and violet.

S No.	Denomination	Certificates Printed	VFine	EFine	Unc
32	.05	23,968,000	$ 3.	$ 5.	$ 20.
32☆		18 reported	–	–	–
33	.10	23,064,000	4.	5.	22.
33☆		25 reported	–	–	–
34	.25	14,776,000	4.	8.	40.
34☆		15 reported	–	–	–
35	.50	10,032,000	8.	20.	90.
35☆		1 reported	–	–	–
36	1.00	25,480,000	9.	20.	100.
36☆		8 reported	–	–	–
37	5.00	8,600,000	100.	200.	1,000.
37☆		none reported	–	–	–
38	10.00	24,800,000	95.	175.	750.
38☆		4 reported	–	–	–

Series 521, issued May 25, 1954, withdrawn May 27, 1958.

Face 25¢: green and tan.

Back: green and tan. The female head was engraved by A.L. Wasserback.

Remarks: The designs are the same for the 5¢, 10¢ and 50¢ notes. The colors are: 5¢ face, yellow and green with blue print, back, yellow with blue print; 10¢ face, blue and green with violet print, back, pale blue with violet print; 50¢, violet with pale green print for face and back.

Series 521 *(continued)*

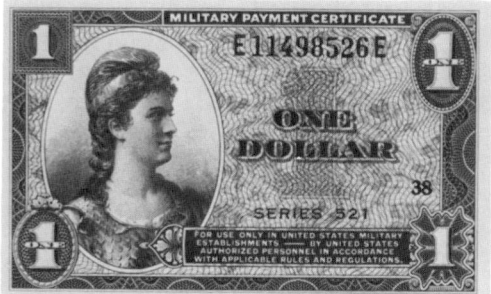

Face $1: orange, pale blue and brown. *Liberty* was engraved by G.F.C. Smillie.

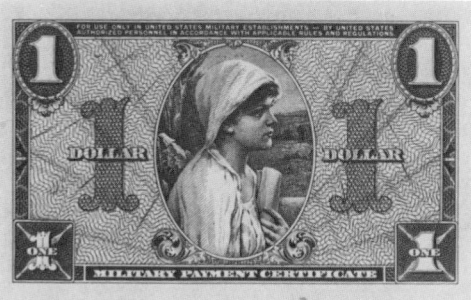

Back: pale blue and brown. The female profile was engraved by John Eissler.

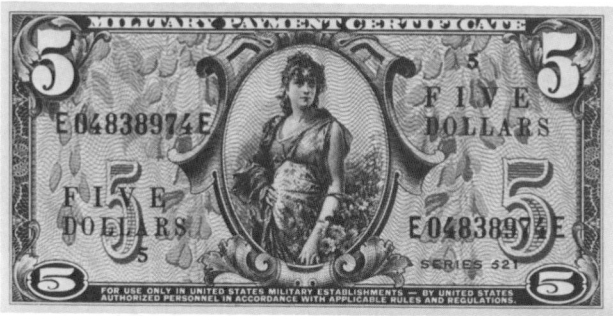

Face $5: violet, green and blue. *Flowers of the South* was engraved by L.S. Schofield and D.S. Ronaldson.

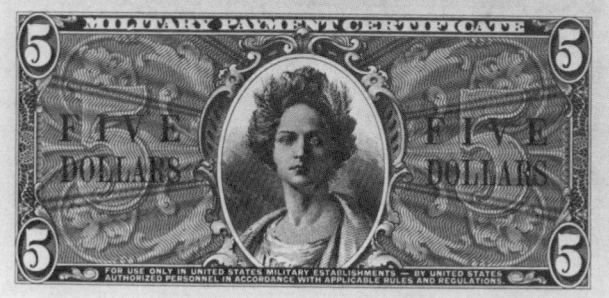

Back: violet and blue. The female head was engraved by G.F.C. Smillie.

Series 521 *(continued)*

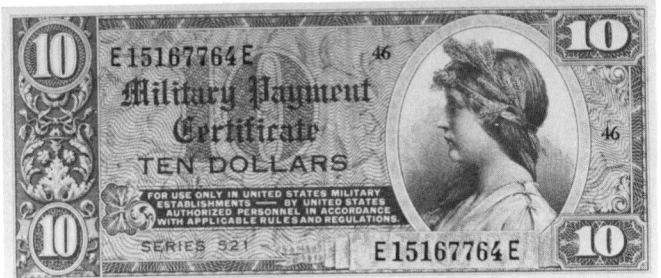

Face $10: gold, pale blue and reddish-tan. *Ceres*, based on *Antique Poesy* by J. Lefebvre, was engraved by G.F.C. Smillie.

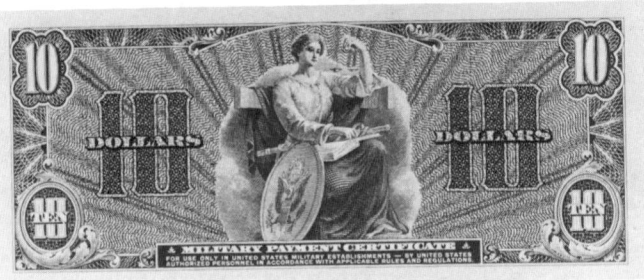

Back: reddish-tan and blue. *Justice* was engraved by Marcus W. Baldwin.

S No.	Denomination	Certificates Printed	VFine	EFine	Unc
39	.05	27,216,000	$ 2.	$ 5.	$ 20.
39☆		20 reported	–	–	–
40	.10	26,880,000	3.	6.	22.
40☆		12 reported	–	–	–
41	.25	14,448,000	5.	10.	55.
41☆		10 reported	–	–	–
42	.50	11.088,000	6.	15.	80.
42☆		7 reported	–	–	–
43	1.00	28,000,000	5.	18.	80.
43☆		8 reported	–	–	–
44	5.00	6,400,000	200.	300.	1,500.
44☆		7 reported	–	–	–
45	10.00	24,400,000	150.	300.	1,200.
45☆		3 reported	–	–	–

Series 541, issued May, 1958, withdrawn May 26, 1961.

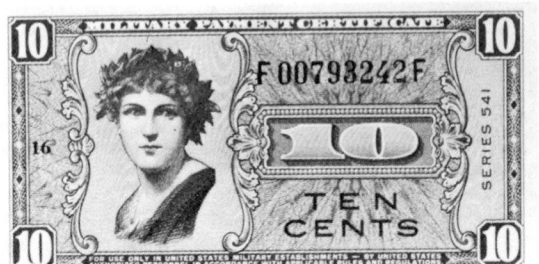

Face 5¢: green and violet. Back: pale green and violet.

Face 10¢: orange and green. The female portrait was engraved by A.L. Wasserback.

Series 541 *(continued)*

Back 10¢: orange and green.

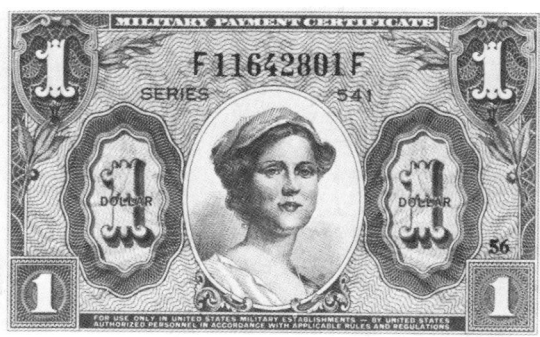

Face $1: gold, green and blue. The female was engraved by E.J. Hein.

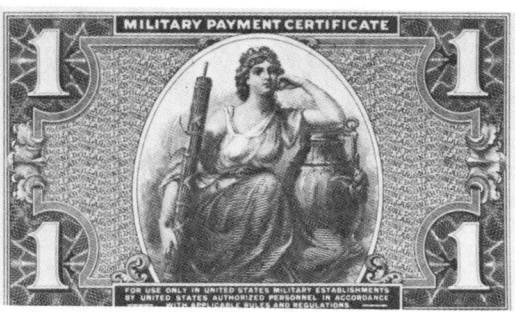

Back: gold and blue. The *Female with Fasces* was engraved by G.F.C. Smillie.

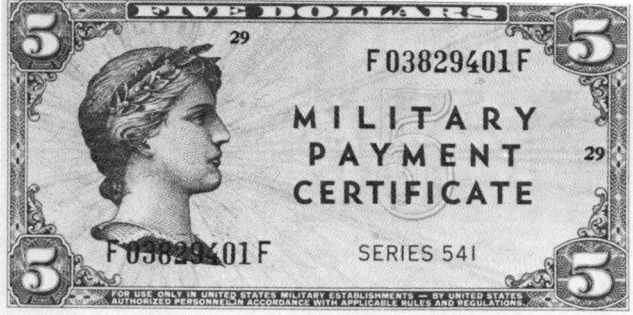

Face $5: yellow, green and red.

Remarks: The designs are the same for the 5¢, 25¢ and 50¢ notes. The colors are: 5¢ face, green with violet print, back, pale green with violet print; 25¢ face, green and pink with blue print, back, pink with blue print; 50¢ face, green and yellow with red print, back, yellow with red print.

Series 541 *(continued)*

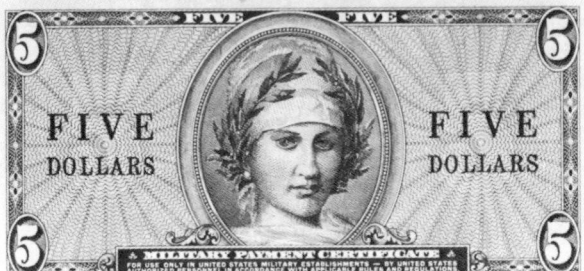

Back $5: pale green and red. The female was engraved by J.C. Benzing.

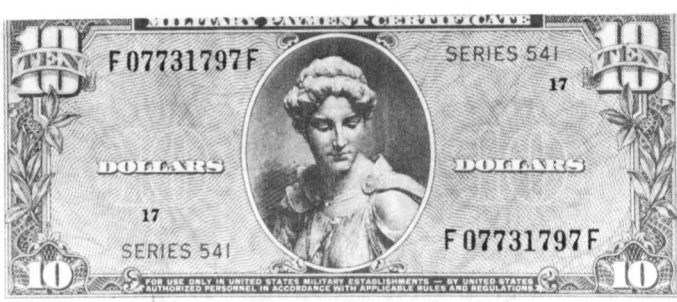

Face $10: aqua and brown. The female was engraved by G.F.C. Smillie.

Back: aqua and brown.

S No.	Denomination	Certificates Printed	VFine	EFine	Unc
46	.05	18,816,000	$ –	$ 1.	$ 3.
46☆		40 reported	–	–	–
47	.10	18,816,000	1.	3.	12.
47☆		61 reported	–	–	–
48	.25	12.096,000	3.	7.	20.
48☆		19 reported	–	–	–
49	.50	8,064,000	4.	10.	50.
49☆		75 reported	–	–	–
50	1.00	20,160,000	18.	40.	250.
50☆		13 reported	–	–	–
51	5.00	6,000,000	550.	900.	3,000.
51☆		none reported	–	–	–
52	10.00	21,200,000	300.	750.	1,700.
52☆		8 reported	–	–	–

Series 591, issued May 26, 1961, withdrawn Jan. 6, 1964 (Jan. 13 in Europe).

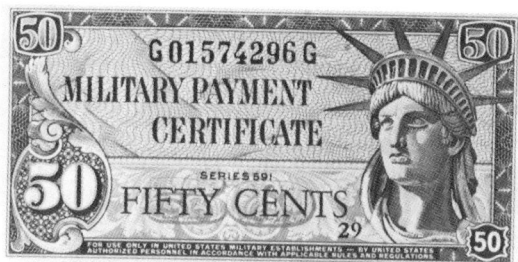

Face 50¢: blue and green with brown print. *Liberty*, also seen on a U.S. 17¢ stamp, was engraved by M. Fenton.

Back: pale blue with brown print.

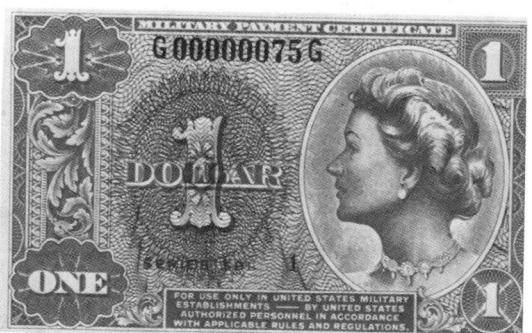

Face $1: purple and blue with reddish-blue print. The female profile was engraved by R. Bower.

Back: purple with reddish-orange print.

Remarks: The designs are the same for the 5¢, 10¢ and 25¢ notes. The colors are: 5¢ face, yellow and green with red print, back, yellow with red print; 10¢ face, pink and green with blue print, back, pink with blue print; 25¢ face, blue and purple with green print, back, purple with green print.

Series 591 *(continued)*

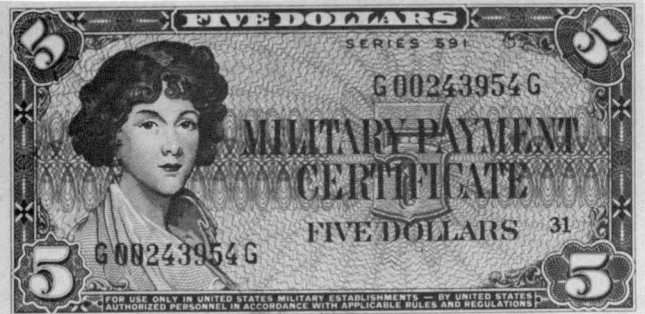

Face $5: violet and green with blue print. The female portrait is based on the Gilbert Stuart painting of *Miss Ann Izard*; it was engraved by C. Brooks.

Back: violet with blue print.

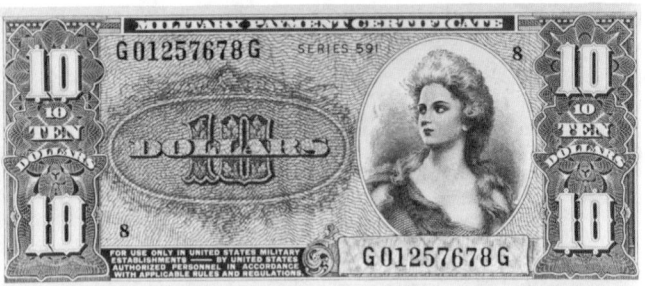

Face $10: red and green.

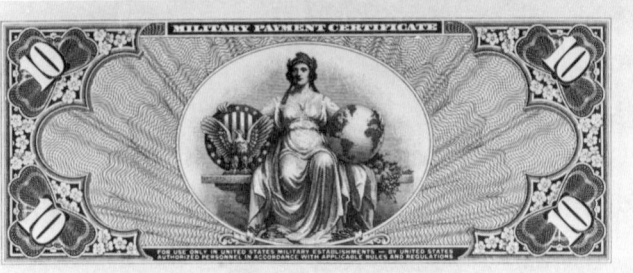

Back: red and green

Series 591 *(continued)*

S No.	Denomination	Certificates Printed	VFine	EFine	Unc
53	.05	7,392,000	$ 2.	$ 6.	$ 45.
53☆		24 reported	–	–	–
54	.10	8,400,000	3.	7.	55.
54☆		4 reported	–	–	–
55	.25	4,704,000	15.	25.	110.
55☆		none reported	–	–	–
56	.50	3,696,000	28.	45.	200.
56☆		3 reported	–	–	–
57	1.00	10,080,000	20.	40.	180.
57☆		6 reported	–	–	–
58	5.00	2,400,000	290.	600.	1,950.
58☆		1 reported	–	–	–
59	10.00	6,800,000	190.	275.	2,500.
59☆		4 reported	–	–	–

Series 611, issued Jan. 6, 1964 (Jan. 13 in Europe), withdrawn April 28, 1969.

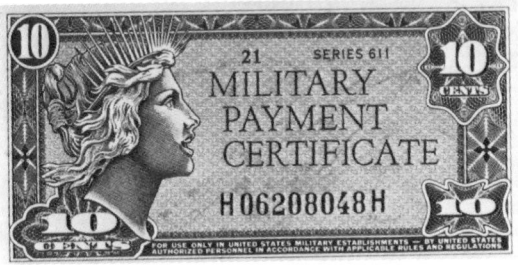

Face 10¢: aqua with green print. *Liberty*, by C. R. Chickering, was engraved by Arthur Dintaman.

Back: aqua, violet and green.

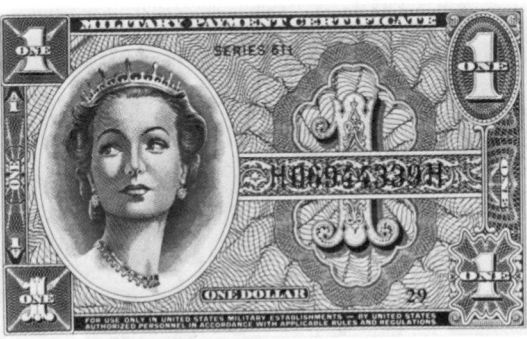

Face $1: vivid orange with aqua print. *Tiara* was painted by C.R. Chickering and engraved by M. Fenton.

Remarks: The designs are the same for the 5¢, 25¢ and 50¢ notes. The colors are: 5¢ face, violet and green with blue print, back, the same colors; 25¢ face, aqua with pale brown print, back, pale blue with brown print; 50¢ face, yellow and green with red print, back, yellow with red print.

Series 611 *(continued)*

Back $1: vivid orange with aqua print.

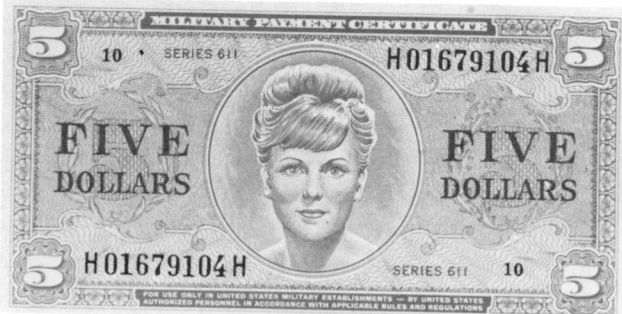

Face $5: pale blue and violet with vivid orange print. The female head by C.R. Chickering, was engraved by C. Brooks.

Back: violet with blue print.

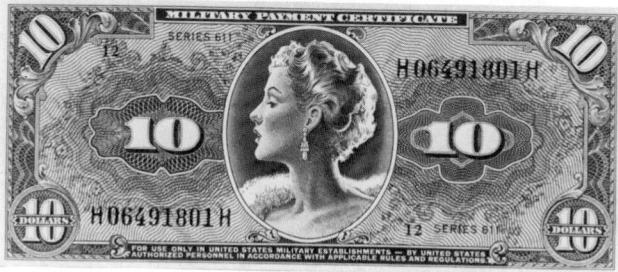

Face $10: pale blue and violet with blue print. The female profile, by C.R. Chickering, was engraved by M. Fenton.

Series 611 *(continued)*

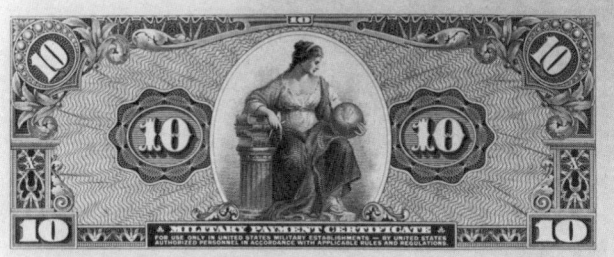

Back $20: violet with blue print. The engravers were J. Eissler and R. Bower.

S No.	Denomination	Certificates Printed	VFine	EFine	Unc
60	.05	9,408,000	$ 1.	$ 2	$ 8.
60☆		123 reported	–	–	–
61	.10	10,080,000	2.	3.	17.
61☆		145 reported	–	–	–
62	.25	5,376,000	4.	8.	25.
62☆		5 reported	–	–	–
63	.50	4,704,000	8.	12.	45.
63☆		1 reported	–	–	–
64	1.00	10,640,000	8.	12.	45.
64☆		156 reported	–	–	–
65	5.00	2,800,000	60.	140.	400.
65☆		10 reported	–	–	–
66	10.00	8,400,000	50.	110.	330.
66☆		19 reported	–	–	–

Series 641, issued August 31, 1965, withdrawn October 21, 1968.

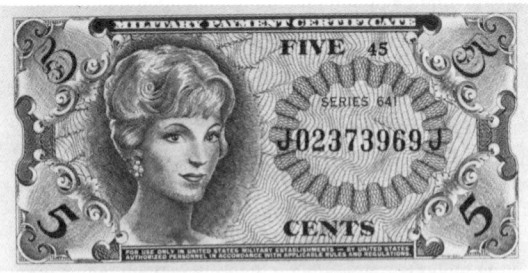

Face 5¢: pale blue and purple with dark blue numerals. The female was engraved by R. Bower.

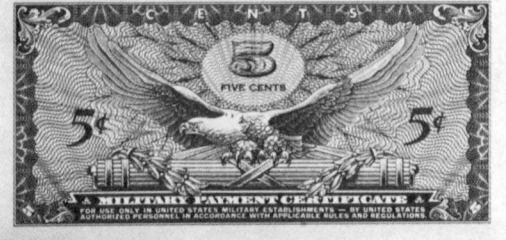

Back: pale blue and purple.

Remarks: The designs are the same for the 10¢, 25¢ and 50¢ notes. The colors are: 10¢ face, aqua and red, red numerals with green print, back, aqua and red with green print; 25¢ face and back, aqua with deep green numerals and red print; 50¢ face and back, aqua with brown numerals and orange print.

Series 641 *(continued)*

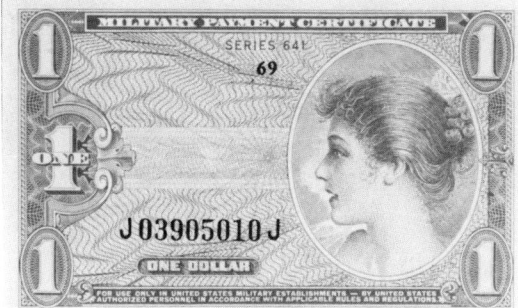

Face $1: yellow and green with red print. The female profile was engraved by E.J. Hein.

Back: yellow and red. (See $1 note, No. 28 for same border design.)

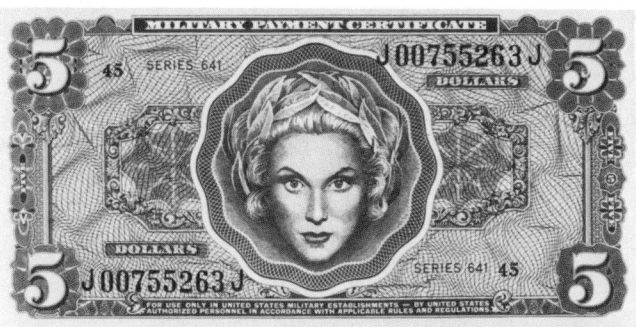

Face $5: red and aqua. The female, *Laura*, was engraved by R. Bower. (See Nos. 361–371 for the same border design.)

Back: similar to face. *Europe* was engraved by A. Dintaman. The source for this profile is *Architectural Armaments in Berlin*, printed by Rommeler & Jonas in Dresden. (See Nos. 361–371 for the same border design.)

Series 641 *(continued)*

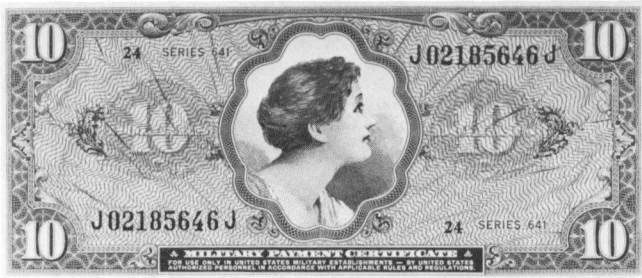

Face $10: aqua, orange and brown. The female profile was originally engraved by Marcus W. Baldwin. (See *Commerce* on No. 186.)

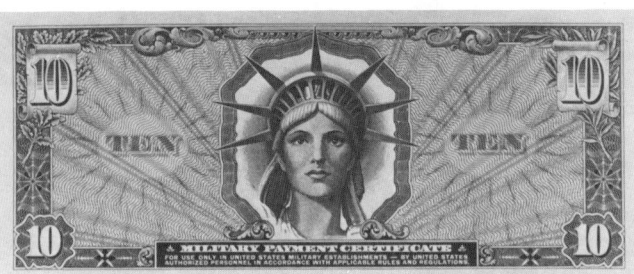

Back: orange and brown. *Liberty* was engraved by R. Bower.

S No.	Denomination	Certificates Printed	VFine	EFine	Unc
67	.05	22,848,000	$ –	$ 1.	$ 2.
67☆		38 reported	–	–	–
68	.10	23,520,000	–	1.	2.
68☆		20 reported	–	–	–
69	.25	12,096,000	–	1.	4.
69☆		22 reported	–	–	–
70	.50	11,424,000	1.	2.	8.
70☆		10 reported	–	–	–
71	1.00	33,040,000	4.	5.	15.
71☆		12 reported	–	–	–
72	5.00	6,800,000	25.	50.	125.
72☆		7 reported	–	–	–
73	10.00	20,400,000	20.	50.	160.
73☆		20 reported	–	–	–

Series 651, issued April 28, 1969, withdrawn May 19, 1969
(Japan), June 11, 1969 (Libya), November 19, 1973 (Korea).

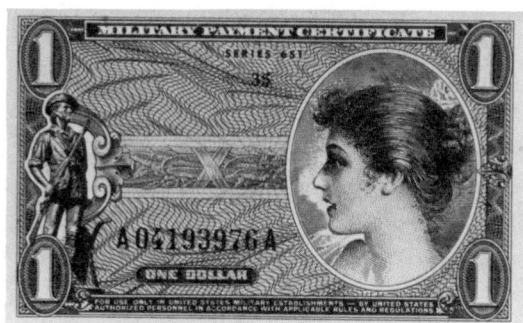

Face $1: aqua, deep red and green.
Back: red and green.

Face $5: aqua, red and brown.
Back: same as face.

Face $10: aqua, brown and purple.
Back: brown and purple.

Remarks: An adaptation of the *Minute Man* statue by Daniel Chester French was used on the $1, $2 and $5 certificates, and on the 1941, U.S. Defense Postal Savings Stamps.

Series 651 *(continued)*

S No.	Denomination	Certificates Printed	VFine	EFine	Unc
74	.05	4,032,000	– – – – – – –2 confirmed– – – – – –		
74☆		–	–	–	–
75	.10	7,960,000	– – – – – – –2 confirmed– – – – – –		
75☆		–	–	–	–
76	.25	2,688,000	– – – – – – –2 confirmed– – – – – –		
76☆		–	–	–	–
77	.50	2.016,000	– – – – – – –6 confirmed– – – – – –		
77☆		–	–	–	–
78	1.00	6,720,000	$ 3.	$ 5.	$ 20.
78☆		1 reported	–	–	–
79	5.00	1,600,000	45.	60.	130.
79☆		–	–	–	–
80	10.00	3,600,000	45.	60.	175.
80☆		5 reported	–	–	–

Series 661, issued October 21, 1968, withdrawn August 11, 1969.

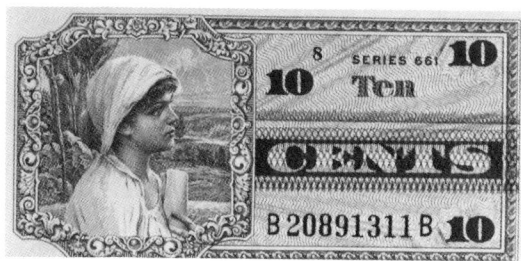

Face 10¢: violet, aqua and blue with blue numerals. The female profile was engraved by John Eissler.

Back: blue and violet.

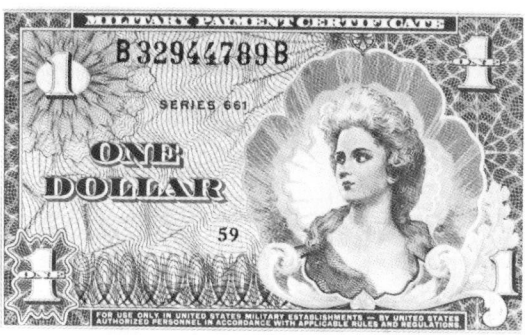

Face $1: purple, aqua and blue. The female was engraved by A.L. Wasserback.

Remarks: The designs are the same for the 5¢, 25¢ and 50¢ notes. The colors are as follows: 5¢ face, red, aqua and green, back, green and red; 25¢ face, orange, aqua and brown, back, orange and brown; 50¢ face, aqua and pale reddish orange, orange-red numerals, back, orange-red and aqua.

Series 661 *(continued)*

Back $1: blue, purple and pale blue. *Mt. Ranier and Mirror Lake* are also seen on the U.S. 1934, 3¢ postage stamp.

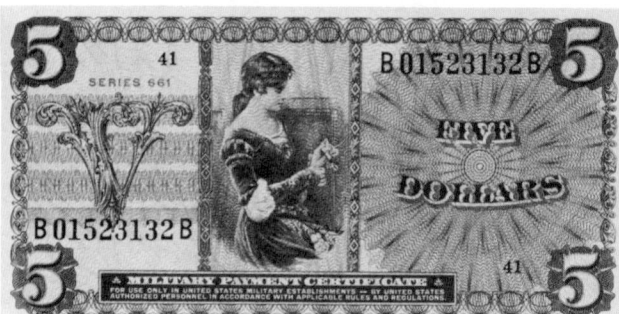

Face $5: red, aqua and brown. *Meditation* was engraved by G.F.C. Smillie.

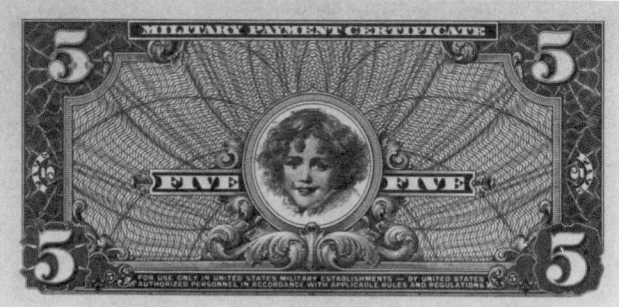

Back: red and brown. The head was engraved by Marcus W. Baldwin.

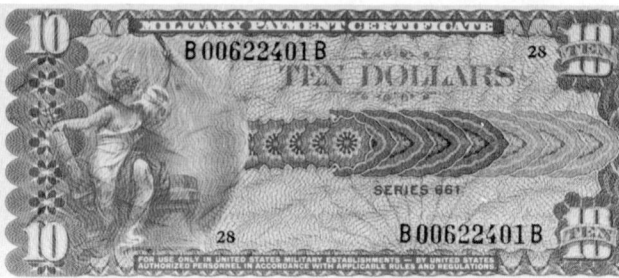

Face $10: aqua, orange and red. *Union and Civilization* was engraved by G.F.C. Smillie. (See No. 773)

Series 661 *(continued)*

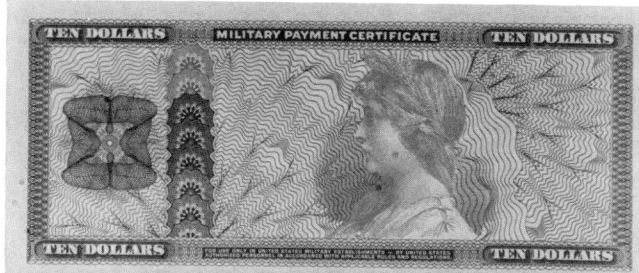

Back $10: orange and red. *Ceres*, based on *Antique Poesy* by J. Lefebvre, was engraved by G.F.C. Smillie.

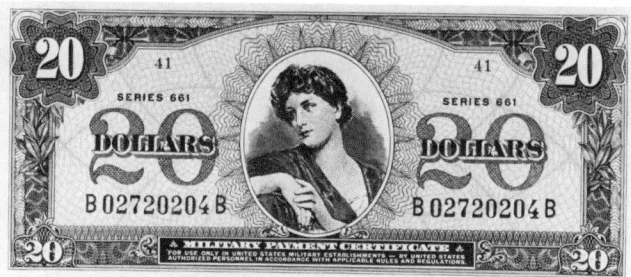

Face $20: aqua, tan and grey. The female was engraved by F.T. Howe, Jr.

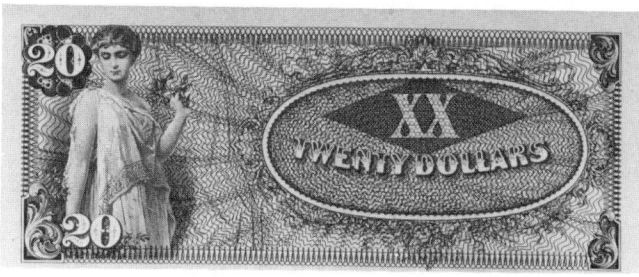

Back: grey and tan. *The Bouquet* was engraved by E. Felver.

S No.	Denomination	Certificates Printed	VFine	EFine	Unc
81	.05	23,520,000	$ –	$ 1.	$ 2.
81☆		12 reported	–	–	–
82	.10	23,520,000	–	1.	2.
82☆		50 reported	–	–	–
83	.25	13,440,000	–	1.	6.
83☆		13 reported	–	–	–
84	.50	10,080,000	–	1.	6.
84☆		4 reported	–	–	–
85	1.00	33,040,000	1.	2.	8.
85☆		56 reported	–	–	–
86	5.00	7,200,000	2.	3.	7.
86☆		13 reported	–	–	–
87	10.00	4,800,000	95.	200.	500.
87☆		7 reported	–	–	–
88	20.00	8,000,000	70.	150.	400.
88☆		10 reported	–	–	–

Series 681, issued August 11, 1968, withdrawn October 7, 1970.

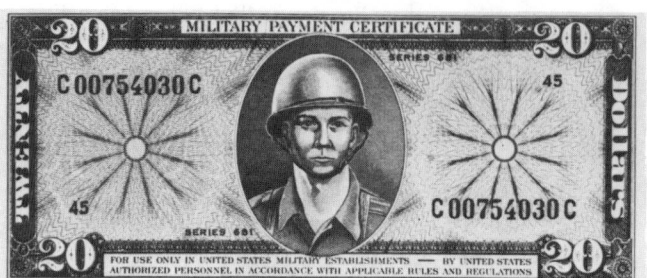

Face $20: aqua, blue, brown and pink. The *Soldier* was engraved by A. Dintaman.

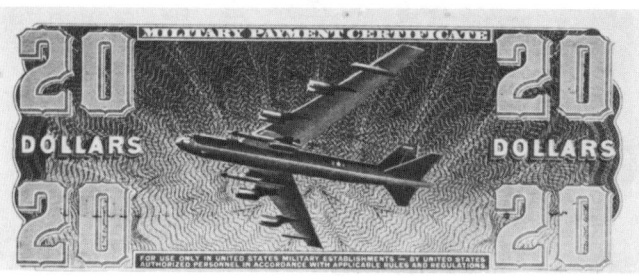

Back: brown and red. The *B52A Bomber* was engraved by E. Felver.

5¢ Face: aqua, blue and green. The *Submarine Thomas A. Edison* and the *Astronaut* were engraved by E. Felver. Back: blue and green. The same designs appear on the 10¢, 25¢ & 50¢ notes.

25¢ Face: aqua, blue, green and red. Back: blue and red.

$1 Face: aqua, red and purple. The *Pilot* was engraved by C. Brooks. Back: violet and orange.

10¢ Face: aqua, blue and purple. Back: blue and purple.

50¢ Face: aqua, blue and brown. Back: blue and brown.

$5 Face: aqua, pale green and purple. The *Sailor* was engraved by J. Creamer. Back: yellow and purple.

$10 Face: aqua, pale red and blue. The *Tank* was engraved by A. Dintaman. Back: blue and brown

S No.	Denomination	Certificates Printed	VFine	EFine	Unc
89	.05	14,112,000	$ –	$ 1.	$ 2.
89☆		30 reported	5.	10.	25.
90	.10	14,112,000	–	1.	2.
90☆		15 reported	8.	15.	40.
91	.25	8,736,000	1.	2.	5.
91☆		5 reported	–	–	–
92	.50	6,720,000	1.	2.	5.
92☆		31 reported	5.	10.	30.
93	1.00	22,400,000	2.	3.	7.
93☆		26 reported	8.	14.	30.
94	5.00	4,800,000	4.	5.	20.
94☆		9 reported	100.	200.	–
95	10.00	3.200,000	15.	25.	125.
95☆		15 reported	60.	175.	–
96	20.00	6,400,000	20.	25.	110.
96☆		40 reported	60.	150.	–

Series 692, issued October 7, 1970, withdrawn March 15, 1973 (fractional notes June 1, 1971).

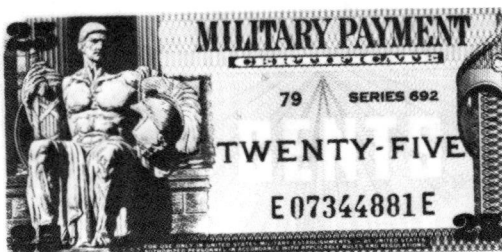

Face 25¢: yellow, blue and grey.

Back: grey and blue.

Face $1: violet, grey-blue, green and reddish-brown.

Back: grey-blue. The *Bison* design was also used on U.S. 30¢ postage stamps in 1923 and on No. 483 in this catalog.

Series 692 *(continued)*

Face $5: blue, brown and orange. The female portrait was engraved by E. Felver.

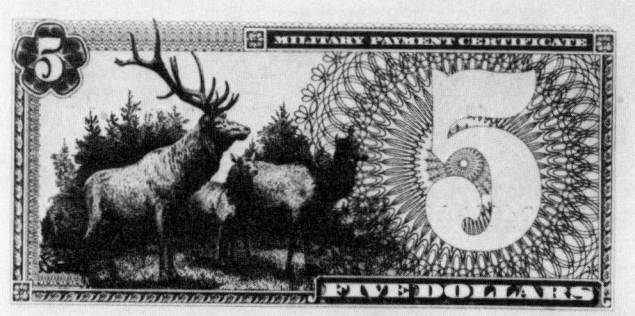

Back: brown and tan.

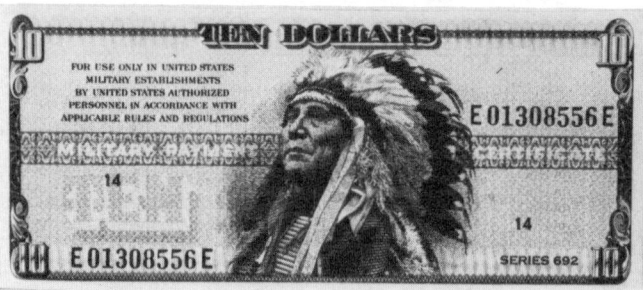

Face $10: blue, purple, pink and red. *Chief Hollow Horn Bear*, of the Brule Sioux, is also seen on U.S. 14¢ postage stamps of 1923 and 1931. The portrait, based on a photograph by DeLancey Gill, was engraved by L.S. Schofield.

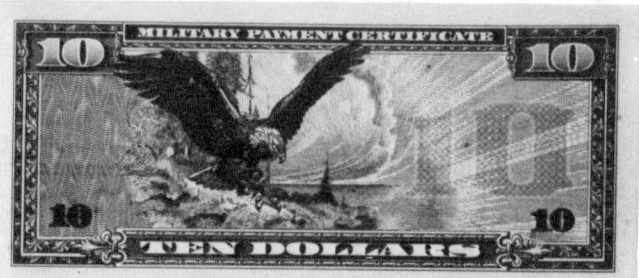

Back: blue and purple. The *Eagle*, by W.A. Roach, was engraved by C. Brooks.

Series 692 *(continued)*

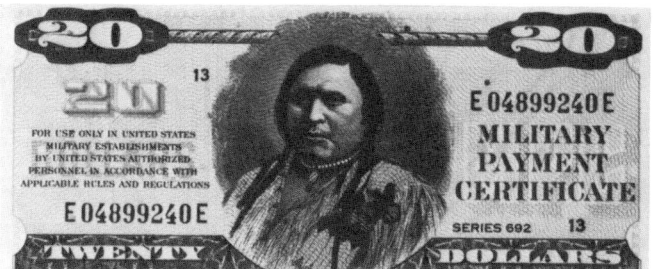

Face $20: purple, deep orange and pale red. The portrait of *Chief Ouray* was engraved by F.H. Noyes.

Back: purple and blue.

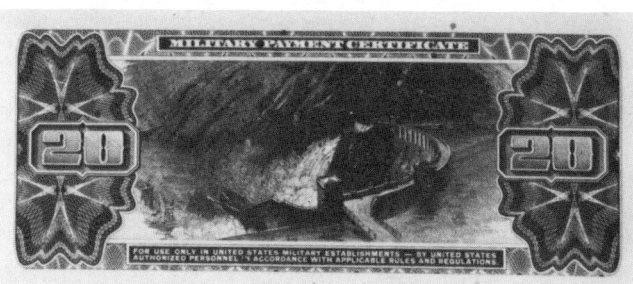

S No.	Denomination	Certificates Printed	VFine	EFine	Unc
97	.05	14,112,000	$ 1.	$ 2.	$ 4.
97☆		72 reported	12.	25.	40.
98	.10	14,112,000	2.	3.	5.
98☆		62 reported	12.	25.	50.
99	.25	8,736,000	3.	4.	10.
99☆		19 reported	–	35.	60.
100	.50	6,720,000	4.	5.	18.
100☆		16 reported	–	33.	60.
101	1.00	22,400,000	4.	5.	20.
101☆		28 reported	17.	30.	65.
102	5.00	4,800,000	45.	75.	160.
102☆		2 reported	–	–	–
103	10.00	3,200,000	90.	150.	350.
103☆		3 reported	–	–	–
104	20.00	6,400,000	75.	150.	340.
104☆		19 reported	125.	500.	1,000.

Remarks: Although Series 691 was never issued, an example of the $1 is in a private collection. The $10 denomination was displayed by the Bureau of Engraving and Printing at the 1978 convention of the American Numismatic Association. Both denominations are similar to the respective notes in Series 541.

Face 5¢: tan, pink and reddish-brown. The sculpture *Guardianship*, by James Earl Fraser, guards the entrance to the National Archives. Back: same colors.
10¢ Face: aqua, orange, blue and green. Back: aqua, blue and green.
50¢ Face: gold, pink and purple. Back: brown and purple.

SELECT BIOGRAPHIES OF BANK NOTE DESIGNERS
AND ENGRAVERS

There is increasing interest in the artists who designed and engraved the subjects on U.S. currency. Presented here are a few brief biographies of designers and engravers extracted from a work-in-progress devoted to this subject by the author.

The numbers at the end of each biography refer to those in this catalog.

MARCUS W. BALDWIN. b. Irvington, NJ 31 March 1853, d. NYC 15 July 1925. He served his apprenticeship at American Bank Note Co. (ABNCo) under Louis Delnoce and Alfred Jones. Baldwin was employed by both ABNCo and the National Bank Note Co. (NBNCo). In 1880 he formed Baldwin, Gleason & Co. Baldwin engraved privately until 1891 when he joined the Bureau of Engraving and Printing (BEP).

See Nos. 483, 618, 620, 850 & 1429. In addition see military payment certificates Series 481, 50¢; Series 661, $5; Series 521, $10.

JOACHIM C. BENZING. b. Ellicott City, MD 19 Nov. 1880. At 14 he studied clay modeling with George Morgan, medalist at the U.S. Mint. Benzing learned engraving under James Blakie and in 1895 was apprenticed at E.A. Wright Co. in Philadelphia. In 1900 he was with ABNCo and in 1905 with the BEP.

Benzing engraved the portrait of Thomas Jefferson on all small-size $2 notes and the Lincoln Memorial on the back of all small-size $5 notes.

CHARLES BROOKS. b. Washington, DC 26 April 1905. He was educated in Philadelphia and was apprenticed at E.A. Wright Co. where he engraved from October 1920 to February 1925. After working as a self-employed engraver Mr. Brooks joined the BEP on 23 March 1938 and remained until 29 August 1947. After working at the Security Bank Note Co. he returned to the BEP; Mr. Brooks retired in December 1966.

See military payment certificates: Series 591, $5; Series 611, $5; Series 681, $1 and Series 692, $10.

WILLIAM CHORLTON. b. Manchester, England 20 March 1847, d. 1874. He came to the U.S. about 1852. At 16 Mr. Chorlton was engraving for the NBNCo under Alfred and James Smillie. He joined the BEP about 1872.

See Nos. 154, 618, 619, 620 & 1435.

LUIGI DELNOCE. b. Italy 1822, d. Melrose (Bronx), NY 1880. He studied engraving with John W. Casilear. From 1855 until 1860 Delnoce worked as a book illustrator. He engraved for six bank note companies and the BEP.

See Nos. 153, 171, 274, 728, 799, 953, 1013, 1122, 1151, 1207, 1212, 1403 & 1461.

FREDERICK GIRSCH. b. Beidingen, near Darmstadt, Germany 31 March 1821, d. Mt. Vernon, NY 18 December 1895. He supported his mother and four sisters by painting. After study at the Royal Academy, Girsch engraved for G.G. Lange in Darmstadt. In 1848 he went to Paris. The following year he arrived in NYC where he initially engraved book illustrations. As a bank note engraver Girsch worked for Danforth, Wright & Co., ABNCo and the NBNCo.
 See Nos. 207, 463, 464, 497, 1151, 1350, 1370, 1530, 1539 & 1568.

HENRY GUGLER. b. Germany 1816, d. 1880. He came to the U.S. in 1853 and almost immediately began to engrave for bank note companies. On 15 January 1863, Gugler was employed as one of the first engravers at the National Currency Bureau (BEP).
 See Nos. 245, 466, 724, 727 & 1379.

ALFRED JONES. b. Liverpool, England 7 April 1819, d. NYC 28 April 1900. By 1834 he was serving as an apprentice with Rawdon, Wright, Hatch & Edson in Albany, NY. Jones studied at the National Academy of Design in NYC. After a trip to Europe for more study he returned to the U.S. and engraved for bank note companies. In 1866 Jones became the president of the United States Bank Note Co. He became the superintendent of the Picture Department at ABNCo.
 See Nos. 509, 567, 700, 703, 1014 & 1404.

THEODORE A. LIEBLER. b. Constanz (Baden), Germany 22 February 1830, d. Brooklyn, NY 10 August 1890. He came to the U.S. in 1848. It is possible that he designed the eagle trademark for ABNCo.
 See Nos. 29, 497 & 567.

CHARLES SCHLECHT. b. Stuttgart, Germany 1843, d. NYC 1932. He came to the U.S. in 1852. Schlecht was apprenticed at ABNCo in 1859; additional instruction came from Charles Burt and Alfred Jones. In 1864 he joined the Western Bank Note Co. but returned to ABNCo. In 1893 he joined the BEP where he remained until 1900.
 See Nos. 45, 178, 590, 808, 843, 1014, 1242, 1370, 1376 & 1405.

WALTER SHIRLAW. b. Paisley, Scotland 6 August 1838, d. Spain 26 December 1908. Born to American parents, the family returned to the U.S. in 1841. At age 12 Shirlaw was apprenticed at Rawdon, Wright, Hatch & Edson; he attended school in the evenings. He was employed at Western Bank Note Co. as a designer and engraver from 1865–1870. He returned from a European trip in 1877. Shirlaw did illustrations for *Harper's Monthly.* He helped to found the Chicago Institute of Art and a few other art organizations.
 See Nos. 274; 358; 540.

The food stamp program was initiated in May 1939 and was discontinued early in 1943. At the peak of 1941, as many as four million low-income people purchased orange, 25–cent Food Order Stamps and were given a 50% bonus in blue 25–cent Food Order Stamps.

Issued in booklet form with four to a page, the stamps were perforated and, like postage stamps had glue on the back. These stamps were then glued to a $10 book for redemption at the local bank.

The first three issues of food stamps read "FSCC" (Federal Surplus Commodities Corporation) in the upper corners; the last issue read "USDA" (United States Department of Agriculture). All food stamps were printed by the Bureau of Engraving and Printing (BEP). Many have been observed with "SPECIMEN" or "PAID" overprinted on them.

In 1961, President John F. Kennedy reinstated a food stamp program to "increase the amount and variety of foods being distributed to low-income families." In 1961, 25–cent and $1 grey Food Stamp Coupons were issued. Fewer than $40 million of these were issued. Before 1967 Food Coupons bore no series date.

By 1970 the purple $5 Food Coupon was added in $30 booklets and serial numbers were, for the first time, printed on the food coupons themselves. Before this time only the covers had serial numbers.

In 1971 the American Bank Note Company (ABNCo) was called upon to assist the BEP in producing the ever-increasing number of food coupons. By 1972 the BEP was producing higher-value "household books" for limited distribution by mail in a pilot program. And for the first time more than one denomination of coupons was used in these books.

The bicentennial designs, in multidenominational books, were introduced in March 1975 when the United States Bank Note Corporation (USBNC) took on some of the printing responsibilities. With only a few changes, these designs are still in use. These were the designs that caught the eye of paper money collectors. Originally $2, $7, $40, $50 and $65 denomination books were issued, with the $10 book being added in January 1979. Serial prefix letters indicate the value of the book: A=$2; B=$7; C=$40; D=$50; E=$65 and F=$10 books.

According to the USDA, food stamps are not allowed to be collected. Nevertheless, examples have found their way into collections. Many collectors think that in the future this restriction will be changed, just as the restriction to hold gold certificates was relaxed, and these coupons will become collectible items.

The BEP also issued a 25–cent food stamp as part of the USDA plan to provide funds for milk for mothers and infants. These certificates do not have serial numbers and were issued from 1970 to 1976 in a pilot program. These, as all issues since 1961 measure slightly smaller than current Federal Reserve notes.

Until January 1, 1979 (except for 14 months in 1971–1972) participating stores had scrip or tokens prepared to be used as change substitutes, redeemable only at the issuing store or chain of stores. The USDA now permits coins to be used as change

for coupons under $1, and only $1 coupons to be used as change for both $5 and $10 coupons.

Replacement certificates for the current issues are indicated in the same way as Federal Reserve notes, with a star. Replacement types vary as indicated. Until 1977 replacements were indicated by deleting the serial number suffix letter. Since 1981 ABNCo has used stars as replacements up to two serial number ranges: one commencing with a "0" and the other beginning with "5." Booklet covers are also printed in replacement format; all denominations have been observed.

Prefix and suffix letters represent the actual block letters used for individual series.

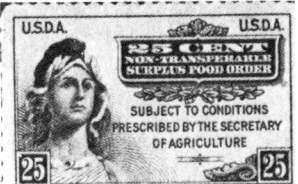

A food stamp from the early days of the program.

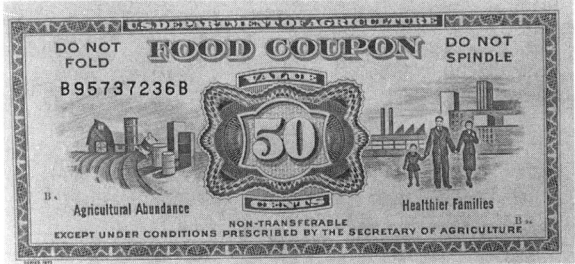

Series 1973

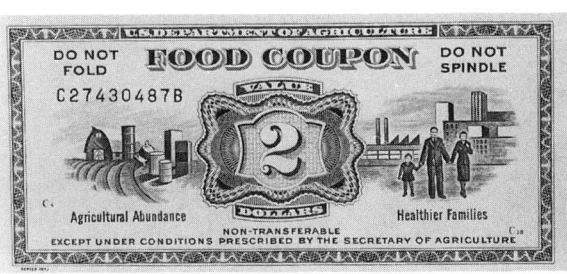

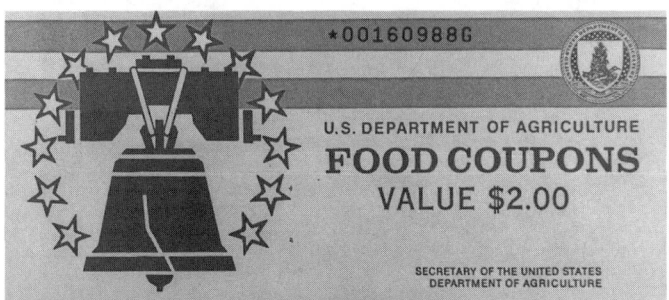

A booklet cover with
replacement number.

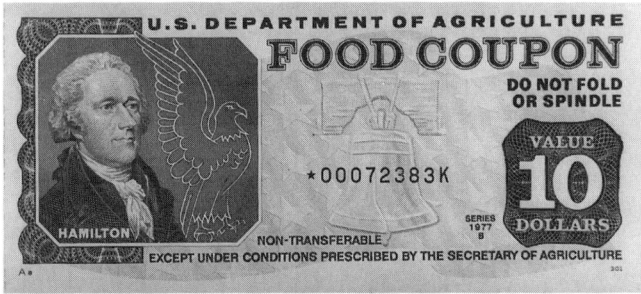

Series 1977B
replacement note

Booklet Denominations
(Observed High Serial Numbers to the Next Highest Million)

Series	Printer	$2	$7	$40	$50	$65	$10	Replacement Blocks
1975	BEP	A99G	–	–	–	–	–	–G
	BEP	A99P	–	–	–	–	–	–P
	BEP	A30R	–	–	–	–	–	–
	BEP	A03J	B07H	C02H	D04H	–	–	–H, –J
	BEP	A01Q	–	–	–	–	–	–Q
1975A	ABNCo	A13A	B99A	C84A	D68A	E19A	–	–A
	ABNCo	–	B95C	–	–	–	–	–C
	ABNCo	–	B13B	C05B	D05B	E01B	–	–B
1975B	USBNC	A45G	–	–	–	E42G	–	–G
	USBNC	A08H	–	–	–	E05H	–	–
1976	BEP	A20P	–	–	–	–	–	–
	BEP	A03Q	–	–	–	–	–	–
1976A	ABNCo	–	B02A	C31A	D36A	E24A	–	–A, + –A
	ABNCo	–	B02B	C03B	D03B	–	–	

Series	Printer	$2	$7	$40	$50	$65	$10	Replacement Blocks
1976B	USBNC	A16G	B26G	–	–	E20G	–	–G
	USBNC	A07H	–	–	–	–	–	–
1977A	ABNCo	–	B21A	C22A	D57A	E35A	–	+ –A
	ABNCo	–	B03B	C04B	D02B	E02B	–	+ –B
1977B	USBNC	A99K	–	–	D05K	E12K	–	+ –K
	USBNC	A58M	–	–	–	–	–	–
1978A	ABNCo	A73A	B31A	C35A	D55A	E55A	F34A	+ –A
	ABNCo	–	B02B	–	D01B	E02B	F06B	+ –B
1978B	USBNC	A99G	B35G	–	–	–	–	+ –G
	USBNC	A80K	–	–	–	–	–	–
	USBNC	A04J	B04J	–	–	–	F33A	–
1979A	ABNCo	–	–	C41A	D21A	E41A	F28A	+ –A
	ABNCo	–	–	–	D01B	E02B	F01B	–
1979B	USBNC	–	B78M	C19M	–	–	–	+ –M
	USBNC	–	B01L	C01L	–	–	–	–
1980A	ABNCo	–	B88A	C22A	D62A	E82A	–	+ –A, + O–
	ABNCo	–	B02B	C02B	D02B	E01B	–	–
1980B	USBNC	A33G	B58G	C23G	D04G	E30G	F39G	+ –G
	USBNC	A05H	B04H	C01H	D01H	E01H	F04H	–
1981A	ABNCo	–	–	C13C	D27C	E88C	–	+ O–, + 5–, + –5A
	ABNCo	–	–	C12A	D06A	–	–	+ 5–, + –5A
	ABNCo	–	–	C01D	D01D	E02D	–	–
1981B	USBNC	A99K	B58K	C33K	–	–	F95K	+ –K
	USBNC	A22M	B86M	–	–	–	–	+ –M
	USBNC	A04J	B05J	–	–	–	F03J	–
1982A	ABNCo	–	–	C33E	D33E	E80E	–	+ 0–, + 5–
	ABNCo	–	–	–	D01F	–	–	–
1982B	USBNC	A57G	B45G	–	–	–	F44G	+ –G
	USBNC	A01H	–	–	–	–	F05H	–
1983A	ABNCo	–	–	C28N	D22N	E76N	–	+ O–, + 5–
	ABNCo	–	–	–	–	E20A	–	–
	ABNCo	–	–	–	D01P	–	–	–
1983B	USBNC	A95U	B89U	–	–	–	F40U	+ –U
	USBNC	–	–	–	–	–	–	–
1984A	ABNCo	A99Q	B99Q	C42Q	D22Q	–	F18Q	+ O–, + 5–
	ABNCo	A01R	–	C01R	–	–	–	–
1984B	USBNC	A04W	B17W	–	–	E89W	–	+ –W
	USBNC	–	–	–	–	E10Y	–	–
1985A	ABNCo	A88S	B97S	C44S	D24S	–	F22S	+ 5–
1985B	USBNC	–	–	–	–	E90G	–	+ –
	USBNC	–	–	–	–	E12K	–	–
1986A	ABNCo	A30C	B70C	C25C	D05C	–	F30C	+ 5–
1986B	USBNC	–	–	C17M	D13M	E71M	–	+ –
	USBNC	–	–	–	–	E10U	–	–
1987A	ABNCo	A70E	B91E	–	–	–	F36E	+ 5–
1987B	USBNC	–	–	C24W	D24W	E94W	–	+ –
	USBNC	–	–	–	–	E01Y	–	–
1988A	ABNCo	A65N	B90N	C20N	D30N	–	F38N	+ 5–
1988B	USBNC	–	–	C32G	D15G	E81G	–	+ –
1989A	ABNCo	A99A	B99A	C53A	D51A	–	F48A	+ 5–
1989B	USBNC	–	–	–	–	E99K	–	+ –
	USBNC	–	–	–	–	E35M	–	–
1990A	ABNCo	⎤						
1990B	USBNC	⎦	These two series were in production when this catalog was printed					

CHAPTER FOUR

Care and Preservation
of Paper Money

ALTHOUGH much information – some good and some bad – has appeared on the care and preservation of coins has appeared in print, the same for paper money is noteworthy for its paucity. This may be due to the relatively recent growth in interest in the field of syngraphics but, at any rate, the serious collector should evince a high degree of concern for this facet of the hobby. Therefore, the question of how best to preserve our notes from future deterioration must be addressed. To get at answers to these queries, we must first consider the material with which we are dealing.

United States bank notes are in all instances made from cellulose from one or more natural sources and in varying degrees of basic quality. For the most part, the quality of the paper made from cellulosic raw material is very high which means that it is essentially pure cellulose with no significant inclusion of process chemicals or fillers other than very small quantities of uniquely identifiable materials used for anticounterfeiting purposes. The devices printed on the paper substrate are normally derived from mineral type pigments but, in some cases, the colors may be organic in nature. In the former case the stability of the pigments to outside influences will generally be greater than in the latter case, despite the fact that the organic dyes used will be the most stable types available.

We can conveniently divide the discussion of the care and preservation into two parts, viz., measures related to the paper itself and considerations regarding the pigments of the printed devices.

Cellulose has a certain affinity for water vapor and, as a result, there will always be small amounts of moisture incorporated into the molecular structure. The proportion will depend on the relative humidity and temperature of the storage area. Too little moisture may cause a certain degree of embrittlement of the paper with consequent increased susceptibility of damage on handling. Too great an amount of moisture can enhance deterioration of the cellulose by a small amount of acid or alkali

inadvertently present from some undefined former exposure either in the manufacturing process or from environmental pollution. In addition, fungus growth may be induced. Therefore, it is best to store notes in an enclosure wherein the relative humidity is about 45% and the ambient temperature is not above 20C (68F). The presence of excessive acid or alkaline in the note can be ascertained with the aid of a small drop of distilled water and a piece of pH paper (obtainable from drug stores or local scientific supply houses).

Place the drop of water on the note at the edge or other non-critical location. Do not contaminate the paper with moisture from the fingers! The pH indication should be between 6 and 7. If it is outside this range, soak the note for 5–10 minutes in a solution made from one fourth teaspoon of baking soda in one cup distilled water, blot dry with a clean cotton towel and rinse with distilled water three times by one minute soaks, followed by blotting with the towel.

Circulated notes often have dirty surfaces or disfigurements from pencil or pen streaking. To avoid possible damage to the printed devices, it is usually best to leave such extraneous material undisturbed. However, if one is irresistibly tempted to effect some sort of cleaning, it is best to judiciously use a soft gum eraser, on the unprinted portions of the note only. Always remember that erasers contain abrasive filler to a greater or lesser extent, depending on the purpose for which the eraser was designed. Soft gum erasers have minimum content of such fillers which can quickly remove printing ink along with the dirt, particularly if the filler is coarse and present to a high degree as in pencil erasers.

HOUSING OF PAPER MONEY

The question of suitable storage containers for bank notes is an important one since the wrong choice can lead to eventual irreparable damage to the paper itself or to the legends and devices. Paper envelopes of all types are to be avoided since the paper contains residues of the chemicals used in the papermaking process and these can be ultimately harmful. There are several types of plastic materials that can be used as holders. If chosen properly, they have the advantage of transparency that permits display of the note without actual handling. The following list is arranged in decreasing order of desirability.

1. Mylar – a polyester terephthalate – has no added chemicals such as plasticizers or ultraviolet light stabilizers, is mechanically strong in the biaxially oriented condition and offers excellent clarity. It is heat sealable at 425–450F.

2. Biaxially oriented crystal polystyrene film has excellent clarity, good strength but may contain small amounts of ultraviolet light stabilizers. If the film is a grade approved for food packaging they are not likely to be harmful to bank notes. The film is heat sealable at 250–350F.

3. Uncoated propylene homopolymer or randomly polymerized propyleneethylene copolymer films are mechanically strong in the biaxially oriented state, have good clarity and contain small quantities of ultraviolet light stabilizers that are likely to be harmful. They are generally somewhat more limp than Mylar films of the same thickness and are heat sealable at 300–320F.

4. Cellulose triacete is a cast type film used for photographic film substrate and contains no plastizers or ultraviolet light stabilizers. It has good clarity and strength but is not heat sealable.

5. Cellophane is regenerated cellulose, has good strength and clarity and is heat sealable at 180–350F due to residual acetate moeities. It has no plasticizer nor stabilizer.

Irrespective of the type of film chosen for security paper storage, it must be remembered by the collector that exposure of the notes to ultraviolet light from any source should be minimized since, in the inevitable presence of oxygen and small amounts of moisture, slow deterioration of the inks and even the cellulose itself can occur.

BEWARE OF "RESTORED" PAPER MONEY

Before you attempt to clean a bank note with the intention of reclassifying it as a better condition note, reconsider—one could easily become a victim of the practice.

First, bleaching agents such as Chlorox are so strong and so alkaline that the paper itself, as well as some of the inks used in the device printing, may be harmed, particularly if the bleach is not removed completely by thorough washing. Residue of chemicals can cause slow deterioration over extended periods of time. Second, common solvents such as rubbing alcohol, cleaning fluid and carbona are effective in dissolving only oily material and this will not generally remove significant amounts of dirt from the note. In addition, they are likely to leave traces of impurities that they themselves contain, and they may dissolve portions of some of the printing inks from the devices. Third, strong laundry-type detergents are usually quite alkaline in nature and, as a consequence, may damage the cellulose substrate, particularly if they are not thoroughly removed by washing or neutralized with baking soda as noted earlier.

Drying a note after washing can result in scorching if a hot iron is used. A steam iron can leave obvious blisters. Beware of notes that seem sticky and too thick. This is usually the result of starching the paper in an effort to restore body. Toning may have been done by applying coffee to cover bleached areas. Be especially careful with the 1929 series, which has numerals, names and signatures overprinted in black ink on dry paper, all of which are easily damaged or removed by washing and drying; know that the wet-printed notes issued prior to the 1957 silver certificate series in uncirculated condition should have minor ripples and creases because they were allowed to dry in the pack and should have these features to be virginal.

After the bath and the dryer, beware of the eraser and the scissors. Soft erasers may sometimes be ethically used to remove a minor pencil mark. However, exten-

sive erasures can be detected by the loss of surface sheen and mottled scarring. The use of scissors to trim the edge of a bill is the worst offense. Check the edges and the size of the bill if there is any doubt.

In order to protect your hobby, learn to detect the signs of fraud.

The preceding was extracted from Peter Huntoon's four-part series in *Coin World,* March 7, 14 and April 4 and 11, 1973.

CARE OF YOUR COLLECTION

Captain Kidd was primarily a coin collector, but the James boys were more interested in paper money. Things have not changed much, and the syngraphist should give some thought to the security of his collection before, rather than after, a tragedy happens.

Fortunately, paper money is light in weight and can be kept in a variety of containers in the home or in a bank safe deposit box. However, based on news stories that seem to be a regular part of hobby publication coverage, the latter place is the safer of the two.

Insurance can be obtained in most areas for collections, even though art, jewels and other items of value are certain targets for burglars. Regions usually differ in premiums and requirements for insurance, but the American Numismatic Association now has a group plan for members in this organization. Additional information may be obtained by writing to the association at 818 North Cascade Avenue, Colorado Springs, CO 80903–3279.

A record of identification is of prime importance. No recovery is possible without complete proof of ownership. Syngraphists have an advantage over the coin or stamp collector since bank notes, with very few exceptions, have identifying serial numbers. An accurate record of all the notes in your collection can be made with little effort.

A record of ownership, as well as a complete record of the price paid for each item, is necessary for resale or auction. We all must go some day, and when we do we should leave our heirs a record that will not complicate their lives and require them to pay unnecessary taxes. For instance, if you purchased a $20 note for $200 and it later sells for $250, only $50 is taxable.

It is advisable to designate at least one person in your family to be familiar with your collection, where it is kept and the records of purchase. It would also be a good idea to suggest the names of a few dealers or friends who could assist if disposition of the collection is considered.

NOTE-ISSUING NATIONAL BANKS

The alphabetical listing of cities in the United States that follows allows quick iden-
tification of cities that have issued national bank notes and the charter numbers of
these banks. A specialized catalog on the subject should be consulted for additional
data relating to national banks.

This list of issuing banks is based on the work of Steven R. Jennings whom I wish
to thank. Gratitude is extended to Peter Huntoon, Don Kelly, John Hickman and Dean
Oakes who also contributed. Going back to the source, Louis Van Belkum is to be
thanked and praised for his research, which culminated in the first comprehensive
listing of national bank notes.

City	Charter #	City	Charter #	City	Charter #	City	Charter #
Abbeville, AL	5987, 10959	Albertville, AL	11819, 11820	Ambia, IN	9510	Arcadia, CA	13335
Abbeville, LA	5807	Albia, IA	3012, 8603	Amboy, IL	5223	Arcadia, FL	5534, 8728
Abbeville, SC	3421		1799	Amboy, MN	9775	Arcadia, IN	9488
Abercrombie, ND	8419	Albion, IL	8429, 9025	Ambridge, PA	8459, 10839	Arcadia, LA	7476
Aberdeen, MD	4634	Albion, IN	8912		13087	Arcanum, OH	4839, 9255
Aberdeen, MS	3656	Albion, MI	1544, 3316	Ambrose, ND	9386	Arcata, CA	10372
Aberdeen, SD	2980, 3326		7552	Amenia, NY	706	Archer City, TX	5711
	3932, 8642	Albion, NE	3960, 4173	American Falls, ID	8869	Arcola, IL	2204
Aberdeen, WA	4407, 9535	Albion, NY	166, 1509	Americus, GA	2009, 2839	Ardentsville, PA	9139
	11751, 12704		4998		8305	Ardmore, OK	4393, 4723
	13091	Albion, PA	9534, 13871	Americus, KS	10902		5922, 8354, 9905, 10394
Abilene, KS	2427, 3777	Albright, WV	10480	Ames, IA	3017, 10408		11093, 12472, 13677
	8379	Albuquerque, NM	2614, 3222	Amesbury, MA	2929	Ardsley, NY	12992
Abilene, TX	3195, 3336		7186, 11442, 12485, 13814	Amesville, OH	7235	Arenzville, IL	9188
	4166, 6475, 7028, 7944	Alden, MN	6631	Amherst, MA	393	Argos, IN	9726
	13727	Alderson, WV	5903, 9523	Amherst, NE	9092	Argyle, MN	5907
Abingdon, IL	3377	Aledo, IL	9649, 7145	Amityville, NY	8873	Argyle, NY	8343, 13521
Abingdon, VA	5150, 8819	Alex, OK	10193	Amo, IN	8154	Arkadelphia, AR	10087
	14223	Alexander, ND	11297	Amsterdam, NY	1307, 1335	Arkansas City, KS	3360, 3992
Abington, MA	1386	Alexander. . . . City, AL	7417		2239, 2920		4487, 4640
Absecn, NJ	10823	Alexandria, IN	4835		4211		10746
Achille, OK	10347, 10380	Alexandria, LA	5021	Anconda, MT	3965, 9583	Arlington, GA	8314
Ackerman, MS	9251	Alexandria, MN	2995, 5859		12542	Arlington, IA	9664
Ackley, IA	8762	Alexandria, PA	11263	Anacortes, WA	4458	Arlington, MA	4664, 11868
Ada, MN	5433, 10665	Alexandria, SD	5918, 10187	Anadarko, OK	5905, 5923	Arlington, NE	4583
Ada, OH	5425	Alexandria, VA	651, 1716		6307	Arlington, NJ	8627
Ada, OK	5620, 5633		7093	Anaheim, CA	6481, 10228	Arlington, OR	3676, 3918
	7071, 12591	Alexandria Bay, NY	5284		11823	Arlington, SD	5916, 13286
Adair, IA	8699	Alexis, IL	4967	Anamoose, ND	9390, 9412	Arlington, TX	5806, 7345
Adairville, KY	8814	Algona, IA	3197	Anamosa, IA	1813, 4696	Armour, SD	8012
Adams, MA	462, 4562	Algonac, MI	12944	Anawalt, WV	10392	Armstrong, IA	5442
Adams, MN	8059	Alhambra, CA	8490, 9966	Andalusia, AL	5970, 11955	Arnettsville, OH	9563
Adams, NE	9223	Aliquippa, PA	9902, 8590	Anderson, IN	44, 2346	Arnold, PA	11896
Adams, NY	71, 1531	Allegan, MI	1829		4685, 10290	Artesia, CA	8063
	2845, 4061	Allegany, NY	7009	Anderson, SC	2072, 9104	Artesia, NM	7043, 9468
	4103	Allegheny, PA	198, 776	Anderson, TX	7337	Arthur, IL	5233
Adamsburg, PA	5777		2235, 2261	Andes, NY	302, 11243	Arvada, CO	7501
Addington, OK	10001		4991	Andover, MA	1129	Asbury Park, NJ	3451, 3792
Addison, NY	5178	Allen, NE	8372	Andover, NY	13909, 8146		6673, 13363
Addison, PA	6709	Allen, OK	9620	Angelica, NY	564	Ashaway, RI	1150
Adel, GA	9777	Allendale, IL	8293, 10318	Angleton, TX	14204	Ashburnham, MA	2113
Adel, IA	8981	Allendale, NJ	12706	Angola, IN	7023	Ashdown, AR	10486, 13534
Adena, OH	6016	Allendale, SC	11111	Ann Arbor, MI	22, 2714	Asheboro, NC	8953
Adrian, MI	1973, 9421	Allenhurst, NJ	12891	Anna, IL	5525, 4449	Asheville, NC	3418, 4094
Adrian, MN	7960, 9033	Allentown, NJ	3501	Anna, TX	12867		5110, 8772
Adrian, MO	10375	Allentown, PA	161, 373	Annapolis, IL	10257		12244
Afton, IA	2326		6645, 1322	Annapolis, MD	1244, 826	Ashford, AL	10102
Afton, NY	11513	Allenwood, PA	11593	Anniston, AL	6021, 4250	Ashland, AL	9580
Afton, OK	8790, 10339	Allerton, IA	2191, 9231		3041, 11753	Ashland, KS	3710, 5386
Aiken, SC	9650	Alliance, NE	4226, 5657	Annona, TX	7257	Ashland, KY	2010, 3944
Ainsworth, NE	8992, 4089		13617	Annville, PA	2384		4559, 12293
Aitkin, MN	6803, 10783	Alliance, OH	2041, 3721	Anoka, MN	2800, 3000		4559, 3944
Akdale, NE	13339	Alma, KS	3769, 5104		13547	Ashland, NE	2121, 2921
Akron, CO	10901, 8548		8357, 10195, 13601	Anoka, NE	6464		13435
Akron, IA	7322	Alma, NE	3580	Ansley, NE	7393	Ashland, OH	183
Akron, NY	5631	Alma, WI	8338	Anson, TX	6091, 8897	Ashland, OR	5747, 9431
Akron, OH	27, 40	Almena, KS	8255	Ansonia, OH	9194	Ashland, PA	403, 2280
	2698, 2716, 2698, 2946	Almont, MI	12793	Ansted, WV	8904		5615
	6763, 9953	Alpena, MI	2847	Antelope, MT	11350	Ashland, VA	11978
Akron, PA	9364	Alpha, MI	10601	Anthony, KS	3384, 3385	Ashland, WI	3196, 3590
Alachua, FL	8980	Alpha, NJ	12823		3394, 6752		3607, 13870
Alameda, CA	2431, 9220	Alpine, TX	7214, 12289	Anthony, RI	1161	Ashley, ND	10864
	10150, 11942	Alta, IA	7126	Antigo, WI	5143, 5942	Ashley, PA	8656
Alamogordo, NM	5244, 8315	Altamont, IL	8733, 13993	Antioch, CA	9892	Ashtabula, OH	975, 2031
Alamosa, CO	3114, 7904	Altamont, NY	9866	Antler, ND	7855		5075
	8541	Altavista, VA	9295	Antlers, OK	7667, 8082	Ashton, ID	10269
Alba, TX	6896	Alton, IL	1420, 1445	Apache, OK	7127, 12120	Ashton, SD	3437
Albany, GA	3872, 5512		5188	Apalachicola, FL	6274	Aspen, CO	3485, 4733
	6636, 7777, 9729, 12863	Altona, IL	13625, 11331	Apollo, PA	5723		8815
	12863	Altoona, PA	247, 2781	Appalachia, VA	9379	Aspermont, TX	5786
Albany, IL	6089	Alturas, CA	7219	Appleton, MN	4831, 8813	Aspinwall, PA	8824
Albany, MO	7205	Altus, OK	8775, 12155	Appleton, WI	1650, 1749	Assumption, IL	5508
Albany, NY	267, 789		13756		1820, 2565	Astoria, OR	3486, 4403
	1045, 1123, 1282, 1289	Alva, OK	5587, 6490		4937		13354
	1291, 1301, 3282	Alvarado, TX	3644	Appleton City, MO	2636	Atchison, KS	1672, 2082
Albany, OR	2928, 4326	Alvin, TX	7070	Appomattox, VA	11205		2758, 3612, 11405
Albany, TX	5680, 3248	Alvord, TX	6067, 8071	Aransas Pass, TX	10274	Atglen, PA	7056
Albemarle, NC	11091	Amarillo, TX	4214, 4710	Arapaho, OK	10967	Athena, OR	4516
Albert. . . Lea, MN	3560, 4702		6865, 11629	Arapahoe, NE	3302	Athens, AL	6146
	6128, 6431	Amber, PA	3220	Arcade, NY	10410	Athens, GA	1639, 6525

City	Charter #
Athens, NY	10856
Athens, OH	233. 7744
	10479
Athens, PA	1094. 4915
	5202
Athens, TN	3341. 10735
Athens, TX	4278. 6400
Athol, MA	708. 2172
	13733
Atkinson, NE	6489. 7881
Atlanta, GA	1559. 1605
	2064. 2424. 5030. 5045
	5318. 5490. 9105. 9617
Atlanta, IL	2283. 3711
Atlanta, NY	12071
Atlanta, TX	4922. 7694
Atlantic, IA	2762. 1836
Atlantic City, NJ	5884. 8800
	2527. 4420
	3621
Atlantic Highlands, NJ	4119
Atmore, AL	10697
Atoka, OK	5791. 8994
	7666
Attalla, AL	7951
Attica, IN	577. 3755
Attica, KS	10359
Attica, NY	199. 2437
Attleboro, MA	2232
Attleborough, MA	1604
Atwater, MN	10570
Atwood, IL	6359
Atwood, KS	10644
Aubrey, TX	7495
Auburn, AL	12455
Auburn, CA	9227
Auburn, IN	2238. 6509
Auburn, ME	154. 2270
Auburn, NE	4588. 3343
Auburn, NY	1285. 1350
	1345. 1351
Auburn, PA	9240
Audubon, IA	4891
Augusta, GA	1613. 1703
	1860
Augusta, IL	6751
Augusta, KS	6643
Augusta, KY	4612. 4616
Augusta, ME	367. 406
	498
Ault, CO	8088. 8167
Aurelia, IA	7108. 9724
Aurora, IL	38. 1792
	1909. 2945. 3845. 4469
	4596. 13565
Aurora, IN	699. 2963
Aurora, MN	11345
Aurora, MO	4409
Aurora, NE	2897. 8246
	9056
Aurora, NY	412
Austin, MN	1690. 4131
Austin, NV	1331
Austin, PA	12562
Austin, TX	2118. 2617
	3289. 4308
	4322
Avella, PA	7854
Avery, TX	10638
Avoca, MN	11224
Avova, PA	8494
Avon Park, FL	10826
Avondale, PA	4560
Avonmore, PA	7594
Ayden, NC	13554
Ayer, MA	3073
Aylesworth, OK	10385
Ayrshire, IA	5479
Azusa, CA	8065, 8074
Babylon, NY	4906. 10358
Bagley, IA	6995
Bagley, MN	6813
Bagwell, TX	10657
Bailey, TX	12741
Bainbridge, GA	6004
Bainbridge, NY	2543
Bainbridge, PA	9264
Baird, TX	3286, 5493
Baker, MT	10443
Baker, OR	6768
Baker City, OR	2865, 4206
Bakersfield, CA	6044, 10357
	11327
Bakerton, PA	11757
Balaton, MN	6840
Baldwin, NY	11474
Baldwin, WI	10106
Baldwinsville, NY	292
Ballinger, TX	3533
	4193, 6757
Ballston Spa, NY	954, 1253
Bally, PA	9402
Baltimore, MD	204, 414
	814, 826, 1109, 1252
	1303, 1325, 1336, 1337
	1384, 1413, 1432, 1489
	1797, 2453, 2499, 2623
	4218, 4285, 4518, 4530
	4533, 5776, 5984, 9639
	11207, 13745
Baltimore, OH	7639
Bancroft, IA	5643
Bancroft, NE	8863
Bandon, OR	9718
Bangor, ME	112, 306
	518, 1095, 1437, 1687
	2089
Bangor, PA	2659, 4513
	14170
Bangor, WI	13202
Banning, CA	9459
Baraboo, WI	2079, 3609
Barberton, OH	5230, 5819
Barbourville, KY	13906
	6262, 7284
Bardwell, KY	8331
Bardwell, TX	10678
Barker, NY	10126
Barnard, KS	8396
Barnegat, NJ	8497
Barnesboro, PA	5818
Barnesville, GA	6243, 12404
Barnesville, MN	4959, 6098
Barnesville, OH	911, 2908
	6621
Barnum, MN	11761
Barnwell, SC	11287
Barre, MA	96, 2685
	10165
Barre, VT	2109, 7068
Barrington, IL	11283
Barry, IL	5771
Bartlesville, OK	5310, 6258
	7032, 9567
Bartlett, TX	7317, 5422
Barton, MD	6399
Barton, VT	2290
Bartow, FL	4627, 13389
Basin, WY	10858
Bassett, VA	11976
Bastrop, TX	4093
Batavia, IL	339, 4646
	9500
Batavia, NY	340, 1074
	2421
Batavia, OH	715
Batesburg, SC	5595
Batesville, AR	7556, 8864
Batesville, IN	7824
Batesville, OH	2219
Bath, ME	61, 494
	761, 782, 1041, 2743
Bath, NY	165, 10235
Bath, PA	5444
Bathgate, ND	4537, 11112
Baton Rouge, LA	2633, 9834
	13737
Battle Creek, MI	1205, 3314
	3896, 7013, 7589, 11852
	13858, 14185
Battle, MN	8756, 10710
Baxter Springs, KS	1838, 5952
	11056
Bay City, MI	410, 2145
	2853, 4953
	13622
Bay City, TX	6062, 7753
Bay Shore, NY	10029
Bayard, NE	9666
Bayard, WV	11664
Bayfield, WI	7158
Bayonne, NJ	8454
Bayside, NY	7939
Bazile Mills, NE	8469
Beach, ND	9484
Beach Haven, NJ	11658
Beallsville, OH	7025
Beardsley, MN	7438
Beardstown, IL	3640
Beatrice, NE	2357, 3081
	4148, 4185
Beattyville, KY	7751
Beaumont, TX	4017, 5201
	5201, 5825, 5841, 9357
Beaver, KS	11177
Beaver, PA	3850, 5042
	8185
Beaver City, NE	3619, 9119
Beaver Creek, MN	9321
Beaver Dam, WI	851, 3270
	4602, 7462
Beaver Falls, PA	3356, 4894
	14117
Beaverdale, PA	11317
Beckley, WV	6735, 9038
	10589
Bedford, IA	2298, 5165
Bedford, IN	1892, 3013
	5173, 5187, 13788
Bedford, PA	3089
Bedford, VA	11328
Bedford City, VA	4257
Beech Creek, PA	13205
Beecher, IL	7726
Beemer, NE	6287
Beeville, TX	4238, 4866
Beggs, OK	6868, 10482
Bel Air, MD	2797, 3933
	9474, 13680
Belden, NE	10025
Belden, NM	6597
Belfast, ME	840, 4806
	7586, 13762
Belfast, NY	9644
Belifield, ND	9539
Belington, WV	6618, 6619
Bellaire, OH	1944, 7327
	13914
Belle Fourche, SD	4646
Belle Plaine, IA	2012, 4754
	14069
Belle Plaine, MN	7273
Belle Vernon, PA	4850
Bellefontaine, OH	1784, 2480
	11726
Bellefonte, PA	459
Bellerose, NY	13234
Belleville, IL	2154, 11478
	13236
Belleville, KS	3386, 9559
Belleville, NJ	8382, 12019
Belleville, PA	5306, 10128
Bellevue, OH	2302
Bellevue, PA	5509, 8761
Bellevue, TX	8672
Bellflower, CA	12328, 12754
Bellingham, WA	7372, 7474
	9070
Bellmore, NY	11072
Bellows Falls, VT	1653
Bellport, NY	12473
Bells, TX	7524
Bellville, TX	4241
Bellwood, PA	7356
Belmar, NJ	5363, 13848
Belmond, IA	8748
Belmont, OH	4864, 6391
Beloit, KS	3231, 6701
Beloit, WI	836, 2163
	2407, 2725
Belpre, OH	8420
Belton, TX	2735, 3295
	4167, 7509, 8518, 13810
Belvidere, IL	1097, 3190
Belvidere, NJ	1096, 4980
	3628
Bement, IL	4829
Bemidji, MN	5582, 8241
Bend, OR	9363, 13093
Bendersville, PA	9114
Benedict, NE	8105
Benjamin, TX	7669
Benld, IL	7728
Bennettsville, SC	6385
Bennington, OK	7099, 10343
Bennington, VT	130, 2395
Benson, MN	6154
Benson, NC	12614
Benson, PA	7935
Bentleyville, PA	8196, 9058
	13663
Benton, AR	9494
Benton, IL	6136, 8234
Benton, PA	6328
Benton Harbor, MI	4261, 10143
	10529
Bentonville, AR	7523, 8135
Berea, KY	8435
Berea, OH	2004
Beresford, SD	10813
Bergenfield, NJ	11368
Berkeley, CA	5380, 7849
	11495, 12320
Berlin, MD	8319
Berlin, NH	4523, 5622
	14100
Berlin, NJ	9779
Berlin, PA	5823, 6512
Berlin, WI	400, 4620
	461
Bernardsville, NJ	6960
Bernville, PA	8913
Berryville, AR	10406
Berryville, VA	7338
Bertha, MN	7373
Berthoud, CO	7995, 8033
Bertram, TX	11519
Bertrand, NE	8466
Berwick, PA	568, 6162
Berwind, WV	9909
Berwyn, IL	12426

City	Charter #	City	Charter #	City	Charter #	City	Charter #
Berwyn, OK	7209	Bloomfield, NJ	4056		3246, 14021	Brighton, IA	2033, 5554
Berwyn, PA	3945, 13999	Blooming Grove, TX	4768, 7055	Boulder Valley, MT	4323	Brighton, IL	9397
Bessemer, AL	4220, 6961		13555	Bound Brook, NJ	3866, 8512	Brillion, WI	7224
	11905, 13789	Blooming Prairie, MN	6775	Bovey, MN	11054	Brinsmade, ND	8502
Bessemer, MI	13607, 3947	Bloomington, IL	819, 2386	Bowbells, ND	7116	Bristol, CT	2250
Bethany, MO	8009		2676, 2386	Bowdoinham, ME	944	Bristol, NH	5151
Bethel, CT	1141, 10289	Bloomington, IN	1888, 8415	Bowerston, OH	7486	Bristol, PA	717
Bethel, ME	7613	Bloomsburg, PA	5211, 4543	Bowie, TX	4265, 4785	Bristol, RI	1292, 1562
Bethel, OH	5627	Bloomsburgh, PA	293		8330	Bristol, SD	8480
Bethel, VT	962	Bloomsbury, NJ	2271, 10712	Bowling Green, KY	2149, 5900	Bristol, TN	2167, 2796
Bethesda, OH	5602	Blossburg, PA	5007, 13381		7804, 9365, 10448, 11589		13640
Bethlehem, PA	138, 2050	Blossom, TX	5733	Bowling Green, OH	4045	Bristol, VA	4477
Beverly, MA	969	Blue Ball, PA	8421	Bowman, ND	8976	Bristol, VT	6252
Beverly, NJ	8704	Blue Earth, MN	5393, 7641	Boyceville, WI	11128	Bristow, NE	9448
Beverly, OH	133	Blue Hill, NE	3419	Boyd, MN	6571	Bristow, OK	6260, 10115
Beverly Hills, CA	11461	Blue Mound, IL	9530	Boyertown, PA	2137, 2900	Britt, IA	5020
Bicknell, IN	7155	Blue Ridge, GA	6079	Boyne City, MI	9020	Briton, SD	6073, 13460
Biddeford, ME	1089, 1575	Blue Ridge Summit, PA	12281	Boynton, OK	6511	Broadway, VA	6666
Big Lake, MN	11611	Bluefield, WV	11109, 6674	Bozeman, MT	2027, 2803	Brockport, NY	382, 13965
Big Rapids, MI	1832, 2944		4643, 7734		3075, 4968	Brockton, MA	2152, 2504
Big Run, PA	5667	Bluffton, IN	58, 13305, 13317		7441	Brockwayville, PA	5497
Big Spring, TX	4306, 6668	Bluffton, OH	5626, 11573	Braddock, PA	2799, 2828	Brodhead, WI	1710
	13984, 12543	Blum, TX	6069		6796, 13866	Broken Arrow, OK	7115, 7600
Big Stone Gap, VA	11765	Boaz, AL	10441, 11870	Bradentown, FL	10245		10255
Big Timber, MT	4590, 4932	Bode, IA	10371	Bradford, OH	9163, 14077	Broken Bow	3445, 3449
Biggsville, IL	3003	Bogalusa, LA	8959	Bradford, PA	2428, 2470		3927, 5995
Biglerville, PA	7917	Bogata, TX	10483, 10639		4199		10424
Billings, MT	3097, 4593	Bogota, NJ	11543	Bradford, VT	7267	Bronson, MI	9704
	9355, 12407	Boise, ID	8346, 10083	Bradley Beach, NJ	10224	Bronte, TX	8641
Billings, OK	5960		10751	Bradshaw, NE	8097	Bronxville, NY	8240
Biloxi, MS	10576	Boise City, ID	1668, 3471	Brady, TX	4198, 7827	Brookfield, MO	12820
Binford, ND	8265	Boise City, OK	11084		8573	Brookhaven, MS	10494
Binghamton, NY	202, 1189	Bokchito, OK	6683, 7499	Braggs, OK	10437	Brookings, SD	3087, 6462
	1513, 2136		9838	Braham, MN	7387	Brookline, MA	3553
Biola, CA	11769	Bolivar, MO	7271	Braidwood, IL	1964, 11895	Brooklyn, CT	1360
Birdsboro, PA	3905	Bolivar, PA	6135, 12355	Brainerd, MN	2590	Brooklyn, IA	3284
Birdseye, IN	8835	Bolton Landing, NY	13089	Braintree, MA	11347	Brooklyn, NY	658, 923
Birmingham, AL	2065, 3185	Bonham, TX	3094, 4540	Braman, OK	10003		1223, 1491, 1543, 2976
	3442, 3587, 3679, 3734		5146	Branchville, NJ	7364, 13855		10054
	3993, 7020, 12906, 13358	Bonita, TX	10163	Brandom, MN	10862	Brookneal, VA	10835, 11960
Birmingham, CT	1098	Bonner Springs, KS	9197	Brandon, VT	278, 404	Brookport, IL	6713
Birmingham, MI	9874, 13703	Bonners Ferry, ID	10727	Brantley, AL	7991	Brooksville, FL	9891, 13320
Bisbee, AZ	7182	Boone, IA	2051, 3273	Brasher Falls, NY	10943	Brooksville, KY	8830
Bisbee, ND	6733		6838, 13817	Brattleboro, VT	470, 1430	Brookville, IN	1619, 5629
Bishopville, SC	10263	Boonton, NJ	4274		2305		7805
Bismarck, ND	2434, 2677	Boonville, IN	2207, 9266	Brawley, CA	9673	Brookville, OH	9553
	2986, 3169, 9622, 13398		10613	Braymer, MO	7351	Brookville, PA	897, 2392
Biwabik, MN	8697	Boonville, MO	1584, 10915	Brazil, IN	3583, 5267		3051
Bixby, OK	10467	Boonville, NY	2320, 8022		8620	Browerville, MN	7227
Black Lick, PA	8428	Boothbay Harbor, ME	5589	Brea, CA	13001, 13877	Brown Station, NY	9482
Black River		Bordentown, NJ	9268	Breckenridge, MN	4644, 6335	Browns Valley, MN	7341
Falls, WI	3897	Boscobel, WI	1771	Breckenridge, TX	7422, 14027	Brownstown, IL	10397
Black Rock, AR	11312	Boston, MA	200, 322	Breese, IL	9893	Brownstown, IN	9143
Blackduck, MN	9147		322, 359, 379, 408	Bremen, OH	9768	Brownstown, PA	9026
Blackfoot, ID	7419		460, 475, 505, 514	Bremerton, WA	9280	Brownsville, PA	135, 648
Blackstone, MA	1207		515, 524, 525, 529	Brenham, TX	3015, 10860		2457, 2673
Blackstone, VA	9224		536, 545, 551, 554		13678	Brownsville, TN	6042
Blackwell, OK	5460, 6916		578, 582, 595, 601	Brewster, MN	10946	Brownsville, TX	4577, 7002
	7583		603, 609, 615, 625	Brewster, NY	2225		12236, 12792
Blackwood, NJ	9597		629, 635, 643, 646	Brewster, WA	9170	Brownsville, NE	1846
Blaine, WA	4470, 4471		654, 665, 672, 677	Bricelyn, MN	6478	Brownwood, TX	2937, 4344
Blair, NE	2724, 8027		684, 716, 778, 806	Bridgehampton, NY	9669		4344, 8312, 9812, 13588
Blair, OK	10368, 12130		847, 932, 936, 974	Bridgeport, AL	4591, 11168	Bruin, PA	8919
Blair, WI	10667		985, 993, 1005, 1015	Bridgeport, CT	910, 921	Brundidge, AL	7429
Blairstown, NJ	5621, 9833		1028, 1029, 1099, 1295		927, 928	Brunson, SC	10832
Blairsville, PA	867, 4919		1442, 1469, 1527, 1675		11168	Brunswick, GA	3753, 4944
	13868		1699, 1827, 1993, 2103	Bridgeport, IL	8347	Brunswick, MD	8244, 14044
Blakely, GA	7018		2111, 2112, 2277, 2289	Bridgeport, NE	9711	Brunswick, ME	192, 1118
Blanchard, IA	4902		2304, 2373, 2846, 3923	Bridgeport, OH	214, 6624		1315
Blanchard, OK	8702		4202, 5155, 5163, 5840		14050	Brunswick, MO	4083
Blanchardville, WI	11114		6104, 9579, 11137, 11339	Bridgeport, PA	8329	Brunswick, NE	10033
Blanchester, OH	8588		11903, 12336, 12540	Bridgeport, TX	8731	Brush, CO	6437, 8520
Blanco, TX	8134	Boswell, IN	5476	Bridgeton, NJ	1346, 2999	Brushton, NY	9643
Blandinsville, IL	8908, 13597	Boswell, OK	7651, 8353		9498	Bryan, OH	237, 2474
Bliss, NY	10754		10363	Bridgeville, PA	6636		13740
Blissfield, MI	11813	Boswell, PA	6603	Bridgewater, SD	6925, 7426	Bryan, TX	3446, 4070
Blockton, IA	8211	Bosworth, MO	7573	Bridgton, ME	9181	Bryn Mawr, PA	3766
Bloomfield, IA	1299, 9303	Bottineau, ND	6085, 7879	Brigham City, UT	6036	Buchanan, MI	2046, 3925
Bloomfield, NE	6503	Boulder, CO	2352, 2355	Brighton, CO	7577	Buchanan, VA	4460, 9375

City	Charter #	City	Charter #	City	Charter #	City	Charter #
Buckeye City, OH	7631		13154, 13844		13713		10533, 11496
Buckhannon, WV	4760, 13646	Caldwell, TX	6607, 6614	Canon City, CO	3879, 8433		1168.
Bucksport, ME	1079	Caledonia, IL	10567	Canonsburg, PA	4570, 13813	Caspian, MI	11802
Bucyrus, OH	443, 3274	Caledonia, MN	7508	Canton, IL	415, 3593	Cass Lake, MN	6352
Buda, TX	12241	Caledonia, NE	5648	Canton, MA	663	Cassandra, PA	1272
Buena Vista, CO	8735	Calera, OK	11182	Canton, MD	4799	Casselton, ND	2792, 714.
Buena Vista, GA	7963	Calexico, CA	9686, 9705	Canton, MO	7729	Cassopolis, MI	181.
Buena Vista, VA	4314, 9890	Calhoun, GA	7549	Canton, MS	6847	Cassville, MO	897
Buffalo, NY	235, 453	Califon, NJ	9260	Canton, NY	3696, 8531	Castle, MT	457.
	850, 4741, 5174, 6184	California, MO	1712	Canton, OH	76, 2489	Castle Rock, CO	6556
	7823, 11319, 11435, 11768	California, PA	4622	Canton, PA	2505, 9317	Castle Shannon, PA	912.
	11836, 11883, 12313, 12337	Calilpatria, CA	10687	Canton, SD	2830, 4637	Castleton, NY	842, 581.
	12445, 13219, 13220, 13441	Calistoga, CA	7388, 9551	Canton, TX	8891	Castleton, VT	159.
	13952	Callaway, NE	9258	Canyon, TX	5238, 7961	Castlewood, SD	600.
Buffalo, OK	8896	Callicoon, NY	9427, 13590		14090	Catasauqua, PA	1411, 828.
Buffalo, WY	3299	Calumet, MI	3457	Canyon City, OR	6491	Catawissa, PA	4548, 744.
Buffalo Center, IA	5154	Calvert, TX	3742	Capac, MI	10631	Catlettsburg, KY	2740, 4200
Buhl, ID	11065	Calvin, OK	6980, 7053	Cape Girardeau, MO	4611		960.
Burbank, CA	10099		10226	Cape May, NJ	5839, 9285	Catlin, IL	727.
Burgettstown, PA	2408, 6944	Camas, WA	10686	Cape May		Cato, NY	985
Burkburnett, TX	8706, 13668	Cambridge, IA	9014	Court House, NJ	7945	Catonsville, MD	509.
Burley, Id	10341, 12256	Cambridge, IL	2540, 2572	Carbondale, CO	9009	Catskill, NY	1198, 129.
Burlingame, KS	4040, 9157	Cambridge, MA	433, 614	Carbondale, IL	4904, 7598	Cavalier, ND	1011.
Burlington, IA	351, 751		731, 770		12596	Cave City, KY	791.
	1744		11152	Carbondale, PA	664	Caverna, KY	220.
Burlington, KS	1979, 3170	Cambridge, MD	2498, 4085	Cardiff, TN	4303	Cawker City, KS	2640, 461.
	6955		5880	Cardington, OH	127	Cayuga, IN	918.
Burlington, NC	8649, 13613	Cambridge, MN	7428	Carey, OH	6119	Cazenovia, NY	1271, 567.
Burlington, NJ	1222	Cambridge, NE	6506	Caribou, ME	6190	Cecil, PA	7076, 1409
Burlilngton, VT	861, 1197	Cambridge, NY	1275	Carlinville, IL	2042, 4299	Cedar Falls, IA	2177, 387.
	1698	Cambridge, OH	141, 1942	Carlisle, IN	8805		550.
Burlington, WA	9808, 10648		2861, 2872	Carlisle, KY	5959	Cedar Grove, NJ	1313.
Burlington, WI	1933, 11783		6566, 13905	Carlisle, PA	21, 4444	Cedar Rapids, IA	483, 56.
Burlington		Cambridge City, IN	70, 2734	Carlsbad, NM	5487, 6884		2511, 364.
Junction, MO	6242		8871		12569		5113, 916.
Burnet, TX	3007, 6966	Cambridge		Carlstadt, NJ	5416	Cedar Rapids, NE	828.
Burnham, PA	11257	Springs, PA	6533, 9430	Carlton, MN	6973	Cedar Vale, KS	5608, 653.
Burns, OR	6295, 8691		14029	Carlyle, IL	5548	Cedarburg, WI	141.
Burnside, KY	8903	Cambridgeport, MA	1228	Carmel, NY	976	Cedaredge, CO	1027
Burnside, PA	11902	Camden, AL	8217	Carmen, OK	6719, 6844	Cedarhurst, NY	1185.
Burr Oak, KS	3880, 7302	Camden, AR	4066, 14096		10203, 12498	Cedartown, GA	4075, 1183.
Burr Oak, MI	9497	Camden, ME	2311, 6231	Carmi, IL	4934, 5357	Celeste, TX	532.
Burt, IA	5685, 5703	Camden, NJ	431, 1209	Carmichaels, PA	5784	Celina, OH	552.
Butron, OH	6249		3372, 13120	Carnegie, OK	11763	Celina, TX	604.
Burwell, NE	7340		13203	Carnegie, PA	6174, 12934	Cement, OK	814.
Bushnell, IL	1791, 4709	Camden, NY	2448	Carondelet, MO	454	Center, CO	974.
Butler, IN	9286	Camden, OH	8300, 14316	Carpio, ND	7315	Center, TX	5971, 724.
Butler, MO	1843, 2561	Camden, SC	9083	Carrier Mills, IL	8015	Centar Hall, PA	1219.
	6405	Camden, TN	8506	Carrington, ND	5551	Center Point, IN	925.
Butler, NJ	6912	Cameron, MO	4259	Carroll, IA	3969	Center Point, TX	604.
Butler, OH	6515	Cameron, TX	4086, 5484	Carroll, NE	5957	Centerburg, OH	818.
BUTLER, PA	309, 4374		13731	Carrollton, GA	5264	Centerville, IA	337, 219.
	5391, 9814	Cameron, WV	6020	Carrollton, IL	2390		284.
Butte, MT	4283	Camp Hill, PA	12380	Carrollton, KY	2592, 3074	Centerville, IN	37, 269.
Butte, NE	9623	Campbell, CA	11572	Carrollton, MO	4079	Centerville, SD	547.
Butte City, MT	2566	Campbell, MN	6259	Carrollton, OH	5396, 11714	Centerville, TN	3288, 962.
Buxton, ND	10814	Campbell, MO	6885		13883	Central City, CO	1652, 212.
Buzzards Bay, MA	1322	Campbell, NE	8975	Carrolltown, PA	5855	Central City, KY	822.
Byars, OK	7389	Campbell, TX	7348, 10473	Carson, ND	13454	Central City, NE	2871, 838.
Byers, TX	8787	Campbellsport, WI	6222	Carson City, NV	9242	Central City, PA	1196.
Byersville, OH	5641	Campbellsville, KY	6342	Carter, MT	10995	Central Park, NY	1295.
Byromville, GA	9607	Canaan, CT	8511	Cartersville, GA	4012, 12635	Central Square, NY	1010.
Cabool, MO	8877	Canadian, OK	9993	Carterville, IL	7889	Central Valley, NY	999.
Caddo, OK	5246, 7368	Canadian, TX	6826	Carthage, IL	1167	Centralia, IL	1001, 330.
	10010	Canajoharie, NY	1122, 1257	Carthage, MO	2013, 3005		11904, 1192.
Caddo Mills, TX	9637		13876		4441, 4815	Centralia, KS	382.
Cadiz, OH	100, 1447	Canal Dover, OH	4293, 4331	Carthage, NY	2442, 3672	Centralia, MO	687.
	2444, 4853	Canadaigua, NY	259, 2765		6094, 13584	Centralia, OK	770.
Cainesville, MO	8407		3817, 10047	Carthage, OH	8488	Centralia, PA	956.
Cairnbrook, PA	10704	Canastota, NY	1525, 4419	Carthage, SD	10833	Centralia, WA	4439, 8736
Cairo, IL	33, 785	Canby, MN	6366, 7427	Carthage, TN	7928		1309.
	3735, 6815	Canby, OR	10619	Carthage, TX	6152, 6197	Centreville, MD	2341, 320.
	13804	Cando, ND	5798, 7377	Caruthers, CA	11330	Centreville, MI	209.
Calais, ME	1425	Candor, NY	353	Caruthersville, MO	10784, 14092	Ceredo, WV	477.
Caldwell, ID	4690, 8225	Caney, KS	5349, 5516	Casey, IA	8099	Ceylon, MN	602.
	9333	Canfield, OH	3654	Casey, IL	6026, 8043	Chadron, NE	382.
Caldwell, KS	3658, 6333	Cannel City, KY	7891		13673	Chadwick, IL	5619
Caldwell, NJ	7131, 9612	Cannelton, IN	9401, 9682	Cashion, OK	6161	Chaffee, MO	9928
Caldwell, OH	2102, 6458	Cannon Falls, MN	2387, 6704	Casper, WY	6850, 7083	Chalfont, PA	12582

City	Charter #
Challis, ID	9477
Chamberlain, SD	2911, 4282
	8550, 9301
	13483
Chambersburg, PA	593, 4272
Champaign, IL	913, 2829
Champlain, NY	316
Chandler, OK	5354, 6142
	6269
Chanute, KS	3819, 4036
	6072
Chappaqua, NY	12746
Chappell, NE	9790
Chardon, OH	4671, 13569
Chariton, IA	1724, 6014
	9024, 13458
Charleroi, PA	4534, 13585
	14123
Charles City, IA	1810, 2579
	4677, 5979
Charles Town, WV	7270
Charleston, IL	763, 1851
	11358, 14024
Charleston, SC	1621, 1622
	2044, 10708
Charleston, WV	1795, 3236
	4412, 4667
	8569, 13509
Charlestown, IN	6952
Charlestown, NH	537
Charlestown, WV	1868
Charlotte, MI	1758, 3034
Charlotte, NC	1547, 1781
	2135, 2314
	5055, 9164
Charlottesville, VA	1468, 1742
	2594, 6005
	9246, 10618
	11517
Charter Oak, IA	4376
Chartiers, PA	4762
Chase City, VA	9291
Chaska, MN	8378
Chateaugay, NY	8893
Chatfield, MN	6608
Chatham, VA	10821
Chatsworth, IL	5519
Chattanooga, TN	1606, 1746
	2559, 3691, 4060, 4456
	7817, 7848, 9176, 13746
Cheboygan, MI	3235
Checotah, OK	5128, 10051
	10063, 11920
Chehalis, WA	4203, 9389
Chelsea, IA	5412
Chelsea, MA	533, 4074
	9651, 11270
	14087
Chelsea, OK	5955
Chelsea, VT	1004, 2120
	4929
Cheltenham, PA	12526
Cheney, WA	4542, 9080
	9144
Cheraw, SC	9342
Cherokee, IA	3049, 10711
Cherokee, KS	5447
Cherokee, OK	6677, 9008
	9884
Cherry Creek, NY	10481, 14078
Cherry Tree, PA	7000
Cherry Valley, NY	1136, 13748
Cherryvale, KS	3277, 4288
	4749, 7383
Cherryville, NC	9548
Chesaning, MI	11454
Chesapeake City, MD	6845
Chester, IL	4187
Chester, MT	11105
Chester, NY	1349
Chester, PA	332, 355
	2904, 6654
Chester, SC	1804, 8471
	10663
Chester, VT	4380
Chester, WV	6984
Chesterhill, OH	5552
Chestertown, MD	1500, 4327
	9744, 13798
Chetopa, KS	1902, 11374
Cheviot, OH	8478
Chewelah, WA	8789
Cheyenne, WY	1800, 2652
	3416, 8089, 11380
Chicago, IL	8, 225
	236, 276, 320, 466, 508
	642, 698, 713, 724, 818
	966, 1678, 1693, 1709, 1734
	1845, 1867, 1978, 2047, 2048
	2450, 2601, 2670, 2826, 2894
	3179, 3278, 3500, 3502, 3503
	3647, 3677, 3847, 3698, 3882
	3916, 4073, 4489, 4605, 4666
	4787, 5106, 5111, 6290, 6535
	6723, 7358, 7926, 8121, 8842
	8532, 9010, 9750, 10179, 10237
	10247, 10305, 10337, 10763
	11009, 11092, 11737, 11999
	12001, 12004, 12227, 12605
	12285, 12391, 12873, 12945
	13119, 13146, 13216, 13674
	13684, 14110, 14245, 14246
Chicago Heights, IL	5876, 13373
Chickasha, OK	5431, 5547
	8203, 9938
Chico, CA	8798, 9294
	13711
Chicopee, MA	1056
Childersburg, AL	10066
Childress, TX	4571, 5992
	6024, 12666
Chilhowie, VA	8875
Chillicother, IL	5584
Chillicothe, MO	3686, 4111
Chillicothe, OH	128, 1172
	1277, 2993
	5634
Chilton, WI	5933
Chino, CA	10271
Chinook, MT	6097, 10053
	13837
Chipley, FL	7778
Chippewa Falls, WI	2125, 3778
Chisholm, MN	7647
Chittenango, NY	179
Chokio, MN	5969
Chowchilla, CA	11151
Chrisman, IL	7111
Christiana, PA	2849, 7078
Christiansburg, VA	7937
Christopher, IL	8260
Churchs Ferry, ND	6337
Churdan, IA	6737
Cicero, IL	10720, 11662
Cimarron, KS	3751, 13329
Cimarron, NM	9292
Cincinnati, OH	20, 24
	32, 93, 620, 630, 844
	1185, 2922, 2315, 2495
	2524, 2542, 2549, 2616
	2664, 2730, 2798, 3461
	3606, 3639, 3642, 3707
	8438, 12446
Circle, MT	11101
Circleville, OH	1118, 172
	2817
Cisco, TX	4134, 6115
	7360, 11357
Citronelle, AL	6835
Clairton, PA	6495
Clanton, AL	11515
Claremont, CA	9467, 10208
Claremont, NH	596, 4793
	13829
Claremore, OK	4987, 10117
Clarence, IA	7682
Clarendon, TX	5463
Clarinda, IA	2028, 3112
Clarington, OH	5762
Clarion, IA	3788, 3796
Clarion, PA	774, 3044
Clark, SD	3479, 6409
Clark, WV	10157
Clarkfield, MN	6448
Clarks, NE	6939
Clarks Summit, PA	10383
Clarksburg, WV	1530, 4569
	7029, 7681
Clarksdale, MS	6595, 12222
Clarkston, WA	6742
Clarksville, AR	9633, 11580
Clarksville, OH	7370
Clarksville, TN	1603, 2720
	3241
Clarksville, TX	3973, 4982
	13428, 13974
Clarksville, VA	1658
Clatskanie, OR	14001
Claude, TX	7123
Claxton, GA	10333
Clay, KY	8943
Clay Center, KS	3072, 3345
Clay Center, NE	3574
Clay City, IN	9540
Clay City, KY	4217
Claysburg, PA	10232
Claysville, PA	4255, 4273
	9307
Clayton, MO	12329, 12333
	13481
Clayton, NJ	10471
Clayton, NM	5713
Clayton, NY	3797, 5108
Cle Elum, WA	10469
Clear Lake, IA	7869
Clear Lake, SD	6357, 12877
Clear Spring, MD	9699
Clearbrook, MN	11392
Clearfield, IA	9549
Clearfield, PA	768, 855
	4836, 8464
	13998
Clearwater, FL	12905
Cleburne, TX	2982, 4035
	4386, 6791
	10411, 13017
Clementon, NJ	14006
Clendenin, WV	7275
Clermont, FL	11921
Cleveland	7, 13
	773, 786, 807, 1666, 1689
	2662, 2690, 2956, 3202, 3272
	3545, 3950, 4318, 4782, 5006
	5090, 5152, 5191, 5194, 5350
	5653, 5678, 5805, 5911, 7386
	7487, 10276, 11141, 11376
	11862
Cleves, OH	7456, 13774
Cliffside Park, NJ	11618, 14162
Clifton, AZ	5821
Clifton, CO	9875
Clifton, IL	6318
Clifton, KS	7178
Clifton, NJ	11983, 12690
Clifton, TX	7245
Clifton Forge, VA	6008, 9177
	14180
Clifton Heights, PA	6275, 14122
Clifton Springs, NY	8717
Clinton, CT	1314
Clinton, IA	994, 2469
	3736
Clinton, IL	1926
Clinton, IN	6480
Clinton, KY	9098
Clinton, MA	440
Clinton, MN	7161
Clinton, MO	1940, 7806
	8509
Clinton, NJ	1114, 2246
Clinton, NY	10295
Clinton, OK	6851, 6940
	9985
Clinton, SC	8041
Clintonville, PA	6948, 9154
Clintonville, WI	6273
Clintwood, VA	8362
Clio, SC	11153
Cloquet, MN	5405
Closter, NJ	8394
Clover, SC	11439
Cloverdale, CA	11282
Cloverdale, IN	10465
Clovis, CA	10213
Clovis, NM	8767, 8784
Clutier, IA	5366
Clyde, KS	3115, 11775
Clyde, NY	304, 2468
Clyde, OH	4197
Clyde, TX	8106, 8780
Clymer, PA	9898
Coachella, CA	10292
Coal City, IL	10132
Coal Creek, TN	10028
Coaldale, PA	9739, 11188
Coalgate, OK	5647, 7321
Coalinga, CA	9323
Coalport, PA	6887
Coalville, UT	7696
Coatesville, IN	8447
Coatesville, PA	575, 3990
Cobden, IL	5630
Cobleskill, NY	461
Cochran, GA	7567
Cochranton, PA	4971
Cockeysville, MD	4496
Cody, WY	7319, 8020
Coeburn, VA	6899
Coeur d' Alenen, ID	6793, 7120
	13288
Coffee Springs, AL	11259
Coffeen, IL	7579
Coffeyville, KS	3324, 6797
Cohoes, NY	1347
Coin, IA	7309
Cokato, MN	12395
Colbert, OK	7962, 10381
Colby, KS	3512, 13076
Colchester, IL	8485
Cold Spring, MN	8051
Cold Spring, NY	4416
Coldwater, KS	3703, 6767
Coldwater, MI	1235, 1924
	14116
Coleman, TX	3433, 4683
	13595
Coleraine, MN	8322
Coleridge, NE	9796, 10023
Colfax, IA	7114, 13686
Colfax, WA	3076, 3119
	7095, 10511
College Corner, OH	5277
College Springs, IA	11295
Collegeville, PA	8404
Collingswood, NJ	7983, 13969

City	Charter #
Collins, MS	9728
Collinsville, AL	11337
Collinsville, IL	6125
Collinsville, OK	6138, 9965
	10280
Collinsville, TX	6300
Collyer, KS	11855
Colman, SD	6688
Colony, KS	11531
Colorado, TX	2801, 2893
	4395, 4950
	5276
Colorado City, CO	6238
Colorado Springs, CO	2179, 3913
	5283, 8572
Colton, CA	3573, 8608
	13356
Colton, WA	4788
Columbia, AL	8095
Columbia, IL	7717, 13805
Columbia, KY	6769
Columbia, MO	67, 1467
	1770
Columbia, MS	10326
Columbia, PA	371, 641
	3873
Columbia, SC	1680, 1765
	6871, 8133, 9687, 10315
	10597, 12412, 137412
Columbia, SD	3352
Columbia, TN	1713, 2568
	4849, 7870
Columbia City, IN	7132, 7175
Columbiana, OH	6296
Columbus, GA	1630, 2338
	3937, 4691
Columbus, IN	1066
Columbus, KS	6103
Columbus, MS	2638, 10361
	10738
Columbus, MT	9396
Columbus, NE	2807, 5180
	8328
Columbus, OH	123, 591
	599, 2423, 2605, 3610
	4443, 4579, 4697, 5029
	5065, 7584, 7621, 7745
	7818, 9282
Columbus, WI	178
Columbus Junction, IA	2032
Colusa, CA	10072
Colville, WA	8104
Comanche, OK	6299, 8366
Comanche, TX	3561, 4246
	7105
Commerce, GA	7431
Commerce, OK	10689
Commerce, TX	4021, 6224
Como, TX	9931
Compton, CA	8085
Compton, IL	7031
Concord, CA	9945
Concord, MA	833
Concord, MI	3251
Concord, NC	3903
Concord, NH	318, 758
	2447
Concordia, KS	3066, 3090
	3748
Condon, OR	7059, 8261
	14241
Conewango Valley, NY	10930
Confluence, PA	5307
Conneaut, OH	3492
Conneaut Lake, PA	6891, 13980
Conneautville, PA	143, 12189
	13942
Connell, WA	8958
Connellsville, PA	2329, 4481
	4861, 6452
	7445, 13491
Connersville, IN	1034, 6265
Conrad, IA	9447
Conrad, MT	9759
Conroe, TX	6394, 12809
Conshohocken, PA	2078, 2671
Constantine, MI	813, 2211
Converse, IN	11671
Convoy, OH	8017
Conway, AR	13719
Conway, MA	895
Conway, NH	9476
Conway, SC	9690, 10536
	10537
Conway, WA	11984
Conway Springs, KS	8467
Conyers, GA	11255
Conyngham, PA	13392
Cookeville, TN	9667, 9692
Coolidge, TX	7231
Coolville, OH	8175
Coon Rapids, IA	5514, 6080
Cooper, TX	4500, 5533
	10626, 13046
Coopersburg, PA	9034
Cooperstown, ND	5375, 13362
Cooperstown, NY	223, 280
	420, 7305
Copenhagen, NY	10077
Coplay, PA	9113
Copperhill, TN	9027
Coquille, OR	6849
Coral Gables, FL	13008
Cordell, OK	6052, 6647
	9972
Corinth, MS	9094, 9751
Corinth, NY	6479
Cornelia, GA	9613
Corning, AR	7311
Corning, IA	2936, 4268
	8100, 8725
Corning, NY	2655
Cornish, OK	7420
Cornwall, NY	7344, 10084
Corona, CA	7867, 8436
Corona, NY	8853
Corpus Christi, TX	4423, 7668
	12235
Corry, PA	569, 605
	4479, 4823
Corsicana, TX	3506, 3645
	3915, 11022
Cortez, CO	8967, 9100
Cortland, NY	226, 2272
	2827
Cortland, OH	4772
Corunna, MI	1256
Corvallis, OR	4301, 8750
Corwith, IA	5775, 10146
Corydon, IN	6625, 7760
Coshocton, OH	1920, 5103
	6892, 13923
Cottage Grove, OR	5642
Cotton Plant, AR	10723
Cottonwood, ID	7923
Cottonwood, MN	6584
Cottonwood Falls, KS	2764, 6590
Cotulla, TX	7243
Coudersport, PA	4948
Coulterville, IL	12000
Council Bluffs, IA	1479, 1684
	3427, 5838, 9306, 14028
Council Grove, KS	2001, 5757
Courtenay, ND	6210
Covina, CA	5830, 8222
Covington, GA	8945
Covington, IN	9860
Covington, KY	718, 1847
	1859, 2722
	4260, 8110
	8564
Covington, OH	5530
Covington, TN	10491
Covington, TX	7147
Covington, VA	4503, 5326
Cowden, IL	9700
Coweta, OK	6879, 10031
Cowgill, MO	6926
Coxsackie, NY	1398
Coyle, OK	12148
Cozad, NE	4165, 13426
Crafton, PA	6010, 13860
Craig, CO	10558
Craig, NE	9591
Cranbury, NJ	3168
Crandall, TX	5824, 5938
Crandon, WI	9387, 12814
Cranford, NJ	7171, 12263
Crary, ND	6407
Crawford, NE	6900
Crawford, TX	10400
Crawfordsville, IN	571, 2533
	7773
Creede, CO	4716
Creedmoor, NC	8902
Creighton, NE	4242, 8797
Crescent City, IL	6598
Crescent Heights, CA	11880
Cresco, IA	4897
Cresson, PA	5768
Cresson, TX	8965
Cressona, PA	9318
Crestline, OH	5099, 13273
Creston, IA	2586, 2833
	12636
Crete, NE	2706, 4820
	9731
Crewe, VA	9455, 14052
Cripple Creek, CO	4845
Crockett, CA	11326
Crockett, TX	4684, 5953
Crofton, NE	8186
Croghan, NY	10948
Crookston, MN	2567, 3262
Crosby, MN	9838
Crosby, ND	10596
Crosbyton, TX	9989
Cross Plains, TX	8583
Crossville, IL	8801
Crossville, TN	9809
Crowell, MI	9792
Croton on Hudson, NY	9171
Crowqell, TX	6402, 9178
Crowley, LA	5520, 10700
	12523
Crown Point, IN	2183
Crows Landing, CA	9765
Crystal, ND	7918
Crystal Falls, MI	7525, 11547
Crystal Lake, IA	5305, 9853
Cuba, IL	11144
Cuba, NY	1143, 2451
Cuba City, WI	5632
Cucamonga, CA	7152
Cuero, TX	4140, 8562
	14164
Culbertson, MT	8168
Cullman, AL	7097, 9614
Cullom, IL	8684
Culpeper, VA	3570, 5394
	5591
Culver City, CA	11732
Cumberland, IA	7326
Cumberland, MD	381, 1519
	2416, 5332
Cumberland, RI	1404
Cumby, TX	5719
Curtis, NE	8812
Curwensville, PA	300, 6969
	7430
Cushing, OK	6893, 8730
	10332
Custer, SD	4448
Custer City, OK	8727, 9981
Cut Bank, MT	9576
Cutchogue, NY	12551
Cuthbert, GA	10270
Cuyahoga Falls, OH	378
Cynthiana, Ky	1900, 2561
Dagsboro, DE	8971
Dahlgren, IL	7751
DAngerfield, TX	4701, 7090
Dale, PA	1296
Dale, WI	8113
Dalhart, TX	6762, 7971
Dallas, OR	7072, 7471
Dallas, PA	8161
Dallas, TX	2157, 245?
	3008, 3132, 3623, 366?
	3834, 3985, 4127, 421?
	4415, 4707, 5078, 705?
	7113, 8664, 9245, 934?
	10331, 10564, 10965, 1174?
	11996, 12186, 12707, 1273?
	1374?
Dallas City, IL	560?
Dallastown, PA	664?
Daltoon, GA	390?
Dalton, OH	637?
Damariscotta, ME	44?
Dana, IN	599?
Danbury, CT	943, 113?
Danielsville, PA	793?
Dansville, NY	75, 448?
Danvers, IL	674?
Danvers, MA	594, 745?
Danville, IL	113, 258?
	4731, 581?
Danville, IN	15?
Danville, KY	1600, 160?
	2409, 33?
	338?
Danville, PA	325, 107?
Danville, VA	1609, 198?
	9343, 947?
	101?
Danville, VT	15?
Darby, PA	44?
Dardanelle, AR	127?
Darlington, SC	2512, 99?
Darlington, WI	3161, 330?
	141?
Dauphin, PA	115?
Davenport, IA	15, 8?
	1671, 26?
	40?
Davenport, OK	86?
Davenport, WA	4002, 75?
David City, NE	2902, 38?
	39?
Davidson, OK	116?
Davidsville, PA	114?
Davis, OK	5298, 74?
Davis, SD	114?
Davis, WV	48?
Dawson, GA	4115, 64?
Dawson, MN	6321, 135?
Dawson, PA	46?
Dawson, TX	10694, 112?
Dawson Springs, KY	115?

City	Charter #	City	Charter #	City	Charter #	City	Charter #
Deckertown, NJ	1221		4708		7932, 7938	Dyersville, IA	9555
Decorah, IA	493, 5081	Denver, CO	1016, 1651	Dougherty, IA	5576	Dysart, IA	5934
Dedham, MA	669, 12567		1955, 2351, 2523, 2694	Douglas, AZ	6633	Eads, CO	8412, 14213
Deep River, CT	1139		3269, 4084, 4113, 4159	Douglas, WY	3556, 8087	Eagle, CO	9013
Deep River, IA	6705		4358, 4382, 6355, 7408	Dover, DE	1567	Eagle Bend, MN	6266
Deer Creek, MN	7268, 13303		8774, 9887, 10064, 11564	Dover, ME	3690	Eagle Grove, IA	3439, 4694
Deer Lodge, MT	1975, 9899		12517, 13098	Dover, NH	1043, 1087	Eagle Lake, TX	7534
Deer River, MN	9131	Denver, PA	6037		1353, 5274	Eagle Pass, TX	4490, 5060
Deerfield, WI	11577	Deport, TX	6430	Dover, NJ	2076, 5136		5181
Deerwood, MN	9703	Deposit, NY	472, 9434	Dover, PA	9362, 14049	Eagle River, WI	12124
Defiance, OH	1906, 2516	Dequeen, AR	5929	Dover Plains, NY	822	Earle, AR	9324
	4661, 13457	Derby Line, VT	1368	Dowagiac, MI	1625, 10073	Earlville, IL	3323, 7555
Dekalb, TX	8449	Derew, OK	12104	Downers Grove, IL	9725	Earlville, NY	4493
Del Norte, CO	4264	Deridder, LA	9237, 14168	Downey, CA	11701	East Aurora, NY	9950
Del Ray, CA	11041	Derry, NH	499	Downing, PA	338, 661	East Berlin, PA	6878, 14091
Del Rio, TX	5294, 7433	Derry, PA	6756, 12912	Downington, PA	8646	East Bernstadt, KY	10254
Deland, FL	9657, 13388		13794	Downs, KS	3563, 3569	East Brady, PA	5321, 5356
Deland, IL	5699	Des Moines, IA	389, 485		11318	East Cambridge, MA	449
Delano, CA	9195		950, 1970, 2307, 2583	Downsville, NY	7878	East Chicago, IN	7601, 10171
Delano, MN	9903		2631, 2886, 13312	Doyle, TN	10190		12058, 13531
Delavan, IL	1248, 3781	Des Plaines, IL	10319	Doylestown, PA	573		13532
Delaware, OH	243, 853	Detriot, MI	97, 116	Dozier, AL	9681	East Conemaugh, PA	6979
	7505, 13535		1433, 1542, 2365, 2591	Drake, ND	9524, 12393	East Ely, NV	9578
Delaware City, DE	1332		2707, 2870, 3357, 3487	Drayton, ND	6225	East Fairview, ND	10425
Delhi, LA	10912, 14225		3514, 3730, 6492, 8703	Dresden, OH	5144, 6529	East Grand	
Delhi, NY	94, 1323		10527, 10600, 12847	Driggs, ID	10278	Forks, MN	4638
Dell Rapids, SD	3508, 9693	Detroit, MN	3426, 8122	Dry Ridge, KY	7012	East Greenville, PA	5166
Delamr, DE	7211	Detroit, TX	4682	Dry Run, PA	10811	East Greenwich, RI	1405
Delmont, PA	9996	Detroit Lakes, MN	13075	Dryden, NY	6487	East Haddam, CT	7812, 1480
Delphi, IN	1949, 6986	Devil's Lake, ND	3397, 3714	Dublin, GA	6374, 8128	East Hampton, NY	7763
Delphos, KS	7532		5886	Dublin, IN	8804	East Islip, NY	9322
Delphos, OH	274, 2885	Devine, TX	7212	Dublin, PA	13133	East Jaffrey, NH	1242
	6280, 12196	Devol, OK	11535	Dublin, TX	4062, 4866	East Liverpool, OH	2146, 2544
Delta, CO	5467, 8675	Dewey, OK	8270, 9986		5836		5098
Delta, OH	5577	Dewitt, IA	3182	Dubois, ID	11508	East Mauch	
Delta, PA	4205, 4367	Dewitt, NE	4895	Du Bois, PA	2969, 5019	Chunk, PA	8446
	5198, 14201	Dexter, IA	10030		7453	East Newark, NJ	9661
Delta, UT	11529	Dexter, KS	9225	Du Bois City, PA	2969	East Northport, NY	12593
Deming, NM	3160, 4746	Dexter, ME	2259	Dubuque, IA	317, 846	East Orange, NJ	4766
	6974	Dexter, MO	11320		1540, 1801, 2327, 3140	East	
Demopolis, AL	4394, 10035	Dexter, NY	8463	Ducktown, TN	9565	Palestine, OH	6593, 13850
Denison, IA	4784	Diagonal, IA	9125	Ducor, CA	10301	East Peoria, IL	6724, 14010
Denison, TX	2099, 3058	Dickens, TX	8303	Dluth, MN	1954, 2768	East Port	
	4447, 12728	Dickinson, ND	4384, 7663		3453, 3626, 4001, 4421	Chester, CT	12973
Dennison, OH	6836, 6843		8201, 12401		6520, 9327, 9374, 11810	East Rochester, NY	10141
	13802	Dickinson, TX	12855		12140, 13078, 13116	East Rockaway, NY	12818
Denton, MD	2547, 5122	Dickson, TN	6930, 8292	Dumont, NJ	11361	East Rockaway, NY	12818
Denton, MT	10819		10577	Dunbar, PA	7576	East Saginaw, MI	637, 1550
Denton, TX	2812, 2949	Dickson City, PA	9851, 12459	Duncan, OK	5379, 7289		2761, 3123
Dayton, IA	5302	Dieterich, IL	9582		8616, 10244, 12065, 12812	East Saint	
Dayton, OH	9, 10	Dighton, KS	3888, 9773	Duncannon, PA	4142, 8778	Louis, IL	5070
	898, 1788, 2604, 2874	Dike, IA	5372	Dundee, IL	5638		8932, 10399
	2678, 3821, 4054	Diller, NE	7355	Dundee, NY	2463		11596, 12178
Dayton, PA	5742	Dillon, MT	3120, 3173	Dundellen, NJ	8501	East Setauket, NY	11511
Dayton, TN	4362, 5679	Dillon, SC	10908	Dunkerton, IA	6722	East Smithfield, PA	10042
Dayton, WA	2520, 2772	Dillonvale, OH	5618, 14011	Dunkirk, IN	4888	East Stanwood, WA	13439
	3799, 4473	Dillsboro, IN	6882	Dunkirk, NY	2619, 2916	East	
	8090, 9443	Dillsburg, PA	2397	Dunkirk, OH	6628, 6652	Stroudsburg, PA	4011, 5578
Daytona, FL	10545	Dillwyn, VA	11480	Dunlap, IA	4139	East Worchester, NY	9060
De Funiak		Dinuba, CA	9156, 9158	Dunmore, PA	9868	East Hampton, MA	428
Springs, FL	7404	Divernon, IL	10296	Dunn, NC	7188	Eastland, TX	4466, 7183
De Kalb, IL	2702, 14008	Dixon, CA	10120	Dunnell, MN	6738	Eastman, GA	9593
De Leon, TX	5660, 7553	Dixon, IL	902, 1881	Duquesne, PA	4730	Easton, MD	1434, 4046
De Pere, WI	2133, 6469		3294, 13856	Du Quoin, IL	4737	Easton, PA	1171, 1233
De Smet, SD	3435, 5355	Dodd, City, TX	5728	Durand, MI	5415		2385, 5118
De Witt, AR	10178	Dodge, NE	7333	Durand, WI	10791, 13529	Eastport, ME	1495
Deadwood, SD	2391, 2461	Dodge Center, MN	6623, 6682	Durango, CO	2637, 4126	Eaton, CO	6057, 8658
	3552, 4983	Dodge City, KS	3596, 7285		14095	Eaton, OH	530, 3889
Dearborn, MI	12989	Dodgeville, WI	6698	Durant, OK	5129, 5590		7557
Decatur, AL	3699, 10336	Doland, SD	3522		6928, 10538	Eaton Rapids, MI	2367
Decatur, IL	477, 2124	Dolgeville, NY	6447		13018, 14005	Eatontown, NJ	10110
	4576, 4920	Dolores, CO	10770	Durham, NC	3811, 7698	Eau Claire, WI	2069, 2759
	5089	Dolton, IL	8679		13657		8281, 13564
Decatur, IN	3028	Dongola, IL	10086	Dushore, PA	4505	Ebensburg, PA	5084, 6209
Decatur, MI	1722	Donora, PA	5835, 13644	Dwight, IL	8044	Economy, PA	7528
Decatur, NE	8988	Doon, IA	6764	Dyer, IN	6909	Eddy, NM	4455
Decatur, TX	2940, 5665	Dorchester, MA	156	Dyersburg, TN	5263	Eddyville, KY	7492
	4116, 13623	Dorchester, NE	3390			Eden, ME	3941
Decherd, TN	7397	Dothan, AL	5249, 5909			Edenburg, PA	6182

City	Charter #
Edgartown, MA	1274, 7957
Edgeley, ND	7914
Edgerton, WI	7040, 13932
Edgewater, NJ	8401, 13893
Edgewood, TX	10624
Edina, MO	9490
Edinboro, PA	7312
Edinburg, IN	6905
Edinburg, TX	13315, 14124
Edmeston, NY	3681
Edmond, KS	9160
Edmond, OK	6156, 10151
Edmore, ND	6601
Edna, KS	7590
Edna, TX	8123
Edwards, NY	10569
Edwardsville, IL	5062, 11039
Edwardsville, PA	8633, 9862
Effingham, IL	4233
Egam, SD	7252
Egeland, ND	7872
El Campo, TX	6112
El Centro, CA	9349, 9350
El Dorado, AR	7046, 7323
El Dorado, KS	1957, 3035
	3213, 3833, 4981, 6494
El Dorado, OK	8126, 8944
	9963
El Monte, CA	6993
El Paso, IL	2997, 5510
El Paso, TX	2521, 2532
	3608, 5239, 7075, 7514
	7530, 9155, 10140, 10974
	12769
El Reno, OK	4830, 5985
Elba, AL	6897
Elberton, GA	9252, 14061
Elbow Lake, MN	4617
Eldon, IA	5342
Eldora, IA	5140, 9233
	14286
Eldorado, IL	7539
Eldorado, TX	8575
Eldorado Springs, MO	10055
Eldred, PA	9416
Electra, TX	10050
Elgin, IL	1365, 2016
	4735, 7236
Elgin, MN	7184
Elgin, NE	5440
Elgin, OR	6644
Elgin, TX	4410, 8156
Elida, NM	8348
Elizabeth, CO	8271
Elizabeth, NJ	487, 1436
	11744
Elizabeth, PA	5114
Elizabeth City, NC	4628
Elizabethton, TN	9558, 10976
Elizabethtown, KY	3042, 6028
Elizabethtown, PA	3335
Elizabethville, PA	5563
Elk City, KS	8145, 8708
Elk City, OK	5766, 6164
	9952
Elk Point, SD	5901
Elk River, MN	8757
Elkader, IA	1815
Elkhart, IN	206, 2502
	4841
Elkhorn, Wi	873
Elkin, NC	5673
Elkins, WV	4718, 7060
	8376, 12483
	14002
Elkins Park, PA	13030
Elkland, PA	5043
Elko, NV	7743
Elkton, MD	1236, 4162
Elkton, SD	6368
Ellendale, ND	6398, 9521
	9631
Ellensburg, WA	3037, 3867
	9079, 11045
Ellenville, NY	45, 2117
Elicott City, MD	3585, 13773
Elliott, IA	6857
Elloree, SC	10679
Ellsworth, KS	3249, 3447
Ellsworth, ME	3814, 3804
	14303
Ellsworth, MN	5570
Ellsworth, PA	6929
Ellwood City, PA	4818, 5899
	8678, 11570
Elm Creek, NE	3999
Elm Grove, WV	8983
Elmer, NJ	6707
Elmhurst, IL	9836
Elmira, NY	918, 149
	811, 1391
	4105, 5137
Elmore, MN	5377
Elmore, OH	6770
Elmsford, NY	12956
Elmwood, NE	5787
Elmwood Place, OH	6314
Elsinore, CA	11922
Elverson, PA	10775
Elwood, IN	4675
Elwood, NE	7204
Ely, MN	8592
Ely, NV	8561, 9310
Elyria, OH	438, 2863
Elysburg, PA	10837
Emaus, PA	7139
Emerson, NE	7425
Emery, SD	11812
Emeryville, CA	9410
Emlenton, PA	4615, 5481
Emma, TX	8515
Emmetsburg, IA	3337, 8035
Emmett, ID	6145
Emmons, MN	6784
Emory, TX	6814
Emporia, KS	915, 1983
	5498, 1781
Emporia, VA	8688, 9732
	12240
Emproium, PA	3255
Enderlin, ND	6486
Enfield, IL	7948
Engle, NM	8662
Englewood, CO	9907
Englewood, KS	9097
Englewood, NJ	4365
Englishtown, NJ	7223
Enid, OK	5335, 8231
	9586, 10202
Enloe, TX	6271
Ennis, TX	2939, 3532
	7331, 12110
	13667
Enosburg Falls, VT	7614, 13986
Ensley, AL	5962
Enterprise, AL	6319, 10421
Enterprise, OR	3912
Enumclaw, WA	12114
Ephrata, PA	2515, 4932
Equality, IL	6978
Erick, OK	8010, 10875
Erie, IL	6951
Erie, KS	3963
Erie, PA	12, 535
	606, 870
	14219
Erskine, MN	11173
Erwin, TN	9720, 10583
Escanaba, MI	3761, 8496
Escondido, CA	7801, 8040
Esmont, VA	8003
Essex, IA	5738, 5803
Estherville, IA	4700
Ethan, SD	13549
Etna, PA	6453
Etowah, TN	9162
Eudora, AR	12813
Eufaula, AL	2309, 3622
	5024
Eufaula, OK	5902, 5967
	10388
Eugene, OR	10345
Eugene City, OR	3458, 3986
Eunice, LA	8677
Eureka, CA	5986, 10528
Eureka, KS	3148, 5655
	7303
Eureka, NV	11784
Eureka Springs, AR	8495
Eutaw, AL	3931
Evans City, PA	8854
Evanston, IL	4767, 5279
	13709
Evanston, WY	8534, 8612
Evansville, IN	28, 730
	989, 1772, 2188, 2692
	3281, 6200, 7478, 8492
	8832, 12132, 12444
Evansville, WI	1729
Evart, MI	12561
Eveleth, MN	5553, 6991
Everett, PA	6220
Everett, WA	4686, 4738
	4796, 6053
	11693
Evergreen, AL	7687
Everly, IA	7828
Excelsior Springs, MO	7741
Exchange, PA	8410
Exeter, CA	9370
Exeter, NE	3121, 3117
Exeter, NH	1147, 12889
Exeter, PA	13177
Exira, IA	6870
Export, PA	7624, 14051
Eyota, MN	5374
Fabens, TX	11700
Factory Point, VT	3080
Factoryville, PA	9130
Fair Haven, VT	344, 2422
Fairbanks, AK	7718
Fairbury, IL	1987
Fairbury, NE	2994, 8995
	10340
Fairchance, PA	8245
Fairchild, WI	7264
Fairchild, MN	9771
Fairfax, OK	7972, 8202
Fairfax, SC	10979
Fairfax, SD	8711, 12325
	13302
Fairfax, VA	6389
Fairfield, AL	11766
Fairfield, CA	10984
Fairfield, IA	1475, 8986
Fairfield, IL	5009, 6609
Fairfield, ME	2175, 4973
Fairfield, MT	11307
Fairfield, NE	3493
Fairfield, PA	9256
Fairfield, TX	4291
Fairhaven, MA	490
Fairhaven, WA	4171, 4387
	5243
Fairland, IN	8337
Fairmont, MN	4936, 5423
	8551
Fairmont, NE	3230
Fairmont, WV	961, 9462
	9645, 13811
Fairmount, IL	11443
Fairmount, ND	6255, 11641
Fairport, NY	10869
Fairport Harbor, OH	6068
Fairview, MO	8916
Fairview, MT	12015
Fairview, NJ	12465
Fairview, OK	7117, 9767
Fairview, WV	10219
Falfurrias, TX	11792, 14072
Fall River, MA	256, 439
	590, 612, 679, 924
	1288, 6821
Falls City, NE	2746
Falls City, TX	8606
Falls Creek, PA	6384
Falls Village, CT	1214
Falmouth, KY	11947
Falmouth, MA	1320
Far Rockaway, NY	9271
Fargo, ND	2377, 2514
	3602, 4256, 5087, 8170
	11555, 12026, 13323
	11668
Farmer City, IL	2156, 3407, 4958
Farmersburg, IN	11035
Farmersville, IL	10057
Farmersville, TX	3624, 6011
Farmingdale, NY	8882
Farmington, IA	5579
Farmington, ME	901, 4859
	586
Farmington, MN	1687
Farmington, NH	2022, 13764
Farmington, NM	6183, 9151
Farmland, IN	9054
Farmville, VA	5683, 9222
Farnhamville, IA	11907
Farragut, IA	6700
Farrell, PA	10415
Farwell, TX	8431
Fawn Grove, PA	9385
Fayette, AL	10377
Fayette, IA	9592
Fayette City, PA	5646, 6800
Fayetteville, AR	7346, 7952
	8786
Fayetteville, NC	1756, 2003
	5677, 8682
Fayetteville, NY	1110
Fayetteville, TX	10954
Fayetteville, WV	5434, 8345
Federalsburg, MD	10210
Felicity, OH	2882
Felton, DE	9132
Fenninmore, WI	9522, 13599
Fenton, MI	81
Ferdinand, IN	7830
Fergus Falls, MN	2030, 2648
	2934
Fernandina, FL	4558, 10024
Ferndale, WA	11667
Ferris, TX	6376, 6553
Ferrum, VA	12311
Fertile, MN	5988, 6693
Fessenden, ND	5408
Findlay, IL	6861, 8212
Findlay, OH	36, 3477
	3729
Fingal, ND	7295
Finley, ND	7324

City	Charter #
Finleyville, PA	6420
Firth, ID	11198
Fishers, IN	10419
Fishkill, NY	971
Fishkill Landing, NY	35
Fitchburg, MA	702, 1077
	2153, 2265
Fitzgerald, GA	6082, 8250
	8966, 13550
Flagstaff, AZ	11120
Flandreau, SD	5854
Flatonia, TX	4179
Fleetwood, PA	8939
Fleischmanns, NY	8847
Fleming, CO	11571
Fleming, KY	11988
Flemingsburg, KY	2323
Flemington, NJ	892, 2331
Flint, MI	1588, 1780
	3361, 7664
	10997
Flint Hill, VA	11797
Flora, IL	1961, 11509
Flora, IN	7802, 8014
Floral Park, NY	12449
Florala, AL	8910
Florence, AL	3981, 4135
Florence, AZ	10998
Florence, CA	12624
Florence, CO	5381
Florence, SC	9747
Floresville, TX	6320, 8519
Florida, NY	9956, 13825
Floyd, IA	9821
Floydada, TX	7045
Flushing, MI	2708
Flushing, NY	9691
Flushing, OH	3177
Fogelsville, PA	12975
Foley, MN	7933
Follett, TX	12101
Fond du Lac, WI	555, 6550
	3685, 6015
Fonda, IA	6550
Fonda, NY	1212
Fontana, CA	12976
Fontanelle, IA	7061
Foraker, OK	10356
Ford City, PA	5130
Fords, NJ	11428
Fordyce, AR	9501
Forest, OH	7518
Forest City, IA	4889, 5011
Forest City, NC	9203, 12461
Forest City, PA	5518, 9248
	14205
Forest Grove, OR	8036, 8554
Forest Lake, MN	11652
Forestville, NY	10444
Forman, ND	6474
Formoso, KS	8596
Forney, TX	4014, 6078
	9369
Forrest, IL	7680
Forrest City, AR	10550, 13637
Forsyth, GA	5644
Forsyth, MT	7320
Fort Atkinson, WI	157
Fort Benton, MT	2476, 4194
Fort Bragg, CA	9626, 13787
Fort Branch, IN	9073, 9077
Fort Collins, CO	2622, 5503
	7837, 14146
Fort Dodge, IA	1661, 1947
	2763, 4566
	11304
Fort Edward, NY	1218, 1348
	3330, 7630
Fort Fairfield, ME	4781, 13843
Fort Gaines, GA	6002
Fort Gibson, OK	6539, 8079
	10561
Fort Howard, WI	4783
Fort Kent, ME	11403, 14224
Fort Lauderdale, FL	12020
Fort Leavenworth, KS	8796
Fort Lee, NJ 8874	12497
Fort Madison IA	1611, 3974
Fort Meade, FL	10386
Fort Mill, SC	9941
Fort Morgan, CO	7004, 7832
Fort Myers, FL	9035, 14195
Fort Payne, AL	4064, 11451
Fort Pierre, SD	4237, 9587
Fort Plain, NY	467, 2860
Fort Scott, KS	1763, 1927
	3175
Fort Sill, OK	5753
Fort Smith, AR	1631, 1950
	3634, 4995
	7240, 10609
Fort Stockton, TX	9848
Fort Towson, OK	8078
Fort Valley, GA	7459
Fort Wayne, IN	11, 865
	1100, 2439, 2701, 3285
	4725, 7725, 13818
Fort Worth, TX	2349, 2359
	2689, 3131, 3221, 3631
	4004, 4848, 4946, 7165
	12371
Fortville, IN	9299
Foss, OK	6736
Fosston, MN	6889
Fostoria, OH	2831, 9192
Fountain, CO	6772
Fowler, CA	7390, 10312
Fowler, CO	7637
Fowler, IN	5430
Fowler, KS	9595
Fox Lake, WI	426
Foxboro, MA	9426
Frackville, PA	7860
Framingham, MA	528
Francestown, NH	576
Francis, OK	7185, 10454
Frankford, DE	8918
Frankfort, IN	1854, 6217
Frankfort, KS	2809
Frankfort, KY	4090, 4091
	5376
Frankfort, NY	3582, 10351
Franklin, IN	50, 78
	2769, 3338, 3967, 13378
	14075
Franklin, LA	4555
Fraknklin, NE	3549
Franklin, NH	2443
Franklin, NY	282
Franklin, OH	738, 2282
	5100, 8000
Franklin, PA	189, 1176
	5221
Franklin, TN	1834, 3062
	8443
Franklin, TX	7838
Franklin Square, NY	12997
Franklinville, NY	2345, 2755
	8157
Frankston, TX	7623
Frazee, MN	7024
Frederic, WI	8491
Frederica, DE	5421
Frederick, MD	1138, 1267
	1449, 1589
	3476, 13747
Frederick, OK	8140, 8206
	10095, 13760
Frederick, SD	8624
Fredericksburg, IA	10541
Fredericksburg, PA	8783
Fredericksburg, VA	1582, 5268
	10325, 13603
Fredericktown, OH	5640
Fredericktown, PA	5920
Fredonia, KS	3835, 7218
Fredonia, NY	841, 9019
Fredonia, PA	7471, 13884
Freeburg, IL	7941
Freedom, PA	5454, 9543
Freehold, NJ	452, 951
	4182, 7436
Freeland, PA	6175
Freeland Park, IN	7437
Freeman, SD	6181
Freemont, NE	13408
Freeport, IL	319, 385
	2875, 13695
Freeport, NY	7703, 11518
Freeport, OH	11216
Freeport, PA	2286, 7366
	13826
Freeport, TX	10420
Fremont, IN	10718
Fremont, NE	1974, 2848
	3188, 4504
Fremont, OH	5, 2703
	13997
Frenchtown, NJ	1459
Fresno, CA	3321, 3870
	5162, 8718
	11473
Fresno, MT	11096
Friend, NE	2960
Friendly, WV	5814
Friendship, NY	265, 2632
	11055
Friendsville, MD	6196
Fries, VA	12290
Frisco, TX	6346
Front Royal, VA	2967
Frost, TX	6968, 13507
Frostburg, MD	1412, 4149
	4926, 13979
Fruita, CO	8840
Frum, TX	10418
Fryburg, PA	9480
Fulda, MN	6054
Fullerton, CA	5654, 9538
	12764
Fullerton, NE	2964, 5384
Fulton, KY	4563, 6167
Fulton, MO	8358
Fulton, NY	968, 1178
Fultonville, NY	2869
Gadsden, AL	3663, 8560
	13412, 13728
Gaffney, SC	5064, 10655
Gage, OK	8543
Gainesboro, TN	5536
Gainesville, AL	1822
Gainesville, FL	3894, 8802
	10310
Gainesville, GA	3983, 7616
Gainesville, NY	5867
Gainesville, TX	2802, 2836
	3229, 6292
Gaithersburg, MD	4608
Galax, VA	8791
Galena, IL	831, 979
	3279
Galena, KS	4798
Galesburg, IL	241, 491
	3138
Galeton, PA	7280
Galion, OH	419, 1984
	3581
Gallatin, MO	5827
Gallatin, TN	1707, 4236
	5545
Gallipolis, OH	136
Gallitzin, PA	6442, 13533
	14181
Gallup, NM	9988, 11900
Galva, IA	10501
Galva, IL	827, 2793
Galveston, TX	1566, 1642
	4153, 4321, 8068, 8899
	12475
Ganado, TX	10076
Gap, PA	2864
Garden City, KS	3448, 3900
	7646
Garden City, SD	11558
Garden Grove, CA	11251
Garden Grove, IA	5464
Gardena, CA	10453
Gardener, IL	9406
Gardiner, ME	740, 939
	1174, 3219
	9609
Gardiner, OR	10676
Gardner, MA	884
Garfield, NJ	8462, 13946
Garfield, WA	9185, 12231
Garland, TX	7140, 7989
Garner, IA	4810, 8367
Garnett, KS	2973, 4032
	5292
Garretson, SD	7755
Garrett, IL	6192
Garrett, PA	6741
Garrettsville, OH	2034
Garrison, ND	9778, 13501
Gary, IN	8426, 11094
Gary, SD	9393, 10846
Gary, WV	8333, 13505
Gas City, IN	4825
Gasport, NY	10623
Gastonia, NC	4377, 7536
	11477
Gate City, VA	7135, 7208
	13502
Gatesville, TX	4097, 4388
	4732, 6150
	8928
Gaylord, KS	6970
Geary, OK	6163, 10020
Genesee, PA	9783
Geneseo, IL	534, 2332
Geneso, NY	886
Genessee, ID	4808
Geneva, AL	5714, 10307
Geneva, IL	8740
Geneva, NE	4052, 4484
Geneva, NY	167, 949
Geneva, OH	153, 2719
Genoa, NE	5189, 6805
Genoa, NY	9921
Gentry, AR	12340
George, IA	9910
George West, TX	12919
Georgetown, CO	1991, 2199
	2394
Georgetown, DC	682, 1928
Georgetown, DE	5930
Georgetown, IL	5285, 7365
	13448
Georgetown, KY	2927, 8579
Georgetwon, MA	2297
Georgetown, OH	2705, 5996
Georgetown, TX	4294
Geraldine, MT	10803
Gering, NE	8062, 9694
Germantown, NY	12242

City	Charter #	City	Charter #	City	Charter #	City	Charter #
Germantown, OH	86, 10058	Goodland, KS	6039, 7882	Gravette, AR	8237	Gresham, NE	8172
Gettysburg, PA	311, 611		14163	Grayson, KY	12982	Gretna, LA	13732
Gettysburg, SD	8776	Goodrich, ND	8077	Grayville, IL	4999, 6460	Grey Eagle, MN	8729, 12607
Geyser, MT	10952	Goodwater, AL	12960	Great		Greybull, WY	10810
Geyserville, CA	11678	Gordon, NE	8521	Barrington, MA	1203	Gridley, CA	11164
Gibbon, NE	3921	Gordon, TX	5759	Great Bend, KS	3363, 5705	Gridley, IL	11208
Gibsland, LA	10049	Gordonsville, VA	10287		11707	Griffin, GA	2075, 11597
Gibson City, IL	8174	Goree, TX	8200	Great Falls, MT	3525, 4434	Griffithsville, WV	10097
Gig Harbor, WA	13057	Goreville, IL	7606		4541, 10530	Griggsville, IL	2116
Gilbert, MN	9262	Gorham, IL	10690	Great Neck		Grinnell, IA	1629, 2953
Gill, CO	9697	Gorham, NH	9001	Station, NY	12659		7439, 13473
Gillespie, IL	7903, 12314	Gorman, TX	7410	Greeley, CO	3178, 4437	Griswold, IA	3048, 8915
Gilman, IL	5856	Gormania, WV	8751		7604, 10038	Groesbeck, TX	4269, 6461
Gilmer, TX	5288, 5741	Goshen, IN	146, 2067		13928		14126
Gilmore City, IA	6611		14113	Greeley, NE	7622	Groton, NY	1083
Gilroy, CA	10166	Goshen, NY	1399, 1408	Green Bay, WI	874, 1009	Groton, SD	7885
Girard, KS	3216	Gotebo, OK	10389		1819, 2132	Grove, OK	10119
Girard, OH	4884	Gothenburg, NE	4890, 6282		3884	Grove City, OH	6827
Girard, PA	54, 7343		8113	Green City, MO	8570, 9029	Grove City, PA	5044, 5501
	14191	Gouverneur, NY	2510, 13911	Green Forest, AR	10422	Groveton, NH	5258, 5317
Girardville, PA	4422	Gowrie, IA	5707	Green Lane, PA	2131, 9084	Groveton, TX	6329, 14104
Gladbrook, IA	5461	Graceville, FL	7423		14214	Grundy, VA	11698
Gladstone, MI	10886, 14111	Graceville, MN	7213	Green River, WY	10698	Grundy Center, IA	3225, 3396
Glasco, KS	7683	Graettinger, IA	5571, 6610	Green Spring, OH	2037	Guernsey, WY	5295
Glasgow, KY	4819, 5486	Grafton, MA	188, 824	Greencastle, IN	219, 2896	Guilford, CT	5358
	6872, 8439	Grafton, ND	2840, 3096		10409	Guilford, ME	4780
	9722, 13651	Grafton, WV	2445	Greencastle, PA	1081, 5857	Gulfport, MS	6188, 13553
Glasgow, MT	7990, 8655	Graham, CA	12673	Greene, IA	3071, 6880	Gunnison, CO	2686, 2975
Glassborough, NJ	3843	Graham, NC	8844	Greeneville, TN	13482	Gunter, TX	6404
Glassport, PA	5708	Graham, TX	4391, 4418	Greenfield, IA	5334	Guntersville, AL	10990
Glen Campbell, PA	5204		5897	Greenfield, IL	8473	Gurdon, AR	13210
Glen Head, NY	13126	Graham, VA	7734, 7782	Greenfield, MA	474, 920	Guthrie, OK	4348, 4383
Glen Lyon, PA	13160	Granada, CO	7809	Greenfield, OH	101, 10105		4705, 7299
Glen Rock, NJ	12609	Granburg, TX	3727	Greenleaf, KS	3567	Guthrie Center, IA	5424, 7736
Glen Rock, PA	435	Granbury, TX	5808	Greenport, NY	334, 3232	Guttenberg, NJ	8390, 12806
Glen Rose, TX	5795	Grand Forks, ND	2564, 2570	Greens Fork, IN	7124		14014
Glen Ullin, ND	9016, 13410		3301, 3504, 4372, 4812	Greensboro, AL	5693	Guymon, OK	8138, 9964
Glencoe, MN	2571		13790, 11142	Greensboro, GA	6967, 8452	Gypsum, KS	9695
Glendale, CA	7987	Grand Gorge, NY	7618	Greensboro, NC	2322, 5031	Hackensack, NJ	1905, 5921
Glendive, MT	7101, 8055	Grand Haven, MI	1849, 4578		5168, 9123, 10112, 13761		7799, 12014
Glendora, CA	8652	Grand Island, NE	2779, 3101		13364		13364
Glens Falls, NY	980, 1293		4357, 9395	Greensburg, IN	1890, 2844	Hackettstown, NJ	1259, 8267
	4846, 7699	Grand Junction, CO	3860, 6137		5435	Haddon Heights, NJ	9413, 13550
Glenside, PA	9668		7766, 13902	Greensburg, KS	3667, 10557	Haddonfield, NJ	3996
Glenville, WV	5939	Grand Meadow, MN	6933	Greensburg, PA	1894, 2558	Hagerman, ID	10294
Glenwood, IA	1862	Grand Rapids, MI	294, 812		2562, 4974	Hagerman, NM	7503
Glenwood, MN	7742		2460, 2611, 2890, 3293		14055	Hagerstown, IN	7902
Glenwood City, WI	11083		3488, 13328, 13758, 13799	Greensburgh, IN	356	Hagerstown, MD	1431, 1893
Glenwood		Grand Rapids, MN	6563	Greenup, IL	6191, 8115		4049, 4856
Springs, CO	3661, 3772	Grand Rapids, WI	1998, 4639	Greenup, KY	7037		12590
	6957		10330	Greenville, AL	5572	Hailey, ID	3895, 9145
Glidden	IA 4814	Grand Ridge, IL	6684	Greenville, IL	1841, 9734		11053
Globe, AZ	6579, 8193	Grand River, IA	9737	Greenville, KY	4356	Haledon, NJ	12854
Gloucester, MA	549, 899	Grand Saline, TX	5696, 5722	Greenville, MI	2054, 3243	Halifax, PA	5601
	1162, 2292		8884, 12745		11843	Hallettsville, TX	4338
	13604	Grand Tower, IL	7712	Greenville, MS	3765	Hallock, MN	6934
Gloucester, VA	10658	Grandfield, OK	10006	Greenville, NC	8160	Hallowell, ME	310, 532
Gloucester City, NJ	3936	Grandview, TX	4389, 7269	Greenville, OH	1092, 2992		624, 3247
Glouster, OH	8423	Granger, TX	6361, 11642		7130, 13944	Hallstead, PA	7702
Gloversville, NY	1474, 1938	Grangeville, ID	6927	Greenville, PA	2251	Hallwood, VA	7659
	3312, 9305	Granite, OK	8342	Greenville, RI	1498	Halstad, MN	7196
Goff, KS	7416	Granite City, IL	5433, 6564	Greenville, SC	1935, 5004	Halstead, KS	3443
Golconda, IL	7385, 14173	Granite Falls, MN	8416		8766, 9190	Hamburg, IA	2364, 6017
Golden, CO	2140, 6497	Grant's Pass, OR	4168		10635, 11499	Hamburg, NJ	8227
Golden City, MO	7684, 10633	Grant, NE	4170	Greenville, TN	4177	Hamburg, PA	9028, 14250
Goldendale, WA	4031	Grant City, MO	3380	Greenville, TX	2998, 3016	Hamden, NY	12017
Goldfield, IA	5373	Grant Park, IL	5124, 11952		3646, 5035	Hamilton, IL	9883
Goldfield, NV	9078	Grantham, PA	9727		7510, 8581	Hamilton, KS	6932
Goldsboro, NC	5048, 10614	Grantsburg, WI	8444	Greenwich, CT	8243	Hamilton, MO	4151
Goldsboro, PA	9072	Grantsville, MD	5943	Greenwich, NY	1266, 2517	Hamilton, MT	9486
Goldthwaite, TX	4687, 6092	Granville, IL	10458, 14035	Greenwich, OH	7001	Hamilton, NY	1334
Goliad, TX	4565, 7548	Granville, NY	2294, 3154	Greenwood, AR	6786, 10983	Hamilton, OH	56, 829
Gonic, NH	838		4985, 7255	Greenwood, IN	8422, 8461		3840
Gonvick, MN	10830	Granville, OH	388, 2496	Greenwood, MS	7216	Hamilton, TX	4451
Gonzales, TX	6277, 8392	Grapevine, TX	5439, 8318	Greenwood, NE	3403	Hamilton, VA	9861
Good Thunder, MN	11552		12708	Greenwood, NY	8058	Hamilton Square, NJ	12646
Goodhue, MN	7603	Grass Range, MT	10939	Greenwood, SC	7027	Hamlet, NC	10851
Gooding, ID	9371	Grass Valley, CA	3648, 12433	Gregory, SD	8600, 9377	Hamlin, TX	8252, 8427
Goodland, IN	7863	Gratz, PA	9473	Gregory, TX	10241		12700

City	Charter #	City	Charter #	City	Charter #	City	Charter #
Hamlin, WV	8171	Hartington, NE	4528, 5400		4396, 4406, 5671	Hillside, NJ	11727
Hammond, IN	3478, 8199	Hartley, IA	4881	Helena, OK	8349, 12081	Hindsboro, IL	5538
Hammond, LA	11977, 14086	Hartsdale, NY	12705	Hemet, CA	10764	Hingham, MA	1119
Hammond, NY	10216	Hartselle, AL	8067	Hemingford, NE	10242	Hinsdale, IL	11308
Hampden, ND	7650	Hartshorne, OK	7050, 11064	Hemphill, TX	13526	Hinton, WV	5562, 7998
Hampstead, MD	9755	Hartsville, IN	7354	Hemphill, TX	8526		10348
Hampton, GA	10089	Hartsville, SC	10137	Hempstead, NY	4880, 11375	Hobart, NY	193, 4497
Hampton, IA	2573, 7843	Hartwell, GA	11695	Hempstead, TX	4905	Hobart, OK	5915, 5954
	13842	Hartwick, NY	11657	Henderson, IA	7382		6267, 6358
Hampton, NE	8285	Harvard, NE	4129	Henderson, KY	1615, 2931		10288
Hampton, VA	6778, 6842	Harvey, IA	6936		13757, 13983	Hoboken, NJ	1444, 3744
	13775	Harvey, IL	8667	Henderson, NC	5032, 5033	Hobson, MT	10715
Hampton Bays, NY	12987	Harvey, ND	5488	Henderson, NE	8183	Hodgenville, KY	6894, 9843
Hamtramck, MI	11082	Harwich, MA	712	Henderson, TX	13443, 6176		13479
Hancock, MD	7859, 13853	Haskell, OK	7822, 10160		6780	Hohenwald, TN	11985
Hancock, MI	2143, 9087	Haskell, TX	4333, 4474	Hendersonville, NC	10734, 9571	Hoisington, KS	9232, 12694
	14249		7825, 14149		8837	Holbrook, AZ	12198
Hancock, MN	6996, 7033	Hastings, MI	1745, 13857	Hendricks, MN	6468, 9457	Holcomb, NY	10046
Hancock, NY	8613	Hastings, MN	496, 1538	Hendricks, WV	7845	Holden, MO	10384
Hanford, CA	5863, 6873		11212	Hennessey, OK	5473, 6111	Holdenville, OK	5270, 5735
	7658	Hastings, NE	2528, 3086		10209		6540, 7619
Hankinson, ND	6218, 8084		3099, 3732, 13515, 13953	Henning, MN	6906		10013
Hanley Falls, MN	6285	Hastings, OK	8209, 8210	Henrietta, TX	3022, 4068	Holdrege, NE	3208, 3875
Hannaford, ND	7727		10094	Henry, IL	1482, 7049		4345
Hannibal, MO	1571, 4010	Hastings, PA	11227	Henry, SD	10416	Holland, IN	9090
	6635	Hastings upon		Henryetta, OK	6867, 10349	Holland, TX	8008
Hanover, NH	1145	Hudson, NY	8586	Heppner, OR	3953, 3774	Holland Patent, NY	5299
Hanover, PA	187	Hatboro, PA	2253	Hereford, TX	5604, 6812	Hollidaysburg, PA	57, 2744
Hanska, MN	11288	Hatfield, PA	13026	Herington, KS	4058		6874
Hardin, MT	9215	Hattiesburg, MS	5176, 5177	Herkimer, NY	3183, 5141	Hollis, OK	8056, 8061
Hardwick, CA	10364		12478	Herman, MN	8049		8825, 10240
Harlan, IA	5207, 10354	Hatton, ND	6743, 7905	Hermansville, MI	11954		10249
Harlan, KY	9791, 12243	Havana, IL	2242	Herminie, PA	10188	Hollister, CA	9378, 13510
	12295	Havana, NY	301, 343	Hermiston, OR	9281	Holliston, MA	802
Harlem, MT	7644	Havelock, IA	7294	Hermon, NY	5605	Holly, CO	7704
Harleysville, PA	9541	Havelock, NE	9772	Hermosa Beach, CA	12209	Holly, MI	1752, 1965
Harlowtwon, MT	9270, 11085	Havensville, KS	5506		12271	Holly Grove, AR	12296
Harmony, MN	8683	Haverhill, MA	481, 484	Herndon, PA	6049, 13982	Holly Hill, SC	10680
Harmony, PA	2335		589, 633, 3510, 4833	Herndon, VA	9635	Hollywood, CA	7543, 7803
Harper, KS	3265, 3431		14266	Heron Lake, MN	5383	Holstein, IA	4553
	8307, 8308	Haverstraw, NY	2229	Herrin, IL	5303, 8670	Holton, KS	3061, 5041
Harrah, OK	9980	Haviland, OH	10436	Hershey, PA	12688	Holtville, CA	9770
Harriman, TN	4501, 4654	Havre, MT	5676, 9440	Hettinger, ND	8991, 11677	Holyoke, CO	9278
	11915, 12031		9782	Heuvelton, NY	10446	Holyoke, MA	1246, 1939
Harrington, DE	3883	Havre de Grace, MD	3010, 5445	Hiawatha, KS	2589		2430, 3128
Harrington, WA	9210	Hawarden, IA	4594, 13939	Hibbing, MN	5745, 12568		4703
Harris, IA	6949	Hawkeye, IA	8900	Hickman, KY	4465	Homer, IL	2965, 11882
Harrisburg, IL	4003, 5153	Hawkinsville, GA	7580	Hickory, NC	4597	Homer, LA	4216, 11638
Harrisburg, OR	9146	Hawley, MN	7772	Hickory, PA	7405	Homer, NY	2398, 3186
Harrisburg, PA	201, 580	Hawley, PA	6445	Hicksville, NY	11087	Homer City, PA	8855
	3713	Hawley, TX	8535	Hicksville, OH	4867, 5802	Homestead, FL	13641
Harrisburg, TX	12840	Hawthorne, NJ	12663	Hico, TX	4366, 7157	Homestead, PA	3829, 5365
Harrison, AR	5890, 10801	Haxtun, CO	11099	Higgins, TX	8249, 8179	Hominy, OK	7927, 10002
	12291	Hay Springs, NE	8760	Higginsport, OH	9394	Honaker, VA	10252
Harrison, NE	8888, 12552	Hayes Center, NE	8031	High Bridge, NJ	5333	Hondo, TX	5765
Harrison, NJ	13034	Haynesville, AL	7975	High Point, NC	3490, 4568	Honea Path, SC	12381
Harrison, NY	12601	Hays, PA	6507	Highland, IL	6653	Honesdale, PA	644
Harrison, OH	8228	Hays City, KS	3885	Highland, KS	9136	Honey Grove, TX	2867, 4112
Harrison, OK	6753	Hayward, CA	10018	Highland, NY	5336		13416
Harrisonburg, VA	1572, 5261	Hayward, WI	7831	Highland Falls, NY	8838, 8850	Honeybrook, PA	1676
	11694	Hazard, KY	8258	Highland Park, NJ	12598	Honolulu, HI	5550
Harrisville, NY	10767	Hazelhurst, PA	8380	Highland Park, PA	13196	Hood River, OR	7272
Harrisville, PA	6859, 13812	Hazleton, PA	3893, 4204	Highmore, SD	7794	Hooper, NE	5297
Harrisville, WV	6790	Headland, AL	7424, 13752	Hightstown, NJ	1737, 1759	Hoopeston, IL	2808, 9425
Harrodsburg, KY	1807, 2531		11445	Highwood, MT	11131		13744
	13612	Healdsburg, CA	10204, 10184	Hills, MN	6199	Hoosick Falls, NY	2471, 5874
Hart, MI	6727	Healdton, OK	11018	Hillsboro, IL	2789, 8006	Hooversville, PA	6250, 11413
Hartford, AL	7592	Hearne, TX	4976	Hillsboro, KS	6120		14156
Hartford, AR	11748, 11830	Heavener, OK	9888, 10239	Hillsboro, ND	3400, 3411	Hop Bottom, PA	9647
Hartford, CT	121, 361	Hebbronville, TX	12995	Hillsboro, OH	2499, 9243	Hope, AR	8594, 10579
	486, 670, 756, 1165	Hebron, ND	10741	Hillsboro, OR	3966, 9917		12533
	1300, 1321, 1338, 1377	Hebron, NE	2756		9923	Hope, IN	5726
	10796, 13038	Hecla, SD	9679	Hillsboro, TX	4900, 3786	Hope, ND	5893, 8395
Hartford, KS	8197	Hedrick, IA	5540, 12656		3762, 3046	Hope, NJ	10118
Hartford, KY	5792	Hegewisch, IL	8605	Hillsborough, NH	1688	Hope, NM	9441
Hartford, MI	9854	Hegins, PA	13994, 9107	Hillsborough, OH	787, 2039	Hopedale, IL	9398
Hartford, WI	8671	Helena, AR	13520, 3662	Hillsdale, MI	168, 1470	Hopedale, OH	6938
Hartford City, IN	6959	Helena, MT	1649, 1960		14062	Hopewell, NJ	4254
			2105, 2732, 2757, 2813	Hillsdale, NJ	12902	Hopewell, PA	9638

City	Charter #
Hopewell, VA	10866
Hopkins, MO	4174
Hopkinsville, KY	3856
Hopkinton, MA	626
Hopkinton, RI	1054
Hoquiam, WA	4390, 4427
Horatio, AR	10447
Hornellsville, NY	262, 2522
Horse Cave, KY	7602
Horseheads, NY	8301
Horton, KS	3810
Hot Springs, AR	2832, 2887
	7531
Hot Springs, SD	4370, 6339
	9166
Hot Springs, VA	8722
Hotchkiss, CO	5976
Houghton, MI	1247, 3334
	5896, 7676
Houlton, ME	2749, 4252
Houston, PA	5908
Houston, TX	1644, 2092
	3517, 4028, 4350, 4463
	5858, 8288, 8645, 9226
	9353, 9712, 10152, 10225
	12055, 12062, 12070, 13925
	13943, 13683
Houtzdale, PA	6695
Howard, KS	3242, 3794
Howard, PA	9249
Howard, SD	6585
Howe, TX	5670, 5681
Howell, MI	11586, 14144
Hoxie, KS	5687
Hubard, IA	8970
Hubbard, OH	2389
Hubbard, TX	5008, 7407
Hubbell, MI	9359, 13824
Hudson, IA	5659
Hudson, MA	2618
Husdon, NY	396, 990
	1091
Hudson, OH	9221
Hudson, SD	7335
Hudson, WI	95
Hughes Springs, TX	6922
Hughesville, PA	3902, 8924
Hugo, CO	8489, 10786
Hugo, OK	6130, 7747
Hugoton, KS	11300
Hull, IA	6953
Humboldt, IA	8277, 13766
Humboldt, IL	7168
Humboldt, KS	3807, 6963
Humboldt, NE	3238, 7065
Hume, IL	11108
Hummelstown, PA	2822
Humphrey, NE	5337
Hunter, ND	6985
Hunter, NY	7485
Huntingburg, IN	31, 4965
Huntington, PA	6090
Huntington, IN	145, 2508
Huntington, NY	6587
Huntington, WV	3106, 4607
	7359, 9598
Huntington Beach, CA	7868
Huntington Park, CA	11925
Huntland, TN	8601
Huntsville, AL	1560, 4067
	4689, 8765
Huntsville, AR	8952
Huntsville, TN	10192
Huntsville, TX	4208
Hurley, WI	4304, 11594
Huron, OH	4778
Huron, SD	2819, 2989
	3267, 3636, 8781, 8841
Hurricane, WV	11670
Hustonville, KY	2917
Hutchinson, KS	3180, 3199
	3861, 8430, 10765, 13106
Hutchinston, MN	10147
Huttig, AR	10060
Hutto, TX	9625
Hyannis, MA	1107, 13395
Hyattsville, MD	7519
Hyde Park, MA	7920
Hyde Park, VT	1163
Hydro, OK	9944, 10442
Hyndman, PA	4063, 6615
Hynes, CA	9919
Iaeger, WV	11268, 12372
Ida Grove, IA	3930
Idabel, OK	8486, 11913
Idaho Falls, ID	5820, 6982
	11278
Idaho Springs, CO	2962, 5989
Ilion, NY	1670, 9109
Imogene, IA	8295
Imperial, CA	6027
Imperial, NE	9762
Independence, IA	1581, 2187
	3263
Independence, KS	3021, 4499
	4592, 13492
Independence, MO	1429, 4157
Independence, OR	3972, 3979
Independence, VA	10834
Indiana, PA	313, 7993
	14098
Indianapolis, IN	55, 581
	617, 783, 869, 984
	1878, 2556, 4158, 5116
	5672, 5845, 6513, 9537
	9829, 10121, 10671, 13759
Indianola, IA	1811
Indianola, NE	9093
Inglewood, CA	9093
Intercourse, PA	9216
Interlaken, NY	13037
International Falls, MN	7380
Inwood, IA	7304, 8257
Inwood, NY	12460
Iola, KS	5287
Iona, MN	7128
Ionaia, MI	275, 5789
	14187
Iowa City, IA	18, 977
	2738, 2821
Iowa Falls, IA	3252, 7521
Iowa Park, TX	5589
Ipswich, MA	4774
Irasburg, VT	1541
Ireton, IA	4794
Iron Mountain, MI	3806, 11929
Iron River, MI	8545, 14102
Ironton, MN	10382
Ironton, OH	98, 242
	4336
Ironwood, MI	3971, 9517
	11469, 12387
Irving, IL	8647
Irvington, NJ	7981
Irvington, NY	6371
Irvington, VA	5290
Irvona, PA	11115
Irwin, PA	4698, 5255
Isanti, MN	10554
Ishpeming, MI	2084, 3095
	5668, 13931
Island City, OR	3313
Island Pond, VT	4275
Islip, NY	8794
Ismay, MT	9103
Italy, TX	5663, 6471
Itasca, TX	4461, 4924
	5749
Ithaca, MI	3217, 6485
	9654
Ithaca, NY	222, 729
	1561
Itta Bena, MS	10688
Iuka, MS	10154
Ivanhoe, MN	6467, 6637
	11627
Ivesdale, IL	6133
Jacksboro, TX	4483, 5761
	7814
Jackson, AL	5983
Jackson, GA	5709, 9186
	13897
Jackson, KY	9320
Jackson, MI	1065, 1533
	11289, 13741
Jackson, MN	5852, 6992
	7494, 7797
Jackson, MO	7494
Jackson, MS	1610, 3332
	6646, 10463
	10523, 13708
Jackson, OH	1903
Jackson, TN	2168, 3576
	10334, 12790
Jackson Center, OH	8536
Jacksonville, AL	4319
Jacksonville, FL	2174, 3327
	3869, 4332, 6888, 8321
	9049, 9628, 10136
Jacksonville, IL	511, 1719
	5763
Jacksonville, TX	5581, 6883
Jamica, NY	8268
Jamica, VT	1564
Jamesburg, NJ	288
Jamesport, MO	7460
Jamesport, CA	10284, 10362
Jamestown, ND	2578, 2580
	3331, 4561
	7820
Jamestown, NY	548, 938
	1563, 3846, 8453, 9748
	11360
Janesville, WI	83, 749
	2748
Jasonville, IN	7342
Jasper, AL	7746
Jasper, FL	7757
Jasper, MN	6523
Jasper, MO	6369
Jasper, TX	6134, 10478
Jayton, TX	9845
Jeanerette, LA	7768
Jeanette, PA	4092, 5527
	7792
Jefferson, GA	9039
Jefferson, IA	8262, 10123
Jefferson, NC	8571
Jefferson, OH	427, 2026
Jefferson, PA	9660, 11370
	14071
Jefferson, TX	1777, 4721
	8770
Jefferson, WI	1076
Jefferson City, MO	1809, 2055
	13142
Jefferson City, TN	11479
Jefferson Park, Chicago, IL	10108
Jeffersonville, IN	956, 1466
Jeffersonville, NY	10456
Jellico, TN	7636, 7665
Jenkins, KY	10062
Jenkintown, PA	2249, 12530
Jennings, LA	5966, 7765
Jermyn, PA	6158
Jerome, ID	9680
Jerome, PA	12029
Jersey City, NJ	374, 695
	1182, 3680, 9229, 12255
	12397, 12939
Jersey Shore, PA	1464, 6155
	13197
Jerseyville, IL	2328, 4952
Jessup, PA	9600
Jesup, IA	2856
Jetmore, KS	3805
Jewell, IA	5743
Jewell City, KS	3591
Jewett, OH	13150
Jewett City, CT	1478
Johnson, NE	8161, 8383
Johnson City, TN	3951, 5888
	6236, 11839
	13635
Johnsonburg, PA	4544
Johnston City, IL	7458
Johnstown, CO	8636
Johnstown, NY	2418
Johnstown, PA	51, 2739
	4212, 5059, 5913, 7465
	10590, 12098, 13781
Joliet, IL	512, 1882
	4520, 6423
Jonesboro, AR	8086
Jonesboro, IL	12373
Jonesboro, TN	4715
Jonesville, VA	8384, 9924
Joplin, MO	3841, 4425
	8947, 13162
Jordan, MN	11218
Jordan, NY	12375
Joseph, OR	8048
Judsonia, AR	10439
Julesburg, CO	8205, 9603
Junction City, KS	1977, 3543
	4284
Junction City, OR	10218
Juneau, AK	5117
Juniata, PA	8238
Kahului, HI	8207
Kalamazoo, MI	191, 1359
	3210, 3211
Kalida, OH	7074
Kalispell, MT	4586, 4651
	4803, 8635
Kanawha, IA	9018
Kane, PA	5025
Kankakee, IL	1793, 4342
Kanorado, KS	11860
Kansas, IL	2011, 9293
Kansas, OH	11598
Kansas City, KS	3706, 3726
	4381, 6311, 8602, 9309
	13801
Kansas City, MO	1612, 1901
	1995, 2440, 2613, 3456
	3489, 3544, 3637, 3760
	3793, 3863, 3904, 4251
	4464, 4494, 4786, 5138
	5250, 8660, 8738, 9172
	9326, 9311, 9404, 9560
	9677, 10039, 10231, 10413
	10892, 11037, 11344, 11377
	11472, 11491, 12794, 13801
Karnes City, TX	5614, 8565
Kasson, MN	2159, 4969
	10580, 11042
Kaufman, TX	3836, 4492
	10757
Kaukauna, WI	3641
Kaw City, OK	8577, 10075

City	Charter #
Keansburg, NJ	10402
Kearney, NE	10376
	3526, 3958, 6600, 8651
	13013
Kearny, NJ	13537
Keene, NH	559, 877
	946, 2299
Keeseville, NY	1753
Keewatin, MN	10903
Keithsburg, IL	1805
Kellog, ID	9566
Kelso, WA	8639
Kemmerer, WY	5480
Kemp, TX	5932
Kenbridge, VA	12251
Kendallville, IN	41, 2687
	12532
Kendrick, ID	4790
Kenedy, TX	8013, 12182
	12187
Kenefic, OK	10104
Kenmare, ND	6064, 6555
Kenmore, NY	12208
Kennebec, SD	10098
Kennebunk, ME	1254
Kennett Square, PA	2526
Kennewick, WA	8948
Kenosha, WI	212, 12351
Kenova, WV	9913
Kensal, ND	7943
Kensington, KS	7493
Kent, OH	652
Kent, WA	10174, 12217
Kenton, OH	2500, 3505
Kenton, TN	10404
Keokuk, IA	80, 1441
	1992, 14309
Keota, OK	8177, 10298
Kerens, TX	7529, 13656
Kerkhoven, MN	11365
Kerman, CA	9234
Ketchikan, AK	12578
Ketchum, ID	3142
Kewanee, IL	1785, 2501
	4854
Kewanna, IN	8192, 10616
Key West, FL	4672, 7942
Keyport, NJ	3164, 4147
Keyser, WV	6205, 13831
Keystone, WV	10369
Kezar Falls, ME	9826
Kiefer, OK	8553
Kiester, MN	10603
Kilgore, TX	5750, 12698
Killeen, TX	5750
Killingly, CT	450
Kimball, NE	13420
Kimball, WV	11502, 13484
Kimballton, IA	9619
Kinderhook, NY	929, 1026
King City, MO	4373, 6383
Kingfisher, OK	5328, 5740
	5790, 6702
	9954
Kingman, KS	3509, 3559
	3737, 7412
Kings Mountain, NC	5451
Kings Park, NY	12489, 14019
Kingsbury, CA	8409
Kingsbury, TX	10266
Kingsley, IA	9116
Kingsport, TN	10842
Kingston, NY	451, 955
	1050, 1149, 2493, 13822
Kingston, OH	9536
Kingston, OK	7893, 9881
Kingston, PA	12921, 14023
Kingston, RI	1158
Kingston, TN	12319
Kingsville, TX	12968
Kingwood, WV	1608, 6332
Kinmundy, IL	6143
Kinsley, KS	3759, 5810
Kinsman, OH	3077
Kinston, NC	9044, 9085
Kiowa, KS	8220
Kiowa, OK	8638
Kirklin, IN	9115
Kirksville, MO	2713, 5107
	5871, 8276
Kirkwood, IL	2313
Kirwin, KS	3454
Kittanning, PA	69, 2654
	3104, 5073
	6127
Kitzmillerville, MD	8302
Klamath Falls, OR	7167, 11801
Klemme, IA	6659
Knightstown, IN	872, 9152
Knob Noster, MO	1877
Knox, IN	5919
Knox, ND	6898
Knox City, TX	7953
Knoxville, IA	1871, 1986
	4633, 12849
	13707
Knoxville, IL	759, 3287
Knoxville, PA	9978
Knoxville, TN	391, 2049
	2658, 3708, 3837, 4102
	4648, 10327, 10401, 13539
Kokomo, IN	894, 2375
	4121, 6261
Konawa, OK	7633, 8213
Koppel, PA	11938, 14070
Kosse, TX	9205
Kramer, ND	8029
Kulm, ND	11069
Kutztown, PA	1875, 5120
L'Anse, MI	9509
L'Anse Creuse, MI	12661
La Coste, TX	10189
La Crosse, WI	1313
La Fayette, GA	7247
La Fayette, IN	23, 417
	882, 930, 1967, 2213
	2717, 3280, 4468, 4656
	5889, 5940, 7415, 11148
La Feria, TX	12747
La Grande, OR	3655, 4452
	9314, 13602
La Grange, GA	3093, 7762
La Grange, IN	2184, 4972
La Grange, MO	1839
La Grange, TX	3906
La Habra, CA	11827
La Hapea, IL	8468
La Harpe, KS	7226
La Jara, CO	9840
La Junta, CO	4507
La Moure, ND	6690, 9714
La Plata, MD	8456
La Porte, IN	377
La Rue, OH	6675
La Salle, IL	2804
Laceyville, PA	8845
Lacon, IL	347
Lacona, NY	10175
Laconia, NH	1645, 4037
Lacrosse, KS	3970
Lacrosse, WI	2344, 3412
	5047, 7347
Ladonia, TX	4311, 4515
	5739
Ladysmith, WI	5535, 7966
	11826
Lafargeville, NY	13365
Lafayette, CO	8909
Lafayette, LA	5023, 13209
Lafollette, TN	7225, 12467
Lahaina, HI	8101
Lahoma, OK	9974
Lake, IL	2858
Lake Ariel, PA	9886
Lake Arthur, LA	7047
Lake Arthur, NM	8584
Lake Benton, MN	4509, 6696
Lake Charles, LA	4154, 5157
	6088, 10836
	13573
Lake City, CO	2354
Lake City, FL	7540
Lake City, IA	4966
Lake City, MN	1740
Lake City, SC	10681
Lake Crystal, MN	6918, 11401
	13972
Lake Forest, IL	8937
Lake Geneva, WI	3125, 5592
Lake George, NY	8793
Lake Hamilton, FL	11703
Lake Linden, MI	3948
Lake Mills, IA	5123
Lake Norden, SD	13221
Lake Park, MN	7143
Lae Preston, SD	10758
Lake Providence, LA	6291
Lake Ronkonkoma, NY	13130
Lake Village, AR	11262, 13632
Lake Wilson, MN	11293
Lake Worden, SD	10714
Lake Worth, FL	11716
Lakefield, MN	6537
Lakehurst, NJ	12571
Lakeland, FL	9811, 13370
Lakeport, NH	4740
Lakeview, OR	7244, 11121
Lakeview, TX	12835
Lakewood, NJ	5232, 7291
Lakewood, NM	8782
Lakewood, OH	13715
Lakota, ND	4143, 5455
Lamar, AR	12238
Lamar, CO	3749, 9036
	14254
Lamar, MO	4057, 14196
Lamar, SC	11080
Lamberton, MN	7221
Lambertville, NJ	1272, 2339
Lamesa, TX	11163
Lamont, OK	7783
Lampasas, TX	3261, 5645
	7572
Lanark, IL	1755
Lancaster, KY	1493, 2888
Lancaster, MA	583
Lancaster, MN	11356
Lancaster, MO	2218
Lancaster, NH	2600
Lancaster, NY	11912
Lancaster, OH	137, 1241
	7517, 9547
Lancaster, PA	333, 597
	683, 2634, 3367, 3650
	3987
Lancaster, SC	7858
Lancaster, TX	11423
Lancaster, WI	7007
Lander, WY	4720
Landisville, PA	9312
Lanesboro, MN	10507
Langdon, ND	4802, 9075
Langhorne, PA	430, 3063
	7735
Lansdowne, PA	13151
Lansford, ND	8187
Lansford, PA	5234, 7051
Lansing, IA	405
Lansing, MI	264, 1953
	3513, 8148
Lansingburgh, NY	1426, 1534
Lapeer, MI	1731
Laporte, PA	9528
Laporte City, IA	4114
Laramie, WY	4989
Laramie City, WY	2110, 2518
	3615
Larchmont, NY	6019
Laredo, TX	2486, 4146
	5001
Larimore, ND	2854, 6286
Larned, KS	2666, 7125
Las Animas, CO	6030
Las Cruces, NM	7720
Las Vegas, NM	2436, 2454
La Salle, IL	114, 2503
Lathrop, MO	5544
Laton, CA	9818
Latonia, KY	6248
Latrobe, PA	3831, 3910
	5744, 13700
	14133
Laurel, DE	6726
Laurel, MD	4364
Laurel, MS	6681, 6923
	11898
Laurel, MT	8669, 8716
Laurel, NE	9793, 9979
Laurel Springs, NJ	12022
Laurens, IA	4795
Laurens, SC	3540, 10652
Laurinburg, NC	5651
Laurium, MI	8598
Lavonia, GA	8470
Lawler, IA	10599
Lawrence, KS	1590, 1732
	3584, 3849
	3881
Lawrence, MA	1014, 1048
	1962, 2347, 3977, 4300
Lawrence, NE	8851
Lawrenceburg, IN	82, 1418
	2612, 2889
	4281, 7909
Lawrenceburg, KY	2190, 7497
	8604, 8862
Lawrenceburg, TN	6093
Lawrenceville, GA	11936
Lawrenceville, IL	5385
Lawrenceville, PA	9702
Lawrenceville, VA	9433
Lawton, MI	12084
Lawton, OK	5914, 8375
	9962, 12067
Layton, UT	7685
Le Mars, IA	14253
Le Raysville, PA	6350
Le Roy, IL	6586
Le Roy, MN	7109
Le Sueur, MN	7199
Le Sueur Center, MN	6921
Lead, SD	4631
Leadville, CO	2420, 3746
	3949
Leaksville, NC	12259
Leavenworth, KS	182, 1448
	3033, 3194
	3908
Lebanon, IN	2057, 2660
Lebanon, KS	5799
Lebanon, KY	1694, 2150
	3988, 4271
Lebanon, NH	808
Lebanon, OH	1238, 2360
	4239, 8507

City	Charter #	City	Charter #	City	Charter #	City	Charter #
Lebanon, OR	9127, 10164	Liberal, KS	6720, 13406	Liverpool, PA	8326	Louisburg, NC	7554, 1026
Lebanon, PA	240, 655	Liberal, MO	7094	Livingston, IL	11845	Louisiana, MO	3103, 311
	680, 4955	Liberty, IN	1925, 2007	Livingston, MT	3006, 3605	Louisville, GA	620
	4979	Liberty, MO	3712		4117	Louisville, KY	109, 77
Lebanon, TN	1664, 1708	Liberty, NE	4080	Livingston, NJ	13129		788, 790, 1908, 206
	5754, 8714	Liberty, NY	4925, 10037	Livingston, TX	6169		2161, 2164, 2171, 278
Lebanon, VA	6886	Liberty, PA	11127	Livingston Manor, NY	10043		4145, 4956, 5161, 519
Lee, MA	885	Libertyville, IL	6514, 6670	Livonia, NY	13006		5312, 7457, 9241, 1432
Leechburg, PA	5502, 9290	Lidgerwood, ND	5772, 8230	Llano, TX	4316, 4371	Louisville, OH	963
Leeds, AL	13359		12776		5853, 7119	Loup City, NE	3373, 727
Leeds, MO	9383	Ligonier, PA	6281, 6832	Lock Haven, PA	507, 1273		1362
Leeds, ND	6312		13432, 13658		11692	Lovelady, TX	874
Leesburg, FL	11038	Lilly, PA	8450	Lockhart, TX	4030, 5491	Loveland, CO	7648, 811
Leesburg, VA	1738, 3917	Lima, IN	1234		13934		1362
Leesport, PA	9495	Lima, MT	11492	Lockland, OH	4133	Loveland, OH	6779, 681
Leesville, LA	6264	Lima, OH	2035, 2497	Lockney, TX	9126, 9193	Lovell, WY	1084
Leesville, Sc	9057		2859, 3772, 5125, 8701	Lockport, IL	8933	Lovelock, NV	765
Leetonia, OH	3519		13767	Lockport, NY	211, 639	Lovingston, VA	1195
Leger, OK	6113, 7159	Lime Springs, IA	6750		1039	Lovington, IL	549
Lehigh, IA	5868	Limerick, ME	2785	Lodgepole, NE	9741	Lowell, IN	5369, 593
Lehigh, OK	5755, 8189	Limon, CO	11504	Lodi, CA	7719, 11126		676
Lehighton, PA	2308, 6531	Lincoln, AL	10131		12112	Lowell, MA	331, 50
Leicester, MA	918	Lincoln, AR	11825	Lodi, CA	7719, 11126		753, 781, 960, 98
Leigh, NE	9831	Lincoln, IL	2126, 3369		12112		1329, 4753, 6077, 1234
Leipsic, OH	6565		3613, 14118	Lodi, NJ	9420	Lowell, MI	128
Leland, IL	7864	Lincoln, KS	3464, 6672	Lodi, OH	53, 7017	Lowell, OH	532
Lemars, IA	2728, 2818	Lincoln, NE	1798, 1899		10677	Lowville, NY	348, 242
Lemasters, PA	8405, 10950		2750, 2988, 3571, 4435	Logan, IA	6771	Loysville, PA	1152
Lemmon, SD	9269, 12857		4606, 5213, 7239, 8885	Logan, KS	6841	Lubbock, TX	6195, 820
Lemoore, CA	7779		13017, 13333	Logan, OH	92, 7649		1268
Lemoyne, PA	13494	Lincoln, PA	3198		9284	Lucas, KS	756
Lenapah, OK	9951	Lincoln Park, MI	12999	Logan, UT	4670	Ludington, MI	2773, 1401
Lenoir, NC	8445, 13523	Lincolnton, NC	6744, 8184	Logan, WV	8136, 13954	Ludlow, KY	532
Lenoir City, TN	8673	Lind, WA	9101		3084, 5076, 13580	Ludlow, MO	7900, 865
Lenox, IA	5517, 14040	Lindale, TX	7956	Logansport, IN	1031, 2596		1329
Lenox, MA	4013	Linden, AL	7148	Loganton, PA	9345	Lufkin, TX	5797, 600
	10059	Linden, NJ	11545	Loma Linda, CA	13332	Luling, TX	4266, 1391
Leominster, MA	513, 3204	Linden, TN	10181	Lometa, TX	10232	Lumberton, MS	561
Leon, IA	1696, 5489	Linden, TX	10476	Lonaconing, MD	7732	Lumberton, NC	739
Leonard, TX	5109, 12382	Lindenhurst, NY	8833	London, KY	3943, 7890	Luray, KS	1006
Leonardsville, NY	217	Lindsay, CA	7965, 9710	London, OH	1064, 10373	Luray, VA	6031, 620
Leonardtown, MD	6606	Lindsay, OK	6171, 6710	Lone Oak, TX	6605, 7657	Lusk, WY	1139
Leonia, NJ	11950	Lindsborg, KS	3589	Lone Wolf, OK	10096	Luther, OK	856
Leoti City, KS	3844	Linville, AL	7516, 7551	Long Beach, CA	5456, 6730	Luverne, AL	799
Lerna, IL	8224		8856		6749, 8510, 8870, 11873	Luverne, MN	3428, 777
Leroy, KS	6149	Lineville, IA	7261		12819		8977, 1263
Leroy, NY	937, 3283	Linn Creek, MO	7853	Long Beach, NY	11755, 13074	Luxemburg, MO	1351
	6087	Linn Grove, IA	7137	Long Branch, NJ	4138, 6038	Luzerne, PA	892
Leslie, AR	10138	Linton, IN	7411, 14258	Long Island City, NY	10329	Lykeus, PA	1106
Leslie, MI	2162	Linton, ND	9590, 11665	Long Prairie, MN	6208, 7080	Lyle, MN	570
Lestershire, NY	7813	Lipan, TX	10598	Longmont, CO	3354, 4653	Lynbrook, NY	8923, 1160
Letcher, SD	9188	Lisbon, IA	2182		7839, 11253	Lynch, NE	978
Lewes, DE	5148	Lisbon, ND	3669	Longton, KS	8525, 9911	Lynchburg, OH	1177
Lewis, KS	10863	Lisbon, NY	12018	Longview, TX	4077, 6043	Lynchburg, VA	1522, 155
Lewisburg, PA	745, 784	Lisle, NY	10816		12411		2506, 2760, 730
Lewisburg, TN	8934	Litchfield, CT	709	Longview, WA	12392	Lyden, WA	1180
Lewiston, ID	2972, 3023	Litchfield, IL	3962, 10079	Loogootee, IN	7241	Lyndhurst, NJ	104
	5600, 10212	Litchfield, KY	5314	Loomis, NE	5419	Lyndon, KS	722
	11745, 13819	Litchfield, MN	6118, 13486	Lorain, OH	2625, 5371	Lyndon, VT	114
Lewiston, ME	330, 2260	Litchfield, NE	8093	Lordsburg, CA	9599	Lyndonville, VT	315
Lewiston, PA	1579	Litchville, ND	8298	Lordsburg, NM	8880	Lyndora, PA	857
Lewistown, IL	1808, 4941	Lititz, PA	2452, 5773	Lorena, TX	8621	Lynn, MA	638, 69
Lewistown, MT	7274, 12608		9422	Lorimor, IA	12248		1201, 2563, 3429, 458
Lewistown, PA	5289, 10506	Little Falls, MN	4034, 4655	Los Altos, CA	11522		11169, 1326
Lewisville, AR	9354		13353	Los Angeles, CA	2491, 2938	Lynnville, IN	886
Lewisville, IN	5526	Little Falls, NJ	8829		3538, 4096, 5927, 5993	Lynville, TN	855
Lewisville, OH	8978	Little Falls, NY	1344, 2400		6545, 6617, 6864, 7632	Lyons, GA	797
Lewisville, TX	7144		2406		8117, 8827, 9515, 10656	Lyons, IA	66, 72
Lexington, IL	2824	Little Ferry, NJ	12378		12410, 12454, 12545, 12755		453
Lexington, KY	760, 906	Little Rock, AR	1648, 3300		12804, 13187	Lyons, KS	3577, 535
	1720, 2393, 2901, 3052		3318, 6902, 9037, 14000	Los Banos, CA	9933		1404
	3942	Little Rock, IA	8119	Los Gatos, CA	10091	Lyons, MI	200
Lexington, NC	5698	Little York, IL	6065	Lost Nation, IA	5402	Lyons, NE	622
Lexington, NE	4161	Littlefork, MN	11863	Lott, TX	6223, 13647	Lyons, NY	1027, 74
Lexington, OK	5462, 7207	Littlestown, PA	9207	Loudon, TN	12080	Lyons Falls, NY	1283
Lexington, SC	9296	Littleton, CO	7533, 11949	Loudonville, OH	6657	Mabank, TX	642
Lexington, TN	12324	Littleton, NH	1885	Louisa, KY	7110, 7122	Mabel, MN	903
Lexington, VA	7173	Live Oak, FL	6055	Louisa, VA	10968	Mabton, WA	975
Libby, MT	9594	Livermore, CA	8002, 9914	Louisburg, KS	11798	Macedon, NY	1249

City	Charter #	City	Charter #	City	Charter #	City	Charter #
Machias, ME	11462		6817		12027	McClusky, ND	8881
Mackinaw, IL	8732	Mankato, MN	1683, 2005	Marquette, NE	8400	McComb City, MS	7461
Macksburg, IA	6852		3562, 4727, 6519, 14220	Mars, PA	5599	McConnellsburg, PA	8083, 13765
Macomb, IL	967, 1872	Manlius, IL	8648	Marseilles, IL	1852	McConnelsville, OH	46, 2712
	9169	Manning, IA	3455	Marshall, AR	10794, 10795		5259
Macon, GA	1617, 3740	Manning, SC	11155	Marshall, IL	4759	McCook, NE	3379, 9436
	4547, 8365, 8990, 9212	Mannington, WV	5012	Marshall, MI	1515, 1518		8823
	10270, 10945	Mannsville, OK	6578		2023, 14009	McCumber, ND	7846
Macon, MO	2862	Manor, PA	6456	Marshall, MN	4595, 4614	McCune, KS	12191
Maddock, ND	8226	Manor, TX	7146	Marshall, MO	2884	McDonald, PA	4752, 5058
Madelia, MN	7100, 13784	Mansfield, AR	11195, 11196	Marshall, TX	3113, 4101	McDonough, GA	7969
Madera, CA	7336, 10197	Mansfield, IL	6096		12703	McFarland, CA	10387
Madera, PA	7400	Mansfield, LA	7232, 11669	Marshall, VA	10253	McGehee, AR	13280
Madill, OK	6365, 7723	Mansfield, MA	5944	Marshalltown, IA	411, 2115	McGill, NV	9452
	10286, 13021	Mansfield, OH	436, 480		2971, 4359	McGregor, IA	323
Madison, FL	7190		800, 2577	Marshfield, MO	10009	McGregor, TX	4076, 5504
Madison, GA	7300	Mansfield, PA	8810, 8831	Marshfield, OR	7475		7599
Madison, IL	8457		13618	Marshfield, WI	4573, 5437	McHenry, ND	8124
Madison, IN	111, 1457	Mansfield, TX	7201		14125	McIntosh, MN	6488
Madison, KS	5529	Mantua, OH	5370	Mart, TX	5850, 7546	McIntosh, SD	9283
Madison, ME	4647	Manville, WY	11352	Martin, TN	5617, 9112	McKees Rocks, PA	5142, 14107
Madison, MN	6795, 13561	Mapleton, MN	6787	Martinez, CA	8692, 12511	McKeesport, PA	2222, 4625
Madison, NE	3773, 8317	Mapleton, PA	11244	Martinsburg, PA	7974		4876, 7559
	10021	Maplewood, MO	12955	Martinsburg, WV	1524, 2144		13967
Madison, NJ	2551	Maquoketa, IA	999		4811, 6283	McKinney, TX	2729, 2909
Madison, SD	3149, 3151	Maquon, IL	8482	Martinsville, IL	6721		14236
	3597, 10636	Marathon, IA	4789	Martinsville, IN	794, 4964	McLean, TX	7413
Madison, WI	144, 9153	Marathon, NY	3193		13643	McCleansboro, IL	6649, 9408
Madison, WV	6510	Marble, MN	11608	Martivsville, VA	7206, 9847	McLoud, OK	6660
Madisonville, KY	8386, 8451	Marble Falls, TX	4545	Marysville, CA	11123	McMinnville, OR	3399, 3857
Madisonville, OH	8557	Marblehead, MA	676, 767	Marysville, KS	2791		9806
Madisonville, TX	6356	Marceline, MO	7066	Marysville, PA	7353	McMinnville, TN	2221, 2593
Magdalena, NM	10268	Marcellus, NY	9869	Maryville, MO	3268, 4243		7834
Mahaffey, PA	7610	Marcus, IA	9819	Maryville, TN	10542	McPherson, KS	3521, 3791
Mahanoy City, PA	567, 3997	Marengo, IA	2428	Mascoutah, IL	9736, 13795		3803
Mahnomen, MN	8726, 12941	Marengo, IL	1870	Mason, MI	1764, 12697	McVeytown, PA	8773
Mahopac, NY	13121	Marfa, TX	8674	Mason, OH	7403	McVille, ND	10721
Makoti, ND	11184	Margaretville, NY	5924	Mason, TX	4378, 7098	Meade, KS	7192
Malad City, ID	8822	Marianna, FL	6110	Mason City, IA	2574, 4587	Meade Center, KS	3695, 3853
Malakoff, TX	10403	Maricopa, CA	9957		10428	Meadville, PA	115, 871
Malden, MA	588, 11014	Marienville, PA	5727	Mason City, IL	1850		4938
Malden, WA	9351	Marietta, GA	3830	Masontown, PA	5441, 6528	Mebane, NC	11697
Malone, NY	598, 914	Marietta, OH	142, 859	Massena, NY	6694	Mechanicsburg, PA	326, 380
	3307, 3366		4164, 5212	Massillon, OH	216, 1318		8969
	11897		13971		4286	Mechanicsburgh, OH	2325
Malta, IL	5815	Marietta, OK	5345, 5958	Matadoe, TX	11002	Mechanicsville, MD	9429
Malta, MT	9738		8278	Matawan, NJ	6440	Mechanicville, NY	3171, 5037
Malta, OH	2052	Marietta, PA	25, 2710	Matewan, WV	10370	Medaryville, IN	8537
Malvern, AR	7634		10707	Matoaka, WV	11264, 12839	Medford, MA	5247, 12979
Malvern, IA	2247, 4834	Marine, IL	10582	Matteawan, NY	4914	Medford, NJ	1191
	8057	Marine City, MI	11260	Matthews, IN	5998	Medford, OK	5796
Malvern, PA	3147	Mariner Harbor, NY	8194	Mattituck, NY	13445	Medford, OR	7701, 8236
Mamaroneck, NY	5411, 13592	Marinette, WI	4123, 4137	Mattoon, IL	1024, 2147		13771
Manasquan, NJ	3040, 9213	Marion, IA	117, 2753		10045, 10144	Medford, WI	5695
Manassas, VA	5032, 6748	Marion, IL	4502	Mauch Chunk, PA	437, 469	Media, PA	312, 3666
Manawa, WI	8710	Marion, IN	4189, 7758		2852, 6534	Medical Lake, WA	9030
Manchester, IA	4221		13717, 13729	Maud, OK	8294	Medicine Lodge, KS	3253, 3594
Manchester, KY	7605	Marion, KS	3018, 3928	Maud, TX	10182	Medina, NY	229, 4986
Manchester, MO	7643		7911, 10980	May, TX	8327	Medina, OH	2053, 2091
Manchester, NH	574, 1059	Marion, NC	6095	Maybrook, NY	11927		4842, 5139
	1153, 1520, 2362, 4693	Marion, ND	9161	Mayetta, KS	9934	Meeker, CO	7435
Manchester, OH	1982, 9091	Marion, NY	10546	Mayfield, KY	2245, 5033	Meeteetse, WY	6340
Manchester, TN	5528	Marion, OH	287, 5650		6834	Melissa, TX	10008
Manchester, VA	9663		6308	Mays, IN	8700	Melrose, MA	4769
Manchester, VT	1488	Marion, SC	10085	Mays Landing, NJ	8582	Melrose, MN	7566
Mancoc, CO	9674	Marion, VA	6839, 11718	Maysville, GA	7986	Melrose, NM	8397
Mandan, ND	2585, 10604	Marion, WI	12286, 14130	Maysville, KY	1702, 2467	Melvin, IA	5616
Mangum, OK	5508, 5811	Marion Center, PA	7819		2663, 9561	Memphis, MO	2432
	7328	Marissa, IL	6691, 13735	Maysville, OK	8999, 10283	Memphis, TN	336, 1225
Manhasset, NY	11924	Marked Tree, AR	11122	Maytown, PA	9461		1407, 1636, 2096, 2127
Manhattan, IL	8713	Marlboro, MA	158, 2770	Mayville, ND	3673		3633, 4307, 5056, 9184
Manhattan, KS	2094, 3782	Marlboro, NY	8834	Mayville, WI	10653		10540, 12348, 13349
	4008	Marlborough, MA	2404	Mazon, IL	10186	Memphis, TX	6107, 8005
Manheim, PA	912, 3635	Marlin, TX	4706, 5606	Mcadoo, PA	8619	Mena, AR	7163, 7829
Manilla, IA	5873, 6041	Marlinton, WV	6538, 13783	McAlester, OK	13770		13693
Manistee, MI	2539, 2606	Marlow, OK	7149	McAlisterville, PA	9526	Menahga, MN	11740
Manistique, MI	5348, 13513		10205, 12129	McArthur, OH	2036	Menard, TX	10044
Manitowoc, WI	852, 4975	Marmarth, ND	9082	McCloud, CA	9479	Menasha, WI	1714, 3724
Mankato, KS	3745, 3812	Marquette, MI	390, 6003	McClure, PA	7769	Mendon, OH	9274

City	Charter #	City	Charter #	City	Charter #	City	Charter #
Mendota, IL	1177, 5086	Milbank, SD	6473, 8698		6429, 7689	Montour Falls, NY	10497, 13583
	13611		13407	Minotola, NJ	10440	Montoursville, PA	6997
Menominee, MI	3256, 4454	Milburn, OK	7842, 9920	Mishawaka, IN	5167	Montpelier, ID	7381
Menominie, WI	2851	Mildred, PA	9552	Mission, TX	10090	Montpelier, IN	5278
Mentone, IN	8368	Miles, TX	6935, 7414	Missoula, MT	2106, 3995	Montpelier, OH	5315, 5341
Merced, CA	3733, 9437	Miles City, MT	2752, 3275	Missouri Valley, IA	3189		13912
	10353, 13028		5015, 12536	Mitchell, IN	6433	Montpelier, VT	748, 857
Mercedes, TX	11879	Milford, DE	2340	Mitchell, NE	7026		13915
Mercer, PA	392, 2256	Milford, IA	5539, 9298	Mitchell, SD	2645, 3508	Montrose, CO	4007, 7288
	4909, 13846	Milford, IL	5149		7455	Montrose, PA	2223, 6746
Mercersburg, PA	9330	Milford, MA	866, 2275	Moab, UT	10925	Moody, TX	5774
Merchantville, NJ	8323	Milford, MI	2379	Moberly, MO	4000	Moore, MT	8539
Meriden, CT	720, 1382	Milford, NH	1070	Mobile, AL	1595, 1817	Moore, OK	12035
Meridian, ID	10221	Milford, NJ	8779		5219, 7062, 13097, 13195	Moore, TX	8817
Meridian, MS	2957, 3176	Milford, NY	5210		13414	Moorestown, NJ	3387
	7266, 13551	Milford, OH	3234, 8188	Mobridge, SD	10744, 11590	Mooresville, IN	6876
Meridian, TX	4016	Milford, PA	5496		13467	Mooresville, NC	9531
Merit, TX	7378	Mill Creek, OK	7197, 8546	Mocanaqua, PA	12349	Moorfield, WV	3029
Merkel, TX	5661, 7466		12188	Modesto, CA	3136, 10988	Moorhead, MN	2569, 4713
	7481, 10052	Millbrook, KS	3758	Mohall, ND	7008		13297
Merrick, NY	12503	Millburn, NJ	8661	Mohawk, NY	1130	Moose Lake, MN	12947
Merrill, OR	10056	Millbury, MA	572, 13835	Mohnton, PA	8968	Mora, MN	7292
Merrill, WI	3704, 4736	Milledgeville, GA	9672	Molalla, OR	11271	Moravia, NY	99, 2353
	10176	Millen, GA	9088	Moline, IL	160, 1941	Morehead, KY	7593
Merrimac, MA	268	Miller, SD	6789	Moline, KS	7318, 8369	Morenci, MI	5669
Mertzon, TX	9810	Millerburg, PA	2252	Momence, IL	7079	Morgan, TX	6247
Mesa, AZ	11130	Millersburgh, OH	1923	Monaca, PA	5878, 5879	Morgan, UT	6958
Meshoppen, PA	5429	Millerstown, PA	2241, 7156	Mondovi, WI	5779	Morgan City, LA	6801
Mesquite, TX	6140	Millersville, PA	9259	Monessen, PA	5253, 5956	Morganfield, KY	2209, 7490
Metcalf, IL	7954	Millerton, NY	2661		11487	Morganton, NC	5450
Methuen, MA	1485, 12800	Millheim, PA	9511	Monett, MO	5973	Morgantown, IN	7652
Metropolis, IL	3156, 5254	Millsap, TX	12687	Monmouth, IL	85, 1706	Morgantown, WV	1502, 2458
	8745	Millsboro, PA	7310		2205, 2751, 4313, 4400		5583
Metuchen, NJ	7754, 13916	Millstadt, IL	8425	Monmouth, OR	10071	Morrill, NE	9653
Mexia, TX	3014, 5697	Milltown, IN	8650	Monongah, WV	7545	Morrilton, AR	10434
	11964, 12190	Milltown, NJ	10935	Monongahela City, PA	5968	Morris, IL	531, 8163
Mexico, MO	2881	Millville, NJ	1270, 5208	Monroe, IA	2215, 7357	Morris, MN	2933, 6310
Mexico, NY	5293	Millville, PA	5389	Monroe, LA	3692, 4082	Morris, NY	4870
Meyersdale, PA	2258, 5801	Milnor, ND	8264, 8280		8654, 10153, 11242, 13655	Morris, OK	8876, 11932
	5833	Milroy, IN	11782	Monroe, MI	1587	Morrison, IL	1033
Miami, FL	6370, 6774	Milton, FL	7034, 13968	Monroe, NC	8712	Morrisonville, IL	6745
	13570	Milton, IA	10243	Monroe, NY	7563	Morristown, NJ	1113, 1188
Miami, OK	5252, 10019	Milton, ND	6518	Monroe, OH	7947	Morristown, NY	8371
Miami Beach, FL	12047, 13828	Milton, OR	9201	Monroe, WA	9372, 9478	Morristown, SD	9817
Miamisburg, OH	3876, 4822	Milton, PA	253, 711	Monroe, WI	230	Morristown, TN	3432, 8025
Michigan City, IN	2101, 2747	Milton, WV	12765	Monroeville, AL	12642	Morrisville, NY	245
	9381	Milwaukee, WI	64, 1003	Monroeville, OH	2438	Morrow, OH	8709, 8741
Middleborough, KY	7086		1017, 1438, 1483, 2715	Monrovia, CA	3743, 7705	Moscow, ID	3408, 4584
Middleborough, MA	3994		4816, 4817, 5458, 6853	Monrovia, IN	6354	Moscow, PA	9340
Middlebourne, WV	6170		12564, 12628, 12816	Monrovia, MD	9238	Moss Point, MS	8593
Middleburg, NY	2487	Minatare, NE	13316	Monson, MA	503	Motley, MN	7764
Middleburg, PA	4156	Minco, OK	8644	Montague, TX	3165	Motordale, MN	11550
Middlebury, VT	1195	Minden, LA	10544	Montclair, NJ	9339, 9517	Mott, ND	9489
Middleport, NY	9206	Minden, NE	3057, 9400		12268, 12675	Moulton, IA	5319
Middleport, OH	2210, 4472	Mineola, NY	9187, 13404	Monte Vista, CO	7228	Moulton, TX	5399
	8441	Mineola, TX	5127, 8037	Monterey, CA	7058	Moultrie, GA	7565, 13161
Middlesborough, KY	4201	Mineral Point, WI	3203	Monterey, IN	9784	Mound City, IL	7443
Middletown, CT	397, 845	Mineral Springs, AR	1113	Monterey, VA	9043	Mound Valley, KS	8107
	1216, 1340	Mineral Wells, TX	5511, 12734	Monterey Park, CA	12061	Mounds, IL	10445
Middletown, DE	1181, 3019		12669	Montesano, WA	4779, 5472	Mounds, OK	6263
Middletown, IL	7791	Minersville, PA	423, 6131	Montevideo, MN	6860	Moundville, WV	5717, 14142
Middletown, NY	523, 1276	Minerva, OH	1930, 5344	Montezuma, GA	6576	Mount Airy, MD	7160
	1473, 3333, 13956	Mingo Junction, OH	5694, 14183	Montezuma, IN	2961	Mount Airy, NC	4896
Middletown, OH	1545, 2025	Minneapolis, KS	3353, 3731	Montezuma, IA	7463	Mount Auburn, IL	9922
Middletwon, PA	585, 7826		4931	Montgomery, AL	1814, 2029	Mount Calm, TX	10297, 13669
Middletown Springs, VT	3150	Minneapolis, MN	710, 719		4180, 5877, 7141, 8284	Mount Carmel, IL	4480, 5782
Middleville, NY	11656		1623, 2006, 2795, 3098		8460, 12993	Mount Carmel, PA	3980, 8093
Midland, MD	5331		3145, 3206, 3784, 4739	Montgomery, IN	5734		5251, 6620
Midland, PA	8311		4951, 6449, 8720, 9409	Montgomery, MN	11215	Mount Carroll, IL	409
Midland, SD	10637		11861, 12282, 12972, 13096	Montgomery, NY	7982, 13559	Mount Clemens, MI	2214, 12971
Midland, TX	4368		13108	Montgomery, PA	5574, 8866	Mount Gilead, OH	258, 2459
Midland City, AL	8458	Minnesota, MN	6413, 6917	Montgomery, WV	5691, 9740	Mount Healthy, OH	7661
Midlothian, TX	7775, 8568	Minnesota Lake, MN	6204, 6532	Monticello, GA	9329, 9346	Mount Holly, NJ	1168, 1356
	13670	Minnewaukan, ND	5500	Monticello, IA	2080		2343
Midway, PA	6626	Minoa, NY	13476	Monticello, IL	4826, 13865	Mount Holly Springs, PA	8493
Mifflinburg, PA	174, 4039	Minonk, IL	9601	Monticello, IN	2208, 6172	Mount Hope, KS	5559
	5147	Minooka, IL	9208	Monticello, KY	1931, 6419	Mount Hope, WV	11049
Milaca, MN	9050	Minot, ND	4009, 6315	Monticello, NY	1503	Mount Jackson, VA	3209
Milan, MO	3110			Montour, IA	7469	Mount Jewett, PA	7473

City	Charter #	City	Charter #	City	Charter #	City	Charter #
Mount Joy.	667, 1516	Nacogdoches, TX	4405, 5991	New Bethlehem, PA	4978, 5051	New Rochelle, NY	6427
Mount Kisco, NY	5026		6627	New Bloomfield, PA	5133	New Rockford, ND	6393
Mount Morris, NY	1416	Nampa, ID	8370, 10693	New Boston, TX	5636, 8522	New Salem, ND	6428
Mount Morris, PA	6983		10916	New Braunfels, TX	4295, 7924	New Salem, PA	5837, 6599
Mount Olive, IL	7350, 13452	Nanticoke, PA	3955, 7406	New Bremen, OH	7851, 14294	New Sharon, IA	8950
Mount Olive, NC	10629		13524	New Brighton, MN	4302	New Tripoli, PA	9656
Mount Orab, OH	10692	Nantucket, MA	714	New Brighton, NY	3444	New Ulm, MN	631, 2318
Mount Pleasant, IA	299, 922	Nanuet, NY	13314	New Brighton, PA	632, 3259	New Vienna, OH	10947
Mount Pleasant, MI	3215	Napa, CA	7176		4549, 7395	New Wilmington, PA	9554
Mount Pleasant, OH	492, 6640	Naper, NE	9665	New Britain, CT	1184, 3668	New Wilson, OK	10574
	6667	Napperville, IL	4551		12846	New Windsor, MD	747
Mount Pleasant, PA	386, 4875	Nples, TX	7194, 8585	New Brockton, AL.	10457	New York, NY	29, 62
	4892, 9198	Napoleon, ND	11378	New Brunswick, GA	3116		87, 254, 290, 307
Mount Pleasant, TN	9319	Napoleon, OH	1917, 5218	New Brunswick, NJ	208, 587		341, 345, 376, 384
Mount Pleasant, TX	4722, 6139	Nappanee, IN	8785		3697		387, 444, 687, 733
Mount Prospect, IL	3839, 10048	Nara Visa, NM	8663	New Canaan, CT	1249		750, 891, 905, 917
Mount Rainier, MD	6144, 12443	Narrows, VA	11444	New Carlisle, IN	5639		923, 964, 972, 998
Mount Sterling, IL	2402	Narrowsburg, NY	12496	New Carlisle, OH	6594		1000, 1067, 1075, 1080
Mount Sterling, KY	2185, 2216	Nash, OK	11306	New Castle, IN	804, 2202		1090, 1105, 1116, 1121
	6129, 6160	Nashua, IA	2411		9852		1196, 1215, 1224, 1231
Mount Sterling, OH	5382, 9095	Nashua, NH	84, 1310	New Castle, KY	2196		1232, 1250, 1261, 1278
Mount Union, PA	6411, 10206		2240, 2741	New Castle, ME	953		1290, 1297, 1324, 1352
Mount Vernon, IL	1996, 5057	Nashville, GA	9106	New Castle, PA	562, 1156		1357, 1370, 1371, 1372
	5689	Nashville, IL	6524, 8221		4676, 8503		1373, 1374, 1375, 1388
Mount Vernon, IN	366	Nashville, TN	150, 771	New Castle, VA	10993		1389, 1393, 1394, 1443
	7786, 12466, 12780		1296, 1669, 2200, 2513	New Concord, OH.	6976		1461, 1476, 1497, 1499
Mount Vernon, MO	13504		3032, 3228, 6524, 6729	New Cumberland, PA	7349		1556, 1624, 1691, 2370
Mount Vernon, NY	1772, 5271		8221, 9106, 9532, 9659	New Cumberland, WV	6582		2507, 2598, 2608, 2668
	8516		9774, 13103	New Decatur, AL.	6380, 10423		2976, 3359, 3415, 3700
Mount Vernon, OH	908, 1051	Nashwauk, MN	10736, 11579	New Duluth, MN	4750		3771, 4152, 4335, 4512
	3328, 7248	Natchez, MS	3701, 6305	New Egypt, NJ	8254, 13910		4567, 4581, 4645, 4855
	7638		12537, 13722	New England, ND	9776		4898, 5003, 5112, 5237
Mount Vernon, SD	7582	Natick, MA	2107	New Florence, PA	10353, 13907		5783, 5990, 6198, 6253
Mount Vernon, TX	5409, 7674	National City, CA.	9512	New Freedom, PA.	6715, 13887		6284, 6425, 6441, 7107
Mount Vernon, WA	4529	National City, IL	9118, 12991	New Hampton, IA	2588, 7607		7203, 7447, 7450, 8634
	10602, 12154	Natoma, KS	9384	New Harmony, IN	6699, 13542		8665, 8922, 8926, 9219
Mount Washington, OH	9761	Natrona, PA	5729	New Hartford, NY	11785		9360, 9569, 9717, 9939
Mount Wolf, PA.	9361, 14121	Naugatuck, CT	3020	New Haven, CT	2, 227		9955, 10778, 11034, 11655
Mountain Grove, MO	7282	Nauvoo, IL	8898		796, 1128, 1202, 1243		11844, 12123, 12214, 12252
Mountain Home, ID	6521	Navasota, TX	4253, 5190		1245, 2682, 13704		12280, 12300, 12344, 12352
Mountain Lake, MN	9267	Nazareth, PA	5077, 5686	New Haven, IL	8053		12398, 12406, 12419, 12419
Mountain View, CA	10324	Nebo, IL	10492	New Haven, PA	6408		12550, 12553, 12825, 12874
Mountain View, OK	5656	Nebraska City, NE	1417, 1855	New Holland, OH	7187		12885, 12892, 12897, 12900
Mountville, PA	3808		2536	New Holland, PA	2530, 8499		12965, 13027, 13035, 13045
Moweaqua, IL	7739	Neche, ND	11110	New Hope, PA	11015		13105, 13149, 13193, 13237
Muir, MI	2017	Nederland, TX	6596	New Iberia, LA	3671, 4524		13254, 13260, 13292, 13295
Mulberry, IN	4801, 10234	Needles, CA	4873		6858		13296, 13304, 13334, 13336
Mulberry Grove, IL	7379	Neenah, WI	1602, 2603	New Kensington, PA	4913, 13084		13360, 13959
Muldrow, OK	6717, 9975		6034		13571	Newark, AR	9022
Mulhall, OK	9032	Neffs, OH	9799	New Lexington, OH	2056, 6505	Newark, DE	1536
Mullan, ID	8906	Neffs, PA	12471		13596	Newark, NJ	52, 362
Mullica Hill, NJ	6728	Negaunee, MI	2085, 3717	New Lisbon, OH	2203		1217, 1220, 1251, 1316
Mullins, SC	9876		9556	New London, CT	196, 666		1452, 1818, 2040, 2045
Muncie, IN	793, 2234	Neihart, MT	4600		978, 1037		2083, 9605, 9912, 12570
	4674, 4809, 4852, 7454	Neillsville, WI	9606, 14200		1175		12604, 12711
Muncy, PA	837, 3480	Neligh, NE	3495, 4110	New London, IA	5420, 8352	Newark, NY	349, 6802
Munday, TX	7106, 8215		5690, 13568	New London, OH	1981, 4712	Newark, OH	858, 3191
Munfordville, KY	11336	Neodesha, KS	6895, 6914		10101		7787, 9199
Munhall, PA	8795	Neoga, IL	5426, 7841	New London, WI	5013	Newark Valley, NY	10111
Munich, ND	7569		13892	New Market, NH	1330	Newberg, OR	7537, 9358
Munising, MI	9000	Neosho, MO	6382	New Market, VA	10568	Newberry, SC	1844
Murfreesboro, NC	11557	Nephi, UT.	3537, 8508	New Martinsville, WV	5266	Newburg, WV	7626
Murfreesboro, TN	1692, 2000	Nescopeck, PA	10251, 12159	New Martamoras, OH	5999	Newburgh, NY	468, 1106
Murphy, NC	9458	Ness City, KS	3542, 8081	New Milford, CT	1193		1213
Murphysboro, IL	4019, 4804		8142	New Milford, PA	8960	Newburyport, MA	279, 584
Murray, KY	10779	Netcong, NJ	6692	New Orleans, LA	162, 1591		1011, 1047
Murray, UT	6558	Nevada, IA	2555, 14065		1626, 1747, 1774, 1778	Newcastle, TX	10472
Muscatine, IA	692, 1577	Nevada, MO	3959, 9382		1796, 1825, 1898, 1937	Newcastle, WY	7198
Muskegon, MI	1730, 2081	Nevada, TX	5721		2086, 3069, 3978, 4337	Newcomerstown, OH	5262
	3088, 4125, 4398, 4840	New Albany, IN	701, 775		5649, 7498, 7876, 8734	Newdale, ID	10975
Muskogee, OK	4385, 5236		965, 2166		13688, 13689	Newell, IA	10191
	6911, 9023, 9701, 10113	New Albany, MS	8514	New Paltz, NY	1186	Newfoundland, PA	12911
	10321, 12277, 12890, 12918	New Albany, PA	8973	New Paris, OH	9211	Newkirk, OK	5272, 8214
Myerstown, PA	5241, 9752	New Alexandria, PA	6580	New Philadelphia, OH	1999		9011
Mylo, ND	7857	New Bedford, MA	261, 690	New Point, IN	8408	Newman, CA	9760
Mystic, CT	1268		743, 799, 2262, 12405	New Prague, MN	7092	Newman, IL	7575
Mystic Bridge, CT	251	New Berlin, NY	151, 10199	New Richmond, OH	1068, 7542	Newman Grove, NE	5282
Mystic River, CT	645	New Berlin, PA	7897	New Richmond, WI	11412	Newnan, GA	1861, 3382
Myton, UT	11702	New Bern, NC	11632, 13298	New Roads, LA	7169		6047, 8477

City	Charter #	City	Charter #	City	Charter #	City	Charter #
Newport, AR	6758	North East, PA	741, 4927	Oberlin, OH	72, 2718	Oneonta, NY	2151, 8920
Newport, DE	997		9149	Oblong, IL	8607, 8696	Onida, SD	11585
Newport, IN	1897	North Easton, MA	416	Ocala, FL	3470, 3815	Onley, VA	7258, 14190
Newport, KY	2276, 2726	North Fort Worth, TX	6822, 8287		6825, 9926	Ontario, CA	6268, 9935
	4765	North Girard, PA	12363		10578		13092
Newport, NH	888, 3404	North Kansas City, MO	10367, 13690	Ocean City, NJ	6060, 12521	Ontario, OR	5822, 9348
Newport, NY	1655	North Manchester, IN	2903, 3474	Ocean Grove, NJ	5403	Ontonagon, MI	6820, 13929
Newport, PA	4917, 5245	North Merchantsville, NJ	9391, 12903	Ocean Park, CA	7690, 8069	Opelika, AL	3452, 9550
	7716	North Platte, NE	3496, 4024	Ochiltree, TX	8769, 8911		11635
Newport, RI	1021, 1492	North Providence, RI	1856, 1616	Ocilla, GA	8580	Opelousas, LA	4340, 6920
	1532, 1546, 1565, 2554	North Rose, NY	10016	Oconomowoc, WI	5505, 13616		9872
Newport, TN	9632	North Tonawanda, NY	6809	Oconto, WI	3541, 5521	Opheim, MT	11097
Newport, VT	2263	North Vernon, IN	4678, 9122		14233	Opp, AL	7985
Newport, WA	8828	North Wales, PA	4330	Odebolt, IA	4511, 5817	Oquawka, IL	6086
Newport News, VA	4635, 6781	North Yakima, WA	3355, 3862	Odell, IL	9624*	Orange, CA	8181, 9878
	11028, 11364	Northampton, MA	383, 418	Odessa, DE	1281	Orange, MA	2255
Newsome, TX	10661		1018	Odessa, MO	4141	Orange, NJ	1317, 4724
Newton, IA	650, 2644	Northboro, IA	9015	Odessa, NY	13493	Orange, TX	4118, 6050
	13609	Northborough, MA	1279	Odessa, TX	6410, 8169		13666
Newton, IL	5869, 14074	Northfield, MN	2073, 5895		8925, 13608	Orange, VA	5438, 5532
Newton, KS	2777, 3297		13350	Odessa, WA	9052		7150
	3473, 4860	Northfield, VT	1638	Odgen, IL	5304	Orange City, IA	6132
Newton, MA	789, 3598	Northfork, WV	8309	Odin, IL	9525	Orange Cove, CA	11616
	13252	Northport, NY	5936	Odon, IN	7260	Orangeburg, SC	5269, 10650
Newton, NC	6075	Northumberland, PA	566, 7005	Oelwein, IA	5778		10674, 13918
Newton, NJ	876, 925	Northwood, IA	8373	Ogalalla, NE	3652	Orbisonia, PA	8985, 10335
Newton Falls, OH	7391	Northwood, ND	5980, 9754	Ogden, UT	2597, 2880	Ord, NE	3339, 3481
Newtonville, MA	488	Norton, KS	3687, 8339		3139, 7296	Ordway, CO	8695
Newtown, PA	324	Norton, VA	6235, 9746	Ogensburg, NY	2446	Oregon, IL	1969
Newville, AL	9927	Nortonville, KS	5359	Oil City, PA	173, 5240	Oregon, WI	10620
Newville, PA	60, 9588	Norwald, CT	754, 942		5565, 14274	Oregon City, OR	8556
Nezperce, ID	6697		2342	Okanogan, WA	9411	Oriskany Falls, NY	6630
Niagara, WI	11051	Norwalk, OH	215, 931	Okawville, IL	11754, 11780	Orland, CA	10378
Niagra Falls, NY	4899, 11489		11275	Okeana, OH	9450	Orlando, FL	3469, 3802
	12284	Norway, IA	7287	Okemah, OK	6477, 7677		10069
Nicholasville, KY	1831	Norway, ME	1956, 13750	Oklahoma City, OK	4402, 4770	Orleans, IN	5558
Nichols, NY	9399	Norway, MI	6863		4862, 5159, 5716, 6678	Orleans, NE	3342, 8567
Nicholson, PA	7910	Norway, SC	11189		6981, 8472, 9564, 9584	Orono, ME	1134
Niles, MI	1761, 1886	Norwich, CT	224, 458		9856, 11230	Orosi, CA	9167, 10328
	13307		657, 1187, 1379, 1481	Okmulgee, OK	5418, 6241	Oroville, CA	6919, 10282
Niles, OH	4190, 4977	Norwich, NY	1354, 3011		6855, 9696, 9947, 12048	Oroville, WA	8279
Nixon, TX	10682	Norwood, MA	8474		13751	Orrville, OH	6362, 6379
Noble, IL	9527	Norwood, OH	6322, 8505	Okolona, MS	9196		13742
Noble, OK	9937	Nowata, OK	5401, 6367	Oktaha, OK	10015	Ortonville, MN	6459, 6747
Noblesville, IN	4882, 9756		9948, 9949	Olanta, SC	10748	Orwell, VT	228
Nocona, TX	4621, 5338	Numidia, PA	11981	Olathe, CO	9719	Orwigsburg, PA	4408
	7617, 8610, 11959	Nunda, NY	2224	Olathe, KS	1828, 3720	Osage, IA	1618, 4885
Nogales, A	6591, 11012	Nuremburg, PA	12563	Old Forge, NY	10964	Osage City, KS	3813
Nokomis, IL	1934, 7547	Nutley, NJ	11409, 12750	Oldham, SD	10256, 12662	Osakis, MN	6837
Nome, ND	9287	Nyack, NY	1286, 2378	Olean, NY	1887, 2376	Osborn, OH	9675
Nora Springs, IA	4761	O'Fallon, IL	6924		7102, 9822	Osborne, KS	3319, 3472
Norcatur, KS	8290	O'Keene, OK	5887	Oley, PA	8858		5834
Norco, LA	13839	O'Neill, NE	3424, 5770	Olin, IA	7585	Osceola, IA	1776, 6033
Norfolk, NE	2774, 3347	Oak Harbor, OH	6632	Olive, CA	10891	Osceola, NE	6493
	3741, 7329	Oak Hill, WV	12075	Olive Hill, KY	7281	Osceola, PA	6501
Norfolk, VA	1137	Oak Park, IL	11507	Oliver Springs, TN	11998	Osceola Mills, PA	11966
	1704, 3368, 4743, 6032	Oakaloosa, IA	147	Olivia, MN	9063, 13081	Oshkosh, NE	10081
	9885, 10194	Oakdale, CA	7502	Olney, IL	1641, 2629	Oshkosh, WI	218, 1568
Normal, IL	4930	Oakdale, PA	5327		14217		1787, 2877, 4196, 4508
Norman, OK	5248, 5612	Oakes, ND	6457, 6988	Olney, TX	8982, 12676		5557, 6604, 9347, 13806
	6450, 7293, 12036, 12157	Oakesdale, WA	4122, 9150	Olustee, OK	8316, 8754	Oskaloosa, IA	1101, 2417
Normangee, TX	10275	Oakford, IL	8256		9960		2895, 8076
Norris City, IL	7971	Oakland, CA	2248, 2266	Olympia, WA	3024, 4297	Osnabrock, ND	7234
Norristown, PA	272, 1148		9502, 12665		5652	Ossining, NY	6552
	2581	Oakland, IL	2212	Olyphant, PA	8806, 14079	Oswego, KS	3038, 11576
North Adams, MA	1210, 2396	Oakland, MD	5623, 6588	Omaha, IL	10291	Oswego, NY	255, 296
North Arlington, NJ	12033		13776	Omaha, NE	209, 1633		821, 1355
North Attleborough MA	3365, 7675	Oakland, ME	2231		2665, 2775, 2978, 3163	Otis, CO	10852
	9086	Oakland, NE	4610, 10022		3516, 3603, 4087, 4270	Ottawa, IL	1154, 1465
North Baltimore, OH	4347	Oakland, OK	5404		9466, 9730	Ottawa, KS	1718, 1910
North Belle Vernon, PA	11995	Oakland City, IN	9562	Omaha, TX	10426	Ottawa, OH	7006
North Bend, NE	3059, 7449	Oakley, KS	10041	Omemee, ND	6475	Ottumwa, IA	107, 1726
North Bend, OR	9328	Oaklyn, NJ	12621	Omro, WI	5566		2621
North Bennington, VT	194	Oakmont, PA	7642	Onaga, KS	12353	Overbrook, KS	7195
North Bergen, NJ	12732	Oakville, TX	8807	Onancock, VA	4940, 13878	Overly, ND	8096
North Berwick, ME	1523	Oberlin, KS	3511, 4642	Oneida, IL	10752	Overton, NE	7925, 13446
North Creek, NY	9716		7298	Oneida, NY	519, 1090	Ovid, MI	3264
North East, MD	7064				2401	Ovid, NY	7840
				Oneida, TN	8039	Owasso, OK	7964
				Oneonta, AL	12006	Owatonna, MN	1911, 2123

City	Charter #	City	Charter #	City	Charter #	City	Charter #
	4928		1427, 2649, 5320, 13621		10535	Piketon, OH	7039
Owego, NY	862, 1019	Parkesburg, PA	2464	Peoria, IL	176, 207	Pikeville, KY	6622, 7030
	1311, 2996	Parksley, VA	6246		1117, 2878, 3070, 3214		11944
Owensboro, KY	2576, 4006	Parkston, SD	7662		3254, 3296, 5361	Pikeville, TN	10470
	9456, 14138	Parkton, MD	9444, 13867	Pepperell, MA	5964	Pilger, NE	5937, 5941
Owensville, IN	5432	Parlier, CA	10124	Pequot, MN	11267		13453
Owenton, KY	1963, 2868	Parma, IN	11496	Percy, IL	7627	Pilot Point, TX	4777
	2968, 14026	Parnassus, PA	7363	Perham, MN	6276	Pickneyville, IL	6025, 13975
Owosso, MI	1573, 3410	Parshall, ND	11226	Perkasie, PA	5736	Pine Bluff, AR	2776, 6680
Oxford, AL	7073, 9925	Parsons, KS	1951, 11537	Perry, AR	6706		14056
Oxford, MA	764	Parsons, WV	9610	Perry, FL	7865	Pine Bush, NY	9940, 13960
Oxford, MS	9865	Pasadena, CA	3499, 3568	Perry, IA	3026, 10130	Pine City, MN	11581
Oxford, NC	5885, 8996		9121, 9366, 9610, 10082	Perry, NY	4519	Pine Grove, PA	8151
Oxford, NE	7520		10167, 11425, 12385	Perry, OK	6972, 14020	Pine Plains, NY	981
Oxford, NY	273, 14025	Pasco, WA	9265	Perryopolis, PA	6344	Pinebluff, AR	10768
Oxford, OH	4599, 6059	Pascoag, RI	1512	Perryville, MD	11193	Pineville, KY	4598, 7215
Oxford, PA	728, 2906	Paso Robles, CA	9844, 12172	Perryville, MO	11402	Pineville, WV	7672, 8749
Oxnard, CA	9481	Passaic, NJ	3572, 12205	Perth Amboy, NJ	5215, 11351	Piper City, IL	5322
Ozard, AL	7629		12834, 13123		12524	Pipestone, MN	3982, 10936
Ozona, TX	7748	Patchogue, NY	6785, 12788	Peru, IL	441, 2951		13399
Ozone Park, NY	8865	Paterson, LA	5843		13577, 13903	Pizua, OH	1006, 1061
Pacific Grove, CA	13375	Paterson, NJ	329, 4072	Peshtigo, WI	5658		3750
Paducah, KY	1599, 2070		12383, 12560, 12726	Petaluma, CA	2193, 6904	Pitcairn, PA	5848, 11892
	2093, 12961	Patoka, IN	9352		9918	Pitman, NJ	8500
Paducah, TX	10230	Patterson, NJ	810	Peterborough, NH	1179	Pittsburg, CA	11359
Page, ND	6463	Patterson, PA	9678	Petersburg, IL	3043	Pittsburg, KS	3463, 3475
Paia, HI	10451	Patton, PA	4857, 8233	Petersburg, IN	5300		4136, 8418
Painesville, OH	220, 2842	Paulding, OH	5862, 5917	Petersburg, ND	11185	Pittsburg, TX	4863, 7376
	13318, 14232	Pauls Valley, OK	5091, 6639	Petersburg, PA	10313	Pittsburgh, PA	48, 198
Paint Rock, TX	8306		7892	Petersburg, TN	10306		252, 291, 432, 613
Painted Post, NY	3800, 11956	Paulsboro, NJ	5981	Petersburg, VA	1378, 1548		619, 668, 675, 678
	13664	Paw Paw, MI	1521		1769, 3515, 7709, 13792		685, 700, 705, 722
Paintsville, KY	6100, 7164	Pawcatuck, CT	919	Peterson, IA	4601		727, 757, 776, 926
	13023, 13763	Pawhuska, OK	5961, 7883	Peterstown, WV	9721		1057, 1894, 2195, 2236
Paisley, OR	10432		8313, 11314, 13527	Petoskey, MI	5607		2237, 2261, 2278, 2279
Palatine, IL	11934	Pawling, NY	1269	Petty, TX	5569, 10169		2281, 2415, 2711, 2745
Palatka, FL	3223, 3266	Pawnee, IL	7440	Pharr, TX	10169		3874, 4222, 4339, 4883
	4813, 13214	Pawnee, OK	5224, 5492	Phelps, NY	9839		4910, 4918, 5017, 5225
Palestine, IL	8892		7611	Phenix, RI	1460		6023, 6153, 6216, 6301
Palestine, TX	3694, 4436	Pawnee City, NE	2825, 4078	Philadelphia, MS	1460		6567, 6725, 6806, 7560
	7170, 12556		6541	Philadelphia, PA	1, 213		7581, 12414, 13153, 13701
Palisades, CO	8004	Pawpaw, IL	6228		234, 286, 352, 413		14271
Palisades Park, NJ	11909, 14088	Pawtucket, RI	843		522, 538, 539, 540	Pittsfield, IL	1042
Palmer, MA	2324	Paxton, IL	1876, 2926		541, 542, 543, 544	Pittsfield, MA	1082, 1260
Palmerton, PA	8930	Payette, ID	5906, 8075		546, 547, 556, 557		2525
Palmyra, MO	1735, 2979	Paynesville, MN	11332		560, 561, 563, 570	Pittsfield, ME	4188, 13777
Palmyra, NJ	11793	Peabody, KS	3134		592, 602, 610, 623	Pittsfield, NH	1020
Palmyra, NY	295	Peabody, MA	958		656, 723, 755, 1647	Pittston, PA	78, 11865
Palo Alto, CA	7069, 13212	Peapack-Gladstone, NJ	12002		1743, 2291, 2317, 2462	Placentia, CA	10092
Palouse, WA	9499, 12184	Pearisburg, VA	8091		2731, 3085, 3371, 3423	Placerville, CA	12056
Palouse City, WA	4186	Pearl River, NY	10526		3468, 3491, 3498, 3507	Plain City, OH	5522
Pampa, TX	9142	Pearsall, TX	6989, 13572		3557, 3604, 3684, 3723	Plainfield, CT	10145
Pana, IL	4038, 6734	Peckville, PA	7785		4050, 4192, 5459, 7522	Plainfield, IN	7011
Panama City, FL	10346	Pecos, TX	8771		7929, 11539, 11908, 12573	Plainfield, NJ	447, 2243
Pandora, OH	11343	Pedricktown, NJ	8007		12860, 12931, 13003, 13032		13174, 13692
Panora, IA	3226	Peekskill, NY	1422, 8398		13113, 13175, 13180, 13325	Plains, MT	7172
Paola, KS	1864, 3350	Peirce City, MO	4225		14120	Plainview, MN	6293
	3795, 3991	Pekin, IL	1637, 2287	Philippi, WV	6302, 6377	Plainview, NE	9504
Paoli, PA	12358		3770, 9788		14053	Plainview, TX	5475, 9081
Paonia, CO	6671	Pelham, GA	9870	Philipsburg, PA	4832, 5066		9802
Paragould, AR	6846, 10004	Pelham, NY	11951	Phillips, ME	2267, 4957	Plainville, CT	9313
	13155	Peilican Rapids, MN	6349	Philips, WI	7434, 13487	Plainville, KS	7313
Paris, AR	11592, 14209	Pell City, AL	9506	Phillipsburg, KS	3601	Plankinton, SD	3130
Paris, IL	1555, 2100	Pella, IA	1891, 2063	Phillipsburg, MT	4658, 4843	Plano, TX	3764, 5692
	3376, 6361		8047	Phillipsburg, NJ	1239, 5556		13511
Paris, KY	6323, 14076	Pemberton, NJ	8129	Philmont, NY	7233, 13945	Plant City, FL	10236
Paris, MO	1803, 3322	Pembina, ND	3438	Philo, IL	6211	Plantsville, CT	12637
	5794	Pembroke, GA	8680	Phoebus, VA	12267	Platte City, MO	2356, 4329
Paris, TN	9334	Pen Argyl, PA	4352, 7710	Phoenix, AZ	3054, 3728	Platteville, CO	8755, 9451
Paris, TX	3638, 4411	Penbrook, PA	9344, 12197		4729, 11559	Platteville, WI	4650
	5079, 8542	Pender, NE	4791, 5308	Phoenixville, PA	674, 1936	Plattsburg, MO	4215
Park City, UT	4564	Pendleton, OR	2630, 3665	Picture Rocks, PA	11643	Plattsburg, NY	2534, 5785
Park Falls, WI	10489		4249, 7301, 9228, 13576	Piedmont, AL	7464		6613, 13548
Park Rapids, MN	5542, 13692	Penn's Grove, NJ	5387	Piedmont, WV	1883, 3629	Plattsburgh, NY	266, 321
Park River, ND	3436	Penn Yan, NY	2405		4088		3174
Parker, SD	3675	Pennington, NJ	5718	Pierce, NE	4280	Plattsmouth, NE	1914
Parkers Landing, PA	6045	Pennsboro, WV	7191, 7246	Pierre, SD	2941, 4104	Plaza, ND	9689
Parkers Prairie, MN	6661	Pennsburg, PA	2301, 2334		4279, 14252	Pleasant Hill, MO	1751, 7154
Parkersburg, IA	9846	Pensacola, Fl	2490, 4837	Pikesville, MD	8867	Pleasant Unity, PA	6581
Parkersburg, WV	180, 864		5603, 9007				

City	Charter #	City	Charter #	City	Charter #	City	Charter #
Pleasanton, CA	9897	Porter, OK	7615, 8676	Providence, RI	134, 565		6466
Pleasanton, KS	8803	Porterville, CA	6808		636, 772, 948, 983	Ravenswood, IL	10215
Pleasanton, TX	8103, 13642	Portland, CT	1013		1002, 1007, 1030, 1036	Ravenswood, WV	10759
Pleasantville, NJ	6508, 12510	Portland, IN	7180		1126, 1131, 1151, 1173	Ravia, OK	7976
Plentywood, MT	10438	Portland, ME	221, 878		1283, 1302, 1319, 1328	Rawlins, WY	4320, 5413
Plesantville, IA	5564		941, 1023, 1060, 1451		1339, 1366, 1369, 1396		9557
Plevna, MT	11074		1511, 4128, 4868, 13710		1429, 1472, 1506, 2913	Raymond, IL	6910
Plum Creek, NE	3292		13716		5925, 13901, 13981	Raymond, MN	8050
Plumer, PA	854	Portland, ND	7693, 13594	Provincetown, MA	736	Raymond, MT	11078
Plumville, PA	7887	Portland, OR	1553, 3025	Provo City, UT	2641, 4486	Raymond, WA	11672
Plymouth, IL	12658		3184, 3402, 3422, 3536	Pryor Creek, OK	5546, 12117	Raymondville, TX	12789
Plymouth, IN	2119		3719, 4514, 9180, 10300	Pueblo, CO	1833, 2134	Reading, MA	4488, 13558
Plymouth, MA	779, 996		10534, 12557, 12613, 13294		2310, 4108	Reading, PA	125, 693
Plymouth, MI	1916, 3109		13299		4498		696, 2473, 2552, 2899
	4649, 12953	Portland, PA	6665, 13606	Puente, CA	9894		4887
Plymouth, NH	2587	Portsmouth, NH	19, 401	Pukwana, SD	9958	Reardan, WA	13444
Plymouth, OH	1904, 7035		1025, 1052, 2672	Pulaski, NY	1496	Rebersburg, PA	11789
Plymouth, PA	707, 6881	Portsmouth, OH	68, 935	Pulaski, TN	1727, 1990	Rector, AR	10853
Pocahontas, IA	6303, 12544		1088, 1948, 1958, 7781		2635, 4679, 6076	Red Bank, NJ	445, 2257
Pocahontas, VA	7847		13832	Pulaski, VA	4071, 11387		4535, 11553
Pocasset, OK	10960	Portsmouth, VA	9300, 11381	Pullman, WA	4699	Red Bluff, CA	10114
Pocatello, ID	4023, 4827	Porum, OK	8479, 10649	Punta Gorda, FL	10512	Red Cloud, NE	2811, 3181
	6347			Punxsutawney, PA	3030, 5702	Red Creek, NY	10781
Pocomoke City, MD	4191	Poseyville, IN	7036, 8149, 13503		5965, 9863	Red Hook, NY	752
	6202, 14106	Poste City, TX	9485	Purcell, OK	4636, 4756	Red Lake Falls, MN	3659, 9837
Point Marion, PA	6114, 9503	Poteau, OK	7104, 7118		7697, 12134	Red Lion, PA	5184, 6708
Point Pleasant, NJ	5712	Poth, TX	10320	Purcellville, VA	6018	Red Lodge, MT	9841
Point Pleasant, WV	1504, 5701	Potomac, IL	6824	Purdon, TX	10927	Red Oak, IA	2130, 2230
	13231	Potsdam, NY	868, 5228	Purdy, MO	10122		3055, 6056
Point Pleasant Beach, NJ	13215	Pottstown, PA	608, 3494	Putnam, CT	448		13785
Poland, NY	2441, 4223		4714	Putnam, TX	9749	Red Wing, MN	1487, 7307
	9804	Pottsville, PA	649, 1152	Puyallup, WA	4224		13396
Polk, NE	8533		1663, 8964	Quaker City, OH	1989	Redding, Ca	10070, 10100
Polo, IL	1806	Poughkeepsie, NY	465, 659	Quakertown, PA	2366, 6465	Redfield, SD	3398, 6256
Polo, MO	7884		1305, 1306, 1312, 1380	Qanah, TX	4144, 4361		8125
Polson, MT	9449	Poultney, VT	1200, 2545		5972, 9906	Redkey, IN	9670
Pomeroy, IA	6063		9824, 13261, 14234		12307	Redlands, CA	3892, 8073
Pomeroy, OH	132, 1980	Powell, WY	10265, 10565	Quantico, VA	12477		7259, 12316
Pomeroy, WA	3460, 11416	Powhatan Point, OH	7759	Quarryveille, PA	3067, 8045	Redmond, OR	11294, 11302
Pomona, CA	3518, 4663	Purague, OK	7177, 8159	Quincy, FL	7253	Redondo Beach, CA	7895, 8143
Ponca, NE	3627	Prairie City, IA	6755	Quincy, IL	424, 703	Redwood, NY	10374
Ponca City, OK	5474, 6061	Prairie City, IL	2254		2519, 3752	Redwood City, CA	7279
	9616, 9801	Prairie City, OR	9763	Quincy, MA	517, 832	Redwood Falls, MN	5826
	13891	Prairie Grove, AR	8030	Quincy, MI	2550	Reed City, MI	4413
Pond Creek, OK	6655, 7103	Prairie View, KS	9373	Quincy, WA	9102	Reeder, ND	9684
	10005	Pratt, KS	3649, 3787	Quinlan, TX	11970	Reedley, CA	8857, 9688
Pontiac, IL	1837, 2141		6229	Quinton, OK	6517	Reedsville, PA	4538
Pontiac, MI	434, 1574	Prattville, AL	9055	Quitman, GA	7994, 11290	Reedsville, VA	10827
	2607, 3388, 11549, 12288	Prescott, A	3122, 4851		14255	Reedy, WV	10285
	13600, 13739		13262	Racine, OH	9815	Reform, AL	11233
Pontotoc, MS	9040	Prescott, IA	5912	Racine, WI	457, 1802	Refugio, TX	12462
Poolesville, MD	8860	Prescott, WI	10522		2557, 10938	Reidsville, NC	11229
Poplarville, MS	8719	Presque Isle, ME	3827, 13768	Radcliffe, IA	6435	Remington, IN	8060, 11355
Poquoson, VA	12092	Preston, IA	8273	Radford, VA	6782, 11690	Remsen, IA	6975
Port Allegany, PA	3877, 6066	Preston, ID	7526	Rahway, NJ	881, 896	Remsen, NY	6482
Port Angeles, WA	4315, 6074	Preston, MN	6279, 9059		5260, 12828	Reno, NV	2478, 7038
Port Arthur, TX	5485	Prestonsburg, KY	7254	Rake, IA	11735		8424
Port Chester, NY	402	Price, UT	6012	Raleigh, NC	1557, 1682	Renova, PA	3763
Port Chicago, CA	11561	Primghar, IA	4155, 6650		1766, 3389, 9067, 9471	Rensselaer, IN	6651
Port Clinton, OH	6227, 13989	Princeton, IL	903, 2165	Ralston, OK	6232	Renville, MN	6583
Port Deposit, MD	1211, 5610		2413	Ralston, PA	9508	Renwick, IA	7988
	13840	Princeton, IN	2066, 2180	Ramona, OK	7251	Republic, PA	10466
Port Gibson, MS	5715		8166, 9463	Ramsey, IL	9895	Reserve, MT	10986
Port Henry, NY	1697, 4858		10551	Ramsey, NJ	9367	Rexburg, ID	7133
Port Huron, MI	1857, 4446	Princeton, KY	3064, 5257	Randall, KS	11887	Reynolds, GA	9615
Port Jefferson, NY	5068	Princeton, MN	4807, 7708	Randolph, IA	7833	Reynolds, ND	10496
Port Jervis, NY	1363	Princeton, NJ	1681, 4872	Randolph, MA	558	Reynoldsville, PA	4908, 7620
Port Lavaca, TX	5367	Princeton, TX	8611	Randolph, NE	7421, 7477		8263, 13957
Port Leyden, NY	11742	Princeton, WI	5978, 13904	Ranger, TX	8072	Rhinebeck, NY	1157
Port Neches, TX	11799	Princeton, WV	8219	Ransom, KY	8289	Rhinelander, WI	4312, 11646
Port Norris, NJ	10036	Prineville, OR	3851	Rantoul, IL	5193	Rhyolite, NV	8686
Port Richmond, NY	6198	Proctor, MN	11125, 11974	Rapid City, SD	3237, 3401	Rialto, CA	8768, 11867
Port Royal, PA	11369, 11373	Proctorsville, VT	1383		14099	Rib Lake, WI	6711
Port Townsend, WA	2948	Prophetstown, IL	1968, 6375	Raton, NM	4734, 6363	Rice Lake, WI	6663
	4290, 13351	Prosperity, SC	6994, 12774		8098, 8120	Rices Landing, PA	7090
Port Washington, WI	9419	Prospect Park, NJ	12861		12924	Riceville, IA	8442
Portage, PA	7367	Prosser, WA	7489, 9417	Ravena, NY	9529	Richburg, NY	2553
Portage, WI	4234	Providence, KY	9708	Ravenna, NE	4043	Richfield, MN	12115
Portales, NM	6187, 8364	Providence, PA	521	Ravenna, OH	106, 350	Richfield Springs, NY	2651

City	Charter #	City	Charter #	City	Charter #	City	Charter #
Richford, VT	11615		2383, 8026, 8111, 12538		9423	Saint Albans, WV	9640
Richland, IA	5611		13330	Rosedale, IN	9006	Saint Anne, IL	5470
Richland, MI	9099	Rochester, PA	2977, 5170	Rosedale, MS	10745, 12073	Saint Ansgar, IA	10684
Richland, PA	8344		7749	Roselle, NJ	8483	Saint Anthony, ID	5764, 7230
Richland Center, WI	7901	Rock Creek, OH	7790	Rosemount, MN	11776	Saint Anthony, MN	1830
Richlands, VA	10850, 10857	Rock Falls, IL	6998	Roseville, CA	11961, 11992	Saint Augustine, FL	3462, 11420
Richmond, CA	9735, 12341	Rock Hill, SC	3616, 5134	Roseville, IL	5883	Saint Charles, IL	2021, 6219
Richmond, IN	17, 1102		9407	Roseville, OH	5555	Saint Charles, MN	6237
	1988, 2090, 2680, 3413	Rock Island, IL	108, 1889	Roslyn, NY	13326	Saint Charles, MO	260
Richmond, KS	11728		2155	Rosslyn, VA	8389	Saint Clair, MI	1789
Richmond, KY	1309, 1728	Rock Lake, ND	8019	Rossville, IL	5398, 9877	Saint Clair Heights, MI	10632
	1790, 2374, 4430, 7653	Rock Rapids, IA	3153, 7089	Roswell, NM	5220, 6714	Saint Clairsville, OH	315, 4993
	9832	Rock River, WY	3920, 4755		6777		13922
Richmond, ME	662, 909		11342	Rotan, TX	8693	Saint Cloud, FL	9707
Richmond, MI	10742	Rock Valley, IA	5200	Round Hill, VA	11569	Saint Cloud, MN	2790, 3009
Richmond, TX	10350	Rockaway, NJ	8566	Roundup, MT	9165		4797, 11818
Richmond, VA	1111, 1125	Rockdale, TX	4175	Rouses Point, NY	11969	Saint Croix Falls, WI	11526
	1155, 1570, 1628, 1754	Rockford, IA	3053	Rowlesburg, WV	9288, 10250	Saint Edward, NE	5346, 5793
	5229, 8666, 10080, 10344	Rockford, IL	429, 479	Roxbury, NY	7678	Saint Elmo, IL	9388
Richwood, OH	9199		482, 883, 1816, 3952	Roxton, TX	5710	Saint Francisville, IL	8846
Richwood, WV	8434, 13627		4325, 9823, 11679, 11731	Roy, MT	10991	Saint Helena, CA	3757
Rico, CO	4334		13652	Royal, IA	10395	Saint Helens, OR	11200
Ridge Farm, IL	5313, 8630	Rockland, MA	3868	Royal Oak, MI	12657	Saint Ignace, MI	3886
Ridgefield, CT	5309	Rockland, ME	1446, 2097	Royalton, MN	6731	Saint James, MN	4859, 7021
Ridgefield Park, NJ	9780		2371	Royalton, VT	1673	Saint James, NE	8335
Ridgeville, IN	8351	Rockland, MI	5199	Royersford, PA	3551, 4751	Saint Jo, TX	5325, 8402
Ridgeway, MO	6549	Rockmart, GA	8628	Royse City, TX	6551	Saint John, KS	3467, 7844
Ridgewood, NJ	5205, 11759	Rockport, IN	6194	Rugby, ND	6341	Saint Johns, MI	1539, 3378
Ridgewood, NY	9414	Rockport, MA	1194	Rule, TX	8242	Saint Johns, OR	9047, 10103
Ridgway, IL	9439	Rockport, TX	4438	Rulo, NE	3674	Saint Johnsbury, VT	489, 2295
Ridgway, PA	5014, 5945	Rockville, CT	186, 509	Rumford, ME	6287	Saint Johnsville, NY	375
Ridley Park, PA	10847	Rockville, IN	63, 2361	Runge, TX	6522	Saint Joseph, MI	1866, 5594
Ridgelsville, PA	9202		5067	Rupert, ID	10429, 10517	Saint Joseph, MO	1580, 1667
Rifle, CO	6178	Rockville, MD	3187	Rural Retreat, VA	10061		2898, 2970, 4053, 4228
Rigby, ID	11458	Rockville Centre, NY	8872	Rural Valley, PA	6083, 13908		4939, 6272, 8021, 9042
Rimersburg, PA	6569, 6676	Rockwall, TX	3890, 4717	Rush City, MN	6954	Saint Lawrence, SD	12547
Ringling, OK	10548		4911, 6679, 6703, 8204	Rush Springs, OK	8336	Saint Louis, MI	3239
Ringtown, PA	6950		13402	Rushford, MN	6436, 6862	Saint Louis, MO	89, 139
Rio, WI	8632	Rockwell, NC	10217	Rushville, IL	1453		170, 283, 1112, 1381
Rio Grande, TX	11591	Rockwell City, IA	5185, 11582	Rushville, IN	1456, 1869		1501, 1665, 1858, 2835
Ripley, MS	9204	Rockwood, PA	5340, 9769		7374, 12420		4048, 4178, 4232, 4262
Ripley, NY	6386	Rockwood, TN	4169, 12257	Rushville, NE	4176, 9191		4575, 5002, 5172, 5788
Ripley, OH	289, 933		12264	Rusk, TX	4346		6773, 7179, 7570, 7715
	2837, 3291	Rocky Ford, CO	7082, 9117	Russell, KS	3657		7808, 8455, 9297, 9460
Ripley, OK	10449	Rocky Mount, NC	7362, 10608	Russell, KY	8792		11973, 11989, 12066, 12216
Ripley, WV	10762	Rocky Mount, VA	6685, 8984	Russell Springs, KS	3775		12220, 12389, 12491, 12506
Ripon, WI	425, 3146	Rocky River, OH	12347	Russell Springs, KY	11348		12916, 13264, 13726
	4305	Rodeo, CA	11201	Russellton, PA	10493	Saint Maries, ID	10771
Rippey, IA	7609	Roebling, NJ	11620	Russellville, AL	11846	Saint Marys, KS	3374, 4619
Ririe, ID	10920	Roff, OK	5417, 10172	Russellville, AR	4582	Saint Marys, OH	4219, 14132
Rising Star, TX	7906	Rogers, AR	7789, 10750	Russellville, KY	2169, 6546	Saint Marys, PA	6589
Rising Sun, IN	1959	Rogers, TX	5704		9842	Saint Marys, WV	5226
Rising Sun, MD	2481	Rogersville, TN	4015	Russellville, TN	10508	Saint Michael, PA	12588
Ritzville, WA	5751, 8743	Roland, IA	11249	Russiaville, IN	5524	Saint Paris, OH	2488, 8127
River Falls, WI	7087	Rolette, ND	7866	Ruston, LA	11795	Saint Paul, MN	203, 725
Riverbank, CA	10200, 10427	Rolfe, IA	4954	Rutherford, NJ	5005		1258, 2020, 2943, 2959
Riverhead, NY	4230	Rolla, MO	1865	Ruthton, MN	5892		3233, 3689, 6828, 8108
Riverside, CA	3348, 4757	Rolla, ND	6157	Ruthven, IA	5541		10940, 11741, 12922, 13131
	6833, 8377	Rome, GA	2368, 3670	Rutland, VT	820, 1450	Saint Paul, NE	3126, 3129
	8907		4369, 9636, 10302, 10303		1700, 2905, 2950, 3311		3891
Riverside, IL	12386	Rome, NY	1376, 1410	Ryan, OK	5800	Saint Paul, VA	8547
Riverside, NJ	6823, 8484		1414, 2410	Ryder, ND	9214	Saint Peter, IL	9896
	12984	Rome, PA	10246	Rye, NY	5662	Saint Peter, MN	1794
Roanoke, VA	2737, 2907	Romeo, MI	354, 2186	Sabetha, KS	2954, 2990	Saint Petersburg, FL	7730
	4026, 4027, 4531, 6798	Romney, WV	9766		4626		7796, 12623
	8152, 10532, 11191, 11817	Romulus, NY	11739	Sabina, OH	8411	Saint Regis Falls, NY	7733
Roaring Spring, PA	12304	Ronan, MT	9864	Sabinal, TX	7807	Saint Thomas, ND	4550
Robert Lee, TX	8659	Ronceverte, WV	5280, 6226	Sac City, IA	4450	Salamanca, NY	2472, 2610
Robinson, IL	5049, 13605	Rondout, NY	34, 1120	Saco, ME	1528, 1535	Salem, IL	1715
Roby, TX	5865	Roodhouse, IL	8637	Saco, MT	9789	Salem, IN	2173
Rochelle, IL	1907, 1922	Roosevelt, NJ	8437	Sacramento, CA	2014, 7776	Salem, MA	407, 634
Rochester, IN	1952, 7655	Roosevelt, NY	11953		8504, 10107		647, 691, 704, 726
Rochester, MI	9218, 13841	Rosalia, WA	9273		11875		817
Rochester, MN	579, 2088	Roscoe, NY	8191	Saegertown, PA	3911	Salem, MO	7921
	2316	Roscoe, PA	5495	Saguache, CO	9997	Salem, NC	1659
Rochester, NH	2138, 11893	Roseau, MN	6783, 11848	Saginaw, MI	1768, 2492	Salem, NJ	1326, 3922
	13861	Rosebud, MT	11437		3482, 13800	Salem, NY	1127, 3245
Rochester, NY	527, 1072	Rosebud, TX	5513, 8066	Saint Albans, VT	269, 1583		3309, 7588
	1104, 1282, 1362, 1397	Roseburg, OR	4624, 8955			Salem, OH	43, 973

City	Charter #	City	Charter #	City	Charter #	City	Charter #
	2691	Sandy Spring, MD	5561	Scranton, ND	10405	Shattuck, OK	8687, 9987
Salem, OR	2816, 3405	Sanford, FL	3798, 13157	Scranton, PA	49, 77	Shaw, MS	7200
	9021	Sanford, ME	5050		1946, 2697, 4183, 8235	Shawano, WI	5469, 6403
Salem, SD	5898, 12784	Sanford, NC	6616, 13791		8737, 13947	Shawnee, OK	5095, 5115
Salem, VA	1824	Sanger, CA	9308	Scribner, NE	6901		5875, 6416, 9998, 12339
Salem, WV	7250	Sanger, TX	7886, 8690	Sea Bright, NJ	14177	Shawneetown, IL	915, 1775
Salida, CA	11601	Santa Ana, CA	3520, 7980	Sea Isle City, NJ	12279		7752, 9435
Salida, CO	4172, 7888		9904, 11869	Seabreeze, FL	12546	Sheboygan, WI	2123, 11150
	8951		13200	Seabright, NJ	5926	Sheboygan Falls, WI	5947
Salina, KS	2538, 3531	Santa Anna, TX	8109	Seaford, DE	795, 3693	Sheffield, AL	3617, 6759
	4317, 4742	Santa Barbara, Ca	2104, 2456	Sealy, TX	6390, 10398	Sheffield, IA	12430
	4945	Santa Cruz, CA	8403, 9745	Searsport, ME	2642	Sheffield, PA	6193
Salinas, CA	5074, 13380		10571	Seattle, WA	2783, 2966	Shelbina, MO	1711, 9137
Salisbury, MA	1049	Santa Fe, NM	1750, 2024		2985, 4059, 4124, 4229	Shelburn, IN	7513
Salisbury, MD	3250, 6761	Santa Maria, CA	7480		4375, 4397, 9662, 9789	Shelby, NC	6776, 7959
Salisbury, MO	8359	Santa Monica, CA	3845, 6945		10026, 11280, 12153, 13230	Shelby, NE	7949
Salisbury, NC	2981, 9076		12787		13581	Shelby, OH	1929
Salisbury, PA	6106	Santa Paula, CA	4120	Seabastopol, CA	9648, 11161	Shelbyville, IL	2128, 7396
Sallisaw, OK	5596, 7571	Santa Rosa, CA	3558, 12201	Sebee, KY	7242	Shelbyville, IN	1263, 4800
	9973, 10474	Santa Rosa, NM	6081	Secaucus, NJ	9380		7946
Salmon, ID	8080, 9432	Santo, TX	8176	Secor, IL	6007	Shelbyville, TN	2198, 3530
Salt Lake City, UT	1646, 1695	Sapulpa, OK	5951, 7768	Sedalia, MO	1627, 1971		10785
	1921, 2059, 3306, 4051	Saranac Lake, NY	5072, 8935		2919, 4392	Sheldon, IA	3848, 7880
	4310, 4341, 4432, 9403	Sarasota, FL	10414, 12751	Sedan, KS	3855, 4150	Sheldon, ND	6977
	9652, 10308		13352		7535	Shellburne Falls, MA	1144
Saltsburg, PA	2609	Saratoga, WY	8961	Sedgwick, CO	9045	Shelley, ID	11434
Saltville, VA	11265	Saratoga Springs, NY	893, 1227	Sedro-Woolley, WA	7908	Shellman, GA	8417
Salyersville, KY	8905		2615	Seeley, CA	10462	Shelton, NE	4042, 9200
Samson, AL	8028	Sarcoxie, MO	5515	Sehome, WA	3976, 4351	Shenandoah, IA	2363, 2679
San Angelo, TX	2767, 3260	Sardinia, OH	7800	Seiling, OK	8615		8971, 11588, 12950, 14057
	4659, 6807	Sardis, OH	7711	Selby, SD	9376	Shenandoah, PA	3143, 4546
	10664	Sargent, NE	7384	Selbyville, DE	6718		9247, 13619
San Antonio, TX	1657, 2883	Sarles, ND	7852	Selins Grove, PA	357	Sheraden, PA	5977
	3298, 3738, 4525, 4748	Sasakwa, OK	10314	Selinsgrove, PA	8653	Sherburn, MN	6348
	5179, 5217, 6956, 7316	Saugerties, NY	1040, 1208	Sellersville, PA	2667	Sherburne, NY	1166
	10148, 10793, 12162, 13578	Sauk Centre, MN	3155, 6417	Selma, AL	1537, 1736	Sheridan, IN	5296, 6070
	14283	Sault Ste Marie, MI	3547, 3747		7084	Sheridan, OR	8721
San Augustine, TX	6214, 6245	Sausalito, CA	12453	Selma, CA	5395, 10293	Sheridan, WY	4604, 8257
San Bernardino, CA	3527, 3818	Savanna, IL	8540, 13886	Selma, NC	10739	Sherman, TX	3159, 5192
	8618, 10931	Savannah, GA	1255, 1640	Selmer, TN	8836		5864, 10607
San Diego, CA	3050, 3056		3406, 13068	Seminole, OK	9514	Sheyenne, ND	8886
	3780, 3828, 4886, 6869		13472	Seminole, TX	8465	Shickshinny, PA	5573
	9483, 7418, 10391, 10435	Savannah, MO	5780	Seneca, IL	1773	Shiner, TX	5628
San Dimas, CA	10068	Savannah, TN	8889	Seneca, KS	2952, 5101	Shingle House, PA	6799
San Fernando, CA	9575, 10273	Savona, NY	11349	Seneca, MO	7656	Shinnston, WV	9453
San Francisco, CA	1741, 1994	Savoy, TX	7645	Seneca Falls, NY	102, 1240	Shippensburg, PA	834, 6946
	3555, 3592, 5105, 5096	Saxton, PA	7229		3329	Shippenville, PA	7874
	5688, 6426, 6592, 7691	Sayre, OK	6058, 9959	Senecaville, OH	7399	Shirley, IN	9209
	7713, 7894, 8487, 9141		9976	Senoia, GA	8527	Shoemakersville, PA	11841
	9174, 9655, 9683, 9882	Sayre, PA	5666, 5684	Sentinel, OK	9995	Shoshone, ID	6577, 9272
	12364, 12579, 13016, 13044	Sayville, NY	5186	Sequin, TX	5097	Shoshoni, WY	7978, 8232
San Jacinto, CA	7997	Scandia, KS	3779	Sesser, IL	8758	Shreveport, LA	3595, 3600
San Joaquin, CA	11484	Scappoose, OR	10992	Seven Mile, OH	9518		5752, 5844, 8440, 10870
San Jose, CA	2158, 3715	Scarsdale, NY	11708	Seven Valleys, PA	9507		11521, 13648
San Juan, PR	6484	Scenery Hill, PA	7262	Seward, NE	2771, 3060	Shullsburg, WI	4055
San Leandro, CA	9800, 12802	Schaefferstown, PA	8962	Seward, PA	11899	Sibley, IA	3320
	13217	Schellburg, PA	10666	Sewickley, PA	4462, 13699	Sidell, IL	8374
San Luis Obispo, CA	3826, 7877	Schenectady, NY	1226, 4711	Seymour, CT	5499	Sidney, IA	5145
San Marcos, TX	3344, 3346	Schenevus, NY	4962	Seymour, IA	8247, 11210	Sidney, MT	9004, 10552
San Mateo, CA	9424	Schoharie, NY	1510	Seymour, IN	1032, 4652	Sidney, NE	6201, 13425
San Pedro, CA	7057	Schoolcraft, Mi	1725	Seymour, MO	9932	Sidney, NY	3822, 8513
San Rafael, CA	10177, 12640	Schulenburg, TX	8034	Seymour, TX	4263, 5904		13563
San Saba, TX	7700, 9781	Schuyler, NE	2778, 3152		7482	Sidney, OH	257, 5214
Sanborn, IA	4824	Schuylerville, NY	1298	Seymour, WI	6575		7862
Sanborn, ND	8448	Schuylkill Haven, PA	5216	Shakopee, MN	1597, 3039	Siegfried, PA	5227
Sanbornton, NH	1333	Schwenksville, PA	2142		3127	Sierra Madre, CA	8707
Sand Springs, OK	12079	Schwertner, TX	10956	Shamokin, PA	689, 3045	Sigourney, IA	1786
Sandersville, GA	7934, 9641	Scio, OH	5197		5625, 6942	Siloam Springs, AR	9871, 13274
	13725	Scituate, RI	1552		12805		13506
Sandoval, IL	9786	Scobey, MT	10838, 11098	Shamrock, TX	7306	Silver City, NM	3539, 3554
Sandpoint, ID	8341, 9263	Scotia, CA	9787	Shannee, OK	12441		8132
Sandstone, MN	9464	Scotland, SD	7048	Shannon City, IA	9723	Silver Creek, NY	10159, 10258
Sandusky, OH	16, 210	Scott City, KS	8808	Sharon, ND	9005	Silver Spring, MD	9830
	2061, 2810, 3141, 4792	Scottdale, PA	5974, 13772	Sharon, PA	1685, 2244	Silver Springs, NY	6148
	6455	Scottsbluff, NE	6240, 9581		6560, 8764	Silverton, CO	2930, 7984
Sandwich, NH	1071	Scottsboro, AL	8963		13803	Silverton, OR	11106
Sandy Hill, NY	184, 2838	Scottsdale, AZ	4098	Sharon, SC	9533	Silverton, TX	8816
	3244, 6470	Scottsville, KY	8599, 9356	Sharon Springs, NY	7512	Sing Sing, NY	471
	8297	Scottsville, VA	5725	Sharpsville, PA	6829, 7873	Sioux Center, IA	7369

City	Charter #	City	Charter #	City	Charter #	City	Charter #
Sioux City, IA	1757, 1976	South			2433, 2435, 4907, 12481	Stilwell, OK	9970
	2535, 3124, 3940, 3968	Charleston, OH	171, 2754	Springfield, MN	8269	Stockbridge, MA	1170
	4209, 4235, 4431, 4510	South Charleston, WV	11340	Springfield, MO	1677, 1701	Stockport, OH	8042
	4630, 5022, 7401, 10139	South Chicago, IL	3102		3718, 4360, 5082, 5209	Stockton, CA	2077, 2412
Sioux Falls, SD	2465, 2823	South Danvers, MA	616		9315, 10074		2794, 10817
	2843, 3393, 3586, 4629	South Deerfield, MA	8150	Springfield, OH	238, 263	Stockton, IL	13666
	9915, 10592	South East, NY	830		1146, 2098, 2620, 5160	Stockton, KS	3440, 7815
Sioux Rapids, IA	7189, 9585	South Fallsburg, NY	11809		9446, 14105		8274
	13400	South Fork, PA	6573	Springfield, OR	8941	Stone, KY	11890
Sipesville, PA	11849	South Framingham, MA	2485	Springfield, SC	10586	Stone Lake, WI	10322
Sisseton, SD	5428, 6395	South Glens Falls, NY	5851	Springfield, SD	8942	Stoneboro, PA	6638
Sistersville, WV	5027, 5028	South Haven, MI	1823	Springfield, TN	2019, 6189	Stoneham, MA	4240
	6548	South McAlester, OK	5052		12639	Stonewall, OK	7054
Skaneateles, NY	303, 5360		5537, 6230, 6406	Springfield, VT	122	Stonington, CT	735
Skiatook, OK	9969, 10464	South Milwaukee, WI	4893	Springvale, ME	7835	Stonington, IL	5291
Skowhegan, ME	239, 298	South Norwalk, CT	502, 2643	Springville, NY	2892, 6330	Storm Lake, IA	2595, 10034
Slatersville, RI	1035	South Omaha, NE	3611, 4589	Springville, PA	11393		10223
Slatington, PA	2293, 6051		4632, 8949	Spur, TX	9611, 10703	Story City, IA	9017, 10222
Slaughter, WA	4457		9908	Spurgeon, IN	12028	Stoughton, WI	5222, 9304
Slayton, MN	5256	South Otselic, NY	7774	Stafford, KS	3852, 8883	Stoystown, PA	5682, 14089
Sleepy Eye, MN	6387	South Pasadena, CA	8544	Stafford Springs, CT	686, 3914	Strasburg, PA	42, 2700
Sligo, PA	8946	South Pittsburg, TN	3660	Stamford, CT	4, 1038	Strasburg, VA	8746, 8753
Slippery Rock, PA	6483, 8724	South Plainfield, NJ	11847		12400	Stratford, OK	8524
Slocomb, AL	7871, 7940	South Pueblo, CO	2541, 2546	Stamford, NY	2602	Stratford, TX	8018
Smethport, PA	8591	South River, NJ	6179	Stamford, TX	5560, 7640	Strausstown, PA	10452, 13863
Smith Center, KS	3546, 3630	South Saint Paul, MN	6732		13598	Strawberry Point, IA	9069
Smithfield, NC	10502, 11440	South San Francisco, CA	12364	Stanford, KY	1204, 1705	Strawn, IL	7151
Smithfield, OH	501, 13171	South Shore, SD	7686, 11689		2788, 3954, 5132, 14039	Strawn, TX	10229, 12775
Smithfield, PA	6642	South Sioux City, NE	4557	Stanley, ND	9472	Streator, IL	2170, 2176
Smithfield, UT	10135	South Weymouth, MA	618	Stanley, VA	10973		2681, 4476
Smithton, IL	13525	South Worcesther, NY	103	Stanton, IA	6434	Streeter, ND	10724
Smithton, PA	5311	Southhampton, NY	10185	Stanton, MI	2914	Stromsburg, NE	8286
Smithtown Branch, NY	9880	Southbridge, MA	934, 11388	Stanton, NE	3364, 7836	Strong City, KS	3002
Smithville, TN	13056	Southport, CT	660, 2814	Stanton, TX	8112, 8094	Stronghurst, IL	5813
Smithville, TX	7041	Spalding, NE	7574		9053	Stroud, OK	6306
Smyrna, DE	2336, 2381	Spangler, PA	7181	Stanwood, WA	11935	Stroudsburg, PA	2787, 3632
Smyrna, TN	9807	Spanish Fork, UT	9111	Staples, MN	5568, 8523	Stuart, IA	2721
Snohomish, WA	3887, 4526	Sparta, GA	7067, 12317	Stapleton, NY	6562, 7290	Stuart, NE	6947
Snow Hill, MD	3783, 6297	Sparta, IL	7015	Starbuck, MN	9596	Stuart, OK	10007, 11315
Snow Hill, NC	10887	Sparta, TN	3614, 7912	Starkville, MS	3688	Stuart, VA	11901
Snyder, OK	10311, 10317	Sparta, WI	1115, 11463	Starkweather, ND	6397	Sturgis, KY	6244
Snyder, TX	5580, 7635	Spartanburg, SC	1848, 4996	State Center, IA	8931	Sturgis, MI	825, 3276
	14270		6658, 14211	State College, PA	7511, 12261	Sturgis, SD	3739, 6990
Socorro, NM	2627, 4485	Spartansburg, PA	9110	Statesboro, GA	7468	Stuttgart, AR	10459
	4574	Spearfish, SD	4874, 8248	Statesville, NC	3682, 9335	Sudan, TX	12725
Sodus, NY	9418	Spearville, KS	10161	Staunton, IL	10173, 10777	Suffern, NY	5846
Soldier, ID	10162	Spencer, IA	3898, 6941	Staunton, VA	1585, 1620	Suffield, CT	497
Soldiers Grove, WI	13308	Spencer, IN	2178, 9715		2269, 6903	Suffolk, VA	4047, 9733
Solomon, KS	9794	Spencer, MA	2288, 13394	Steamboat Springs, CO	6454	Sugar City, CO	6472
Somerfield, PA	8901	Spencer, NE	7325	Steele, MO	12452	Suisun, CA	10149, 11684
Somers, NY	1304	Spencer, WV	10127	Steele, ND	8997	Sullivan, IL	7692
Somers Point, NJ	12559	Spirit Lake, IA	4758, 8032	Steelton, PA	3599	Sullivan, IN	1932, 2369
Somerset, KY	1748, 3832		13020	Steelville, MO	8914	Sulphur, OK	5748, 9046
	5881, 11544	Spiro, OK	9275	Stephen, MN	9064	Sulphur Springs, TX	3466
Somerset, OH	7237	Spokane, WA	4668, 9182	Stephenville, TX	4081, 4095		3989, 12845, 13653
Somerset, PA	4100, 4227		9589, 12418		8054, 12730	Summerfield, OH	6662
	5452, 13900		13331	Sterling, CO	5624, 7973	Summerville, PA	6739
Somersworth, NH	1180, 1183	Spokane Falls, WA	2805, 3409		9454	Summit, MS	9753, 10338
Somerton, OH	7984		3838, 4005, 4025, 4044	Sterling, IL	1717, 2709	Summit, NJ	5061
Somerville, MA	4771		4277		13963	Sumner, IA	8198
Sommerville, NJ	395, 4942	Spokogee, OK	6804	Sterling, KS	3207	Sumner, IL	6907
Somerville, OH	9859	Sprague, WA	3528	Sterling, NE	4163	Sumpter, OR	6547
Sonoma, CA	7202, 10259	Spring City, PA	2018	Sterling City, TX	9813	Sumter, SC	3082, 3809
	10461	Spring City, TN	9470	Sterrett, OK	7950		10129, 10660
Sonora, TX	5466	Spring Grove, PA	6536, 8141	Steubenville, OH	1062, 1164		10670
Soper, OK	10366	Spring Lake, NJ	5730, 13898		2160, 3310, 5039, 7688	Sunbury, PA	1237, 6877
Souderton, PA	2333, 13251	Spring Mills, PA	11213	Stevens Point, WI	3001, 4912	Sundance, WY	4343
Sour Lake, TX	6810, 6856	Spring Valley, IL	3465	Stevenson, AL	9855	Sunman, IN	8878
	11021	Spring Valley, MN	6316	Stevensville, MT	10709	Sunnyside, NM	8617
South Amboy, NJ	3878	Spring Valley, NY	5390	Steward, IL	6543	Sunnyside, WA	8481
South Auburn, NE	3628	Spring Valley, OH	7896	Stewardson, IL	9438	Superior, NE	3529, 5397
South Bend, IN	126, 1739	Springdale, AR	8763	Stewartstown, PA	4665, 6444		14083
	4764, 6334	Springdale, PA	8320	Stewartsville, MO	4160	Superior, WI	2653, 9140
South Bend, WA	4467	Springfield, IL	205, 1662	Stewartville, MN	5330, 13615		14109
South Berwick, ME	959		1733, 2688	Stigler, OK	7432, 7217	Susquehanna, PA	3144
South Bethlehem, PA	3961		3548	Stillwater, MN	1514, 1783	Susquehanna Depot, PA	1053
South Boston, VA	5872	Springfield, KY	1767		2674	Sutersville, PA	6270
	8414, 8643	Springfield, MA	14, 181	Stillwater, OK	5206, 5347	Sutherland, IA	3618
			308, 982, 987, 988, 1055		5436		

City	Charter #	City	Charter #	City	Charter #	City	Charter #
Sutton, NE	3240, 3653	Telluride, CO	4417	Tolar, TX	8001	Tucson, A	2639, 4287
Sutton, WV	6213, 9604	Temecula, CA	10556	Toledo, IA	6432, 13073		4440, 11159
Swanton, VT	1634, 4943	Tempe, AZ	5720	Toledo, IL	5273, 13682	Tucumcari, NM	6288, 14081
Swanville, MN	10824	Temple, OK	6570	Toledo, OH	91, 248	Tulare, CA	8626, 10201
Swarthmore, PA	7193		8310, 9967		607, 809, 1895, 2296	Tulia, TX	6298
Swayzee, IN	8820, 13862	Temple, TX	3227, 3858		3820, 4585, 14030	Tullahoma, TN	3107, 4020
Swea City, IA	5637		4404, 6317	Tolland, CT	1385	Tully, NY	5746
Sweden, OH	4506	Tenafly, NJ	8614	Tolley, ND	7810	Tulsa, OK	5171, 5732
Swedesborough, NJ	2923	Tennyson, IN	8956	Toluca, IL	4871, 11333		6669, 8552, 9658, 9942
Sweet Springs, MO	11372	Terlton, OK	9991	Tom Bean, TX	11019		9943, 10262, 10342, 10906
Sweetwater, TN	11202	Terra Alta, WV	6999	Tombstone, AZ	6439		12042, 12043, 13679
Sweetwater, TX	5781, 11468	Terra Bella, CA	9889	Toms River, NJ	1400, 2509	Tunkhannock, PA	835, 6438
Swineford, PA	7003	Terral, OK	7996	Tonasket, WA	10407, 14166	Tupelo, MS	4521
Swissvale, PA	6109	Terre Haute, IN	47, 1103	Tonawanda, NY	4869	Tupelo, OK	8609, 10531
Sycamore, IL	1896, 9572		2742, 3929, 7562, 7922	Tonkawa, OK	7444, 8595	Tupper Lake, NY	8153
Sycamore, OH	11383		13938	Tonopah, NV	8530	Turbotville, PA	9803
Sykesville, MD	8578, 8587	Terre Hill, PA	9316	Topeka, KS	1660, 1945	Turlock, CA	7738
Sykesville, PA	7488, 14169	Terrell, TX	3816, 4990		2192, 2646, 3078, 3790	Turners Falls, MA	2058
Sylacauga, AL	7451, 7484	Terril, IA	10238		3909, 7907, 10390, 11398	Turnersville, TX	8843
	10879	Texarkana, AR	4401, 7138		12740	Turtle Creek, PA	6568, 6574
Sylvania, GA	10829	Texarkana, TX	3065, 3785	Toppenish, WA	7767	Turtle Lake, ND	8821
Sylvester, GA	6180		3998, 7392	Topton, PA	3358, 8223	Tuscaloosa, AL	3678, 6173
Syracuse, KS	8114	Texas City, TX	9936, 10040	Toronto, KS	6819	Tuscola, IL	1723
Syracuse, NE	3083	Texhoma, OK	8852	Toronto, OH	8705, 8826	Tuscumbia, AL	1853, 11281
Syracuse, NY	6, 140	Texico, NM	8173, 8391	Toronto, SD	6381	Tustin, CA	10134
	159, 1287, 1341, 1342	Thayer, KS	9465	Torrance, CA	10396, 14202	Tuttle, ND	11338
	1401, 1569, 5286, 5465	The Dalles, OR	3441, 3534	Torrington, CT	5231, 5235	Tuttle, OK	8475
	6965, 12122, 13393	Theresa, NY	8158	Torrington, WY	9289	Tuxedo, NY	11404
Tabor, IA	4609	Thermopolis, WY	5949, 12638	Tottenville, NY	8334	Twin Bridges, MT	11008
Tacoma, WA	2924, 3172	Thief River Falls, MN	5894	Towanda, KS	11154, 12935	Twin Falls, ID	7608, 11274
	3417, 3789, 4018, 4069	Thomas, OK	7278, 7771	Towanda, PA	39, 2337	Twin Valley, MN	6401
	4426, 4623, 6006, 12292	Thomasboro, IL	8155	Tower, MN	3924	Two Harbors, MN	6304, 12307
	12667	Thomaston, CT	3964	Tower City, ND	6557	Tyler, MN	6203
Taft, CA	10088	Thomaston, ME	890, 1142	Tower City, PA	6117, 14031	Tyler, TX	3651, 4353
Taft, TX	12309	Thomasville, AL	5664, 7371	Town of Union, NJ	9544		4747, 5343, 6234, 7515
Tahlequah, OK	5478, 6414	Thomasville, GA	3767	Towner, ND	7955		13110
	10468, 11485	Thomasville, NC	8788	Townsend, MA	805	Tyndall, SD	6792
	12089	Thompson, CT	1477	Townsend, MT	9982	Tyrone, OK	10032
Tahoka, TX	8597	Thompson, IA	5054	Towson, MD	3588, 8381	Tyrone, PA	6516
Talihina, OK	7780	Thompson, ND	11599	Toyah, TX	8355	Tyrone, PA	4355, 6499
Talladega, AL	3899, 4838	Thompsontown, PA	10211	Tracy, MN	4992		6516
	7558	Thomson, GA	9302	Tracy City, TN	7314	Uhrichsville, OH	2582
Tallahassee, FL	4132	Thorndale, TX	5882	Traer, IA	5135	Ukiah, CA	10977
Tallapoosa, GA	7220	Thornton, IA	8340	Trafalgar, IN	7491	Ulen, MN	7081
Tallassee, AL	10766	Thornton, TX	8538	Trafford City, PA	6962	Ullin, IL	8180
Tallulah, LA	12923	Thorntown, IN	1046, 5842	Tranquility, CA	11433	Ulster, PA	9505
Taloga, OK	7019	Three Forks, MT	9337	Traverse City, MI	3325	Ulysses, PA	8739
Tama City, IA	1880	Three Rivers, MI	600, 1919	Tremont, IL	6421, 9325	Unadilla, NY	1463, 9516
Tamaqua, PA	1219, 7286		3133	Tremont, PA	797, 6165	Union, NY	9276
Tamaroa, IL	8629	Three Springs, PA	10183	Trenton, IL	10125	Union, OR	2947, 8387
Tampa, FL	3497, 4478	Throckmorton, TX	6001	Trenton, MO	1966, 3946	Union, SC	2060, 9742
	4539, 4949, 7153, 10958	Thurman, OH	2181		3957, 4933	Union Bridge, MD	9066
Tampico, IL	9230	Thurmond, WV	8998	Trenton, NE	8218	Union City, IN	815, 5094
Tannersville, NY	11057	Thurmont, MD	5829	Trenton, NJ	281, 1327	Union City, MI	1826, 2392
Tarboro, NC	8356	Ticonderoga, NY	4491, 9900		3709, 12949	Union City, PA	110, 5131
Tarentum, PA	2285, 4453	Tiffin, OH	900, 907		13039		8879, 14093
	5351, 13940		3315, 5427	Trenton, TN	8406, 12438	Union City, TN	3919, 4442
Tarkio, MO	3079		7795	Trenton, TX	5737		9239, 9629
Tarpon Springs, FL	12274	Tifton, GA	6542, 8350	Trevorton, PA	7722	Union Point, GA	7330
Tarrytown, NY	364, 2626	Tigerton, WI	5446, 14150	Trinidad, CO	2300, 3450	Union Springs, AL	7467, 12962
Taunton, MA	766, 947	Tilden, NE	9217, 10011	Trinity, TX	10078, 13706	Union Springs, NY	342
	957	Tillamook, OR	8574	Triumph, IL	7660	Uniontown, KY	8622
Taylor, ND	12502	Timblin, PA	11204	Tropico, CA	10412	Uniontown, PA	270, 681
Taylor, TX	3027, 3859	Timpson, TX	6177	Troup, TX	6212		5034, 12500
	5275	Tioga, PA	8092	Troutdale, VA	11990	Unionville, MO	3068, 3137
Taylorville, IL	3579, 5410	Tioga, TX	7714	Troutville, VA	9764		13268
	8940	Tionesta, PA	5038, 5040	Troy, AL	5593, 7044	Unionville, NY	11448
Tazewell, TN	7740	Tippecanoe City, OH	3004, 8839	Troy, KS	8162	University Place, NE	7737
Tazewell, VA	6123, 11533	Tipton, IA	2983, 6760	Troy, NY	163, 621, 640	Upland, CA	8266, 9570
Teague, TX	8195, 13067		13232		721, 904, 940, 963	Upper Marlboro, MD	5471
Tecumseh, MI	1063	Tipton, IN	6251, 7496		991, 992, 1012, 2873	Upper Sandusky, OH	90, 5448
Tecumseh, NE	2955, 4276	Tipton, OK	11052		7612	Urbana, IL	2915
	6166	Tishomingo, OK	5809, 7042	Troy, OH	59, 2727	Urbana, OH	863, 916
Tecumseh, OK	5376, 7756		10012, 10431		3825		2071, 2915
	10304	Titonka, IA	5597	Troy, PA	4984, 8849		4805
Tekamah, NE	4324	Titusville, PA	622, 879	Truman, MN	6364	Utica, MI	12826
Telford, PA	9257		2466, 2863	Trumansburg, NY	7541	Utica, NE	8811
Tell City, IN	2201, 5756	Tobias, NE	3725, 7578	Tuckahoe, NJ	8681, 14189	Utica, NY	185, 1308
	7375	Toccoa, GA	6687	Tuckahoe, NY	10525, 13889		1392, 1395

City	Charter #	City	Charter #	City	Charter #	City	Charter #
Utica, OH	7596	Vineland, NJ	2399, 2918	Warren, IL	849, 9096	Waukegan, IL	945, 10355
Uvalde, TX	4517, 5175	Vinita, OK	4704, 5083	Warren, IN	7930	Waukesha, WI	1086, 1159
	6831		5860, 6602	Warren, MN	5866, 11286		2647
Uxbridge, MA	1022	Vinton, IA	1593, 5088	Warren, OH	74, 1578	Waukomis, OK	7967, 10227
Vacaville, CA	9795	Vinton, VA	11911		2479, 3362, 6289, 6353	Waukon, IA	4921, 10207
Valdosta, GA	4429	Virginia, IL	1471, 2330	Warren, PA	520, 2226	Waupaca, WI	4414, 4424
Vale, OR	8528, 9496	Virginia, MN	6527		4879		14063
Valentine, NE	6378	Viroqua, WI	8529, 14058	Warren, RI	673, 1008	Waupen, WI	3391, 7898
Valier, MT	9520	Visalia, CA	7063, 9173		1419	Waurika, OK	8715, 8744
Vallejo, CA	9573, 11206		12678	Warrensburg, MO	1856, 5156		8861
Valley City, ND	2548, 2650	Volant, PA	11834	Warrensburgh, NY	9135	Wausa, NE	9994, 10017
	5364, 11417, 13324, 13385	Volga, SD	6099	Warrenton, VA	6126, 9642	Wausau, WI	2820, 4744
Valley Falls, KS	11816	Wabash, IN	129, 3935		12966	Wauseon, OH	7091
Valley Junction, IA	5891		6309	Warsaw, IL	495, 9929	Wautoma, WI	7136, 8689
Valley Mills, TX	9148	Wabasha, MN	3100	Warsaw, IN	88	Waverly, IA	3105
Valley Stream, NY	11881	Waco, TX	2189, 3135	Warsaw, NC	11767	Waverly, IL	6116
Valley View, TX	7731		3901, 4309, 4349, 6572	Warsaw, NY	737	Waverly, KS	6101
Valliant, OK	9992		8818, 9828, 10220, 11140	Warsham, MA	1440	Waverly, NY	297, 1192
Valparaiso, IN	105, 2403	Waconia, MN	11410	Wartrace, TN	9627		12954
	2704, 6215	Waddams Grove, IL	11675	Warwick, NY	314	Waverly, OH	5635
Van Alstyne, TX	4289, 7016	Wadena, MN	4821, 4916	Warwick, RI	1284	Waverly, TN	5963, 9331
Van Buren, AR	7361		12507	Waseca, MN	6544, 9253	Waverly, VA	10914
Van Buren, ME	10628	Wadesboro, NC	4947	Washburn, ND	6327	Waxahachie, TX	2974, 3212
Van Hook, ND	10966	Wadesville, IN	8927	Washington, DC	26, 526		4379, 13516
Van Nuys, CA	10168	Wadsworth, OH	5828, 5870		627, 875, 1069, 1893	Waycross, GA	4963
Van Wert, OH	422, 2628	Wagener, SC	10485		1928, 2038, 2358, 2382	Wayland, NY	5196
Vancouver, WA	3031, 6013	Wagoner, OK	5016, 6048		3425, 3625, 4107, 4195	Wayne, NE	3392, 4354
	8987, 9646, 13137, 14186		7628		4244, 4247, 4522, 5046		9244
Vandalia, IL	1517, 1779	Wahoo, NE	2780, 3118		6716, 7446, 7936, 9545	Wayne, PA	12504
	4994	Wahpeton, ND	2624, 4106		10316, 10504, 10825, 13762	Wayne City, IL	10460
Vanderbilt, PA	8190		4552, 7695	Washington, GA	8848, 8894	Waynesboro, GA	7899
Vandergrift, PA	5080, 7816		12875	Washington, IA	398, 1762	Waynesboro, PA	244, 4445
Vassar, MI	2987, 8723	Wailuku, HI	5994		2656, 6122		5832, 11866
Veblen, SD	9858	Waitsburg, WA	4681, 8895		13849	Waynesboro, VA	7587, 9261
Veedersburg, IN	11044	Wakarusa, IN	11043	Washington, IN	2043, 3842	Waynesburg, PA	305, 839
Velasco, TX	4662	Wakeeney, KS	3776	Washington, KS	2912, 3160		4267, 5085, 6105, 13134
Venice, CA	10233	Wakefield, MA	1455	Washington, MO	5388		13873
Ventnor City, NJ	10248	Wakefield, MI	11305	Washington, NC	4997	Waynesville, NC	6554
Ventura, CA	7210, 9685	Wakefield, NE	5368, 9984	Washington, NJ	860, 5121	Waynesville, OH	2220
	12996	Wakefield, RI	1206, 1554	Washington, OK	10277	Waynoka, OK	9709
Venus, TX	5549, 7798	Wakita, OK	5982	Washington, PA	586, 3383	Weatherford, OK	5352, 5758
Verden, OK	8759, 8859	Wakonda, SD	7968		4181, 9901		7238
Vergennes, VT	1364, 2475	Walden, NY	2348, 5053	Washington, VA	6443	Weatherford, TX	2477, 2723
Vermilion, IL	10365		10923	Washington Court House, OH	284, 1972		3975
Vermilion, SD	4603, 7352	Waldoboro, ME	744, 1108		4763, 13490	Weatherly, PA	6108
	13346	Waldron, AR	5849	Washingtonville, NY	9065	Webb City, MO	4475, 8016
Verndale, MN	6022	Walhalla, ND	9133	Washtucna, WA	9054	Webbers Falls, OK	8024
Vernon, IN	4688	Walker, MN	8476	Wastland, TX	11258	Webster, MA	2312, 11236
Vernon, NY	1264	Walla Walla, WA	2380	Waterbury, CT	780, 791		13411, 13780
Vernon, TX	4033, 4130		3956, 9068		2494, 3768	Webster, NY	13145
	5203, 7010	Wallace, ID	4773, 9134	Waterbury, VT	1462	Webster, PA	6937
Vero, FL	11156	Wallingford, CT	2599	Waterford, NY	1229	Webster, SD	6502, 8559
Verona, PA	4877	Wallins Creek, KY	12202	Waterford, PA	10027	Webster City, IA	1874, 2984
Versailles, KY	1835	Wallkill, NY	10155	Waterloo, IA	792, 2910		3420
Versailles, MO	7256, 13367	Wallowa, OR	9002		5120, 5700, 6854, 13702	Webster Springs, WV	8360, 14013
Versailles, OH	9336	Walnut, IL	2684	Waterloo, IL	10180	Weedsport, NY	11020
Vevay, IN	346	Walnut Creek, CA	10281	Waterloo, NY	368	Weehawken, NJ	12829
Vian, OK	10573	Walnut Park, CA	12572	Watertown, MA	2108	Weeping Water, NE	3523, 5281
Viborg, SD	13589	Walnut Ridge, AR	9332, 12083	Watertown, NY	73, 671	Wehrum, PA	7112
Vicksburg, MS	803, 3258	Walnut Springs, TX	8130		1490, 1507, 1508, 2657	Weiser, ID	6754, 8139
	3430, 6121	Walsenburg, CO	7022		4296	Weissport, PA	10214
	7507	Walterboro, SC	9849	Watertown, OH	6943	Welch, WV	9048, 9071
Victor, CO	5586	Walters, OK	6612, 7811	Watertown, SD	2935, 3349		13512
Victoria, TX	4184, 10360		14108		3414, 7504	Welcome, MN	6331
Victoria, VA	12183	Waltham, MA	688	Watertown, WI	1010, 9003	Weldon, NC	5767
Victorville, CA	11005	Walthill, NE	9816, 8685	Waterville, ME	762, 798	Welectka, OK	6324, 6689
Vidalia, GA	9879	Walton, NY	4495		880, 2306	Wellesley, MA	7297
Vienna, GA	9618	Waltonville, IL	11516	Waterville, MN	7283	Wellington, CO	7793
Vienna, IL	4433	Wamego, KS	3434	Waterville, NY	1361	Wellington, KS	2879, 3091
Vienna, SD	7597	Wampum, PA	6664, 14112	Waterville, WA	4532		3564, 3865
Vienna, VA	11764	Wanette, OK	6641, 8304	Watervliet, MI	10498		8399
Villa Grove, IL	7088	Wapakoneta, OH	3157, 3535	Watkins, NY	358, 456	Wellilngton, OH	464, 2866
Ville Platte, LA	10588		9961		3047, 9977	Wellington, TX	8102, 9805
Villisca, IA	2766, 7506	Wapanucka, OK	5950, 8123	Watonga, OK	5804		13249
	14041	Wapato, WA	9129	Watseka, IL	1721	Wells, MN	4669, 6788
Vincennes, IN	1454, 1873	Wappingers Falls, NY	9326	Watsontown, PA	2483, 3459	Wells, NY	13289
	3864, 4901	Ware, MA	628	Watsonville, CA	9621	Wells River, VT	1406
Vincetown, NJ	370	Warner, NH	1674	Waubay, SD	6124	Wellsborough, PA	328, 3938
		Warner, OK	8809				

City	Charter #	City	Charter #	City	Charter #	City	Charter #
Wellsburg, WV	1387, 1884		10142	Wickliffe, KY	543	Winifred, MT	11006
	14295	Westfield, NY	504, 3166	Wilber, NE	2991, 6415	Winnebago, MN	5406, 10393
Wellston, MO	8011		12476	Wilburton, OK	6890, 10170	Winnebago, NE	9671
Wellston, OH	3565	Wastfield, PA	9513	Wilcox, NE	7861	Winnemucca, NV	3575
Wellston, OK	9983, 12078	Westhope, ND	7162	Wilcox, PA	12933	Winner, SD	11119
Wellsville, NY	2850, 4988	Westminster, MA	2284	Wildwood, NJ	6278	Winnsboro, SC	2087
Wellsville, OH	1044, 6345	Westminster, MD	742, 1526	Wilkes Barre, PA	30, 104	Winnsboro, TX	5674, 6168
Wellsville, PA	8498		1596		732, 2736, 9235, 13852	Winona, MN	550, 1643
Welsh, LA	6360, 6418	Weston, OH	6656	Wilkinsburg, PA	4728, 5265		1782, 1842, 2268, 3224
Wenatchee, GA	8064	Weston, WV	1607, 13634		13823		10865
Wendell, ID	9491	Westport, CT	394	Wilkinson, IN	9279	Winona, WV	9850
Wendell, MN	10898	Westport, IN	9175	Williams, IA	5585	Winslow, AZ	12581
Wenona, IL	3620	Westport, NY	9405	Williamsburg, IN	8625	Winslow, IN	9159
Wernersville, PA	8131	Westville, IL	7500	Williamson, WV	6830, 10067	Winsted, CT	1494, 2414
Weslaco, TX	12641	Westville, NJ	10430	Williamsport, Md	1551		2419
Wesley, IA	5457	Westville, OK	10158	Williamsport, OH	10267	Winston, NC	2319, 2425
Wessington, SD	8325	Westwood, NJ	8777	Williamsport, PA	175, 734		4292, 9916
Wessington Springs, SD	6446	Westmore, KS	8974		1505, 2139, 2227, 3705	Winston-Salem, NC	12278
West, TX	5543, 8239	Wetonka, SD	11441	Williamstown, MA	3092	Winter, CA	13312
	13935	Wetumka, OK	7724	Williamstown, NJ	7265	Winter Garden, FL	379, 12100
West Alexander, PA	5948	Wetumpka, AL	7568	Williamstown, WV	6233, 11483		11389, 13383
	8954, 11993	Wetumpka, OK	5935	Willimantic, CT	2388	Winters, CA	10133
West Allis, WI	6908	Wewoka, OK	6254, 8052	Williston, ND	5567, 8324	Winterset, IA	1403, 2002
West Baden, WI	6388	Weyauwega, WI	7470	Willisville, IL	10911	Winthrop, ME	552
West Bend, WI	11060	Weymouth, MA	510	Willits, CA	11566	Winthrop, MN	7014, 14042
West Chester, PA	148, 552	Wharton, NJ	13047	Willmar, MN	6151	Winthrop, NY	10747
	2857	Wharton, TX	4903, 6313	Willoughby, OH	11994	Wiscasset, ME	1549
West Concord, MN	5362, 14167	What Cheer, IA	3192	Willow City, ND	6766, 7332	Wise, VA	10611
West Conshohocken, PA	8890	Whatcom, WA	4099	Willows, CA	9713	Wisner, NE	4029, 6866
West Derry, NH	8038	Wheatland, WY	8432	Wills Point, TX	5018, 6071	Witt, IL	7538, 10264
West Elizabeth, PA	6373	Wheaton, IL	9368	Willsboro, NY	11971		13144, 13650
West Englewood, NJ	12402	Wheaton, MN	6036, 8993	Wilmerding, PA	5000, 6325	Woburn, MA	746, 7550
West Frankfort, IL	7673	Wheeler, OR	12427	Wilmetter, IL	10828		11067, 14033
West Greenville, PA	249	Wheeling, WV	360, 1343	Wilmington, DE	473, 1190	Wolbach, NE	8413
West Grove, PA	2669		1424, 1594, 5164, 10455		1390, 1420	Wolcott, NY	5928
West Hempstead, NY	13104	White, SD	6294, 7134		3393	Wolf Point, MT	11036
West Hoboken, NJ	9867	White City, KS	7970	Wilmington, IL	1177	Wolfborough, NH	1486
West Liberty, OH	2942	White Hall, IL	7077, 7121	Wilmington, NC	1656, 4726	Wolfe City, TX	3984, 8178
West Liberty, KY	7916	White Hall, MD	9469		4960, 5182, 7913, 9124		13199
West Meriden, CT	250	White House Station, NJ	9061		12176	Wolfeboro, NH	8147
West Middlesex, PA	6913	White Lake, SD	8291, 8332	Wilmington, OH	365, 1997	Wood River, IL	11876
West Milton, OH	9062	White Pigeon, MI	4527		8251	Wood River, NE	3939
West Minneapolis, MN	7958, 12518	White Plains, NY	6351, 12574	Wilmot, MN	5301	Woodbine, IA	4745
West Moreland, KS	3304	White River Junction, VT	3484, 9108	Wilmore, KY	9880	Woodbine, MD	8799
West New York, NJ	12064	White Rock, SD	6185	Wilmot, SD	11399	Woodbine, NJ	1199, 3716
West Newton, PA	5010	White Salmon, WA	10000	Wilson, NC	2321, 13626		8299
West Orange, NJ	9542	White Sulphur Springs, MT	3375	Wilson, PA	6794	Woodbury, TN	9089
West Palm Beach, FL	11073, 12057	Whitefish, MT	8589	Wilsonville, IL	12630	Woodhull, IL	10716, 12525
	13300	Whitehall, MI	2429	Wilton, ND	11712	Woodlake, CA	10309
West Paterson, NJ	12848	Whitehall, MT	11024	Wilton, NH	13247	Woodland, CA	9493, 10878
West Plains, MO	5036	Whitehall, NY	285, 1160	Wilbledon, ND	6712, 8917	Woodlawn, IL	11771
West Point, GA	8046		2233, 8388	Winamac, IN	7761, 8747	Woodlawn, PA	10951
West Point, MS	2891	Whiteland, IN	9492	Winburne, PA	7334	Woodmere, NY	12294
West Point, NE	3340, 3370	Whitesboro, NY	11284	Winchendon, MA	3300	Woodridge, NY	11059
West Randolph, VT	2274	Whitesboro, TX	5847, 10634	Winchester, IL	1484, 1821	Woodsfield, OH	5414
West Salem, IL	9338	Whitesburg, KY	10433	Winchester, IN	889	Woodstock, IL	372, 2675
West Seneca, NY	6964, 12925	Whitestone, NY	8957	WInchester, KY	995, 2148		6811, 14137
West Superior, WI	3926, 4399	Whitestown, NY	1458		3290	Woodstock, MN	7625
	4680, 4878	Whitesville, NY	7850	Winchester, MA	5071, 11103	Woodstock, VA	5449
West Troy, NY	1265	Whitewater, WI	124, 2925	Winchester, NH	887	Woodstock, VT	1133
West Union, IA	2015	Whitewright, TX	4692, 6915	Winchester, TN	8631, 8640	Woodstown, NJ	399, 11734
West Union, OH	9487, 13198	Whiting, IA	10861	Winchester, VA	1535, 6084	Woodsville, NH	5092
West Union, WV	6424, 13881	Whiting, IN	6526	Windber, PA	5242, 6848	Woodville, OH	7707
West Winfield, NY	801, 7483	Whitinsville, MA	769		14082	Woodward, OK	5575
West York, PA	8938	Whitman, MA	4660	Winder, GA	9051, 10805	Woonsocket, RI	970, 1058
Westboro, MA	421	Whitmire, SC	6102	Windham, CT	1614		1402, 1409, 1421, 1463
Westbrook, MN	6412	Whitney, TX	7875, 7915	Windham, NY	12164, 13962	Woonsocket, SD	5946
Westbury, NY	11730		13649	Windom, MN	5063, 6396	Wooster, OH	828, 1912
Westerly, RI	823, 952	Whitney Point, NY	7679	Windsor, CO	8296, 9120		4657, 7670
	1169	Whittier, CA	5588, 7999	Windsor, IL	7339	Worcester, MA	79, 442
Westernport, MD	5831	Wibaux, MT	8259	Windsor, MO	9519		455, 476, 765, 1073
Westervelt, IL	10641	Wichita, KS	1913, 2782	Windsor, NY	9415		1135, 2273, 2699, 7595
Westerville, OH	7671		2786, 3524, 3683, 3756	Windsor, PA	12063	Worden, IL	10669
Westfield, IL	8216		5169, 6392, 9758, 11010	Windsor, VT	816, 3257	Worland, WY	8253
Westfield, MA	190, 1367		12346		7721	Wortham, TX	6686
Westfield, NJ	4719, 8623	Whichita Falls, TX	3200, 4248	Winfield, IA	10640	Worthington, MN	3550, 5910
			10547, 11762, 13665, 13676	Winfield, KS	3218, 3351		8989
		Wickford, RI	1592		4556	Worthington, WV	10450
				Winfield, TX	10488	Wray, CO	8752, 9676

City	Charter #
Wrentham, MA	1085
Wrightsville, GA	8023
Wrightsville, PA	246
Wssex, CT	8936
Wyalusing, PA	5339, 10606
Wyandotte, KS	1840
Wyandotte, MI	12616
Wyanet, IL	9277
Wyckoff, NJ	12272
Wylie, TX	5483
Wymore, NE	9138
Wymore, NE	4210
Wyndmere, ND	7166
Wynne, AR	10807
Wynnewood, OK	5126, 5731
Wyoming, DE	9428
Wyoming, IA	1943
Wyoming, IL	2815, 6629
Wyoming, NY	13229
Wyoming, PA	8517
Wytheville, VA	9012, 12599
Xenia, IL	12096
Xenia, OH	277, 369
	2575, 2932
Yakima, WA	2876
Yale, MI	5482
Yale, OK	10014
Yankton, SD	2068, 4613
	9445
Yardley, PA	4207, 13950
Yardville, NJ	12606
Yarmouth, MA	516
Yates, ND	9698
Yates, Center, KS	3108, 6326
Yazoo City, MS	12587
Yazoo City, MS	3566
Yoakum, TX	4363, 8694
Yonkers, NY	653, 2074
	9825, 13319
York, NE	2683, 3162
	4245, 4935
	7821
York, PA	197, 604
	694, 2228, 2303, 2958
	9706
York Springs, PA	7856
York Village, ME	4844
Yorktown, TX	6987
Yorktown, VA	11554
Yorkville, IL	6239
Yorkville, SC	6931
Youngstown, OH	3, 2217
	2350, 2482, 2693, 4970
	12332, 13586
Youngsville, PA	8165
Youngwood, PA	6500
Ypsilanti, MI	155
Yerka, CA	10299, 10731
	13340
Yukon, OK	6159, 10196
Yuma, AZ	7591, 9608
Yuma, CO	10093
Zanesville, OH	131, 164
	1230, 2529, 4298, 5760
	5769
Zelienople, PA	6141, 7409
Zillah, WA	9576

CATALOG NUMBER CROSS REERENCE OF TYPE NOTES

Large-Size Notes

Type	$1	$2	$5	$10	$20	$50	$100
Demand Notes	–	–	242	463	700	–	–
United States Notes	1–28	153–170	243–273	464–492	701–723	926–941	1120–1136
National Bank Notes							
First Charter Period	29–35	171–177	274–286	497–508	728–740	953–964	1151–1162
Second Charter Period	–	–	287–315	509–539	741–772	965–986	1163–1183
Third Charter Period	–	–	316–342	540–566	773–798	987–1012	1184–1206
National Gold Bank Notes	–	–	343–348	567–577	799–807	1013–1014f	1207–1211
Compound Interest Treasury Notes	–	–	–	493–495	724–726	942–944	1137–1139d
Interest-Bearing Notes	–	–	–	496	727	945–952	1139g–1150
Silver Certificates	36–61	178–196	349–372	578–602	808–827	1014g–1028	1212–1221
Treasury (Coin) Notes	62–67	197–202	373–379	612–617	843–847	1043	1242–1243
Refunding Certificates	–	–	–	603–604	–	–	–
Gold Certificates	–	–	–	605–611	828–842	1029–1042	1222–1241
Federal Reserve Notes	–	–	380–381	618–619	848–849	1044–1045	1244–1245
Federal Reserve Bank Notes	68	203	382	620	850	1046	–

Small-Size Notes

Type	$1	$2	$5	$10	$20	$50	$100
United States Notes	69	204–206	383–385	–	–	–	–
Silver Certificates	70–94	–	386–388	621–625	–	–	–
Federal Reserve Notes	95–111	207	391–420	628–655	853–878	1047–1073	1250–1273
Gold Certificates	–	–	–	699	925	1119	1319
Federal Reserve Bank Notes	–	–	389	626	851	1047	1248
National Bank Notes	–	–	390	627	852	1048	1249

Bibliography

Annual Reports of the Director of the Bureau of Engraving and Printing, Government Printing Office, Washington, DC.

Appleton's Cyclopaedia of American History. D. Appleton & Co., New York, 1887.

Bayley, Rafael A. *The National Loans of the United States of America from July 4, 1776 to June 20, 1880*, as prepared for the Tenth Census of the United States. Washington, DC, 1882.

Blake, George H. *United States Paper Money.* Published by the author, 1908.

Bowen, Harold L. *State Bank Notes of Michigan.* Havelt Advertising Service Inc., 1956.

Clain-Stefanelli, Elvira and Vladimir. *American Banking.* Acropolis Books, Ltd., Washington, DC, 1975.

Columbia Viking Desk Encyclopedia. Viking Press, New York, 1968.

Coudert, L.L. *The Romance of Intaglio Bank Notes.* American Bank Note Co., New York, 1925.

DeKnight, W.F. *History of the Currency of the Country and the Loans of the United States.* Government Printing Office, Washington, DC, 1897.

Dillistin, William H. *A Descriptive History of National Bank Notes.* Printed by the author, 1956.

Fielding, Mantle. *Dictionary of American Painters, Sculptors and Engravers.* James F. Carr, New York, 1965.

Friedberg, Robert. *Paper Money of the United States.* Coin and Currency Institute, Inc., New York, 1989.

Gengerke, Martin. *United States Paper Money Records.* Published by the author, New York, 1989.

Gould, Maurice. *Hawaiian Coins, Tokens and Paper Money.* Whitman Publishing Co., Racine, WI, 1960.

Gould, Maurice, and L.W. Higgie. *The Money of Puerto Rico.* Whitman Publishing Co., Racine, WI, 1962.

Griffiths, William H. *Story of American Bank Note Company.* American Bank Note Company, New York, 1959.

Groce, George C. and David H. Wallace. *New York Historical Society Dictionary of Artists in America, 1564–1860.* Yale University Press, New Haven, 1957

Haxby, James. *Standard Catalog of United States Obsolete Bank Notes, 1782–1866.* Krause Publications, Iola, WI, 1988.

Hepburn, A. Barton. *A History of Currency in the United States.* MacMillan Co., New York, 1924.

Hessler, Gene. *An Illustrated History of U.S. Loans, 1775–1898.* BNR Press, Port Clinton, OH, 1988.

_____. *U.S. Essay, Proof and Specimen Notes.* BNR Press, Port Clinton, OH, 1980.

Hickman, John, and Dean Oakes. *Standard Catalog of National Bank Notes*. Krause Publications, Iola, WI, 1982.

History of the Bureau of Engraving and Printing 1862–1962. Treasury Department, Washington, DC, 1964.

Hodder, M.J. and Q.D. Bowers. *The Standard Catalogue of Encased Postage Stamps*. Bowers and Merena, Wolfeboro, NH, 1989.

Hunter, Dard. *Papermaking*. Dover Publications, New York, 1978.

Huntoon, P. "The United States $500 & $1,000 National Bank Notes." *PAPER MONEY*. Society of Paper Money Collectors. No. 136, July/Aug. 1988, pp. 103–121.

Huntoon, P. and L. Van Belkum. (ed. M.O. Warns). *The National Bank Note Issues 1929–1935*. The Society of Paper Money Collectors, 1970.

Isted, John. *U.S. Large-Size Currency*. Unpublished manuscript.

Knox, John Jay. *United States Notes*. T. Fisher Unwin, London, 1885.

Lehman-Haupt, H. *Gutenberg and the Master of the Playing Cards*. Yale University Press, New Haven & London, 1966.

Limpert, Frank Alvin. *United States Paper Money, Old Series 1861–1923 Inclusive*. Published by the author, 1948.

Morris, Thomas F., II. (ed. Barbara R. Mueller). *The Life and Works of Thomas F. Morris, 1852–1898*. Published by the author, 1968.

Murray, Douglas D. *Handbook of United States Large Size Star Notes*. Published by the author, Kalamazoo, MI, 1985.

Muscalus, John A. *Famous Paintings Reproduced on Paper Money of State Banks, 1806–1866*. Published by the author, 1969.

Newman, Eric P. *The Early Paper Money of America*. Krause Publications, Iola, WI, 1990.

O'Donnell, Chuck. *The Standard Handbook of Modern United States Paper Money*. Krause Publications, Iola, WI, 1982.

Radford, C., MD. *The Souvenir Card Collectors Society Number System*. Souvenir Card Collectors Society, Tulsa, OK, 1989.

Schwan, Carlton F. *Military Payment Certificates*, BNR Press, Port Clinton, OH, 1981.

Schwan, Carlton F. and Joseph E. Boling. *World War II Military Currency*. BNR Press, Port Clinton, OH, 1978.

Shafer, Neil. *A Guide of Modern United States Currency*. Western Publishing Co., Racine, WI, 1979.

_____. *A Guide Book of Philippine Paper Money*. Whitman Publishing Co., Racine, WI, 1964.

Springs, Agnes Wright. *The First National Bank of Denver: the Formative Years 1860–1865*. Bradford-Robinson Printing Co., Denver, Colorado, undated.

Timberlake, Richard. *Gold, Greenbacks, and the Constitution*. The George Edward Durrell Foundation, Berryville, VA, 1991.

Van Buren, A.H., & S. Edmonds. "The Master of the Playing Cards," *The Art Bulletin*. March 1974, pp. 12–30.

Publications:

Coin World
PAPER MONEY
Bank Note Reporter
The Essay-Proof Journal
The Numismatist

Auction catalogs and price lists:

Bebee's (James M. Wade Collection)
Bowers & Merena
Currency Auctions of America
William P. Donlon
Albert A. Grinnell (reprinted by W.T. Anton, Jr. and M. Perlmutter, 1971)
Hickman & Oakes
John Hickman
Lyn F. Knight
Dean Oakes
Robert A. Siegal
R.M. Smythe
Stack's
Superior Stamp & Coin Co.

Index

Acts, Congressional:
 H.R. 5661 (postal notes), 387.
 Dec. 26, 1814 (fee for note signers), 38.
 July 17, 1861, 10, 19.
 April 7, 1866 (restricts images of living persons on currency), 354.
 March 3, 1873 (restricts images of living persons on currency), 354.
 January 14, 1875, 351.
 April 17, 1876, 351.
Adams Express Co., 13.
African-American Registers of the Treasury, 27.
Agriculture, 69, 205.
Allen, J.A., 172.
Allen and Rowell (photographers), 305.
Altar of Liberty, 278, 328.
America, 191, 229, 315, 329.
America Contemplating a Bust of Washington, 70.
American Bank Note Co., 4, 15, 17, 19, 36, 43, 73, 99, 114, 151, 267 165, 197, 198, 230, 235, 236, 240, 267, 268–270, 299, 347, 351, 353, 355, 358, 359, 361, 363, 366, 367, 389, 440, 472, 473.
American Express Co., 387.
American Numismatic Association, 479.
America Presented to the Old World, 118.
America Seizing the Lightning, 159, 165.
anti-photographic green ink, 31.
Antique Poesy, 450, 464.
Arabs, 2.
Archambault, A.M., 171.
Architectural Armaments in Berlin, 459.
Army and Navy, 347.
Arrival of the Sirius, 1838, 303.
Art, 151.
assignats, 5.
Astronaut, 466.
Atlantic Cable, 207.
awards to author, *vii*.

Bainbridge, William, 348.
Baker, E.D., 166, 330.
Baldwin Bank Note Co., 307.
Baldwin, George D., 207, 269, 298.
Baldwin, Marcus W., 80, 155, 201, 211, 246, 281, 325, 348, 436, 450, 460, 464, 470.
bank note, first in Europe, 5.
Bank of America (Morocco, IN), 13.
Bank of Battle Creek, MI, 13.
Bank of Canada, 7.
Bank of Detroit, 12.
Bank of England, 5.
Bank of New York, 6.

Bank of North America, 6, 409.
Bank of the United States, 6, 10.
Bannister, James, 17, 118, 157, 270, 338.
Baptism of Pocahontas, The, 198.
Baron, James, 204.
Battle of Lake Erie, 270.
Battle of Lexington, The, 198.
Benton, Thomas H., 278, 279.
Benzing, J.C., 88, 110, 134, 327, 452, 470.
Berger, Anthony, 80, 127, 129, 134, 262, 366.
Bering, Vitus, 431.
Bermuda (ship), 369.
B-52A Bomber, 466.
Bierstadt, Edward, 119.
bills of credit, 11.
Bison, 467.
Blashfield, Edwin H., 105.
Book of Hours of Catherine of Cleves, 3.
Bouquet, The, 465.
Bower, Richard, 453, 458–460.
Bradbury Wilkinson & Co. Ltd., 441.
Brady, Matthew, 127, 129, 134.
Breen, Walter, 262, 276, 319, 333, 365.
Brockway, William E. "Long Bill", 317.
Brooks, Charles, 91, 219, 454, 457, 466, 468, 470.
Bruce, Blanche K., 27.
Buchanan, James, 72.
"buffalo bill", the, 155.
Bureau of Engraving and Printing, 79, 105, 125, 235, 268, 269, 307, 315, 321, 331–333, 337–339, 345, 351, 390, 408, 442, 469, 472.
Bureau of the Public Debt, 306, 317, 331, 337.
Burt, Charles, 9, 72, 77, 78, 79, 81, 100, 105, 107, 108, 110, 193, 127, 129, 134, 157, 159, 165, 198, 207, 229, 232, 233, 243, 262, 264, 279, 296, 297, 300, 305–307, 312, 320, 321, 324, 325, 329, 330, 341, 349, 357, 358, 362, 366–368.

Caduceus, 233.
Capitol, The, 100, 201.
Carpenter, Joseph R., 351, 368.
Casilear, Durand, Burton and Edmonds, 18.
Casilear, George W., 81, 354, 359, 367, 394.
Casilear, John W., 193, 233.
Ceres, 450, 465.
Chaffee, James B., 102.
Chalmers, C.M., 108.
C(hange-over) Day, 442.
Chapman, John G., 198.
Chappell, Alonzo, 243.
Chase Manhattan Bank, 138.

Chase, Salmon P., 10, 12, 20, 42, 47, 73, 157, 232, 316, 342, 343, 350.
Chiang Kai-shek, 4.
Chickering, Charles R., 456, 457.
China, 2.
Chorlton, H.L., 82, 171, 176, 271.
Chorlton, William, 100, 328, 470.
Christian IX, King, 441.
Citizens National Bank, 267.
Civilization, 303.
Civil War (American), 10.
Clark, Spencer M., 20, 29, 354.
Clark, William, 155.
Clay, Henry, 15, 228.
Cleveland, Grover, 47, 211, 214, 326, 327.
Clinton, DeWitt, 312.
Clymer, George, 19, 171.
Cobb, Howell, 70.
Colman, John, 5.
Columbia, 315, 358.
Columbian Bank Note Co., 194, 351, 358, 362.
Columbus' Discovery of Land, 74, 129.
Columbus in His Study, 312.
Columbus in Sight of Land, 118.
Commerce, 460.
Composition and Reflection, 446.
compound interest treasury notes misdated, 39.
Comstock, Anthony, 125.
Conant, Charles A., 436.
Concordia, 77.
Confederate notes, 14.
Continental Bank Note Co., 118, 316.
Continental Congress, 5, 6, 11, 409.
Continental currency, 5, 11, 12, 14.
Cook, Captain James, 431.
Cooper, D.M., 82, 103, 172, 205, 245, 277, 280, 320, 324.
Cooper, James Fenimore, 11.
COPE-PAK, 21–26.
Coppenhaver, W.A., 82, 172, 280.
counterfeiting, 3.
Courtney, 163.
Courturier, Hendrick, 16.
Cox, Kenyon, 281.
Crabb, Michael A., Jr., 249.
Crawford, Thomas, 15, 113, 315.
Crawford, William H., 368.
Creamer, J., 466.
Croome, W., 234.

Dallas, Alexander, 68.
damaged currency, 53.
Darley, Felix O.C., 9, 11, 198.
Decatur, Stephen, 204, 348.
Declaration of Independence, 112, 270.
Declaration of Independence (signers of), 112.
Delaroche, Paul, 266.
de la Rue, Thomas, 50.
de Legazpi, Miguel Lopez, 434.

Delnoce, Louis, 100, 102, 103, 118, 165, 236, 262, 270, 276, 300, 318, 329, 334, 347, 470.
de Léon, Juan Ponce, 439.
de Muelles, Jacques, 4.
DeSoto Discovering the Mississippi in 1541, 159, 308.
Dexter, Samuel, 367.
Dintaman, Arthur, 111, 456, 459, 466.
Discovery of the Mississippi by DeSoto, 316.
Dodge, John Wood, 232.
Dougal, W.H., 82, 107, 172, 242, 277, 280, 324.
Douglas, Stephen, 341.
Doyle, Rev. Richard, *viii*.
drachma, 1.
Draper, Toppan, Longacre and Co., 11.
Dunlap & Clarke, 389.
Duplessis, 229.
Duthie, James, 354, 355, 359, 363.

Eagle and Harbor Scene, 69.
Eagle and Ships, 68.
Eagle and Stars, 328.
Eagle of the Capitol, 80, 157, 338.
Eagle's Nest, The, 300, 332.
Eagle with Flag, 84, 307.
Eagle with Shield, 314.
Earle, H.K., 190.
École des Beau Arts, 266.
Egypt, 2.
8 real, 11.
Eissler, John, 246, 249, 250, 260, 283, 293, 309, 326, 327, 349, 435, 449, 458, 463.
Electricity Presenting Light to the World, 125.
Ellis, L.F., 79.
Embarkation of the Pilgrims, 236, 342.
Engraving and Printing Bureau of the Treasury Department, 20.
E Pluribus Unum, 62, 66, 67, 70, 72, 151, 206, 229, 278, 299, 321, 331.
Europe, 459.
Essay Proof Journal, 266.
Everett, Edward, 241.

Fabriano, Italy, 2.
Farmer and Mechanics, 267.
Farmers Bank of Sandstone, 13.
Farming, 176.
Farragut, David G., 280.
Federal Surplus Commodities Corporation, 472.
Felver, Edward, 465, 466.
Female with Fasces, 451.
Fenton, Charles, 118.
Fenton, M., 453, 456, 457.
Fessenden, William P., 161, 360.
First Division of the National Currency Bureau, 20.
First National Bank of Boston, 6.
Fisk, James, 300.
Flowers of the South, 449.
flying money, 1.
Forbes Lithographic Co., 442.

forbidden titles, 410.
Fort Worth, Texas, 21.
Franklin and Electricity, 159, 165.
Franklin, Benjamin, 8, 47, 65, 170, 229, 281, 283, 293, 349, 379, 385.
Fraser, James E., 467.
Freedom, 113.
French, Daniel C., 134.
French Revolution, 5.
Fulton, Robert, 105.

Gallatin, Albert, 37, 68, 166, 295.
Garfield, James, 110, 119, 207.
Gault, J., 379.
General Scott's Entrance into Mexico, 318.
Gengerke, Martin, 73, 101, 117, 153, 158, 167, 168, 172, 195, 230 197, 207, 209, 210, 235, 244, 249, 262, 296, 322.
German, C.S., 151.
Gill, Delancey, 468.
Girsch, Frederick, 151, 159, 232, 270, 299, 303, 308, 334, 357, 361, 471.
gold coins (vignette), 123, 165, 203.
goldsmith recipt, *viii,* 123, 165, 203.
grading, 52.
Grant, Ulysses S., 47, 80, 124, 125, 244, 246, 249, 250, 260, 373.
Great Eagle, The, 234.
Great Seal of the United States, 30, 88, 127, 208, 323.
greenbacks, 10, 27.
Gresham's Law, 12.
Guardianship, 467.
Guardian, The, 264.
Gugler, Henry, 115, 153, 196, 312, 471.
Gutenberg Bibles, 3.
Gutenberg, Johann, 3.
Gwenn, Edmund, 4.

Hall, A.W., 89.
Hall, E.M., 79, 82, 88, 103, 106, 107, 126, 171, 172, 242, 277, 280, 293, 320, 323, 324.
Hall, J.R., 277.
Hall, Tolman W., 13.
Hall, W.H., 172, 245.
Hamilton, Alexander, 5, 6, 47, 99, 113, 166, 177, 179, 180, 190, 193, 227, 230, 302, 321, 322, 323, 325.
Hamilton Tool Co., 23.
Hancock, Gen. Winfield Scott, 103.
Hanks, Owen G., 230, 264, 302.
Harrison, Benjamin, 122.
Hatch, George W., 58, 64, 231, 265, 299.
Hatch, Lorenzo, 119, 124, 125, 128, 205.
Hawaii overprint, 89, 141, 182.
Hein, E.J., 451, 459.
Helm, A.L., 107, 172, 242, 324.
Hemicycle, 266.
Hendricks, Thomas A., 168.
Herrick, Henry, 347.
Hill, J.R., 172.

Hillegas, Michael, 19, 171.
History Instructing Youth, 79.
Hollow Horn Bear, Chief, 468.
Homer Lee Bank Note Co., 387–389.
Hopkinson, Francis, 29.
Horstman, R., 266.
Howe, F.T., Jr., 465.
Huber, G.L., 91, 116.
Hull, Mary, 357.
Hung Wu, Emperor, 7.
Hunt, Dr. Thomas Sterry, 31.
Huntoon, Peter, 303, 318.
Hurlbut, S.S., 103.
Huston, C.A., 176, 435.

Independence Hall, 283.
Indian Camp, 9.
Indian Maiden as America, 65, 68.
Industry, 65, 176, 205.
Ingham, Charles Cromwell, 312.
Ingham, Samuel D., 10.
In God We Trust, 30, 31, 90, 91, 111, 124, 135, 144, 184, 221, 255, 288.
Inman, Henry, 209, 308.
insurance, 479.
intaglio, 2.
interest-bearing treasury notes misdated, 38.
In the Turret, 267.
Introduction of the Old World to the New, 153.
Isted, John, 167, 168, 209, 210, 235, 262, 340.
Izard, Anne, 454.

"Jackass note", 153.
Jackson, Andrew, 48, 115, 156, 173, 176, 215, 216, 232, 336–340, 349, 380, 412.
Jacobs, W.M., 277.
Jalabert, 78.
James I, King of Catalonia and Aragon, 4.
Japan, 3, 4.
Jarvis, John W., 368.
Jefferson, Thomas, 6, 48, 50, 107, 110, 112, 349, 353, 359.
Jiao Zi, 1.
Jocelyn, Nathaniel, 353, 355.
Johnson, Andrew, 20, 81, 369.
Joliet, IL, 176.
Jones, Alfred, 70, 159, 165, 191, 198, 233, 234, 236, 268, 295, 318, 471.
Jones, R.J., 91.
Jones, William A., 436.
Justice, 62, 64, 67, 72, 231, 265, 296, 301, 314, 317, 321, 329.
Justice with Scales, 364.
Justice with Shield, 233, 264.

Kamehameha III, King, 432.
Kao-Tsung Dynasty, 1.
Kennedy, J., 79, 82, 320.

Kidder National Bank, 41.
Knight, Charles, 155.
Knollwood, Thomas, 358.
Knox, John, 12, 273.
Korea, 3.
Koster, W.P., 264.
Khan, Kublai, 1.
Khan, Ghengis, 4.
King Williams War, 5.

Labor, Plenty, America, Peace and Commerce, 281.
Lamar, Mary, 15.
Lamasure, F., 293.
Landing of Columbus, 118.
Landing of the Pilgrims, 122, 129.
Land, Sea and Air, 211.
Landseer, Edwin, 11.
Lansdowne Portrait of Washington, 264.
Laura, 459.
Law, John, 5.
Lawton, Gen. Henry W., 434, 436.
"Lazy Two", 102.
Legend of Sleepy Hollow, 11.
Lefebvre, Jules, 450, 465.
Lewis and Clark Centennial Exposition, 155.
Lewis, Meriwether, 155.
Liberty, 62, 66, 193, 262, 266, 314, 320, 328, 357, 449, 453, 460.
Liberty and Progress, 163.
Liberty and Union, 300.
Library of Congress, 446.
Liebler, T.A., 77, 118, 153, 159, 165, 328, 329, 471.
Lincoln, Abraham, 48, 80, 81, 127, 134, 151, 196, 262, 306, 307, 350, 354.
Liliuokalani, Queen, 432.
Lincoln Memorial, 134.
Lloyd, Robert H., 89.
Longacre, James B., 11, 170, 334.
Louis IX, 4.
Louis XVI, 5.
Low, Will, 79.
Loyalty, 230.
Luff, G., 232.
Lutz, W.F., 106, 277, 320.
Lydia, 1.
Lyons, Judson, W., 27.

MacArthur, Gen. Douglas, 435.
MacDonough, James, 353.
MacKenzie, Alexander, 431.
Madison, James, 6, 48, 328, 331–335.
Major, James P., 236, 353, 355.
Manning, Daniel, 205.
Mansfield, Joseph King, 297.
Mansfield, Josie, 320.
Man with Scythe, 299.
Many, S.B., 82, 320.

Marcy, William L., 319.
Marks, Julian S., 353.
Marshall, John, 209, 308.
Marshall, W., 353, 355, 359.
Massachusetts Bank, 6.
Massachusetts (battleship), 348.
Massachusetts Colony, 4.
Massachusetts General Court, 5.
Master of the Playing Cards, 3.
McCulloch, Hugh, 201.
McKinley, William, 48, 163, 309, 434, 437.
McLeod, D.R., 88.
McPherson, Gen. James B., 107.
Meade, Gen. Gordon G., 166, 324.
Mechanics, 161.
Mechanics and Agriculture, 106.
Mechanics and Navigation, 239.
Meditation, 464.
Meredith, William, 358.
Mercury, 58, 231, 265.
Michigan General Bank Law of 1837, 12.
Minerva, 67.
Minerva as America, 69.
Ming Dynasty, 1, 4, 7.
Minute Man, 461.
Moneta, 440.
Monroe, James, 17, 48, 276.
Monticello, 110.
Montgomery, W., 126.
Morgenthau, Henry, Jr., 88.
Morris, Gouverneur, 29.
Morris, Robert, 48, 166, 311.
Morris, Thomas F., 79, 105, 125, 320, 389, 409.
Mortar Firing, 196, 302.
Morse, Samuel F.B., 105.
mottos, 30, 31.
movable type, 3.
Mt. Ranier and Mirror Lake, 464.
"Mr. 880", 4.
Murray, Doug, 248, 282.
Murray, Draper, Fairman & Co., 55–58,
Music and Art, 65.
Myers, E.E., 82, 126, 172, 245, 277, 280.

Napier, James C., 27.
National Archives, 467.
National Banking System, 14
national bank note charters (year granted), 45.
National Bank Note Co., 15, 19, 43, 73, 99, 114, 232, 266, 277, 299, 315, 351, 357, 358, 361, 366.
national bank note rarity table, 44.
national motto, 30, 31.
Naval Engagement between the Guerriere and the Constitution, 316.
New Ironsides, 298.
New London, CT, 9, 12.

New London Society United for Trade and Commerce, 5.
New York (battleship), 108.
New York Times, The, 320.
Nichols, W.D., 102, 303, 318, 353, 358.
North Africa (notes for), 89, 136.
Noyes, F.H., 469.
Nutter, H.S., 190.

obol, 1.
Ocean Telegraph, 207.
Ohio Centennial, 1888, 389.
"Old Charter" bills, 5.
"Old Fuss'n Feathers," 269.
"Operation Bernhard", 4.
Ouray, Chief, 469.
Ourdan, Joseph P., 74, 99, 227, 261, 279, 299, 354, 355, 359, 363.

Pablo, 155.
Painting, 151.
Palmstruch, Johann, 4.
Panama, 246.
papyrus, 2.
parchment, 2.
Pauling, F., 190, 345.
Payne, G.A., 111.
Pease, Joseph I., 129, 198.
Phillips, W.G., 104, 172, 277.
"piece of 8", 11.
Pine, Robert Edge, 166.
Pilot, 466.
Pi Sheng, 3.
Pioneer, The, 115.
playing card money, 7.
playing cards, 3.
Pocahontas Presented at Court, 153.
Polo, Marco, 7.
Ponickau, Robert, 84, 88, 106, 126, 127, 320, 323.
Ponickau, William, 320.
"porthole" note, 127.
Powell, W.H., 270, 308.
Pratt, Bela Lyon, 446.
Prender, J.P., 106.
Prayer for Victory, 236.
Price, H., 13.
Prince of Wales, 70.
printing presses, 21, 22, 50.
Progress of Civilization, The, 315.
Prosperity, 299.

"queer" (counterfeit), 4.

"Racakteer Note", 410.
Ransom, C.L., 323, 325.
Rawdon, Freeman, 58, 64, 231, 265.
Rawdon, Wright & Hatch, 17, 18, 60, 61, 63, 64.

Rawdon, Wright, Hatch & Edson, 64, 67, 70, 71, 230, 231, 265.
Reconstruction, 262.
Registers of the U.S. Treasury, 19
Return of Peace, 228
Rice, W.W., 118, 153, 233, 236.
Rip van Winkle, 11.
Rittenhouse, William, 2.
Rizal, José, 435.
Roach, W.A., 468.
Robertson, Archibald, 113.
Romerson, C., 358, 361.
Ronaldson, D.S., 79, 106, 449.
Rose, E.G., 172.
Rose, G.U., 106, 205.
Rose, G.U., Jr., 79, 82. 107, 126, 171, 172, 242, 245, 277, 280, 320, 323, 324.
Romans, 1.
Roosevelt, Franklin D., 88.
Root, H.G., 232.
Rothert, Matthew H., 31.
Rubruk, William of, 4.
Rueff, J.A., 280.
Running Antelope, Chief, 126.
Russell, D.M., 172, 324.

Sailor, 466.
St. Nicholas, 16.
Scenes of Indian Life, 11.
Schlecht, Charles, 79, 103, 105, 166, 168, 204, 209, 241, 245, 280, 308, 311, 319, 348, 471.
Schofield, L.S., 449, 468.
Schoff, S.A., 296.
Schussele, Charles, 74.
Science Presenting Steam and Electricity to Industry and Commerce, 105.
Scott, Gen. Winfield, 268, 269, 299.
Sealey, Alfred, 74, 79, 115, 153, 145, 201, 208, 215, 216, 316, 328, 331–340, 349.
Secretaries of the U.S. Treasury, 19.
Seward, William, 245, 348, 431.
Shensi Province, 2.
Sheridan, Gen. Phillip, 125, 172, 373.
Sherman, John, 239.
Sherman, Gen. William T., 373.
Shirlaw, Walter, 118, 125, 163, 471.
signatures on U.S. paper money, 19, 27–29.
Sir Walter Raleigh Presenting Corn and Tobacco to the English, 102.
Skinner, Charles, 161, 206, 278, 321, 331, 360.
Smillie, G.F.C., 76, 84, 87, 105, 106, 122, 125, 126, 163, 171, 173, 176, 177, 17
Smillie, James, 123, 159, 165, 196, 201, 275, 298, 302, 318.
Smillie, James D., 9, 303.
Smith, Charles, 228, 317.
Smith, Ostrander, 122, 155, 201, 273.
Smithsonian Institution, 322, 334, 342.

Society for the Suppression of Vice, 125.
Society of Paper Money Collectors, 11.
Soldier, 466.
Souvenir Card Collectors Society, 429.
Spain, 4.
Spanish-American War, 439.
Spanish milled dollar, 12, 409.
Spencer, Col. W.E., 317.
Spinner, Francis E., 19, 365.
spit (obol), 1.
Spread Eagle, 261.
Standard Bearer, The, 298.
Standing Liberty, 15.
Stanton, Edwin M., 367.
star (replacement) notes, 35.
Stars and Stripes, 102.
State Bank Notes of Michigan, 13.
state banks, 10.
Stimpson, Alexander L., 13.
Stockholm Banco, 4.
Stuart, Gilbert, 11, 76, 87, 110, 332, 355, 454.
Submarine Thomas A. Edison, 466.
Sully, Thomas, 115, 336.
Sumner, Charles, 305.
Sung Dynasty, 1.
*Surrender of General Burgoyne to General Gates at
 Saratoga*, 303.
Surrender of General Gates at Saratoga, 303.
Swedish Riksbank, 4.

T'ang Dynasty, 1.
Tank, 466.
test pieces, 49, 50.
Thomas de la Rue, 50.
Thomas, George W., 128.
Thomson, Charles, 30.
Thurber, G.W., 102, 303, 318.
"tombstone note", 168.
Toomer, Louis, B., 27.
Toppan, Carpenter & Co., 64, 65, 69–71, 151.
Transportation, 301.
Traveler, The, 299.
Trumbull Gallery, 112.
Trumbull, John, 112, 177, 179, 270, 303, 318, 334.
Ts'ai Lun, 2.
Tudor Press, 442.

"two bits" (origin of), 11.

Union, 70, 270.
Union and Civilization, 201, 464.
U.S. Capitol, 250, 318.
United States Bank Note Corporation, 472.
United States Department of Agriculture, 472, 473.
U.S. Post Office fire, 340.
U.S. Treasury Building, 177, 315.
U.S. Treasury Seal, 29.

Vancouver, George, 431.
Vanderlyn, John, 118, 276.
Vernon, William T., 27.
Versailles portrait of Columbus, 440.
Victoria, Queen, 11.
Victory, 196, 297, 331.

Walker, Robert, 362.
War of 1812, 10.
Warren, R.H., 323.
Washington, George, 12, 49, 50, 62, 69, 74, 76, 79, 84, 87,
 106, 208, 299, 301, 302, 315, 352, 355, 356, 359, 363,
 380, 383–385, 386, 437.
Washington, Martha, 78, 79.
Washington Crossing the Delaware, 236.
Washington Resigning his Commission, 318, 334.
Wasserback, A.L., 448, 450, 463.
"watermellon note", 280.
Wealth, 58, 64, 265.
Webster, Daniel, 153.
Weeks, E.M., 88.
Wells, W.B., 190, 327, 345.
West, Benjamin, 105.
White House, The, 215, 219.
Wier, R.W., 16, 236.
Wilson, Woodrow, 345.
Windom, William, 104.
Winterhalter, F., 70.
woodcut, 2.
Woodward, Judge Augustus B., 12.
Wright, Silas, 243.

Yan H'u, 1.
Young Students, The, 15.

It would be to your advantage to join the Society of Paper Money Collectors, organized in 1961 to further the following objectives:

1. Encourage the collecting and study of paper money.
2. Cultivate fraternal collector relations with opportunities for discussion trading, etc.
3. Furnish information and knowledge through experts, particularly through the Society's *PAPER MONEY* magazine.
4. Encourage research about paper money and publication of the resultant findings.
5. Promote legislation favorable to collectors, providing it is in accord with the general welfare.
6. Advance the prestige of the hobby.
7. Promote exhibits at numismatic and syngraphic meetings.
8. Encourage realistic and consistent market valuations.

PAPER MONEY, the society bimonthly journal, is sent to all members. In addition to informative articles, it lists new members, the collecting specialty of each, and identifies each as a collector or dealer. Member are encouraged to submit articles for publication.

BOOKS that catalog the obsolete currency of individual states are available to members at reduced prices.

MEETINGS, national and regional, take place throughout the year.

DUES are $20 per year and are payable in U.S. funds. Members who join the Society prior to October 1 receive the magazines already issued in the year in which they join. Members who join after October 1 will have their dues paid through December of the following year. They will also receive, as a bonus, a copy of the magazine issued in November of the year in which they join.

JUNIOR MEMBERS, from 12 to 17 years of age, are required to have a parent or guardian sign their application. The "J" that will precede membership numbers will be removed upon notification to the secretary that the member has reach 18 years of age.

SOCIETY OF PAPER MONEY APPLICATION

Check one: _____ Regular, 18 or older _____ Junior, 12 to 17 years

NAME _____ OCCUPATION _____

ADDRESS _____

COMPANY NAME (if any) _____ ___ Collector ___ Dealer ___ Both

SIGNATURE _____ parent or guardian if junior _____

PAPER MONEY INTERESTS _____

SPMC SPONSOR _____

Dues: $20 per year; $25 for members in Canada and Mexico; $30 for other countries; $300 for life membership. Send application and U.S. funds, payable to SPMC to: Ronald Horstman, SPMC, P.O. Box 6011, St. Louis, MO 63139.

SOCIETY OF PAPER MONEY APPLICATION

Check one: _____ Regular, 18 or older _____ Junior, 12 to 17 years

NAME _____ OCCUPATION _____

ADDRESS _____

COMPANY NAME (if any) _____ ___ Collector ___ Dealer ___ Both

SIGNATURE _____ parent or guardian if junior _____

PAPER MONEY INTERESTS _____

SPMC SPONSOR _____

Dues: $20 per year; $25 for members in Canada and Mexico; $30 for other countries; $300 for life membership. Send application and U.S. funds, payable to SPMC to: Ronald Horstman, SPMC, P.O. Box 6011, St. Louis, MO 63139.